ARTHUR FITZWILLIAM TAIT

ARTHUR FITZWILLIAM TAIT

Artist in the Adirondacks

An Account of His Career
by
WARDER H. CADBURY

A Checklist of His Works
by
HENRY F. MARSH

AN AMERICAN ART JOURNAL / KENNEDY GALLERIES BOOK

NEWARK: UNIVERSITY OF DELAWARE PRESS
LONDON AND TORONTO: ASSOCIATED UNIVERSITY PRESSES

Associated University Presses
440 Forsgate Drive
Cranbury, NJ 08512

Associated University Presses
25 Sicilian Avenue
London WC1A 2QH, England

Associated University Presses
2133 Royal Windsor Drive
Unit 1
Mississauga, Ontario
Canada L5J 1K5

The paper used in this publication meets the requirements of the
American National Standard for Permanence of Paper for Printed Library Materials.

Library of Congress Cataloging in Publication Data

Cadbury, Warder H.
 Arthur Fitzwilliam Tait: artist in the Adirondacks.

 (The American art journal/University of Delaware Press
books)
 Includes A. F. Tait's own checklist, edited and
expanded.
 Bibligraphy: p.
 Includes index
 1. Tait, Arthur Fitzwilliam, 1819–1905. 2. Painters—
United States—Biography. 3. Tait, Arthur Fitzwilliam,
1819–1905—Catalogs. 4. Adirondack Mountains Region
(N.Y.) in art. I. Tait, Arthur Fitzwilliam, 1819–1905.
II. Marsh, Henry F., d. 1973. III. Title. IV. Series.
ND237.T323C33 1986 759.13 [B] 82-40347
ISBN 0-87413-224-X (alk. paper)

Printed in the United States of America

Contents

Preface

"AMERICA OWES A HEAVY DEBT OF GRATITUDE TO ARTHUR F. TAIT," WROTE THE editor of *Antiques* in 1933, nearly three decades after the painter's death. "Though born an Englishman, he lived in this country long enough, and loved it deeply enough, to record pictorially distinctive aspects of its life with penetrating sympathy and undeviating accuracy of detail."

This book has been a long time in the making, for it was not until the late 1940s that Arthur J. B. Tait, the artist's son and a retired businessman, decided to write a biography, only to discover with dismay his lack of primary source materials. While the painter did keep a remarkably detailed account of his canvases, he wrote no personal narratives nor even revealing letters to family or fellow artists which would make possible a more three-dimensional portrait of his character and career. But we are grateful to A. J. B. Tait for preserving his father's records of his paintings, for initiating this project, and for jotting down a few pages of anecdotal family traditions. When his niece and her husband, Emma Tait Marsh and Henry F. Marsh, inherited these memorabilia, Henry Marsh worked on the checklist of paintings for a decade or so before I became involved as a partner to research the biography. Both personally and professionally our collaboration was a delight for more than a dozen years. We visited together with our families, and in the intervals exchanged a stream of letters sharing our excitement and pleasure as, little by little, new data were discovered.

Over the years so many owners of Tait's paintings and museum and library staff members have provided useful information that it has become impossible to thank again here each and every one. Individuals who have been especially helpful at critical points are noted with appreciation in appropriate footnotes. A grant from the Penrose Fund of the American Philosophical Society enabled us to begin a permanent reference file of photographs of Tait's paintings. The role of the trustees and personnel of the Adirondack Museum, without whose generous support and patience this project would never have succeeded, is recognized in Craig Gilborn's acknowledgments.

It is a special pleasure to express my gratitude for personal assistance which went beyond the usual conventions of scholarly courtesy. At the beginning of my research, when it was far from clear that enough material could be found to make a biography feasible, Professor Francis S. Grubar put into my hands some references to Tait's early years in New York which he had noted while working on his book on William Ranney. Robert C. Vose of the Vose Gallery in Boston and the late Harry Shaw Newman of the Old Print Shop in New York were from the start generous with information and encouragement. The account of Tait's early years in England owes much to the investigations of the late Arnold Hyde of

Manchester, and of Hilda Lofthouse and Anne C. Snape of Chetham's Library in the same city. Rita Feigenbaum, now Registrar of the Jewish Museum in New York, worked over an early draft of the manuscript, helping me find the right words to say what I meant to say. Margaret Mirabelli sharpened the text of a later draft with deft editorial skills. William L. Sands gave hope and courage at those dark moments when both were in short supply.

Warder H. Cadbury
State University of New York
at Albany

Only Emma Tait Marsh and
Julia M. Cadbury fully know how much
this book has meant—and for their
love and loyalty, this book is dedicated to them.

Acknowledgments

THIS BOOK HAS ACTIVELY ENGAGED THE ATTENTIONS OF A DOZEN PERSONS OF THE staff of or associated with the Adirondack Museum. The project had its inception in 1962 when it was agreed that research would proceed on a book about the life and work of Arthur Fitzwilliam Tait. The Museum was to provide support, with Henry Marsh to continue his years of work locating and cataloguing the artist's paintings and Warder Cadbury to write Tait's biography.

Henry Marsh's primary source was the three-volume "register" in which Tait had recorded almost all of the paintings which he executed in the U.S. during a long and productive career that spanned the years 1851 to 1905, beginning with his arrival in New York City at the age of thirty-one and concluding with his death in Yonkers at eighty-five. The register, some letters, photographs, and other materials belonged to Mr. Marsh's wife, Emma Tait, a granddaughter of A. F. Tait.

The project did not move along as quickly as intended. For one thing, new paintings kept turning up and some of these were not to be found among the 1,500 or so entries in Tait's register. In addition, in contrast to ample documentation about Tait's production of paintings, there existed little material revealing how Tait felt about his craft or about his place among the circle of artists with whom he was acquainted in New York City. The difficult task of putting together information from disparate sources fell to Warder Cadbury, a professor of philosophy at Albany and a student of Adirondack history.

From the Museum's standpoint, Tait was among the most important of the several hundred artists—professionals and amateurs—who are known to have worked in the Adirondacks when the region and its scenic and natural beauties were revealed to the public. This fruitful period of about seventy-five years' duration saw a decline not long after Tait's own death in 1905. Lacking a book, a loan exhibition, "A. F. Tait: Artist in the Adirondacks," for which I was the principal planner, was an interim substitute for the work then still in progress. Henry Marsh's death that year, in 1973, also made the exhibition a capstone to his labors. The exhibition catalogue was dedicated to him, and most of the materials on A. F. Tait were donated by Emma Tait Marsh to the Adirondack Museum not long after.

The Museum wishes to thank Alice Wolf Gilborn for overall and final editing for the Museum, and to Tracy Meehan, registrar, for updating the checklist from 1978 to 1981. William K. Verner, former curator, worked on the checklist during its early stage. In addition to writing the biography, Warder Cadbury was a source of information and suggestions during the twenty-one years he has been involved with the project. Lisa Reynolds was copy editor for the University of Delaware Press.

Other Museum personnel who contributed to the project included Connie Campbell Hutchins, Holman J. Swinney, Marcia Smith, William Crowley, George Bowditch, and Edward and Sarah Comstock, Jr.

The project was made possible by the faithful support of several Museum trustees— Harold K. Hochschild, Walter Hochschild, and Rudolf Wunderlich. Essential at the last stage of preparation were the approval and help of Lawrence Fleischman and John I. H. Baur of the *American Art Journal*, and Thomas Yoseloff of Associated University Presses. To Katharine Turok of Associated University Presses fell the monumental task of assembling the mass of material and the final editing.

Collectors and galleries have freely shared information about their Tait paintings and photographs, notably George Arden, Kennedy Galleries, Inc., Sotheby Parke Bernet Galleries, and Christie's Galleries. Patricia C. F. Mandel conducted research, later published, on the British influences on Tait's painting before he came to the United States.

A personal expression of appreciation goes to Emma Tait Marsh and her daughter Gayle Trumbull of Clearwater and Sarasota, Florida; also to Arthur F. Tait II, of El Paso, and Alan Richard Tait, of Oporto, Portugal.

Craig Gilborn, Director
The Adirondack Museum
Blue Mountain Lake, N. Y.

ARTHUR FITZWILLIAM TAIT

PART I
AN ACCOUNT OF HIS CAREER

by

WARDER H. CADBURY

1

England
1819–1850

FROM THE VERY START OF HIS LONG CAREER AS A PAINTER, ARTHUR F. TAIT ALMOST always enjoyed a knack for doing the right thing at the right time. At an early age he began to acquaint himself not only with art, but with the practical aspects of the art business as well. About 1831, when he was only twelve years old, he went to work at Agnew & Zanetti's Repository of Arts in Manchester, England.[1] The store sold barometers and thermometers, mirrors and frames, cut glass and ormulu, china and bronzes, and "curiosities of every description," as well as paintings and prints.[2] Soon after Tait's arrival Thomas Agnew assumed full management, changed the firm's name to his own, and began to specialize in the fine arts exclusively. His descendants still carry on the family tradition at their internationally distinguished gallery on Bond Street in London.

Agnew proved to be a versatile mentor for Tait. As a young art student Agnew had learned to carve and gild picture frames and to clean and restore old canvases. His aesthetic tastes were progressive enough to admire the work of such contemporary British painters as Turner and Constable. And when he began to encourage and guide the rising class of textile and shipping magnates in the purchase of paintings, Agnew helped develop a new source of patronage for the arts which supplemented that of the landed aristocracy.

According to the tradition that has come down in the Tait family, it was Thomas Agnew who noticed his young employee's appreciation of the prints and paintings in his shop and who then helped him to acquire the fundamentals of the artist's craft. The earliest memento of Tait's long career, a copy of the book *Principles of Design*, signed and dated 1832 by Tait, was probably a gift from Agnew. This English translation from the work of the seventeenth-century French engraver Sebastian LeClerc included both outline drawings of noted marble models from antiquity and detailed examples of various facial expressions that can be produced by changes in the position of the eyes, nose, and mouth. These formulae for depicting traits of human character were typical conventions of the pedagogy of French and Italian art academies.

His duties at Agnew's store kept Tait busy from eight in the morning to eight in the evening, but so strong was his desire to learn that an arrangement was made with the Royal Manchester Institution, now the City Art Gallery, for the young Tait to study there on his own. According to family tradition, he would awaken the janitor at 3 A.M. by throwing pebbles against his window. When the door was unlocked, Tait would take his pencils and paper to the deserted exhibition rooms to make drawings of the plaster casts of Greek and

Roman statuary. This anecdote is similar to that of Benjamin Robert Haydon's sketching the recently arrived Elgin marbles by candlelight.

At this time Tait produced some imaginative drawings of knights in armor and admiring ladies that suggest the influence of Sir Walter Scott's very popular "gothick" novels. The careful treatment of medieval castles reveals an early interest in architecture. Tait also demonstrated a mechanical bent when he decided to make a life-mask of his father. Removing the hardened plaster from his face proved to be an uncomfortable experiment, but the affectionate parent nonetheless began to encourage his son's artistic aspirations.

Arthur Fitzwilliam Tait, the next-to-youngest of ten children, was born August 5, 1819, in a suburb of Liverpool, where his father, William Watson Tait, was engaged in prosperous mercantile and shipping enterprises.[3] Much of his business involved trade between the West Indies and European ports on the North Sea, where he had branch offices and warehouses. He celebrated his self-made success by having his portrait painted,[4] only to be overtaken by a series of misfortunes. The Napoleonic wars cut him off from his commerce with the Continent and he suffered severe losses. Somewhat later, unaware that a peace treaty had been already signed, one of his ships, armed as a privateer, sank a Dutch vessel. When W. W. Tait was compelled to pay a large compensation for this mistake, he sold the comfortable family home and lived very modestly thereafter.

The children of the large family were thus obliged to fend for themselves. The oldest, Jane, had already married well; her husband, William Cawkwell, eventually became a railway executive. Augustus Tait emigrated to Canada and the United States about 1840, while Mortimer Tait became a successful businessman in Manchester. William A. Tait took a position in Oporto, Portugal, with the Royal Mail Steam Packet Company, where some of his descendants are still involved in the travel business.

The youngest son, Arthur, was sent as a small boy to live with his mother's sister and her husband on their farm at Hest Bank, not far from Lancaster. In this rural environment, deprived of a gentleman's education, Tait acquired instead a fondness for animals and for hunting and fishing. These enthusiasms lasted all his life and eventually determined the subject matter of his paintings. As soon as he was old enough, Tait was sent to Manchester to learn a trade and support himself.

Tait was still employed as a clerk at Agnew's when he first met Marian Cardwell. He had introduced himself at a Whitsun Day fair in the spring of 1838 by buying her some ginger nuts. Marian was the daughter of a rope maker and lived not far from Tait's lodgings. A surviving memento of their courtship is a watercolor showing a young man with a pony talking to a girl with an open wicker basket of brook trout.[5] The face of the young woman is believed to be Marian's. However, the hands of both figures are unfinished; in later years Tait continued to have occasional difficulties depicting the human figure.

The earliest documented declaration by Tait that he intended to be an artist is recorded in the marriage register of the Manchester Collegiate Church. Entry number 322, dated December 20, 1838, reads:

> Arthur Fitzwilliam Tait, of full age, bachelor, artist . . . son of William Tait, gentleman, married, by banns, Mary Ann [sic] Cardwell, a minor, spinster. . . . The bridegroom signed the register, but the bride made her mark.

About the time of his marriage Tait quit his job at Agnew's Repository of Arts. "Having attained considerable knowledge of drawing," noted a biographical sketch in an American art journal a few years later, "he threw up his place in the store and set up as a teacher of drawing, in connection with lithography. His experience in the field only served to confirm his artistic tastes. He fully resolved to pursue art as his profession, and lost no opportunity for study in the studio and field."[6] In 1839 he contributed a penciled landscape to the annual exhibition of the Royal Manchester Institution, the first known public showing of his work.[7] And in 1840 the Manchester city directory listed Tait for the first time, giving his occupation as "professor of drawing."

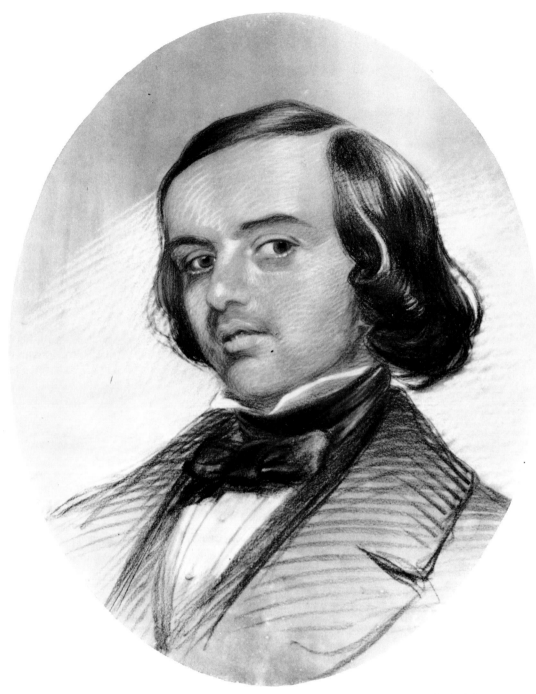

A. F. Tait 1839 by C. A. Dudley. Courtesy of The Adirondack Museum.

The important new method for the mass production of pictorial matter, lithography, was invented at the turn of the century by Johann Aloys Senefelder of Munich. The first English translation of his work, *A Complete Course of Lithography*, was published in 1819, the year of Tait's birth. According to family tradition Tait prudently taught himself the painstaking skills of the lithographer since it would be a more reliable source of income than tuition fees for drawing lessons from occasional students. The Industrial Revolution stimulated further technological improvements in the process of printing from lithographic stones and also created a rapidly growing demand for pictorial materials of all kinds, from maps to advertising posters and package labels. Tait no doubt perceived on the basis of his experience at Agnew's that, in addition to its commercial usefulness, lithography held great promise for the

fine arts, since it would make modestly priced prints, reproductions, and book illustrations easily available to an increasingly large and discriminating market. With his good sense of timing Tait thus learned a new trade that put him in the mainstream of contemporary developments in British graphic arts.

No less opportune was Tait's decision to seek employment as a lithographer and draftsman with two church architects in Manchester, Charles Bowman and Joseph S. Crowther. The Gothic Revival was well under way in England, and these partners who "knew medieval work intimately,"[8] planned to publish some illustrated historical volumes on the subject. The Victorians had enthusiastically embraced the architectural styles of the Middle Ages in an extraordinarily complex movement that mingled literary, romantic, and antiquarian sentiments with moral, liturgical, and theological doctrines. In 1836 Gothic was all but established as a national style when it was selected for the rebuilding of the Houses of Parliament, and the design details of Westminster were the work of Augustus W. N. Pugin, the Gothic Revival's most influential spokesman.

Tait never showed signs of having a religious temperament, and the lack of a formal education probably precluded his appreciation of the subtlety and symbolism of ecclesiastical architecture. The appeal of his new employment was in greater freedom and opportunity, compared to "minding the store" at Agnew's. Since he could often work at home on his own schedule, Tait could also afford some time for artistic studies in the open air. In the summers of 1840 and 1841 he made excursions to Scotland and the Isle of Skye that produced a handful of charming watercolor sketches of the rugged Highlands, done in a somewhat rococo manner with soft rose and lavender pastels.[9] Some of these are landscapes with ancient castles, but one sketch includes two sportsmen fishing. His journal of the second trip reveals a sensitivity to the beauty of loch, mountain and sea.[10] Though it rained frequently and his boots gave him sore feet, Tait obviously enjoyed roughing it on these walking tours.

By 1842 Tait had moved to Liverpool, where the printing firm of MacLure, MacDonald & MacGregor sponsored a large public exhibition on the still-novel art and process of lithography, which "from its infinite variety of application is rendered invaluable for illustrative and commercial purposes."[11] At the same time Tait was invited to hang a scene of Saint Augustine's Church at the annual exhibition of the Liverpool Academy,[12] not far from where he and Marian had taken lodgings on Islington Street. While seeking opportunities for freelance commissions, Tait could still easily pick up and deliver assignments from Bowman and Crowther by traveling the thirty miles to Manchester on the recently completed railroad, one of the first passenger trains in England. His employers apparently commended Tait's skills to other architects, for his earliest known published work, a small drawing of the new Collegiate Institute in Liverpool, appeared in a guidebook of the city in 1842.[13] Since the Gothic building was not entirely finished at that time, Tait must have had access to the plans of its façade.

The next year, 1843, Tait executed both the original drawing and then the stone for a large lithograph of Saint Jude's Church in Liverpool,[14] while the printing was entrusted to the distinguished London firm of Day & Haghe, "Lithographers to the Queen." Saint Jude's architect had been Thomas Rickman, a pioneer in the Gothic Revival, whose nomenclature for the successive phases of medieval English styles is still commonly used today. Since Rickman had died in 1841, this print may have been commissioned as a memorial to him.

After some years in preparation, two large quarto illustrated folios by Bowman and Crowther and published by George Bell finally appeared in 1845 with the title *The Churches of the Middle Ages, being select specimens of Early and Middle Pointed structures, with a few of the purest Late Pointed examples*. The volumes contain 118 exquisitely detailed lithographs of views, floor plans, and elevations. Fifteen of the plates, two of them tinted, have the imprint "On Stone by A.F.T."[15] At about the same time, Bowman and Crowther were busy designing the Hyde Chapel in Cheshire; Tait later did a large lithographic print of that graceful building.[16]

Meanwhile Tait had been working on an ambitious project of his own. In the summer of

1843 he spent much of his free time making careful pencil-and-wash sketches of bridges, tunnels, and panoramic landscapes along the sixty-mile route of the recently completed Manchester and Leeds Railway.[17] His sister's husband William Cawkwell was in charge of the station at Brighouse, which probably provided a convenient place for him to stay while working in the field. The following year Tait devoted himself to the painstaking work of copying his drawings onto the smooth limestone surface of the lithographic plates. In old age he used to reminisce how he had to hold his breath to focus his attention and steady his hand. If he made one slip, the whole picture was ruined.

In 1845 twenty of these lithographs appeared together in a large volume, of which the engraved title page read in part: *Views on the Manchester and Leeds Railway, Drawn from Nature and on Stone, by A. F. Tait.* Accompanying the tinted pictures, printed by Day & Haghe, was a descriptive history written by Edwin Butterworth, an authority on local history and topography. Stamped in gold on the blue cloth cover were the arms of the cities of Manchester and Leeds.[18]

It is not entirely clear how the publication of this handsomely illustrated folio was financed. The dedication page, addressed to the officers of the railroad, asserts that "this humble attempt to depict the magnificent scenery and stupendous works of art [on the railway line] . . . is with their permission, most respectfully inscribed by their most obedient servant, A. F. Tait." This might suggest that the corporation itself had subsidized Tait's labors. However, the railroad's historical archives do not mention Tait or his book, and this was not yet the era of business-sponsored publicity of this kind.[19] The first title page asserts that it was "published for A. F. Tait" by Bradshaw and Blacklock of Manchester, the same firm that has published for many years the well-known Bradshaw's guides, maps, and time-tables for Britain's railways. A second title page notes that the book was "published by A. F. Tait" and gives his street address in Liverpool. It seems probable, therefore, that Tait himself solicited advance subscriptions from prospective patrons. The selling price of the folio of prints is not known, but judging from comparable volumes of the same period, the cost may have been around fifty shillings, more than the wages for six weeks of an agricultural laborer. Curiously enough, Tait does not seem to have kept a souvenir copy for himself, but the one he gave to Chetham's Library in Manchester, inscribed in his own hand "from the artist," is still there.

If Tait had not chosen such a propitious time, the costly project would have been a risky financial venture for an unknown artist. But England was in the grip of a "railway mania" that began in the cities where Tait lived.[20] He was twelve years old when the opening of the first passenger railroad in Britain from Manchester to Liverpool on September 15, 1830, was a national sensation, and he may have been among the nearly half million spectators along the thirty-mile route that day. In the next fifteen years 5,000 miles of passenger track had been built, with an additional 2,000 under construction.

Tait's book of scenes, each nearly 13 by 20 inches, was patterned after a similar volume of views that Thomas Talbot Bury had sketched of the Liverpool and Manchester Railroad and published in 1831, a book that proved popular enough to be reprinted a number of times and in several languages. While Bury left it to others to transfer his sketches onto stone (and he clearly owed a great deal to such people), Tait drew his scenes from nature and then made the lithographs himself. Of interest is the fact that after Bury did another series of railway views in 1837 (which were not a commercial success), he became prominent in the Gothic Revival movement as both architect and antiquarian.

From a contemporary aesthetic point of view this rather specialized genre of early railway prints served two distinct functions—documentary and topographical.[21] Some compositions simply celebrated the triumph of heroic enterprise over the obstacles of nature. Masonry bridges, tunnels, and stations were themselves regarded as works of art. As Francis D. Klingender, the pioneering historian of the art of the Industrial Revolution observed, "While many artists of the time lost themselves in academic banalities, retired into the picturesque or

else sought escape from contemporary life in colourful visions of an imaginary past, the straightforward desire to record the achievements of the engineers continued to inspire many unassuming draughtsmen and illustrators."[22]

On the other hand, some of Tait's prints concentrated on the scenic vistas along the route in which the visible role of the railroad was only a small part of the panorama, perhaps no more than a wisp of smoke in the far distance. Thanks to the iron horse, as the accompanying text observed, "the toil-worn artisans of the great towns are swiftly moved into the midst of the rural districts, to enjoy the delicious, health-inspiring breezes of the hills," and scarcely any other railroad in England could rival "the vast number and agreeable variety of views" now so easily accessible. It was the beginnings of tourism, when the Industrial Revolution was not yet perceived as an ugly scar upon the landscape.

While Tait's handsome folio of railway scenes in 1845 marked a high point in his career as a lithographer, two earlier prints, both copies after the work of other artists, were significant anticipations of his future career as a painter of animals. In 1842 he drew on stone and published *The Sentinel*,[23] which was a careful transposition of *Suspense*, an engraving made in 1837 after a painting by Sir Edwin Landseer.[24] Tait changed only the props surrounding the identical central figure of the bloodhound dog in order to suggest a different sort of story to the viewer's imagination.

A child prodigy from an artistic family, Landseer was the most famous English artist of his generation. His genial personality helped him win the patronage of the upper classes, and he was a special favorite of Queen Victoria. He was a frequent guest at the aristocratic shooting lodges in the Highlands of Scotland, where he found many themes for his canvases. He produced many of the most popular pictures of the nineteenth century, which were constantly reproduced and thus easily accessible to Tait at Agnew's Repository of Arts and elsewhere.

In this century Tait has occasionally been called by journalists the Landseer of America in a well-intentioned tribute to his talent as an animal painter. However, since both artists painted many canvases of deer, it is important not to mistake Landseer's influence upon Tait's style. Consider, for example, Landseer's most famous single work, *The Monarch of the Glen*, painted in 1851. Lord Kenneth Clark has pointed out that the twelve-point Highland stag

> epitomizes the self-satisfaction of the Victorian ruling class—masterful, courageous, aggressively masculine, dominating the whole environment. By deliberately endowing the animal with these human qualities, Landseer makes him an unconscious symbol of his own and his patrons' values. . . . It was commissioned for the House of Lords, but the Commons refused to vote the money and it was sold successively to a peer, a soap manufacturer and a whisky distiller.[25]

A comparison with Tait's *Stag's Head*, which he painted soon after coming to America, shows Tait's more naturalistic style. From the start he eschewed the anthropomorphic melodrama, pathos, humor, sentimentality, and metaphysical allegory that characterized so much of Landseer's popular work.[26] According to family tradition, Tait admired Landseer's genius but felt that he "prettied" his animals too much. Tait's debt to him may have been largely economic; by popularizing animal and sporting art throughout the English-speaking world, Landseer helped create a market for Tait's canvases with similar themes but a quite different manner.

Tait's other lithograph for 1842 was a special kind of animal portrait, *Sir Thomas Fairfax, A Celebrated Short-Horned Bull*.[27] This almost grotesque bovine physique represented a triumph of English scientific agriculture typical of the time. In the first half of the nineteenth century aristocratic landowners spared no effort to capitalize on newly discovered principles of animal husbandry to improve livestock breeds. It was fashionable for a while to fatten animals as much as possible, and the frequent exhibitions of local agricultural societies stimulated a competitive spirit. Animal painters and printmakers thus began to do a brisk business in

private commissions to produce pictures advertising the plump dimensions or stud fees of prize-winning champions. With *Sir Thomas Fairfax*, Tait was venturing into a narrowly specialized but very crowded genre of commercial graphic art. One scholarly bibliography lists nearly 1,000 such livestock prints in Great Britain from 1780 to 1910, but makes no mention of this one.[28]

The publishers of the *Sir Thomas Fairfax* print were R. Ackermann of London and Thomas Agnew in Manchester, which suggests that Tait's former employer may have arranged this special assignment for him. Tait's task was to copy on stone an oil painting by Richard Ansdell of the celebrated bull. Ansdell was a local sporting and animal artist with a growing national reputation. If Tait did not then become acquainted with him through the good offices of Agnew, he certainly had opportunities to see examples of his work at exhibitions in both Liverpool and Manchester. Born in Liverpool in 1815, Ansdell's early career had some parallels to Tait's: he was familiar with farm animals as a boy, he worked for a while in an art dealer's shop, and he found the means at a young age to visit Scotland. He became a member of the Liverpool Academy and was elected its president in 1845 and 1846, before moving to London.

Between 1845, when the illustrated folios on the railway and medieval churches were both published, and 1850, when he sailed for America, Tait advanced his career in two important ways: he produced another series of railway lithographs and learned how to paint with oils.

The Royal Manchester Institution, where as a boy Tait had taught himself sketching, accepted for exhibit in 1847 a view of the Sankey Viaduct between Liverpool and Manchester[29] and the following year a scene of the Vale Royal Viaduct on the line of the London and North Western Railway.[30] This corporation was a recent merger of several shorter railroads making up the trunk route from London to Liverpool, plus some branch lines; with more than 400 miles in operation, it had become the most powerful railway company in England.

A series of fifteen lithographs done by Tait about 1848 of scenes on this same London and North Western Railway have only recently been discovered in the collection of the National Railway Museum in York.[31] Tait's views cover only the Northern Division of the line above Stafford, which suggests that they were intended as a sequel to the splendid folio of lithographs by John Cooke Bourne published some years earlier depicting the southern part of the line from London to Birmingham. While Bourne, "one of the greatest of all artists of industry,"[32] was more interested in the feats of engineering and teams of laborers, Tait's views, for the most part, express a harmony between nature and machine and flatter the railways by stressing their grace and order in the broad landscape. Grazing cattle, milkmaids, and farm carts are depicted side-by-side with tall viaducts, masonry bridges, and canal locks in a bucolic idyll. Even a starkly urban scene such as *Stockport Viaduct* does not convey today the same message as it did when Tait drew it on stone. In his richly illustrated social history of early railway prints, Gareth Rees chose this scene as a frontispiece with this comment:

> At the time the view was intended to express admiration of the giant strides of the railway across industrial towns where every square inch of space was put to some wealth-producing purpose. To modern eyes, the pollution of water and air are most obvious, while the railway seems to demonstrate the inadequacy of nineteenth-century building controls. Nevertheless, Tait produced in this view something which gave the mid-Victorians a sense of pride and achievement, and in which the railway was paramount.[33]

This unique series of Tait's prints in the National Railway Museum includes a title page that identifies the firm of Bradshaw and Blacklock as both printer and publisher. Since no other copies of the views are known, Tait's lithographs probably were never produced in book form and offered for sale. The reason for this lack of commercial success was probably the strong disenchantment of the public following the 1848–49 disastrous stock market crash of speculative railway securities and the abrupt end of the railway mania.[34] For once Tait's usual good timing failed him badly.

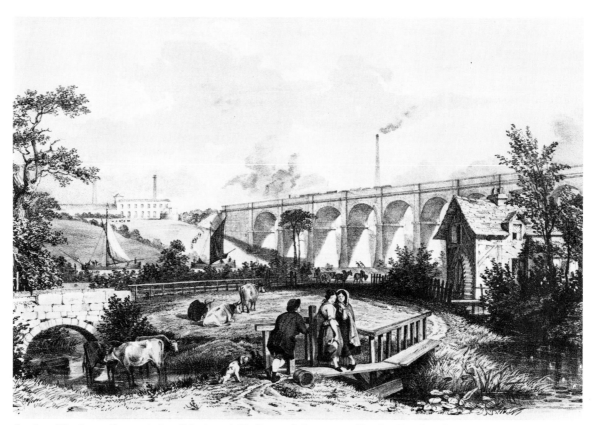

Sankey Viaduct. Copyright, National Railway Museum, York, England.

Stockport Viaduct. Copyright, National Railway Museum, York, England.

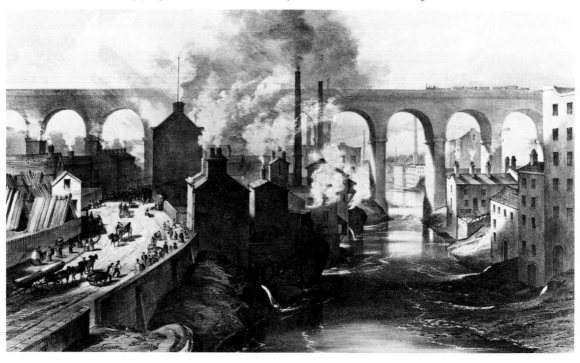

His lack of success with lithography may have only stimulated Tait's resolve to take up the study of oil painting. Among his earliest known works in this new artistic enterprise are six large topographical landscapes, each 23 by 33 inches, which are clearly derived from the scenes connected with the two series of railway prints.[35] The fact that only one of these ambitious landscapes is signed and dated on the front suggests that he was not entirely satisfied with them as finished works of art.

There was nothing unprecedented about Tait's advance from lithography to painting on canvas. The distinguished sporting artist James Ward (1769–1859) abandoned a lucrative trade as a mezzotinter to work with oils. To his surprised royal patron, George III, he explained: "I engrave to live, Your Majesty, but I paint for the pleasure of the art."[36] In this country Winslow Homer, who served an apprenticeship with a Boston print publisher, offered a somewhat different motive: "From the time I took my nose off that lithographic stone, I have had no master, and never shall have any."[37] In one of his very few autobiographical remarks, made many years later, Tait combined both sentiments: "I had to work at a business for twenty years, or until I was 30 years old, before I could practise my profession as an artist."[38]

Two other oil paintings, of a horse and of a Highland shooting scene, both dated 1848, are indications of Tait's future direction. For many years the equine portrait belonged to descendants of Tait's brother in Oporto, Portugal.[39] Curiously enough, he signed this painting "Arthur F. Tait" before adopting his invariable "A. F. Tait." The handsome thoroughbred is depicted with a care and precision that suggest an extremely detailed knowledge of anatomy, while the brushwork of the background is much looser.

How did Tait learn to paint so well so quickly? He always said he was self-taught, but it is natural to look for helpful influences. The nearest and most accessible candidate was William Huggins, an associate of the Liverpool Academy who was well known for his horse and animal paintings. About the same age as Tait, Huggins had an older brother, an architect interested in ancient buildings, who may have first introduced them. Huggins also had a reputation as "one of the kindest-hearted men imaginable, always ready to do a good service for a brother artist."[40]

Like Huggins, Tait used fresh and bright hues. The almost irridescent shimmer and texture of the horse's curried coat and the skillful highlighting and shadow seem to be characteristics Tait adapted from Huggins, who had developed his own special technique for applying a glaze of translucent colors on the canvas so as to reflect the lustrous sheen of animal pelts. The glossy, blue-black fur of the bear in Tait's *The Robber*, a painting done shortly after his arrival in this country, confirms his special virtuosity.

With his sporting scene in Scotland, also done in 1848, Tait engaged in an ambitious project with a canvas measuring 30 by 40 inches.[41] The animals are well done, but the human figures are ill-proportioned and awkward, and he merely brushed on the background landscape. The subject and composition bear a remarkable resemblance to Richard Ansdell's *Shooting Party in the Highlands* of 1840, a painting still in Liverpool in the Walker Art Gallery.[42] Although Tait has substituted a stony path for Ansdell's small stream as the diagonal axis, the other parallels are all but identical: the black and white ponies, the central outcropping of rock, the shooter with the gun on his shoulder, and the gillie with the dogs.

Ansdell probably influenced Tait in other ways. The first two paintings Tait sold after he arrived in New York were similar scenes of deer hunting in Scotland.[43] Ansdell's preference for painting on a grand scale may have encouraged Tait as a novice to attempt a few very large canvases. Finally, Ansdell would sometimes paint the animals in a picture and enlist a landscape artist to do the background. In a similar fashion Tait later learned to collaborate now and then with an artist whose skills complemented his own.

As the decade of the 1840s came to a close, the most important influence upon Tait's career was George Danson, his first cousin on his mother's side and a man of many talents. Danson was a scene painter who designed stage sets and drop curtains for the legitimate theater at Covent Garden and Drury Lane in London. As a young man he had exhibited landscapes at

the Royal Academy, and the Victoria and Albert Museum has one of his watercolors. But Danson also worked al fresco, painting enormous panoramic backgrounds for dramatic outdoor fireworks displays, which had become a very popular form of entertainment for the general public. At Surrey Gardens he organized these fêtes on a regular basis, where each year a new theme such as the siege of Gibraltar, Old London and the Great Fire, or Napoleon's crossing of the Alps was presented. His ability in producing such tableaux has since earned him an honorable mention in the history of British fireworks.[44]

The Robber (52.13). Courtesy of Mr. and Mrs. George Arden.

When Danson made plans to cross the Atlantic and stage his entertainments for American audiences, Tait accepted his invitation to go along as a partner. Both personal and professional reasons seem to have prompted Tait's decision to emigrate. His wife Marian's health was not good, and a change of climate might prove beneficial. His work in lithography had been burdensome and unremunerative. In addition, the competition from more established artists threatened Tait's ambition to succeed as a painter.

Two canvases done in 1850 just prior to his departure reflect the remarkably rapid maturing of his skills with a brush. One was a lustrous portrait of a black Newfoundland dog in which Tait successfully tested his talents by making this copy of a painting by Ansdell.[45] The second was a scene of two draft horses and a freight wagon that bears the name of a Manchester bleaching firm.[46] Tait's brother was in the same business and so may have been

able to negotiate this work as a private commission. But with this exception Tait had no possible entrée to potential patrons among the new mercantile class of industrial entrepreneurs or the titled members of the older aristocracy. Certainly he had no connections with the nobility or royal family such as those enjoyed by Ansdell and Landseer.

Finally, Tait made up his mind to follow his natural bent for sporting art as soon as he arrived in America. He had been fond of the outdoor life since his boyhood on the farm and he had already demonstrated a marked aptitude for painting animals. But in Britain the heaths and forests and trout streams were mostly privately owned by the landed gentry, and trespassers or poachers risked severe punishment. There was simply no easy way Tait could see or hunt or paint game animals and birds. When he did achieve some distinction just a few years later, a newspaper account explained why Tait left home:

> The "country" of England, barred and double-barred as it is against all intruders, afforded few facilities for field experience. This determined the artist to make the United States of America his place of residence.[47]

Notes

At the Adirondack Museum, Blue Mountain Lake, New York are three cloth-bound ruled books in which Tait made both miscellaneous memoranda and a long systematic record of his paintings which was the basis of the edited Checklist of his works printed as a sequel to this biographical sketch. In these notes AFT Register refers to the volume and page of these notebooks, while plain decimal numbers such as 72.8 (the 8th painting for 1872) or ND. 12 (the 12th painting in the Not Dated list) refer to the printed entries in the Checklist.

1. Many years after Tait's death, his son Arthur J. B. Tait jotted down some recollections of his father's career. The artist's granddaughter and her husband, Emma Tait Marsh and Henry F. Marsh, also made valuable notations about some traditions of family history. These brief memoranda of Tait's life, together with other research materials gathered for the writing of this narrative, are in the Library of The Adirondack Museum, Blue Mountain Lake, New York, with the call number MS 72.1.1, Tait Biography Project.

2. *Times* (London), December 30, 1955, p. 3.

3. For a family chart by AFT and related genealogical records, see MS 72.1.2, Adirondack Museum Library.

4. "North Country Notable," *Country Life* 166 (1979): 751.

5. See Checklist No. 38.1.

6. "Arthur F. Tait," *Cosmopolitan Art Journal* 2 (March and June 1858): 103.

7. Catalogue of *The Exhibition of the Royal Manchester Institution, 1839* (Manchester: J. Hayward, 1839), p. 30.

8. Henry-Russell Hitchcock, *Early Victorian Architecture in Britain* (New Haven, Conn.: Yale University Press, 1954), 1:104.

9. ND. 53.

10. MS 72.1.3, Tait Biography Project, Adirondack Museum Library.

11. From the printed announcement of the exhibition that is among the A. F. Tait materials at Yale University Art Gallery, New Haven, Connecticut, Accession No. 149.222.44.

12. Information kindly provided by Mary Bennett, Keeper of British Art, Walker Art Gallery, Liverpool.

13. For details see No. 1 in the Appendix, "Lithographic Work by Arthur F. Tait Done in England," henceforth cited as Appendix.

14. Appendix, No. 4.

15. Appendix, No. 5.

16. Appendix, No. 7.

17. 43.1–17.

18. Appendix, No. 6.

19. Information kindly provided by Mr. E. Fowkes, Archivist, British Transport Historical Records, British Railways Board, London.

20. Henry G. Lewin, *The Railway Mania and Its Aftermath, 1845–1852* (London: Railway Gazette, 1936).

21. A railway historian has observed that Tait's series of twenty lithographs is "well worthy of study." See John Marshall, *The Lancashire & Yorkshire Railway* (New York: Augustus M. Kelley, 1979), 1:270. Four of Tait's scenes are reproduced in this book.

22. Francis D. Klingender, *Art and the Industrial Revolution*, edited and revised by Arthur Elton (St. Albans, Herts: Paladin, 1972), p. 124.

23. Appendix, No. 3.

24. I am indebted to Patricia C. F. Mandel, who pointed out the dependence of Tait's lithograph upon Landseer's engraving in her essay, "English Influences on the Work of A. F. Tait," published in the exhibition catalogue, *A. F. Tait: Artist in the Adirondacks* (Blue Mountain Lake, N.Y.: Adirondack Museum, 1974), pp. 13–18.

25. Kenneth Clark, *Animals and Men* (New York: W. Morrow, 1977), p. 102.

26. For a fresh analysis of the artist, see Richard Ormond, *Sir Edwin Landseer* (Philadelphia, Pa.:

Philadelphia Museum of Art, 1981).

27. Appendix, No. 2.

28. D. H. Boalch, *Prints and Paintings of British Farm Livestock, 1780–1910* (Harpenden, England: Rothamsted Experimental Station Library, 1958).

29. Listed as No. 642 in *Royal Manchester Institution, Exhibition of Modern Artists. The Twenty-Seventh. 1847* (Manchester: Cave and Sever, Printers, 1847).

30. Listed as No. 586 in the 1848 *Royal Manchester Institution Exhibition of the Works of Modern Artists. The Twenty-Eighth. 1848* (Manchester: Cave and Sever, Printers, 1848). The Vale Royal Viaduct was also known as the Weaver Viaduct.

31. Appendix, No. 8.

32. Klingender, *Art and the Industrial Revolution,* p. 133.

33. Gareth Rees, *Early Railway Prints, A Social History of the Railways from 1825 to 1850* (Oxford: Phaidon Press, 1980), p. 9. This book reproduces four other Tait prints.

34. "In the year 1848 . . . the chief desideratum was to attempt to restore the confidence of the investing public, and more particularly that of the existing shareholders in the inherent soundness of the railway industry." (Lewin, *The Railway Mania*, p. 350).

35. 49.2 through 49.7. See also the references in notes 29 and 30 above.

36. Quoted in Stella A. Walker, *Sporting Art, England, 1700–1900* (New York: Clarkson N. Potter, 1972), p. 77.

37. Quoted in Albert Ten Eyck Gardner, *Winslow Homer, American Artist: His World and His Work* (New York: Bramall House, 1961), p. 57.

38. AFT to Franklin Chase, July 24, 1865. Copy in MS 72.1.10, Tait Biography Project, Adirondack Museum.

39. 48.1.

40. H. C. Marillier, *The Liverpool School of Painters, An Account of the Liverpool Academy from 1810 to 1867, With Memoirs of the Principal Artists* (London: John Murray, 1904), pp. 147–48.

41. 48.2.

42. Mary Bennett, *Merseyside Painters, People and Places* (Liverpool: Walker Art Gallery, 1978), p. 23.

43. 51.1 and 51.2.

44. Alan Brock, *A History of Fireworks* (London: Harrap & Co., 1949), pp. 67–68, 75–76.

45. 50.4.

46. 50.5.

47. *Cosmopolitan Art Journal* 2 (March and June, 1858): 103.

2

New York
1850–1854

AFTER A VOYAGE OF FORTY-FIVE DAYS FROM LIVERPOOL, IN THE SAILING SHIP *WATER-loo*, Tait and his wife, Marian, and his cousin, George Danson, disembarked at New York on September 3, 1850. The first order of business for Tait was to help Danson with his plans for a regular fireworks display as a commercial public entertainment. The theme of the proposed pyrotechnic spectacle was the eruption of Mount Vesuvius, a show that Danson had already staged some years earlier at the Surrey Gardens with great success. In order to help persuade capitalists to invest the funds necessary to acquire property and build some permanent structures, Tait constructed, with characteristic attention to detail, a cardboard scale model of the volcano and the doomed city of Pompeii. He also designed a lithographic stone for printing advertising posters to lure customers to the performances each evening.[1]

According to family tradition, Tait and Danson decided that the best site for their project would be across the river from Manhattan in Hoboken, New Jersey, where the financier Colonel John Stevens had developed a large park with promenades known as the Elysian Fields. Their proposal, however, was denied by Stevens because of the carnival atmosphere of their scheme. The only profit to Tait from these negotiations was his introduction to the New Jersey marshes and the opportunities for duck-shooting—and painting wild life—that they offered.

With the help of some money from his father, Tait and Marian had taken quarters at 150 Spring Street in Manhattan. Very little is known about their first year in this country, but a few letters from Tait's father in England reveal his affection and concern for their well-being. On January 9, 1851, he wrote:

> I hope Marian has got more reconciled to America—habit does much and the old saying is that it only required time to make us like anything—I wish I was with you. . . . From the tone of your letter I have fervent hopes of your ultimate success. I am fearful you will be horribly pinched at first. . . . [I] hope you have got someone to aid you in the gardens [i.e., the fireworks project]. If they once see what you can do all will go well.[2]

Two months later Tait's father wrote again:

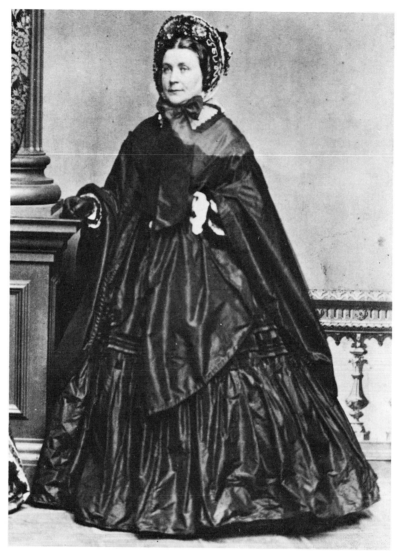

Mariane Cardwell Tait, ca. 1855. Courtesy of The Adiron-
dack Museum.

Your last letter holds out still with succeeding with the gardens. . . . In the Manchester
paper there is an extract of a letter from N. York which confirms what you say of the
American indifference for paintings, and their preference for mirrors.

As is sometimes the case with first impressions, however, Tait's perception of a national
indifference to art proved to be quite mistaken. On the contrary, "American painting was, in
the true sense of the word, a popular art in the generation of 1850," observes Edgar P.
Richardson in a brief sketch of the social and cultural background of the day:

> The middle of the nineteenth century saw the rise of a new middle class, enriched by
> the Industrial Revolution, and very powerful after 1850 in the patronage of the arts.
> This new class of patrons was wealthy but untravelled . . . [and] untouched by classical
> education. Its tastes were simple, pious, and domestic. It valued easily understood
> subject matter, sentiment, and meticulous execution.
> It was not the period of our greatest art, but it was the most fortunate period for the
> artist. Prosperity for a brief moment touched him with its golden wand.[3]

Tait's timing in coming to America could not have been better. Although an unknown,

aspiring artist just off the boat, he was hardly starting from scratch. Over the previous decade and a half in England Tait had become a mature journeyman craftsman with various graphic skills. As it became clear that the fireworks project with Danson would not succeed, Tait began to explore and test the options and opportunities open to him as a painter.

At first he made the acquaintance of John Williams, of the firm of Williams, Stevens & Williams at 363 Broadway. This was primarily a store for mirrors, chandeliers and similar bric-a-brac as well as picture frames and art supplies—a shop not unlike Agnew & Zanetti in Manchester. The store also carried prints and occasional paintings in its windows to attract passers-by. Tait's earliest paintings in this country were introduced to the American public through the good offices of Mr. Williams,[4] who early in 1851 purchased two scenes of deer shooting in Scotland for $25 each,[5] and a few additional paintings within a year. On his part Tait usually bought canvases and paints from Williams, often on credit.

At this time there were virtually no specialized retail art galleries in Manhattan. Tait soon discovered, however, that the American Art-Union was a large, cash buyer of works by native painters. Only a decade old, the Art-Union was nearly twice the size of the London Art Union, after whose subscription lottery it had been patterned. For an annual fee of five dollars each member received a fine art engraving and the Union's handsome monthly bulletin. The remaining income was used to purchase works of art, which in turn were given away to the lucky subscribers whose names were chosen by a raffle once a year.

In 1850 the American Art-Union had purchased 400 art works from 130 artists and then distributed them to winners throughout the country. According to policy, nearly a quarter of the artists helped in this manner were to be new and unknown. Tait therefore had little difficulty selling the Art-Union two of his own paintings, a deer's head and a hunting scene, for over $200.[6] About the same time he sold a pair of canvases depicting grouse and quail for $50 cash to the recently established New Jersey Art Union in Newark.[7]

Unfortunately, further opportunities for Tait to market his canvases in this manner came to an abrupt end in 1852, when the courts prohibited such enterprises as unconstitutional lotteries.[8] The American Art-Union was compelled to dispose of its holdings at public auction, where Tait's hunting scene was purchased by the publisher William H. Appleton for $110.[9]

In the decade or so of its existence, however, the American Art-Union had a stimulating influence upon the nation's cultural development. Its free public exhibition gallery had attracted some three million visitors, and annual attendance equalled more than half the population of New York City. Tait had special reasons to be grateful, for, as Maybelle Mann writes, "the market created by the American Art-Union greatly expanded the possibilities for American artists and opened the door for many who might otherwise have not found their way."[10]

At the beginning, however, Tait's efforts to establish himself as an artist met with—in his own words—"difficulties and annoyances."[11] He got in touch with a print publisher, Alexander H. Ritchie, whose prosperous engraving business employed a team of assistants and copyists. Ritchie commissioned him to paint an historical tableau of George Washington with thirty of his generals and provided Tait with a sketch of the composition and small engravings of the portraits to be included. The job was to pay $300.

Tait painted the background and figures himself, but since he apparently was not comfortable with his ability at portraiture, he made a contract with another artist, James H. Cafferty, to do the faces for $50. Ritchie found the finished painting so poorly executed as to be unfit for publishing. Tait nonetheless insisted on being paid in gold coin. This whole affair with Ritchie caused an unfortunate quarrel in the newspapers some years later,[12] but it did have an unexpected benefit.

Tait's acquaintance with Cafferty proved to be an important introduction to the community of artists in Manhattan. A few years earlier, Cafferty, who was Tait's age, had been one of the founding officers of the New-York Sketch Club, whose membership included T. Addison Richards, Charles Blauvelt, John F. Kensett, and Charles Loring Elliott.[13] This informal

association was patterned after an older and more distinguished organization, the Sketch Club (sometimes known as the XXI),[14] but was limited to younger artists intent upon improving their skills. Gathering at each other's homes or studios, the group devoted its meetings to impromptu sketching upon a given theme, followed by mutual criticism and instruction, and concluded with refreshments and shop talk. Tait was invited to join, although the only memento that has survived is a sketch of a running horse pursued by wolves, dated 1855.[15]

The club elected as honorary members some of the older, established painters in town, including Thomas S. Cummings, longtime treasurer and historian of the National Academy of Design. Describing his impressions of these meetings, Cummings noted that he "frequently had the pleasure of inspecting the works of the 'Evening,' and can speak in praise of their general artistic excellence." With tongue in cheek, Cummings went on to comment about the refreshments: "Whether they commenced on 'milk and honey' and gradually slid into the oysters and champagne in imitation of their older model [the XXI Club], the writer cannot say; he never witnessed anything of the kind, but had, however, frequent misgivings."[16]

These convivial meetings of the New-York Sketch Club provided a useful route to professional advancement. The senior, honorary members had opportunities to single out talented individuals and to invite them to submit a few canvases to the competition for the annual spring exhibition of the National Academy of Design. This recognition came to Tait in 1852, scarcely eighteen months after his arrival in America. The responsibility for choosing the paintings to be included in the public show was the special duty of the Academy's Committee on Arrangements. Tait's friend Cafferty was a member of the committee that year, as were Cummings, Asher B. Durand (who was president of the Academy), Frederick E. Church, Daniel Huntington, and Junius B. Stearns. They selected six of Tait's pictures, a signal honor.

The printed catalogue of the 1852 exhibition names John Osborn as the owner and lender of four of these paintings. A prosperous importer of liquor and wines, Osborn had an office in downtown Manhattan and a home in Brooklyn. He was one of Tait's earliest patrons, a generous benefactor and lifelong friend. According to Tait family tradition they became acquainted through the initiative of Tait's brother William in Oporto, Portugal. William Tait was the wholesaler or shipper who supplied Osborn with cases of port and other fine wines from the vineyards of the Iberian peninsula.

From the start Osborn gave Tait some financial support and other assistance. He seems to have bought a good many of Tait's canvases as soon as the paints were dry, thus providing without delay some cash income to meet domestic expenses. He did not, however, keep the paintings as permanent additions to his private collection. Rather, as the opportunity arose, Osborn would resell them to interested friends, making him, in effect, Tait's agent and an amateur art dealer. For example, Tait was able to write to a patron: "The large picture is now quite finished & to be seen until Saturday at No. 111 Wall St. at John and Robert Osborn's where I should wish you if possible to induce your friend to go see it. Mr. Osborn will be happy to show it to any one who calls."[17]

The six paintings in the Academy exhibition in the spring of 1852 reflect the early influences determining Tait's subjects and style. Four canvases depict the deer and bear of the Adirondack Mountains that he had recently visited. The remaining two paintings, a scene of duck shooting on the tidal marshes not far from New York, and *Trappers at Fault*, a Western scene, attracted special mention in the newspapers. A critic in *The New York Herald* wrote of Tait:

> This artist still exhibits his too rapidly painted pictures, at a store on Broadway, to the admiring gaze of thousands who throng the shilling side of the street. As a colorist, Mr. Tait has a considerable portion of merit, although his manner is a melange made up from the manners of many. . . . He seems to have been bitten by Mr. Ranney, and to have imbibed all his extravagance, but with little of his fidelity and fire.[18]

In the same vein, *The Literary World* noted that such works are examples of

> a style of painting that is becoming painfully conspicuous in our exhibitions and shop-windows, of which glaring red shirts, buckskin breeches, and a very coarse prairie grass are the essential ingredients; and in which Mr. Ranney had the honor to lead the way; but with him there was some character of individuality, which Mr. Tate [*sic*] lacks.[19]

William Ranney is the only artist whose influence upon Tait is unmistakable. They shared an enthusiasm for the outdoor recreations of fishing and hunting. Ranney lived in West Hoboken and painted duck shooting in the nearby Jersey wetlands a number of times. His acquaintance with the Western plains dated from a military tour of duty in Texas during the wars with Mexico in the 1830s. While George Catlin, Karl Bodmer, Alfred J. Miller, and other artists journeyed beyond the Mississippi to document the life and manners of the Indians, it was the white man's encounter with the prairies and mountains and the exploits of the hardy guides and trappers that interested Ranney.[20]

According to the nineteenth-century historian and critic Henry Tuckerman, Ranney's studio

> was so constructed as to receive animals; guns, pistols and cutlasses hung on the walls; and these, with curious saddles and primitive riding gear, might lead a visitor to imagine he had entered a pioneer's cabin or border chieftan's hut: such an idea would, however, have been at once dispelled by a glance at many sketches and studies which proclaimed that an artist, and not a bushranger, had here found a home.[21]

Tait never saw the American West that he painted with such seeming authority. But in Ranney's studio he could find all the props he needed to give his paintings authenticity. There is, for example, an undated photograph of Tait garbed in a buckskin tunic with decorative fringes identical to the suit depicted in *Trappers at Fault* and in several subsequent pictures with a prairie motif. The same photograph shows Tait wearing a beaded wampum pouch that appeared in a painting done in 1851.[22] Evidence suggests that Ranney generously let Tait study and use the artifacts in his studio, as well as his sketches and paintings of the prairie.

Tait borrowed from Ranney the device of placing the flat horizon line just below the center of a painting, which emphasized the vastness of space, increased the sense of depth, and gave figures outlined against the big sky a heroic dimension. At the same time, Ranney and Tait conveyed in their paintings little of the grandeur of nature in the sublime sense such as it is found in the landscapes of Thomas Cole and other artists touched by romanticism. And both applied the genre formula of stressing the incidental.

Tait's early decision to experiment in painting scenes he had never seen was timely, since tales of travelers and trappers on the plains and the gold fields of California were in the public's mind. As a consequence Tait's painting *One Rubbed Out*—perhaps in the window at Williams, Stevens & Williams—caught the eye of Nathaniel Currier, who commissioned another copy with the appropriate dimensions for publishing as a lithograph. At about the same time Currier had employed James Ives as bookkeeper, and his shrewd grasp of the public's taste and his business acumen resulted in a promotion to partnership in 1857. The firm then became Currier & Ives, advertising itself as "Print-Makers to the American People." Ives, in turn, hired as a lithographer Louis Maurer, who also proved to be a valuable asset to the business. Tait, who only recently had worked at the same trade, may have noted with some satisfaction that he received $50 for his painting while Maurer's starting salary was $5 a week. Many years later, as he approached his one-hundredth birthday, Maurer's recollections of Tait's career, while not always entirely reliable, have provided useful information.[23]

The likely source for Tait's *One Rubbed Out* was Ranney's *The Trapper's Last Shot*. If Tait did

not actually see either of the two versions painted by Ranney, he could easily have acquired a copy of the very popular large print published by the Western Art Union. Tait painted his composition three times, which suggests that he was attempting to improve his mastery of an unfamiliar subject. One of these canvases was sent to Oporto, perhaps with John Osborn on a business trip.

In *One Rubbed Out* Tait simply copied the trapper's buckskin suit, with its fringes at the shoulders and down the outside seam of the trousers. While the lurking Indians in the background of Ranney's scene are barely discernible, Tait, in order to heighten the mood of danger, has given them more prominence. Like Ranney, Tait has treated the central figure with the minute precision and high finish inspired by the Dusseldorf school and popular at that time with the critics and the public. Such literal representation, however, has the tendency to immobilize the fluidity of movement, an effect that is only slightly tempered by the use of more open brushwork for the surrounding context. Tait departed from Ranney's somewhat static composition by portraying the horse at full gallop, employing the traditional rocking-horse pose with outstretched legs.

Tait apparently welcomed the publicity such a print might bring, for a second Western scene, *A Check*, was published in 1853. The print is similar in many respects to *The Retreat* by Ranney, which was exhibited at the National Academy two years earlier. At that time a newspaper critic suggested that Ranney would have done better to give a more spacious view of the prairie, which, by its vastness, would have intensified the sense of drama by revealing that there were no rocks or trees to provide cover from the attacking Indians.[24] Tait seems to have borrowed the idea as he composed *A Check*, which shows a lone trapper taking a rear-guard stance while his companion rounds up their baggage-laden horses. Tait would be astonished to learn that one of the several canvases he painted of this same event sold at auction for $200,000 in 1980.

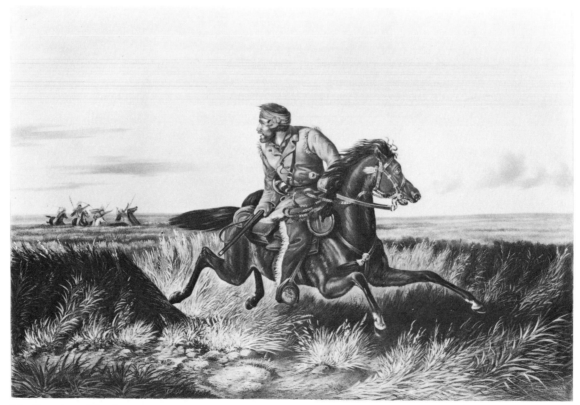

N. Currier. *The Prairie Hunter*, *"One rubbed out."* Courtesy of Kenneth M. Newman, The Old Print Shop, Inc.

So brief was Tait's experiment with frontier art that an account of its conclusion, while coming somewhat later in his career, belongs here. In 1856 Currier purchased and published a pair of his Western paintings, *The Pursuit* and *The Last War-Whoop*. By that date William Ranney was disabled by illness, which compelled Tait to find other sources for paintings of events he had never witnessed. Louis Maurer recalled that James Ives, who had commissioned these works, escorted Tait and himself to the Astor Library. There they studied the narratives and the valuable portfolios of prints by George Catlin and Karl Bodmer, both of whom had traveled extensively among the Plains Indians in the 1830s.

Tait's borrowing was largely from Catlin's pictorial and written accounts of the fierce Comanches. The dying warrior in *The Last War-Whoop* is equipped with that tribe's characteristic round rawhide buckler and plumed lance. In *The Pursuit* Tait has closely followed Catlin's vivid description of a remarkable feat of horsemanship,

> a strategem of war, learned and practised by every young man in the tribe; by which he is able to drop his body upon the side of his horse at the instant he is passing, effectually screened from his enemies' weapons as he lays in a horizontal position behind the body of his horse, with his heel hanging over the horse's back.[25]

These paintings hardly suggest it, but Tait's sympathies, like Catlin's, were on the side of the Indians. It was reported in the press not long afterward that he hoped to be able to travel to the West and to spend some time living among them. His purpose was to "become the more fully acquainted with aboriginal and forest life, and thus glean the knowledge necessary for the elaborate and original works to which he proposes to devote his best powers."[26] This plan never materialized.

The last of Tait's western scenes were painted in 1861, and two were published by Currier

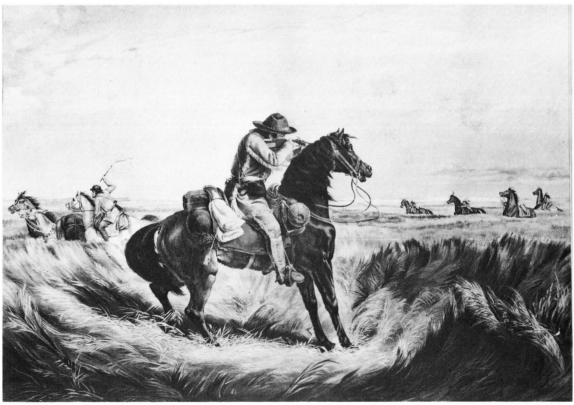

N. Currier. *A Check, "Keep your distance."* Courtesy of Kenneth M. Newman, The Old Print Shop, Inc.

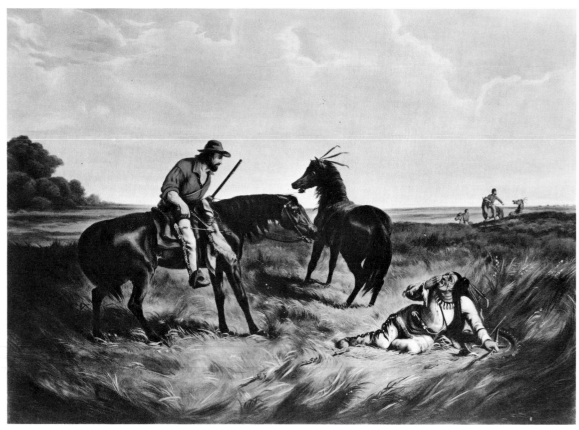

N. Currier. *The Last War-Whoop*. Courtesy of Kenneth M. Newman, The Old Print Shop, Inc.

N. Currier. *The Pursuit*. Courtesy of Kenneth M. Newman, The Old Print Shop, Inc.

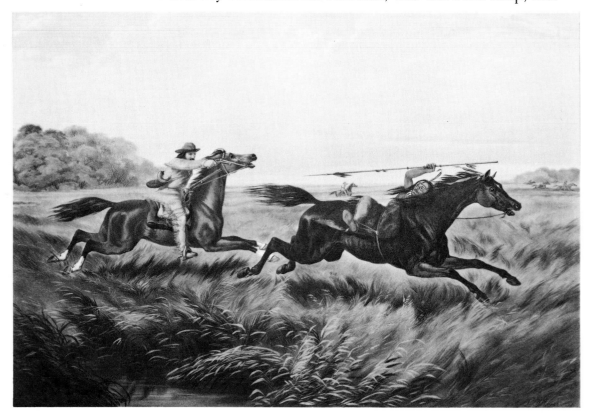

& Ives as *The Buffalo Hunt* and *Fire Fight Fire*. For the picture of the frontiersmen battling smoke and flames, Catlin's stirring words again provide an appropriate caption:

> But who has seen the vivid lightnings, and heard the roaring thunder of the rolling conflagration which sweeps over the *deep-clad* prairies of the West? Who has dashed, on his wild horse, through an ocean of grass, with the raging tempest at his back, rolling over the land its swelling waves of liquid fire?[27]

It is remarkable that Tait's reputation as an artist of the American West he never saw is based upon less than one percent of his total output of paintings. He produced only twenty-two canvases, many of them duplicates featuring buckskin-clad trappers, and eight of these were reproduced by Currier & Ives as handsome prints whose enduring popularity today is a tribute to the artist's versatility. Hermann Warner Williams, Jr., has argued that these dramatic encounters on the prairies "are more believable than, for example, similar scenes by [Charles] Deas, who was actually on the spot. Tait, at his best, was a good painter and a good story teller."[28]

The direction of Tait's career as a painter of birds and animals was evident from the start. During the first four years in New York City, a quarter of his canvases were still-life studies of wildfowl, mostly ducks. At little cost to himself, a day's excursion with a gun to the marshy wetlands of Long Island or New Jersey enabled Tait to bring back to his studio in his game bag a variety of species to place in front of his easel. Before he could afford to journey farther afield to hunt and study wildlife in its wilderness habitat, he made his start as a still-life painter of dead game.

According to family tradition, Tait invented a special method to get the correct effect for

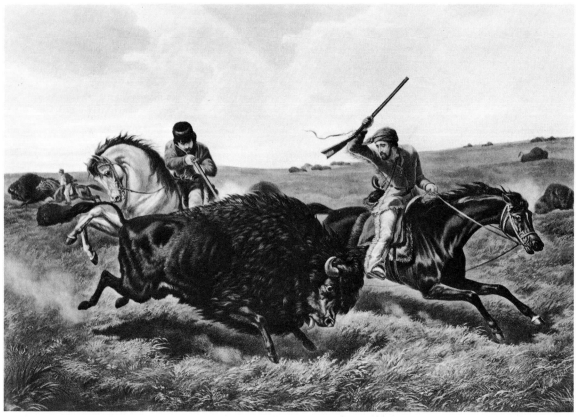

Currier & Ives. *Life on the Prairie, The "Buffalo Hunt."* Courtesy of Kenneth M. Newman, The Old Print Shop, Inc.

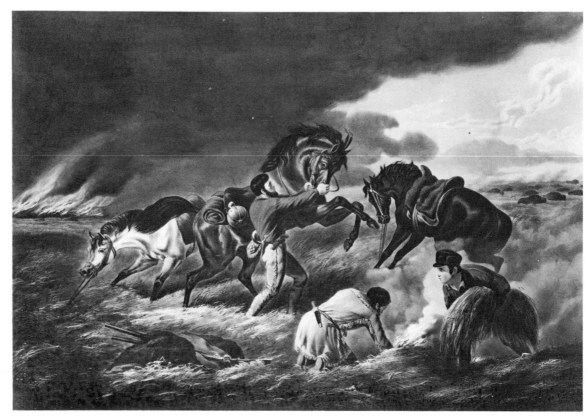

Currier & Ives. *Life on the Prairie—The Trapper's Defense, "Fire Fight Fire."* Courtesy of Kenneth M. Newman, The Old Print Shop, Inc.

the texture of feathers and fur, which he regarded as something of a trade secret. He would wrap a piece of corded silk around his finger, and then roll it gently on the canvas, but only after the paint had slightly dried.

In 1854 Nathaniel Currier published a series of four prints, *American Feathered Game*, after Tait's paintings. The subjects were mallard and canvas back, wood duck and golden eye, woodcock and snipe, and partridges. The same four were reproduced a second time within a shaded oval.

A history of American still-life painting by Professor William Gerdts credits Tait's early introduction of hanging-game panels for the subsequent popularity of William Harnett and others, and for influencing especially Richard LaBarre Goodwin, who often used similar groupings for his "cabin-door" still lifes. "Tait's feathered game," he points out, "is almost invariably shown against a neutral wall with the shadows carefully designed to give the illusion of three dimensionality—a trompe l'oeil device used twenty-five years before the rise of Harnett and his school."[29]

A newspaper reporter in February, 1853, reported his impressions of a meeting of the New-York Sketch Club: "We had the pleasure of inspecting a noble picture, 'Hunters Returning with Game,' (unfinished) by Mr. Tait, a member of the club. It is an effort of the highest merit in its line."[30] With four other works by Tait, this painting was chosen for exhibition at the National Academy of Design later that spring. It was purchased by Goupil & Co. and shipped to France to be copied as a steel engraving.[31] Issues of the print with the title, *Halt in the Woods*, were not ready for public sale in America until 1856.

Goupil & Co., the art publishers and dealers in paintings, was a very large firm with headquarters in Paris and outlets in several European cities. It had recently established a branch office in New York and had employed William Schaus and then Michel Knoedler to open the American market to its wares. Schaus had an important role in persuading Goupil to

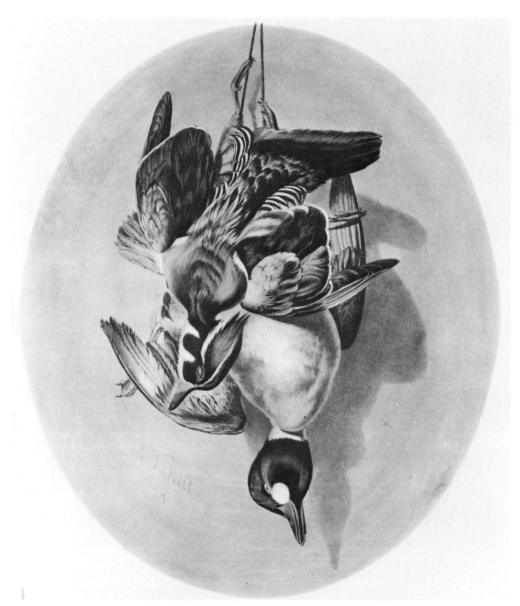

N. Currier. *American Feathered Game, Wood Duck and Golden Eye.* Courtesy of Kenneth M. Newman, The Old Print Shop, Inc.

accept for publication the works of other American artists, including William Sidney Mount and George Caleb Bingham, before establishing his own retail store.[32] Knoedler also left the firm to become a dealer in paintings with his own gallery. Tait came to know both men at this time, but it was a few years later before they became independent agents and were free to do more business with him.

As he explored different ways to publicize his work as an artist, Tait at first had little success outside of New York. He sent a painting to the Boston Athenaeum for exhibition in 1851[33] and another to the Pennsylvania Academy of the Fine Arts in 1852[34] and on occasional years thereafter. But there is no evidence that this exposure brought him any business.

Tait was compelled, therefore, to rely principally upon his own wits and to solicit commissions from patrons as best he could. His early success in selling his paintings to printmakers was not enough to support him. As the opportunities came his way, he painted on request such subjects as a prized bull and a cow and a pet dog. A fine portrait of *A Celebrated Trotting*

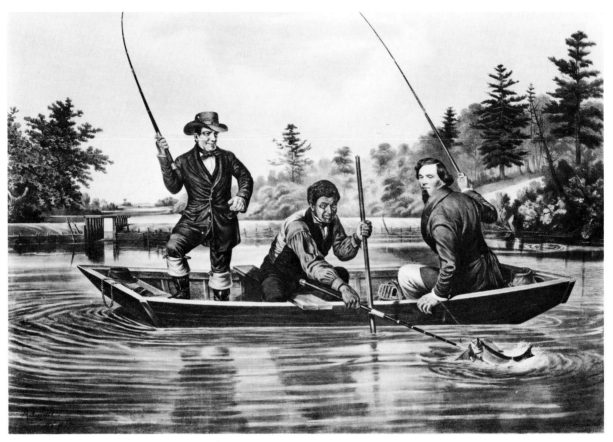

N. Currier. *Catching a Trout*, *"We hab you now, sar!"* Courtesy of Kenneth M. Newman, The Old Print Shop, Inc.

Horse,[35] owned by Edwin M. Day, was included in Tait's canvases exhibited at the Academy in the spring of 1853.

Apart from John Osborn, Tait's most important patron at this time was James H. Clark, a Tammany politician who worked in the auditor's office of the Brooklyn Customs House and who, with his brother, was an enthusiastic sportsman. He paid Tait the princely sum of $450 for *Trout Fishing*, and then permitted its publication by Nathaniel Currier with the subtitle, "We hab you now, Sar." This is one of the very few instances where Tait has identified the persons in his paintings: "Portrait of Mr. Mosher, J. H. Clark [on the right] & Paulos Enos (Darky)."[36]

With the approach of the annual exhibition at the Academy in the spring of 1854, a note in the press reported that "Mr. Tait, who has rapidly risen to occupy the very first rank as a painter of animals and game, will contribute a number of sketches to the Academy. Mr. T. is an Englishman born, but a 'yankee' for all practical intents and purpose."[37]

On May 8, 1854, the Council of the National Academy of Design elected Tait as an associate member.[38] Since the founding of that institution in 1825, such an honor required that the candidate first present a portrait of himself. Tait engaged James Bogle to paint his likeness, perhaps because Bogle had done the same for Ranney for the same purpose two years earlier.

Only one of Tait's paintings was included in the exhibition that year, a fine duck-shooting composition of James Clark and his brother.[39] This, too, was later published by Nathaniel Currier. The painting got mixed reviews in the press. *The New York Daily Tribune* noted that Tait, "who paints birds with great fidelity and beauty, here tries a wider range. . . . The ducks, as a matter of course, are models of excellence; the landscape is not."[40]

Arthur Fitzwilliam Tait, portrait by James Bogle 1854. Collection of the National Academy of Design, New York. Photograph courtesy of the Frick Art Reference Library.

N. Currier. *Wild Duck Shooting, A Good Day's Sport*. Courtesy of Kenneth M. Newman, The Old Print Shop, Inc.

An anonymous critic for *The Evening Mirror* gave a long and enthusiastic description of the painting, concluding with these general comments:

> Mr. Tait is a young Englishman, who has taken permanent lodgment among us, and his progress for two or three years past has been very marked. He loves nature and hunts her out, with gun and brush in hand. . . . His eye is quick and correct; his view broad, and his hand, as an artist, accomplished and decided. His pictures are thoroughly American, and in his province he paints better altogether than any of his competitors in this region.[41]

Notes

1. The somewhat tattered remains of the cardboard model and a copy of advertising poster are at The Adirondack Museum, Blue Mountain Lake, N.Y.

2. These few letters from William Watson Tait are in The Adirondack Museum Library, MS 73.7, Memorabilia Box 1.

3. Edgar P. Richardson, *A Short History of Painting in America* (New York: Crowell, 1963), pp. 156, 158.

4. "Arthur F. Tait," *Cosmopolitan Art Journal* 2 (March and June 1858): 103.

5. 51.1 and 51.2.

6. 51.6 and 51.7.

7. 51.3 and 51.4. See also William H. Gerdts, Jr., *Painting and Sculpture in New Jersey* (Princeton, N.J.: Van Nostrand, 1964), pp. 84–92.

8. E. Maurice Bloch, "The American Art-Union's Downfall," *New-York Historical Society Quarterly* 37 (1953): 331–59.

9. Mary Bartlett Cowdrey, *American Academy of Fine Arts and the American Art-Union*, 2 vols. (New York: New-York Historical Society, 1953), 1:303–4.

10. Maybelle Mann, *The American Art-Union* (Otisville, N.Y.: ALM Associates, 1977), p. 29.

11. AFT letter to the editor, *New York Daily News*,

May 14, 1858, p. 1.

12. The story is told in chap. 4.

13. *New York Mirror*, November 4, 1852, p. 3, has an announcement of the opening meeting of the season at Cafferty's studio and a list of the members, including Tait.

14. Thomas S. Cummings, *Historic Annals of the National Academy of Design* (Philadelphia: G. W. Childs, 1865), pp. 110–13. See also James T. Callow, *Kindred Spirits: Knickerbocker Writers and American Artists, 1807–1855*, (Chapel Hill: University of North Carolina Press, 1967), pp. 12–29. Professor Callow is preparing for publication an annotated edition of the minutes of the Sketch Club, and I am most grateful for his help.

15. 55.9.

16. Cummings, *Historic Annals*, p. 202.

17. AFT to C. D. Stewart, March 15, 1853. Courtesy of Henry Francis du Pont Winterthur Museum, Winterthur, Delaware, Joseph Downs Manuscript Collection No. 71 × 107.17.

18. *New York Herald*, February 17, 1852, p. 2.

19. *Literary World*, May 1, 1852, p. 316.

20. Francis S. Grubar, *William Ranney, Painter of the Early West* (New York: Clarkson N. Potter, 1962), p. 7.

21. Henry T. Tuckerman, *Book of the Artists* (New York: G. P. Putnam & Sons, 1867), pp. 431–32.

22. 51.13.

23. See Harry T. Peters, *Currier & Ives: Printmakers to the American People* (Garden City, N.Y.: Doubleday, Doran & Co., 1929–31), and Fred J. Peters, *Sporting Prints by N. Currier and Currier & Ives* (New York: Antique Bulletin Publishing Co., 1929).

24. Grubar, *William Ranney*, p. 37.

25. Quoted in Marjorie Halpin, *Catlin's Indian Gallery* (Washington, D.C.: Smithsonian Institution, 1965), p. 20.

26. "Arthur F. Tait," *Cosmopolitan Art Journal* 2 (March and June 1858): 104.

27. George Catlin, *Letters and Notes on the Manners, Customs, and Conditions of the North American Indians*, 4th ed. (London: D. Bogue, 1841), 2:18.

28. Hermann Warner Williams, Jr., *Mirror to the American Past* (Greenwich, Conn.: New York Graphic Society, 1973), p. 111.

29. William H. Gerdts and Russell Burke, *American Still-Life Painting* (New York: Praeger, 1971), p. 122.

30. *Evening Mirror*, February 15, 1853, p. 2.

31. 53.2.

32. For more about Schaus, see Alfred Frankenstein, *William Sidney Mount* (New York: Harry N. Abrams, 1975), pp. 152–69.

33. Robert F. Perkins, Jr., and William J. Gavin III, *The Boston Athenaeum Art Exhibition Index, 1827–1874* (Boston: Library of the Boston Athenaeum, 1980), p. 139.

34. Anna Wells Rutledge, *Cumulative Record of Exhibition Catalogues, The Pennsylvania Academy of the Fine Arts 1808–1870* (Philadelphia: American Philosophical Society, 1955), p. 226.

35. 52.22.

36. 54.21.

37. *Evening Mirror*, February 23, 1854.

38. Almost all the standard references give the year incorrectly as 1855. The correct date is confirmed by the minutes of the meeting of the council.

39. 51.12.

40. *New York Daily Tribune*, March 30, 1854, p. 7.

41. *Evening Mirror*, April 21, 1854, p. 2.

3

The Adirondacks
Chateaugay Lake
1852–1859

TAIT'S DISCOVERY OF THE ADIRONDACKS IN NORTHERN NEW YORK DETERMINED THE direction of his career for the next thirty years. In these 9,000 square miles of forested mountain wilderness, almost uninhabited except for deer, bear, and trout, Tait found his true calling as a painter of animals and sporting adventures.

The discovery was accidental, while he was engaged in family matters. His brother Augustus had immigrated to America ten years earlier, had moved from job to job and abandoned for a while his wife and family. In 1851, after some anxious searching, Tait finally found his sister-in-law in the village of Malone on the northern edge of the Adirondacks. While doing what he could to help the woman and her children, he learned of the excellent fishing and hunting a few miles distant at the Chateaugay lakes. When the opportunity arose, Tait made his way to the modest boarding house the Bellows family kept on the shore of Lower Chateaugay Lake.[1]

Thirty years earlier Jonathan Bellows, one of the first settlers in the region, had cleared some land, planted crops, and started a large family. When occasional sportsmen began to appear at the door of his small log house in search of lodging and guides, he realized he could make a better living by providing such visitors accommodations. About 1840 he constructed a twelve-bedroom building that he called the Lake House. It was one of the first hotels in the Adirondacks, a fact that illustrates again Tait's knack for being at the right place at an opportune time. As Bellows got older, active management of the establishment fell to his son Lewis, who was assisted by his brothers Hiram and Francis. The business prospered, especially after the railroad reached the village of Chateaugay (8 miles to the north) in 1850. Toward the end of the century the Lake House was renamed the Banner House and still stands today.[2]

Unfortunately, Tait never wrote an account of his Adirondack experiences, but a contemporary sporting weekly, *The Spirit of the Times*, describes the warm welcome that greeted another visitor at Bellows's front door:

> The old man himself received me, and soon rendered me comfortable by showing me

to a very convenient and pleasant room. . . . Some two hours from the time I arrived, Lewis and Hiram Bellows returned from their hunt . . . with two fawns and one moderately sized buck. . . . After a late dinner we sat and chatted until nine, the principal topics of conversation consisting of . . . adventures with the various kinds of wild animals which make the forest their home. I found Lewis very pleasant and quite intelligent, and one well calculated to act in the capacity of host.[3]

Unlike the private game preserves of Europe, the Adirondack wilderness, still largely unmapped, was a sportsman's paradise free and open to anyone. Tait learned the necessary skills of Adirondack woodcraft and camp life from Lewis Bellows and his brothers. They taught him the local methods of deer shooting, which varied with the season. In the summer dogs would pursue or "drive" the deer out of the thick forest into the waters of a lake, where the hunter and his guide, waiting in a boat, could then easily overtake and kill the swimming animal. In autumn, when the leaves were down, he could still hunt or he could wait for the first snow to stalk the deer by following its tracks.

Tait immediately began to paint the variety of game he found around him. Black bears, not uncommon in the Chateaugay country, seem to have caught his interest from the start. A large canvas, 36″ × 29″, shows a richly furred bear pawing a bee tree in search of honey.[4] In the spring of 1852 Tait selected this picture to be part of the first showing of his works at the National Academy of Design.

Occasionally Tait preferred to get away from the comforts of the boarding house and live outdoors in some remote and scenic spot. From the hotel he traveled by boat through the Narrows to a larger lake, where he made his camp. "This is the first shanty I ever built or lived in," he wrote on the reverse side of a crude oil sketch, "in the forest, built on Chateaugay Upper Lake, Franklin Co., N.Y. on the west side in August, 1852. Painted from nature."[5]

For the next several years Tait spent much time enjoying the hospitality of the Bellows family, pursuing game, and painting now and then. A room at the hotel was put at his disposal to use as a makeshift studio when the weather was wet or cold.[6]

In February, 1853, a Manhattan newspaper account of a meeting of the New-York Sketch Club reported that

> Tait, one of our finest painters of game, and hunting and fishing scenes, has just returned from a long tour in the Chateaugay region, in the northern part of the state. He has brought with him a rare portfolio, which may be seen at his rooms, 150 Spring Street.[7]

In November of the same year another brief item noted that "Tait has been deer stalking and bear hunting for the season, with fine success, judging by his portfolio."[8]

During the fall of 1854 Tait's patron and friend, John Osborn, his wife, and their young son Francis joined Tait at the Bellows's hotel to see the Chateaugay country for themselves. As a memento of this visit Osborn purchased a splendid painting, *With Great Care*, which meticulously depicts an Adirondack shanty with its roof of hemlock bark.[9] Tait himself stands center picture, holding up an empty wine bottle. We do not know the identity of the other persons in the picture, but the sportsmen's trophies—an antlered buck, grouse, ducks, speckled and lake trout—are easy to recognize.

Shortly before James Ives became a full partner in the firm, Nathaniel Currier reproduced as lithographs three paintings Tait executed during his Chateaugay years. Although they were published about the same time that Tait began to keep a systematic and consecutive record of his work, it is curious that he makes no mention of them in his Register. These prints have since become well known to the American public, and each has an interesting history.

The original painting for *Maple Sugaring* was loaned by Currier to the 1856 exhibition of the

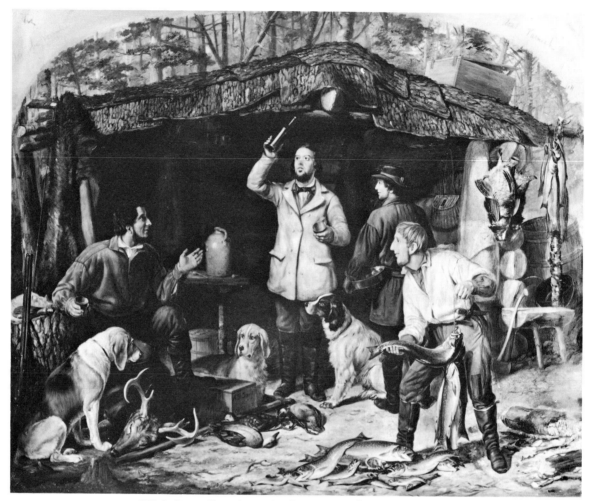

With Great Care (54.30). Courtesy of Louis Madeira.

National Academy of Design, where it failed to impress a somewhat captious newspaper critic:

> If Mr. Tait means to be an artist, he must not allow himself to suppose that a grove of maple trees with the tops cut off by his frame can make a picture. "Sugaring Off" properly treated would have been a pretty picture, and is handled not without spirit; but it is a mis-nomer to call it a "forest scene" in its present state. It should be called a scene of ladies and gentlemen, with kettles, in a cage.[10]

Many years later, in 1933, a group of distinguished collectors ranked what they regarded as the best fifty large-folio Currier & Ives prints; this scene of Tait's was judged number two. Though it was something of a stunt, these connoisseurs hoped to stimulate interest in nineteenth-century Americana at a time when it was not fashionable. Of *Maple Sugaring*, the citation says, "The original painting has been lost. If it were found it might be possible to establish the identity of the persons portrayed."[11]

The painting is still unlocated, but research for this study has discovered that the scene is the sugar bush of Enoch Merrill, who lived not far from Bellows's hotel. Two brothers, Enoch and Paul Merrill, were early settlers at Chateaugay, and Paul's descendants played an important role in the area's subsequent history.[12] Enoch's son, William Clark Merrill, is seated on the log in the center of the picture, surrounded by other members of his clan.[13]

There is no local tradition about this print at Chateaugay today because nearly all of Enoch Merrill's children moved away soon after Tait did the painting.

Not many American artists have chosen to depict maple sugaring. However, one of Tait's contemporaries, Eastman Johnson, spent much time at the end of the Civil War sketching sugar camps in Maine, and he became almost obsessed with the idea of painting a grand panoramic masterpiece on this subject. This ambition was never realized, but he did complete numerous studies intended as elements in the complex final scheme. His biographer, Patricia Hills, has suggested that the manner of Tait's treatment influenced Johnson to abandon his European training in *genre rustique*, with its tendencies toward caricature, mannerism, and a condescending attitude of detached amusement toward ordinary folk:

> The figures are all from the same rural milieu, not contrasting country bumpkins and city sophisticates. In Tait's picture the women as well as the men participate in the work. Johnson followed Tait's lead in breaking down the class distinctions between the participants who work and the others who converse, gossip and play cards. The figures are portrayed with warmth and humanity.[14]

Tait's affection and respect for his Adirondack friends are clearly evident in *Arguing the Point*, painted in 1854. It was copied onto stone by Louis Maurer and published the following year by Nathaniel Currier, who recognized that such a scene, reflecting the dignity of the common man, especially the rural worker and pioneer, would have enormous popular appeal in post-Jacksonian America.

Local tradition at Chateaugay Lake unanimously identifies the man seated on the left holding the newspaper as Anthony Sprague, a local guide. Next to him are Jonathan Bellows and his son Francis. Georgiana, Francis's daughter, tugs at her father's clothing, urging the menfolk to interrupt their discussion of public affairs around the chopping block and to

Currier & Ives. *American Forest Scene—Maple Sugaring*. Courtesy of Kenneth M. Newman, The Old Print Shop, Inc.

N. Currier. *Arguing the Point*. Courtesy of Kenneth M. Newman, The Old Print Shop, Inc.

N. Currier. *American Winter Sports. Trout Fishing "On Chateaugay Lake."* Courtesy of Kenneth M. Newman, The Old Print Shop, Inc.

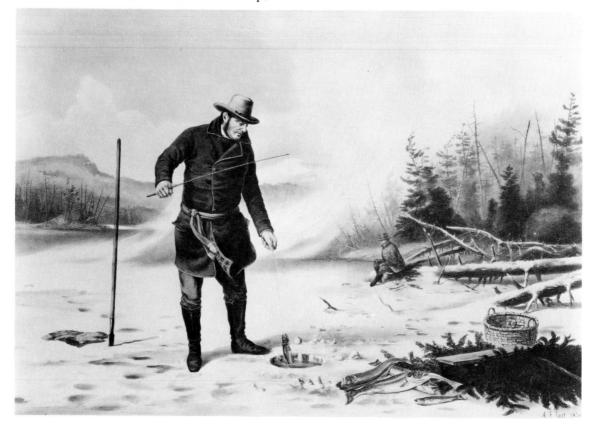

respond to the dinner-call from Sophrone Thurber, the hired girl, who stands in the doorway of the log house.

Hermann Warner Williams, Jr., reproduced this painting in his pioneering book on American genre art to illustrate his thesis that "the true theme of a genre painting is not the incident, but the human condition." In analyzing *Arguing the Point* he notes that "Tait foregoes drama for close observation. . . . The three backwoodsmen are individuals with distinct personalities, and all them show the shrewd, leathery faces of those who spend most of their days out of doors."[15]

The third Tait painting of the Chateaugay country that Currier reproduced as a popular lithograph was a winter scene dated 1854 of fishing through the ice. Evidently Nathaniel Currier wanted a picture of the highest quality. In order to secure the services of Charles Parsons, an Englishman reputed to be a lithographer without peer, Currier agreed to have Parsons's employer, the rival print firm of Endicott & Co., do the printing. Parson's name appears on the print, along with that of Currier as the publisher.

The fisherman's identity has been the subject of considerable speculation. By the time that the print had been selected as number fifteen of the *Best Fifty* in the early 1930s, the grandson of a noted sportsman, Thomas Barbour, had acquired the painting because the fisherman's face seemed so like that of his grandfather. When this claim was published in the newspapers, some descendants of Jonathan Bellows suggested that Bellows was the fisherman, while others said it was Bellows's neighbor and Tait's occasional guide, Anthony Sprague. Still another family tradition in the Chateaugay country asserts that the man was Jehiah Hall, who had done much of the interior carpentry at the Lake House. When Tait painted the picture, the story goes, Hall thought he should take off his long scarf, but Tait told him to keep it on to add color to the scene. When informed of these rival hypotheses, the youngest Barbour remarked: "If it should develop that the old boy fishing through the ice is not Grandpa, I will still look upon the painting with zest."[16]

The care and precision with which his work was reproduced helps account for Tait's preeminence in the eyes of Currier & Ives connoisseurs. Thanks to his prior experience as a lithographer, Tait knew the limitations of the medium. He could paint with these restrictions in mind, so that the prints would be as faithful to the original as the process permitted. Throughout his career Tait would not allow the printmakers to change his compositions in any way.

Comparison of a Tait canvas with its lithographic copy reveals only occasional, minor differences. In his version of *Arguing the Point*, for example, Louis Maurer has added a few more autumn leaves to the tree in the left foreground and has given more emphasis to the impatient cook in the background. In Tait's painting of fishing through the ice, the sportsman correctly keeps his line taut from the tip of his rod to the hook, using his hand only to gently ease the strain. Parsons erred in the lithograph by slightly relaxing the tension from the rod and having the trout pulled from the water by hand alone.[17]

The most ambitious of Tait's paintings at this time was *A Second Shot: Still Hunting on the First Snow in the Chateaugay Forest*. Measuring 54″ × 76″, it is one of Tait's largest works. The painting was his sole contribution to the 1855 exhibition at the National Academy of Design, and was later shown at the Boston Athenaeum.

Tait here portrayed himself as the sportsman in the center about to pull the trigger, and it is an excellent likeness. But the tradition that his companion is Mathew B. Brady, the photographer, cannot be confirmed. Tait was acquainted with Brady, however, and invited him to an artists' reception at the Academy in 1859.

This striking deer-shooting scene has an interesting provenance. Its existence was not even generally known until 1936, when the distinguished firm of Wildenstein offered it for public sale. Harry T. Peters, who had only recently published his definitive account of Currier & Ives and its artists, declared it to be the finest Tait he had ever seen. Although regretting that the canvas was too large to join the several other Tait pictures in his Manhattan apartment, Peters nonetheless hoped to use the picture as a frontispiece for a planned book on Tait that

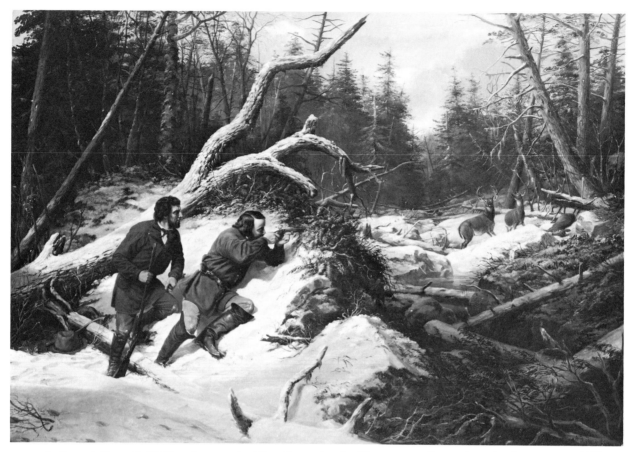

A Second Shot: Still Hunting on the First Snow in the Chateaugay Forest (55.1). Courtesy of The Adirondack Museum.

he never got around to writing. The painting was soon purchased by Carroll S. Tyson, Jr., himself an artist and best known today for his outstanding collection of modern French works, now at the Philadelphia Museum of Art. Tyson was also, however, an admirer of Tait's talents and owned over two dozen examples of his handiwork.

This splendid Chateaugay hunting scene has since come from the Tyson collection to the Adirondack Museum. The large dimensions of the picture indicate that Tait did not think it would be copied directly onto stone when he first painted it in 1855. Within a year, however, it undoubtedly inspired the print *Deer Shooting "On the Shattagee,"* published by Nathanial Currier. Louis Maurer, who did most of the lithographic work, recalled that he copied his own rifle and powder horn when he put in the figures and deer. However, another artist in the firm, Fanny Palmer, did the background and foliage, "taking as her model for this some of the best of Tait's work."[18]

These widely distributed prints encouraged a growing number of sportsmen to visit the Chateaugay lakes, which were already becoming too populated to suit Tait's taste. He preferred more isolated hunting and fishing, so the Bellows family suggested Ragged Lake, a smaller but more remote body of water a few miles to the southwest. In the summer of 1855 Tait made his camp on the shore near the mouth of a stream that is still called Tait Brook. Only one of his paintings, a shanty scene with a hunter and a dead bear, is specifically identified with Ragged Lake. The picture seems to have had some special significance for Tait, since he decided to send it to his brother in Oporto, Portugal, via John Osborn on one of his business trips. But its snowy setting reveals that Tait was not simply a fair-weather outdoorsman, but rather that occasionally he seems to have enjoyed the severe rigors of an Adirondack winter.

Two disagreements with Lewis Bellows about money matters brought Tait's working vacations at Ragged and Chateaugay lakes to an abrupt conclusion. In the fall of 1855 Tait was plaintiff in a hearing before the local justice of the peace. Tait claimed that Bellows was trying to overcharge him $120 for room, board, laundry, and guiding services, a bill that included expenses for Tait's wife, Marian. She had joined him at the Lake House for a while that year, instead of remaining in New York as she usually did during his Adirondack trips. Tait won his case and paid only $2.03.[19]

In December 1855 Tait was summoned to appear in the Franklin County courthouse in Malone to answer a complaint brought against him by Lewis Bellows. The autumn of the previous year Bellows's wife had suffered an injury that required the amputation of her leg. The charge was that Tait had collected gifts of money to help Mrs. Bellows and then refused to relinquish the cash.

The attorney's brief presented to the judge in Tait's defense explained that

> [Tait] is an artist and resides in the city of New York, and . . . for several years past he has been in the habit of resorting to Chateaugay Lake and Ragged Lake in the county of Franklin for the purpose of pursuing his avocation and for recreation, and . . . when on such excursions he has often stopped for considerable periods at the house of the plaintiff. . . .
>
> And the defendant further says that, moved by compassion for the unfortunate condition of Mrs. Bellows, the wife of the said plaintiff, and from purely benevolent motives this defendant suggested to . . . friends and acquaintances of the defendant that they should join with him in a contribution for the purpose of procuring for Mrs. Bellows an artificial leg to be manufactured by Palmer & Co. of Broadway, New York, and which was to be presented to the said Mrs. Bellows as a token of esteem from her friends. . . .

Lewis Bellows claimed that neighbors and patrons of the Lake House had entrusted $153 to Tait, who then kept the money for his own use. Tait responded that he had received pledges to contribute, but only $30 in cash. The case came to trial in the judge's chambers nearly a year later in November, 1856. Twenty-five witnesses, all friends of Bellows, appeared on his behalf at three separate hearings. The verdict announced the following February ordered Tait to pay $125, plus interests and costs, a total of $278.67.

The attorneys who handled Tait's case were Edward Fitch and his law partner and brother-in-law, Ashbel B. Parmelee. Tait became a frequent guest in their homes in Malone and also a good friend during the drawn-out court proceedings. As payment for their legal services, Tait painted portraits of their family members and gave them framed copies of his Currier lithographs.[20]

During this same time Tait painted the portrait of a local merchant in Malone, George W. Hale, who probably outfitted Tait's sporting excursions.[21] This conventional portrait was among the last of ten that Tait produced in his entire career. All were done before he made his mark as an animal painter, and all were likenesses of acquaintances to whom he was indebted.

Since the lengthy litigation with Lewis Bellows made Tait unwelcome in the Chateaugay country, he was compelled to find another section of the Adirondacks for his sporting and painting expeditions. To the south and deeper in the wilderness, near Loon Lake, was a small boarding house called Hunter's Home under the care of Paul Smith. Smith later became the most successful and well-known Adirondack hotel keeper of his time. Tait had met him a few years earlier and had sketched his portrait in ink.[22]

On his way to Loon Lake in September, 1856, Tait stopped overnight at William Martin's hostel on Lower Saranac Lake, the gateway to the woods and waters of the central mountain region.[23] Martin's guest book had already been signed by two of Tait's professional acquaintances who had visited earlier that summer: Frederick E. Church, the landscape painter, and

William James Stillman, who had recently established the influential art journal the *Crayon*. The Adirondacks were beginning to attract other artists.

Tait pushed on to Paul Smith's. Another sportsman who arrived there about the same time described the kind of dinner and welcome that greeted him: "The primest venison steak I ever cut up, smoking hot; large, floury and beautiful potatoes, currant jelly; home-made bread (not to be equalled in any town), good coffee, tea &c., good company, intelligent, well-bred folks, and everything as clean and neat as a new pin."[24] The evening was spent with cigars and talk of the "fur, fin and feather" that were so abundant. "After being promised a dozen shots at deer, if we wanted them, by friend Smith," it was time for bed.

Without his own boat, which had been stored over the winter with friends in Chateaugay, Tait soon found he could not fully enjoy the hunting and fishing. In order to avoid awkward encounters with those testifying against him in the lawsuit with Bellows, he dispatched his host to fetch it with this note of authorization: "Mr. Smith, who will give you this, is the gentleman with whom I have been staying at Loon Lake, and he wishes to get my canoe. . . ."[25]

This birchbark canoe was an important feature in a number of Tait's paintings. It was first depicted at this time in a large picture, 40″ × 60″, called *Deer Driving on the Lakes*. According to Tait's family, Paul Smith is shown in the stern. He holds a dead buck in the water to steady the boat while the hunter in the bow takes aim at another deer on the shore. The painting, completed in the spring of 1857 in time for exhibition at the National Academy of Design, was priced at $200. It received an enthusiastic newspaper review:

> Few canvases on these walls are so remarkable for force and fidelity of treatment as this. The still water, shown with heavy [lily] pads, the bark canoe, the eager hunters . . . are all wonderfully well rendered. Mr. Tait has made his mark above his last year's level. . . .[26]

The theme of sportsmen in a birchbark canoe proved to be so popular with his patrons that Tait repainted it with some variations a dozen times during the next twenty-five years. In 1863 Currier & Ives published one version of it as a lithograph with the title *A Good Chance*. Louis Maurer declared that it was "one of the happiest compositions Tait ever painted."[27]

Tait's repeated portrayal of a birchbark canoe is, however, somewhat puzzling to those familiar with Adirondack watercraft. By the 1860s sportsmen preferred the Adirondack guideboat, a specially designed, lightweight skiff. Easily carried from lake to lake, the boat was unique to the region.[28] Even after Tait acquired a guideboat of his own, he continued to portray the bark canoe in his canvases. Since the original composition of 1857 and the version subsequently published by Currier & Ives proved to be appealingly colorful, Tait evidently saw no reason to change a successful formula for the sake of historical accuracy. It was, for him, a rare instance of artistic license.

In 1857, during his second season with Paul Smith at his Hunter's Home on Loon Lake, Tait became acquainted with James and Seth Wardner, two brothers who had recently built a log home nearby at Rainbow Lake. The following spring, when Tait jotted down a reminder of various things needed for his annual trip to the Adirondacks, the first item on his list was to get some special ammunition for Seth. Other items in this memorandum, dated "June 1858— for the Woods," include tent cloth and mosquito netting, a night lamp for hunting, and fishing rods to be mended. It was John Osborn's generosity that provided Tait with guns, tobacco, gin, one or two cases of port, and brandy.[29]

In preparation for his Adirondack trip Tait did not forget to list needed art supplies: "Sketch box colours—sketching chair, canvas in a roll—solid sketch book & pencils, umbrella." Finally, he made a special notation of "Sketches wanted—1858":

Lake Shore for Deer Hunting (Fight). dogs—men &c.
Old Logs &c. for Bird Pictures—Ferns &c.

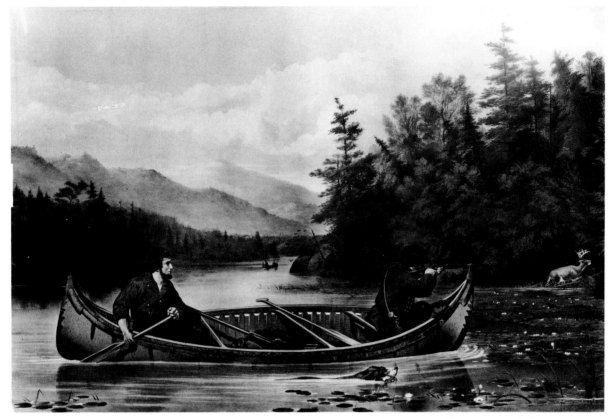

Currier & Ives. *American Hunting Scenes, "A Good Chance."* Courtesy of Kenneth M. Newman, The Old Print Shop, Inc.

A lot of Deer's Heads
Foregrounds for Ducks &c.—Creek scene and some on North Branch rapids for do & Trout fishing[30]

The final item on Tait's list of camping needs was a pair of good boots, to be furnished him by a special friend, James Blackwell Blossom. An enthusiastic sportsman, Blossom was a partner with his brother Josiah in a prosperous naval stores business in New York. For the next several years Jim Blossom was Tait's regular companion on his Adirondack trips. James Wardner recorded their first excursion together in his unpublished memoirs. In the spring of 1858 Seth Wardner said

he intended to take a light guide boat he had made at odd times during the winter and try his hand at guiding fishing parties for Paul Smith's lodge. Paul was working up quite a trade, and needed more guides.
In a few days Seth came back to get me to join him, as he was engaged for a month by a Mr. A. F. Tait . . . [who] had a friend with him who also wanted a guide. They had brought tents and complete camping outfit and wanted to camp out on some good trout stream where they could fish or do as they pleased. Mr. Tait was an artist and spent much time with sketch book or working with oil paints.
Mr. Tait's friend, James Blossom, wanted to camp some place near a rapid stream where he could wade or fish from the shore, as he did not enjoy fishing from a boat or canoe. We moved the tents and camping outfit over to Osgood [Pond] and camped on the outlet near the mouth of Cold Brook. . . .
I guided Mr. Tait and found it a very easy thing to do as he spent so many hours sketching or working on his oil paintings. . . . I learned to appreciate more deeply the many beautiful colors of Nature by seeing him capture them on canvas.

One morning Seth was making a meal entirely of trout, as he often would do, when Mr. Tait quietly got up and walked over to the camp fire. Selecting a piece of charcoal, he . . . drew a good likeness of Seth. It was so perfect any one would recognize it was he. . . .

That fishing expedition was quite a pleasant one for all of us and especially so for me. It was my first experience acting as a guide. . . . I told Mr. Tait I felt guilty in accepting the money, as I did not believe he enjoyed the outing any more than I.[31]

That same summer of 1858, while camping with the Wardners on Bay Pond, Tait met a young landscape painter, Roswell M. Shurtleff. In Shurtleff's unpublished autobiography, now apparently lost, it is reported that "Mr. Tait was very friendly, and offered to further in any way that he could Mr. Shurtleff's desire to become an artist."[32] Tait was well qualified to give such assistance. His accomplishments while hunting and fishing in the Adirondacks were matched by the growing recognition his professional talents were receiving from his peers and the public in New York.

On his return to the city he was greeted with this cordial welcome in the press:

Tait has come in from northern New York, where many weeks have been spent in a real hunter's life. His sketch-book is filled with wood and water life. May he live long enough to paint them all, and many more besides! His dogs and quail and grouse have become a kind of necessity to every well-ordered room.[33]

Notes

1. For a comprehensive account of the Chateaugay country, with bibliography and maps, see Henry C. Ruschmeyer, "Chateaugay Lake: A Case Study in Adirondack Resorts, 1840–1917," Honors thesis, Union College, Schenectady, N.Y., 1966. A copy is also in The Adirondack Museum Library, Blue Mountain Lake, N.Y., MS 70-10.

2. Maitland C. DeSormo, "The Banner House," York State Tradition 19 (Fall 1965): 36–39.

3. "A Trip to the Chateaugay Lakes," The Spirit of the Times 20 (1850): 517.

4. 52.13.

5. 52.28.

6. Thomas Bellows Peck, The Bellows Genealogy, 1635–1898 (Keene, N.H.: Sentinel Printing Co., 1898), p. 213.

7. New York Mirror, February 1, 1853, p. 1.

8. New York Mirror, November 1, 1853, p. 1.

9. 54.30.

10. The Albion, March 29, 1856, p. 153.

11. Best Fifty Currier & Ives Lithographs—Large Folio Size (New York: The Old Print Shop, [1933]), No. 2.

12. Fay Welch, ed., The Old Guide's Story of the Northern Adirondacks, Reminiscences of Charles E. Merrill (Saranac Lake, N.Y.: Adirondack Yesteryears, 1973).

13. See correspondence with the Merrill family, Tait Biography Project, MS 72.1.9, Adirondack Museum Library.

14. Patricia Hills, The Genre Painting of Eastman Johnson, The Sources and Develoment of His Style and Themes (New York: Garland Publishing, 1977), p. 107.

15. Hermann Warner Williams, Jr., Mirror to the American Past, A Survey of American Genre Painting: 1750–1900 (Greenwich, Conn.: New York Graphic Society, 1973), p. 112.

16. There is a file of relevant documents on this painting in Tait Biography Project, MS 72.1.11, Adirondack Museum Library.

17. See "A. F. Tait in Painting and Lithograph—A Gallery Note," Antiques 24 (1933), pp. 24–25.

18. Harry T. Peters, Currier & Ives: Printmakers to the American People (Garden City, N.Y.: Doubleday, Doran & Co., 1929), 1:176.

19. Copies of the legal documents in both suits were kindly provided by the clerk, Franklin County Court House, Malone, N.Y.

20. On October 1, 1858, Tait jotted down an account of his payments to Fitch and Parmelee in his Register, 1:39.

21. 56.24.

22. 53.25.

23. I am grateful to John J. Duquette for allowing me to examine the Saranac Lake House register, 1856–60, for this information.

24. "A Trip to Loon Lake, Franklin Co., N.Y.," The Spirit of the Times 26 (1856): 439.

25. AFT to J. Van Vechten, September 16, 1856. I am indebted to Richard J. Bourcier for providing a copy of this letter.

26. The Albion 35 (1857): 285.

27. Fred J. Peters, Sporting Prints by Currier & Ives (New York: Antique Bulletin Publishing Co., 1930), p. 139.

28. See Kenneth and Helen Durant, The Adirondack Guide-Boat (Camden, Me: International Marine Publishing Co., 1980).

29. AFT Register, 1:152.

30. Ibid., p. 164.

31. James M. Wardner as told to Charles A. Wardner, "Footprints on Adirondack Trails," pp. 6–8, unpublished typescript in Adirondack Museum Library, MS 67-24.

32. Alfred L. Donaldson, A History of the Adirondacks (New York: The Century Co., 1921), 2:41.

33. Cosmopolitan Art Journal 3 (1858–59): 49.

4

New York
1855–1859

WHEN TAIT GOT OFF THE SHIP IN NEW YORK HE HAD COME FROM A NATION WITH A long and rich tradition of both sporting literature and art to a country that was only just beginning to regard hunting and fishing as civilized recreations proper for a gentleman. For all practical purposes Ranney was the first native artist to celebrate these pursuits, but he worked at it only part time and was soon cut down by a fatal illness. For Tait, the decision whether or not to stay in America as a specialist in game animals and birds and fish would depend upon the practical question of whether the public was ready to buy such paintings. As it turned out, the timing of his arrival could not have been more opportune.

A national enthusiasm for field sports, often consciously cultivated after the British fashion, was just starting to take hold with remarkable rapidity. The first American edition of Isaac Walton's classic, *The Compleat Angler*, appeared in 1847, with an appendix on trout fishing in the Adirondacks.[1] An expatriate Englishman, writing under the pen name of Frank Forester, wrote two enormously influential books on shooting and angling in the later 1840s that taught Americans the correct methods and manners that characterize the true sportsman.[2] In 1849 Joel T. Headley published *The Adirondack; Or, Life in the Woods*, the earliest book-length account of the region's hunting and fishing.[3] This was followed in 1854, the same year as Tait's election as an associate member of the Academy, by a similar volume by Samuel H. Hammond with the subtitle, *A Tramp in the Chateaugay Woods*. These books were often reprinted in response to public demand, an encouraging indication that there was also a potential market among gentlemen of means for paintings with the same sporting themes. Tait began to realize that he had the right idea at the right time and right place.

Two events of 1856 suggest that Tait had made up his mind and intended to become a professional artist. He began to keep a detailed record of his work that he maintained until his death forty years later. For each finished painting Tait jotted down in bound ledger books details of its size, subject, buyer, and price. To each consecutive painting he assigned a numerical or alphabetical code, which he both painted on the reverse of the canvas and used to identify the description in his Register. At the same time he added to this record a list from memory of those paintings done since his arrival in America six years earlier. The Register

books, now at the Adirondack Museum, were the working basis for the Checklist of paintings that accompanies this biographical narrative.

Also in 1856 Tait and his wife Marian moved from 150 Spring Street to larger quarters and a more prestigious address at 600 Broadway. Artist' supply shops, as well as framers and dealers in prints and pictures, were all within easy walking distance on the same thoroughfare: William Schaus at 629; Goupil & Co. at 366; Williams, Stevens & Williams at 353. Matthew Brady, the photographer, was at 359 Broadway, and more than seventy artists had studios within a few blocks to the north or south.[4] The move literally put Tait in the middle of the Manhattan art world.

In the spring of 1856 the Academy chose six works by Tait for the annual show, a generous allotment of wall space for a single artist who was not even a full member. Of these paintings a study of quail and young evoked contrasting reactions in the press. The *New York Times* declared, "We have not had so charming a picture in the exhibition for many a day. The drawing so firm, so clear, so mobile, the whole ornithology so perfect, and withal—oh rare union!—the life, the sentiments of those beautiful creatures."[5] However, the *Crayon*, an important new magazine devoted to the visual arts, remarked that "the landscape is the merest apology for Nature, so conventional and thoughtless that it is an offense and a serious injury to the picture."[6]

Further professional recognition came to Tait in 1857 when he was appointed to the Academy's Committee of Arrangements. This committee managed the entire annual spring exhibition, including selection and position of the paintings. The Hanging Committee, as it was also called, dealt with life and death matters. To gratify the desire of each artist to have a large number of his canvases chosen, the paintings were hung inches apart in rows up to the ceiling. Each member was understandably anxious to be assigned a coveted spot "on the line" at eye level, where his painting would catch everyone's attention. To have a work "skied" high out of sight or relegated to a dark corner could provoke bitter anguish in the artist. Since it was impossible for everyone to be entirely pleased with the final arrangements, it seems likely that committee membership was given only to an artist regarded by his peers as open and fair-minded. By shouldering Tait with such an unenviable responsibility, which could and did have unpleasant repercussions, the Academy must have been paying tribute to his judgment and integrity, and perhaps also to his diplomacy.

The work of Tait and the Hanging Committee won praise in the popular tabloid, *Frank Leslie's Illustrated Newspaper*, which called the 1857 show one of the most successful exhibitions in recent years. The article gave Tait prominent notice, for it contained his portrait, done after an ambrotype by Mathew Brady, and a biographical sketch.[7] The account included an anecdote about Tait's sending a haunch of venison to a patron from Chateaugay Lake, but was flawed by errors such as spelling his name as "Tate." A more authoritative appraisal in the *Crayon* adjudged his game bird paintings "exquisitely charming. Would that humanity could always be so truly painted."[8]

In the late fall of 1857, after a tour of the studios to see what various artists had accomplished over the summer, the *Crayon* reported that Tait "still continues to paint those quail and partridge subjects, which have made his name famous in the land. He occasionally adds to these subjects a hunting scene, in which bears and deer figure conspicuously. Mr. T. is also studying landscape, with marked improvement."[9]

On May 11, 1858, Tait was elected to full membership in the National Academy of Design. He received a parchment diploma that entitled him to add the letters "N.A." to his signature, as he nearly always did thereafter. Despite this honor and the distinction of having been reappointed to the Committee of Arrangements for the current exhibition, Tait suddenly found himself the focus of a series of newspaper controversies.

It all began with a painting that in later years became one of his most famous pictures, *A Tight Fix—Bear Hunting—Early Winter*. In its review the *Crayon* praised the painting: "Tait's *Tight-Fix*, exhibiting a struggle between a hunter and a bear in a wood, the ground covered with snow, is a large picture of great power; there can be no question as to the dramatic force

with which this story is told."[10] The *New York Herald* was equally complimentary: "One of the most spirited pictures in the exhibition. The drawing is admirable and the tints strictly true to nature. We have not seen a painting for some time which has pleased us so much."[11] But the *New York Morning Express*, in an unsigned review just the week before Tait's election to the Academy, questioned the painting's originality:

> This composition is set down to the authorship of A. F. Tait, but there is so striking an incongruity of style between the landscape and the figures, that it must be the co-partnership efforts of Tait and [James M.] Hart—a pair that hunt together in this line, without having learned to both keep to the same track. The landscape is passable, except in perspective; the bear is copied from one that may be found in all the primmer [*sic*] books, and the hunter, who is supposed to be "in a fix," occupies the most conceivably awkward position, which makes it necessary for his safety, to introduce a little old man with a rifle in the distance, who is about drawing "a bead" along side a tree, whose dimensions make a pigmy of him. There is some good painting in the picture, but it is full of impossible attitudes and incongruous forms.[12]

Artists often collaborate on paintings, but the charge that Tait had failed to give proper credit for assistance from James McDougal Hart was a serious one. He promptly sent off a letter to the newspaper asserting that "the picture in question is entirely my own, and was painted in 1856, long before I became acquainted with Mr. Hart."[13] He then went on to suggest that such anonymous slander came as revenge from a disappointed artist whose works had been unanimously rejected by Tait and other members of the Hanging Committee for the Academy exhibition.

In the same column of the newspaper Tait's friend and patron John Osborn, in a remarkable letter of his own, promised to donate a thousand dollars to any charitable institution if

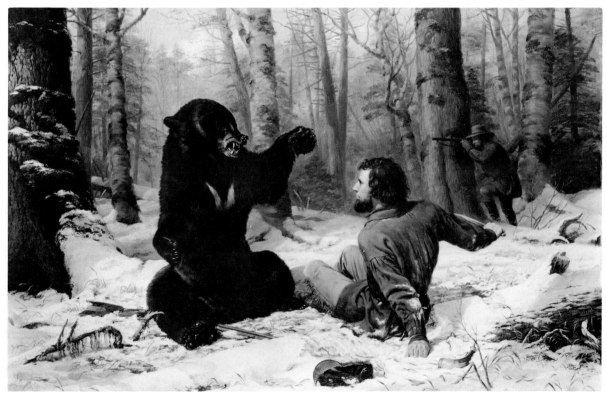

Bear Hunt: Tight Fix (56.3). Courtesy of The Kennedy Galleries, Inc.

anyone could prove to the editor's satisfaction that *A Tight Fix* was not entirely Tait's handiwork. In addition, Osborn offered five hundred dollars for any painting done within six months on the same subject that, in the eyes of the president of the Academy, was equal to Tait's bear fight "in originality, boldness, execution and truthfulness to nature."[14]

Osborn did not lose a penny, but Tait was not entirely candid when he said that *A Tight Fix* was done "long" before he knew James Hart. He had painted it in the winter of 1855–56 and exhibited it that spring at the Pennsylvania Academy of Fine Arts under the title *A Critical Moment.* It was not until the following winter of 1856–57 that Hart, a young Dusseldorf-trained landscapist, moved from his home up the Hudson River at Albany, New York, to a studio in the same building as Tait at 600 Broadway.

Furthermore, Tait failed to mention in his published letter that Hart had worked with him on another painting at the exhibition.[15] This fact was somehow omitted from the official printed program, although the canvas itself did display the signatures of both painters.

James M. Hart was the first and most frequent of several artists to collaborate with Tait. Together they worked on more than two dozen paintings over the next twenty-five years. Unfortunately, little is known of their friendship except for some circumstantial evidence that they may have been together at Loon Lake in the Adirondacks in the summer of 1857. In December of that year the *Crayon* reported that Hart "has on his easel three landscapes, suggested by scenery in the upper counties of the State of New York."[16] One of these may have been his morning scene on Loon Lake that was in the 1858 Academy exhibition. An engraving of the picture reveals stylistic themes characteristic of Tait's work: deer browsing at the water's edge and a flight of ducks against a background of thin fog.[17] Hart, who was no sporting enthusiast, painted in the Adirondacks for some years but found the boarding houses and mountain vistas around Keene Valley more congenial to his tastes and his palette than the wild areas Tait preferred.

Tait and Hart worked together on the same canvases because they found the special skill of one matched a corresponding deficiency in the other. Tait was very good at painting animals, but critics had pointed out that his scenic backgrounds were weak. Hart excelled in landscape. By a simple division of labor they could together create a better picture than either could accomplish by himself. One critic asserted in 1858: "It is very desirable that Tait should continue to paint cattle in Hart's landscapes, but it is equally desirable that whenever Tait borrows the aid of Hart, the entire landscape should be painted by Hart's hand."[18] Over time each learned something from the other. The landscape portions of Tait's paintings improved noticeably, and Hart's cattle scenes became very popular, although his brother William, also a painter, used to say in his broad Scottish accent: "Jeames, he's a fair mon, but he cannot paint a coo."[19]

Another attack in the newspapers upon Tait and his role on the Hanging Committee that spring of 1858 came from "Excelsior," a contributor to the *New York Daily News.* His lengthy "Art Correspondence" appeared on the front pages of the *News* over a two-month period.[20] Even before the Academy exhibition opened, he warned that if the Hanging Committee failed to do its duty properly, he would "show up those narrow-minded carbuncles of the profession in a manner more just than agreeable. I know them and shall not fear to name them." He interpreted the Committee's new policy of making admission to the opening night reception by invitation only as an attempt to "bully the press." Once inside, he wrote, "it was evident at a glance that ignorance and envy had sat in the councils of this august body. . . . There hung the 'works' of the Committee upon the eye line, and the artists of their personal dislike down near the floor and up in a dark corner." As self-appointed defender of artists wronged by the "rhinoceros skinned junto," Excelsior indicted Tait on several charges.

The most serious accusation dated from the previous year, when the Hanging Committee had rejected an engraving, *Washington and His Generals,* by Alexander H. Ritchie. Because Tait had done just such a painting some years earlier as a commission from Ritchie, he insisted that the committee (of which he was a member) refuse the print because it did not give him credit for the original design. According to Excelsior, however, the picture Ritchie

paid Tait to execute turned out to be so bad that after trying to touch it up himself Ritchie gave up and made an entirely new india-ink drawing in which he altered the composition and light. This drawing became the true source of the engraving. Excelsior claimed Tait's painting and Ritchie's print to be utterly unlike, and the rejection of the print by Tait and his committee was "a flagrant act of injustice."

Moreover, Excelsior went on, it was Tait, not Ritchie, who was guilty of plagiarism. One of Tait's paintings at the exhibition was a mirror image of part of Rosa Bonheur's celebrated *Horse Fair*. A second painting, he alleged, had its source in a familiar book of cattle prints by the English artist Thomas Sidney Cooper. "Who," wrote Excelsior, "is this Tait, who bears himself so vauntingly? Who is this mushroom of originality of design?"

The very day of his election as a full member of the Academy, May 11, 1858, Tait wrote a letter to the *Daily News:*

> Like the late Lord Byron, "who awoke one morning and found himself famous," I find myself in a fair way of being scribbled into celebrity by the malevolent attacks of an anonymous slanderer, who has managed to wriggle pretended criticism upon the pictures now on exhibition at the National Academy into several newspapers. . . . In the year 1851 or '52 Mr. Ritchie commissioned me to paint for him a picture of Washington and his Generals, furnishing me with a rough draft of what he wanted, also with some engravings of heads to be inserted. I agreed to execute the picture for three hundred dollars, with the condition that my name should appear on the engraving as the painter. When the picture was finished Mr. Ritchie was very offended because I refused to part with it without the money, and because I declined to take his note at four or six months for the amount. Ultimately finding that I was not to be diddled into taking a promise to pay, instead of actual payment, the money was forthcoming, and Mr. Ritchie attempts to take his revenge by publishing an engraving from the picture with his own name upon

No. 182. An Old " Bar" narrating his Adventures to an intense-ly-interested Hunter.—TAIT.

Caricature, "A Tight Fix," *Harpers Weekly*, May 15, 1858. Courtesy of The Adirondack Museum.

it as the painter, and is astonished that such a disgraceful fraud is not countenanced by the Academy, but that his engraving was rejected as it deserved to be.

Tait concluded by saying that he would not care to risk his reputation on the painting "as it never was a favorite with me—was painted in the midst of difficulties and annoyances, and I have always considered it one of my worst efforts."

A few days later a long letter to the newspaper from Ritchie put an end to the controversy. He pointed out that Tait admitted the first design was in fact Ritchie's pencil sketch. Furthermore, having all but disowned the oil canvas as one of his worst, Tait had also misinterpreted the credit line on the engraving: "Drawn and engraved by A. H. Ritchie." In closing, Ritchie offered to sell the painting back to Tait at the bargain price of $3, one one-hundredth of what he had paid for it. The only condition was that Tait must hang it in the current exhibition, in the place occupied by either his cattle scene allegedly after Cooper or *A Tight Fix* and put a copy of Ritchie's engraving next to it for all to see.

Tait made no reply, leaving the last word to Excelsior, who criticized his bear fight picture for its flaws of design and perspective:

> This state of things is quite enough to put the painter "in a tight fix," and doubtless suggested the title of the picture. . . . In taking a temporary leave of this subject, especially that which relates to the Academy of Design, I want the officers of that old hulk to understand . . . that I do not, and the public do not, regard personal threats, anonymous caricatures, or $1,000 braggadocias as arguments against well sustained and unanswered accusations.

The "anonymous caricature" refers to an illustration in *Harper's Weekly*,[21] a cleverly burlesqued reproduction of *A Tight Fix* with the caption: "An Old 'Bar' narrating his Adventures to an intensely interested Hunter."

The canvas of *A Tight Fix* that provoked all this news copy is a large one, 40″ × 60″. Tait's records identify the locale of the painting as the Chateaugay woods, the price $500, and the buyer a Mr. J. Campbell of the Pacific Bank. Until a friend called it to the author's attention while this book was in progress, the picture hung for many years in the barroom of a private club in California, unrecognized and unknown.

This would conclude the story of *A Tight Fix* if Currier & Ives had not in 1861 commissioned Tait to paint for publication a variation of the same theme with the same title.[22] This second painting has not yet been found, but the lithographic reproduction shows a marked improvement in conception and execution. Gone are the awkward postures of bear and man sitting on the ground and the perspective distortions. Each antagonist stands poised to attack, the hunter's raised and bloodied knife highlighted against the bright, snowy background. At a distance the second hunter, now with the military-style cap so familiar during the Civil War, watches alertly for an opportunity to shoot before the bear can close in again. Tait has successfully captured a moment of tense drama.

Of the more than 7,000 different lithographic subjects published by Currier & Ives, *A Tight Fix* is now considered the rarest and most valuable. Less than a dozen copies are known to exist, including a few uncolored versions. Its reputation was made as early as 1928 when a copy brought $3,000 at auction. By 1970 its price had risen to $8,500.

Such prominence once again aroused speculations about Tait's sources for the theme of *A Tight Fix*. In his article in *Antiques*, Philip Jordan asserts that he "could never believe that Tait relied wholly upon his own imagination in conceiving and composing this exciting episode."[23] Jordan holds that Tait's picture reworked a woodcut illustration in a popular biography of Daniel Boone. While he is aware of Tait's long association with the Adirondacks, Jordan does not choose to relate the subject of the print to the artist's own experiences or to what he might have heard from the local guides.

Louis Maurer provides the evidence that *A Tight Fix* does derive from Tait's Adirondack

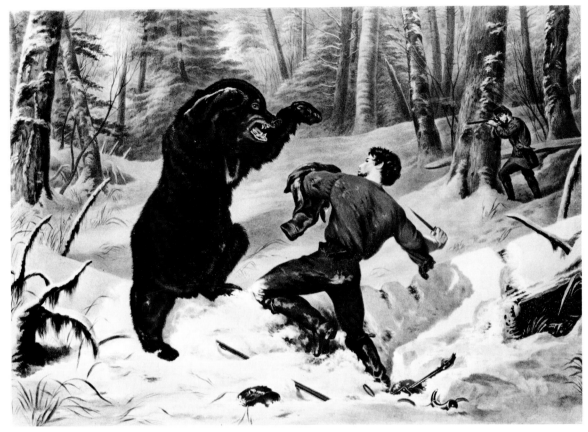

Currier & Ives. *The Life of a Hunter—A Tight Fix*. Courtesy of Kenneth M. Newman, The Old Print Shop, Inc.

experiences. The Currier & Ives lithographer was visiting in Tait's studio while he was painting the picture:

> Tait told . . . his tale of the two hunters who met and surprised the bear. The bear, being as much startled as the hunters, reared and closed with the nearest man. The print shows clearly that the bear actually clawed the man's shoulder. Then for some reason the bear pushed the hunter away with his snout, thus giving the hunter's companion the chance to "draw a bead" on the bear.[24]

Following the 1858 spring show at the Academy, Tait's professional progress and press notices improved. In June alumni and friends of Yale University, fearing that "the appreciation of the Beautiful has not kept pace with their love for the True and the Good,"[25] organized an exhibition of 300 hundred canvases, including two of Tait's bird paintings on loan from one of his patrons. Today Tait is well represented at Yale in the country's oldest college art museum. A number of his paintings and prints were part of a large collection of sporting art that Francis P. Garvan, a connoisseur of Americana, gave to the university in 1932. Nearly two decades later, Tait's oldest son, Arthur James Blossom Tait, contributed a group of his father's sketches.

In the summer of 1858, an important article about Tait in the *Cosmopolitan Art Journal* enhanced his reputation among its 40,000 readers across the country.[26] The Cosmopolitan Art Association, publisher of the *Journal*, was established to raise the cultural level of the nation by distributing as prizes prints, paintings, and statuary. To circumvent the legal prohibitions against lotteries that had caused the demise of the American Art-Union, it included a ticket for the annual drawing of winners as a free bonus for those who bought a subscription to the

magazine. The Association's commercialism and catering to popular tastes offended some conservative artists, but this did not deter Tait, who sold the Association seven canvases in the next two years.[27]

The *Journal's* biographical account is one of the few sources of information about this period in Tait's career. It discusses the connection between Tait's Adirondack experiences and some of his painting techniques:

> Every summer for several years, he has spent in the depths of the vast primeval forests of Northern New York, trapping and gunning after the true back-woodsman fashion. Many a tale of adventure attaches to his wildwood experience; but, what is of more moment, many are the sketches which these experiences with deer, and bear, and moose, have given to his portfolio. . . . Not only does he study through the summers in the forest, but, through his spoils of deer antlers, heads and legs—of birds carefully preserved and cunningly grouped as they were caught in covey; of mosses and grasses and leaves: he carries nature home with him to be his constant companion. Such devotion to study must bring its own great reward.
>
> Mr. Tait works rapidly, but not carelessly. His exquisite bird-pieces are in great demand, and worthily so; for we know of no little paintings more calculated to give pleasure.

The author of this account was probably Samuel Putnam Avery, who also engraved the accompanying portrait of Tait.[28] In later years Avery achieved wealth and fame as an international art dealer, a founder of the Metropolitan Museum, and a benefactor of Columbia University. He had begun as a wood engraver of illustrations for popular magazines and books, but gradually he started to buy, sell, and collect paintings. According to a contemporary, he "had a wonderful power of criticism. He could look over an oil painting and tell an artist just what was lacking. . . . Avery got to know a good many artists by helping them with suggestions. Occasionally he was given a picture by some who recognized that he had been serviceable in pointing out defects before a picture was finished."[29] Perhaps Tait was showing appreciation for just such advice when he gave Avery a painting, which is inscribed "From A. F. Tait to S. P. Avery" on the front, rather than the back of the canvas, an unprecedented departure from Tait's usual practice.[30]

Tait enjoyed further national publicity when Avery arranged for this little picture of does and fawns to be reproduced as a steel engraving in the *Ladies Repository* magazine.[31] A man who came to have important connections in the art world, Avery proved to be a good friend and occasional agent for the sale of Tait's works.

In 1856 the *Crayon* observed that "men love concentrated things. . . . We believe that small careful studies from nature will 'pay' better than . . . huge canvases."[32] Tait's success in making a living was based partly on what he came to regard as his specialty: small canvases ranging from 4″ × 6″ up to 10″ × 14″ that sold from $20 to $75. Over the years the several hundred small pictures that he painted provided a steady income. The record reveals that Tait tended to concentrate on one subject for a while and then to shift to another. At first his specialty was waterfowl, then grouse and quail. In the 1860s it was deer and chickens, and, in his final years, sheep. Such changes in subject matter may reflect changes in Tait's own interests or in popular tastes, or both.

Most of Tait's customers probably bought a painting or two simply to decorate their homes. A few patrons, however, were connoisseurs with different motives. One was Edward G. Faile of Westchester County, a gentlemen farmer with an interest in breeding pedigreed cattle that could compete for prizes at livestock shows. In 1856 he commissioned three small paintings of Devon cows and bulls.[33] A few years later, when Faile was president of the New York Agriculture Society, he asked Tait to paint four larger portraits of his champions.[34]

Tait's work caught the eyes of some prominent art collectors. William T. Walters of Baltimore, who was acquainted with Avery, bought seven paintings in 1857–58,[35] including a

joint picture with James Hart for $300.[36] Samuel B. Fales of Philadelphia loaned his Tait paintings to the exhibitions of the Pennsylvania Academy of the Fine Arts.[37]

Another distinguished patron was Robert M. Olyphant, who purchased three of Tait's quail and grouse pictures in 1856–57.[38] Five years later he began to acquire American paintings exclusively. In 1867 his collection contained one hundred canvases by forty-three native artists.[39] He was a fellow of the National Academy of Design and helped raise funds for its first building. His enthusiasm for American art had several motives. Unlike many of his peers in the mercantile world, Olyphant had no cultural inferiority complex concerning Europe. As a businessman he knew that American paintings could be bought for relatively little, since they were not subject to heavy import taxes. And, as a self-made entrepreneur, he enjoyed using his judgment to recognize the merits of little-known living American artists.

The Reverend Dr. Elias Lyman Magoon purchased art for more spiritual reasons.[40] He published an essay to demonstrate the religious significance of American landscape paintings,[41] and in 1857 he bought two small Tait canvases to add to his substantial and varied private collection.[42]

Just as Samuel Avery was introducing Tait to some prominent patrons, Tait in his turn was occasionally helpful to his fellow artists. He seems to have been asked by Elias Magoon and George Congdon, another important collector, to select for each of them a work by George Innes, whose studio was a few doors away from Tait's.[43] With characteristic generosity Tait gave a small painting to Jasper Cropsey, presumably in return for some favor.[44] As was often the case, however, Tait misspelled his name.

In 1857 Currier & Ives commissioned Tait to do four canvases that they would publish as a set under the title *American Field Sports*. The paintings portrayed pointers and setters hunting woodcock, snipe, grouse, and quail. Tait received $200 for each of the 24″ × 36″ paintings. Louis Maurer served as consultant and reported many years later that "Tait was anxious to produce a set of pictures showing dogs, birds and setting of the finest possible quality. . . . [Maurer] and Tait worked together seeking proper material . . . and finally compromised by making composite pictures, the result of which gives us the most symbolic illustrations of the sport obtainable."[45] Currier & Ives proudly advertised in the *Spirit of The Times*, the principal outdoor magazine of the period, "four elegant prints . . . from paintings by the celebrated artist, A. F. Tait: the best of their kind ever published. They are on heavy plate paper, and each copy carefully colored in the best style of the art. Price $3.75 each, or $14 for the four."[46] Two of the paintings were included in the 1858 exhibition at the National Academy of Design.[47]

When the newspaper publicity in the spring of 1858 finally ended, Tait took a long vacation in the Adirondacks. His Register of paintings, which occasionally served as a diary, mentions that he "returned from the woods & got home at 6 a.m. Nov. 1st." A list of commissions awaiting his attention follows. The first item on the agenda was "a painting for the Ranney Fund."[48]

William Ranney, the painter of Western and sporting scenes, had died a year earlier in the autumn of 1857 after a three-year struggle against consumption. A special fund-raising sale for the benefit of his widow and children was organized by a wealthy young businessman, Nason B. Collins, who was assisted by two artists, William Hart (brother of James) and Tait.[49] Collins had recently purchased a few paintings from Tait[50] and was the owner of James M. Hart's painting of Loon Lake in the Adirondacks. Tait and Hart gathered what still remained in Ranney's studio and enlisted the aid of other artists to touch up some unfinished canvases. One such painting that Tait and William Sidney Mount worked on has come to light, for it has their initials inscribed on the back.[51] Tait then joined with ninety-four other artists who donated works of their own to add to those from the estate.[52] The special auction, held on the evenings of December 20 and 21, 1858, netted about $7,000.

The success of the Ranney sale awakened a new sense of professional solidarity and mutual responsibility among the community of artists in New York that had an enduring consequence. In January, 1859, the press reported that "at a meeting of the artists who had

Currier & Ives. *American Field Sports*, *"A Chance for Both Barrels."* Courtesy of Kenneth M. Newman, The Old Print Shop, Inc.

contributed for the purpose of aiding the widow of Mr. Ranney . . . the subject of the formation of an Artists' Benevolent Society was informally discussed, and a committee . . . was appointed for the purpose of drafting a constitution and by-laws, and reporting at a future meeting to be called by them."[53] The members of this group were Thomas S. Cummings, Charles Loring Elliott, Junius B. Stearns, James H. Cafferty, Nason Collins and Tait. The Artists' Fund Society, as it came to be called, was chartered by the state in 1861, and Tait was elected a trustee. Each year its members contributed a painting to a special public auction, the proceeds of which went into a reserve fund for assistance to any needy artist or his family. As one of the founders, Tait remained a loyal member and supporter of the Society for many years thereafter.

Tait's stature as an artist continued to grow in a variety of ways. He was invited to send a painting to the third annual exhibition of the Washington Art Association in the nation's capital.[54] In the spring of 1859 he was elected as one of six members of the Council of the National Academy of Design. And in a review of the Academy exhibition at the same time, Thomas Bangs Thorpe, himself a painter and sporting writer as well as a sometime visitor to the Adirondacks,[55] wrote:

> James M. Hart and A. F. Tait have united their excellencies in the "Dairy Farm," giving a most happy combination of landscape and cattle. Before this composition there is always a crowd of admirers, including the most cultivated and the most spontaneous of minds. Every separate part of the picture is carefully studied, and there are effects of great beauty.
>
> Mr. Tait goes on improving—his animals are vastly superior to last year in delicacy of handling and variety of design.[56]

A. F. Tait ca. 1860. Courtesy of The Adirondack Museum.

In 1859 Tait may have taken on a pupil, Edwin Forbes, but for a brief time only.[57] Forbes is best known for his battlefield illustrations from the Civil War; he later settled in Boston as a painter of bucolic landscapes.

On April 12, 1859, Arthur Fitzwilliam Tait became a naturalized citizen of the United States, nearly ten years after his arrival. At that time his aged father had written to him from England, ". . . if America does not answer to you, you will return."[58] It was clear that America had indeed answered to Tait.

Earlier that same spring Tait sent a note to Samuel Avery inviting him to an artists' reception hosted by John Osborn. He also mentioned that he was "going out of town today to decide about the place at Woodstock, East Morrisania. I think I shall fix on it and go out there to try it."[59] Tait never was very fond of city life, and in July, 1859, he and Marian (they had no children) moved to the then-rural suburb. The problems of settling in and supervising some remodeling for a studio seems to have prevented or curtailed Tait's annual visit to the wilderness. With the following season, however, he began a new chapter of his Adirondack adventures, despite the ominous political tensions that preceded the Civil War.

Notes

1. See Chapter 9, "Bethune and *The Compleat Angler*," in Charles E. Goodspeed, *Angling in America, Its Early History and Literature* (Boston: Houghton Mifflin, 1939). Goodspeed did not realize that the Reverend George W. Bethune, who was the anonymous editor of the book, was also a member of the Piseco Lake Trout Club, whose Adirondack adventures are narrated in the appendix.

2. Ibid., pp. 163–66.

3. Joel T. Headley, *The Adirondack, Or, Life in the Woods* (1849; reprint ed., Harrison, N.Y.: Harbor Hill Books, 1983). This latest printing has a fine introduction by Philip G. Terrie.

4. See Neil Harris, *The Artist in American Society . . . 1790–1860* (New York: George Braziller, 1966), pp. 267–70.

5. *New York Times*, April 21, 1856, p. 4.

6. *Crayon* 3 (1856): 147.

7. *Frank Leslie's Illustrated Newspaper* 4 (July 11, 1857): 89.

8. *Crayon* 4 (1857): 147.

9. Ibid., p. 378.

10. Ibid., 5 (1858): 177.

11. *New York Herald*, April 23, 1858, p. 3.

12. *New York Morning Express*, May 4, 1858.

13. Ibid., May 8, 1858.

14. Ibid.

15. 57.20.

16. *Crayon* 4 (1857): 378.

17. *Ladies Repository* 20 (January 1860): 62. The engraving, done by James Smillie, was exhibited at the NAD in 1859.

18. *Frank Leslie's Illustrated Newspaper* 6 (July 3, 1858): 74.

19. Quoted in "More about Hart," *Antiques* 96 (1969): 737. See also Bartlett Cowdrey, "Tait and Hart in American Sporting Painting," *Panorama* 3 (1948): 63–66.

20. Unless otherwise noted, the quotations that follow are excerpts from this extraordinarily long series, which appeared on the front page of the *Daily News* on the following dates in 1858: March 29; April 13, 23, and 26; May 1, 7, 13, 14, 19, and 22; and June 5. In all, these columns add up to some fourteen feet. The identity of "Excelsior" has eluded detection.

21. *Harper's Weekly*, May 15, 1858, p. 320.

22. 61.10.

23. Philip D. Jordan, "A Possible Source for 'A Tight Fix,'" *Antiques* 25 (1935): 28–29.

24. Fred J. Peters, *Sporting prints by Currier & Ives* (New York: Antique Bulletin Publishing Co., 1930), p. 139.

25. *The New Englander* 16 (1858): 813.

26. "Arthur F. Tait," *Cosmopolitan Art Journal* 2 (1858): 103–4.

27. 58.55–56, 60.5–6–7–8, 60.48.

28. See Ruth Sieben-Morgen, "Samuel Putnam Avery (1822–1904), Engraver on Wood; A Bio-Bibliographical Study," mimeographed (Hartford, Conn., 1942). This is an unpublished revision of a master's thesis for Columbia University, 1940. On p. 152 is listed the portrait of Tait, but the author did not know its date and place of publication.

29. Henry E. Canfield in the *New York Tribune*, December 13, 1885. The article continues: "He got along in art until he was considered an oracle, when he was given charge of the American exhibit at the Paris Exposition in 1867. He bought a large number of pictures and took a large number more to sell on commission. When he came back with them he had a large collection and opened a gallery. That was his beginning."

30. 58.23.

31. *Ladies Repository* 19 (August 1859). The engraving was done by James Smillie and exhibited at the NAD in 1859.

32. *Crayon* 3 (1856): 158.

33. 56.12–.14.

34. 61.4–.6 and 61.20.

35. 57.21–.23, 58.19, and 58.28–.29. See William R. Johnston, "American Paintings in the Walters Art Gallery," *Antiques* 106 (November 1974): 853–61.

36. 58.40.

37. Anna Wells Rutledge, *Cumulative Record of Exhibition Catalogues of the Pennsylvania Academy of the Fine Arts* (Philadelphia: American Philosophical Society, 1956), p. 226.

38. 56.10–.11.

39. See Frederick Baekland, "Collections of American Painting, 1813–1913," *American Art Review* 3 (November–December 1976): 120–66.

40. See "Our Private Collections," *Crayon* 3 (1856): 374.

41. See James T. Callow, *Kindred Spirits* (Chapel Hill: University of North Carolina Press, 1967), p. 170.

42. 57.15, 57.19.

43. AFT Register, 1:168.

44. 56.19.

45. Peters, *Sporting Prints*, p. 72.

46. *Spirit of the Times* 27 (1857): 432.

47. 57.4 and 57.5.

48. AFT Register, 1:148.

49. For a detailed account see Francis S. Grubar, *William Ranney, Painter of the Early West* (New York: C. N. Potter, 1962), pp. 11–12 and 57–59.

50. 57.27, 58.41–.42, 59.3.

51. ND 8.

52. 58.51.

53. *Daily Tribune*, January 20, 1859.

54. *Catalogue of the Third Annual Exhibition of the Washington Art Association* (Washington, 1859). Item 136 lists "Hunting Scene" by Tait, and J. Snedecor as "Possessor."

55. Thomas B. Thorpe, "A Visit to 'John Brown's Tract,'" *Harper's Monthly* 19 (July 1859): 160–78.

56. *Spirit of the Times* 29 (1859): 134.

57. George Croce and David Wallace, *Dictionary of Artists in America* (New Haven, Conn.: Yale University Press, 1957), p. 234. Also Jack E. K. Ahrend, "Edward Forbes," Master's thesis, University of Maryland, 1966.

58. Adirondack Museum Library, MS 73.7, Memorabilia Box 1.

59. AFT to Samuel P. Avery, March 9, 1859. Avery Collection, Metropolitan Museum of Art.

5

The Adirondacks
Raquette Lake
1860–1869

WHEN TAIT RETURNED TO THE ADIRONDACKS IN THE SUMMER OF 1860, HE decided to make his camp at Raquette Lake in the center of the wilderness. It was a picturesque and remote area, accessible only by small boats and short carries or portages. With many bays and promontories that give it an irregular shape, Raquette Lake is one of the largest and most beautiful lakes in the region.

His former sporting grounds on the northern fringes of the mountains had become too developed to suit Tait's taste for shanty life. The previous season his friend Paul Smith had opened a new seventeen-bedroom hotel on the shores of Saint Regis Lake, just a few miles from the Wardners. The necessary capital for construction had been advanced by several well-to-do gentlemen who wanted a place suitable for their wives and familes.[1] Smith's business prospered and became a famous resort, but this intrusion of civilization spoiled the quiet and solitude Tait preferred.

In 1860 one of Tait's patrons, the sportsman-author Charles E. Whitehead, published a collection of hunting and fishing stories and commissioned Tait to draw the volume's frontispiece.[2] Tait's friend and occasional agent Samuel P. Avery engraved several other pictures for the book, but we do not know whether he also worked on Tait's picture.[3] This is the only known book illustration that Tait did in this country.

Whitehead may have recommended that Tait try his luck at Raquette Lake, for he had made an excursion to the central Adirondacks in 1858.[4] His guide had been Calvin Parker, commonly called Captain Parker in recognition of the time he served as a military scout in the West. A man of many talents, Parker was known as a sharpshooter, bugle player, and waggish raconteur. Parker claimed, for example, that one time he fired his rifle twice at what he thought was a panther on a leafy tree branch directly over his head, only to discover that it was a mosquito in his eyebrow.[5]

In 1860 Captain Parker became Tait's guide and subsequently served him off and on for the following two decades. Together with Jim Blossom and Jim's brother Josiah, they made their camp for the next several years at Raquette Lake on Constable Point (now Antlers Point), which had a sandy beach, a cool spring for drinking water, and an interesting history.

Not long after the Revolutionary War, William Constable, a prosperous New York speculator, was partner in buying a vast tract of wild lands to the west and north. In 1810 his son built Constable Hall in Lewis County. From this baronial mansion three grandsons—William, John, and Stevenson—made long hunting and fishing trips into the Adirondack wilderness. As early as 1839 they regularly used as headquarters the same sandy point of land on Raquette Lake where Tait and his companions decided to camp.[6] In 1851 two young landscape artists, Jervis McEntee and Joseph Tubby, made themselves at home in a comfortable bark shanty on the point. They learned that the Constables "had spent the previous summer here with several other gentlemen and a number of ladies, who, it is said, enjoyed the life exceedingly, and accomplished many fearless expeditions, one of which was the ascent of Blue Mountain."[7]

Raquette Lake had long been a winter moose-hunting ground for French Canadian Indians; indeed, *raquette* is the French word for "snowshoe." But by the late 1850s most of the moose suddenly disappeared, apparently victims of disease. Sportsmen finished off the few surviving stragglers.

When the zoologist Clinton Hart Merriam raised the question in the late 1870s of who killed the last Adirondack moose, he received "a deluge of individual opinion and conflicting statements, together with a meager amount of positive information of a strictly reliable character." John Constable reported that he and his brother Stevenson had killed their last moose in 1856: "I never recur to those hunts with any satisfaction, for much as I enjoyed at the time the tramp of more than a hundred miles on snowshoes [from Constable Hall to Raquette Lake] . . . I must ever regret the part I have taken unwittingly in exterminating this noble animal from our forests."[8]

In the summer of 1861, Tait, Jim and Josiah Blossom, and Captain Parker had two encounters with moose at Raquette Lake that they later reported to Merriam. In the middle of July, while floating for deer on the Marion River, Tait wounded a moose, which got away in the darkness. A week or so later in the same area a hunter shot a moose with a broken jaw, presumably the same animal injured by Tait. This was probably the last corroborated kill of a bull moose in the Adirondacks.

On the twenty-fifth of July Jim Blossom shot a cow moose on the South Inlet of Raquette Lake. He and Tait carefully measured their trophy, which was just over six feet tall at the shoulders; then Tait documented the event by making an oil sketch of the unfortunate creature.[9] As far as we know, this is the only portrait done from nature of this now-extinct, native Adirondack mammal. The probable coup de grace for the species came at the end of August from a party of Philadelphia hunters that killed another cow moose on the Marion River.

Thus Tait and his companions just missed the dubious distinction of killing the last native Adirondack moose. Their contribution to its extirpation does not seem to have caused them any regrets, for a few years later Jim Blossom, while hunting moose in Canada, reminisced in a letter: "The vague notions which Parker used to advance before our green ideas in regard to moose hunting, I always suspected to be founded on ignorance little less than our own. If I had known in July, 1861, as much as I do now, I think 'that bull moose's' horns would now grace my room. By 'that bull moose' you must understand the old fellow that bellowed over Raquette South Inlet hills, after I shot that cow."[10]

A decade of handling guns as a hunter in the Adirondacks evoked a mechanical bent and an inventive turn in Tait's mind. Contemporary firearms, superseding the flintlock, operated on a percussion system. However, just before he could fire, the sportsman had to apply by hand a little metallic cap containing the priming charge of fulminating powder. It was a delicate business. A man with cold fingers, or someone working in the rain, or simply a clumsy fellow could easily drop the cap. Tait wanted to develop a reliable automatic method for priming a gun, since the various spring and lever devices already in use were less than satisfactory. In 1863 he was granted a patent by the federal government for an invention he described as an "Improvement in Self-Priming Hammers for Fire-Arms,"[11] but there is no evidence that it

was ever manufactured or put on the market. Perhaps the new mechanism had its own flaws, and, in any case, Tait was too late. The military was already developing a foolproof, breech-loading cartridge.

Soon after Tait began his annual excursions to Raquette Lake he resumed work for Currier & Ives after a lapse of a few years. The gloomy events of the Civil War stimulated public interest in all kinds of pictures of happy times and places, and printmakers were quick to profit from the increased demand for their colorful lithographs. From 1861 through 1864 fifteen of Tait's paintings were copied on stone and published. Four of these were prairie scenes, but the others all illustrated his Adirondack experiences. Some of the pictures suggest comment or anecdote.

In 1862 Tait portrayed a wilderness idyll in the print *The Home of the Deer*, whose original painting has not been found. The fleecy early morning fog, while true to nature, adds a touch of romantic atmosphere to the scene, though perhaps it was also a device to conceal Tait's lingering difficulties with landscape details.

Paintings of deer, always one of his most popular subjects, compromise nearly fourteen percent or about two hundred of all the works listed in Tait's records. In his treatment of this shy and graceful animal, however, he usually avoided undue sentimentality, even when portraying a doe and her fawns. Nor did he idealize the antlered buck by endowing it with heroic proportions to please the zealous gunner. Years later a native of the Adirondacks, Reuben Cary of Long Lake, reminisced about Tait's attitude toward deer:

> [Old Dight Hough] used to guide for an artist by the name of Tait—as fine a gentle-man as you could find. Well, they were hunting together one day on a pond when Uncle

Currier & Ives. *The Home of the Deer—Morning in the Adirondacks*. Courtesy of Kenneth M. Newman, The Old Print Shop, Inc.

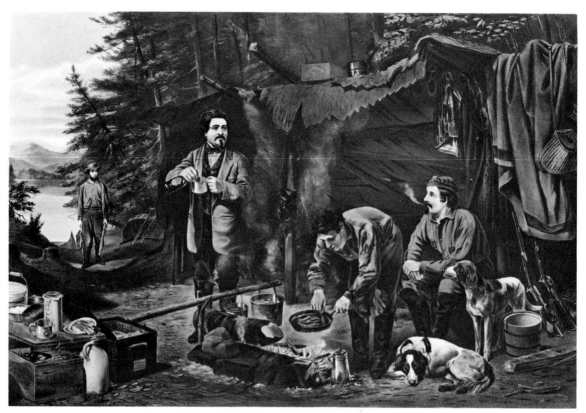

Currier & Ives. *Camping in the Woods*, *"A Good Time Coming."* Courtesy of Kenneth M. Newman, The Old Print Shop, Inc.

Currier & Ives. *American Hunting Scenes*, *"An Early Start."* Courtesy of Kenneth M. Newman, The Old Print Shop, Inc.

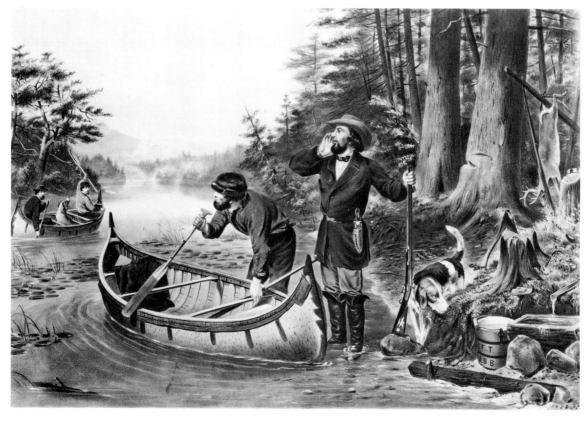

Dight saw a buck walk out on the shore and commence feeding. He paddled up to within shooting range and whispered to Mr. Tait to let him have it. The buck stood there broadside—he was a beauty, too, Uncle Dight said, but the artist never offered to lift the rifle. Finally, the deer jumped up, he hauls up in a hurry and fires.

"Did I hit him, Mr. Hough?"

"Hit him?" says Uncle Dight. "Sugar. You didn't hit the world. What makes you wait so long?"

"Oh, he looked so pretty standing there," explained Mr. Tait.

"Yes, that's just it," snorts Uncle Dight, "You ought to have had a piece of paper and painted his picture."[12]

In *A Good Time Coming* (1862) Tait portrayed his shanty on Constable Point at Raquette Lake. Of the four people in the painting, Tait's memorandum names only the man holding the bottle, John C. Force, a Brooklyn restauranteur and an important collector of Tait's works. This is one of the few instances where Tait himself recorded the identity of a person in his paintings. The natural focus of camp life, the fire, is kindled against one log atop another at the back to reflect a welcome warmth into the bark-roofed shelter. Certain details catch the eye: smoke-blackened cooking buckets hang from poles on forked sticks, while freshly caught trout sizzle in the frying pan and the coffeepot simmers in the hot coals. The wooden packing case of wine bottles in straw has the printed label, "Osborn & Co., Oporto," the firm of Tait's good friend John Osborn, whose imported liquors often supplied Tait's camp.

In 1862 Currier & Ives paid Tait the usual fee of $200 for the painting *Going Out: Deer Hunting in the Adirondacks.* They published it the following year as a large folio lithograph with the title *An Early Start.* The birchbark canoe is a familiar motif, but Tait's records do not identify the sportsmen. Many years later the artist's sons suggested that Jim Blossom occupies the distant boat, with the guide Seth Wardner in the stern, while Tait himself stands foreground with the rifle and Capt. Calvin Parker bends over the canoe. Tait has inscribed his own initials, together with those of James Blackwell Blossom on the wooden water pail in the lower right corner.

The original painting for the print *Brook Trout Fishing* has not been found.[13] Tait's record of it fails to name the fisherman but notes the locale as the Raquette River, probably the stretch below Raquette Lake between Forked and Long lakes. The sartorial elegance of the angler, with his tailed jacket and vest, gold watch and chain, ruffled white shirt and bow tie may strike us today as ludicrous. But Tait has accurately portrayed the spirit and style of the time. Fishing for fun, instead of for food, was then a relatively new concept. The true sportsman uses an artificial fly and lightweight gear to test his skill and to give better odds to the trout. It was gentlemen who preferred such contemplative recreation, and a gentleman always dresses like one.

The final painting in this Currier & Ives group was *American Speckled Brook Trout,* dated 1863. Tait's family tradition is that the artist first made an oil sketch of a single trout from Raquette Lake in 1860.[14] A couple of years later he did two more paintings, each with a second trout, wicker creel, and rod and reel.[15] One he presented to Jim Blossom for Christmas, the other he included in a public sale, where it caught the eye of James Ives. He ordered a larger version, requesting that Tait put more color in it. Tait obliged by adding two more trout, a canteen, and a book of irridescent fishing flies. The print is noteworthy as perhaps the earliest experiment by Currier & Ives in printing a chromolithograph in oil rather than the standard black and white lithographs subsequently colored by hand by a team of factory girls.[16] In 1868 they published *The Alarm,*[17] "a Chromo in Oil Colors From the Original Painting by A. F. Tait." However, the firm proved to be conservative about making such technological innovations and never advertised any fine art pretensions, as did rival printmakers.

Shortly after, in 1865, Tait's relationship with Currier & Ives came to an abrupt end.

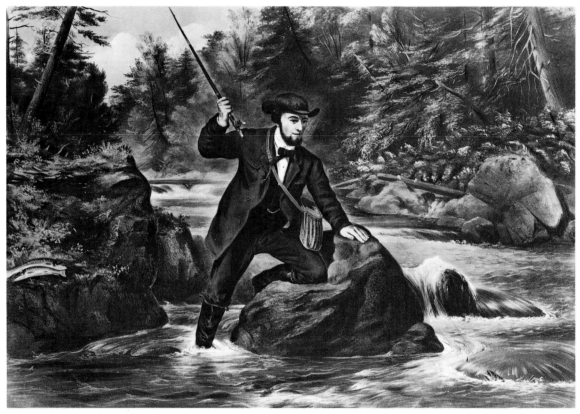

Currier & Ives. *Brook Trout Fishing—An Anxious Moment*. Courtesy of Kenneth M. Newman, The Old Print Shop, Inc.

Almost a decade earlier Nathaniel Currier had published *The Cares of a Family*, depicting a male and female quail and their brood of eleven.[18] The print was very popular for a number of years among those who could afford to buy the large folio lithograph. As was often the case with themes that proved appealing, Currier & Ives decided to publish a smaller, less carefully drawn and inexpensive rendition.[19] Illustrating only the mother quail and eight chicks, this version of *The Cares of a Family* was published in 1865, but it lacked, according to one critic, "the spontaneity and that feeling of aliveness which is evident in the larger print."[20] This unauthorized adaptation outraged Tait, especially since the cheap picture was attributed to him in plain letters. "They never said a word to me," he wrote, "or asked my permission, although it was quite a different picture and much less in size than the first—and even signed my name as artist—they had nothing to say when I called on them for an explanation so I let it go. . . . They have not asked me nor have I given them permission to publish anything for more than a year."[21]

Tait's association with Currier & Ives lasted only a dozen years after his arrival in this country. Nonetheless, between 1852 and 1864, the firm reproduced forty-two of Tait's paintings, far more than they did of the works of George H. Durrie, Eastman Johnson, and other independent artists. The printmakers sought to attract a mass market with pictures that had an element of human interest, anecdote, or drama. For a while, at least, Tait was willing to compose a few canvases to fit his publisher's specifications. These lithographs have since enjoyed such enduring popularity that they are frequently reprinted as attractive examples of nineteenth-century Americana. As a consequence it has been commonplace to classify Tait as a sporting artist or an illustrator of adventurous narratives. "The pictures of Arthur Fitzwilliam Tait," it has been said, "are stories told in paint."[22]

The comprehensive record of Tait's work, however, does not confirm such a facile

Very Suggestive. Courtesy of Sotheby Parke Bernet, New York.

generalization. His canvases depicting the activities of hunters, fishermen, and Western trappers represent less than ten percent of his total output. Furthermore, Currier & Ives or private patrons commissioned all but a few of these story-telling pictures. Most were painted in the first quarter of Tait's fifty-five-year professional career. He was, to be sure, an enthusiastic sportsman. But as an artist he devoted the greatest portion of his efforts to lustrous portraits of birds and animals, both wild and domestic.

Tait's work for Currier & Ives made his name familiar throughout the country. In the remote hamlets of the Adirondacks word spread that this annual visitor was a successful painter with a national reputation. When this information reached Franklin Chase, a young man who taught school and tended store in the settlement of Newcomb, he sat down and wrote to Tait in the spring of 1865. He nourished an ambition to become an artist and offered to serve as Tait's guide in exchange for lessons in painting.

Chase carefully preserved the letters from Tait. While avuncular in tone and marred by an awkward syntax that shows his lack of formal education, they contain the only record of Tait's attitudes towards his vocation. His initial reply to Chase's proposal is dated June 20, 1865:

> In answer, your wish to be an artist is a very laudable one and if you have the natural ability joined to *indominable perserverence* and a will bound to overcome all difficulties, you may succeed—that is, if you have the talent born in you, *not without*. It must be a natural instinct and if you do succeed it is a glorious profession but you have a hard road before you for a long series of years. Have you the pluck to overcome the difficulties— we shall see.

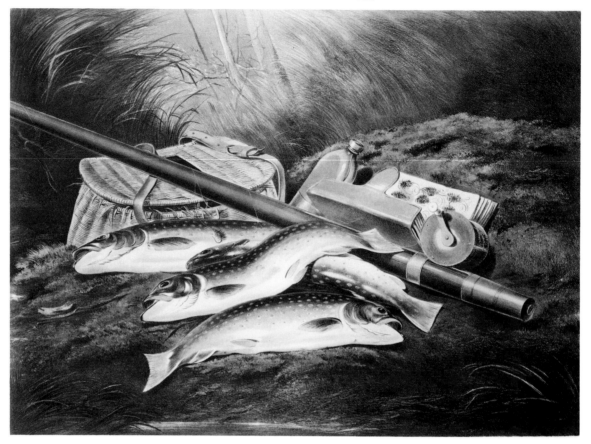

Currier & Ives. *American Speckled Brook Trout*. Courtesy of Kenneth M. Newman, The Old Print Shop, Inc.

In the first place, I would like to see something you have done on paper. Not an oil painting or water colour; but a pencil drawing from some natural object. Do something—it don't matter what and send it to me in a letter—any object in nature, not from an engraving or picture but drawn from nature. Then I will write you again.

With regard to your offer to go with me as guide, I should be glad to have you if I come up to the woods this summer. . . . I will let you know some weeks before and you can come along when I shall be glad to give you all the instruction I can.[23]

Some weeks later, when Chase had mailed some pencil sketches for criticism, Tait wrote again at greater length:

I won't criticize the drawings too severely under the circumstances of your position but I will still remark that you have a good deal of hard work before you . . . not mere laborious work which, when the evening is come, is over, but work that lasts day & night and all the time a man lives, ever to be thought of when not working at it. . . . Art is a very exacting mistress *and won't* hear another rival, and unfortunately very ill *paid* for until you achieve some distinction. . . .

Persevere and you may do something at least better than a back woods existence *perhaps*. I had to work at a business for 20 years or until I was 30 years old before I could practice my profession as an artist. . . .

[You] must begin at the beginning properly, that is you must learn to draw correctly *first of all* as everything else hinges on that. . . . Don't try to draw distant mountains or trees but near objects, any thing you fancy *except (at present) live animals*. . . . But to illustrate what I mean I will send you a few things in a parcel. . . .

It is not known whether Tait and Chase got together that season in the Adirondacks, but

the following year, 1866, they corresponded again. Tait wrote:

> I shall most likely be up at the Lakes this summer . . . and want you to let me know if you still wish to go with me (Mr. Blossom will be with me) and if so on the same terms as you wished for last summer, viz not to be paid in Green Backs but in instruction.
>
> You do all the duties of Guide, but you may have heard they are not very difficult to perform. . . . I to pay all your expenses from and back home and during the trip. You to be entirely at my disposal during that time. In case you leave without my consent to pay your own expenses home again. I to furnish you in Drawing Materials & paints &c. guns, fishing Rods, Tackle & Boats & Board & Lodging wet or dry. . . . You shall have plenty of time to study as we in fact certainly have another guide.

Tait probably had a hand in an oil sketch of a chipmunk,[24] which is one of the few mementos of Chase's artistic endeavors. But no account of their work together in the summer of 1866 has survived.[25]

The final year of Tait's decade at Raquette Lake, 1869, was a pivotal date in Adirondack history. An unusually large number of city dwellers flocked to the mountains that summer, overtaxing the limited supply of accommodations, boats, and guides. This astonishing invasion of novices was precipitated by a bestselling book of stories about Adirondack camp life published that spring, *Adventures in the Wilderness.* Its author, Boston clergyman William H. H. Murray, was probably no stranger to Tait. For several years Murray had come to Raquette Lake, sometimes with his wife and friends, and for a while he even made his headquarters on Constable Point.[26]

That summer of 1869 the newspapers bristled with letters of outrage against the man and his book from those who had suffered the frustrations of hopelessly overcrowded facilities. "Murray's Fools," as the letter writers were called, also accused Murray of murdering invalids, because he had written that outdoor life could be healthful, and of disgracing his vocation, because he had told some humorous tall tales about his hunting and fishing exploits. And they all but blamed him for the weather, which happened to be wet and cold that season.

The throngs attracted to the Adirondacks by Murray's book caused Tait some difficulties in securing a guide. In June, 1869, he wrote to Franklin Chase:

> I shall probably, if all goes well, be up at Long Lake next month sketching *exclusively* by myself (as Mr. Jas. B. Blossom and his brother are gone to New Brunswick). I wish to know if you can be with me for a month or two more or less. . . . I shall be mostly sketching in one place, at least not rambling about much, with a little fishing and hunting to enliven the monotony, so you can have lots of time for drawing also. . . . This year I am poor in pocket so don't be extravagant. I want to pay you for your time but can't afford this year any fancy price but will be willing to pay from 25 to 30 dollars or so . . . & pay all expenses but with no grand ideas.

Tait was too late. Chase had already been in correspondence with two other artists, Willard D. Carpenter and James C. Nicoll, and he had arranged with them to receive painting lessons in exchange for his services as a guide.[27]

By lucky chance Tait discovered that his old companion Captain Parker was available. They had some difficulty, however, finding an unoccupied site, for newcomers crowded around Raquette Lake. They finally settled on Indian Point, where a journalist passing by in his guideboat noted that it was "temporarily occupied by Tait, a New York artist of high repute as a game painter, and one of the most skilled sportsmen on these waters."[28]

Tait's summers at Raquette Lake in the 1860s turned out to be the golden years both for him and for the Adirondacks. Far removed from the anguish of the Civil War and the turmoil of the Reconstruction, the tranquil and unspoiled lakes and forests still had plenty of trout and deer. The wilderness supplied Tait's happiest inspiration, but it was in New York City that he marketed his work.

Notes

1. "Interesting Epistle from 'Fides,'" *Spirit of the Times* 29 (1859): 112.

2. Charles E. Whitehead, *Wild Sports in the South; or, the Camp Fires of the Everglades* (New York: Derby & Jackson, 1860). An identical London edition of the same year was published by Samson Low, Son, & Co. Later printings in 1891 and 1897 have quite different illustrations and lack the Tait frontispiece.

3. Whitehead's book is not listed in Ruth Sieben-Morgen, "Samuel Putnam Avery (1822–1904), Engraver on Wood; A Bio-Bibliographical Study," mimeographed (Hartford, Conn., 1942). Avery did the deer jacking scene opposite p. 352, but it is not clear if the original drawing was Tait's.

4. For his exceptionally interesting narrative, see "Sporting Tour in August, 1858," *Frank Leslie's Illustrated Newspaper* 6 (1858): 378–80, 394–96.

5. H. Perry Smith, *The Modern Babes in the Wood or Summerings in Wilderness* (Hartford, Conn.: Columbian Book Co., 1872), p. 30.

6. For accounts of these excursions by the Constable family and their friends, see "Sporting Expedition to Hamilton County," *Spirit of the Times* 13 (1843–44): 582–83; and "A Month at the Racket [*sic*]," *Knickerbocker Magazine* 48 (1856): 290–94, 356–63, 485–92. Excerpts, with explanatory notes, are published in Kenneth Durant, *Guide-Boat Days and Ways* (Blue Mountain Lake, N.Y.: Adirondack Museum, 1963), pp. 39–41, 101–5.

William Constable purchased the land on the point in 1851, and in 1884 sold it to Charles H. Bennett, who operated the Antlers Hotel there for many years.

7. "The Lakes of the Wilderness," *Great Republic Monthly Magazine* 1 (April 1859): 347. This unsigned narrative is illustrated with drawings that have Jervis McEntee's monogram and is clearly based upon his manuscript diary of the trip of 1851, now in the Adirondack Museum Library, MS 67-19.

8. Clinton Hart Merriam, "The Vertebrates of the Adirondack Region, Northeastern New York," *Transactions of the Linnaean Society* (New York, 1882), 1:41.

9. 61.47.

10. James B. Blossom to Josiah Blossom, September 16, 1870. Copy in Adirondack Museum Library, MS 69.13, kindly provided by Mrs. J. Lawrence Minetree, Josiah Blossom's granddaughter.

11. Letters Patent No. 38,770, dated June 2, 1863, U.S. Patent Office.

12. Paul Brandreth, *Trails of Enchantment* (New York: G. H. Watt, 1930), pp. 195–96.

13. 62.14.

14. 60.51.

15. 62.23 and 62.25.

16. See Peter C. Marzio, *The Democratic Art, Chromolithography 1840–1900, Pictures for a 19th-Century America* (Boston: David R. Godine, 1979), p. 59. Marzio here points out several errors by Harry T. Peters in his two-volume work, *Currier & Ives: Printmakers to the American People* (Garden City, N.Y.: Doubleday, Doran & Co., 1929–31), including the claim that the firm's first chromolithograph was published in 1889, more than twenty years later.

17. 61.14.

18. 55.10.

19. Even the title proved popular, for it was used for another print of a young girl holding a baby chick.

20. Nettie Wolcott Park, "The Cares of A Family," *Antiques* 39 (1941): 136–37.

21. AFT to Louis Prang, April 13, 1867. Courtesy of the Henry Francis du Pont Winterthur Museum, Winterthur, Delaware, Joseph Downs Manuscript Collection No. 71x107.7.

22. Patricia C. F. Mandel, "English Influences on the Work of A. F. Tait," exhibition catalogue of *A. F. Tait: Artist in the Adirondacks* (Blue Mountain Lake, N.Y.: Adirondack Museum, 1974), p. 13.

23. AFT to Franklin Chase, June 20, 1865. I am most grateful to Chase's granddaughter, Mrs. George W. Brown, for copies of this series of letters quoted in this chapter. Tait Biography Project MS 72.1.10, Adirondack Museum Library.

24. Author's collection.

25. Smith, *Modern Babes in the Wood*, p. 401, has an anecdote about Tait and Captain Parker at Shallow Lake from about this time.

26. For an account of Murray's life and his important book, see Warder H. Cadbury's introduction to William H. H. Murray, *Adventures in the Wilderness* (1869; reprint ed., Syracuse, N.Y.: Syracuse University Press, 1970).

27. Franklin Chase file, Tait Biography Project, MS 72.1.10, Adirondack Museum Library.

28. Edward B. Osborne, *Letters from the Woods. Random Rhymes . . .* (Poughkeepsie, N.Y., 1893), p. 40.

6

New York
1860–1869

ON THE EVE OF THE CIVIL WAR AMERICAN ARTISTS WERE BEGINNING TO ENJOY greater prosperity and public esteem than they had ever known before. Rapid industrialization and the expanding transportation system generated new wealth and created larger cities. The growing mercantile class was becoming more sophisticated. Having acquired a taste for luxuries, its members were willing to pay commercial art dealers to advise them about purchasing works that befitted their increasing cultural interests. The exclusive Century Association welcomed painters into membership along with distinguished leaders from the literary, scientific, and business communities. Artists had joined the ranks of respectable, hardworking professionals and were no longer regarded as unconventional eccentrics.

The National Academy of Design, which had so aided Tait's advancement, now began to enjoy sufficient support from affluent patrons to plan a proper building of its own. Their artists' receptions evolved into a combination of exhibition, concert, and *soirée*. These gala, formal-dress affairs became so fashionable that it was difficult to get admission tickets. At long last, writes Neil Harris, "artists were admitted to full equality in the vast benevolent alliance forged to improve the nation's manners and morals. The great Civil War seemed only to intensify the need for the spiritual balm of art."[1]

Before the guns opened fire, however, the increasingly ominous tensions between North and South caused Tait some inconvenience and anxiety, as he revealed in a letter to James R. Lambdin, a Philadelphia portrait painter and longtime officer of the Pennsylvania Academy of the Fine Arts. Lambdin, who had recently served on a special commission to encourage federal patronage of the arts, had arranged the sale of two of Tait's paintings to a friend in Mississippi for three hundred dollars. Writing six months prior to the outbreak of hostilities, Tait thanked him for sending along a check from a Natchez bank. However, he continued, "owing to the existing state of affairs here and at the South, I could do nothing with it. The banks refused to take it even for collection, as they are waiting to see how things go for a short time, and I unfortunately am not in a position *to do as they do*."[2] Tait inquired of Lambdin whether some other, more prompt method of payment could be arranged, remarking that he knew little about technical financial matters. For a few months the general mood of uncertainty and apprehension depressed the market for paintings. "Matters are very bad in art in New York at present," Tait concluded, "everyone pulling long faces."

When war came, however, Tait was quick to take action. In the spring of 1861 he gave a painting of grouse in snow to be sold for the benefit of the Patriotic Fund.[3] One of the most conspicuous contributions northern artists made to the war effort was to support the U.S. Sanitary Commission, an organization devoted to the care of wounded soldiers. Large fund-raising fairs were held in major cities and, in New York, Tait joined many of his colleagues in donating paintings to be sold at the New York bazaar.[4] Some of these fairs presented special loan exhibitions that attracted thousands of viewers, with the sale of tickets and catalogues providing additional receipts. In the absence of public museums such exhibitions gave many Americans, especially those from rural areas, their first opportunity to see the aesthetic accomplishments of their countrymen. These patriotic charity events in turn stimulated wide public interest in the arts and ultimately helped create a larger market for paintings and prints.

At the same time that public interest in the fine arts flowered and a wartime economy was enriching many potential patrons, the number of artists and paintings rapidly increased. By 1860 the annual exhibitions at the National Academy of Design included twice as many paintings as were shown ten years earlier, when Tait first arrived in New York. Membership in the Academy was to increase by fifty percent in the decade to come. These facts help explain why a new kind of enterprise grew up, one specializing in the buying and selling of works of art. As both painters and patrons became increasingly dependent upon the useful services of a middleman, the retail art business came of age.

Once it became possible for Tait to delegate the merchandising of his paintings to others, he felt free to move with Marian out of town to Morrisania, New York. When he first arrived in America in 1850, he had little choice but to stay in Manhattan, which had become the cultural center of the country. The traditional direct dependence of artists upon patrons still prevailed at that time. Only in the city could a painter, especially a newcomer, hope to meet the men of culture and wealth who might favor him with special commissions. And only by cultivating all the introductions that came his way could any artist hope to make a living. For the most part, Tait's studio was his only salesroom and he was his only salesman. But, by 1860, a number of downtown dealers were eager to act as agents for artists like Tait, who had no real taste or aptitude for business matters and who wished to travel or live outside the city.

Lillian B. Miller observed that "The entrance of the middleman into the American art world . . . gradually produced changes in the old system of patronage, and resulted in the beginning of an impersonal art market."[5] In the past a patrician elite had regarded its support of artists as a special obligation, one that mingled honest appreciation with feelings of piety and patriotism. But some of Tait's customers among the new generation of art buyers were more preoccupied with their upward mobility than with *noblesse oblige*. Men with recently acquired fortunes bought paintings in order to certify their eligibility for membership in the upper strata of society. Even ordinary businessmen of humble origin began to hope that acquisition of a work of art by an established painter would confer social respectability upon them. Such trends reversed the earlier situation, when the friendship of patrons not only fed artists, but had lifted them to a higher social status.

Tait and John Osborn, the liquor importer, seem to have considered a special arrangement that would have changed patronage still further in the direction of an impersonal, money-making investment. Tait's records contain the rough draft of a formal financial contract that gives neither date nor proposed partner, but the context suggests a date about 1860, and Osborn was Tait's only acquaintance both loyal and wealthy enough to entertain such a proposal.[6]

A "capitalist," Tait wrote, would pay him a regular monthly or quarterly salary for a period of four years. Since $1,200 annually would provide him with an adequate income, the total investment would amount to about $5,000. Each year Tait would "paint 9 months, travel & sketch 3 months." By the end of the four-year contract period Tait would have to have completed twenty-five paintings that were "large, say 63 by 45 inches," and an equal number of smaller "vignettes" of game birds and animals. He was further bound "not to

execute any other commissions during this arrangement." Some contingency provisions—not specified—would have to be worked out in case either party should die or both agreed to terminate the contract prematurely. As his share of the deal, the "capitalist" would receive agreed-upon interest on the investment—Tait's salary—he had made. In addition, each painting would upon completion become the investor's property, "as security for advances until repaid." The memorandum concluded with the notation that as further profit the capitalist would receive "2 or more of the best pictures to be selected."

Nothing ever came of this proposal, but it does reflect Tait's optimistic view of the American art market. The fact that he makes no mention of who was to sell the paintings or what was to happen should they only be sold at a loss suggests that he thought difficulties regarding sales would not arise. If the pictures sold well, there would be an attractive capital gain. That a liquor importer might contract for Tait's exclusive franchise provides dramatic proof of the changing patronage patterns.

Tait's memorandum, however, shows that he did not always have good business sense. The suggested contract underestimated both his needed income and his productivity. In the four-year period from 1859 through 1862, he turned out 169 canvases, more than three times the projected total of 50. His financial records do not provide exact figures for his gross annual income, but by extrapolation it seems that he probably realized close to $3,000 in 1860 for 52 paintings. Allowing for Sundays off and a short vacation, Tait was earning about $10 a day, the same amount as the per diem allowance paid to members of the U.S. Congress.

Tait's hope that at least half of his canvases would be of a generous 48″ × 60″ dimension was not realized. The largest painting he produced during this time was 26″ × 40″, only one-third of the projected size. This was a commissioned duck-shooting scene that, together with a smaller sketch, brought him the handsome price of $500.[7] The financier August Belmont, who had recently returned home from his diplomatic post with over one hundred European paintings, bought a somewhat smaller game-bird composition in 1859, but the price was not recorded.[8] Another prominent patron of the arts was Robert Leighton Stuart, who enjoyed a palatial home on Fifth Avenue in New York City and a million dollar fortune from his candy and sugar-refining business. His collection of 250 canvases, now at the New-York Historical Society, included *The Latest News*, nearly 2′ × 3′ in size, which Stuart purchased directly from Tait in 1862 for $250.[9]

In order to support himself, Tait was compelled to paint smaller pictures that would sell at modest prices. Eighty percent of his output at this time ranged in size from 16″ × 26″ for $150 down to 9″ × 12″ for $50. Since he was working at the rate of one painting a week, Tait became increasingly dependent upon the services of retail art dealers, since there was no practical way he could personally solicit so many special commissions.

One of the most astute art entrepreneurs was Tait's friend Michel Knoedler,[10] who came to New York in 1846 as agent for Goupil, the distinguished French fine arts firm. In about 1859 he bought out Goupil's interest and conducted the business under his own name. He correctly predicted the migration of business and society uptown, and in 1859 he moved his gallery to a mansion at 772 Broadway. The next year he bought no less than seven of Tait's small paintings for resale.[11] A perceptive middleman, Knoedler was able to guide collectors in the direction of new trends in art fashions. At the end of the sixties, he moved even further uptown, to 170 Fifth Avenue, but by that time his clients were more interested in European imports than American art and so Knoedler's dealings with Tait came to an end.

William Schaus, another former Goupil employee who went into business for himself, continued to handle Tait's work on a consignment basis, or, not infrequently, as repayment for cash advances. From his conversations with customers Schaus learned just what sort of pictures appealed to the art-buying public. This information enabled him to relay commissions to Tait, as well as to order paintings with specific themes to replenish his retail stock. In 1863 Schaus married and went for a visit to Europe. The small painting he received from Tait as a wedding present served also as a bon voyage gift.[12]

In terms of service the most important of Tait's agents was John Snedecor (whose name

until 1875 Tait usually spelled Snedicor), a picture framer who had recently worked his way into the retail art market. While Tait was living in suburban Morrisania, Snedecor did more than sell his paintings and lend him money. He also took care of such details as framing, delivery, and payment for Tait's privately commissioned canvases. In 1860 Snedecor became one of the first New York art dealers to capitalize on the auction as a method of merchandizing paintings. Such auctions became so popular and successful that their number tripled in the next ten years. Competitive bidding in public sales rooms began to replace the older system of friendly and private negotiations between patron and painter in the studio.

Snedecor's Gallery at 768 Broadway was the setting for two special sales of Tait's work. For both occasions the foremost fine-arts auctioneer in the city, Henry H. Leeds, was in charge. On December 18, 1863, fifty-eight Tait canvases were put on the block. About half of these came directly from his studio, where he had worked busily all fall turning out smaller but characteristic quail and grouse pieces. The printed sale catalogue[13] suggests that six of the paintings came on consignment from Currier & Ives, which had no further need of them, having already made lithographic copies. Since this single sale included many of Tait's most important paintings, it is a pity we do not know what prices were realized. His records only indicate that soon afterwards, in a generous and *galant* gesture, he presented small paintings to both Mrs. Snedecor and Mrs. Leeds as thanks.[14]

The second large auction of Tait's pictures took place nearly three years later, on April 5, 1866. "It is very rare for this popular Artist to make a special sale of his works," said the Snedecor-Leeds catalogue, "as they are taken almost as fast as he can paint them."[15] John Snedecor's priced copy of the catalogue indicates that he received a fifteen percent commission, while Tait received about $5,000 for sixty-nine paintings. The most interesting painting in this sale was listed as *The Portage, Waiting for the Boats in the Adirondacks*, an important picture that has not been found. According to Tait's records it had been painted a couple of years earlier on a large 35″ × 55″ mahogany panel. Tait had shipped it to his brother-in-law in London for sale at a minimum price of £250, but when it found no buyers, the painting was returned. Tait's good friend Jim Blossom purchased the work at this auction for $500, plus another $50 for the frame. Ten years later Blossom loaned it for exhibition at the Philadelphia Centennial celebration.

As his reputation grew, Tait became increasingly involved in professional and business activities outside Manhattan. In 1861, despite the disruptions of the Civil War, artists and prominent citizens in Brooklyn joined together to establish the Brooklyn Art Association. Its purposes were to promote social intercourse between artists and laymen and to sponsor regular exhibitions as a means of selling paintings. Tait was first invited to show a few canvases in 1863, and for more than twenty years thereafter he participated regularly in these semiannual affairs.[16] In 1864 the Association took an active role in organizing an art bazaar as part of the Brooklyn Sanitary Fair. This sale of paintings, including five donated by Tait,[17] raised $25,000 for the benefit of wounded soldiers.

Tait's most important patron during the early sixties was a Brooklyn resident, John C. Force. Between 1860 and 1863 he bought a total of sixteen expensive paintings. An Englishman by birth, Force owned a successful restaurant.[18] He was also a theater enthusiast and self-proclaimed Shakespeare scholar who liked to entertain stars of the stage. He was proud of his collection of paintings, said to be valued at $35,000, which included a Gainsborough as well as the Taits. Force was quite willing to send four of his Tait paintings to the 1861 exhibition at the National Academy of Design and to see his name in print in the catalogue as the lender.

Another important Brooklyn friend of Tait's was John F. McCoy, who lent him money and accepted paintings as interest payment. McCoy became impatient when his order for a joint painting by Tait and James McDougal Hart was delayed. Tait tried to reassure him in November, 1866: "Don't think I forget such commissions, but I have not yet been able to see Hart this fall since his summer trip, and of course it will depend on him, but some way I hope to finish this before the holidays."[19] Nine months later Tait wrote again to say that the canvas

was still incomplete, but that he had recently made arrangements to do several paintings with Hart and the picture promised to McCoy would soon be ready.[20] Living in Morrisania made it more difficult for Tait to work with Hart, but, despite this, the record shows that they collaborated on ten pictures between 1864 and 1867.[21]

Elsewhere, public interest in American art lagged behind New York. Nonetheless during the 1860s Tait began to do some business with out-of-town dealers. In the spring of 1863 he sent a small painting to James S. Earle & Son in Philadelphia, whose shop also specialized in mirrors, frames, and imported prints. After three more canvases were shipped off a month later, however, no further orders followed.[22]

Tait had better success in Boston, where Williams & Everett sold seven of his paintings in 1863 and seventeen the following year. This firm ran the only free art gallery in the city, and it was probably there that one of Tait's small paintings of baby chicks caught the attention of Louis Prang.

As a young man Prang had learned the technology of dyes and of printing colored fabrics at his father's calico factory in Germany and then at other textile-manufacturing centers throughout Europe. When the Revolution of 1848 compelled him to immigrate to America as a political refugee, he settled in Boston and set up his own lithographic printing business. During the Civil War the firm began to prosper; it turned out maps of the battlefields, pictures of generals, and some sketches of campaign life by the young Winslow Homer. Prang began to devote much of his time and profits to improving the methods of printing in oil-based colors, a process called chromolithography, because he was fired by an ideal that became his ruling passion—the reproduction in color of fine art as a means of educating the aesthetic tastes of the American public.[23]

Prang's first efforts were disappointing. In 1865 he published facsimiles of two landscapes by a Boston artist, Alfred T. Bricher, which were satisfactory from a technical point of view but which failed to attract any customers. His own salesmen and retail picture shops protested that no one would buy a print that cost an inordinate six dollars. Prang was unwilling to give up so quickly. In his unpublished autobiography he wrote:

> I was determined to test the question thoroughly. An oil painting by A. F. Tait arrested my attention, five downy chicks cunningly grouped on a green plot of grass, so exquisitely painted as I had never seen them painted before. This picture seemed to me to be peculiarly fitted to test the popular appreciation.
>
> It was reproduced by [the chief lithographer] Mr. Harring, printed under my direction, and offered again to the trade. A few were sold by us in this way and the dealers exhibited them to the public. Success followed immediately, the people felt interested in the subject and in a print which resembled so closely an oil painting. $5 was not thought too high to gratify a desire for a good picture to decorate a bare wall and to make a living room more cozy.[24]

This colored print was published in the spring of 1866. In New York, where Prang had recently opened a branch office, a notice in the *Daily Tribune* helped boost its sales:

> Mr. Louis Prang of Boston . . . has just issued a chromolithograph of one of Mr. A. F. Tait's clever little pictures. The chromo-lithography is a perfect facsimile of the original painting, reproducing not only the brush marks, but the very lines of the canvas, in a way that surprises by its ingenuity.[25]

These comments were written by Clarence Cook near the beginning of his long career as an art critic.[26] One of the first Americans to bring to his work high standards, a good education, and a frequently acerbic pen, he became a powerful influence upon popular tastes in architecture and interior decor. Cook's emphasis on "Truth" as a major criterion of aesthetic merit caused him to become embroiled in many controversies, including one with Prang and Tait. In the beginning, however, he was generous in his praise:

Mr. Prang tries with all his might to make his imitations absolutely deceptive, not for the purpose of deceiving, but in order to bring faithful copies . . . within the reach of small purses. . . . We shall not quarrel with him as to methods of interesting people in art. He has our cordial thanks for what he has already done, and our trust that he will do his best to educate the class he works for, in the love of what is true as well as beautiful.[27]

The pretty colored print after Tait's small painting made history as the first successful chromo published in this country, and was probably the most popular chromo published in any country up to that time. Within less than a year, 19,000 copies were sold.[28] All over the nation it received enthusiastic notices in the newspapers. "The little chicks," said one, "are as like nature as they could be without the intervention of a hen."[29]

The print's novelty as a remarkably realistic imitation of an oil painting on canvas helped it to quickly catch the public fancy. This technological innovation seemed newsworthy enough to Clarence Cook to warrant a long column in the *New York Daily Tribune* in May, 1866, just a month after his initial review:

> The recent publication by Messrs. L. Prang & Co. of Boston, of some fine specimens of chromolithography, particularly one representing a "Group of Chickens" after Tait, which we regard as the most creditable piece of work of this class yet produced in America, has excited considerable inquiry as to *how* such work is done; we have therefore thought that a brief description of the process might not prove uninteresting to our readers. . . .[30]

The art of printing from stone rests upon two facts, that oil and water do not mix but oil and limestone do. In ordinary lithography, such as that done by Currier & Ives, the artisan uses a greasy crayon to draw a picture on a flat plate made of a special kind of limestone. The whole surface is then dampened with water and an oily ink applied with a roller. The wet stone repels the ink, which adheres only to the crayon. A piece of paper is placed on the inked plate, pressure applied, and the print is "pulled" from the press.

Chromolithography uses an identical process, except that the inks are oil-based colors similar to those used by artists for painting, and a different stone is used for each color. As a rule the lighter tints are applied first, the darker ones later. Rich variety and subtlety of tones and shades are achieved by superimposing one color upon others. Great care must be given to "registering" so that each successive printing is applied to the paper in exactly the right place. Preparation of each stone—from ten to thirty of them—and the sequential printing of each color involved months of carefully supervised labor. The last impression was made with an embossed and roughened stone, which reproduced the textured appearance of canvas and brush strokes. When mounted, varnished, and framed, the result was a remarkably convincing facsimile of an oil painting.

A series of letters from Tait to Prang document the progress of their business and personal relationship.[31] In the first note, written August 9, 1866, from his home in Morrisania, Tait agreed to accept ten percent of gross sales as royalty payment for prints after his paintings, although a proposed two-year limit did not entirely please him. "Don't say anything more about being 'generous' or we'll quarrel," he added, "but believe I shall always be candid and straightforward in all my dealings with you and hope you will be the same to our mutual advantage." Tait promised to send a canvas of ducklings soon. "It wants about a day's work on it, but I am sick and got the blues and I can't work. I haven't done a thing all this week but loaf about with headache, with the ducks staring me in the face unfinished."

Prang came down from Boston for a visit, and Tait's next letter reveals an increasingly cordial working partnership between artist and printmaker. Having finished the harvest work in his vineyard, Tait was ready to get back to his easel. He wrote to suggest a variety of subjects that might "suit our publishings," including kittens, goslings, lambs, goats, wild duck, and calves. Tait offered to send photographs of some of his paintings to help Prang

decide what would best appeal to his public. "I have been designing a pair of deer and young fawns," he added, "always popular subjects, but you have not got into the sporting subjects . . . what do you think?"

The second of Tait's works that Prang decided to publish was the picture of ducklings that he thought would prove a good sequel to the best-selling baby chicks. Eager to make the most of this new opportunity, Tait deferred both to Prang's technical and merchandising expertise. When preparation of the lithographic stones for the ducklings print encountered difficulties, he was accommodating and modest. "If I had thought the background in them would have given you so much trouble," he wrote, "I would have repainted it to suit. I believe you are right about the ducklings being too crowded. I ought to have arranged them a little different and not put so many in—better luck next time." After the chromolithograph was published in November, 1866,[32] Tait responded to a letter from Prang: "I am sorry you are not pleased with the ducklings, but lay it to the lack of knowledge on my part. We must improve in the future."

Prang sent review copies of this and other prints to Clarence Cook at the *New York Daily Tribune*, but Cook was not pleased this time:

> None of these chromo-lithographs is quite equal to Mr. Prang's previous publications; they are evidently intended for an uncritical market. Still, even that market has its rights, and among them is that of learning the names of the men whose works give it pleasure. Mr. A. F. Tait's "Ducklings" bears the signature of a Mr. Herring on its face. . . .[33]

Cook had misread the name of Mr. Harring, Prang's lithographer, an error which suggested that the original artist was John Frederick Herring, a well-known English sporting painter who had died the year before. If Cook had looked more closely in a darkly tinted corner of the print, he would have seen Tait's own signature.

In this same brief review Cook provoked what soon became a drawn-out newspaper controversy by remarking that Prang's chromolithographs "hinder progress." Contradicting his own words of enthusiasm and praise just six months earlier, Cook declared: "A clever imitation is nothing but an imitation, after all. It can teach nothing, nor benefit anybody."

Prang's rebuttal in the *Tribune* a few days later quickly disposed of the question of who painted Tait's picture and who made the lithograph, and then addressed itself to Cook's "sweeping" and "bold assertion" that his prints hindered progress and were of no value in enlightening the aesthetic tastes of the public. If one good canvas advanced the cause of art, he asked, how could thousands of skillful facsimile copies of it hinder that cause? Chromolithography would be to painting what the printing press was to literature. Almost any picture was better than none, and in the course of time would create a taste for better ones. Furthermore, Prang believed that artists, as well as the public, would benefit from the popularity of his chromolithographs, for "the demand for good original paintings will become immeasurably greater as art education advances."[34]

Arguments concerning reproductions and their merit, which still simmer on to this day, were something of a novelty at the time of Prang's remarkable technological innovation, and Tait had the distinction of finding himself caught in the thick of it. He was apparently not a conscientious reader of the newspapers, for he wrote to Prang a few days later:

> I have just had a visit from a gentleman by the name of Mr. Clarence Cook (introduced by a note from Mr. Noadler [Knoedler]), who called to ask me certain questions about some controversy between himself and you in the Tribune. I have not seen or heard of the articles before now. With regard to my part of this matter, I told him . . . that I agreed with him so far that the artist's name ought to be prominent, as easily made out as on the painting, & that the lithographer's name has *no right on the picture at all or on the chromolithograph*, but ought to be underneath. . . .
> In future I would request you to place it there, as it is continually being told me that

another man's name is on my picture, that I have put Herring's (meaning the English artist) name on one of my pictures to make it sell.

Except for insisting that his own work be unambiguously identified, Tait clearly sided with Prang. Appealing to the principle of the greatest good for the greatest number, he told Cook he believed that the wide dissemination of Prang's chromolithographs made a positive contribution to the nation's cultural well-being. Tait denied the truth of Cook's suggestion that roughing or embossing the prints so they would resemble painted canvas was a deliberate attempt to mislead the unsophisticated buyer. "I did not take his view," he wrote to Prang, "as I don't believe it is your intention to deceive people and try to sell the chromo's as oil paintings." Tait did add, however, that since the surface of his own painting did not have an unusually textured finish, "I think it would be better in the future to publish it smooth."

A few days later Tait wrote again to report that he had made his opinion about the reproduction of paintings "by engraving or any other way" quite clear to Cook: the preferred method was one which "produced the best likeness or nearest facsimile to the original, that your chromos suited me exactly, and the nearer you got to the painting the better." In a postscript Tait added: "Let these folks rail & scold—it is all good for publicity and a good advertisement—'Vive La Bagatelle.'"

Clarence Cook published in the newspaper only part of his interview with Tait. Referring again to the prominence of Harring's name on the print, Cook wrote:

> Mr. Tait's friends had called his attention to the matter as a thing like to injure him, and he himself had remonstrated with Mr. Prang on the subject; and had been promised that the matter would be set right in subsequent issues. . . . Now, we deny Mr. Prang's right to put the name of his workman on the picture of any artist, and he will find that Mr. Tait objects to it quite as strongly as we do, and will not permit it; would never have permitted it, if he had been consulted.[35]

This wrangle over the print after Tait was only the beginning of Cook's long, vitriolic attack upon Prang's notion that "a millenial day for Art is to be ushered in through this invention" of chromolithography. The colored prints, Cook declared, "are of a piece with false diamonds, false hair, false teeth, and with innumerable false appliances by which homely people try to make themselves look pretty, and succeed in making themselves hideous."

A few days later Cook mailed Tait newspaper clippings of both his own and Prang's articles in the *Tribune*. Tait had not seen them before and promptly wrote to Prang:

> I think your article is temperate, gentlemanly, & to the point. Your position is right except one or two trivial matters as about the name of the engraver or lithographer on the print. . . .
> The reply of Mr. Clarence Cook is just as much the other way, is very poor trash & no answer to your arguments, but ungentlemanly vituperation, real Billingsgate, and I wonder the Tribune people inserted it. . . . I should have thought better of him from his appearance.

Off and on for the next couple of years Cook renewed his campaign against Prang. He won a few allies. A column in the *Nation*, for example, warned its readers: "if the buyer chooses . . . the copy of Tait's chickens . . . he ought to know, and it is our business to tell him, how slight a thing it is. It may be well for him to have it, if he cannot have any better piece of fine art. But at least he ought not to suppose for the moment that he possesses anything at all like a truly artistic picture."[36]

But the public simply ignored such criticisms and continued to buy the prints of chicks and ducklings by the hundreds. As Peter Marzio has pointed out in his fine work on "the democratic art," these phenomenal sales were a consequence of two facts. Tait's method of painting

made his canvases especially suited to the technology of chromolithography: "His colors were strong and pure, and he seldom employed color overlap or blending." Aspects of Tait's style were the other factors in making the prints bestsellers: "First, Tait's pictures have an intense realism: the artist does not exist—just the event. The story, complete in every detail, stands before our eyes. Secondly, his animals—particularly his ducks, quail, chickens and deer—evoke a tender reaction. Tait rarely challenges his viewers, preferring instead to present a scene that is at once sympathetic, sentimental and blissful."[37]

Prang's initial successes with Tait prompted him to begin to publish a whole series of color prints of the works of several American painters, including Albert Bierstadt and Eastman Johnson. He sent complimentary copies of his chromolithographs to prominent artists and authors and printed their favorable comments as advertisements. Frederick E. Church and James McDougal Hart, among others, were enthusiastic about the quality of these reproductions.

One of the most articulate of Prang's defenders was Harriet Beecher Stowe, whose sharp but ladylike pen was used "to puncture those most inflated of all live balloons, the 'high art' critics, with a skill that is alike admirable and remorseless."[38] Most people, she wrote, find that "high art"—the old masterworks that interest a few sophisticates—is uncomfortable to live with. "Pretty genre pictures, such as Prang is getting up so many of," she continued, "have a certain value as house ornaments quite independent of considerations of 'high art.'" The urban American does not enjoy the frequently somber mood of classical art "half as much as one of Tait's pictures of chickens picking at a worm or some hens in a barnyard, which put him in mind of the pleasant old days when he was a boy. . . . We have little sympathy with the scornful style in which some self-important art critics have condemned or ridiculed efforts that are bringing beauty and pleasure to so many thousand homes that otherwise poverty would keep bare."

Prang published his third chromolithograph after a Tait painting, *Quails,* in the spring of 1867.[39] Several months earlier Tait had written to Prang: "I shall send you the quail in a few days . . . but would like a little longer time as the paint won't harden enough for my mode of finishing so soon I'm afraid. However, I suppose I must not keep your artist waiting." When Prang expressed some doubt about its success in a competitive market, Tait wrote again: "You must be the judge of what will suit the public in your publications. I can only judge from my own experience. I think it will be popular, yet still quail & young have been published by Currier & Ives and one by [William] Schaus, so perhaps it is best not to publish this subject again at present."

Prang's chromolithograph of Tait's quails required nineteen stones, each with a different color of ink. Prang's own working copy of the progressive proofsheets, now at the Adirondack Museum, graphically demonstrates the meticulous care required at each successive step in the printing process.[40] "These quails," Tait had written to Prang, "are exactly life size . . . closely copied from Nature, and I consider this the best picture of that bird I ever did." A review in a Philadelphia newspaper noted that "in this, as in most of Mr. Tait's drawings, there is a certain pre-Raphaelite minuteness of detail in the herbiage, flowers, and foliage of the foreground, which gives a very agreeable finish to each subject."[41]

The pre-Raphaelite movement in English and American art at midcentury subscribed to the dictum of John Ruskin in his *Modern Painters* of 1843 that the duty of the artist was "neither to choose, nor compose, nor imagine, nor experimentalize: but to be humble and earnest in following the steps of nature and tracing the finger of God."[42] Tait, however, probably never read Ruskin since he was unschooled in the literature of aesthetics and uninterested in philosophical theories about art. Furthermore, he lacked the religious sensibilities that animated the movement and was, essentially, a man with no intellectual or spiritual pretensions. The precise and realistic representation of the grass and other vegetation in the foreground of his little bird pictures, while characteristic of the pre-Raphaelite style, was more likely the consequence of his early discipline in lithography and his basic impulse to paint what he saw.

Clarence Cook, whose devotion to truth in art caused him to prize realistic detail, was pleased with the chromo of quails:

> This time we have no fault to find—and we are glad of it—with Mr. Prang's way of publishing. He has taken honest pains to prevent anyone being deceived into thinking these pictures genuine oil paintings by printing his name as publisher on the picture itself, and has given Mr. Tait full credit for his work by putting his signature where he who runs [sic] may read. This is as it should be. . . .[43]

A Cincinnati monthly literary magazine, the *Ladies Repository*, published in its issue of June 1867 a steel-plate illustration after a canvas by Tait, who, it said, "holds the first position in America as a painter of animals, and is preeminent in the department of birds. . . . We esteem ourselves highly favored in getting one of these pictures of Mr. Tait, as they are in such demand and command such prices that Mr. Tait has hesitated to allow any of his pictures to be engraved."[44] Speaking of the Prang prints, it continued, "we unhesitatingly pronounce these chromo-lithographs vastly superior to many of the expensive paintings that we find on the walls of some our friends' houses."

That same summer of 1867 Josiah Blossom, traveling in Europe on his honeymoon, visited the International Exposition in Paris. His impressions of the U.S. exhibit, organized by Samuel P. Avery, have been preserved in a letter to his brother Jim: "In landscapes, the American pictures stand up very well & I am not ashamed of them, as a whole. . . . Prang's chromo's of Tait's pictures are there—he should have had a painting—it would have formed an 'especial feature' for there is nothing in his special style that I saw, such as your large deer [painting], for instance." Reporting that his money was about all spent except for enough to bring the newlyweds home, he concluded: "I cannot find it in my conscience to stay longer, and you know Tait's saying, 'When the sugar is out, the hunt is up.'"[45]

Tait's only correspondence with Prang for nearly a year was a brief note thanking Prang for the "handsome" semiannual royalty payment. In the late summer and fall of 1867 he devoted most of his time to preparing canvases for an auction on December 23.

On the eve of that sale Tait wrote to Prang explaining his long silence: "I heard from various artists that you were busy on so many of their works I thought you did not want any of mine." Looking ahead to the new year, Tait expressed a curiosity to come to Boston to see Prang's printing establishment and assured him of a warm welcome at his own home whenever he happened to be in New York. "I wish I had you here for a short time after I get over the anxiety of the sale," Tait concluded, "to talk over some ideas I have about some works for publishing." Prang promptly accepted Tait's invitation for a visit to talk over business matters.

Tait's growing desire to become more involved in Prang's thriving enterprise is revealed in a number of subsequent letters. One of his ideas was to publish a chromolithograph of *The Jolly Washerwoman* by Lilly Martin Spencer, whose sentimental genre scenes of domestic life enjoyed a modest vogue at the time.[46] The painting was owned by his friend and patron John Osborn, who would enjoy a share in the profits, along with Tait. "This picture will be a success," Tait wrote, "take my word for it, and a large one, both here and in Europe, if well done." Nothing, however, came of this proposal.

Tait's next suggestion to Prang was far more ambitious, reflecting the feelings of mutual respect that were kindled during their visits together. Prang had confided his need for substantial funds to construct a specially designed building in which to manufacture his chromolithographs. This remark suggested a way Tait might fulfill his desire to become a part of the business. If he could get a personal loan of twenty to thirty thousand dollars from a friend, Tait wrote in a tentative manner, "what terms would you take me on and what chance could I have [?]" Though he is not named, Tait's description of his capitalist friend could only apply to John Osborn: "He knows my business and myself intimately, is my nearest and best friend and has been for 18 years, indeed ever since I came to this country." In making this

proposal Tait did not specify what his duties and remuneration might be. "You can judge for yourself," he wrote, "as to my personal and artistic qualities and what I should be able to do to forward your business in case anything should come of this."

Prang apparently answered in a cordial but not very encouraging fashion. Tait referred to the matter once more:

> I am afraid you misunderstood me. I did not mean a partnership with you but simply wrote to know if your ideas about my coming to some arrangement with you would be facilitated by more capital through my being with you. . . .
>
> I think you are right in having all the management in your own hands. . . . You of course can get along well enough without me—yet it might be mutually advantageous to have me with you . . . we are both in a position to be entirely independent, and although I should like to have a hand in the chromos don't let our former conversations about this matter influence any decisions you may come to, as I shall be very glad to forward any of your project now or hereafter . . . [whenever] you wish for my opinions or artistical services.

Tait never did become more closely involved in Prang's business, though it is clear enough why he wished to. He viewed the sudden popularity of these pretty colored prints as a unique but shortlived opportunity to make some money. "You ought to push chromos as hard as you can *now*," he wrote to Prang, "as I am afraid they will be very common in another year or two, and that will react to the disadvantage of even good chromos. So push them whilst you have the market in your own hands."

A. F. Tait, 1870. Courtesy of The Adirondack Museum.

For Tait himself, however, the success of the prints copied from his own canvases put him in a painful predicament. Though his royalties grew with increasing sales, it became more difficult for him to find buyers for the small oil paintings of birds and animals that were his well-known stock in trade. Tait came to the reluctant conclusion that, for the time being at least, his best chance for economic survival lay with chromolithographs. "I find more and more that I must go into them," he wrote Prang, "largely to repay me for the losses they have caused me in destroying the sales of my specialities, *as they have done completely*. So please think over our conversations about these matters . . . as I would rather have some arrangement with you than anyone else."

These comments apparently dismayed Prang because they contradicted his cherished conviction that by educating the public taste, his chromolithographs would help artists to make a living from their paintings. In his reply Tait prudently took pains to avert a needless quarrel:

> Referring to your letter, I am afraid you are rather touchy on some subjects. I am fully aware of your position with regard to artists and assure you I appreciate it also, and did not intend to parade any of my affairs unnecessarily, but was only and merely stating a fact from my own experience as to the effect of chromos on my own works which is true. Yet what I do in chromos I do with full knowledge of this fact—therefore, let us not mention the subject again.

Anxious to get on with new business, Tait then inquired which sizes Prang preferred for several paintings he had in mind for publication. Prang proved to have a critical eye. He returned a canvas of a pointer and quail, asking Tait to paint a more "finished" duplicate. A companion picture of a cocker spaniel and woodcock also did not entirely please him, but Tait was willing to be accommodating:

> I thought I had made the picture sent about as good as I could—and tried to make it an easy one to chromo. It is all from nature, both dog and bird. Perhaps in trying to suit the chromo I altered my usual style a little. But your criticism is right and what you wish I will do with pleasure and heartily so please send it back at once and I will paint it again and return it at once. But you will find if you could see a woodcock dead that the breast is as I painted it. However, I can alter it somewhat.

The two chromolithographs, a pointer with quail and a spaniel with woodcock, were published in 1869.[47] With the appearance of a somewhat sentimental doe and fawn the following year,[48] Tait's dealings with Prang temporarily came to an end. What royalties Tait earned in the last half of the 1860s is not known, but the extra income was welcome.

Tait correctly predicted that the market for his style of chromolithographs would last only a few years; he was then compelled to reappraise the direction of his professional and personal life. In 1869, concluding what had probably been the most prosperous decade in his career, Tait and Marian decided to move from suburban Morrisania back into Manhattan.

Notes

1. Neil Harris, *The Artist in American Society: The Formative Years, 1790–1860* (New York: George Braziller, 1966), p. 300.

2. AFT to James R. Lambdin, Morrisania, November 30, 1860. Courtesy of the Henry Francis du Pont Winterthur Museum, Winterthur, Delaware, Joseph Downs Manuscript Collection, No. 72x107.20.

3. 61.13.

4. 64.5, 64.18, and 64.21.

5. Lillian B. Miller, *Patrons and Patriotism: The Encouragement of the Fine Arts in the United States, 1790–1860* (Chicago: University of Chicago Press, 1966), pp. 214–15.

6. Register, 1:176.

7. 59.12.

8. 59.43.

9. 62.6

10. The spelling of Knoedler's first name given here is the same as it appears in an essay by his grandson in *A Catalogue of an Exhibition . . . on the Occasion of Knoedler, One Hundred Years, 1846–1946* [New York, 1946].

11. 60.21–.22–.27–.33–.34–.45–.46.

12. 63.16

13. Harold Lancour, *American Art Auction Catalogues, 1785–1942, A Union List* (New York: New York Public Library, 1944), #220.

14. 64.7 and 64.9.

15. Not in Lancour. John Snedecor's priced copy was kindly provided by Robert C. Vose, Jr., of the Vose Galleries in Boston.

16. See Clark S. Marlor, *A History of the Brooklyn Art Association, With an Index of Exhibitions* (New York: W. T. Carr, 1970).

17. 64.11–.12–.13–.15–.17.

18. Some details of the life of John C. Force, who died March 22, 1875, were kindly provided by Richard J. Koke of the New-York Historical Society from several obituary notices. Unfortunately, a copy of the auction catalogue of the sale of Force's art collection (Somerville Art Gallery, April 21, 1875), has not turned up.

19. AFT to John F. McCoy, November 5, 1866. Tait Biography Project, MS 72.1.1, Adirondack Museum Library.

20. AFT to John F. McCoy, June 3, 1867. In Arthur Fitzwilliam Tait, Misc. Papers, Manuscript Division, New York Public Library.

21. 64.8, 65.13–.14, 66.18–.19, 67.7, 67.11, 67.30, and 67.65–.66.

22. 63.18, 63.38–.39–.40.

23. For popular accounts of Prang with many color reproductions of his works, see Larry Freeman, *Louis Prang: Color Lithographer* (Watkins Glen, N.Y.: Century House, 1971), and Katherine M. McClinton, *The Chromolithographs of Louis Prang* (New York: C. N. Potter, 1973).

24. Published here with the kind permission of Prang's granddaughter, Mrs. Louis Roewer. I am especially indebted to Mary M. Sittig for calling this to my attention in her master's thesis, "L. Prang & Company, Fine Art Publishers," George Washington University, 1970.

25. *New York Daily Tribune*, April 27, 1866, p. 7.

26. See Jo Ann W. Weiss, "Clarence Cook: His Critical Writings," Ph.D. diss., Johns Hopkins University, 1976, pp. 58–60.

27. *New York Daily Tribune*, April 27, 1866, p. 7.

28. *Prang's Chromo, A Journal of Popular Art* 1 (January 1868): 1.

29. Ibid., 1 (September 1868): 2.

30. *New York Daily Tribune*, May 23, 1866, p. 2.

31. Quotations from Tait's correspondence with Prang in this chapter are courtesy of the Henry Francis du Pont Winterthur Museum, Winterthur, Delaware, Joseph Downs Manuscript Collection, Nos. 71x107.1–13.

32. 66.47.

33. *New York Daily Tribune*, November 20, 1866, p. 6.

34. Ibid., December 1, 1866, p. 2.

35. Ibid., December 7, 1866, p. 6.

36. *The Nation* 5 (November 1867): 439.

37. Peter C. Marzio, *The Democratic Art, Lithography 1840–1900, Pictures for a 19th-Century America* (Boston: David R. Godine, 1979), p. 102.

38. *Prang's Chromo, A Journal of Popular Art* 1 (December, 1868): 2.

39. 66.48.

40. These are the same proofsheets mentioned in "Tait and Prang," *Antiques* 64 (1953): 400–401.

41. Quoted in *Prang's Chromo, A Journal of Popular Art* 1 (September 1868): 2.

42. Quoted in Linda S. Ferber, *William Trost Richards* (Brooklyn, N.Y.: Brooklyn Museum, 1973), p. 24. See also William H. Gerdts, "The Influence of Ruskin and Pre-Raphaelitism on American Still-Life Painting," *American Art Journal* 1 (Fall 1969): 80–97.

43. *New York Daily Tribune*, March 14, 1867, p. 2.

44. *Ladies Repository* 27 (1867): 384. The painting is 64.10.

45. Josiah Blossom to James Blackwell Blossom, Milan and Paris, May and June, 1867. Copy kindly provided by Josiah Blossom's granddaughter, Mrs. Ralph B. Hirtle.

46. See Robin Bolton-Smith and William H. Truettner, *Lilly Martin Spencer (1822–1902): The Joys of Sentiment* (Washington, D.C.: National Collection of Fine Arts, 1973), pp. 147–48. Tait's friend and dealer, William Schaus, published several large black-and-white lithographs by Mrs. Spencer in the 1850s.

47. 68.1 and 68.3.

48. 68.8.

7

The Adirondacks
South Pond and Long Lake
1870–1882

AS THE SUMMER OF 1870 APPROACHED, TAIT HAD ALREADY OBSERVED HIS FIFTIETH birthday and could not easily evade some disquieting changes in his career. The only recent public recognition of his talent came when the New York State Poultry Association awarded him a first prize gold medal for a picture of Black Poland chickens.[1] His creative powers seemed suddenly to have ebbed, as the rate of his annual production dropped from a record high of seventy-seven paintings in 1867 to thirty-one the following year to a mere sixteen canvases in 1869. A letter in April 1870 to an interested gentleman in California reveals that as a method of promoting sales Tait had begun to mail photographs of his works to potential patrons in distant places.[2] The same letter refers briefly to the vexations of moving from Morrisania back to the city and to the fact that his health was not good.

Tait may have been suffering from no more than one of his occasional attacks of hypochondria. However, even contemplation of the usually rejuvenative power of his annual Adirondack vacation must have been tinged with sadness as he realized he would be alone. His congenial camping companion for many seasons, Jim Blossom, now preferred salmon fishing in Canada; shanty life without him would not be the same.[3] Moreover, the Reverend William H. H. Murray's book on the Adirondacks was still very popular. If it continued to attract crowds of tourists into the woods, the wilderness would never be the same.

For a change, therefore, Tait decided not to rough it, and instead he went to Long Lake and Palmer's boarding house, which *Adventures in the Wilderness* recommended as offering "a view of the lake and mountain scenery rarely surpassed," good food, and a warm welcome.[4] A not entirely flattering glimpse of Tait's arrival appears in the diary of another guest and fellow artist, William E. Norton of Boston. On his return to Palmer's house after a day of sketching, Norton jotted down that "we found some strangers, among them Mr. A. F. Tait the chicken painter from New York City." The following day, July 29, 1870, Norton wrote that "the morning being rainy and dark, we sat listening to Mr. Tait. He is a very sociable man and tells many amusing incidents of himself and others in his quaint English manner which is very pleasant to listen to when not otherwise engaged."[5]

A small sheaf of his pencil sketches that summer indicates that Tait moved about in a

A. F. Tait. *View of Long Lake* (ND. 52). Courtesy of Yale University Art Gallery, gift of Mrs. Arthur Tait.

restless way.[6] He journeyed northward via the Raquette River to Lower Saint Regis Lake, where his guide of former years, Paul Smith, now presided over an elegant hotel. The place had rooms for 200 guests and such civilized features as pianos, billiard tables, and a barber shop. The Gilded Age was invading the wilderness and Tait had no taste for it. He painted a quick study from nature,[7] perhaps to help pay his bill, and made his way back to Long Lake.

This exploratory excursion suggests that Tait was having difficulties finding the kind of campsite that had suited him for the past twenty years, one that combined solitude with fine sporting. As it turned out, just the place he sought was not more than two miles from Palmer's boarding house. South Pond, just far enough from the main route of travelers moving on to Raquette and Blue Mountain lakes, was isolated and quiet. The fishing was so good that even in late summer Tait had a fine catch. He did three paintings of brook and lake trout, which he exhibited the winter of 1870 at the Union League Club.[8]

So pleased was Tait with his discovery of South Pond that for the summer of 1871 he was ready to change the style of his Adirondack vacations and welcome women to his camp in the wilderness. As companions he brought along his wife Marian and her niece, Mary Jane Bortoft. Mary Jane, or Polly, as she was called, was in her midtwenties. Having emigrated from England because of poor health some years earlier, she had recently become a member of the Tait household. To care for the ladies properly, Tait built a comfortable shelter near the water's edge. Unfortunately, his painting of it, *Our Home in the Wilderness, Shanty on South Pond*, has not yet been located.[9] Shopping for supplies at Palmer's was convenient, and Marian and Polly could find temporary accommodations there if they tired of camp life in a spell of rainy weather or if Tait wished to go off on an excursion by himself.

How well this arrangement worked is described by two writers who were traversing the

Adirondacks that summer to gather information for the region's first guidebook. An evening in late June found them at Forked Lake in the comfortable camp of Sidney Hay.[10] A widely traveled man of culture, Hay in recent years had become a near-permanent resident in the region. After dinner they enjoyed an unexpected visit from Tait and Palmer:

> We found Mr. Tait a jolly Englishman, a good sportsman, and a great lover of Nature. "I tell you, gentlemen," said he, in our conversation around that genial camp fire, "some people may call my friend Hay eccentric for spending three-fourths of his time here in the woods alone, but I think, on the whole, he is sensible."
>
> The evening hours passed quickly away in talking over camp scenes, but mainly in listening to entertaining yarns drawn from the excitements of Mr. Tait's twenty successive summers in the wilderness.[11]

A couple of days later the guidebook writers noted that "we again saw this gentleman, his amiable wife and interesting niece at Palmer's on Long Lake, and are pleased to acknowledge the receipt from them of a bottle of claret, and many other favors."[12] And after a short detour to visit South Pond, they wrote:

> This little lake is thickly studded with island gems, most picturesquely commingling, and Blue Mountain, majestic and beautiful, rises not far from its borders.
>
> In this wild and secluded place, Mr. A. F. Tait has erected and nicely furnished a sylvan lodge; and here are produced some of those exquisite paintings that delight so many eyes. We doubt not his genius gathers inspiration from such surroundings, for never was the studio of an artist placed in a lovelier spot.
>
> A master hand is his in throwing the fly, floating for deer, or making the canvas glow with life![13]

Tait and his ménage were evidently delighted with South Pond, for they lingered into late October, watching the soft greens of the summer foliage gradually turn to the rich hues of yellow, red, and brown. The ambience of the place and season did indeed inspire Tait to produce one of his finest works, *Autumn Morning*.[14] The painting is noteworthy in several respects: it is his largest canvas, three by six feet; such a panoramic landscape is a departure from his usual animal pictures; and its emphatically horizontal composition of bands of land and water under a lucid sky contribute to its special "glow." Such qualities mark the painting as an instance of what the art historian Theodore Stebbins, Jr., has described as Tait's "occasional forays into the study of light,"[15] his experimenting in a style that has become known as luminism. While this is not an archetypical luminist canvas in the manner of Kensett or Gifford, it has some of the elements that define luminism: a sharp realism that gives a direct transcription of nature in a meticulous, tightly finished style; the absence of visible brush strokes, concealing the role of artist and of paint as intermediaries, with no trace of impressionism; and a smooth, mirror like surface that gives an almost magical sense of depth. "Luminism," Stebbins concludes, "is American landscape at its most poetic, touching moments as the calm of an Indian summer day . . ."[16]

Tait devoted much of the winter of 1871–72 to working on this large canvas in his New York City studio. By this time in his career he ordinarily drew the composition of a new picture directly on the canvas, but for this painting he worked from a small preliminary study done from nature at South Pond.[17] Why he titled this grand work *Morning Scene on Racquette [sic] Lake* can only be surmised. Misspelling was habitual with Tait, but the change of location may have been prompted by the desire to keep his hideaway on South Pond a secret from the touring public. Or, perhaps he wished to capitalize on a name made famous by Murray's book in order to attract a buyer. He sent the painting to the spring 1872 exhibition of the National Academy of Design, marked $1,250, the highest price he ever asked for any canvas.

Less than a month later, on April 18, Tait was stunned by the unexpected death of his wife, Marian. Replying to a letter of condolence from Prang he wrote: "Mrs. Tait was well

and happy, full of fun with my niece and myself at 11 p.m. on Monday night and went to sleep before 6 a.m. next morning without even a sigh. God help us, it is hard to bear, we mourn not for her but for ourselves. We lived together 34 years and it seems like tearing part of my life from me."[18]

Unable to work or sleep, Tait mentioned that he planned to go to England for a few months for a change of scene. He asked Prang to send copies of his chromolithographs so he might take them along as gifts for relatives. On the trip his wife's niece Polly accompanied him, and on their return they brought her twelve-year-old half-sister, Emma Hough, back with them. Tait may have made a short trip to the Adirondacks that fall of 1872 before the three of them settled in together in his old apartment and studio at the YMCA at 23d Street and Fourth Avenue. Often abbreviated to "The Association Building," the address occasionally appears in Tait's own hand on the reverse of his canvases.

In the summer of 1873 Tait took Polly and Emma on a two-week sightseeing tour to Saratoga and Niagara before they arrived at Long Lake. Their Adirondack sojourn was comparatively short. As they departed for the city they signed their names in the hotel register, along with Captain Parker and Reuben Cary as guides, and added the comment: "from South Pond, sorry to leave our home in the woods."[19]

By this time Tait and Polly had made special plans for a life together. In the early fall Tait returned to Long Lake to purchase from Robert Shaw, who was active in local politics, a tract of some 100 acres on the western shore of the lake, just below Clear Pond Stream and across from Mount Sabattis. The fact that the deed was recorded in Polly's name suggests that the building lot was bought with her money. His real estate business done, Tait lingered in the

Mary Jane Bartoft Tait, 1872. Courtesy of The Adirondack Museum.

Adirondacks long enough to enjoy some sporting. On Raquette Lake he fished with a new friend, Albany dentist J. A. Perkins, with the faithful Captain Parker as guide.

A week before Christmas, 1873, Tait and Polly were married in a small ceremony in his studio. The clergyman who officiated was given a small painting for his services.[20] At about the same time a young architect, J. Cleveland Cady, also received a painting in exchange for "a design of house for woods" to be built on their lakefront acreage.[21] Unfortunately, neither the plans nor the house nor even a good photograph of it survive today. More durable examples of Cady's later work include the old Metropolitan Opera House, the American Museum of Natural History, and various buildings on New England college campuses.

The decision to leave Manhattan and build a year-round home in the Adirondacks seems to have stemmed partly from Tait's recurring anxiety about his well-being. One of the very few autobiographical notations in his Register of paintings reports that "in May, 1874, in poor health, I left the YMCA and New York to live at Long Lake."[22] Always something of a loner, Tait does not seem to have missed the Century Association, which he had joined only recently, or his participation in other professional groups. On the contrary, it appears he found warm friends among the mountain natives, who made him feel welcome in his new home. Under the dateline of Long Lake, April 20, 1874, a local newspaper noted: "A. F. Tait is expected to be in town by the first of May to enter the residence he has been fitting up on the west side of the lake."[23] Soon after he moved in, his neighbor and guide, Reuben Cary, christened his newborn son Arthur Tait Cary.

For the next three years, Polly, Emma, and Tait lived year-round at "Woodside," as they called their home, and they spent long summers there for several years afterwards. Tait's health must have mended quickly, for he was soon shipping paintings by stagecoach and train to dealers, patrons, and exhibitions. This extended stay in the Adirondacks proved to be a happy chapter in his personal life. Tait escaped from most of the anxieties brought on by the economic depression of 1873–78, from divisive tensions within the National Academy of Design, and from the growing worry among artists that new European styles were beginning to crowd the marketplace. He also missed America's Centennial celebrations of 1876. However, the special art exhibition that year in Philadelphia did include his very large work on a mahogany panel, *The Portage, Waiting for the Boats*, lent by his old friend Jim Blossom.[24] This painting has not yet been found.

During Tait's long absence from the city the janitor at the Association Building, William Brazier, forwarded mail, did some errands, and performed other little useful services. Records show that Tait rewarded him with a small painting.[25] Brazier also provided a *pied à terre* on those occasions when Tait was compelled to come to New York to do some business in person, to see his dentist, or to go shopping. On a trip to New York in December, 1876, Tait used the studio of Lemuel Wiles, an artist with whom he had collaborated on a canvas some years earlier,[26] in order to put the finishing touches on some pictures.[27] In 1873 Tait had worked together with Alexander Wyant on a canvas with little success: "I repainted almost all," Tait noted in his Register.[28]

Life in the Adirondacks did not change significantly the way Tait managed his business affairs. His Register of paintings reveals that some familiar names continued to appear among those of new dealers and patrons. John Snedecor, William Schaus, and Williams & Everett were still happy to receive paintings on commission, but they had to share this business with Edward Schenck and Peter Brett in New York City and Annesley & Vint in Albany. A dozen brief business letters from Tait to Peter Brett repeat the familiar problems of coping with frames, deliveries, prices, and patrons. One letter concerns a painting of James Ten Eyck's hunting dogs that Tait priced at $500.[29] Ten Eyck, a wealthy businessman and patron of the arts in Albany, had recently built a camp on North Point on Raquette Lake. He came to visit Tait to discuss the price, and since they could not agree, Ten Eyck decided on a smaller, less expensive version of the painting.

Tait persuaded Brett to go along with his old method of obtaining cash advances against future delivery of paintings. With a tone of urgency he once wrote for two hundred dollars:

In return you shall have either a picture or two, or the cash returned as you wish as soon after I get back as I can do them—but I want the money *now*. You know me well enough to know I shall do what I say, and you shall have *full value* for the accommodation. The other two pictures you shall have in the course of three or four weeks, as soon as I have rested a little and go to work again.[30]

While he was living in the Adirondacks, Tait was necessarily much more dependent upon his dealers to arrange the merchandising of his paintings in the city. His records, however, note a few private sales to such distinguished patrons as Cornelius Vanderbilt[31] and a former governor of Vermont, Horace Fairbanks.[32] About this time Francis Pares Osborn seems to have inherited his father's liquor business and his loyalty to Tait. Frank, as the young Osborn was called, belonged to the New York Yacht Club and flew his personal flag from the mast of an eighty-five-foot centerboard schooner, the *Nettie*. As decorations for the ship's formal diningroom, Tait did a remarkable series of six wall panels of various sporting scenes.[33] Each panel had a concave curve at each end so as to fit closely between the portholes and was appropriately framed with Manila rope.

During the 1870s Tait could not afford to have scruples about undertaking three different commissions for commercial art. The Laflin & Rand Company purchased a characteristic painting of a swimming deer with ducks flying against the background of morning fog.[34] The firm reproduced it as a colored print with the words "Orange Sporting Powder" added in large letters across the top to catch the attention of hunters shopping for gunpowder. Some copies of this advertising poster were pasted on canvas, framed, and varnished, making them appear to the unsophisticated as genuine oil paintings—especially if someone covered the lettering. Tait was not the first American artist to help firearms and ammunition companies

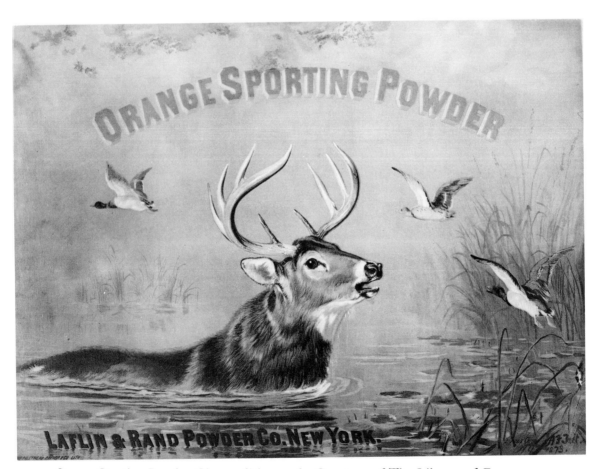

Orange Sporting Powder, Chromolithograph. Courtesy of The Library of Congress.

promote their wares. That distinction may belong to George Catlin, who, a decade or more earlier, executed six illustrations for Colonel Samuel Colt's famous pistols and rifles.[35] But it was about 1890 before "hunting-camp art" really began to flourish with broadsides and calendars by such notable sporting artists as A. B. Frost, Philip Goodwin, and Frederic Remington.[36]

In 1877 Tait painted for Frank Osborn a picture of two small dogs playing among clearly lettered bottles and cases of Piper-Heidsieck champagne. Osborn, who had the franchise to import this world-famous wine, printed up color lithograph copies as advertising posters and paid Tait $500 for his work.[37] In spite of its commercial tone, the painting itself was exhibited in Utica, New York, the Union League Club, and the Lotos Club. A memo in Tait's Register lists twenty or so friends to whom he sent these lithographs as gifts, including Ten Eyck and Perkins in Albany, the Tait family physician, and a taxidermist.[38] Edward Bierstadt, who published a folio of Adirondack photographs and was the brother of the artist Albert Bierstadt, also received a copy.

The W. S. Kimball Company of Rochester sponsored Tait's third and final venture into commercial art, this one to promote cigarettes. In his Register Tait described the scene as "A Girl laying off on Couch puffing Smoke into a Sky Terrier's Face. King Charles Spaniel on cushion at her head, another on her arm & a Sky Terrier on a Table. Cigarette boxes &c. all around."[39] Though clearly intended for publication, neither the painting nor any prints have been found.

Local lore has preserved some incidents from Tait's life as a citizen and taxpayer in the small mountain hamlet of Long Lake. After Tait bought the property from Robert Shaw, who was supervisor of the town, he gave him a painting as a token of friendship. Later Tait found out that there was a substantial discrepancy between the amount of money supposed to be in the village treasury and the sum actually on hand. At the annual town meeting in the spring of 1876 Tait brought up the matter, accusing Shaw of using public funds to stock the shelves of his general store with goods. Since political passions ran high in this community,

Piper-Heidsieck Champagne, Chromolithograph. Courtesy of The Library of Congress.

Tait was promptly voted chairman of a special committee to draw up an indictment. Shaw admitted he had taken the money but claimed that he had used it to help needy neighbors with groceries. No bank in the county would give credit, so during the long winter months some families had little or no cash until the influx of the next summer's tourists. Shaw felt he was quite justified in making these unofficial loans to his constituents to tide them over and the matter was dropped with no hard feelings.[40]

Dan Catlin, a man of legendary strength yet modest demeanor, lived not far from Tait's Adirondack home. In spite of his long-standing diffidence about attempting portraiture, Tait found the man's weathered face so impressive that he used him in two paintings. *The Old Pioneer: Uncle Dan and his Pets* shows Catlin sitting in the sunny doorway of his barn, feeding his geese and chicks. In his records Tait wrote this was "one of my best & most carefully finished works."[41] Winter provides the background for *Snowed In*, in which Catlin and his dog are rescuing sheep from deep, white drifts.[42] Soon afterward *Harper's Monthly* reproduced this painting as part of an article surveying American art. The author, historian, and critic Samuel G. W. Benjamin, wrote:

> Mr. A. F. Tait has devoted his life to rescuing from oblivion species which are fast becoming extinct, unless our game laws are better enforced than they have been hitherto. There is often too finished a touch to the art of Mr. Tait, which deprives it of the force it might otherwise have; but he has, on the other hand, painted game with remarkable truth, and he brings to the subject an inventive fancy that greatly adds to the variety and interest of his works.[43]

Dan Catlin, having somehow got word that his picture had circulated in a national magazine to thousands of homes and that Tait had probably received several hundred dollars for the original painting, decided to sue for compensation for his services as a model. However, his well-known habit of dropping in on a neighbor (including the Taits) at the regular dinner hour and then hurrying on to another family where the food was usually put on the table somewhat later, left him without sympathetic witnesses to testify in his behalf.

The Old Pioneer: Uncle Dan and His Pets (78.14). Courtesy of The Shelburne Museum.

Snowed In (77.13). Courtesy of The Adirondack Museum.

Tait's first child, his son Arthur James Blossom Tait, was born at Woodside on September 21, 1875. Tait was off on an excursion to Raquette Lake when Polly's labor pains began, so she sent her half-sister, Emma, to row across the lake to summon the village midwife. David Helms, a neighbor and guide, went to find the father.

The presence of an active child in the house and a desire to satisfy his lingering wanderlust prompted Tait to devise an ingenious way to obtain quiet and privacy for his work. He built, or had built, what he called his floating studio or scow. This houseboat had square ends and a small cabin equipped with a cot and stove. Thanks to a sail and leeboard and a long oar for a rudder, he could cruise to different parts of the large lake, tie up to a tree or stone on the shore, and paint or loaf as the winds or spirit moved him. On such excursions he preferred to be alone and might be gone for a week at a time. His son A. J. B. Tait has written:

> Father thought he could do better work amidst the quiet of the woods, and, as he said, right on the spot. . . . He told me repeatedly that he never had a drawing or painting lesson, and taught himself everything. This was in answer to my expressions of wonder-

ment at his ability to draw a rough coated bear, and a smooth coated pointer . . . and get the muscles in the right place. He gave me a telescope, with the remark, "This is the best teacher I've ever had, for many times I've sat behind a rock on the shore and watched deer playing and feeding. I made my sketches often within only seventy five feet of them, and had them also in a pen at home to study and sketch."[44]

Arthur J. B. Tait recollected other events from his childhood about his father's experiences with animals and some details about the making of his own artist's materials. On one occasion the small boy was in a boat with his father and Captain Parker when they spied a bear with a cub on her back swimming in the water. They killed the bear and brought the cub home, where it was the subject of many pencil sketches. When the cub grew strong enough to break its chain and kill some chickens and sheep, it was dispatched. Tait bartered paintings for a Jersey heifer and a bull calf, the latter called "Adirondack Chief." Such livestock provided both food for the table and models for the artist's work. The boy used to watch his father grind his own white paint to guarantee its purity and to avoid oxidization. Tait also made his own brushes, as those bought in stores had an annoying tendency to shed hairs.

Beginning in the late fall of 1877, Tait and his family moved back to New York each winter to avoid the coldest part of the year, returning to Long Lake as early as possible the following season. Since much of this time Tait was painting and sketching directly from nature, his records identify the exact scene of his canvases more frequently than in the past. In 1880, for example, a special commission came from Senator O. H. Platt of Connecticut. It was to Platt, who had been a camping companion, that "Adirondack" Murray dedicated his famous book. Tait's memorandum for this painting reads: "View of Platt's Camp. Sketch from nature on Long Lake. Birch Point from my floating studio or scow."[45]

In the spring of 1880 came the birth of Tait's second son, Francis Osborn Tait, named after his loyal patron. At the same time a wealthy businessman from Canajoharie, New York, William J. Arkell, invited members of the Artists' Fund Society, of which Tait had been a founder, to journey as his guests from New York to Buffalo via the Erie Canal on a specially chartered steamer. Receptions and dinners were planned for various stops along the way, with side trips to Trenton Falls and Richfield Springs. The sole purpose of this junket was to enjoy a fortnight of luxurious idleness. Edward Gay, the artist in charge of arrangements, reported that "we have no plans as to painting, but we each intend to do a sketch for Mr. Arkell in return for his generous hospitality."[46]

Tait accepted the invitation and must have looked forward to a pleasant excursion in the company of his peers. On a bright June morning the group of artists assembled on a Manhattan dock and boarded the boat. However, the press disclosed that "Mr. Arthur F. Tait was also at the wharf, but could not accompany the party, in consequence of a recent domestic bereavement."[47] Polly had died of childbed fever. In response to Louis Prang's note of condolences, Tait wrote:

> . . . the baby (a boy) is doing well, so is my other boy, little Blossom. Emma, my wife's sister, has done nobly and had entire charge of them since my wife was sick. She is a treasure. I should have been terribly situated indeed if I had not had her. It is a sad blow for me at my age, but I have got to grin and bear it.[48]

The distraught family withdrew to Long Lake, where they lingered until the first snows of hunting season. An awareness that his Adirondack decades were drawing to a close and Tait's desire to document them are suggested by two paintings. The first provides an interesting variation on a theme Tait portrayed many times, hunters on the lake looking for deer from a birchbark canoe. In reality, such a flimsy craft had long since been replaced by the more stable guideboat, which Tait's neighbors, the Palmers, Carys, and Stantons, had designed and built with such great skill for years. Tait's painting is a tribute to a unique Adirondack artifact.[49] The other canvas, a portrait of Captain Parker, is inscribed on the back: "my old Guide for 20 years."[50]

In midwinter the Artists' Fund Society held a reception for Mr. Arkell to thank him for the summer's excursion and to exhibit the paintings that each, including Tait, had contributed. The guests were treated to a buffet of lobster and chicken salad, stewed oysters, ice cream, and punch. The press reported that "popular academicians went round with boxes of cigars into which journalists were not allowed to dip their fingers unless they promised the most favorable criticisms, as the association was strictly for the benefit of widows and orphans."[51] Tait never had much taste for shop talk, but he enjoyed good food, a black cheroot, and a room full of ladies and gentlemen. Jovial occasions such as this were not part of his life in the Adirondacks.

Returning with Emma and the two boys to Long Lake in the summer of 1881, Tait put up printed posters[52] offering the house, the furnishings, and all but the floating studio for sale. The decision to move back to Manhattan permanently was determined in part by Emma's dislike of the isolated and difficult rural life in the Adirondacks. Now past sixty, Tait may have found that the care of the property, with its bittersweet memories, had become a burden. But the most compelling reason was probably the fact that Tait had recently been selling an average of only two dozen paintings a year, and some of those had gone to pay off old debts. Considering that a general economic recession of several years had just ended, 1879 was exceptional, for Tait produced forty-five paintings. The same year saw publication of a handsome, illustrated, three-volume folio, *Art Treasures of America*.[53] This tribute to the vanity of nouveau-riche art fanciers includes useful lists of paintings in quite a few recently assembled private collections. Six Tait pictures are mentioned (the same number, incidentally, as for Thomas Cole). However, the overwhelming majority of artists represented was European. It was a clear signal of changing public tastes, an omen that promised only hard times ahead for American painters working in traditional, native themes and styles.

Notes

1. 69.15.

2. AFT to Alfred Stebbins of San Francisco, California, April 2, 1870. The original letter, together with letters from many other artists collected by Stebbins, is in a specially bound copy of Henry T. Tuckerman's *Book of the Artists* (New York: G. P. Putnam & Sons, 1867) now in the Waldron Phoenix Belknap, Jr., Library of American Painting, Henry Francis du Pont Winterthur Museum, Winterthur, Delaware.

3. See "Moose and Salmon," *Forest and Stream*, January 8, 1898, p. 31.

4. William H. H. Murray, *Adventures in the Wilderness* (Boston: Fields, Osgood & Co., 1869), p. 44.

5. Norton's diary is in The Adirondack Museum Library, MS 71.1, the gift of the late Florence Norton in memory of her father, the artist. Norton fell in with Murray on the train from Boston and wrote an amusing account of his adventures in the Adirondacks. None of Norton's sketches have turned up.

6. These sketches are among those at the Yale University Art Gallery, 1949.221, numbers 63–69. Some are reproduced in my "Arthur F. Tait" in Howard I. Becker, *A History of South Pond and Origin of Long Lake Township* (Rexford, N.Y., 1963), pp. 89-[90E]. Copy in Adirondack Museum Library.

7. 70.34.

8. 70.30–.31–.32.

9. 71.28.

10. He was the brother of the artist, DeWitt Clinton Hay (1819–87), some of whose Adirondack sketches are at The Adirondack Museum, 76.24.1–16.

11. H. Perry Smith and E. R. Wallace, *The Modern Babes in the Wood . . . and Descriptive Guide to the Adirondacks* (Hartford, Conn.: Columbian Book Co., 1872), p. 212.

12. "Among the Adirondacks," *The Syracuse Daily Journal*, August 9, 1871.

13. Smith and Wallace, *Modern Babes in the Wood*, p. 409.

14. 72.16.

15. Theodore E. Stebbins, Jr., *The Life and Work of Martin Johnson Heade* (New Haven, Conn.: Yale University Press, 1975), p. 108.

16. Ibid., p. 109.

17. 71.30.

18. AFT to Louis Prang, May 10, 1972. Courtesy of the Henry Francis du Pont Winterthur Museum, Winterthur, Delaware, Joseph Downs Manuscript Collection No. 71x107.14.

19. For this information I am grateful to George Kellogg for the opportunity to examine two guest registers from C. H. Kellogg's Long Lake House covering the years 1867 to 1890.

20. 73.29.

21. 73.31.

22. AFT Register, 2:2.

23. *Essex County Republican* (Keeseville, N.Y.), April 30, 1874.

24. 64.8.

25. 73.30 and 77.8.

26. 72.9.

27. 76.25.

28. 73.7.

29. AFT to Peter Brett, June 12, 1876. Photostats of this and eleven other notes from Tait to the dealer Brett are in Tait Biography Project, MS 72.1.8, Adirondack Museum Library. They were kindly provided for this book by Mrs. Jacques Noel Jacobsen, who made use of them in her article, "Arthur F. Tait," *Antiques* 62 (1952): 408–10.

30. Ibid., August 5, 1878.

31. 79.8.

32. 72.10–.11.

33. 79.19–.24.

34. 73.11.

35. See Ellsworth S. Grant, "Gunmaker to the World," *American Heritage* 19 (June 1968): 4.

36. See Richard Baldwin, "Hunting-Camp Gallery," *The American Sportsman* 2 (Winter 1969).

37. 77.1.

38. AFT Register, 1:4.

39. 79.26.

40. Typescript of a hearing before the special committee of the New York State Assembly in connection with a bill introduced to abolish the county of Hamilton, held in Albany, March, 1905, pp. 286–87. Copy in The Adirondack Museum Library.

41. 78.14.

42. 77.13.

43. *Harper's New Monthly Magazine* 59 (October 1879): 687.

44. Tait Biography Project, MS 72.1.1, Adirondack Museum Library.

45. 80.19.

46. Unidentified clipping in the microfilmed papers of Edward Gay, Archives of American Art, Washington, D.C. Reel D-30, frames 583–907.

47. Quoted in Richard G. Coker, *Portrait of an American Painter: Edward Gay* (New York: Vantage Press, 1973), p. 62.

48. AFT to Louis Prang, June 22, 1880. Courtesy of the Henry Francis du Pont Winterthur Museum, Winterthur, Delaware, Joseph Downs Manuscript Collection No. 71x107.15.

49. 80.20.

50. 81.4.

51. *New York World*, January 30, 1881.

52. A partial copy is among the Tait materials at the Yale University Art Gallery, 1949.221.126.

53. Edward Strahan [Earl Shinn], ed., *The Art of America: Being the Choicest Works of Art in the Public and Private Collections of North America* (Philadelphia: G. Barrie, 1879–80).

8

Final Years
1882–1905

THE DECADE OF THE 1870S HAD BEEN A TURBULENT PERIOD IN THE HISTORY OF AMERI-
can painting. The disillusionment and a mood of materialistic industrialization following the
Civil War swept away the lingering phases of the Romantic movement. While Tait enjoyed
the rustic tranquility of his Adirondack home, the National Academy of Design was buffeted
by crises as a new and impatient generation of art students agitated for better professional
training in its school and a larger role in its affairs. Some senior academicians who, like Tait,
were largely self-taught, resisted proposed reforms. A growing frustration over Academy
policies resulted in 1878 in the establishment of a rival organization, the Society of American
Artists. It advocated more liberal and flexible aesthetic viewpoints, adopted more generous
rules about membership and exhibitions, and encouraged women to pursue careers in art.[1]

Young American artists repudiated native themes and styles, and at the very beginning of
their careers crossed the Atlantic in shoals to learn the fresh aesthetic currents flowing from
the studios of foreign masters. As this wave of expatriates began to return home, the Euro-
pean strain became increasingly dominant in American painting.

For a few years Munich replaced Dusseldorf as the chief attraction in Germany for the
young lions who glorified style over subject matter. The Munich technique was a bravura
display of brushwork, of wet paint on wet, of piling thick impasto on canvas, which dissolved
outlines in vibrations of color and atmosphere. Nothing was more alien to the American
conception of clear definition and of hiding technique with a thin, carefully applied film of
paint in which no stroke was visible.

Paris, however, was the principal mecca, with its state-financed École des Beaux-Arts and
such fashionable academicians as Bouguereau, Gerôme, Bonnat, Moreau, and Cabanel.
James Flexner has characterized French academic painting of the period as a "miscegenation
between historical painting and genre. The old conceptions of high style—tableaux large in
scale, literary or anecdotal in conception, and apart from ordinary life—remained, but the
subject matter was no longer exalted or moralistic."[2] The landscapes of the American Hudson
River School began to seem pallid and provincial.

Wealthy Americans also caught the enthusiasm for foreign travel and culture. As they

lavished vast sums of money to build a pseudo-baronial lifestyle patterned after that of European nobility, only original paintings from the Salon or from ateliers along the Seine seemed glamorous or desirable. The department store magnate A. T. Stewart, who owned Tait's painting of old Dan Catlin in the snow with his sheep, caused a sensation when he bought by cablegram, sight unseen, a small painting by Meissonier for $60,000.

The Centennial Exposition of 1876 failed to establish a tradition of national art in the public's mind. Rather, its effect was to make "every foreign artifact more attractive than anything American, and the 'artistic craze' of the late seventies and eighties turned starry eyes to the exotic wares of the Orient . . . [and] to almost anything from the brush of a Frenchman."[3] Public taste veered so sharply and swiftly that many established and prosperous American artists suddenly found it almost impossible, no matter how talented or hardworking, to make a living at all.

These trends pointed to a bleak future for Tait's career at the time he moved back to New York City in the fall of 1881. Together with Emma Hough and his two young boys, he settled again in their old quarters at the YMCA Building on 23d Street. The following spring he and Emma, who was only twenty-three, were married in a private ceremony at Trinity Chapel, after which they mailed wedding announcements to relatives and friends.[4] Tait was so short of cash that he used his paintings to barter with shopkeepers for such bridegroom's needs as a new pair of shoes, an emerald bauble from Tiffany's, and an engagement ring.[5]

The family's domestic economy improved as the management of business matters gradually came under Emma's care. She handled the correspondence and the necessary arrange-

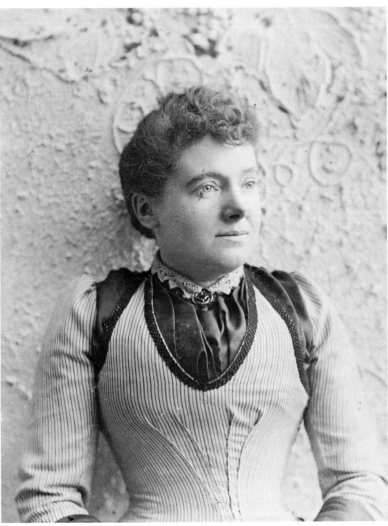

Emma Hough Tait. Courtesy of The Adirondack Museum.

ments for framing and shipping canvases. Occasionally she had to humor Tait to get to work at his easel when patrons became impatient for their paintings.

Tait himself, however, continued to keep the written Register of his works, though his entries for each became increasingly brief. The records note that he used his paintings to pay the rent and to buy linoleum, a writing desk for Emma, and some small bronze statues of hunting dogs that caught his fancy.[6] The last such recorded bartering, in 1896, covers a doctor's fee.[7] In addition, Tait continued on occasion to borrow money from his friends, though his credit was sometimes so poor that he had to put up collateral. A memorandum of 1891 indicates that he gave a painting to an acquaintance "to pay for loan of $300 and interest and I got my wife's diamonds back."[8]

After a lapse of many years, Tait resumed his practice of collaborating with another artist on the same canvas. His former associate, James McDougal Hart, worked with him on just one painting.[9] In 1882–83 the landscapist William L. Sonntag helped him on five pictures.[10] Tait's Register notes that he painted the deer in the center of one of these from nature at Long Lake, while Sonntag did the October foliage in the background.[11] Another occasional co-worker was Edward Gay, who was well known to Tait as the genial master of ceremonies at the annual dinners of the Artists' Fund Society.[12]

The market for American paintings was so depressed that many artists turned to teaching to support themselves, and soon after his return from the Adirondacks Tait also gave it a try. In the fall of 1882 he asked the secretary of the Brooklyn Art Association to ". . . please send an invitation . . . for my pupil, Louis Contoit, who wishes to contribute to your next exhibition."[13] Nothing is known of this student except that Contoit sent a single canvas to each of the annual shows for the next three years.[14] One of these paintings—of a kitten—has turned up. Both Tait's and Contoit's initials are on the front, while the reverse side of the canvas has an inscription presenting the painting as a Christmas gift to Mrs. Francis P. Osborn, daughter-in-law of Tait's old friend John Osborn.[15]

The role of art teacher never appealed to Tait. According to his son, "Father never cared much for pupils as they made him nervous."[16] Contoit's tutelage came to an end in the summer of 1883 when Tait made plans to travel abroad. As a favor Contoit delivered in person an urgent note from Tait to his friend and dealer, Peter Brett, to ask if Brett would buy a couple of Tait's paintings. "I am going to England on the 7 of July," Tait wrote, "so I want to close up all my work as early in the week as possible. If you don't want them please let me know, as in that case I will take them with me. . . . don't forget those cigars."[17]

Tait did not intend to study European art; rather, he was going on a delayed honeymoon and taking the opportunity to visit family in England. On their return in October, 1883, the family moved uptown to an apartment at 432 East 57th Street. Tait also arranged with an old friend, Abraham Dowdney, who had come to America on the same boat with him in 1850, to rent the loft of his large stable as a studio. Some of the box stalls on the ground floor at 411 East 65th Street were used to keep a cow, sheep, and lambs, which served as models for Tait's paintings. A young photographer from Houston, Frank Elliott, wanted to study drawing with Tait, but instead was permitted to live at the studio and keep it warm. Tait's son A. J. B. Tait jotted down some memories of the place:

> My main ambition was to get away with Father on Saturday and go with him to the studio and play about the stable and then sit down to lunch with Father and Frank. Father was a wonderful cook and Frank Elliott thought he was also a cook, and the two tried to outdo each other and I benefitted from the result. . . . Father had a remarkable way with all kinds of animals, both wild and domesticated, and could handle them without any trouble at all.[18]

Once he was permanently reestablished in New York, Tait discovered that the competition from new names and fashions in the art market was so intense that he could no longer expect to sell his works through the very same dealers who earlier in his career had welcomed the

opportunity to be his agent. Samuel P. Avery had been so helpful in the 1850s that Tait had given him a small picture as a token of his appreciation. In 1867, however, Avery disposed of his personal collection of 120 American cabinet paintings for $18,250 and became a major figure in the international art market.[19] He helped found the Metropolitan Museum in 1870 and by the mid-eighties had sold newly popular imported art for a total of $1.5 million. In a letter to a former artist client, Avery explained with regret that he could no longer handle the works of his old friends, since his present customers were buying only "the great foreign names."[20] He went on to say that those who might be interested in American paintings were "a distinct class," who bought "from the exhibitions, the auctions," and not from elegant private galleries such as his own. Tait's experience soon confirmed Avery's observations.

Because of the vogue for European art, the National Academy of Design was compelled to change some of its policies governing exhibitions in order to promote the sale of works by its members. As early as 1876 Tait and the other academicians were occasionally permitted to include in the printed catalog a specific price with a dollar sign with each entry. This replaced the traditional euphemism "the artist," which meant a painting was for sale. Within a few years Tait and his colleagues regularly labeled their wares with a price tag so as to appeal to the cash-and-carry shopper seeking a ready-to-hang decoration for a bare spot on the wall at home. However, by comparing the published list prices with Tait's private records, it is easy to see that the artist often was willing to settle for a smaller figure.

In 1882 the Academy inaugurated a regular fall exhibition in addition to the traditional spring show, so that members had a further opportunity to advertise their pictures. The first year the Hanging Committee permitted Tait to enter eight paintings, ranging from $125 to $400 each. The Academy sales, plus those from occasional exhibitions at the Artists' Fund Society, the American Art Association, and the Lotos Club brought Tait a modest income.

Tait could find only one business agent in New York, Edward Schenck, who was willing to handle his work with any regularity. Schenck's method of merchandising was simple: he held an auction every few weeks. This rapid turnover of stock had the advantage of providing Tait with quick cash soon after a painting was finished, while the more sedate retail gallery might have to keep a picture for months before he received any compensation. But auctions sometimes resulted in disappointing prices. In 1885, for example, Tait consigned two paintings, each with a limit or minimum bid of $150. One fetched $177.50, but the other did not sell.[21] Tait took it back to his studio, reworked it, put it up at the next auction, and got $96, prompting him to remark, "Slaughtered," in his records. Eventually he gave up setting any minimum at all, and occasionally expressed his dissatisfaction with the results by the notation, "Dead horse."[22]

The most noteworthy change in the pattern of Tait's merchandising methods during his final years was the large number of sales he made outside New York City. The metropolitan marketplace was crowded with pictures by foreign artists and by a burgeoning new generation of American painters, compelling him to find customers with less cosmopolitan and modern tastes in distant and smaller cities. Tait succeeded remarkably well, for his records note exhibitions and sales in such widely scattered places as Amsterdam, New York, Montreal, Pittsburgh, Milwaukee, and Chicago. Two dealers in Boston, William Hatfield at Doll & Richards and G. C. Folsom, took paintings on consignment, as did the Bendann Art Gallery in Baltimore.

By far the most helpful out-of-town dealer was James D. Gill of Springfield, Massachusetts, who frequently visited Tait in his studio when he came to the city on buying trips.[23] Gill never handled foreign pictures, partly because he wanted to be sure he was not selling a copy or a forgery. Starting in 1878 he held an annual exhibition and sale, accompanied by a copiously illustrated catalogue, and native artists were grateful and proud for this opportunity to display their work. The newspapers of the day noted that if only more dealers had "similar talent and tact in selecting and selling, the multitude of American artists would be more prosperous than they are." When the results of the National Academy of Design's show and sale of 1891 proved to be especially dispiriting, the *New York Times* suggested that it

might be a good idea the following year for the Academy to bypass Manhattan and open its exhibition in Springfield, "which shows a far warmer approach than this city for the work of Americans." Between 1881 and his death twenty-four years later, Tait sent Gill nearly six dozen paintings, including eleven in the year 1893.

In these final decades Tait turned out most of his canvases for the retail trade because he rarely received special commissions from private patrons. On those few occasions when he did paint to order, however, he was well paid. In 1886, for example, he traveled to White Plains, New York, to do two portraits of pet dogs and accepted $250 for each.

The year 1888 was a turning point in Tait's career. In August the whole family paid a final visit to the Adirondacks as the guests of Rev. Joseph T. Duryea of Brooklyn at his camp on Buck Mountain Point on Long Lake. On the way back to the city Tait jotted down their names in the local hotel register and the wistful comment, "Going home."[24] The year coincides with Tait's last identifiable Adirondack canvas, a characteristic scene of deer along the shore of Raquette Lake.[25] Tait bartered the painting for a large granite monument at Polly's grave in Woodlawn Cemetery.

The most striking fact about the final phase of Tait's long career was that he gave up painting wild game animals and birds, the very kind of pictures that had first brought him recognition and success. He now devoted himself to portraying domestic animals and fowl, subjects that comprise about a third of his entire output of over 1,600 works. Thirty-seven percent of these were of chickens and twenty-nine percent were sheep, with horses, cattle, and dogs making up the remainder.

New social attitudes toward sport and art patronage had depressed the market for paintings related to hunting and fishing. When Tait arrived in America four decades earlier, patrician circles regarded these outdoor pastimes as the mark of a gentleman; collecting sporting art was a visible symbol of rank. Subsequently, hunting and fishing became popular with all classes of society. Tait's acquaintance "Adirondack" Murray had played no small role in promoting nationally a more egalitarian and democratic attitude towards such recreations. In defense of his influential book of 1869 Murray had written: "I have no sympathy at all with those gentlemen who would selfishly monopolize the Adirondack Wilderness for their own exclusive amusement. . . . It belongs to the country at large."[26] Such sentiments prevailed, and by 1885 the region was on its way to becoming by an act of the legislature a forest preserve, where any citizen, no matter how humble his station, enjoyed an equal opportunity to try to catch a trout or shoot a deer.

As a consequence, while the number of sportsmen increased dramatically, an oil painting with an American hunting and fishing motif no longer conveyed the same distinctive mark of superior status. Rich men turned their attention to such expensive diversions as fine horses and custom-built racing boats. At the same time collecting the newly fashionable European art served both to embellish their ostentatious mansions and to create the impression of a cosmopolitan sophistication.

Tait's lifelong friendship with the Osborn family reflects these changing patterns. In the 1850s John Osborn was proud to own and show off Tait's large canvases with a sporting theme. His son, Francis Pares Osborn, was no less loyal, but he purchased very few paintings. When he bought a pair of bird-shooting scenes with a Gordon setter and an Irish water spaniel, he used them to decorate his yacht. In 1886 the younger Osborn commissioned a special painting of himself and his wife. Dressed in the stylish equestrian costume of the upper classes, from elegant black silk top hats to smartly polished leather boots, they posed with their well-bred saddle horses, "Black Eagle" and "Princess." In the foreground stands their pedigreed collie and, in the background, are the spacious lawns and grand shade trees of their estate. Tait received a handsome $400 for his efforts, but it was a small sum for the Osborn family to spend on a portrait that symbolized its generation's values and tastes.[27]

Toward the end of the nineteenth century American art collectors fancied small landscape paintings of the Forest of Fontainebleau and of peasant life around the hamlet of Barbizon. Canvases by Jean-Baptiste Corot, Charles-Emile Jacque, Constant Troyon, and Jean-

Francois Millet, among others, brought extraordinarily high prices in the galleries and auction rooms. The names of these Barbizon painters became household words through widely sold engravings after their works, many of which focused on placid sheep and cows in a natural and familiar habitat. Such creatures were pronounced beautiful because, to paraphrase Millet's definition of beauty, they were "in place."[28]

When Tait spent three months visiting friends in Chicago in 1893, he had ample opportunity to see for himself the Barbizon paintings that dominated a special loan exhibition of American-owned, foreign masterworks at the World's Columbian Exposition. They influenced Tait more in terms of subject than of style. While his handling of color in the background landscape and sky did become somewhat softer and more delicate in his later years, he still preferred the hues of direct sunlight and meticulous detail rather than the muted tones and hazy, atmospheric quality so characteristic of the Barbizon mood. Public enthusiasm for European "animalscapes" reassured Tait that his own bucolic works would find a ready market among the less well-to-do. The new trend was confirmed for Tait when his host in Chicago took a landscape painting down from his livingroom wall and asked Tait to add some cattle to the scene.

Tait's records document his shift to domestic animals from wild game. In 1884, for example, seventy-five percent of his works related to sporting. Ten years later ninety percent of his output depicted farm livestock, more than half of which were sheep. In the decade prior to his death Tait painted little else except sheep, so that the only way he could distinguish one canvas from the next in his register was to jot down the number standing up and lying down ("three up, two down").

These rural idylls appealed to an urban population; they provided an anodyne for the anxieties and tensions of a competitive industrial society. "To soothe, to give repose, to evoke sentiment, such is their mission," said the influential art critic James Jackson Jarves.[29] For the thousands of Americans who had recently left their farms to make new lives for themselves in the manufacturing cities along the eastern seaboard, these paintings seemed anything but vapid. They helped assuage the pangs of nostalgia and loss.

In addition, some of Tait's audience probably perceived that domestic animals had biblical connotations. Sheep especially had spiritual significance, for John the Baptist had proclaimed Christ to be the Lamb of God, and the analogy of a shepherd with his flock was a common theme in Western devotional literature and art.

The Victorian era, with its passion for symbols and pious preoccupation with proprieties, ordained that certain kinds of pictures were proper to each part of the home. Fortunately, Tait's specialty of farmyard animals enjoyed multiple uses. In the diningroom, for example, where a painting of something edible was virtually *de rigueur*, a cattle or sheep canvas would be most appropriate. If mounted in a velvet-lined shadowbox, the same sort of painting would be just right for the front hall. Pictures of chicks, goslings, or lambs, enshrined in elaborate gilt frames of *fleurs de lis*, belonged in the ladies' parlor and the children's nursery. Merging together with bibelots and bric-a-brac, the fashions of interior decorating decreed row upon row of paintings on the walls, thus blurring the distinction between art and artifact.

Tait's subjects deftly shifted from Adirondack game to quiet pastorals of sheep and cows at just the right moment in American cultural and economic history. By catering to a new generation of art buyers, he remained productive and financially secure, unlike some of his contemporaries who never ceased painting in the idiom of the Hudson River School. A comparison with the financial ups and downs of Jasper F. Cropsey illustrates how successful Tait was.[30] Cropsey's most profitable year, 1865, brought him an income of almost $9,000. In 1866 Tait realized $5,000 from the sale of his paintings at auction, plus as much as $20,000 in royalties from Prang's chromolithographs. Within a couple of years competition from foreign art caused Cropsey's income to drop precipitously to less than $1,000. During the 1870s he remained in dire straits despite the concerted efforts of his wife to sell his pictures. In 1885 Cropsey had the good fortune to auction sixty-seven of his works for about $5,000, but the same year Tait received about the same sum for only half as many paintings.

Since he apparently could have sold more paintings if he had wanted to work harder, Tait seems to have been satisfied with a modest but comfortable standard of living. He could afford to give his family relief from the city's heat each summer in the rural countryside of Orange and Putnam counties. There the boys had space to play and Tait had live models for pictures of farm livestock.

The art critics no longer mentioned Tait's works at exhibitions, but when he was eighty-two he received a letter of warm tribute from a young Barbizon-trained American painter, Carlton Wiggins:

> My dear Mr. Tait,
> When I saw your little sheep picture at the Lotos Club I was so charmed with it that I regretted exceedingly that I had not seen it before you left the Club, so that I might have expressed to you in person what I felt in regard to it.
> It is certainly as fine an example as I have ever seen of yours and in detail [the] painting shows no falling off of your powers, notwithstanding the good age to which you have arrived. May you live many more years and paint equally well.[31]

Not all of Tait's peers were so cordial. In response to an invitation in 1898 from the Pennsylvania Academy of the Fine Arts to compete for a place in its annual exhibition, Tait suggested what he described as one of his best and most recent canvases, then at his framer's:

> If you are in the city and you could call there to see it, and it meets your approval I will let you have it for the Ex[hibition]. But I will not send it to be put before your jury of selection for their approval. . . . My paintings do not meet the approval of the *Impressionists*. They [i.e., mine] are too carefully painted, and two of your artists on your committee are not friends of mine, although both academicians.[32]

Despite his advancing years, Tait's mind, no less than his hands, remained agile. When he was past eighty he invented an improvement in the construction of the canvas stretchers used by artists that was registered by the U.S. Patent Office.[33] Tait modified the design of a wedge-shaped metal key in each mitered corner of the wooden frame so that it was easy to adjust yet secured the desired tension on the cloth uniformly. A further purpose was to prevent warping. Some years earlier another painter and fellow academician, Aaron Draper Shattuck, patented a similar device, which was marketed by the F. W. Devoe paint and artists' supply firm.[34] Tait's invention, however, was never manufactured commercially on a large scale.[35]

Off and on over the years Tait kept in touch with his old friend and publisher Louis Prang. Since the mid-1860s, when chromolithographs after Tait's paintings first brought success to the Boston firm, Prang had expanded and diversified his business into a wide variety of such commercial art products as package labels and trade cards. In the 1870s Prang became a pioneer in the greeting card industry, for which he again enlisted Tait's talents. In exchange for a diamond ring for his wife, Tait painted to order half a dozen vignettes, four by six inches, of chicks, ducklings, and fawns.[36] It is not clear whether Prang used any of Tait's sketches. There is one design described in Tait's records as a *Deer (Buck) head and shoulders at Gaze* that may have inspired a colorful card printed in 1883 (it bore the sentiment "I will always be your deer").[37] Tait's name, however, does not appear on the card, and Prang knew from past experiences how sensitive he was about such matters.

Not long after he had moved back to New York from the Adirondacks, Tait wrote to Prang with some urgency, asking Prang to lend him some money. "Either I will repay it," he continued, "or you can apply it to the work if things suit you. . . . You know I am always at your service."[38] Between 1889 and 1891 Prang published four more Tait paintings as chromolithographs.[39] Instead of a royalty on sales, as in former agreements, Tait was paid a flat $200 for each.

In 1897 Tait and his family moved out of Manhattan to a house in Yonkers at 82 Waring Place. The following year he wrote to Louis Prang:

> I am as usual well and work harder than ever I did, and all my friends say better than ever I did. I have been jogging along about as usual and leading a very quiet life. My two boys are grown up, 18 and 22 years old and good as gold, both of them. My wife is a great blessing to us all and I should not be what I am but for her care and love.[40]

Tait made his last move to a home he had built nearby at 15 Fairfield Place in Ludlow Park in 1900. According to his wife, these final years were among the happiest of his life: "He was still able to get to the country north of Yonkers and spend time among the farm animals and fowl, depicting them in their rural setting, and, at the same time, to enjoy his many friends and acquaintances in Yonkers."[41]

A warm and gregarious man, Tait always preferred as his intimates people from the worlds of theater, business, and the professions rather than artists. On Sunday evenings he and Emma would invite a large group for supper in their home, and he relished the role of host. But he was fussy about food and disliked the English emphasis on boil and broil. Even at someone else's dinner party, if things were not to his taste, he would announce, "God sends food and the devil sends cooks." Stubbornly independent, with little patience for social amenities, Tait tended to ignore visitors he did not like, even to the point of deliberately falling asleep in their presence.

He was broad in build and an inch under six feet in height; his long white hair reached below his shoulders. Not without a touch of vanity, he rolled it up each night in a handkerchief around his large head. He read popular travel and adventure narratives voraciously. Though he had a book that contained a thousand songs, he was not musical; he used to say he could get the better of anyone because he could sing them all to the same tune. He never worked late at night, though he often painted for an hour in the evening after dinner and a pipe. His studio was tidy, his manner methodical. He loved his home and domesticity.

"The worst of getting on in years," he once wrote to Prang, "is that you are apt to outlive your friends."[42] There were, however, some happy exceptions. In 1894 at the Sportsman's Show in New York he ran into James Wardner, who had been his host and guide at Rainbow Lake nearly forty years earlier. "The Adirondacks and I have changed," said Wardner in his greeting, "but you haven't. Time has dealt kindly with you." "That's due largely to my young wife who has taken such good care of me," was Tait's reply. As they visited together, Tait remarked that he had recently come across an old sketchbook of his that included a drawing of Wardner's shanty. With characteristic generosity he promised to copy it in oil as a souvenir for his old friend.[43]

In 1900 Tait exchanged letters with Ashbel Parmelee Fitch, the son of the lawyer in Malone who helped him nearly half a century earlier during the litigation over the artificial limb for Lewis Bellows's wife. As a gift Tait sent him a sketch painted in 1855 of the High Falls on the Chateaugay River. "I have always had a vivid remembrance of our first meeting at your father's home in Malone," he wrote, "and your enthusiasm as a fisherman. Long may you live to enjoy it."[44] Fitch indeed had become such an enthusiastic sportsman that he had purchased large tracts of woodland wilderness around the shores of Ragged Lake as a private game preserve. In his reply Fitch thanked Tait for the painting and added, "Aside from this token of your remembrance, you are not likely to be forgotten in my family, as Tait Brook goes through my own land into the lake opposite my [summer cottage] . . . at Ragged Lake."

The name of this small brook by whose banks Tait had once made his camp is, apart from his paintings, the only durable commemoration of his long association with the Adirondacks. And for years it was misspelled "Tate" on the official topographical quadrangle map of the area, first published in 1906, a year after Tait's death. After the Board of Geographic Names of the U.S. Department of the Interior received documented information gathered during the

research stage of this book, they agreed to rectify the error in subsequent printings. Tait's name is now indelibly on the map as it should be.[45]

Equally secure is Tait's place as a tributary, though not a large one, to the mainstream of nineteenth-century American painting. His name subsequently never fell into the obscurity that overtook some of his peers. Over the years his pictures have always attracted a steady following, both from the general public and from a few collectors, connoisseurs to whom the phrase "a Tait painting" has a special meaning.

The enduring appeal of Tait's work does not simply reflect the parochial interests of the sportsman or the partisan perspective of an Adirondack buff. His canvases have a density and texture, a lustrous vitality and color quite independent of their subject or locale, so that with experience one can identify them at a glance. Tait had a style that was all his own, the unique individuality that marks a true artist. Tait was no unrecognized genius, but then neither did his reach exceed his grasp. Although limited in scope, the genre of animal painting can succeed only in the hands of a talented painter. As Henry James reminded us, "We must grant the artist his subject, his idea, his *donné;* our criticism is applied only to what he makes of it."[46]

The record suggests that Tait has made his mark in American art. More than seventy of his canvases can be seen in nearly thirty museums, from Boston to Denver, and Saint Johnsbury, Vermont, to Shreveport, Louisiana. In 1974 the National Endowment for the Arts made possible a survey exhibition of Tait's work at the Adirondack Museum. Tait's canvases have recently appeared in special exhibitions, including one entitled *Man and His Kine* at the DeCordova Museum, Lincoln, Massachusetts,[47] and another featuring only cows at the Queens Museum.[48] A growing number of scholarly publications in American art history have discussed Tait's work when appropriate.

The United States Information Agency sponsored an exhibition of paintings of the American West that toured several eastern European countries in 1974–75 with great success. The Amon Carter Museum at Fort Worth, Texas, organized the show and selected a Tait prairie scene as the cover illustration for the catalog, which was printed in several different language editions. Further evidence of Tait's international standing appears in a recently published *Dictionary of British Sporting Painters,* which includes Tait and comments that his work was "of very fine quality."[49]

Tait's work is as popular today with many Americans as it was in the past. His reputation in the marketplace has steadily kept pace with the increasing values of nineteenth-century native paintings, which have been immune from the extreme price fluctuations that reflect changing tastes or speculative fevers. Indeed, his canvases have become so valuable that in several instances his signature has been forged on spurious paintings.

A contemporary appraisal of Tait's critical reputation has been offered by the late Hermann Warner Williams, Jr., director for many years of the Corcoran Gallery of Art in Washington, D.C.:

> Though Tait had been a solid and respected painter, he was not an innovator and failed to perceive the symbolic significance of man in the wilderness, so dramatically conveyed by that later wanderer in the Adirondacks, Winslow Homer. Any nineteenth-century American artist would suffer by comparison with . . . Homer, but it is nonetheless interesting to compare Tait's Adirondacks with Winslow Homer's immensely different vision of the same woodlands.[50]

At the time of Tait's death on April 28, 1905, he was, after the venerable Daniel Huntington, the oldest member of the National Academy of Design, where he had exhibited an impressive total of 193 paintings over a span of fifty-three years. Tait had the satisfaction of seeing both his sons married and the arrival of two grandchildren. One of the last entries in his Register of paintings, done with a frail hand, reads: "Frank, wife and baby here, can't do much."[51] At the funeral service his Yonkers friend and neighbor Reverend James E. Freeman

(later Episcopal bishop of Washington), spoke on "The Unfinished Picture," which remained on the easel in his studio. Though Tait had sometimes said he wished to be buried in the village cemetery at Long Lake, he was interred at Woodlawn Cemetery in Westchester County. An artist's palette and brushes are carved into the granite of his monument. As an epitaph Tait might well have chosen an adage he coined while camping out in the Adirondacks. When food supplies ran low and it was time to return home, he would say, "When the sugar's out, the hunt is up."

Notes

1. For a balanced survey of these events see Lois Marie Fink, *Academy: The Academic Tradition in American Art* (Washington, D.C.: National Collection of Fine Arts, 1975), esp. pp. 50–89.

2. James T. Flexner, *Nineteenth-Century American Painting* (New York: G. P. Putnam's Sons, 1970), p. 156.

3. Russell Lynes, *The Art-Makers of Nineteenth-Century America* (New York: Atheneum, 1970), p. 424.

4. The brief biographical sketch of Tait in *M & M Karolik Collection of American Water Colors & Drawings 1800–1875* (Boston: Museum of Fine Arts, 1962), 1:282, has somewhat garbled the details of his three marriages.

5. 82.12, 82.7, and 82.18.

6. 85.6, 85.23, 89.11, and 85.32.

7. 96.23.

8. 91.1.

9. 81.18.

10. 82.3, 82.8, 82.18, 83.12 and 83.13. See also Nancy Dustin Wall Moure, *William Louis Sonntag, Artist of the Ideal* (Los Angeles: Goldfield Galleries, 1980), pp. 31–32.

11. 82.8.

12. 85.8, 85.9, 93.22 and N.D. 12 & N.D. 13.

13. AFT to Theodore E. Smith, November 13, 1882; in AFT Misc. Papers, Manuscript Division, New York Public Library. Published with permission.

14. Clark S. Marlor, *A History of the Brooklyn Art Association with an Index of Exhibitions* (New York: J. F. Carr, 1970), p. 156.

15. 83.45.

16. Arthur J. B. Tait Memoranda, Tait Biography Project, MS 72.1.1, Adirondack Museum Library.

17. Tait-Brett letters, Tait Biography Project MS 72.1.8, Adirondack Museum Library.

18. Arthur J. B. Tait Memoranda, Tait Biography Project, MS 72.1.1, Adirondack Museum Library.

19. Benson J. Lossing, *History of New York City* (New York: G. E. Perine, 1884), 2:840–43, where Avery has contributed a valuable sketch of the major art sales and collectors of the time.

20. Quoted in Robin Bolton-Smith and William H. Truettner, *Lilly Martin Spencer: The Joys of Sentiment* (Washington, D.C.: National Collection of Fine Arts, 1973), p. 69.

21. 85.3 and 85.4.

22. 88.25.

23. The following account of Gill comes from Jeffrey R. Brown, *Alfred Thompson Bricher, 1837–1908* (Indianapolis, Ind.: Indianapolis Museum of Art, 1973), Appendix 1: "James D. Gill's Art Galleries," pp. 86–88.

24. Entry dated September 3, 1888, Long Lake House guest register, microfilm reel no. 4.3, Adirondack Museum Library.

25. 86.9.

26. William H. H. Murray, *Adventures in the Wilderness* (1869; reprint and enl. ed., Syracuse, N.Y.: Syracuse University Press, 1970), Appendix, p. 93.

27. 86.9.

28. Quoted in Peter Bermingham, *American Art in the Barbizon Mood* (Washington, D.C.: National Collection of Fine Arts, 1975), p. 76.

29. Ibid., ch. 7, "Artful Animals and Pleasant Peasants."

30. See William S. Talbot, *Jasper F. Cropsey, 1823–1900* (Washington, D.C.: National Collection of Fine Arts, 1970), pp. 42–43.

31. Carleton Wiggins to AFT, February 27, 1901. Tait Biography Project, MS 72.1.1, Adirondack Museum Library.

32. Tait's letter, dated November 16, 1898, is in the archives of the Pennsylvania Academy of the Fine Arts, Philadelphia, and is published here with permission.

33. United States Patent Office, "Specifications forming part of Letters Patent No. 659,994, dated October 16, 1900."

34. W. T. Chase and Jeremy R. Hutt, "Aaron Draper Shattuck's Patent Stretcher Key," *Studies in Conservation* 17 (1972): 12–29.

35. Two somewhat different cast-iron wedges have turned up. See 01.22, 02.14, and 03.2.

36. 79.34–.39.

37. Larry Freeman, *Louis Prang: Color Lithographer* (Watkins Glen, N.Y.: Century House, 1971), p. 107.

38. AFT to Louis Prang, January 14, 1883. Katherine M. McClinton kindly provided a copy.

39. The prints were *The Dash for Liberty* (89.17), *Take Care* (90.8), *Kluck, Kluck* (90.9), and *The Intruder* (90.13).

40. AFT to Louis Prang, December 7, 1898. Courtesy of the Henry Francis du Pont Winterthur Museum, Winterthur, Delaware, Joseph Downs Manuscript Collection No. 71x107.16.

41. Henry F. Marsh, "Arthur F. Tait," *Yonkers Historical Bulletin* 17 (1970): 3–7.

42. AFT to Prang, December 7, 1898.

43. See Charles A. Wardner, "Sunset on Adirondack Trails," pp. 364–65, unpublished typescript, Adirondack Museum Library (also on microfilm reel 4.31). The sketchbooks have not been found, but the painting from the sketch of the shanty is 58.61.

44. Excerpts from Tait's letter and Fitch's reply are found in Morton Cross Fitch, "History of Ragged Lake" (Mimeographed, Providence, Rhode Island, 1934), pp. 55–56. A copy is at The Adirondack Museum. Members of the Fitch family still own Ragged Lake and Tait Brook, and their help and hospi-

tality is here gratefully acknowledged.

45. See *Decisions on Geographic Names in the United States*, List No. 6401, January through April, 1964 (Washington, D.C.: U.S. Board on Geographic Names, Department of the Interior), p. 47.

46. Quoted in Stella A. Walker, *Sporting Art, England 1700–1900* (New York: C. N. Potter, 1972), p. 72.

47. *Man and His Kine* (Lincoln, Mass.: De Cordova Museum, 1972), nos. 47 and 71.

48. *Cows* (Flushing, N.Y.: Queens County Art and Cultural Center, 1976), no. 26.

49. S. H. Paviere, *A Dictionary of Sporting British Painters* (Leigh-on-Sea, England: F. Lewis Ltd., 1965).

50. In Robert Elman, *The Great American Shooting Print* (New York: Knopf, 1972), Introduction, p. [x].

51. 04.9.

PART II
A CHECKLIST OF HIS WORKS
by
HENRY F. MARSH
Introduction to the Checklist

BEGINNING SEVERAL YEARS AFTER HIS ARRIVAL IN NEW YORK CITY IN SEPTEMBER 1850, and continuing to the entry of December 5, 1904, written in a tremulous hand several months before his death at the age of 86, A. F. Tait listed most of his output of oil paintings in three ruled notebooks now in the library of the Adirondack Museum in Blue Mountain Lake, New York. The notebooks, titled in the artist's hand "A Record of Paintings by A. F. Tait," contain entries of 1,557 paintings, most giving title or brief description, dimensions, ground, price and buyer. All of the artist's entries are included in what Henry Marsh and, later, Adirondack Museum editors called the "A. F. Tait Checklist." The term Register, also adopted by the editors, refers to Tait's three notebooks.

That a particular painting is not in the Checklist does not mean that it is not by Tait. His earliest entries, in volume 1 of the Register, were recorded from memory; some paintings were omitted, while others were out of sequence. After 1856 Tait would record a painting at the time it was finished and then place a corresponding number on the back of the painting. But, for reasons known only to him, he did not enter every one of his paintings in the Register. Supplementing Tait's record, therefore, are about 180 paintings that have been reliably attributed to Tait on the basis of history, inscription(s), and style. These have been listed in the Checklist by the year they were painted, at the end of his entries for the given year. A number of these paintings, both oils and watercolors, date from Tait's formative years as a student and journeyman artist in Great Britain.

Following the Checklist is a section listing 49 paintings attributed to Tait but impossible to match with the Checklist entries since the dates are unknown. This section also includes collective entries for over 160 sketches by Tait, the majority of which are in the Yale University Art Gallery. The dates of about half of these sketches are known.

A portion of Tait's livelihood was derived from the publication and sale of reproductions of his paintings. Reference in corresponding entries is made to these reproductions, principally lithographs by Currier & Ives and chromolithographs by Louis Prang. Institutional owners are mentioned when known; private owners are not.

<div align="right">
Alice Wolf Gilborn, Editor

The Adirondack Museum
</div>

Key to the Checklist

Sample Entry

1. GOOD DOG SCOTTY 2. 75.18

3. A. F. Tait / N.Y. 1875 [LR] 4. Canvas: 20¼ × 30¼

5. A. F. Tait / Long Lake / Hamilton Co / N.Y. / 1875 / No. 46 / "Good Dog Scotty"

6. [No.] *46 Good Dog Scotty. Dog trying to dig Sheep out of Snow. 20 × 30 Canvas finished Jan'y 7th 1876. sent off to Wm. Hatfield (Snedecors[)] Jan'y 10th 1876 for Artist Fund Sale sold there to a Mr. L G Tillotson for $540 without Frame Jan'y 27th 1876.*

7. Painting on permanent loan to Amherst College from the Jones Library, Amherst, Massachusetts.

HOW TO USE CHECKLIST

1. Upper left
 Title: Tait's title if known; if not, dealer's or owner's title. Brackets indicate no known title or title taken from subject of painting.

2. Upper right:
 Adirondack Museum Checklist number: year painting done followed by order in which it was painted. For example: 75.18 = eighteenth painting recorded by Tait for 1875. Dated paintings known to be by Tait but not listed in his Register are added to Checklist by year, following Tait's last entry for that year. These are indicated by "No AFT Number" at entry 6.

3. Below title left:
 Tait's signature, date, position as it appears on the front of painting (if known). NA (National Academy) sometimes but not always appears after Tait's signature.

4. Below Checklist number right:
 Type of support, medium *other than* oil, dimensions of painting in inches, height by width. There are some discrepancies between the dimensions Tait entered in his Register and the actual size of painting. Until the 1870s Tait gave width first, height second; he then reversed dimensions in his entries. His measurements were not always exact. When actual measurements are unknown and Tait's measurements are in question, a question mark appears in brackets

5. Below Tait signature left:
 Information written by Tait on back of painting: Title, signature, place, date, Register number or letter, not always in that order. NA sometimes but not always appears after Tait's signature. Place may refer to the scene painted and/or Tait's current home address. No line slashes appear in the inscription when breaks are unknown. In spite of some inconsistencies, Tait's punctuation has been preserved whenever possible.

6. In italics:
 Tait's Register number or letter(s), followed by his remarks. Tait started a numerical record of his paintings in 1851. These early entries, many from memory, are sometimes out of chronological order, corresponding numbers have not been recorded on the backs of paintings, and some paintings have been omitted. In 1856 Tait began a second numerical sequence and in 1869 a third sequence, changing to a letter code in 1878. Occasionally numbers or letters on the backs of paintings do not agree with those entered in the Register. Tait's remarks appear essentially as they do in his Register, including inconsistent punctuation and some misspellings, such as "Racquette" for Raquette Lake. Until 1875, when he began to spell the name correctly, Tait wrote "Snedicor," instead of Snedecor. Except for Checklist No. 57.25, "Snedicor" has not been corrected editorially in the early entries; other corrections of names and some punctuation appear in brackets. In cases where Tait entered his selling price in code it has been translated into dollars and bracketed. Unclear words or punctuation are followed by a question mark in brackets. For consistency, a period has been supplied after all entries. The bracketed date and location following the number or letter code appeared in Tait's Register at the top of the page indicating a new year; they were not included in the Register entry itself. Other bracketed words in italics are by Tait but have been inserted editorially from another place in the Register.

7. Below Tait's Register entry:
 Editorial remarks, cross references, relining information, identification of individuals in paintings when supplied by Tait, family members, or friends. Nineteenth-century reproductions, exhibition history, and sales to 1906. Institutional owners when known.

Checklist

[SKETCH OF A HARBOR] 33.1

Pen on paper: 8 × 13

This is a sketch on the back of a sheet of paper that is a journal of a trip by AFT and his father from Guernsey to Manchester, June 1833. The journal carries a notation by AFT: "Written by W. W. Tait, my Father when he & I came from Guernsey, the drawing by me, age 13 years. [signed] A. F. Tait."

[PORTRAIT OF MARIAN CARDWELL] 38.1

Painted by A. F. Tait / in 1838 [LR]　　Watercolor on paper: 17¾ × 23¾

[Nothing on back]

The woman portrayed is Marian Cardwell, first wife of AFT. It has been a Tait family belief that AFT could not, in his earlier years, paint hands; this picture verifies that belief.

[CUPID] 40.1

A. F. Tait, Oct. 1840 [LL]　　Pencil on paper: 5½ × 3¼

[Nothing on back]

A sketch of a statue of Cupid preparing to shoot an arrow. Probably done by AFT at the Royal Manchester Institution, where he spent much time training himself in drawing. Original in scrapbook of Francis Osborn Tait.

[CUPID] 40.2

A. F. Tait, Oct 1840 [LC]　　Pencil on paper: 5½ × 3¼

[Nothing on back]

A sketch of a statue of Cupid probably done by AFT at the Royal Manchester Institution, where he spent much time training himself in drawing. Original in scrapbook of Francis Osborn Tait.

[PORTRAIT OF WILLIAM WATSON TAIT] 42.1

A. F. Tait / 42 [Beneath right shoulder]　　Pencil on paper: 12 × 8½

[Nothing on back]

At bottom center it is inscribed by AFT, "For Francis Osborn Tait from his Father."

RAILROAD BRIDGE OVER THE MERSEY, STOCKPORT 43.1

[Not signed or dated]　　Pencil and wash on paper: 12¼ × 14¼

RR Bridge over the Mersey / Stockport 1843.

Collection of the Yale University Art Gallery, New Haven, Connecticut.

WAKEFIELD, YORKSHIRE 43.2

[On front, LR]

Wakefield, Yorkshire / England.　　Pencil and wash [Not signed or dated]　　on paper: 9¾ × 13¾

[Nothing on back]

Reproduced in *Views on the Manchester and Leeds Railway* (Manchester, 1845).

Collection of the Yale University Art Gallery, New Haven, Connecticut.

HEBDEN BRIDGE STATION 43.3

[Not signed or dated]　　Pencil and wash on paper: 9¼ × 13¼

Manchester & Leeds R.R. / Hebden Bridge Station / near Halifax, Yorkshire / England.

Reproduced in *Views on the Manchester and Leeds Railway* (Manchester, 1845).

Collection of the Yale University Art Gallery, New Haven, Connecticut.

LITTLEBORO AND ROCHDALE 43.4

A. F. Tait / 43 [LL]　　Pencil and wash on paper: 9½ × 13½

Littleboro & Rochdale

Reproduced in *Views on the Manchester and Leeds Railway* (Manchester, 1845).

Collection of the Yale University Art Gallery, New Haven, Connecticut.

BRIGHOUSE 43.5

A. F. Tait / 43 [LC]　　Pencil and wash Brighouse near Halifax,　　on paper: 9½ × 15½ Yorkshire, England [UC]

Brighouse from Clifton / off the old coal pit.

Reproduced in *Views on the Manchester and Leeds Railway* (Manchester, 1845).

Collection of the Yale University Art Gallery, New Haven, Connecticut.

GAUXHOLME VIADUCT 43.6

[Not signed or dated] Pencil and wash
 on paper: 9¾ × 13½

Gauxholme Viaduct / Looking toward Manchester / 1843

Reproduced in *Views on the Manchester and Leeds Railway* (Manchester, 1845).

Collection of the Yale University Art Gallery, New Haven, Connecticut.

WHITELEY'S VIADUCT 43.7

[Not signed or dated] Pencil and wash
 on paper: 9¾ × 13¼

Near Todmorden, Yorkshire, England / 1843.

Reproduced in *Views on the Manchester and Leeds Railway* (Manchester, 1845).

Collection of the Yale University Art Gallery, New Haven, Connecticut.

RASTRICK TERRACE AND VIADUCT 43.8

[Not signed or dated] Pencil and wash
 on paper: 9¾ × 14¼

Todmorden / Yorkshire 1843.

Reproduced in *Views on the Manchester and Leeds Railway* (Manchester, 1845). Title taken from lithograph.

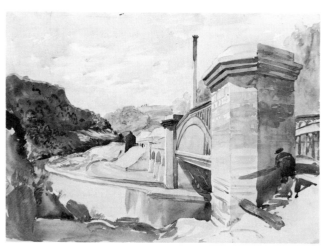

TODMORDEN VIADUCT AND BRIDGE 43.9

Todmorden Viaduct on the Pencil and wash
Manchester & Leeds R. W. / on paper: 10¾ × 14½
England 1843.

[Nothing on back]

Reproduced in *Views on the Manchester and Leeds Railway* (Manchester, 1845).

Collection of the Yale University Art Gallery, New Haven, Connecticut, gift of Mrs. Arthur J. B. Tait. Courtesy of Yale University Art Gallery.

BRIDGE OVER THE IRWELL, 43.10
MANCHESTER

[Not signed or dated] Pencil and wash
 on paper: 10 × 14

Bridge over the Irwell, Manchester & L'pool RR / old cathedral church in distance 1843.

Reproduced in *Views on the Manchester and Leeds Railway* (Manchester, 1845).

Collection of the Yale University Art Gallery, New Haven, Connecticut.

NORMANTON STATION 43.11

[Not signed or dated] Pencil and wash
 on paper: 10 × 14

Normanton Station.

Reproduced in *Views on the Manchester and Leeds Railway* (Manchester, 1845).

Collection of the Yale University Art Gallery, New Haven, Connecticut.

SOWERBY BRIDGE FROM KINGS CROSS 43.12

A. F. Tait / 43 [LR] Pencil and wash
 on paper: 9½ × 13½

Sowerby Bridge, near King's Cross, Yorkshire England / 1843

Reproduced in *Views on the Manchester and Leeds Railway* (Manchester, 1845).

TODMORDEN FROM THE NORTH 43.13

A. F. Tait / 43 [LL] Pencil and wash
 on paper: 9½ × 13½

[Rough drawing on back]

Reproduced in *Views on the Manchester and Leeds Railway* (Manchester 1845).

BRIGHOUSE AND BRADFORD STATION 43.14

A. F. Tait 43 [LL] Pencil and wash
 on paper: 9½ × 13½

[Nothing on back]

NEWTON VIADUCT 43.15

[Not signed or dated] Pencil and wash
 on paper: 9½ × 13½

Newton Viaduct near L'pool, Manch / England. [UR]

47.1 [Gypsy Campers], watercolor: 24 × 29. Courtesy of Mr. and Mrs. George Arden.

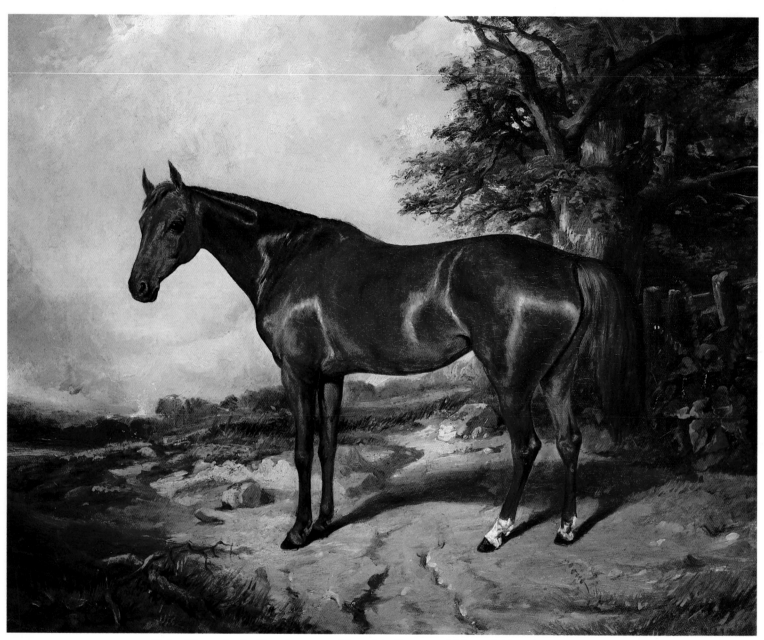

48.1 [Portrait of a Horse], canvas: 20 × 24. Courtesy of Mr. and Mrs. George Arden.

49.2 [View from Alderley Edge], canvas: 23 × 33. Courtesy of Mr. and Mrs. George Arden

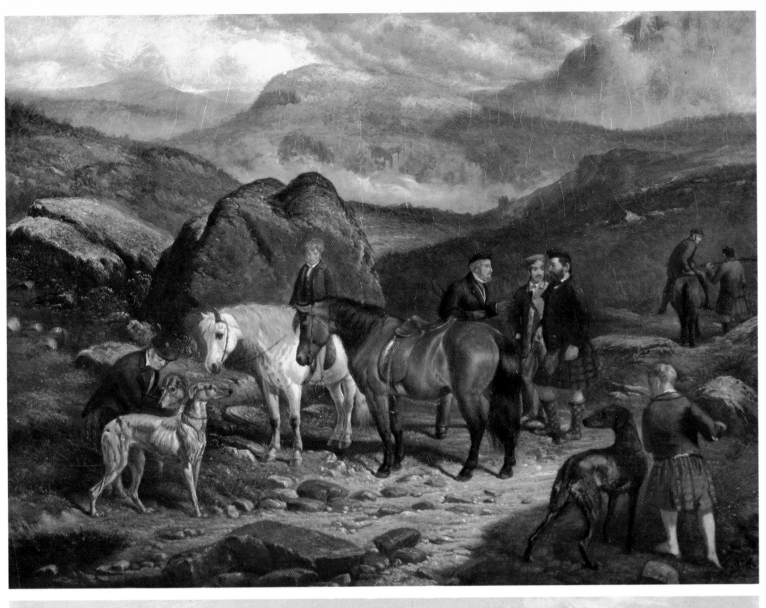

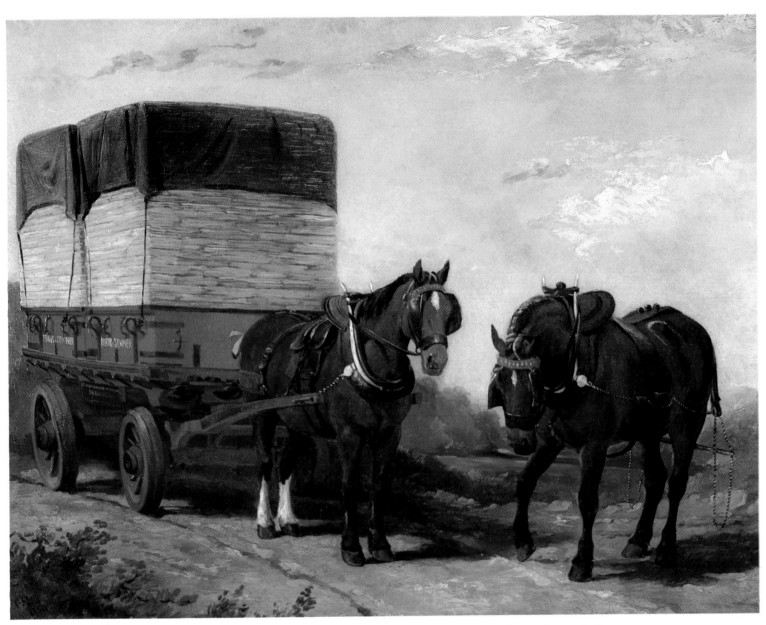

50.5 [Two Horses and a Wagon], canvas: 20 × 24. Courtesy of Mr. and Mrs. George Arden.

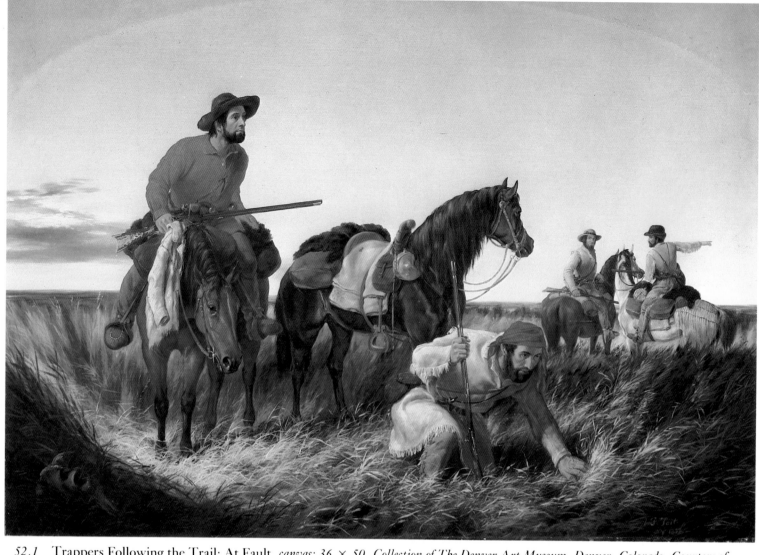

52.1 Trappers Following the Trail: At Fault, *canvas: 36 × 50. Collection of The Denver Art Museum, Denver, Colorado. Courtesy of The Denver Art Museum, The Helen Dill Collection.*

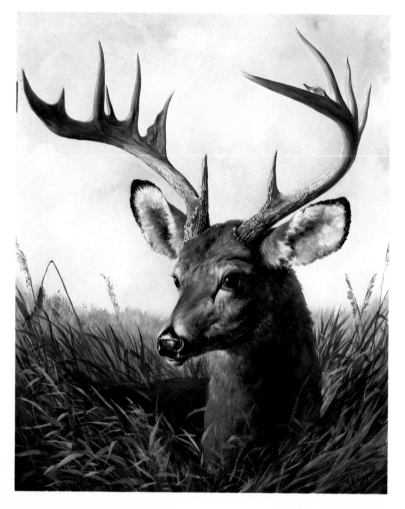

52.4 Stag's Head, *canvas: 36 × 29. Courtesy of Mr. and Mrs. George Arden.*

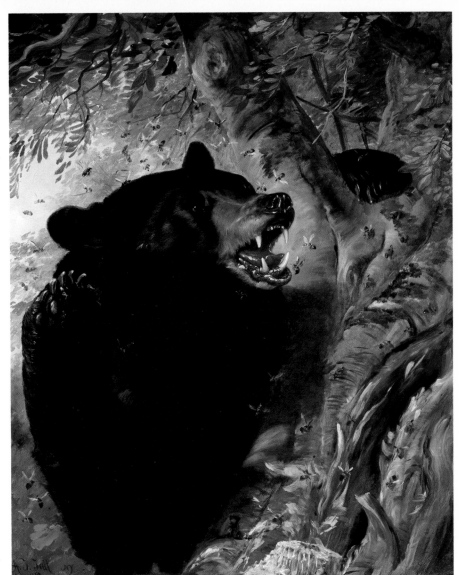

*52.13 The Robber, canvas: 36 × 29. Courtesy of
Mr. and Mrs. George Arden.*

*52.26 The Check [II], canvas: 44 × 30. Courtesy of
Mr. and Mrs. George Arden.*

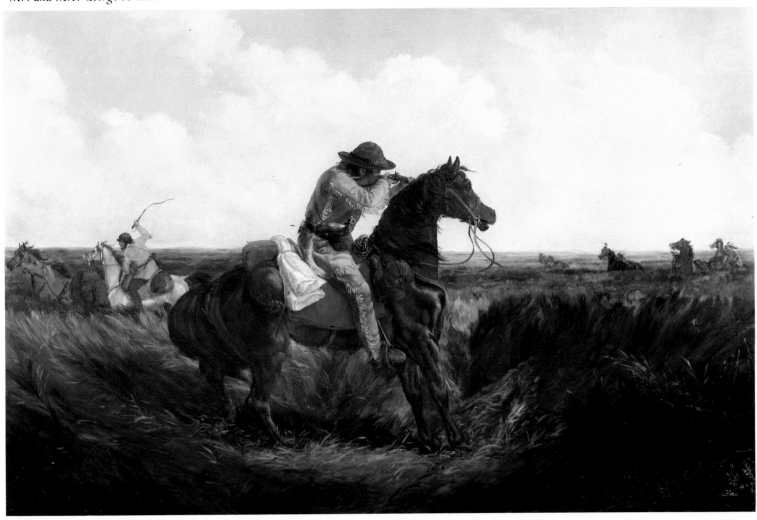

52.32 [Lunch Time], canvas: 20 ×
26¼. Courtesy of Mr. and Mrs.
George Arden.

54.28 Arguing the Point, panel:
19¾ × 24. Collection of the R. W.
Norton Art Gallery, Shreveport,
Louisiana. Courtesy of the R. W.
Norton Art Gallery, © 1971.

[HALIFAX] 43.16

A. F. Tait 43 [LR] Pencil and wash
on paper: 11 × 16

[Nothing on back]

Reproduced in *Views on the Manchester and Leeds Railway* (Manchester, 1845).

WEST ENTRANCE, SUMMIT TUNNELL 43.17

A. F. Tait 43 [LL] Pencil and wash
on paper: 14 × 10

[Nothing on back]

Reproduced in *Views on the Manchester and Leeds Railway* (Manchester, 1845).

[GYPSY CAMPERS] 47.1

A. F. Tait / 1847 [LL] [Unknown]:
Watercolor: 24 × 29

[Nothing on back]

[No AFT number; no Register entry]

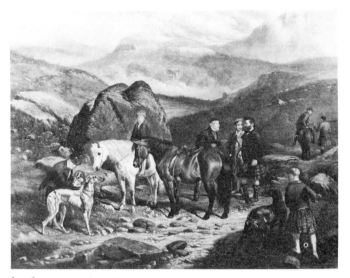

lands consisting of six men, two boys, two horses, and three dogs.

Courtesy of Mr. and Mrs. George Arden.

[PORTRAIT OF A HORSE] 48.1

Arthur F. Tait / 1848 [LL] Canvas: 20 × 24

[Relined; inscription, if any, lost]

[No AFT number; no Register entry]

Courtesy of Mr. and Mrs. George Arden.

[HUNTING PARTY] 48.2

A. F. Tait / 1848 [LR] Canvas: 40 × 30½

[Unknown]

[No AFT number; no Register entry]

Painting depicts a hunting party in the Scottish High-

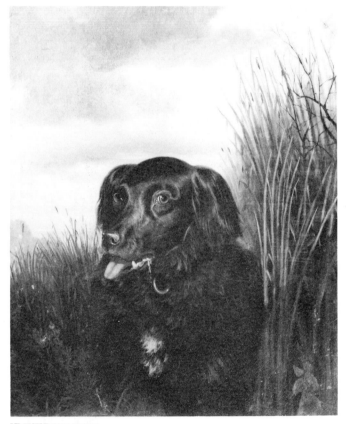

[RETRIEVER] 49.1

[Not signed or dated] Canvas: 24 × 20

A. F. Tait, 1849

[No AFT number; no Register entry]

Depicts the head of a retriever amongst rushes. May be dated 1848.

Courtesy of Mr. and Mrs. George Arden.

[VIEW FROM ALDERLEY EDGE] 49.2

A. F. Tait, 1849 [LL] Canvas: 23 × 33

[Unknown]

[No AFT number; no Register entry]

Done in connection with *Views on the London and North Western Railway.*

Courtesy of Mr. and Mrs. George Arden.

[A VIEW OF BRIGHOUSE, YORKSHIRE] [49.4]

[Not signed or dated] Canvas: 23 × 33

[Nothing on back]

[No AFT number; no Register entry]

Done in connection with the *Views on the Manchester & Leeds Railway.*

Courtesy of Mr. and Mrs. George Arden.

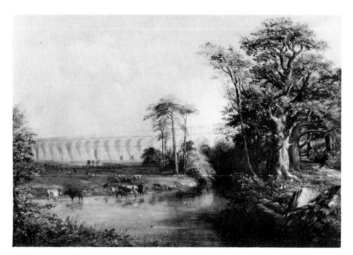

[VIADUCT NEAR ALDERLEY EDGE] [49.3]

[Not signed or dated] Canvas: 23 × 33

[Relined: original inscription lost. Photograph of signature: A. F. Tait 1849]

[No AFT number; no Register entry]

Done in connection with *Views on the London and North Western Railway.*

Courtesy of Mr. and Mrs. George Arden.

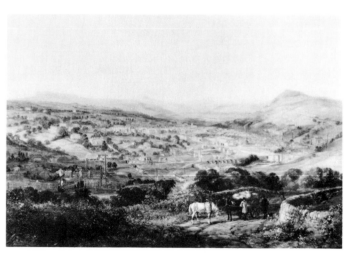

[A VIEW OF HALIFAX, YORKSHIRE] [49.5]

[Not signed or dated] Canvas: 23 × 33

[Unknown]

[No AFT number; no Register entry]

Possibly related to the *Views on the Manchester & Leeds Railway.*

Courtesy of Mr. and Mrs. George Arden.

See 43.16.

[A VIEW OF VICTORIA STREET, [49.6]
MANCHESTER]

[Not signed or dated] Canvas: 23 × 34

[Nothing on back]

[No AFT number; no Register entry]

Done in connection with *Views on the London and North Western Railway.*

A VIEW OF LONDON ROAD, [49.7]
MANCHESTER

[Not signed or dated] Canvas: 23 × 34

[Nothing on back]

[No AFT number; no Register entry]

Done in connection with *Views on the London and North-western Railway.*

[THE FAMILY PROTECTOR] 50.1

A. F. Tait 1850 [?] Canvas: 50¼ × 40

[Relined; inscription, if any, lost]

[No AFT number; no Register entry]

An English stag and hind with two fawns, probably done by AFT before coming to the United States.

REALITY 50.2

A. F. Tait / N.Y. 1850 [LR] Canvas: 18 × 24

A. F. Tait / N.Y. 1850 / "Reality."

[No AFT number; no Register entry]

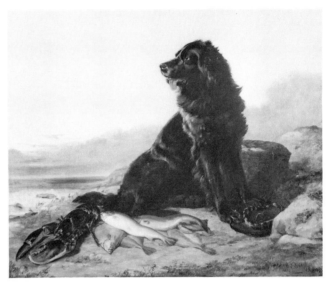

[Unknown]

[No AFT number; no Register entry]

The scene of this painting is a beach at early evening, with a black dog guarding a catch of five fish, a lobster, and a crab. Under his paws is a tam, and to his side is a wicker basket.

Painting seems to have been copied in part from Richard Ansdell's "On Guard, A Newfoundland," 1842, in the Forbes Magazine Collection.

Courtesy of Mr. and Mrs. George Arden.

[DUCKS] 50.3

A. F. Tait N.Y. 1850 [LL] Canvas: 6 × 10

[Relined; inscription, if any, lost]

[No AFT number; no Register entry]

[GUARDING THE CATCH] 50.4

A. F. Tait / 1850 [LR] Canvas: 24 × 29½

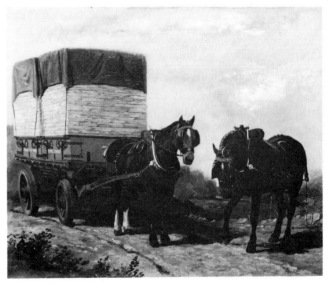

[TWO HORSES AND A WAGON] 50.5

A. F. Tait / 1850 [LL] Canvas: 20 × 24

[Unknown]

[No AFT number; no Register entry]

On the wagon is inscribed "Blair Sumner, Bleacher," the name of a firm listed in the Manchester directories.

Courtesy of Mr. and Mrs. George Arden.

DEER STALKING IN SCOTLAND: 51.1
STEALING ON DEER

[Unknown] Canvas [?]: 18 × 26 [?]

[Unknown]

[No.1] *1 Deer stalking in Scotland. Stealing on deer in antici-
pation.* [Purchaser:] *W.* [Williams] *& Stevens and sold thence
to A. A.* [American-Art] *Union.* [Size:] *18 × 26* [Price
received:] *25.0* [$25.00].

One of a pair with 51.2.

DEER STALKING IN SCOTLAND: 51.2.
GETTING READY

A. F. Tait 1851 [LL] Canvas: 18 × 26¼

[Unknown]

[No.] 2 [*Deer Stalking in Scotland. . . :*] *Getting ready* [?]
resting [Purchaser, with 51.1:] *W.* [Williams] *& Stevens and
sold thence to A. A.* [American-Art] *Union* [Size:] *18 × 26*
[Price received:] *25.0* [$25.00].

Courtesy of Mr. and Mrs. George Arden.

One of a pair with 51.1.

GROUSE SHOOTING 51.3

[Unknown] [Unknown]: 18 × 36 [?]

[Unknown]

[No.] *3 Grouse Shooting. Purchaser, New Jersey Art Union.
36 × 18. Price received 50* [$50.00].

One of a pair with 51.4. Awarded to D. D. Benjamin in
the December 1851 New Jersey Art Union Lottery.

PARTRIDGE SHOOTING 51.4

[Unknown] [Unknown]: 18 × 36 [?]

[Unknown]

[No.] *4 Partridge Shooting. Purchaser, New Jersey Art Un-
ion. 36 × 18. Price received 50* [$50.00].

One of a pair with 51.3. Awarded to R. Van Buskirk in
the December 1851 New Jersey Art Union Lottery.

[THE HUNTER'S DILEMMA: I] 51.5

A. F. Tait / N. York 1851 Canvas: 33¼ × 44¼
[on rock mid - LL]

[Sealed; inscription, if any, unavailable]

[No.] *5 Hunter & dead deer Purchaser—Hooper & Bro.
America Artist's Asso. Distribution. Jan. 15th 1852. 34 ×
44. Price received 200* [$200.00].

See 51.13.

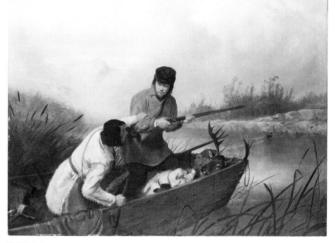

LET HIM GO 51.6

[Not signed or dated] Canvas: 34⅛ × 44¼

[Relined; inscription, if any, lost]

[No.] *6 "Let Him Go." (Hunter in a boat) Purchaser A. Art
Union 34 × 44. Price received 200* [$200.00] *with frame.*

This painting has been relined but still carries American
Art-Union label on the stretcher showing the date as
December 1851.

Courtesy of Christie's, New York, New York.

DEER'S HEAD 51.7

[Unknown] [Unknown]: 22 × 36 [?]

[Unknown]

[No.] *7 Deer's Head. Purchaser A. Art Union. 36 × 22.*

WASHINGTON AND HIS GENERALS 51.8

[Unknown] [Unknown]: 42 × 64 [?]

[Unknown]

[No.] *8 Washington & his generals. Ritchie Engraver Commis-
sion 64 × 42 Price received 300* [$300.00].

TRAPPER AT BAY 51.9

A. F. Tait / N.Y. 1851 [LR] Canvas: 34¼ × 44

[Unknown]

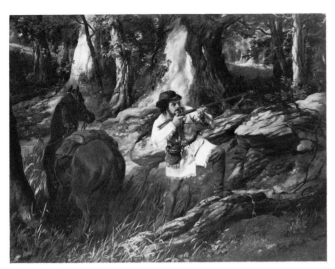

[No.] *10 Trapper at Bay* [Purchaser:] *Williams & Stevens* [Size:] *34 × 44* [Price; bracketed with No. 11 (51.10), together:] *150* [$150.00] [Bracketed left with No. 11 (51.10) and together marked:] *Pair.*

Courtesy of Mr. H. H. Thomas.

One of a pair with 51.10.

TRAPPERS: ALARM 51.10

[Unknown] [Unknown]: 34 × 44 [?]

[Unknown]

[No.] *11 Do.* [Trapper at Bay] *- Alarm* [Purchaser:] *Do. Do.* [Williams & Stevens, but marked over in pencil:] *Jno Osborn* [Size:] *34 × 44* [Price, bracketed with No. 10 (51.9), together:] *150* [bracketed left with No. 10 (51.9) and together marked:] *Pair.*

One of a pair with 51.9.

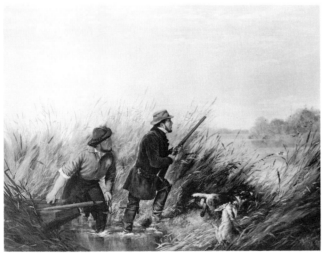

DUCK SHOOTING 51.11

A. F. Tait / N.Y. 1853 [LR] Canvas: 30½ × 44

A. F. Tait, N.Y. 1851, Nov.

[No.] *12 Duck Shooting. Purchaser Jno. Osborn. Esq. N.Y. 34 × 44 Price received 100* [$100.00].

Exhibited at the National Academy of Design 27th Annual Exhibition, 1852, titled "Duck Shooting, A Good Shot" and owned by John Osborn. Back is marked "1851, Nov." See discrepancy front and back dates, above.

Courtesy of Kennedy Galleries, Inc., New York, New York.

See 53.1.

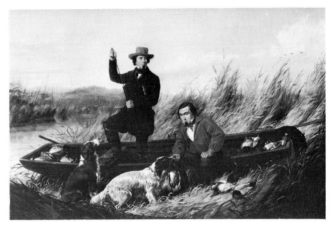

DUCK SHOOTING, SOME OF THE 51.12
RIGHT SORT

A. F. Tait / N.Y. 1851 [LR] Canvas: 34½ × 44

A. F. Tait, N.Y. 1851. Nov.

[No.] *37 Duck Shooting "Some of the right sort." size: 44 × 34 Commission for Jas. Clark, Esq. Brooklyn.*

Exhibited at the National Academy of Design 29th Annual Exhibition, 1854, titled "Duck Shooting, Some of the Right Sort" and owned by James Clark. A hand-colored lithograph was published by N. Currier, 1854, titled "Wild Duck Shooting, A Good Day's Sport."

Courtesy of Mr. George A. Butler.

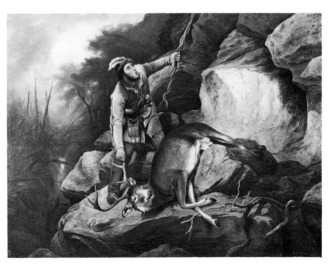

51.13

[THE HUNTER'S DILEMMA: II] 51.13

A. F. Tait 1851 [LR] Canvas: 34 × 44

[Nothing on back]

[No AFT number; no Register entry]

Collection of the Shelburne Museum, Shelburne, Vermont. Courtesy of Shelburne Museum.

See 51.5.

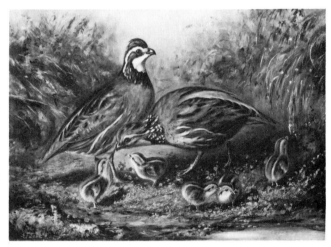

[THE CARES OF A FAMILY] 51.14

A. F. Tait 1851 [LL] Canvas: 12 × 16

[Unknown]

[No AFT number; no Register entry]

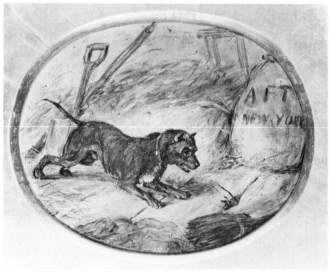

TOO LATE 51.15

AFT / New York [UL on bag] Oil Sketch on Paper:
 5½ × 6½ Oval

[Also below painting, "Too Late!! N. York, Nov. 1st 1851 A. F. Tait."]

[Unknown]

[No AFT number; no Register entry]

Courtesy of Mr. and Mrs. George Arden.

[TRACKING] 51.16

A. F. Tait / N.Y., 1851 [LL] Canvas: 36 × 50½

[Nothing on back]

[No AFT number; no Register entry]

See 52.1 for a similar painting.

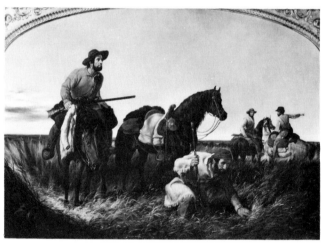

TRAPPERS FOLLOWING THE TRAIL: 52.1
AT FAULT

A. F. Tait / N.Y. 1852 [LR] Canvas: 36 × 50

[Nothing on back]

[No.] 9 *Trappers Following the Trail (At fault). Purchaser* [crossed out: *Jno. Osborn Esq. New York;* above, written in pencil:] *Chas. A. Davis: Size: 50 × 36 Price received 100* [$100.00].

Exhibited at the National Academy of Design 27th Annual Exhibition, 1852, titled "Trappers At Fault, Looking For the Trail" and owned by John Osborn.

Collection of The Denver Art Museum, Denver, Colorado. Courtesy of The Denver Art Museum, The Helen Dill Collection.

See 51.16 for a similar painting.

ONE RUBBED OUT 52.2

[Not signed or dated] Canvas: 26 × 36

[Nothing on back]

[No.] 13 *One rubbed out. (Galloping Trapper on horse) Price received 100* [$100.00].

Courtesy of Christie's, New York, New York.

See 52.3 and 52.17.

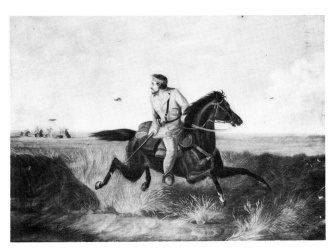

52.2

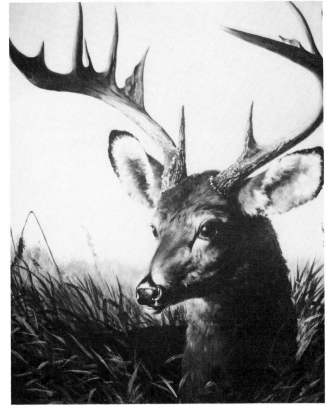

52.4

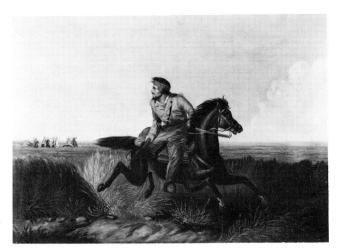

ONE RUBBED OUT 52.3

A. F. Tait / N.Y. 1852 [LR] Canvas: 14 × 20

[Relined; inscription, if any, lost]

[No.] *14 Small copy of "do"* [meaning No. 13 (52.2)]. *Purchaser, Mr. Currier for publishing. 20 × 14. Price received 50* [$50.00].

A hand-colored lithograph was published by N. Currier, 1852, titled "The Prairie Hunter, 'One Rubbed Out.'"

Collection of the Joslyn Art Museum, Omaha, Nebraska. Courtesy of the Joslyn Art Museum, Northern Natural Gas Company Collection.

See 52.2 and 52.17.

STAG'S HEAD 52.4

A. F. Tait / N.Y. 1st 1852 [LR] Canvas: 36 × 29

[Relined; inscription, if any, lost]

[No.] *15 Stags Head (Life size) Purchaser. Jno. Osborn. Price received 30* [$30.00].

Courtesy of Mr. and Mrs. George Arden.

DEAD GAME 52.5

[Unknown] [Unknown]: [Unknown]

[Unknown]

[No.] *16 Dead Game. Price received 50* [$50.00].

LANDSCAPE, VIEW IN ENGLAND 52.6

[Unknown] [Unknown]: [Unknown]

[Unknown]

[No.] *17 Landscape. (View in Eng'd). Price received 50* [$50.00].

PORTRAIT 52.7

[Unknown] [Unknown]: [Unknown]

[Unknown]

[No.] *18. Portrait. Gift to Cap't Harvey. 3/4.*

PORTRAIT 52.8

[Unknown] [Unknown]: [Unknown]

[Unknown]

[No.] *19 Do. Do. [Portrait Gift to] Mr. Delaney 1/8.*

PORTRAIT 52.9

[Unknown] [Unknown]: [Unknown]

[Unknown]

[No.] *20　Do. Do. [Portrait Gift to] Mr. Reynolds ¾.*

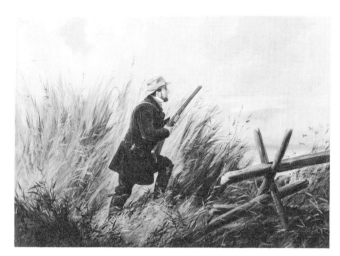

DUCK SHOOTING　　　　　52.10

A. F. Tait / N.Y. 1852 [LL]　　　Canvas: 20 × 27

[Sealed; inscription, if any, unavailable]

[No.] *21　Duck Shooting—Small—Gift to American Artists Ass.*

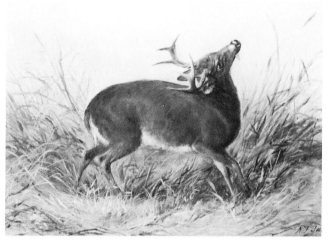

WOUNDED DEER　　　　　52.12

A. F. Tait [LR]　　　　　Canvas with board
　　　　　　　　　　　　backing: 14 × 18

[Nothing on back]

[No.] *23.　Wounded deer. Jno. Osborn, Esq. [$100.00].*

Exhibited in the National Academy of Design 27th Annual Exhibition, 1852, titled "Wounded Deer" and owned by John Osborn.

Courtesy of Mr. Marshall R. Berkoff.

THE REPRIMAND　　　　　52.11

A. F. Tait / 1.2. N.Y. 1852 [LL]　Canvas: 36⅛ × 61¼

[Relined; inscription, if any, lost]

[No.] *22　The Reprimand. Child & Fawn. Jno. Osborn. Esq. [$100.00].*

Exhibited at the National Academy of Design 27th Annual Exhibition, 1852, titled "The Reprimand. Ah! You naughty fawn, you have been eating the flowers again" and owned by John Osborn.

Collection of the Brooklyn Museum, Brooklyn, New York, gift of Mrs. Donald Oenslager. Courtesy of the Brooklyn Museum.

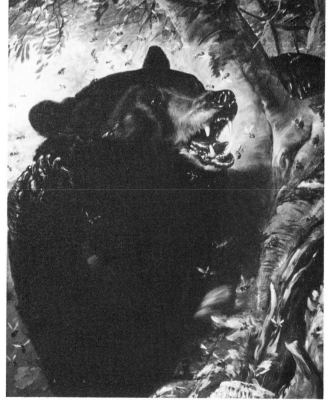

THE ROBBER　　　　　52.13

A. F. Tait / N.Y. 1852 [LL]　　　Canvas: 36 × 29

[Relined; inscription, if any, lost]

[No.] *24. The Robber. (Bear & Bees).* [$100.00].

Exhibited in the National Academy of Design 27th Annual Exhibition, 1852, titled "The Robber more Bitter than Sweet" and listed as for sale.

Courtesy of Mr. and Mrs. George Arden.

QUAIL SHOOTING 52.14

[Unknown] [Unknown]: [Unknown]

[Unknown]

[No.] *25. Quail Shooting—(Reynolds).*

TRAPPER LOOKING OUT 52.15

A. F. Tait / 1852 [LL] Canvas: 24 × 36

[Unknown]

[No.] *26. Trapper Looking Out—L. B. Brown.* [$100.00].

One of a pair with 52.16.

TRAPPER RETREATING OVER 52.16
RIVER

A. F. Tait / N.Y. '52 [LR] Canvas: 24¼ × 36¼

[Nothing on back]

[No.] *27. Trapper Retreating over River—L. B. Brown.*

One of a pair with 52.15.

Collection of the Yale University Art Gallery, New Haven, Connecticut. Courtesy of Yale University Art Gallery, Whitney Collections of Sporting Art, given in memory of Harry Payne Whitney (B.A. 1894) and Payne Whitney (B.A. 1898) by Francis P. Garvan (B.A. 1897).

ONE RUBBED OUT 52.17

[Unknown] [Unknown]: [Unknown]

[Unknown]

[No.] *28.* [Written in pencil and crossed out: *2nd Looking for Quail*] *One Rubbed Out.* [In pencil: *Osborn*] *Oporto.*

See 52.2 and 52.3.

PORTRAIT OF BEPPO 52.18

[Unknown] [Unknown]: [Unknown]

[Unknown]

[No.] *29. Portrait of Beppo—Mr. Brown.*

PORTRAIT OF CATTLE 52.19

[Unknown] [Unknown]: [Unknown]

[Unknown]

[No.] *30. Portrait of Cattle.—Mr. Brown.*

PORTRAIT OF BULL, OTSEGO 52.20

[Unknown] [Unknown]: [Unknown]

[Unknown]

[No.] *31. Portrait of Bull. (Otsego). Mr. Fail.*

PORTRAIT OF COW 52.21

[Unknown] [Unknown]: [Unknown]

[Unknown]

[No.] *32 Portrait of Cow. Mr. Fail.*

52.22

[PORTRAIT OF A CELEBRATED 52.22
TROTTING HORSE]

A. F. Tait / N.Y. 1852 [LR] Canvas: 22 × 30

[Nothing on back]

[No.] 33 Portrait of horse. Mr. Day.

Exhibited at the National Academy of Design Exhibition, 1853, titled "Portrait of a Celebrated Trotting Horse" and owned by Edward M. Day.

Collection of the National Museum of Racing, Inc., Saratoga Springs, New York. Courtesy of National Museum of Racing, Inc.

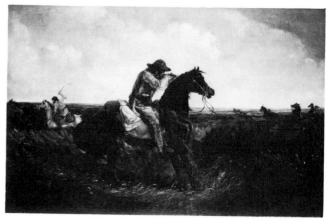

THE CHECK [II] 52.26

A. F. Tait / N.Y. '52 Canvas: 44 × 30

[Unknown]

[No AFT number; no Register entry]

See 52.23, 52.27, and 54.20.

Courtesy of Mr. and Mrs. George Arden.

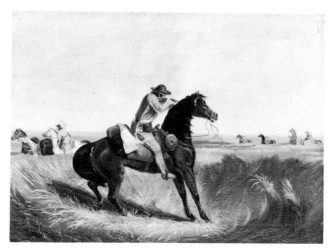

THE CHECK [I] 52.23

[Not signed or dated] Canvas: 26 × 36

[Relined; inscription, if any, lost]

[No.] 34. "The Check." (Comp'n to One Rubbed Out [52.2]) Geo. Williams.

A hand-colored lithograph was published by N. Currier, 1853, titled "A Check, 'Keep Your Distance.'"

See 52.26, 52.27, and 54.20.

PORTRAIT OF HORSE 52.24

A. F. Tait / 1852 [LR] Canvas: 22 × 30

[Relined; inscription, if any, lost]

[No.] 39 Portrait of Horse for Mr. Heyser. [$125.00].

SWEEPSTAKES 52.25

[Unknown] [Unknown]: [Unknown]

[Unknown]

[No.] 40 Sweepstakes. Do for Mr. Heyser for Ship Sweepstakes. [$100.00].

May be dated 1852.

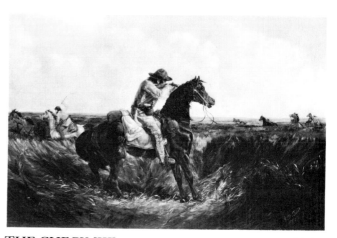

THE CHECK [III] 52.27

A. F. Tait / N.Y. 52 [LR] Canvas: 29¾ × 44

[Relined; in a hand other than AFT's: "A. F. Tait, NY 1852"]

[No AFT number; no Register entry]

See 52.23, 52.26, and 54.20.

[LOG SHANTY] 52.28

[Not signed or dated] Board: 12 × 16

[See remarks]

[No AFT number; no Register entry]

On the back is the inscription, "This is the first Shanty I ever built or lived in / in the Forest. Built on Chateaugay Upper Lake, Franklin Co., N.Y. / on the west side in August 1852 / painted from nature by A. F. Tait."

Courtesy of Mr. Robert D. Bogert.

52.28

[SKETCH OF ROCK AND TREES] 52.29

[Not signed or dated] Board: 12 × 16

1852.

[No AFT number; no Register entry]

Collection of the Yale University Art Gallery, New Haven, Connecticut.

[SKETCH OF ROCK AND TREES 52.30
AT CHATEAUGAY LAKE]

[Not signed or dated] Board: 12 × 16

Chateaugay Lake / Franklin Co / from Nature by / A. F. Tait / 1852.

[No AFT number; no Register entry]

Collection of the Yale University Art Gallery, New Haven, Connecticut.

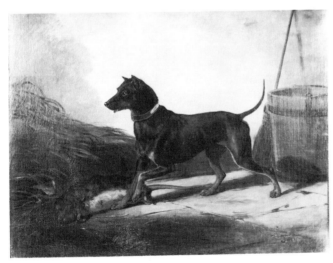

[UNKNOWN] 52.31

A. F. Tait / N.Y. '52 [LR] Canvas: 20 × 26

[Nothing on back]

[No AFT number; no Register entry]

This painting depicts a Manchester terrier standing over a dead muskrat.

Courtesy of Mr. William J. Engleman.

[LUNCH TIME] 52.32

A. F. Tait / 1852 [LR] Canvas: 20 × 26¼

[Unknown]

[No AFT number; no Register entry]

DUCK SHOOTING 53.1

A. F. Tait / N.Y. 1853 [LR] Canvas: 30½ × 44

A. F. Tait, N.Y. 1851, Nov.

[No. *12:* for Register entry see 51.11]

Identical to 51.11.

THE RETURN FROM HUNTING: 53.2
THE HALT IN THE WOODS

A. F. Tait / N.Y. 1855 Canvas: 45 × 63
[overpainted in LR]
A. F. Tait [LL]

[Nothing on back]

[No.] *35 The Return from Hunting, "The Halt" in the woods. Goupil, Dec. 1853.*

Exhibited at the National Academy of Design 28th Annual Exhibition, 1853, titled "Return From Hunting. The Halt In The Woods. A scene near Chateaugay Lake, Franklin Co., N.Y." and listed as for sale.

Note discrepancy between date on painting, date entered in Register.

According to AJB Tait the artist has portrayed himself on the right smoking a cigar. A note by Ann Inshaw Wing (1830–1912) confirms this and identifies the man on the left getting water from the brook as her husband, John Wing.

A steel engraving by Cottin, 22 × 31 inches, was printed by Goupil & Co. in Paris and published by the New York office of the firm at 366 Broadway. The copyright, dated 1856, was in Tait's name. Some apparently later strikes from the same plate were printed by Fishel, Adler & Schwartz, 94 Fulton Street, N.Y.

Collection of the Hibbing Public Library, Hibbing, Minnesota. Courtesy of the Hibbing Public Library.

BASE IS THE SLAVE THAT 53.3
PAYS

A. F. Tait / N.Y. 1853 [LL] Canvas: 33½ × 39½

[Relined; inscription, if any, lost]

[No.] 36 *"Base is the slave that pays" from Shakespeare / Pistol, Bartolfo & Nym, Act 2nd Scene 1st. San Francisco, 1853.*

William Davidge, depicted in this scene from *Henry V* as "Pistol," was a close friend of AFT and an actor of note at the time of the painting. Exhibited at the National Academy of Design 28th Annual Exhibition, 1853, titled "Repudiation."

SIX SMALL GROUPS OF 53.4–.9
DEAD GAME

[See remarks] [See remarks]: [See remarks]
 oval

[See remarks]

[No AFT numbers] *6 Small oval groups of Dead Game. 3 W. S. & W. 1 Mr. Jn. Osborn 2 to Oporto 1 Jas Clark.*

Some of these paintings may actually have been done in 1854. See individual entries for each painting, 53.4 through 53.6, 53.7, 53.8, and 53.9.

[GROUP OF DEAD GAME] 53.4–.6

[Unknown] [Unknown]: [Unknown] oval

[Unknown]

[No AFT numbers; see collective entry 53.4–9]

Three of "6 small oval groups of Dead Game," presumably having gone to Williams, Stevens, & Williams. For the others see 53.7–53.9.

[GROUP OF DEAD GAME] 53.7

[Unknown] [Unknown]: [Unknown]

[Unknown]

[No AFT number; see collective entry 53.4–.9]

One of "6 small oval groups of Dead Game" (for the others see 53.4 through 53.6 and 53.8 and 53.9). This one presumably went to John Osborn or James Clark.

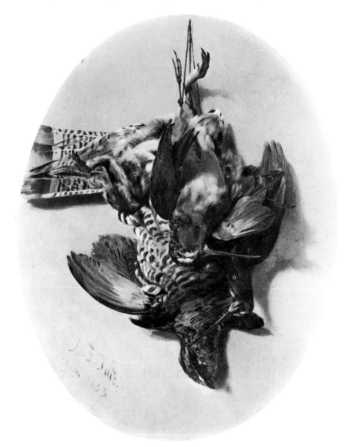

[DEAD GAME: SNIPE, WOODCOCK 53.8
AND PRAIRIE HEN]

A. F. Tait / 1853 [LL] Board: 16 × 12 oval

A. F. Tait, 150 Spring Street, N.Y.

[No AFT number; for Register entry see group entry 53.4–.9].

One of the "6 small oval groups of Dead Game," listed in a collective register entry and one of the two noted by AFT as having gone to Oporto, Portugal. The signature on the back of this painting is to one side and usually hidden by the oval frame.

See 53.9.

Courtesy of Mr. and Mrs. George Arden.

[DEAD GAME: DUCK AND GROUSE] 53.9

A. F. Tait / Quebec 1853 Board: 16¼ × 12½

[Unknown]

[No AFT number; for Register entry see group entry 53.4–.9.]

See 53.8.

GROUP OF FISH 53.10

[Unknown] [Unknown]: [Unknown]

[Unknown]

[No.] *41 Group of Fish. Painted at Chateaugay Lake. Mr. Arnold.* [$75.00].

May be dated 1854.

GROUP OF DEER 53.11

[Unknown] [Unknown]: [Unknown]

[Unknown]

[No.] *42 Group of Deer. Painted at Chateaugay Lake.*

May be dated 1854.

BUCK'S HEAD 53.12

[Unknown] [Unknown]: [Unknown] oval

[Unknown]

[No.] *43 Small oval of Buck's Head Jno. Osborn, Esq.* [$25.00].

May be dated 1854.

DOE'S HEAD 53.13

[Unknown] [Unknown]: [Unknown]

[Unknown]

[No.] *44 Small oval of Doe's head, reclining. Jas. Clark, Esq.* [$25.00].

May be dated 1854.

GROUSE 53.14

[Unknown] [Unknown]: [Unknown] oval

[Unknown]

[No.] *45 Grouse. oval. Davis, esq.* [$25.00].

May be dated 1854.

GROUSE 53.15

[See 55.6] [See 55.6]

[See 55.6]

[No.] *46. Do. [Grouse].* W.S.W. [Williams, Stevens, & Williams] [$25.00].

May be dated 1854.

For a painting matching this description but dated 1855, see 55.6.

[GROUP OF DUCKS: RED HEAD 53.16
AND MALLARD]

[Unknown] [Unknown]: [Unknown]

[Unknown]

[No.] *47 Group of Ducks. Red Head & Mallard* W.S.W. [Williams, Stevens, & Williams] [$25.00].

May be dated 1854.

[GROUP OF DUCKS: WOOD DUCK 53.17
AND GOLDEN EYE]

[Unknown] [Unknown]: [Unknown]

[Unknown]

[No.] *48 Group of ducks. Mr. Davis. Wood duck & Gold eye.* [$25.00].

May be dated 1854.

[GROUP OF DUCKS: WOOD DUCK 53.18
AND GOLDEN EYE]

[Unknown] [Unknown]: [Unknown]

[Unknown]

[No.] *49 do. [Group of Ducks] Ra [?] Do. [Wood Duck & Gold Eye (?)] in Frame* [$50.00].

May be dated 1854.

[GROUP OF DUCKS: WOOD DUCK 53.19
AND GOLDEN EYE]

[Unknown] [Unknown]: [Unknown]

[Unknown]

[No.] *50 Do. [Group of Ducks] Do.* [?; followed by another ditto mark, possibly indicating *Wood Duck & Gold Eye* from No. 48] *in Frame* [$50.00].

May be dated 1854.

[GROUP OF DUCKS: WOOD DUCK 53.20
AND GOLDEN EYE]

[Unknown] [Unknown]: [Unknown]

[Unknown]

[No.] *51 Do. [Group of Ducks] Wood duck & Golden Eye presented to Mrs. Osborn. Sold to Mr. Davis* [$25.00].

May be dated 1854.

See 53.22.

[GROUP OF DUCKS: WOOD DUCK] 53.21

[Unknown] [Unknown]: [Unknown]

[Unknown]

[No.] *52 Do.* [*Group of Ducks*] *Wood Duck W.S & W.* [Williams, Stevens & Williams] [no price indicated].

May be dated 1854.

GROUP OF DUCKS: WOOD DUCK 53.22

[Unknown] [Unknown]: [Unknown]

[Unknown]

[No.] *53 Do.* [*Group of Ducks*] *Do.* [*Wood*] *Do.* [*Duck*] *Mrs. Osborn much better instead of former one* [presumably 53.20].

STUDY FOR HALT IN THE WOODS 53.23

[Not signed or dated] Canvas: 15 × 21½

[See remarks]

[No AFT number; no Register entry]

Written on stretcher at bottom, "Mr. Tait / Portland Hotel / Shrewsbury" and on stretcher at top "A. Tait, 150 Spring."

See 53.2.

DEER 53.24

[Unknown] [Unknown]: [Unknown] oval

[Unknown]

[No AFT number; no Register entry]

[PORTRAIT OF PAUL SMITH] 53.25

[Not signed or dated] [Unknown]: [Unknown]

[See remarks]

[No AFT number; no Register entry]

The back of this sketch is annotated "Paul Smith / Painted by Tate [*sic*] / 1853 / Property of / Ralph Earle."

ROB ROY 54.1

A. F. Tait / N.Y 1854 [LL] Canvas: 28½ × 36½

[Sealed; inscription, if any, unavailable]

[No.] *38* [*Group of Dead Game. Painted in Quebec* crossed out] *Portrait of Dog Rob Roy for Barrett Esq'r.* [$75.00].

GROUP OF DUCKS: WOOD DUCK 54.2–.8
AND GOLDEN EYE

[See remarks] [See remarks]: [See remarks]

[See remarks]

[No.] *54* [through *60*] *Do.* [*Group of Ducks;* here and elsewhere dittos appear to refer to Register No. 52—see 53.21—and apply to items No. 54 through No. 60; across these marks is written:] *Delivered 12 Groups to this Date, March* [Apparently applies to the seven of this group and to five, possibly drawn from 53.7—53.9, 53.19, 53.20 or 53.25; the following general comment is then entered:] *March 6th, / 54. Rec'd from W.S. & W. up to March 6th / 54 for these* [?] *Ducks $100 for first set of 4 in 1853*

[Possibly among 53.4–53.6, 53.15, 53.16 and 53.21] *and 25$ when I went to Chateaugay in August 1853, and $85 this year, leaving* [blank].

For continuation of the account with Williams, Stevens, & Williams, see 54.13–.16.

[GROUP OF DUCKS] 54.2

A. F. Tait / N.Y 1853 [LL] Board: 16½ × 12¼
 Oval

Woodduck & Golden Eye / By A. F. Tait / Belongs to John Osborn Esq. /Brooklyn, N.Y.

[No.] *54* [See 54.2–.8].

GROUP OF DUCKS 54.3

[Unknown] [Unknown]: [Unknown]

[Unknown]

[No.] *55* [see 54.2–.8].

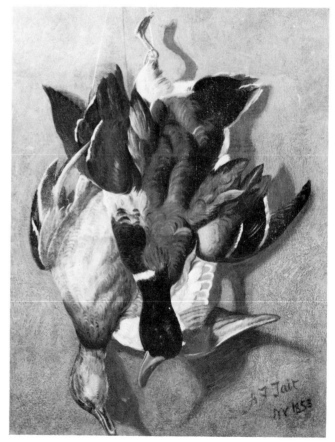

GROUP OF DUCKS 54.4

A. F. Tait / N.Y. 1853 [LR] Canvas: 15½ × 11½

[Relined; inscription, if any, lost]

[No.] *56* [see 54.2–.8].

Courtesy of Sotheby Parke Bernet, Agent: Editorial Photocolor Archives, New York, New York.

[GROUP OF DUCKS] 54.5

[Unknown] [Unknown]: [Unknown]

[Unknown]

[No.] *57* [see 54.2–.8].

GROUP OF DUCKS 54.6

[Unknown] [Unknown]: [Unknown]

[Unknown]

[No.] *58* [see 54.2–.8].

GROUP OF DUCKS 54.7

[Unknown] [Unknown]: [Unknown]

[Unknown]

[No.] *59* [see 54.2–.8].

GROUP OF DUCKS 54.8

[Unknown] [Unknown]: [Unknown]

[Unknown]

[No.] *60* [see 54.2–.8].

[DEAD GAME: MALLARD AND 54.9
PINTAIL]

[Unknown] [Unknown]: [Unknown]

[Unknown]

[No AFT number; see 54.9–.10, then:] *Mallard & Pintail*.

One of a pair with 54.10.

TWO DUCK PICTURES 54.9–.10

[See remarks] [See remarks]: [See remarks]

[See remarks]

[No AFT numbers] *March 26th del'd to W S W.* [Williams, Stevens, & Williams] *2 Duck Pictures.*

See individual entries 54.9 and 54.10.

[DEAD GAME: SHOVEL BILL 54.10
AND RED HEAD]

A. F. Tait [halfway up on R] Board: 17 × 14 oval

[Nothing on back]

[No AFT number; see 54.9–.10, then:] *Shovel Bill & Red Head. (Backs).*

One of a pair with 54.9.

[DEAD GAME: TEAL AND SHOVEL 54.11
BILL DUCKS]

[Unknown] [Unknown]: [Unknown]

[Unknown]

[No AFT number] *Del'd March 30th* [to Williams, Stevens & Williams] *the Painting* [?] *Teal and Shovel Bill (both breasts).*

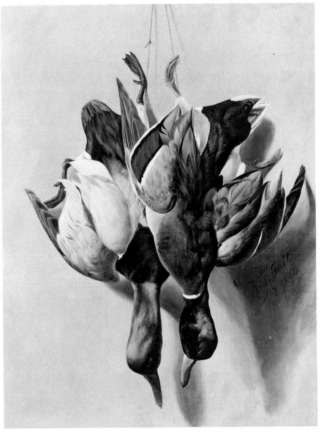

DUCKS: MALLARD AND CANVAS BACK 54.12

A. F. Tait / N.Y. 1854 [LR] [Unknown]: [Unknown]

[Unknown]

[No AFT number] *Del'd one Painting to N. Currier in a Frame Rec'd* [$50.00] *for Picture & copyright. Mallard & Canvas Backs.*

A hand-colored lithograph was published by N. Currier, 1854, titled "American Feathered Game, Mallard and Canvas Back Ducks."

Courtesy of Christie's, New York, New York.

FOUR DUCK PICTURES 54.13–.16

[See remarks] [See remarks]: [See remarks]

[See remarks]

[No AFT number] *4 Duck Pictures Del'd. May 30th. to W. S. W.* [Williams, Stevens, & Williams] *$120.00 to go towards my a/c.* [In margin in pencil:] *June.*

For each painting see 54.13–54.16, but note that there is some doubt whether the actual paintings described necessarily fit with this particular Register entry.

See 54.2–.8.

[DEAD GAME: WILD DUCKS] 54.13

A. F. Tait / N.Y. '54 [LR] Board: 16½ × 12½ oval

[Sealed; inscription, if any, unavailable]

[No AFT number; for possible Register entry see 54.13–.16]

[DEAD GAME: WILD DUCKS] 54.14

A. F. Tait / N.Y. 1854 [LR] Board: 16½ × 12½ oval

[Sealed; inscription, if any, unavailable]

[No AFT number; for possible Register entry see 54.13–.16]

[DEAD GAME: WILD DUCKS] 54.15

A. F. Tait / N.Y. 1854 [LR] Board: 16½ × 12½ oval

[Sealed; inscription, if any, unavailable]

[No AFT number; for possible Register entry see 54.13.–.16]

[DEAD GAME: WILD DUCKS] 54.16

A. F. Tait / N.Y. 1854 [LL] Board: 16½ × 13½ oval

No. 17 1854 / Male Mallard and / Canvas Back Ducks / A. F. Tait / New York March 1854.

[No AFT number; for possible Register entry see 54.13–.16]

TWO PAINTINGS: DUCKS 54.17–.18

[See remarks] [See remarks]: [See remarks]

[See remarks]

[No AFT number] *June 26th. Del'd two Paintings Ducks (Misfits [?]) $60. Rec'd 30$. Canvas Back & Mallard and Shovel Bill & Red Head.*

CANVAS BACK AND MALLARD 54.17

[Unknown] [Unknown]: [Unknown]

[Unknown]

[No AFT number; see 54.17–.19.] *Canvas Back & Mallard. . . .*

One of a pair with 54.18.

SHOVEL BILL AND RED HEAD 54.18

[Unknown] [Unknown]: [Unknown]

[Unknown]

[No AFT number; see 54.17–.19] *. . . and Shovel Bill & Red Head.*

One of a pair with 54.17.

DEAD DUCKS 54.19

[Unknown] [Unknown]: [Unknown]

[Unknown]

[No AFT number] *Large Group of Dead Ducks went to London.*

It is not clear whether this entry refers to only one or to several paintings nor whether it indicates paintings not previously listed or old ones.

THE CHECK [IV] 54.20

[Unknown] [Unknown]: [Unknown]

[Unknown]

[No AFT number] *The Check repainted for London.*

For other versions of this subject see 52.23, 52.26, and 52.27.

TROUT FISHING 54.21

A. F. Tait / N.Y. 1854 [LL] Canvas: 30 × 45

[Relined; inscription, if any, lost]

[No AFT number] *"Trout Fishing" 44 × 34 Portrait of Mr. Mesier [?], J. H. Clark & Paulus Enos (Darky) Edw S Mesier [?] [$450.00].*

A hand-colored lithograph was published by N. Currier, 1854, titled "Catching A Trout, 'We hab you now, Sar!'"

DUCK SHOOTING OVER DECOYS 54.22

A. F. Tait / N.Y. 1854 [LR on boat] Canvas: 30 × 44

[Nothing on back]

[No AFT number] *Duck Shooting. 34 × 44. (Raynor). &c.*

The painting carries the label from a National Academy of Design exhibition stating, "'Duck Shooting over Decoys' / Artist, A. F. Tait / Exhibitor, A. F. Tait, N.Y."

DEER'S HEAD 54.23

[Unknown] [Unknown]: [Unknown]

[Unknown]

[No AFT number] *Oval Deers Head. Life size. J. K. George, Baltimore.*

CANVAS BACK DUCKS 54.24

[Unknown] [Unknown]: [Unknown]

[Unknown]

[No AFT number] *Oval. Canvas Back Ducks. do. [J. K. George, Baltimore].*

Probably one of a pair with 54.25.

RUFFED GROUSE 54.25

[Unknown] [Unknown]: [Unknown]

[Unknown]

[No AFT number] *Oval. Ruffed Grouse. Do. [J. K. George, Baltimore].*

Probably one of a pair with 54.24.

Collection of the R. W. Norton Art Gallery, Shreveport, Louisiana. Courtesy of the R. W. Norton Art Gallery, © 1971.

[HUNTING IN THE ADIRONDACKS] 54.26

A. F. Tait / N.Y. 1854 [LR] Canvas: 34 × 44

[Relined; inscription, if any, lost]

[No AFT number; no Register entry]

The title is taken from the back of a photograph of the painting, which is inscribed "Hunting In The Adirondacks. From The Osborn Collection."

Courtesy of Christie's, New York, New York.

[FISHING THROUGH THE ICE] 54.27

A. F. Tait / N.Y. 1854 [LR] Canvas: 28 × 35½

[Relined; inscription, if any, lost]

[No AFT number; no Register entry]

A hand-colored lithograph was published by N. Currier, 1856, titled "American Winter Sports, Trout Fishing 'On Chateaugay Lake' (Franklin Co., N.Y.)."

ARGUING THE POINT 54.28

A. F. Tait / N.Y. 1854 Panel: 19¾ × 24
[LL, end of cut log]

[Nothing on back]

[No AFT number; no Register entry]

Exhibited at the National Academy of Design 31st Annual Exhibition, 1856, titled "Arguing The Point—Settling The Presidency" and owned by John Osborn. A hand-colored lithograph was published by N. Currier, 1855, titled "Arguing The Point." The location is Lower Chateaugay Lake, showing, in part, the hotel built and kept by Jonathan Bellows. The figures (left to right) are: Anthony Sprague, a local guide; Jonathan Bellows, hotel owner; Francis Bellows, son of Jonathan; Georgiana Bellows; and Sophrone Thurber, a hired girl.

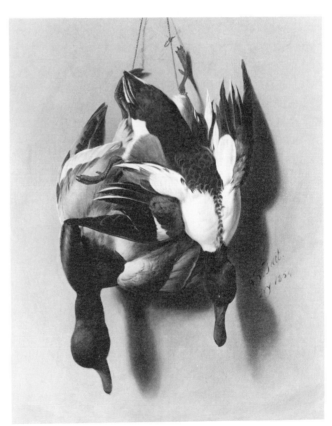

DEAD GAME 54.29

A. F. Tait, N.Y. 1854 [Unknown]: [Unknown]
[one-third up on R]

[Unknown]

[No AFT number; no Register entry]

Register entries for 1854, one of which may apply to this

painting, include the following: 54.2–.8, 54.9, 54.17–.19, 54.24.

Courtesy of Christie's, New York, New York.

WITH GREAT CARE 54.30

A. F. Tait / N.Y. U.S. 1854 Panel: 20 × 24
[on end of box; also see remarks] arch top

[Nothing on back]

[No AFT number; no Register entry]

Exhibited at the National Academy of Design 32d Annual Exhibition, 1857, titled "The Empty Bottle—A Shanty Scene on the Lakes, Northern N.Y." and owned by John Osborn. The front of the painting also includes the inscriptions, UL corner, "Not to be varnished" and, UR corner, "Don't varnish this picture. / A. F. Tait / N.Y. 1854 / With Great Care / A. F. Tait / 150 Spring St., N.Y."

Courtesy of Mr. and Mrs. Louis C. Madeira.

[DEAD GAME] 54.31

A. F. Tait / N.Y. 1859 [LL] Panel: 16½ × 12½

[Unknown]

[No AFT number; no Register entry]

Courtesy of Congoleum Corporation.

STILL HUNTING ON THE FIRST 55.1
SNOW: A SECOND SHOT

A. F. Tait / N.Y. 1855 [LR] Canvas: 54 × 76

[See remarks]

[No AFT number] *Large painting. Still Hunting on First Snow.*

According to Tait family tradition, this painting shows AFT firing over a snow-covered mound at one of two deer (another having been shot) while Mathew Brady

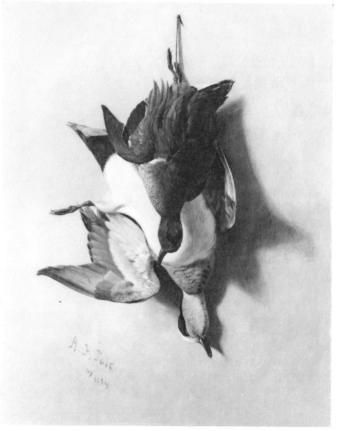

54.31

watches. Exhibited at the National Academy of Design 30th Annual Exhibition, 1855, titled "A Second Shot: Still Hunting on the First Snow in the Chateaugay Forest." Exhibited and sold at Leeds Sale, December 18, 1863. An inscription on the back of the painting states: "In 1891 I cleaned and varnished with mastic varnish, A. F. Tait, N.A., 53 East 56th St., New York. Can be rubbed off / A second shot, still Hunting on the first snow in the Adirondacks Forest—Adirondacks." The painting was relined and the above inscription lost. In addition, on the stretcher is written "A. F. Tait, 150 Spring Street, New York, Feb'y 1855."

Collection of the Adirondack Museum, Blue Mountain Lake, New York.

AMERICAN RUFFED GROUSE 55.2

A. F. Tait N.Y. 1855. [LR] Canvas: 20 × 24¼ arch top

American Ruffed Grouse

[No AFT number] *Pair of Ruffed Grouse & Young. 20 × 24. in frame / Sold to W. S. Fales,* [Samuel B. Fales] *Phila.* [$110.00].

Probably one of a pair with 55.3.

QUAIL AND YOUNG 55.3.

[Unknown] [Unknown]: 24 × 20 [?]

[Unknown]

[No AFT number] *Pair of Quail & Young. 20 × 24 in frame.*

Probably one of a pair with 55.2.

[RUNNING HORSE PURSUED 55.4
BY WOLVES]

A. F. Tait / N.Y. 1855 [LR] Wash drawing on paper
 on cardboard: 9¾ × 11¾

[Nothing on back]

[No AFT number; no Register entry]

In addition to AFT's signature and date at LR of drawing, there is also at the LR "New York Sketch Club / March 2," followed by the year in undecipherable numerals. The description is given as "A wash drawing of a running horse pursued by wolves."

SUGARING OFF 55.5

A. F. Tait, N.Y. / 1855 Canvas: 36 × 24
[LL, near end of log]

[Unknown]

[No AFT number; no Register entry]

A hand-colored lithograph was published by N. Currier, 1855, titled "American Forest Scene. Maple Sugaring." Exhibited at the National Academy of Design 31st Annual Exhibition, 1856, titled "Sugaring Off. Forest Scene in Early Spring" and owned by N. Currier. Exhibited and sold Leeds Sale December 18, 1863.

RUFFED GROUSE 55.6

A. F. Tait / N.Y. '55 [LR] Board: 10 × 14

"Ruffed Grouse" / Vulge: "Partridges" / or Pheasant in / Pen'a.

No. 46. *Grouse* — *W.S.W.* [Williams, Stevens, & Williams]. [$25.00].

See 53.15.

SKETCH OF HIGH FALLS, 55.7
CHATEAUGAY RIVER,
NEAR MALONE, N.Y.

[Unknown] [Unknown]: [Unknown]

[Unknown]

[No AFT number; no Register entry]

Correspondence between AFT and Ashbel P. Fitch indicates that this painting was done in 1855 and given to Fitch by AFT in 1900.

[THE LAST WAR WHOOP] 55.8

A. F. Tait / N.Y. 1855 [LR] Canvas: 30 × 44½

[Nothing on back]

[No AFT number; no Register entry]

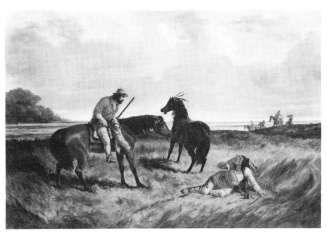

Collection of the Milwaukee Art Museum, Milwaukee, Wisconsin. Courtesy of Milwaukee Art Museum.

Companion to 55.9. See also, ND. 39.

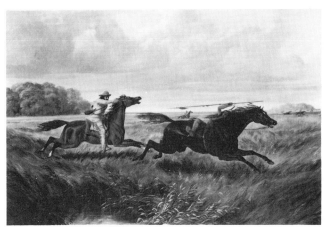

[THE PURSUIT] 55.9

A. F. Tait / 1855 [LR] Canvas: 30 × 44½

[Nothing on back]

[No AFT number; no Register entry]

Collection of the Milwaukee Art Museum, Milwaukee, Wisconsin. Courtesy of Milwaukee Art Museum.

Companion to 55.8. See also, ND. 38.

[THE CARES OF A FAMILY] 55.10

[Unknown] [Unknown]: [Unknown]

[Unknown]

[No AFT number; no Register entry]

A hand-colored large folio lithograph was published by N. Currier in 1856 titled "The Cares of a Family." A small oval folio state depicting only a part of the original and printed in reverse was published in 1865. A similar small folio, undated, has the note "Presented by the Illinois Infirmary, Charleston, Ills."

See ND. 20.

DINING OUT 56.1

[Unknown] [Unknown]: 24 × 36 [?]

[Unknown]

[No.] *1 Feb'y 23rd. Fox and Canada Grouse Size 36 × 24.*

Exhibited at the National Academy of Design 32d Annual Exhibition, 1857, titled "Dining Out, Fox and Canada Grouse" and owned by W. P. Jones.

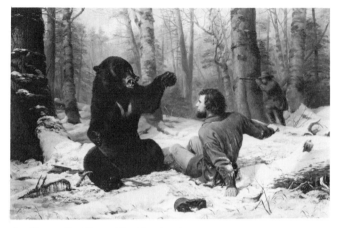

J. Campell, Esq., Pacific Bank. Price $500.00—ret'd by W.S.W. [Williams, Stevens, & Williams] *Co. date when sold Nov. 1856. all to go to acct $500. Exh. Phila. 1856. Exh. NA, N.Y., 1858, #179.*

Exhibited at the National Academy of Design 33d Annual Exhibition, 1858, titled "A Tight Fix. Bear Hunting. Early Winter" and owned by J. Campbell. This is not the original for the Currier & Ives print, "The Life of A Hunter, A Tight Fix," for which see 61.16.

Courtesy of Kennedy Galleries, Inc., New York, New York.

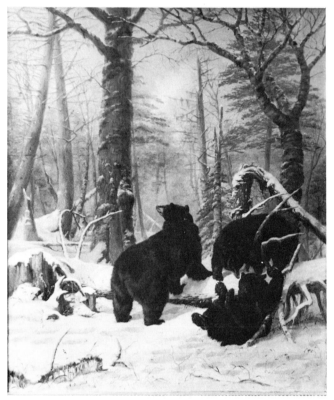

[A GOOD SHOT: BLACK BEAR 56.2
HUNTING IN NORTHERN NEW YORK]

A. F. Tait / N.Y. '56 [LL] Canvas: 47½ × 39

[Nothing on back]

No. 2 [Feb'y] 24th. Bear alarmed Snow scene. Size 36 × 24. No. 2. Ex. NA. 1856. Sold to [blank]. *Size altered to 48 × 40. Price* [blank]. *Uriah Levinson. date when sold* [blank].

A later entry reads *May. Altering Bear Alarmed for U Levinson* [$100.00]. Exhibited at the National Academy of Design 31st Annual Exhibition, 1856, titled "A Good Shot. Black Bear Hunting in Northern N.Y.," and owned by the artist.

BEAR HUNT: TIGHT FIX 56.3

A. F. Tait / New York, '56 Canvas: 39½ × 60
[LR on log]

[Nothing on back]

No. 3. "Snow Scene" in Chateaugay Woods, N.Y. March 25th. Bear Hunt—"Tight Fix" (Size 60 × 40). Sold to

DEER HUNTING ON THE LAKES 56.4

[Unknown] [Unknown]: 17 × 24

[Unknown]

No. 4 April 20th. "Deer Hunting on the Lakes." Split Rock Point, Chateaugay. size 24 × 17 for Oporto with Jno. Osborn Esq. Sold $150.

One of a pair with 56.5.

BRINGING HOME GAME: WINTER 56.5
SHANTY AT RAGGED LAKE

A. F. Tait / N.Y. / 1856 [LL] [Unknown]: 17 × 24

No. 5 Painted by A. F. Tait / 600 Broadway, N.Y. / April 30th 1856 / 24 × 17 / Bringing Home Game /

Winter Shanty At Ragged Lake / Franklin Co. / State of New York (in Dec. 1855) / U.S. North America

No. 5 April 30th. Shanty Scene. Hunter with dead Bear at Ragged Lake. Franklin Co. N.Y. Size 24 × 17 $100 M. [Mortimer] *L. Tait. Companion to No. 4* [56.4]—*for Oporto with J. O.* [John Osborn].

Courtesy of a private collection.

One of a pair with 56.4.

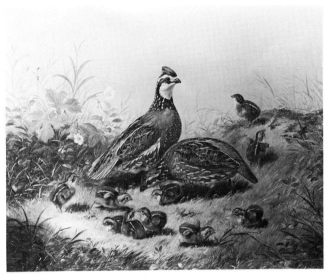

Collection of the Yale University Art Gallery, New Haven, Connecticut. Courtesy of Yale University Art Gallery, Whitney Collections of Sporting Art, given in memory of Harry Payne Whitney (B.A. 1894) and Payne Whitney (B.A. 1898) by Francis P. Garvan (B.A. 1897).

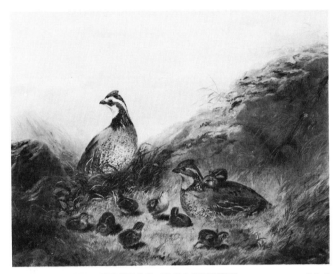

QUAIL AND YOUNG: DOMESTIC HAPPINESS 56.6

A. F. Tait / N.Y. '56 [LL] Canvas: 20 × 24

No. 6 / Quail and Young. Domestic Happiness. / Painted by A. F. Tait / N.Y. / 1856 / Presented to C. S. C. by E. M. D.

No. 6 June. Ruffed Grouse & young for Mr. Congdon. [$100.00] *24 × 20.*

Note that AFT registers the subject as "Ruffed Grouse" but names the subject "Quail" on the back of the painting.

Courtesy of Sotheby Parke Bernet, Agent: Editorial Photocolor Archives, New York, New York.

QUAIL AND YOUNG 56.7

[Unknown] [Unknown]: 20 × 24 [?]

[Unknown]

[No.] *7 Quail & Young for Mr. Day. 24 × 20.*

QUAIL AND YOUNG 56.8

A. F. Tait / N.Y. 1856 [LR] Canvas: 19¾ × 24

No. 8 / Amer. Quail & Young / Painted by / A. F. Tait / 600 B'way, N.Y. / 1856.

[No.] *8 24 × 20. Quail & Young. sent to Mr. Johnson. Phila. Bought by* [blank]. [$112.00].

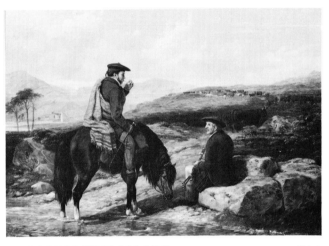

CROSSING THE MOORS, GLEN FINNAN, SCOTLAND 56.9

A. F. Tait / N.Y. '56 [LR] Canvas: 23 × 32

Crossing The Moors / No. 9 / Glen Finnan / Scotland / Painted by / A. F. Tait / N.Y. / 1856.

[No.] *9. 32 × 23. Crossing the Moors—Glen Finnan. Scotland. for Williams Stevens & Co. to go to acct $100.* [$100.00].

QUAIL AND YOUNG 56.10

A. F. Tait / N.Y. '56 [LL] Board: 10 × 14

"A Family Circle" / Am. Quail (female) & Young / A. F. Tait / 600 Broadway, N.Y. / August 1856.

[No.] *10. 14 × 10 (on Millboard) Quail & Young. R. M. Oliphant.* [Olyphant] [$50.00].

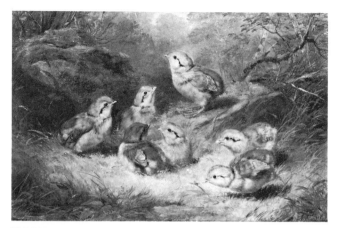

YOUNG RUFFED GROUSE 56.11

A. F. Tait / N.Y. '56 [LR] Canvas: 10 × 14

American Ruffed Grouse (Young). / Painted by A. F. Tait / 600 Broadway, N.Y. / August 1856 / No. 11.

[No.] *11 14 × 10. Ruffed Grouse (Young). R. M. Oliphant [Olyphant] [$50.00].*

THREE PAINTINGS ON MILLBOARD 56.12–.14

[See remarks] [See remarks]: [See remarks]

[See remarks]

[Nos.] *12, 13, 14. Three Ptgs on Millboard (2) 14 × 10 & one 12 × 9. Two cows & Bull. E. G. Faile. (West Chester) the lot [$50.00].*

For individual paintings see 56.12, 56.13, and 56.14.

See 61.4–.6; 61.20.

[UNKNOWN] 56.12

[Unknown] Board: 10 × 14 [?]

[Unknown]

[No. *12;* for Register entry see 56.12–.14]

First in a series of three paintings, including 56.13 and 56.14.

TITANIA 56.13

A. F. Tait / N.Y. 1856. [LR] Board: 10 × 14

"Titania" (1854) Daley's Devon Herd of Zoohl, Mopts og. [*sic*] Edw. G. Faile, Esq. Painted by A. F. Tait, 600 Broadway, N.Y., 1856, No. 13.

[No. *13;* for Register entry see 56.12–.14]

Second in a series of three paintings, including 56.12 and 56.14.

Courtesy of Christie's, New York, New York.

[UNKNOWN] 56.14

[Unknown] Board: 9 × 12 [?]

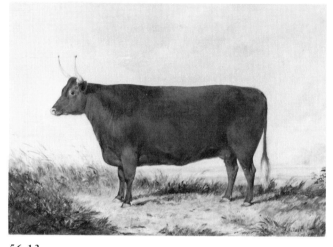

56.13

[Unknown]

[No. *14;* for Register entry see 56.12–.14]

Third in a series of three paintings, including 56.12 and 56.13.

RUFFED GROUSE AND YOUNG 56.15

A. F. Tait 1856 [LL] Canvas: 20 × 24½

American Ruffed Grouse & Young / painted by / A. F. Tait / 600 Broadway, N.Y. / June, 1856

[No.] *15 Male & Female Ruffed Grouse & Young. 24 × 20. bought by H. G. DeForrest [$100.00] Frame $10.00. 19 West 30th St. between B'way & 5 Av.*

WOODCOCK AND YOUNG 56.16

[Not signed or dated] Canvas: 20 × 22½

Male & Female / Woodcock & young / U.S. North Am. / Painted by A. F. Tait / 600 Broadway / N.Y. / Dec'r 1856 / No. 16.

[No.] *16. Woodcock (Male & Female) & young. 24 × 20. N. Currier.* [$125.00].

A hand-colored lithograph was published by Currier & Ives, 1857, titled "A Rising Family."

Courtesy of Kennedy Galleries, Inc., New York, New York.

PORTRAIT OF 56.17
JAMES B. BLOSSOM

[Unknown] [Unknown]: [Unknown]

[Unknown]

[No.]. *17 Portrait of Jas. B. Blossom. 23 Dec'r 1856. (Cabinet).*

PORTRAIT OF 56.18
FRANCIS PARES OSBORN

[Unknown] [Unknown]: [Unknown]

[Unknown]

[No.] *18 Portrait of Francis Pares* [Osborn]. *Cabinet. Present to Mrs. Jno Osborn, Dec. 31st, 1856.*

AMERICAN RUFFED GROUSE 56.19

A. F. Tait / N.Y. '56 [LR] Board: 7½ × 9¼ oval

American / Ruffed Grouse / To Mr. Cropsy / with the artists / best wishes. / A. F. Tait / 600 Broadway / N.Y. / May 1856.

[No AFT number; no Register entry]

The Mr. Jasper F. Cropsy [Cropsey] referred to was an artist contemporary with AFT.

[FOUR PORTRAITS] 56.20–.23

[See remarks] [See remarks]: [See remarks]

[See remarks]

[No AFT number; the following appears elsewhere in the Register on a page containing an account with Edward Fitch, dated October 1, 1858.] *Edw'd Fitch. Oct 1st 1858 Dr. Lithographs in Frames 50. Cash 25—Do. 15. do. on Octr. 1st. 1858 on my return from Malone after settling with Bellows (paid* [?] *in Studio) 25. Likeness of Mrs. Parmlee* [sic]*—100 Frame for Do.—10* [56.20] *Likeness of Mrs Fitch & Frame 35.* [56.23] *do. of Mr Do* [Fitch] *& Ashbal* [sic] *& Frame 50* [56.24] *do. do. Elly 35.—*[56.23; total:] *295.—.*

Two of these paintings have been found but only one bears a legible date, 1856 (56.22). Because of this date, the other three portraits are assumed to have been done in 1856, hence their inclusion here in the Checklist.

[LIKENESS OF MRS. PARMELEE] 56.20

[Unknown] [Unknown]: [Unknown]

[Unknown]

[No AFT number; see 56.20–.23]

This portrait is listed by AFT in his Register in connection with the settlement of his account with Edward Fitch, October 1, 1858, in which he states, "Likeness of Mrs. Parmlee [sic]."

PORTRAIT OF 56.21
FANNY PARMELEE FITCH

[Unknown] Board: 15¼ × 11¼

[Nothing on back]

[No AFT number; see 56.20–.23]

Painting referred to in record of account with Edward Fitch dated October 1, 1858.

PORTRAIT OF EDWARD FITCH 56.22
AND HIS SON,
ASHBEL PARMELEE FITCH

A. F. Tait, 1856 [LL] Board: 15¼ × 11¼

[Nothing on back]

[No AFT number; see 56.20–.23]

Painting referred to in record of account with Edward Fitch, dated October 1, 1858.

[LIKENESS OF ELLY] 56.23

[Unknown] [Unknown]: [Unknown]

[Unknown]

[No AFT number; see 56.20–.23]

This portrait is listed by AFT in his Register in connection with the settlement of his account with Edward Fitch, October 1, 1858, in which he states, "Likeness of Elly."

PORTRAIT OF 56.24
GEORGE WASHINGTON HALE,
OF MALONE, N.Y.

A. F. Tait / N.Y. 1856 [LR] Board: 13¾ × 10 oval

[Nothing on back]

[No AFT number; no Register entry]

Courtesy of Nancy M. Hale and Dorothy G. Hale.

YOUNG RUFFED GROUSE 56.25

A. F. Tait / '56 / NY [LR] Board [?]: 10 × 12⅜ oval

No. 14 / Young Ruffed Grouse / A. F. Tait / 600 Bwy / NY

[No Register entry]

Subject of painting does not coincide with Tait's Register entry for No. 14, 1856. Painting similar to 56.11.

HEN QUAIL AND YOUNG 57.1

[Unknown] [Unknown]: 11 × 9 [?]

56.24

[Unknown]

[No.] *19 Jan'y 10th, 1857. Rollin Sanford. Small (Hen quail & young) 9 × 11. [$50.00].*

Exhibited at the National Academy of Design 32d Annual Exhibition, 1857, titled "Motherly Care, Quail and Young" and owned by Rollin Sanford.

HEN QUAIL AND YOUNG 57.2

A. F. Tait / N.Y. '57 [LL] Board: 14¾ × 12¼

No. 20 / Am. Quail & Young / A. F. Tait / 600 Broadway / N.Y. / 1857

[No.] *20. Jan. 10th. Hen quail & young. 12 × 14. [$50.00].*

Exhibited at the National Academy of Design 32d Annual Exhibition, 1857, titled "Anxiety. Quail and Young" and owned by Rollin Sanford.

AMERICAN RUFFED GROUSE 57.3

A. F. Tait / '57 [LR] Canvas: 24 × 36

Am. Ruffed Grouse / Painted by / A. F. Tait / 600 Broadway / N.Y. / U.S / No. 21.

[No.] *21 Feb'y 6th. Pair of Ruffed Grouse & Pointer. 36 × 24. Mr. Alex White, 238 W. 31st St., N.Y.*

Exhibited at the National Academy of Design 32d An-

nual Exhibition, 1857, titled "Ruffed Grouse" and owned by Alex White. This painting has been relined.

Courtesy of Kennedy Galleries, Inc., New York, New York.

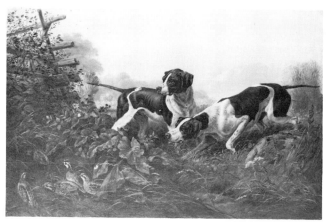

QUAIL SHOOTING 57.4

A. F. Tait / N.Y. 1857 [LR] Canvas: 24 × 36¼

Painted by A. F. Tait, N.A. / 600 B'w'y N.Y. / in 1857 & repainted in 1884 by him / A. F. Tait, N.A. / 52 E. 23 St. / N.Y. / Relined 1884.

[No.] *22 March 2nd. Quail Shooting. 36 × 24. (2 Pointers & Quail). N. Currier.*

A hand-colored lithograph was published by Currier & Ives, 1857, titled "American Field Sports. 'On A Point.'" Exhibited at the National Academy of Design 33d Annual Exhibition, 1858, titled "Quail Shooting," and owned by N. Currier.

Collection of the Yale University Art Gallery, New Haven, Connecticut. Courtesy of Yale University Art Gallery, Whitney Collections of Sporting Art, given in memory of Harry Payne Whitney (B.A. 1894) and Payne Whitney (B.A. 1898) by Francis P. Garvan (B.A. 1897).

RUFFED GROUSE SHOOTING 57.5

A. F. Tait / N.Y. '57 [LL] Canvas: 24 × 36½

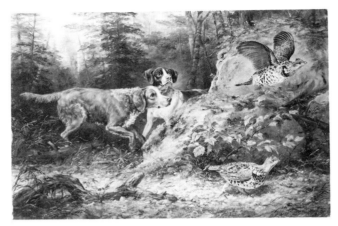

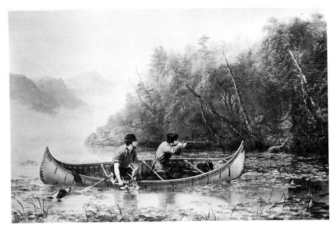

"Ruffed Grouse Shooting" N. Am. / Painted by / A. F. Tait / 600 Broadway / N.Y. / March 1857 / No. 23.

[No.] *23. March 21st. Ruffed Grouse Shooting. Setter & pointer in forest / grouse flying / 36 × 24 N. Currier, Esq.*

Following the back inscription is a six-pointed star composed of two triangles. Exhibited at the National Academy of Design 33d Annual Exhibition, 1858, titled "Grouse Shooting" and owned by N. Currier. A hand-colored lithograph was published by Currier & Ives, 1857, titled "American Field Sports: 'Flush'd'."

Courtesy of Christie's, New York, New York.

QUAIL SHOOTING 57.6

[Unknown] [Unknown]: 24 × 36 [?]

[Unknown]

[No.] *24 March 26th. Quail Shooting. G. V. Lausten. Dash & Nick. 36 × 24. Painted in conjunction with Jas. Hart.*

WOODCOCK SHOOTING 57.7

[Unknown] [Unknown]: 24 × 36 [?]

[Unknown]

[No.] *25. Woodcock Shooting. 36 × 24. Setter & pointer. man firing. Bird flying. a bit—another Bird going to spring.*

A hand-colored lithograph was published by Currier & Ives, 1857, titled "American Field Sports, 'A Chance for Both Barrels'." Sold Leavitt Galleries, New York City, March 12, 1880, titled "A Chance for Both Barrels" with size given as 24 × 36.

DEER DRIVING ON THE LAKES 57.8

A. F. Tait / N.Y. 1857 [LR] Canvas: 40 × 60

"Deer Driving" on The Lakes, Northern New York, U.S.A. A. F. Tait 600 Broadway, N.Y. 1857. #26.

No. 26 [1857. May.] Deer Driving on the lakes. Northern N.Y.—Size 60 × 40. Finished May 6th—price [$200.00].

Exhibited at the National Academy of Design 32d Annual Exhibition, 1857, titled "A Slight Chance, Deer Hunting on The Lakes, Northern, N.Y.," and owned by the artist.

Courtesy of Kennedy Galleries, Inc., New York, New York.

GROUSE CHICKENS 57.9

A. F. Tait [?; date has Board: 10 × 14
chipped out] [LR]

No. 27. / "Grouse Chickens" / Painted by / A. F. Tait / 600 Broadway / N.Y. / 1857.

No. 27 Grouse chickens. 14 × 10. June 8th, 1857. Rich'd Goodman, 60 E. 30. [$50.00].

GROUSE CHICKENS 57.10

[Unknown] [Unknown]: 10 × 14 [?]

[Unknown]

No. 28 June. Grouse Chickens. 14 × 10. Mr. Arnold. Frame [$9.00] [$50.00].

GROUSE CHICKENS 57.11

[Unknown] [Unknown]: [Unknown] Round

[Unknown]

No. 29. June 11 Small Round—Grouse Chickens. Mons. Noedler [Monsieur Knoedler].

GROUSE CHICKENS 57.12

[Unknown] [Unknown]: 10 × 14 [?]

[Unknown]

No. 30. June 12 Grouse chickens 14 × 10.

FEMALE GROUSE AND CHICKENS 57.13

[Unknown] [Unknown]: 20 × 24 [?]

[Unknown]

No. 31 June 18 Female grouse & chickens. 24 × 20.

SNIPE SHOOTING 57.14

A. F. Tait / N.Y. 1857 [LR] Canvas: 24½ × 36½

[Relined; inscription, if any, lost]

No. 32 June 20th. Snipe shooting. (Currier) 24 × 36.
[$200.00].

A hand-colored lithograph was published by Currier &
Ives, 1857, titled "American Field Sports, 'Retrieving'."

QUAIL AND YOUNG 57.15

A. F. Tait / 57 [LR] Board: 10 × 14

No. 33 / Quail & Young / Painted by A. F. Tait / 600
Broadway / N.Y. / July 1857

No. 33 Female quail & young. 14 × 10. Oliphant
[Olyphant]. [$50.00].

GROUSE AND YOUNG 57.16

A. F. Tait / N.Y. '57 [LR] Canvas: 20 × 24

[Relined; inscription, if any, lost]

[No.] 34 Male & Female Grouse & 6 young ones. U. Levinson.

DUCK SHOOTING 57.17

[No signature or date shows Canvas: 38 × 50
because of extensive restoration]

[Relined; inscription, if any, lost]

[No.] 35 Duck shooting. 50 × 38. Mott & Walters.
[$200.00].

QUAIL AND YOUNG 57.18

[Unknown] [Unknown]: 14 × 22 [?]

[Unknown]

No. 36 Quail & Young with Burdock Leaves. 22 × 14. to
C. H. [Charles R.] Stewart—with Frame 7$—[$57.00].

RUFFED GROUSE AND YOUNG 57.19

[Unknown] [Unknown]: 14 × 17 [?] oval

[Unknown]

[No.] 37. Study from nature (from sketch) with Ruffed grouse
& young. small size oval 17 × 14. Dr. Magoon. [$25.00].

[WATERING PLACE] 57.20

A. F. Tait and James M. Hart, [Unknown]: 14 × 21
1857 [LL]

[Nothing on back]

[No.] 38 Cattle & Landscape (drinking) 22 × 14. Exhibited
N.A. 1858. C. P. Steward [Charles R. Stewart], 236 W.
23rd St. [$50.00].

Exhibited at the National Academy of Design's 33d An-
nual Exhibition, 1858, titled "Watering Place" and

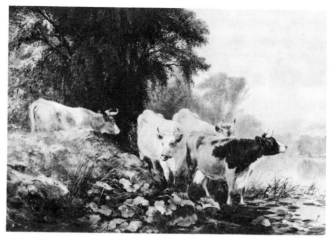

owned by Charles R. Stewart. James M. Hart did the
landscape.

QUAIL AND YOUNG 57.21

[Unknown] [Unknown]: 14 × 22 [?]

[Unknown]

[No.] 39 Quail & young—Sun Shower—Shelter. 22 × 14.
with Burdock leaves. W. T. Walters, Baltimore, Md.

The Register indicates that this painting and 57.22 were
sold together to Walters for $150.00.

QUAIL AND YOUNG 57.22

[Unknown] [Unknown]: [Unknown]

[Unknown]

[No.] 40 Quail & young. small size. Frame 7$ W. T. Wal-
ters. Baltimore.

The Register indicates that this painting and 57.21 were
sold together to Walters for $150.00.

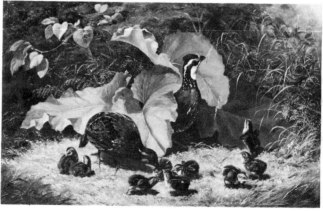

QUAIL AND YOUNG 57.23

A. F. Tait / N.Y. 1857 [LL] Canvas: 14¼ × 22

Quail & Young / No. 41. 1857 Dec'r / Painted by / A. F.
Tait / 600 Broadway / N.Y.

[No.] *41 Quail & young—Burdock leaves. Dec. 1. Frame 9$. size 22 × 14—W. T. Walters, Balt. Md.* [$90.00].

Courtesy of Kennedy Galleries, Inc., New York, New York.

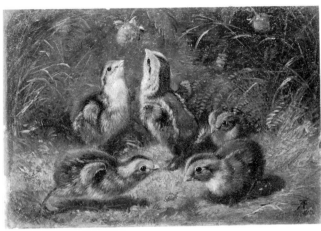

YOUNG QUAIL 57.24

[Monogram, LR; undated] Board: 4¾ × 6½

No. 42 / Young Quail / A. F. Tait / 600 Broadway / 1857.

[No.] *42 Young quail. 6 × 4½ in. Mr. Burt.* [$50.00].

YOUNG QUAIL 57.25

[Unknown] [Unknown]: 4½ × 6 [?]

[Unknown]

[No.] *43 Young quail. 6 × 4½ in. Snedicor* [Snedecor].

YOUNG QUAIL 57.26

[Unknown] [Unknown]: 7½ round [?]

[Unknown]

[No.] *44 Young quail. 7½ round. Jas. M. Hart.*

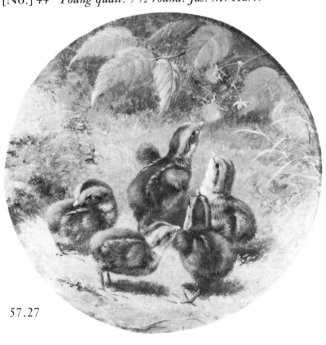

57.27

YOUNG QUAIL 57.27

A.F.T. [LC] Board: 7½ round

No. 45 / by A. F. Tait / 600 Broadway / N.Y. / 1857

[No.] *45 Young quail. 7½ round. Collins.* [$20.00].

Courtesy of Post Road Gallery, Larchmont, New York.

AMERICAN DEER 57.28

[Unknown] [Unknown]: [Unknown]

[Unknown]

[No.] *46 American deer—male & Female. Dr. Magoon.* [$25.00].

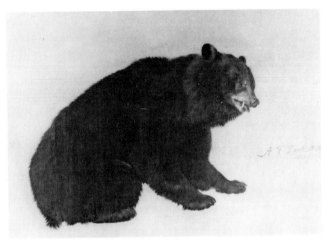

STUDY OF BEAR 57.29

A. F. Tait, N.A. / 1857 Canvas: 13 × 18¾
[To right of bear]

[Nothing on back]

[No AFT number; no Register entry]

This is a study taken from AFT's portfolio after his death.

Courtesy of Mrs. Henry F. Marsh.

[DEER IN FOREST] 57.30

A. F. Tait / N.Y. 1857 [LR] Canvas: 15½ × 12½

[Relined; inscription, if any, lost]

[No AFT number; no Register entry]

Typewritten paper label pasted on back of stretcher reads, "This painting of young fawn in the forest by A. F. Tait was purchased from Laetitia Hart, daughter of James Hart, at her home in Brooklyn. Miss Hart stated this painting was given to James M. Hart by Mr. Tait many years ago, and that all his life, although he had many offers for same, he would never part with it as he was extremely fond of it."

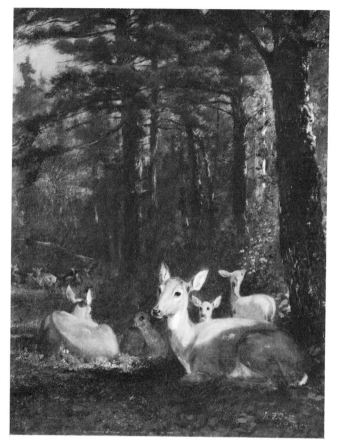

Collection of The Art Museum, Princeton University, Princeton, New Jersey, bequest of Gilbert S. McClintock. Courtesy of The Art Museum, Princeton University.

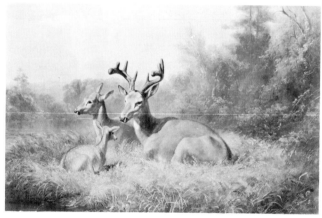

AMERICAN DEER IN JULY 58.1

A. F. Tait / 1850, N.Y. [LR] Canvas: 13½ × 20

No. 47. American Deer in July, 1857. Painted by A. F. Tait / 600 B'way / N.Y. 1858.

No. 47 American Deer in July. 21 × 14. Alex White, Esq.—Chicago.

Courtesy of Kennedy Galleries, Inc., New York, New York.

RUFFED GROUSE AND YOUNG 58.2

[Unknown] [Unknown]: 14 × 22 [?]

[Unknown]

[No.] 48 Ruffed Grouse & young.—Exhibited A.D. N.Y. 1858. 22 × 14. C. P. Stewart.

QUAIL AND YOUNG 58.3

[Unknown] [Unknown]: 14 × 22 [?]

[Unknown]

[No.] 49 Quail & young. 22 × 14. Riggs of Baltimore Paid this to Snedicor and 25 [$25.00].

YOUNG QUAIL 58.4

[Unknown] [Unknown]: 5 × 6½ [?]

[Unknown]

[No.] 50 Young quail. 6½ × 5. Mr. Skaats. Sold to Mr. Kinsets friend bought at Leeds Sale Dec'r 1859.

YOUNG QUAIL 58.5

[Unknown] [Unknown]: 5 × 7½ [?] round

[Unknown]

[No.] 51 Young quail. round 7½ × 5. Mrs. R. S. Willis.

YOUNG GROUSE 58.6

[Unknown] [Unknown]: 5 × 6½ [?]

[Unknown]

[No.] 52 Young grouse. Mr. Skaats. 6½ × 5 Sold to Mr. Kinsets friend bought in Dec'r 1859 at Leeds Sale.

GROUP OF DEER IN LANDSCAPE 58.7

[Unknown] [Unknown]: 8 × 12 [?]

[Unknown]

[No.] 53 Group of deer in landscape. 12 × 8. Mr. M. Smith, 456 3rd Av.

AT HOME 58.8

[Unknown] [Unknown]: 14 × 22 [?]

[Unknown]

[No.] 54 American Deer (group of 3) C. P. Stewart. 22 × 14. Exhibited N.Y. 1858.

Exhibited at the National Academy of Design 33d Annual Exhibition, 1858, titled "At Home" and owned by Charles Stewart. Illus. *Frank Leslie's Illustrated* (May 29, 1858), p. 408 (wood-engraving).

AMERICAN DEER IN JULY 58.9

[Monogram and] July '57 [LR] Board: 7½ × 5½

N 55 / in July / American Deer / "Cervus Virginius" /

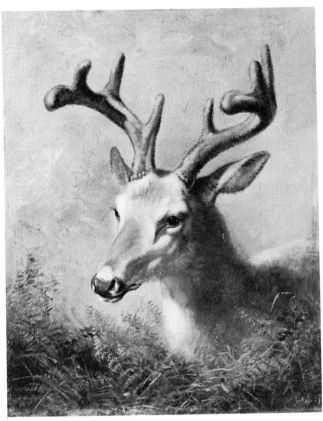

Painted by / A. F. Tait / 600 Broadway / N.Y. / Jan'y 1858.

[No.] *55 Deer's Head. 6 × 4. Mr. Avery.*

Courtesy of Mr. and Mrs. George Arden.

DEER'S HEAD 58.10

[Unknown] [Unknown]: 4 × 6 [?]

[Unknown]

[No.] *56 Deer's Head. 6 × 4. Mr. M. Smith.*

CATTLE AND SHEEP 58.11

A. F. Tait / 1858. [LL] Board: 10¼ × 14

No. 57. / Painted by A. F. Tait / Feb'y 1858 / 600 B'way / N.Y.

[No.] *57 Cattle & Sheep. Mr. M. Smith. 8 × 10.*

AFT listed the size incorrectly, since the painting bearing his "No. 57" has been measured recently.

YOUNG QUAIL 58.12

[Unknown] [Unknown]: 4 × 6 [?]

[Unknown]

[No.] *58 Young quail. 6 × 4 McCoy—Brooklyn.*

BUCK, DOE, AND FAWN 58.13

[Unknown] [Unknown]: 5 × 6½ [?]

[Unknown]

[No.] *59 Group of deer. Buck Doe & Fawn. 6½ × 5. Frame. Marcus Spring. Eagleswood. Perth Amboy. [$40.00].*

LAKE SCENE: INDIAN IN CANOE 58.14
SHOOTING DEER

[Unknown] [Unknown]: 16 × 24[?]

[Unknown]

[No.] *60 Lake Scene. Indian in canoe shooting deer Size 24 × 16. C. P. Stewart. Paid [$50.00].*

YOUNG QUAIL 58.15

[Unknown] [Unknown]: 4 × 6 [?]

[Unknown]

[No.] *61 Young quail. 6 × 4. Frame. Newel.*

YOUNG QUAIL 58.16

[Unknown] [Unknown]: 4 × 6 [?]

[Unknown]

[No.] *62 Young quail. 6 × 4. Frame. Mr. Nelson. (Darien).*

DOWN THE ROAD 58.17

A. F. Tait / N.Y. 1858 [LR] Canvas: 35 × 55

No. 63. / "Down the Road" / in Franklin Co. N.Y. / Painted by A. F. Tait / 600 Broadway / N.Y. / March 1858.

[No.] *63. Down the road. Cattle in Franklin Co. 1858. Size 56 × 36 inches (Finished March 29, 1858.) Sent to the Exhibition on 10th Street. Academy of Design. Framed by Snedicor. [$30.00].*

The amount stated in the Register is what AFT paid Snedecor for the frame. Exhibited at the National Academy of Design 33d Annual Exhibition, 1858, titled "Down the Road in Franklin County" and listed as for sale.

GROUSE CHICKENS 58.18

[Unknown] [Unknown]: 8 × 12 [?]

[Unknown]

[No.] *64 Grouse chickens. 12 × 8. Came back, went to Boyle Frame Snedicor. Mrs. Bullard. 65 Pierpont St., Brooklyn.*

RUFFED GROUSE AND YOUNG 58.19

[Not signed or dated] Canvas: 14 × 22

No. 65. / Ruffed Grouse & Young / by A. F. Tait / 600 Broadway / N.Y. / 1858

[No.] *65 Pair of Ruffed grouse & 13 young. 22 × 14. Frame W. T. Walters, Baltimore.*

RUFFED GROUSE AND YOUNG 58.20

A. F. Tait / N.Y. 1858 [LL] Canvas: 14 × 22

No. 66 / Ruffed Grouse & Young / by A. F. Tait / 600 Broadway / N.Y. / April 1858.

[No.] *66 Pair of Ruffed grouse & 10 young. 22 × 14. Newell, Clinton Av. Brooklyn. Frame lent.*

Painting has been relined since back inscription was recorded.

YOUNG RUFFED GROUSE 58.21

A. F. Tait / N.Y. [LR] Canvas: 9½ × 12½ oval

Young Ruffed Grouse by A. F. Tait 600 Broadway, 1858, No. 67.

[No.] *67 Young ruffed Grouse. oval 12 × 9. J. B. Murray, Esq.—Goupils furnished frame.* [Nos. 67 and 68 (58.21 and 58.22) bracketed and marked:] *these two for Goupils. received* [$80.00].

Originally sold with 58.22. Painting has been relined and back inscription carefully recorded on the stretcher.

YOUNG QUAIL 58.22

[Unknown] [Unknown]: 9 × 12 [?] oval

[Unknown]

[No.] *68 Young quail. oval 12 × 9. match to 67* [58.21]— *J. R. Murray* [Nos. 67 and 68 (58.21 and 58.22) bracketed and marked (see 58.21)].

The reference to "67" in the Register is to 58.21, with which it was originally sold.

DOE AND FAWNS 58.23

A. F. Tait to S. P. Avery / Board: 8 × 10 oval
1858 [LL]

S. P. Avery—247—

[No.] *69 Deer (Doe & two Fawns) oval. no frame. Sam P. Avery.*

A steel engraving by James Smillie, titled "Maternal Affection," was published in *The Ladies Repository* 19 (August 1859). It was also exhibited at the 34th Annual National Academy of Design Exhibition the same year.

GROUSE CHICKENS 58.24

[Unknown] [Unknown]: [Unknown] oval

[Unknown]

[No.] *70 Grouse chickens. oval $10.00 Frame.* [$50] *Mr. Ludington.*

QUAIL CHICKENS 58.25

[Unknown] [Unknown]: 9 × 12 [?] oval

[Unknown]

[No.] *71 Quail chickens. oval 12 × 9* [$50.00] *Frame $10. Mr. Cox 349 B'way.*

GROUSE CHICKENS 58.26

[Unknown] [Unknown]: 9 × 12 [?] oval

[Unknown]

[No.] *72 Grouse Chickens. oval 12 × 9. Mr. Schaus.* [$40.00] *pay* [$30.00] *10$ to go to a/c.*

DOE AND TWO FAWNS 58.27

A.F.T. [LR] Board: 7 × 9

No. 73 / Cervus Virginius / in July / by A. F. Tait / 600 B'way, N.Y. / 1858

[No.] *73 Deer—Doe & two Fawns. 6 × 4. Mr. McCoy.*

In addition to the back inscription given above, the name "McCoy" is written, UL, in brush.

YOUNG GROUSE 58.28

[Unknown] [Unknown]: 9 × 12 [?] oval

[Unknown]

[No.] *74 Young Grouse. oval 12 × 9. Frame $10. W. T. Walters. Baltimore.*

RUFFED GROUSE 58.29

A. F. Tait / N.Y. '58 [LR] Canvas: 9½ × 12¼ oval

Ruffed Grouse / No. 75 / by A. F. Tait / May 1858 / 600 Broadway / N.Y.

[No.] *75 Young quail. oval 12 × 9. Frame $10. W. T. Walters. Baltimore.*

[TWO BEAR CUBS] 58.30

[Unknown] [Unknown]: 9 × 6½ [?]

[Unknown]

[No.] *76 Two cubs. Am. Blk Bear. size 6½ × 9. Mr. Thorne. N.Y.* [$30.00].

DEER'S HEAD IN JULY 58.31

[Unknown] [Unknown]: 4 × 6 [?]

[Unknown]

[No.] *77 Deers head in July. 6 × 4. Frame [$]4.00. Frodsham England.*

YOUNG GROUSE 58.32

[Unknown] [Unknown]: [Unknown]

[Unknown]

[No.] *78 Young Grouse. Mr. Noedler [Knoedler].*

YOUNG QUAIL 58.33

A. F. Tait / N.Y. 1858 / Canvas: 9½ × 12½ oval
Long Lake [LR]

"Young Quail" / by A. F. Tait / 600 B'way N.Y. / 1858 / June. / No. 79.

[No.] *79 Young quail. no frame. Mr. Noadler [Knoedler] (Goupils).*

QUAIL SHOOTING WITH MR. MOTT 58.34

[Unknown] [Unknown]: 24 × 36 [?]

[Unknown]

[No.] *80 Quail shooting with Mr. Mott. 36 × 24. no frame [$100.00].*

HEN QUAIL AND YOUNG 58.35

[Unknown] [Unknown]: [Unknown]

[Unknown]

[No.] *81. One hen quail & young rather smaller than life. Mr. Crane (Blauvelt) in xchange for one of Blauvelt Pictures. Sold B's painting for 50$ to Mr. Pares.*

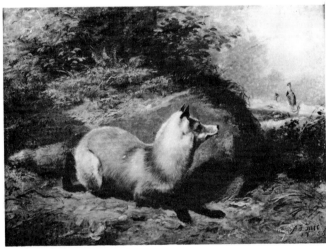

ANTICIPATION 58.36

A. F. Tait / N.Y. '58 [LR] Board: 6½ × 9

Anticipation / The Poacher / Am. Fox & Grouse / by A. F. Tait / 600 B'way, N.Y. / 1858 / No. 82.

[No.] *82 Fox & Grouse called Anticipation. 9 × 6½. Mr. Thorne. [$30.00].*

Courtesy of Mr. Daryl Parshall.

DOE AND TWO FAWNS 58.37

[Unknown] [Unknown]: 9 × 12 [?]

[Unknown]

[No.] *83. Doe & two fawns. 12 × 9. Mr. Doyle in exchange.*

HEN QUAIL AND YOUNG 58.38

A. F. Tait / N.Y. 58 [LC] Canvas: 9 × 12 oval

[Relined; inscription, if any, lost]

[No.] *84. Hen quail & young. 12 × 9. To Cariss. Baltimore to fill the two frames sent to W. T. Walters. [$35.00]. Sold by Cariss to Mr. Watts, Baltimore.*

DEER AND FAWN 58.39

[Unknown] [Unknown]: 9 × 12 oval

[Unknown]

[No.] *85 Deer & Fawn. oval 12 × 9. to Cariss. Came back Nov. 1858 at Snedicors. Presented to Jas. Blossom Front St. N.Y.*

SUNNY SIDE 58.40

[Unknown] [Unknown]: 19½ × 23 [?] arch top

[Unknown]

[No.] *86. Sunny Side. (Ducks in brook—joint with Jas. M. Hart—W. T. Walters, Baltimore—round top 23 × 19½. bought in frame, my frame. [$22.00] price to be [$300.00] including frame.*

FOX AND GROUSE 58.41

[Unknown] [Unknown]: 8 × 11 [?]

[Unknown]

[No.] *88 Fox & grouse in distance 11 × 8 [$30.00] Mr. Collins.*

TWO DEER AND FAWN 58.42

[Unknown] [Unknown]: 8 × 11 [?]

[Unknown]

[No.] *89 Two deer & Fawn. 11 × 8 [$30.00] Mr. Collins.*

DEER AND FAWN 58.43

[Not signed or dated] Board: 8 × 10½ oval

No. 90. Cervus Virginius / A. F. Tait 600 B'way / N.Y.

[No.] *90 Deer & Fawn. for Ives. oval 10 × 8 [$25.00].*

DEER'S HEAD IN JULY 58.44

[Unknown] [Unknown]: 9 × 11 [?]

[Unknown]

[No.] *91 Deers Head in July 11 in × 9 in. Mr. McCoy (Present).*

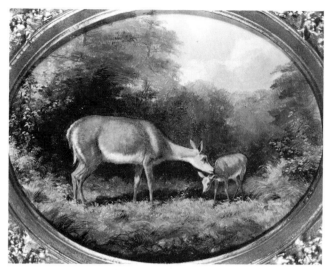

58.43

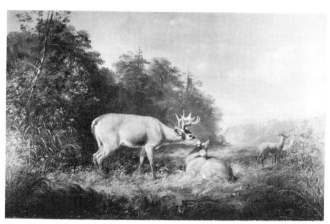

96," not "No. 6"; (b) AFT's address should be "600 Broadway" and not "400 Broadway"; and (c) the "Cervus Vero" should probably be "Cervus Virginius."

Courtesy of Mr. Daryl Parshall.

YOUNG RUFFED GROUSE 58.45

[Unknown] [Unknown]: 8 in. round [?]

[Unknown]

[No.] 92 *Young ruffed Grouse. Round 8 in. Dr. Cram (per Avery)* [$25.00].

YOUNG RUFFED GROUSE 58.46

[Unknown] [Unknown]: 9 × 12 [?] oval

[Unknown]

[No.] 93 *Young ruffed grouse. 12 × 9 oval. Schaus* [$40.00].

YOUNG RUFFED GROUSE 58.47

A. F. Tait / N.Y. 1858 [LR] Panel: 8 × 10

"Young Ruffed Grouse" / by A. F. Tait / 600 B'wy / N.Y. / No. 94.

[No.] 94 *Young Ruffed Grouse. J. B. Stearns (xchange).*

[DEVON CATTLE] 58.48

[Unknown] [Unknown]: [Unknown]

[Unknown]

[No.] 95 *Group of cattle. Devons. Edw. Fail[e] 20 West 29th St.*

[CERVUS VERO] 58.49

A. F. Tait / N.Y. 1858 [LL] Canvas: 15 × 22½

Cervus Vero / No. 6 / Painted by A. F. Tait / 400 Broadway / N.Y. / Nov. 1858.

[No.] 96 *Group of deer. 22 × 14. Paid Nov. 23rd. 61 Fifth Ave. Mr. Thorne Finished Nov. 19th* [$125.00].

This painting has been relined and the restorer has copied the back inscription on new canvas. However, he has made mistakes: (a) AFT's number should be "No.

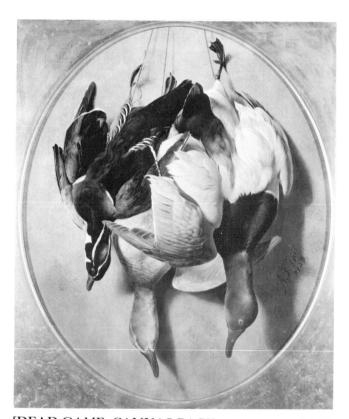

[DEAD GAME: CANVAS BACK 58.50
AND WOOD DUCK]

A. F. Tait / N.Y. '58 [LR] Panel: 24 × 19¾

New York / Male & Female Canvas back ducks & male Wood Duck / A. F. Tait / 600 Broadway / finished 1858 / A. F. Tait.

[No.] 97 *24 × 20 on panel. Male & Female canvas back duck & wood Duck.* [$110.00] *and frame by Snedicor. Dwight Townsend Esq.*

Courtesy of Newhouse Galleries, Inc., New York, New York.

CERVUS VIRGINIUS 58.51

A. F. Tait / N.Y. '58 [LR] Canvas: 12 × 18

"Cervus Virginius." / Painted by / A. F. Tait / 600 B'way / N.Y. / No. 98 / for The Ranny [Ranney] Fund / Dec. 1, 1858.

[No.] *98 Deer. 18 × 12. Contribution to Ranny Fund Dec. 1st 1858.*

This painting has been relined, and the back inscription is preserved on a photograph attached to the back on the stretcher.

[COCK AND HEN QUAIL AND 58.52 YOUNG]

[Unknown] [Unknown]: 8½ × 6 [?]

[Unknown]

[No.] *99. 1858 Hen quail & young & mate. Sun Shower. 6 × 8½. Dec 18th. 1858. Mr. R. L. Chilton. Washington. Paid* [$35.00].

[DOE AND FAWNS] 58.53

[Unknown] [Unknown]: 8 × 6 [?]

[Unknown]

[No.] *100 Group of Doe & 2 Fawns. 6 × 8. Mrs. Bullard.*

GROUSE CHICKENS 58.54

[Unknown] [Unknown]: 8 × 6 [?]

[Unknown]

[No.] *101 Grouse chickens. 6 × 8. Mrs. Bullard.*

GROUSE AND YOUNG 58.55

[Unknown] [Unknown]: 14 × 22 [?]

[Unknown]

[No.] *102 Grouse and young 22 × 14. Cosmopolitan Art Union.* [$90.00].

[BUCK, DOE, AND TWO FAWNS] 58.56

[Unknown] [Unknown]: 12 × 18 [?]

[Unknown]

[No.] *103 Deer (Buck Doe & two Fawns) 18 × 12. Cosmop. Art. Union.* [$60.00].

HEN QUAIL AND YOUNG 58.57

[Unknown] [Unknown]: 10 × 14 [?]

[Unknown]

[No.] *104 Hen quail & young. 14 × 10. by Snedicor.* [$70.00] *including frame.*

HEN QUAIL AND YOUNG 58.58

[Unknown] [Unknown]: 10 × 14 [?]

[Unknown]

[No.] *105 Hen quail & young. 14 × 10.*

QUAIL AND YOUNG 58.59

A. F. Tait / 1858 [LC] Canvas: 9¾ × 12¾

No. 64 / Quail & Young / A F Tait / 600 Broadway / NY / June 1858

[No Register entry]

Subject of painting does not coincide with Tait's Register entry for No. 64, 1858. Painting may be same as 58.18. Painting similar to 89.18.

Courtesy of Sotheby Park Bernet, Agent: Editorial Photocolor Archives, New York, New York.

[BUCK AND DOE] 58.60

Jas M. Hart and A. F. Tait / Board: 13½ × 9½ N.Y. 1858 [LL] arch top

[Unknown]

[No AFT number; no Register entry]

Courtesy of Congoleum Corporation.

WARDNER'S HOTEL 58.61

A. F. Tait / 1858 [LR] Board: 14 × 20½

[Relined; inscription, if any, lost]

[No AFT number; no Register entry]

Actually painted in 1894 from a charcoal sketch done in 1858. The shanty at Rainbow Lake and A. F. Tait are mentioned in "Footprints on Adirondack Trails" by Charles A. Wardner and again in Wardner's "Sunset on Adirondack Trails," two unpublished typescripts in the Adirondack Museum Library, Blue Mountain Lake, New York.

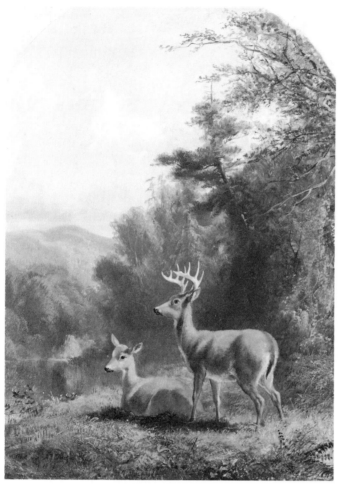

58.60

[QUAIL AND YOUNG] 59.1

A. F. Tait / '59 [LL] Canvas: 14 × 22

[Nothing on back]

[No.] *87 Pair of Quail & young ones. 22 × 14. Mr.
Thorne. [$125.00].*

Catalogued by front date; originally listed in AFT Register under 1858 listings.

[DOE AND FAWNS] 59.2

A. F. Tait / '59 [LL] Board: 6¾ × 9½

No. 106 by A. F. Tait, 600 B'way, 1859

[No.] *106. [Jan'y 1859.] Group of deer (Doe & two Fawns)
6 × 9½ (through Snedicor) [$35.00].*

YOUNG QUAIL 59.3

[Unknown] [Unknown]: [Unknown]

[Unknown]

[No.] *107 Young Quail. [$30.00]. Mr. Collins Friend.*

[YOUNG GROUSE] 59.4

[Unknown] [Unknown]: 8 × 6 [?]

[Unknown]

[No.] *108 [1859] Young Grouse. 6 × 8. Mr. Moore by
Snedicor.*

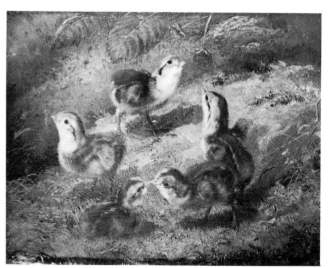

YOUNG QUAIL 59.5

A.F.T.—'59 [LR] Board: 6 × 8

Young Quail / No. 109 / by A. F. Tait / 600 B'way N.Y.
1859

[No.] *109 Young quail. 6 × 8. Moore by Snedicor.*

[GUARDING DEER] 59.6

[Unknown] [Unknown]: 9½ × 12½ [?]

[Unknown]

[No. 110] *200 Watching deer. 12½ × 9½. (Two hounds &
dead deer). [$50.00] Mr. Isham.*

[DEER] 59.7

[Unknown] [Unknown]: 10 × 8 [?]

[Unknown]

[No. 111] *201. Deer. "Buck & Doe." 8 × 10. Mr. Wood.*

A CLOSE SHOT 59.8

[Unknown] [Unknown]: 24 × 36 [?]

[Unknown]

[No. 112] *202 A Close Shot. (One deer in water) for the National Academy presentation picture April 1859 on my election as N.A. Size 36 × 24. no frame.*

Exhibited at the National Academy of Design 34th Annual Exhibition, 1859.

[DEER AND FAWN] 59.9

[Unknown] [Unknown]: 8 in. round [?]

[Unknown]

[No. 113] *203 Deer & Fawn. 8 in. round. Mr. Thos. Frazer. [$35.00].*

[DUCK SHOOTING] 59.10

[Unknown] [Unknown]: [Unknown]

[Unknown]

[No. 114] *204 Sketch for Duck Shooting. Mr. Townsend's Painting. Hart & Tait. Moore. [$50.00].*

Sketch for 59.12. Size is probably 13 × 8½ or 8½ × 13 according to Register entry no. 116 (59.12).

YOUNG QUAIL 59.11

[Unknown] [Unknown]: 8 × 6 [?]

[Unknown]

[No. 115] *205 Young Quail. 6 × 8. Moore [$35.00].*

DUCK SHOOTING: A GOOD 59.12
MORNING'S SPORT

[Unknown] [Unknown]: 26 × 40 [?]

[Unknown]

[No.] *116 [206 crossed out] [1859 600 Broadway N.Y.] Duck shooting. A good morning's sport. for Dwight Townsend, Esq. size 40 in × 26 [$500.00] with sketch 13 × 8½ [59.13]. 301 West 22nd St.*

Exhibited at the National Academy of Design 34th Annual Exhibition, 1859, titled "Duck Shooting, A Good Morning's Sport" and owned by Dwight Townsend. For a finished sketch of this painting, done in collaboration with James M. Hart, see 59.14.

[SKETCH FOR DUCK SHOOTING: 59.13
A GOOD MORNING'S SPORT]

[Unknown] [Unknown]: 8½ × 13 [?]

[Unknown]

[No. 116A; see 59.12]

Sketch for large painting 59.12. For other sketches see 59.10 and 59.14.

[DUCK SHOOTING] 59.14

A. F. Tait & J. M. Hart / Canvas: 12 × 18
1859. [LL]

No. 117 / Painted by / J. M. Hart & A. F. Tait / 600 B'way / N.Y.

[No.] *117 Sketch for the above [see 59.12 and 59.13]. Snedicor frame. Joint Hart & Tait. H. Moore. Center St.*

A finished sketch for 59.12. Exhibited and sold at Leeds Sale, December 18, 1863.

[DOE AND FAWN] 59.15

[Unknown] [Unknown]: 8 in. round [?]

[Unknown]

[No.] *118 Deer. Doe & Fawn. 8 in. circular. (no frame) [$25.00] Mr. Lathrop.*

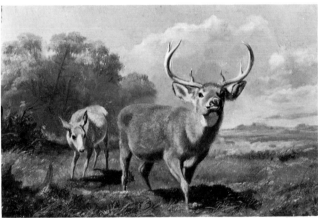

[BUCK AND DOE] 59.16

A. F. Tait / 1860 [LL] Panel: 7½ × 11

[Nothing on back]

[No.] *119 Deer. (Buck & Doe) 10 × 8. (Frame S.).*

[POINTERS AND QUAIL] 59.17

[Unknown] [Unknown]: 15 × 26 [?]

[Unknown]

[No.] *120. Dogs. (two pointers and quail) 26 × 15. (Frame S.) Horace Jones. [$110.00].*

DOE AND FAWN 59.18

[Unknown] [Unknown]: 8 in. round [?]

[Unknown]

[No.] *121 Doe & Fawn. Circular 8 in. (Dr. Manning) (Per Avery) [$25.00].*

[DEER'S HEAD] 59.19

[Unknown] [Unknown]: 9 × 8 [?] arch top

[Unknown]

[No.] *122 Deers Head. Sketch from Nature 8 × 9* [Here AFT shows rough outline of painting showing arch top] *round top.*

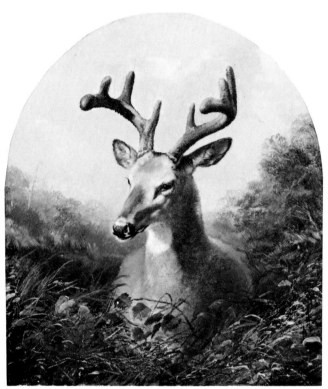

DEER'S HEAD 59.20

A. F. Tait / 59 [LR] Canvas: 9 × 8 arch top

No. 123 / By A. F. Tait / 600 B'way / N.Y. / 1859

[No.] *123 Deers Head. 8 × 9 Arch Top. Sketch from nature.*

[DEER BROWSING] 59.21

[Unknown] [Unknown]: 9 × 12 [?]

[Unknown]

[No.] *124 Deer Browsing. Sketch from nature at Loon Lake. 12 × 9. Sq'r.*

DEER'S HEAD 59.22

[Unknown] [Unknown]: 9 × 8 [?]

[Unknown]

[No.] *125 Deers Head. 8 × 9. from nature. Painted out and painted Dec'r 16th 1862 [62.22] a Group of tame Chickens presented to Mrs. Wm. F. Heins, Woodstock, Morrisania, Westchester Co. N.Y.*

This entry refers to the painting's original name, "Deer's Head." For the revised painting see 62.22.

[DEER'S HEAD] 59.23

[Not signed or dated] Canvas: 8 × 10

No. 126 / A. F. Tait N.Y. 1859

[No.] *126. Deer's Head. 8 × 10.*

[DEER'S HEAD] 59.24

[Unknown] [Unknown]: 10 × 8 [?]

[Unknown]

[No.] *127* [followed by a presumed "ditto" for *Deers Head*] *8 × 10.*

[DEER'S HEAD] 59.25

[Unknown] [Unknown]: 10 × 8 [?]

[Unknown]

[No.] *128* [followed by a presumed "ditto" for *Deers Head*] *8 × 10.*

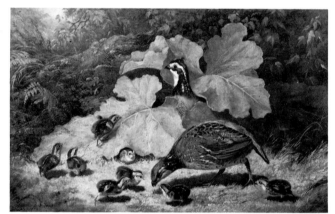

[QUAIL AND YOUNG] 59.26

A. F. Tait / 1859 [LL] Canvas: 14½ × 22¼

[Nothing on back]

[No.] *129 2 Quail & Young 22 × 14 Mr. McGuire Washington.*

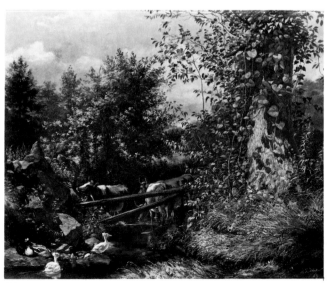

59.27

[CATTLE AND DUCKS] 59.27

A. F. Tait / '59 [LR] Canvas: 20 × 24

[Relined; inscription, if any, lost]

No. 130. 24 × 20. Sketch from nature. Landscape. Cattle & ducks.

Collection of the Mead Art Museum, Amherst College, Amherst, Massachusetts. Courtesy of the Mead Art Museum.

[SKETCH: DUCKS, BROOK, ETC.] 59.28

[Unknown] [Unknown]: 14 × 22[?]

[Unknown]

[No.] 131. 22 × 14. Sketch from nature. Ducks, brook, etc. Jno. Force (Brooklyn.) [$100.00] Frame Snedicor Jno. F. to pay for it.

[SKETCH: SWAN AND GOOSE] 59.29

[Unknown] [Unknown]: [Unknown]

[Unknown]

[No.] 132. Figure with swan & goose for Photograph.

[DEER'S HEAD] 59.30

[Unknown] [Unknown]: [Unknown]

[Unknown]

[No.] 133. a Deers Head (Buck[)].

[DEER'S HEAD] 59.31

[Unknown] [Unknown]: [Unknown]

[Unknown]

[No.] 134 [followed by a presumed "ditto" for *a Deers Head] Doe.*

[BUCK IN JULY] 59.32

[Unknown] [Unknown]: 9 × 15 [?]

[Unknown]

[No.] 135 a Deer. (Buck in July[)]. 15 × 9.

[OLD STUMP] 59.33

[Unknown] [Unknown]: 9 × 13 [?]

[Unknown]

[No.] 136. old Stump and Foliage from Nature. 13 × 9 returned to Studio Jan'y 1860.

[UNKNOWN] 59.34–.35

[Unknown] [Unknown]: [Unknown]

[Unknown]

[No.] 140 Two Sketches for W. T. Walters.

[SKETCH FOR W. T. WALTERS] [I] 59.34

[Unknown] [Unknown]: [Unknown]

[Unknown]

[No.] 140 [See 59.34–.35].

First of two sketches for W. T. Walters.

[SKETCH FOR W. T. WALTERS] [II] 59.35

[Unknown] [Unknown]: [Unknown]

[Unknown]

[No.] 141 [See 59.34–.35].

Second of two sketches for W. T. Walters.

PLEASANT THOUGHTS 59.36

[Unknown] [Unknown]: 12 × 18 [?]

[Unknown]

[No.] 142 [Sept.] Pleasant thoughts. girl at well & ducks. size 18 × 12.

Exhibited and sold at Leed's Sale, 1863.

[BROOKSIDE] 59.37

[Unknown] [Unknown]: 14 × 18 [?]

[Unknown]

[No.] 143. [Sept.] Ducks sunning—Brook Side. Size 18 × 14.

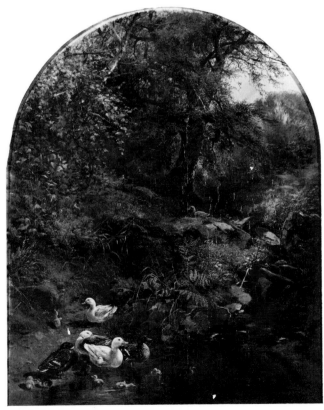

59.38

[DUCKS] 59.38

[Unknown] [Unknown]: 11 × 19 [?]

[Unknown]

[No.] *144. Ducks in Jas. M. Hart sketch from nature. 19 ×
11. Fence & Brook.*

Courtesy of Sotheby Parke Bernet, Agent: Editorial
Photocolor Archives, New York, New York.

THE PETS 59.39

[Unknown] [Unknown]: 14 × 18 [?]

[Unknown]

[No.] *145 "The Pets["] 18 × 14. Girl & boy, 1 Fawn goat,
rabbits & Hen & Chickens. Frame. Snedicors Sale.*

See 59.40.

[PETS] 59.40

[Unknown] [Unknown]: 10 × 14[?]

[Unknown]

[No.] *146. 14 × 10. Rabbits, Goat, Hen & chickens and
cock. part of above. Pepoon. paid* [$40.00] *No frame.*

See 59.39.

CHICKENS 59.41

A. F. Tait / N.Y. '59 [LR] Canvas: 9½ × 12½

No. 147 / A. F. Tait / M.N.Y. / 1859

[No.] *147 Chickens. 12 × 9½. no frame.* C. S. Snedicors
Fund.

HEN QUAIL AND YOUNG 59.42

[Unknown] [Unknown]: 10 × 14 [?]

[Unknown]

[No.] *148 Hen quail & young. 14 × 10. instead of 147*
[59.41]. *Frame Cr. S. Snedicor Fund.*

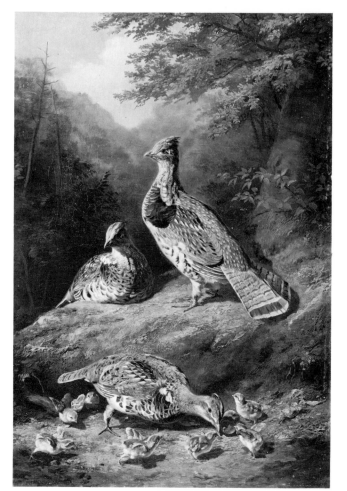

GROUSE AND YOUNG 59.43

A. F. Tait / N.Y. 1859 [LR] Canvas: 35 × 24

[Unknown]

[No.] *149 Cock & two hens. Grouse & Young. 35 × 24.
Mr. A. Belmont. no frame.*

FOWL YARD 59.44

[Unknown] [Unknown]: 12 × 14 [?]

[Unknown]

[No.] *150 Fowl yard. Rabbits Goat & c. no frame. 14 × 12.
(Mr. McCoy's Friend). paid.*

[GROUSE AND YOUNG] 59.45

[Unknown] [Unknown]: 6 × 8 [?]

[Unknown]

[No.] *151. Sketch for 149* [59.43]. *8 × 6 finished up. Paid.
Mr. Collins friend. Frame still to be paid for.*

JEALOUSY 59.46

[Unknown] [Unknown]: 8 × 6 [?]

[Unknown]

[No.] *152. Jealousy. Doe & two fawn. 6 × 8. Frame. Snedicor's sale Feb'y 2nd.*

MATERNAL AFFECTION 59.47

A. F. Tait / N.Y. 1859 Panel: 8¼ × 12

No. 153 / Maternal Affection / A. F. Tait / Xmas 1859 / Woodstock / Morrisania / N.Y.

[No.] *153 Maternal Affection. 13 × 9. Presented to Chas. Morrison* [?] *Frame debit to S.*

"Chas. Morrison" may possibly be "Church Morrisania" in Register.

YOUNG QUAIL 59.48

A. F. Tait / 1859 [LL] Panel: 7 × 9½

No. 154 / Young Quail / A. F. Tait / Morrisania / N.Y. / 1859

[No.] *154 7 × 9½. Young Quail. (Presented New Years) To Jas. B. Blossom. no frame.*

[QUAIL AND YOUNG] 59.49

A. F. Tait / '59 [LL] Canvas: 14 × 22

[Nothing on back]

[No.] *155. [1860] 14 × 21. Two quail & young. Jan'y 9th to Haughwout on a/c [$100.00] no frame.*

DAIRY FARM 59.50

[Unknown] [Unknown]: 29 × 18½

[Unknown]

[No AFT number; no Register entry]

This painting is a collaboration with James M. Hart. Exhibited at the 34th Annual National Academy of Design Exhibition, 1859, titled "The Dairy Farm," and owned by Edwin Thorne.

[SKETCH OF ROCK AND TREE] 59.51

July 1859 [LC] Canvas: 23¾ × 17

[Nothing on back]

[No AFT number; no Register entry]

This painting was left to AFT's son, Arthur J. B. Tait, in 1905.

[STUDY OF TREE] 59.52

Aug. 14, 1859 [LR] Canvas: 24 × 17

[Nothing on back]

[No AFT number; no Register entry]

This painting was presented by AFT to Reuben Cary, a guide, Long Lake, N.Y., when Cary's newborn son was named Arthur Tait Cary. There is no signature by AFT

on the front, but the date shown at LR is by AFT.

Courtesy of Mr. James W. Emerson.

YOUNG QUAIL 60.1

[Unknown] [Unknown]: 8 in. round [?]

[Unknown]

[No.] *156 "Young Quail" Circular 8 × 8. Frame. Snedicors Sale.*

GROUSE 60.2

[Unknown] [Unknown]: 8 in. round [?]

[Unknown]

[No.] *157 Grouse. circular 8 × 8. Frame. Snedicors sale.*

YOUNG QUAIL 60.3

[Unknown] [Unknown]: 12 × 9 [?] oval

[Unknown]

[No.] *158 Young Quail. 9 × 12 oval. Frame. Snedicor sale.*

YOUNG GROUSE 60.4

[Unknown] [Unknown]: 12 × 9 [?] oval

[Unknown]

[No.] *159 Young Grouse. 9 × 12 oval. Frame. Jan 30 / 60. Snedicor.*

YOUNG GROUSE 60.5

[Unknown] [Unknown]: 8 × 12 [?]

[Unknown]

[No.] 160 Young Grouse. 12 × 8. Feb'y 2nd / 60. no Frame.
Cosmopolitan Art Union.

QUAILS 60.6

A. F. Tait / '60, N.Y. [LL] Canvas: 8 × 12

161 / Quails / A. F. Tait / 1860

[No.] 161 Young Quail. 12 × 8 Cosmop. Art Union. deliv-
ered to Mr. Derby Feb'y 2nd 60.

On August 2, 1860, AFT received $100 for 60.6, 60.7
and 60.8.

DEER AND FAWN 60.7

[Unknown] [Unknown]: 8 × 12 [?]

[Unknown]

[No.] 162 Deer & Fawn. 12 × 8. Cosmop. Art Union.
See 60.6.

DUCK AND YOUNG 60.8

[Unknown] [Unknown]: 8 × 12 [?]

[Unknown]

[No.] 163 Duck & Young. 12 × 8 Cosmop. Art Union.
See 60.6.

FOWLS 60.9

A. F. Tait [LR] Canvas: 24 × 35½

[Unknown]

[No.] 164 Fowls (in barn—still life &c) 24 × 36. Exhibited
in N.A. of Design 1860. Jno. C. Force.

Exhibited at the National Academy of Design 35th An-
nual Exhibition, 1860, titled "Fowls" and listed as for
sale.

MORE FREE THAN WELCOME 60.10

A. F. Tait / N.Y. 1860 [L.R.] Canvas: 14 × 21

No. 165 / A. F. Tait / Morrisania N.Y. March 1860

[No.] 165 Farm Yard—Fowls & ducks. "More free than
welcome" Pigeons. Jno. C. Force. 14 × 21. Ex. N.A.D.
1860.

Exhibited at the National Academy of Design 35th An-
nual Exhibition, 1860, titled "More Free Than Wel-
come" and listed as for sale.

YOUNG GROUSE 60.11

[Unknown] [Unknown]: 12 × 9 [?] oval

[Unknown]

[No.] 166 Young Grouse. 9 × 12 oval. Snedicor's Friend
[$53.00].

HEN QUAIL AND YOUNG 60.12

[Unknown] [Unknown]: 12 × 9 [?] oval

[Unknown]

[No.] 167 Hen Quail & young. 9 × 12 oval. at Snedicors.
sold in August.

YOUNG GROUSE 60.13

[Unknown] [Unknown]: 12 × 9 [?] oval

[Unknown]

[No.] 168. Young Grouse. 9 × 12 oval. Snedicor's Friend.
[$53.00].

HEN QUAIL AND YOUNG 60.14

[Unknown] [Unknown]: 12 × 9 [?] oval

[Unknown]

[No.] 169 Hen quail & young. 9 × 12 oval. at Snedicor.
Sold in August.

TWO SETTERS ON QUAIL 60.15

A. F. Tait / 1860 [LL] Canvas: 21 × 35¼

170 / A. F. Tait / Morrisania, N.Y. / 1860.

[No.] 170 May 14/60. Two Setters—on Quail. Jno. C. Force
21 × 35 [$100.00].

GOING OUT 60.16

[Unknown] [Unknown]: 10 × 14 [?]

[Unknown]

[No.] 171 May Going Out. Boy with two setters. 14 × 10
Jas. Burt. [$50.00].

[RABBITS, PIGEONS, AND 60.17
CHICKENS]

[Unknown] [Unknown]: 9 × 12 [?]

[Unknown]

[No.] *172 Rabbits. Pidgeons, and Hen & Chickens. 12 × 9 N. B. Collins' friend.*

For a smaller version of this, see 60.18.

RABBITS AND PIGEONS 60.18

[Unknown] [Unknown]: 4 × 6 [?]

[Unknown]

[No.] *173 Rabbits & Pidgeons—Small 6 × 4 reduction of above [60.17] with the hens &c. Paid. no frame. Geo. B. Warren. Jun'r. Troy.*

[DUCK, RABBITS, AND GAME 60.19 CHICKENS]

[Not signed or dated] Panel: 8¾ × 11¾

No. 174 / 1860 / by A. F. Tait / Morrisania / N.Y.

[No.] *174 Muscovy Duck (Drake) Rabbits & Game cock & hens. 11½ × 9 in.*

Exhibited and sold at Leeds Sale, December 18, 1863.

GROUP OF DEER 60.20

[Unknown] [Unknown]: 16 × 12 [?]

[Unknown]

[No.] *175 Group of Deer—Buck, Doe lying down and fawn—[word unclear] in distance. 12 × 16. Jas. M. Hart painted background. Jas. Burt for [$40.00]—case of Boots.*

DUCKS 60.21

[Unknown] [Unknown]: [Unknown]

[Unknown]

[No.] *176 June 25th 1860 Ducks. Goupils [$40.00 and with No. 177 (60.22):] to acct.*

Possibly a companion or duplicate of 60.22.

DUCKS 60.22

[Unknown] [Unknown]: [Unknown]

[Unknown]

[No.] *177 Do. [June 25th 1860] Ducks. Goupils [$40.00 and with No. 176 (60.21):] to acct.*

Possibly a companion or duplicate of 60.21.

DUCKS 60.23

[Unknown] [Unknown]: [Unknown]

[Unknown]

[No.] *178 Ducks. Avery's friend. [$30.00] paid.*

WAITING FOR HIS MISTRESS 60.24

A. F. Tait / 1860 [LL] Canvas: 23¼ × 35¾

No. 179. by A. F. Tait Morrisania, N.Y. 1860.

[No.] *179 Horses (two horses & a blk Newfoundland Dog in a shed—"Waiting for his Mistress." Louis B. Brown. 36 × 24. [$200.00] paid.*

HORSE'S HEAD 60.25

[Unknown] [Unknown]: 7 in. round [?]

[Unknown]

[No.] *180 (Guy) Horses Head. Louis B. Brown. 7 in circle. [$50.00] paid.*

NEWFOUNDLAND DOG 60.26

[Unknown] [Unknown]: 7 in. round [?]

[Unknown]

[No.] *181 Newfoundland Dog. 7 in circle. L. B. Brown [$50.00] paid.*

GROUP OF DEER 60.27

[Unknown] Panel: 10 × 12 [?]

[Unknown]

[No.] *182. Group of deer. 12 × 10. Goupils. on panel. [$40.00].*

DEER AND FAWN 60.28

[Unknown] [Unknown]: 8 × 11 [?]

[Unknown]

[No.] *183. Deer & Fawn. 11 × 8.*

DUCK SHOOTER WITH SWAN 60.29 AND WILD GOOSE

[Unknown] Photograph: 12 × 16 [?]

[Unknown]

[No.] *184 Duck shooter with Swan and wild goose—Painted over photograph. Mr. Wood, Coachman. size about 16 × 12. [$30.00] paid.*

[TWO RABBITS] 60.30

A. F. Tait / 1860 [LR] [Unknown]: 4¼ × 6

[Nothing on back]

[No.] *145 Duo Rabbits 6 × 4 Mr. Burt. paid* [$20.00].

HEN QUAIL AND YOUNG 60.31

[Unknown] Board: 10 × 14 [?]

[Unknown]

[No.] *146 Hen quail & young ones. 14 × 10 (Millboard) Mr. Smiths friend.*

DUCKS REPOSING BY BROOKSIDE 60.32

[Unknown] [Unknown]: 12 × 18 [?]

[Unknown]

[No.] *147 Ducks reposing by Brookside. 18 × 12. Box by Snedicor.*

DUCKS 60.33

[Unknown] [Unknown]: 9 × 12 [?] oval

[Unknown]

[No.] *148 Ducks (at the side of Brook) 12 × 9 oval. Goupil.*

This painting, together with 60.34, sold to Goupil. AFT records he received $80.00 for pair—$40.00 to his account and $40.00 in cash.

HEN QUAIL AND CHICKENS 60.34

[Unknown] [Unknown]: 12 × 9 [?] oval

[Unknown]

[No.] *149 Hen Quail & chickens. 9 × 12 oval.*

See 60.33.

COCK AND HEN QUAIL AND YOUNG 60.35

[Unknown] [Unknown]: 16 × 26 [?]

[Unknown]

[No.] *150 Oct'r 30th/60 Cock & Hen Quail & Young. 26 × 16 with Dock Leaves.* [$150.00] *Mr. Lambdin Phila.*

Probably one of a pair with 60.36.

RUFFED GROUSE AND YOUNG 60.36

[Unknown] [Unknown]: 16 × 26 [?]

[Unknown]

[No.] *151. Ruffed Grouse & Young. 26 × 16. Mr. Lambdin Phila.*

Probably one of a pair with 60.35.

FEEDING TIME 60.37

[Unknown] [Unknown]: 10 × 14 [?]

[Unknown]

[No.] *152. Feeding Time (Man with hay and 4 Shetland ponies (Walton's) 14 × 10. Sketch finished for 153* [60.38]. *Jno C Force.*

Finished sketch for 60.38.

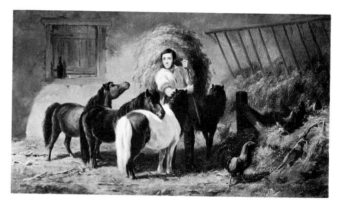

FEEDING TIME 60.38

A. F. Tait / 1860 N.Y. [LR] Canvas: 16 × 26½

No. 153 / "Feeding Time" / A. F. Tait / Nov. 1860.

[No.] *153 Feeding Time 26 × 16. same as above* [60.37]. *at Goupils Feb'y 5th. Jno. C. Force.*

Exhibited at the National Academy of Design 36th Annual Exhibition, 1861, titled "Feeding Time" and owned by John C. Force. Finished sketch for this work was also sold to John C. Force (60.37).

NEW JERSEY 60.39

A. F. Tait / N.Y. 1860 [LR] Canvas: 16 × 26

No. 154. / "New Jersey" / Painted by A. F. Tait / Morrisania, Nov. 1860

[No.] *154. Portrait of New Jersey (Horse) 26 × 16. Rec'd Nov'r* [$100.00] *on a/c. Lewis G. Brown. Presented to Jno. C. Force.*

[BARN YARD] 60.40

A. F. Tait, N.Y. / 1860 [LR] Canvas: 16 × 26

155 / A. F. Tait / Morrisania / N.Y. / 1860.

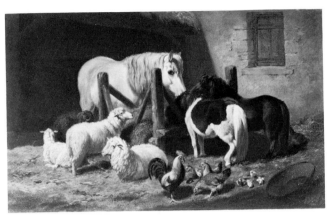

[No.] *155 Dec'r 1st 1860 Straw yard White Horse. 2 Ponies, Sheep &c. 16 × 26. Mr. Wood paid* [$50.00].

This painting has been relined and back inscription preserved by photography.

Collection of the Butler Institute of American Art, Youngstown, Ohio. Courtesy of the Butler Institute of American Art.

[SKETCH OF PONIES] 60.41

[Unknown] [Unknown]: [Unknown]

[Unknown]

[No.] *156 small sketch of ponies. Edw. Burt 15$* [$15.00].

DOE AND FAWN 60.42

[Unknown] [Unknown]: 7 in. round [?]

[Unknown]

[No.] *157 Doe & Fawn. 7 in circular. S. P. Avery.* [$25.00].

QUAIL AND YOUNG 60.43

[Unknown] [Unknown]: 10 × 12 [?]

[Unknown]

[No.] *158 Quail & young. 12 × 10.*

RUFFED GROUSE 60.44

[Unknown] [Unknown]: 9 × 12 [?]

[Unknown]

[No.] *159 Ruffed Grouse. 12 × 9. Jas. Blossom.*

YOUNG GROUSE 60.45

[Unknown] [Unknown]: 9 × 12 [?]

[Unknown]

[No.] *160 Young Grouse. Goupil. paid for* [$40.00] *12 × 9.*

QUAILS 60.46

A. F. Tait / '60, N.Y. [LL] Canvas: 8 × 12

No. 161 / QUAILS / A. F. Tait / N.Y. / 1860

[No.] *161 Quail & Young, Goupil 12 × 9. Dec. 27th / 60. paid for* [$40.00].

[CHICKENS] 60.47

[Unknown] [Unknown]: 7 × 9 [?]

[Unknown]

[No.] *162 Group of chickens 9 × 7. Wood, Esq.*

YOUNG GROUSE 60.48

A. F. Tait / 1860 [LR] Board: 9 × 12

No. 163 / Young Grouse / A. F. Tait / Morrisania, N.Y. 1860.

[No.] *163 Young Grouse. 12 × 9 millboard. Cosmop. A.U.* [Cosmopolitan Art Union].

CHICKENS 60.49

A. F. Tait / N.Y. 1860 [LR] Canvas: 9 × 12

[Nothing on back]

[No AFT number; no Register entry]

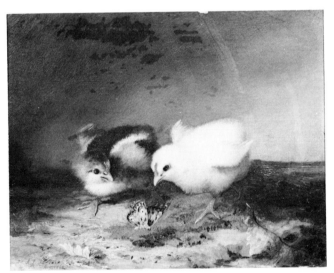

CHICKENS 60.50

A. F. Tait / N.Y. 1860 [LL] Canvas: 9 × 11

[Nothing on back]

[No AFT number; no Register entry]

[STUDY OF A BROOK TROUT] 60.51

[Not signed or dated] Board: 8 × 12

[Nothing on back]

[No AFT number; no Register entry]

Emma H. Tait, AFT's third wife, stated, "This is a study of a trout AFT caught at Racquette [Raquette]

Lake in 1860." The study was later incorporated in two paintings, 62.25 and 63.1.

Courtesy of Mrs. Henry F. Marsh.

[STUDY AT RAQUETTE LAKE] 60.52

[Not signed or dated] Canvas: 16¾ × 23¼

Painted from nature, a study / by A. F. Tait about 1860 while at Raquette Lake / (Adirondacks) N.Y. / Given to his son in 1900. / Arthur J. B. Tait. / Presented to my dear friend of many years as a / token of my love & esteem / by Arthur J. B. Tait, Sept. 21–1948.

[No AFT number; no Register entry]

The entire back inscription is in the handwriting of Arthur J. B. Tait who presented the sketch to John K. Lovell.

Collection of The Adirondack Museum, Blue Mountain Lake, New York. Courtesy of The Adirondack Museum.

[DORKING CHICKENS] 61.1

A. F. Tait / N.Y. 1861 [LR] Board: 8 × 10

No. 164 / A. F. Tait / Morrisania / N.Y. / 1861

[No.] 164 Feb. 4th. Hen & chickens &c (Dorkings) Snedicor 8 × 10.

Collection of The Adirondack Museum, Blue Mountain Lake, New York. Courtesy of The Adirondack Museum.

[SHEEP AND CHICKENS] 61.2

[Unknown] [Unknown]: 10 × 8 [?]

[Unknown]

[No.] 165 Sheep, Cock, Hen & chickens (Game). Feb'y 4th 8 × 10.

POINTERS AND WOODCOCK 61.3

[Unknown] [Unknown]: 24 × 36 [?]

[Unknown]

[No.] 166 Dogs (Pointers) and woodcock. 36 × 24. Jno. C. Force.

[DEVON BULL, "CAYUGA"] 61.4

A. F. Tait / N.Y. 1861 [LR] Canvas: 12 × 18

[Unknown]

[No.] 167. Bull 18 × 12. E. G. Faile.

One of four cattle paintings, including 61.5, 61.6, and 61.20, done for E. G. Faile.

See 56.12–.14.

[DEVON COW, "EVELEEN"] 61.5

A. F. Tait / N.Y. 1861 [LR] Canvas: 12 × 18

[Unknown]

[No.] 168 Cow (Eveleen) 18 × 12. E. G. Faile.

See 61.4.

COW: "BOWLEY" 61.6

[Unknown] [Unknown]: 12 × 18 [?]

[Unknown]

[No.] *169 Cow (Bowley) 18 × 12. E. G. Faile.*

See 61.4.

CHICKENS 61.7

[Unknown] [Unknown]: 7 × 9 [?]

[Unknown]

[No.] *170. [Feb'y. 1861] [Sheep & Fowl crossed out] chickens. 9 × 7 Snedicor.*

[SHEEP AND FOWL] 61.8

A. F. Tait / 1861 [LR] Panel: 9 × 12

N "*171 / A. F. Tait / Morrisania, N.Y. Feb*" 1861

[No.] *171. Sheep and Fowl. 12 × 9. Finished Feb. 5th.*

Exhibited and sold at Leeds Sale, December 18, 1863.

[YOUNG DUCKS] 61.9

[Unknown] [Unknown]: 7 × 9 [?]

[Unknown]

[No.] *172. Young Ducks. 9 × 7. Mr. Wood.*

[FOWL] 61.10

[Unknown] [Unknown]: 9 × 8 [?] arch top

[Unknown]

[No.] *173. Group of Fowl. 8 × 9.* [Here AFT shows small sketch of square with arch top.]

PLEASANT REMEMBRANCES: 61.11
POINTERS AND WOODCOCK

A. F. Tait / N.Y. 1861 [LR] Canvas: 24⅜ × 36¼

[A label on back states, "No. 1. / Pointers & Woodcock. / A. F. Tait / belonging to / John C. Force / 16 High St. Brooklyn."]

[No.] *174. [Setters crossed out] Pointers & Woodcock. Feby. 37 Exhibition 1862. 36 × 24. Jno. C. Force.*

Exhibited at the National Academy of Design 37th Annual Exhibition, 1862, titled "Pleasant Remembrances:

Pointers and Woodcock" and owned by John C. Force.

Collection of the Yale University Art Gallery, New Haven, Connecticut. Courtesy of Yale University Art Gallery, Whitney Collections of Sporting Art, given in memory of Harry Payne Whitney (B.A. 1894) and Payne Whitney (B.A. 1898) by Francis P. Garvan (B.A. 1897).

WOODCOCK 61.12

[Unknown] Panel: 9 × 11 [?]

[Unknown]

[No.] *175. Woodcock. on panel. March 37 Exhibition 1862. 11 × 9. Jno. C. Force.*

Exhibited at the National Academy of Design 37th Annual Exhibition, 1862, titled "Woodcock" and owned by John C. Force.

GROUSE IN SNOW 61.13

[Unknown] [Unknown]: 10 × 14 [?]

[Unknown]

[No.] *176 March Grouse in snow. 14 × 10. Patriotic Fund. Sold at the Mar. Xchange $55/-/.*

[THE ALARM] 61.14

A. F. Tait / 1861 [LR] [Unknown]: 10 × 14

[Unknown]

[No.] *177. [1861 March] Doe two Fawns and 3 Grouse 14 × 10 Jno. M. Ives.*

A chromolithograph was published by Currier & Ives, 1868, titled "The Alarm."

[DOE, FAWNS, AND FROG] 61.15

[Unknown] [Unknown]: 14 × 22 [?]

[Unknown]

[No.] *178. Doe & two Fawns and Frog. 22 × 14. Jno. C. Force. [$80.00].*

[THE LIFE OF A HUNTER— 61.16
A TIGHT FIX]

[Unknown] [Unknown]: 24 × 36 [?]

[Unknown]

[No.] *179 Bear Hunting in Northern New York. 37th Exhibition 1862. a tight fix. 36 × 24. for publishing by N. C. Currier & Ives. [$200.00].*

A hand-colored lithograph was published by Currier & Ives, 1861, titled "The Life of A Hunter, A Tight Fix." Apparently the painting was then sold again in 1862, since it was shown at the National Academy of Design 37th Annual Exhibition, 1862, titled "Bear Hunting, Northern New York. A Tight Fix" and listed as for sale. Exhibited and sold at Leeds Sale, December 18, 1863.

See 56.3.

SPANIELS AND DUCKS 61.17

[Unknown] [Unknown]: 35 × 21 [?]

[Unknown]

[No.] 180 *Spaniels & duck. 21 × 35 in. Jno. C. Force.
[$100.00] 37 Exhibition 1862.*

Exhibited at the National Academy of Design 37th Annual Exhibition, 1862, titled "Pleasant Remembrances, Spaniels and Ducks, Long Island, N.Y.," and owned by John C. Force. Exhibited and sold at Leeds Sale, December 18, 1863.

[SPANIEL AND DUCKS] 61.18

[Unknown] [Unknown]: 9 × 12 [?]

[Unknown]

[No.] 181 *Spaniel at rest & two ducks. Jno. C. Force. 12 × 9. present.*

THE SENTINEL 61.19

[Unknown] [Unknown]: 14 × 22 [?]

[Unknown]

[No.] 182 *The Sentinel. Buck on the lookout and does. 22 × 14.*

Exhibited at Leeds Sale, December 18, 1863.

CAYUGA 61.20

[Unknown] [Unknown]: 14 × 22 [?]

[Unknown]

[No.] 183 *Bull (Cayuga). 22 × 14. E. G. Faile, Esq.*

One of four cattle paintings, including 61.4, 61.5, and 61.6, done for E. G. Faile.

See 56.12–.14.

THE SENTINEL 61.21

A. F. Tait / N.Y. 1861 / AFT [LR] Canvas: 20¼ × 30

A. F. Tait / N.Y. 1861.

[No.] 184 [July 2nd 1861] *The Sentinel. Buck on the lookout and a doe lying down (old maple) Lake Scene. 37th Exhibition 1862. Jas. B. Blossom. pd. [$50.00] and [$150.00] of old a/c makes [$200.00].*

This painting has been relined and Tait's signature copied onto new backing. Exhibited at the National Academy of Design 37th Annual Exhibition, 1862, titled "Pleasant Remembrances—'Wide Awake.' Hamilton Co., N.Y." and owned by James B. Blossom.

THE LIFE OF A HUNTER: 61.22
CATCHING A TARTAR

A. F. Tait [LL] Canvas: 24 × 36¼

No. 185. A. F. Tait, Del., N.Y. 1861, U.S. Morrisania.

[No.] 185 *Catching a Tartar. Lake scene Buck with hunter down in water (old maple &c) another man coming up to help in the distance. canoe in distance. 36 × 24.*

As the painting has been rebacked, the inscription, not in AFT's writing, has been copied on the new backing as shown. A hand-colored lithograph was published by Currier & Ives, 1861, titled "The Life of A Hunter, Catching a Tartar." Exhibited and sold at Leeds Sale December 18, 1863.

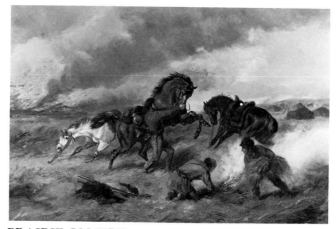

PRAIRIE ON FIRE 61.23

A. F. Tait / 1861 [LL] Board: 14 × 20

No. 186 / A. F. Tait / Morrisania / N.Y. 1861

[No.] 186. *Prairie on fire. on millboard. Sketch for no. 188. Size 20 × 14. 3 figures & 3 horses lighting fire one holding horse two lighting fire in foreground.*

This is a smaller, and perhaps preliminary, version of 61.25, and probable companion of 61.24.

Courtesy of Mr. Frederick R. Caffrey.

BUFFALO HUNT ON PRAIRIE 61.24

[Unknown] Board: 14 × 20 [?]

[Unknown]

[No.] *187. Buffalo Hunt on Prairie. Two horsemen and Buffaloe on millboard. Sketch for #189* [61.26]. *Size 20 × 14. Companion to above* [61.23].

This is a smaller, and perhaps preliminary, version of 61.26 and probable companion of 61.23.

[LIFE ON THE PRAIRIE: 61.25
THE TRAPPER'S DEFENSE,
FIRE FIGHT FIRE]

[Unknown] [Unknown]: 24 × 36 [?]

[Unknown]

[No.] *188 Prairie on fire. size 36 × 24. Currier and Ives.* [$75.00].

This is a larger and perhaps more finished version of 61.23 and probable companion of 61.26. A hand-colored lithograph was published by Currier & Ives, 1862, titled "Life On the Prairie, The Trapper's Defense, 'Fire Fight Fire.'" Exhibited and sold at Leeds Sale, December 18, 1863.

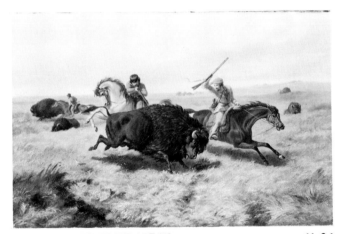

[LIFE ON THE PRAIRIE: 61.26
THE BUFFALO HUNT]

A. F. Tait / N.Y. 1861 [LL] Canvas: 23¾ × 35¾

No 189. 1861 / A. F. Tait / Morrisania, N.Y.

[No.] *189 Buffalo hunt. 36 × 24. Currier and Ives.* [$75.00] *I to have extra if any.*

This is a larger and perhaps more finished version of 61.24 and probable companion of 61.25. A hand-colored lithograph was published by Currier & Ives, 1862, titled "Life On The Prairie, The 'Buffalo Hunt.'" Exhibited and sold at Leeds Sale December 18, 1863.

Courtesy of Christie's, New York, New York.

DUCK SHOOTING 61.27

[Unknown] [Unknown]: 14 × 22 [?]

[Unknown]

[No.] *190 Duck Shooting. 22 × 14.* [*Doe & two Fawns foggy morning* crossed out] *Sketch for 194* [61.31; *size 20 ×*

24 Currier & Ives crossed out] *Mr. Townsend N.Y.* [the following deleted entry elsewhere:] *195 Duck Shooting. 22 × 14 Mr. Townsend sketch for 194* [61.31] *paid for in a Bbl* [barrel?] *Sugar.*

Sketch for 61.31.

CATTLE IN SHED 61.28

A. F. Tait 1861 [LR] Canvas: 14 × 22

[Unknown]

[No.] *191 Cattle in Shed. 22 × 14.*

For probable companion see 61.29 and possibly 61.30.

CATTLE IN FARM YARD 61.29

A. F. Tait 1861 [LR] Canvas: 14 × 22

[Unknown]

[No.] *192 Cattle in farm yard. 22 × 14. Mr. Camp. 2 Bbl Sugar & 1 syrup.*

For probable companion see 61.28 and possibly 61.30.

[WHITE HORSE WITH SHEEP] 61.30

[Unknown] [Unknown]: 14 × 22 [?]

[Unknown]

[No.] *193 White Horse & sheep chickens &c in straw yard 22 × 14.*

For possible companions see 61.28 and 61.29.

DUCK SHOOTING WITH DECOYS 61.31

A. F. Tait / 1861. [LR] Canvas: 14 × 22

No. 194 / Duck Shooting with Decoys / Long Island / N.Y. / U.S.A. / A. F. Tait / 1861

[No.] *194 Duck Shooting. 22 × 14. Two men in reeds. Decoys &c.* [$50.00] *Chas. Bowman. England.*

For the sketch, see 61.27.

Courtesy of Mr. and Mrs. George Arden.

[THE HOME OF THE DEER] 61.32

A. F. Tait / 1861 [LR] Canvas: 20 × 24

[Unknown]

[No.] 195 *Doe & two Fawns. foggy morning. 20 × 24.
Currier & Ives.*

A hand-colored lithograph was published by Currier &
Ives, 1862, titled "The Home of the Deer, Morning in
The Adirondacks." Exhibited and sold at Leeds Sale De-
cember 18, 1863.

[DOE AND FAWNS] 61.33

[Unknown] [Unknown]: 12 × 18 [?]

[Unknown]

[No.] 196 *Doe & two fawns. Foggy Morning. Something like
195 [61.32]. 18 × 12. Mr. Houghwout.*

FARM YARD 61.34

[Unknown] [Unknown]: 12 × 18 [?]

[Unknown]

[No.] 197 *Farm yard. two Cows—two sheep & cock & hens.
18 × 12 Mr. Houghwout.*

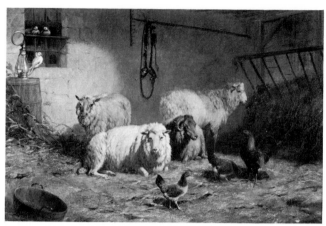

Courtesy of Sotheby Parke Bernet, Agent: Editorial
Photocolor Archives, New York, New York.

[DOE AND FAWNS] 61.35

A. F. Tait / N.Y. / 1862 [LR] Canvas: 16 × 26

[Relined; inscription; if any, lost]

[No.] 198 *Two Fawns & Doe. something like 195. 26 × 16.
Mr. L. Brown.*

Courtesy of Mr. Peter H. B. Frelinghuysen.

[FARM YARD] 61.36

A. F. Tait / 1861 [LL] Canvas: 12¼ × 18¼

No. 199 / A. F. Tait / N.Y. 1861

[No.] 199 *Farm yard. Sheep & chickens in shed. John C.
Force. 37 Exhibition 1862.*

Exhibited at the National Academy of Design 37th An-
nual Exhibition, 1862, titled "Sheep & c.," and owned
by John C. Force.

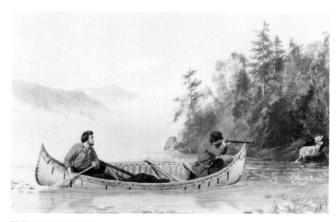

DEER DRIVING, NORTHERN NEW YORK 61.37

A. F. Tait, N.A. / N.Y. Canvas: 14 × 22
U.S. / 1862 [LR]

Deer Driving / Northern N.Y. / U.S.A. / No. 200 /
A. F. Tait, N.A. / N.Y. 1861.

[No.] 200 *Deer hunting on lake two men in a canoe. 22 ×
14. Chas. Bowman. Messrs. Whitehead & Heatherington. Ex-
change Alley. North Liverpool.*

PIGEON SHOOTING 61.38

A. F. Tait / N.Y. 1861 [LR] Canvas: 20¼ × 30½

No. 201 / A. F. Tait / Morrisania / N.Y. / Dec. 1, 1861.

[No.] 201. *[1861] Pigeon Shooting. 20 × 30. Two men in
Bough house—Decoys &c. 37th Exhibition 1862. Messrs. Cur-
rier & Ives.*

A hand-colored lithograph was published by Currier &
Ives, 1862, titled "Pigeon Shooting, 'Playing the De-
coy.'" Exhibited at the National Academy of Design
37th Annual Exhibition, 1862, titled "Pigeon Shooting,
Northern New York" and listed as for sale.

Collection of the Yale University Art Museum, New
Haven, Connecticut. Courtesy of Yale University Art

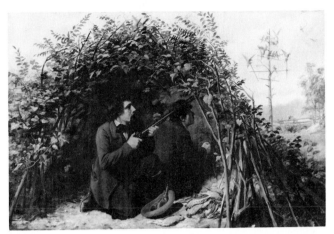

Gallery, Whitney Collections of Sporting Art, given in memory of Harry Payne Whitney (B.A. 1894) and Payne Whitney (B.A. 1898) by Francis P. Garvan (B.A. 1897).

STRATAGEM: TRAPPERS IN AMBUSH 61.39

[Unknown] [Unknown]: 9 × 12 [?]

[Unknown]

[No.] *202 Sketch* [for 62.2] *12 × 9. Stratagem. Trappers in ambush. Currier & Ives.*

One of two painted sketches for Currier & Ives (see 61.40). Only 61.39 was executed in finished form on another canvas (62.2) for reproduction.

THE RESCUE 61.40

[Unknown] [Unknown]: 9 × 12 [?]

[Unknown]

[No.] *203 Sketch the rescue. 12 × 9 Currier & Ives.*

One of two painted sketches for Currier & Ives (see 61.39).

[UNKNOWN] 61.41

A. F. Tait / '61 [LR] Canvas: 34 × 37

[Nothing on back]

[No AFT number; no Register entry]

The owner describes the painting as a picture of a brown dog, perhaps a Brittany Spaniel, looking around a large rock at a wounded black game bird, which is lying on its side, dying.

[CAMP IN THE ADIRONDACKS 61.42–.50
NINE VIEWS OF THE ADIRONDACKS]

[See remarks] [See remarks]

[See remarks]

[No AFT number; no Register entry]

In one frame with a nine opening mat are five paintings and four drawings by AFT. Subjects include deer head, moose head, camp settings and frontier cabins, grouped together under the title "Camp in the Adirondacks." Done in 1861 while AFT was camping at Constable Point on Raquette Lake with his friend James B. Blossom.

See individual entries for 61.42 thru 61.50.

Collection of The Adirondack Museum, Blue Mountain Lake, New York.

[VIEW OF A LOG CABIN 61.42
WITH TWO COWS AND GEESE]

[Not signed or dated] Paper on cardboard:
 5⅛ in. round

[Nothing on back]

[No AFT number; no Register entry]

See collective entry 61.42–.50.

[LAKE VIEW WITH TWO BOATS— 61.43
TWO MEN TO A BOAT]

[Not signed or dated] Board: 4½ × 12
 chamfered corners

[Nothing on back]

[No AFT number; no Register entry]

See collective entry 61.42–.50.

[TWO MEN FISHING BY A 61.44
WATER FALL]

[Not signed or dated] Paper on cardboard:
 5⅛ in. round

[Nothing on back]

[No AFT number; no Register entry]

See collective entry 61.42–.50.

[SWIMMING BUCK] 61.45

A. F. Tait [LR] [Undated] Paper on cardboard:
 6⅝ × 5¼ arch top

[Nothing on back]

[No AFT number; no Register entry]

See collective entry 61.42–.50.

[LAKE SHORE VIEW WITH CANOE 61.46
AND DRESSED BUCK]

[Not signed or dated] Board: 8⅛ × 12
 top corners rounded

[Nothing on back]

[No AFT number; no Register entry]

See collective entry 61.42–.50.

[SWIMMING COW MOOSE] 61.47

A. F. Tait [LR] Paper on cardboard:
 6⅝ × 5¼ arch top

[Nothing on back]

[No AFT number; no Register entry]

It is quite likely that this is the moose shot on this trip by
James B. Blossom, one of AFT's hunting companions.
See collective entry 61.42–.50.

[CAMPFIRE AND LEAN-TO] 61.48

A. F. Tait 1861 [LR] Paper on board:
 5¼ in. round

[Nothing on back]

[No AFT number; no Register entry]

See collective entry 61.42–.50.

[CAMPFIRE AND LEAN-TO] 61.49

JBB AFT [LL] Board: 4½ × 12
 chamfered corners

[Nothing on back]

[No AFT number; no Register entry]

JBB are James B. Blossom's initials.

See collective entry 61.42–.50.

[VIEW OF A LOG CABIN, DOCK 61.50
AND TWO BOATS]

A. F. Tait 1861 [LR] Paper on cardboard:
 5¼ in. round

[Nothing on back]

[No AFT number; no Register entry]

See collective entry 61.42–.50.

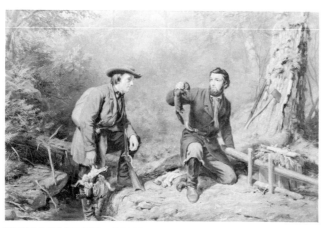

THE MINK TRAPPERS, 62.1
NORTHERN NEW YORK

A. F. Tait / N.Y. 1862 [LR] Canvas: 20¼ × 30

"Mink Trapping" / Northern N.Y. / No. 204 / A. F. Tait
Morrisania, N.Y. / Jan. 1862

[No.] *204 The Mink Trappers, Northern N.Y. 30 × 20.
Two men one standing on left hand side resting his left elbow on
his knee—holding in his right two Ruffed grouse—the other
kneeling having just taken a mink out of a dead fall trap, gun
leaning against a tree and axe stuck into the tree on right. Very
carefully finished. Delivered Feby 2, Sunday to John C. Force in
a sleigh at my place. price $175.00—[$100.00] cash [$75.00]
left to the a/c. John C. Force 37th Exhibition, 1862.*

Exhibited at the National Academy of Design 37th An-
nual Exhibition, 1862, titled "A Prime Skin, Mink Trap-
ping, Northern New York," and owned by John C.
Force.

Collection of the Munson-Williams-Proctor Institute,
Utica, New York. Courtesy of Munson-Williams-
Proctor Institute.

See 62.5.

THE STRATAGEM 62.2

[Unknown] [Unknown]: 20 × 30 [?]

[Unknown]

[No.] *205 The Stratagem.—3 trappers in foreground laying
in ambush for Indians in background with camp fire & sham
figures & Indians.*

A hand-colored lithograph was published by Currier &
Ives, 1862, titled "American Frontier Life, 'The
Hunter's Stratagem.'" Exhibited and sold at Leeds Sale,
December 18, 1863.

See 61.39.

QUAIL AND YOUNG 62.3

A. F. Tait N.A. / '62 [LR] Board: 8¾ × 12 oval

Quail and young / A. F. Tait / Morrisania, Westches-
ter C / N.Y. / No. 200 [?] 1862

[No.] *206 [Feby 4th.] Quail and Young. Oval 12 × 9.*

Companion painting to 62.4.

BUCK AND DOE 62.4

A. F. Tait / '62 [LR] Board: 8¾ × 12 oval

AM Red deer / A. F. Tait / Morrisania, Westchester c /
N.Y. / No. 207 1862

[No.] *207. [Feb 4] Buck & Doe Deer. 12 × 9 oval. Com-
panion to 206* [62.3].

MINK TRAPPING, 62.5
NORTHERN NEW YORK

A. F. Tait / 1862 [LR] Canvas: 20 × 30

[Relined; inscription, if any, lost]

[No.] *208 Mink Trapping. Northern N.Y. for Currier &
Ives. 20 × 30. Figure on left holding up mink, figure on right*

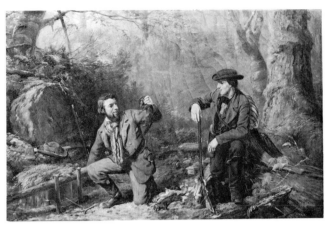

standing regarding & leaning against a stump. Hat & axe on rock at the left. [$150.00].

A hand-colored lithograph was published by Currier & Ives, 1862, titled "Mink Trapping, 'Prime.'" Exhibited and sold Leeds Sale, December 18, 1863. For an earlier version of this painting see 62.1.

Collection of the Shelburne Museum, Shelburne, Vermont. Courtesy of Shelburne Museum.

THE LATEST NEWS 62.6

A. F. Tait / N.Y. / 1862 [LL] Canvas: 21 × 34

"The Latest News"/ A. F. Tait, N.A. / Morrisania / New York / U.S. / April 1862 / No. 209.

[No.] *209. The latest news. Farm Yard. Cows, sheep, two shetland ponies. Fowls & Pidgeons. 22 × 34. R. L. Stewart* [Robert Leighton Stuart], *5th Avenue. Paid for* [$250.00].

Collection of the New-York Historical Society, New York, New York, on permanent loan from the New York Public Library. Courtesy of The New-York Historical Society, The Stuart Collection.

[AFTER THE RIDE] 62.7

A. F. Tait / N.Y. 1862 [LR] Canvas: 14 × 22

[Relined; inscription, if any, lost]

[No.] *210 Portrait of Horse (Grey) & Esquimaux Dog for Mr. Tiffany. 22 × 14.* [$100.00].

Courtesy of Mr. and Mrs. George Arden.

[POINTER AND SETTER] 62.8

[Unknown] [Unknown]: [Unknown]

[Unknown]

[No.] *211. Two dogs (Pointer & setter) in joint Painting with Mr. Brown—he to do the landscape. for Mr. M. Ward* [$100.00].

This is a painting by AFT and William M. Brown.

A GOOD CHANCE 62.9

A. F. Tait / N.Y. 1862 [LR] Canvas: 20 × 30

No. 212 / "A Good Chance." / Adirondack Region, Hamilton Co. Northern N.Y. / A. F. Tait, N.A. / Morrisania, N.Y. / 1862.

[No.] *212. "A Good Chance." Lake Scene. Canoe & two men in it, one going to fire at a deer jumping on the shore—another canoe in distance.* [$200.00] *20 × 30. Currier & Ives.*

A hand-colored lithograph was published by Currier & Ives, 1863, titled "American Hunting Scenes: A Good Chance."

Collection of the Yale University Art Gallery, New Haven, Connecticut. Courtesy of Yale University Art Gallery, Whitney Collections of Sporting Art, given in memory of Harry Payne Whitney (B.A. 1894) and Payne Whitney (B.A. 1898) by Francis P. Garvan (B.A. 1897).

YOUNG GROUSE 62.10

A. F. Tait & W. M. Brown, Canvas: 12 × 18
1862 [LL]

No. 213. "Young Grouse" (Ruffed) A. F. Tait and Brown. 1862.

[No.] 213 *Young Grouse painted jointly with Brown of Brooklyn. Mr. M. Ward. 36 × 24.*

Apparently AFT listed the size incorrectly since the number on the back of the painting is the same as the number in the Register.

YOUNG QUAIL 62.11

[Unknown] [Unknown]: 8 × 10 [?]

[Unknown]

[No.] 214 *Young quail. 10 × 8. June 17/62. Jno. Snedicor. 30$ to the a/c.*

QUAIL AND YOUNG 62.12

A. F. Tait 1862 [LR] [Unknown]: 18½ × 24

[Unknown]

[No.] 215 *June 27th. Quail & Young. 24 × 18½ for Wm. Schaus. paid June 30th, 1862.* [$125.00] *each.*

See note below for 62.13.

WOODCOCK AND YOUNG 62.13

A. F. Tait / N.Y. 1862 [LR] Canvas: 18¼ × 24¼

[Relined; inscription, if any, lost]

[No.] 216 *June 27th. Woodcock & Young. 24 × 18½ for Wm. Schaus—paid.* [$125.00] *each.*

A lithographic print of this painting, together with a

companion print of the same subject as the painting 62.12 above, have proved problematic. Both prints are without lettering and without Tait's signature, but are identical in size to the canvases. Sketchy information in the file at The Adirondack Museum suggests that Maurer was probably the lithographer, that the publisher was F. Heppenheimer, and that three or four pairs are known to exist.

Collection of the Yale University Art Gallery. New Haven, Connecticut. Courtesy of Yale University Art Gallery, Whitney Collections of Sporting Art, given in memory of Harry Payne Whitney (B.A. 1894) and Payne Whitney (B.A. 1898) by Francis P. Garvan (B.A. 1897).

AN ANXIOUS MOMENT 62.14

[Unknown] Canvas: 20 × 30 [?]

[Unknown]

No. 217. [*July 1st. 1862*] *Trout fishing. on The Racquet River. "an anxious moment." 20 × 30. Currier & Ives.*

A hand-colored lithograph was published by Currier & Ives, 1862, titled "Brook Trout Fishing, 'An Anxious Moment'." Exhibited and sold at Leeds Sale December 18, 1863.

RUFFED GROUSE AND YOUNG 62.15

A. F. Tait, N.Y. 1862 [LR] Canvas: 24 × 20

No. 218 American Ruffed Grouse. A. F. Tait. N.A. Morrisania, Westchester County, N.Y. July 1862.

[No.] 218 *Ruffed Grouse & young. 24 × 20. Upright. Wm. Schaus* [$125.00].

A GOOD TIME COMING 62.16

A. F. Tait / N.Y. / 1862 [CL] Canvas: 20¼ × 30

"A Good Time Coming" / on Racquette Lake, Hamilton Co., N.Y. / No. 219. A. F. Tait / Morrisania / Westchester Co. / N.Y., U.S. / 1862.

[No.] *219 "a Good time coming." Shanty Scene. 4 figures, one cooking, two sitting on the right, one (John C. Force) standing. Holding bottle of Champaign and tin cup—man coming up from the landing. 20 × 30. finished Sept. Currier and Ives. [$200.00].*

A hand-colored lithograph was published by Currier & Ives, 1863, titled "Camping In The Woods: 'A Good Time Coming.'" Exhibited and sold at Leeds Sale, December 18, 1863.

Collection of The Adirondack Museum, Blue Mountain Lake, New York. Courtesy of The Adirondack Museum.

GOING OUT: DEER HUNTING IN THE ADIRONDACKS
62.17

A. F. Tait / 1862 [LL] Canvas: 19½ × 29½

[Relined; inscription, if any, lost]

[No.] *220 Going Out. Deer Hunting in the Adirondacks, Northern N.Y. 20 × 30. two men in canoe middle distance. figure in foreground standing on shore calling to them. another figure in red shirt holding boat. Dog, pail, water trough. Currier & Ives. finished Oct 12/62. [$200.00].*

A hand-colored lithograph was published by Currier & Ives, 1863, titled "American Hunting Scenes, 'An Early Start.'" Exhibited and sold at Leeds Sale, December 18,

1863. A. J. B. Tait, son of AFT, noted the following: "In canoe with dog—Bow man is Jas. B. Blossom and Seth Wardner, a guide is in stern. Man with paddle about to enter canoe is Capt. Calvin Parker, guide for AFT for a number of years. Man holding rifle and calling to canoe moving is AFT."

Collection of The Adirondack Museum, Blue Mountain Lake, New York. Courtesy of The Adirondack Museum.

IN THE WOODS: TAKING IT EASY
62.18

A. F. Tait / N.Y. 1862 [LR] Canvas: 19½ × 29

"In the Woods" / Northern N.Y. / No. 221 / A. F. Tait / Morrisania / Westchester Co. / N.Y.

No. 221 [1862]Nov'r 7th 1862 In the Woods. taking it easy. Four hunters with dog, grouse & trout. 20 × 30. for Currier & Ives. no frame [$200.00] paid.

This painting has been relined and the inscription copied on the new canvas; the "In" appears as "To." A hand-colored lithograph was published by Currier & Ives, 1863, titled "Camping In The Woods, 'Laying Off.'" Exhibited and sold at Leeds Sale, December 18, 1863.

YOUNG QUAIL
62.19

[Unknown] [Unknown]: 10 × 14 [?]

[Unknown]

[No.] *222 14 × 10. Wm. Schaus. finish'd Dec. 12th. del'd Dec 13/62. Paid same time. no frame. [$50.00].*

YOUNG RUFFED GROUSE
62.20

[Unknown] [Unknown]: 10 × 14 [?]

[Unknown]

[No.] *223 Young Ruffed Grouse. 14 × 10. Wm. Schaus. finished Dec. 11th. Del'd Dec. 13th/62. Paid same time. no frame [$50.00].*

GIRL AT WELL
62.21

[Unknown] Paper: [Unknown]

[Unknown]

[Entire entry crossed out] [No.] *224 Girl at Well. photograph col'd in oil from No. 142 (59.36) "Pleasant thoughts." presented to Wm. F. Heins (until called for) no frame.*

CHICKENS
62.22

[Unknown] [Unknown]: 8 × 4 [or 9] round top [?]

[Unknown]

[No.] *225 [but may be 125] [1862] Little (Hen) chickens. a group. 8 × 4 [or 9] upright circular top no frame. Wm. F. Heins. Del'd Dec. 17th 1862 [$30.00].*

This is the painting referred to elsewhere in the Register as a new subject done on an old canvas.

See 59.22.

VERY SUGGESTIVE 62.23

[Unknown] [Unknown]: 8 × 9 round top [?]

[Unknown]

[No.] 226 *"Very Suggestive." "Trout" Fishing. "Basket." Fly Book, Rod &c. 8 × 9 circular top. presented to Jas. B. Blossom Xmas 1862. received from him in Xmas present of circular plated silver tray.*

DEAD GAME 62.24

[Unknown] Panel: 24 × 19½ oval

[Unknown]

[No.] 227. *"Dead Game." (Canvas Backs, Male & Female and Wood Duck) on panel 24 × 19½ for Oval frame. Painted on again added Green winged Teal & another Wood Duck. John C. Force.* [$125.00].

AMERICAN SPECKLED TROUT 62.25

A. F. Tait / N.Y. 1862. [LR] Canvas: 9 × 15

No. 228 "American Speckled Trout" / A. F. Tait / Morrisania / Westchester Co., N.Y. / Just caught. Suggestive of pleasant doings.

[No.] 228 *Two "Trout" size of life. Rod, Reel & Basket. Size 15 × 9 in.*

For a study of this painting see 60.51. Exhibited and sold at Leeds Sale, December 18, 1863.

62.26

[BARN YARD] 62.26

[Unknown] Canvas: 24 × 36

[Relined; inscription, if any, lost]

[No AFT number; no Register entry]

This is a painting by AFT and William M. Brown.

[SPANIEL AND WOODCOCK] 62.27

A. F. Tait / N.Y. 1862 [LR] [Unknown]: [Unknown]

[Unknown]

[No AFT number; no Register entry]

AMERICAN SPECKLED BROOK TROUT 63.1

[Unknown] Canvas: 14 × 22

"American Speckled Brook Trout" / Just Caught / "Very Suggestive of Happy Days" / No. 229 / A. F. Tait / Morrisania / Westchester Co. / N.Y.

[No.] 229. *[1863] 4 Trout size of life. Rod. Basket. Fly Book & Flask. 22 × 14—very suggestive of good times. finished Jan'y 12th, 1863. Ives (Currier & Ives).*

A chromolithograph was published by Currier & Ives, 1864, titled "American Speckled Brook Trout."

Collection of the Princeton University Library, Prince-

ton, New Jersey. Courtesy of Princeton University Library, The Kienbusch Angling Collection.

See 60.51 and 62.25.

COCK AND HEN QUAIL AND YOUNG 63.2

[Unknown] [Unknown]: 18 × 24 [?]

[Unknown]

[No.] *230 [1863] Cock & Hen Quail and young. size 24 × 18. finished Jan'y 14th, 1863. Wm. Schaus. price [$125.00] Paid Jan. 17th.*

CHICKENS 63.3

[Unknown] Panel: 11 × 9 [?]

[Unknown]

[No.] *231 Six Young Chickens (Hen) 9 × 11 on panel. Painted for Wm. Schaus (presentation) Feb'y 1st. in exhibition 1863.*

Exhibited at the National Academy of Design 38th Annual Exhibition, 1863, titled "Chickens" and owned by William Schaus.

[YOUNG CHICKENS] 63.4

[Unknown] Board: 8 × 10 [?]

[Unknown]

[No.] *232 Five young chickens. 10 × 8 millboard. sold by Schaus Feb'y 9th with Snedicor frame [$8.00] by Schaus to me. Paid for.*

QUAIL CHICKENS 63.5

[Unknown] Board: 8 × 10 [?]

[Unknown]

[No.] *233 Quail Chickens 10 × 8 millboard. to Snedicor sold & paid for $50.00 nett about April 1st, frame and commission deducted.*

AFT reused this number for his next painting (63.6).

YOUNG CHICKENS 63.6

[Unknown] [Unknown]: 9 × 12 [?] oval

[Unknown]

[No.] *233 [A] Feb'y 10th. Young (tame) Chickens. 12 × 9 oval. after a shower. paid 9$ for Frame. Snedicor Frame $9.00. went to Baltimore, sold in Baltimore to Avery friend for $80.00 including frame. paid Snedicor for Frame.*

See 63.5.

FOUR FAWNS 63.7

[Unknown] [Unknown]: 9 × 12 [?] oval

[Unknown]

[No.] *234 4 Fawns—Feb'y 10th. 12 × 9 oval. Snedicor Frame [$9.00] to Baltimore. came back. Sold to Williams, Boston.*

FAWNS 63.8

[Unknown] Board: 5½ × 6 [?]

[Unknown]

[No.] *235 Feb'y 12th 1863 Fawns—size 6 in. × 5½ on millboard. finish'd Feb'y 12th. Jno. C. Force [$25.00] to a/c.*

WAR 63.9

[Unknown] Panel: 10 × 14 [?]

[Unknown]

[No.] *236. "War." Young Domestic Chickens Scrambling with wasp &c. on panel 14 × 10. Wm Schaus. finished Feb'y 26. paid for at time of delivery Feb'y 26th $50.00. if sold for more, half the surplus to be paid me. May 4th received the difference $18.00.*

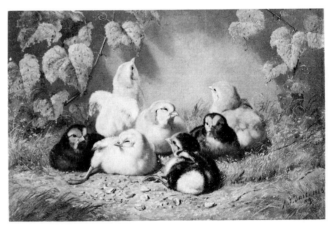

SUNSHINE AFTER A SHOWER 63.10

A. F. Tait, 1863 / N.Y. [LR] Panel: 10¾ × 14½

Sunshine "After a Shower" / A. F. Tait / Morrisania / Westchester Co. / N.Y. / March 1863.

[No.] *237 "Sunshine after a Shower." Young Domestic Chickens Sunning. on panel 14 × 10. Wm Schaus. finished March 2nd. paid for $50.00. if sold for more half of surplus to be paid me. May 4th $18.00 rec the difference.*

PEACE 63.11

[Unknown] Panel: 10 × 14 [?]

[Unknown]

[No.] *238. "Peace." young domestic chickens [amongst strawberries crossed out]. finished May 2nd. del'd 4th. on panel. Wm. Schaus. 14 × 10. del'd & paid for $68.00 May 4th same time as 242 [63.17] & received the difference $18.00 making $68.00.*

See 63.17.

FAWNS 63.12

[Unknown] Paper: 4 × 6 [?]

[Unknown]

[No.] *238.A Fawns (on paper) 6 × 4. Avery Friend. April 3rd [$20.00] ret'd to Avery (from Baltimore) for sale.*

AFT apparently exchanged this painting for his No. 249 (63.24).

THREE CHICKENS 63.13

[Unknown] Paper: 4 × 6 [?]

[Unknown]

[No.] *238.B. 3 chickens (on paper) 6 × 4. Avery Friend [$20.00].*

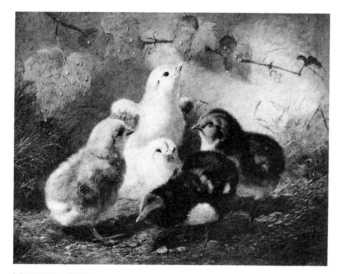

[CHICKENS] 63.14

A. F. Tait '63 [LR] Board: 8 × 10

No. 239 / A. F. Tait / Morrisania / Westchester Co., N.Y. / March 1863.

[No.]*239. 5 chickens (domestic) 10 × 8. finished March 10th / 63. Sold March 14th. Williamson. Boston.*

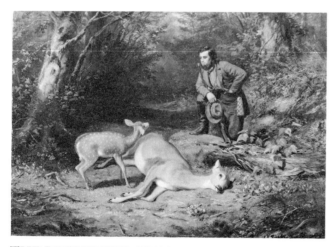

THE REGRETTED SHOT 63.15

A. F. Tait / N.Y. 1863 [LR] Panel: 12 × 16

[Unknown]

[No.] *240 [March 1863] The Regret. (the regretted shot) Dead Doe & Fawn looking at a Hunter with elbow leaning on his knee, hat in hand. Strawberry Blossoms. 16 × 12 on panel (very finished). Paid for March 14th. 63. Wellington Esq. Brooklyn. [$200.00] with frame $10.00.*

Exhibited at the National Academy of Design 40th Annual Exhibition, 1865, titled "The Regretted Shot" and owned by Wellington. This painting was destroyed by fire in 1953.

FAWNS 63.16

A. F. Tait / 1863 [LR] Board: 7¾ × 9¾

No. 241 / Fawns / (American Deer / Cervus Virginius) / A. F. Tait / Morrisania / Westchester Co. / N.Y. / March 1863.

[No.] *241 Three Fawns (playing) 10 × 8 del'd March 18th to Snedicor No. 233 with Young Quail. Schaus wedding day.*

SHOWER 63.17

[Unknown] Panel: 10 × 14 [?]

[Unknown]

[No.] *242 Shower—chickens under a leaf in a shower. 14 × 10 Panel. finished May 2nd del'd to Wm Schaus and settled his a/c up to date before he left for Europe per Persia. paid for $68.00.*

See 63.11.

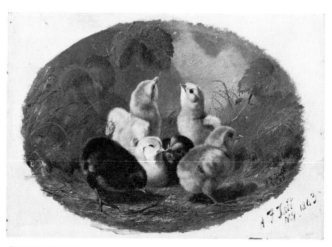

CHICKENS 63.18

A. F. Tait / N.Y. 1863 [LR] Board: 9 × 12 oval

No. 243 / 1863 / A. F. Tait / Morrisania / Westchester Co. / N.Y. / U.S.

[No.]*243 Chickens. 12 × 9 oval on Millboard. Jas. S. Earle & Son (Phila) $70 paid June 3rd / 63.*

Courtesy of Shepherd Gallery, Associates, New York, New York.

See 63.38–.40.

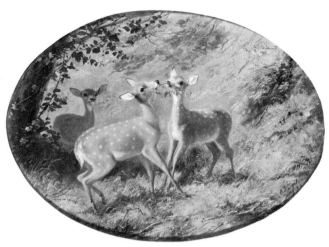

THREE FAWNS 63.19

A. F. Tait / N.Y. '63 [LR] Board: 10 × 13¼ oval

No. 244 / A. F. Tait / Morrisania / Westchester Co. / N.Y. / U.S. / 1863.

[No.] *244 Three Fawns. 12 × 9 oval Millboard. del'd thru Snedicor. E. C. Moore.*

CHICKENS 63.20

[Unknown] Board: 8 × 10 [?]

[Unknown]

[No.] *245 [1863] Chickens. 10 × 8 millboard. Del'd to Schaus April 3rd. paid for in settlement.*

CHICKENS 63.21

[Unknown] Panel: 9 × 11 [?]

[Unknown]

[No.] *246 Chickens. 11 × 9 Mohog[any] Panel Jno Snedicor. sold April 2nd for [$85.00]. frame and commission [$16.00]. Nett [$69.00] paid. This day I settled Snedicor a/c up in full to date.*

CHICKENS 63.22

A. F. Tait / 1863 [?] Panel: 8¾ × 11

No. 247. A. F. Tait / Morrisania / Westchester Co. / N.Y. / U.S.

[No.] *247 Chickens. 11 × 9 Mahog[any] Panel Jno. Snedicor advance [$50.00]. Sold April 25th for Maine.*

CHICKENS AND DUCKLINGS 63.23

[Unknown] Board: 9 × 12 [?]

[Unknown]

[No.] *248 Chickens & 3 ducklings. 12 × 9 sqr millboard. del'd to Avery April 2nd. Avery's friend Baltimore. [$80.00] in frame. Snedicors frame.*

THREE CHICKENS 63.24

[Unknown] Paper: 4 × 6 [?]

[Unknown]

[No.] *249 3 chickens on paper 6 × 4. Avery's friend Baltimore instead of No. 238a.*

For AFT 238a see 63.12.

[THE YOUNG ENTYMOLOGISTS] 63.25

A. F. Tait / N.Y. 1863 [LR] Board: 10 × 12

[Unknown]

[No.] *250 6 domestic chickens. 12 × 10 millboard, grass &c & Lady cow [bug]. Paid for by ch'k May 25th / 63. Williams & Everett Boston.*

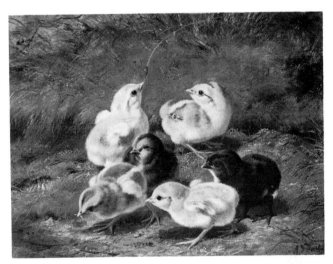

[CHICKENS] 63.26

A. F. Tait / 1863 [LR] Board: 12¼ × 14¼

No. 251 / A. F. Tait / Morrisania / Westchester Co. / N.Y. U.S. / 1863.

[No.] *251. 6 domestic chickens. 12 × 10. grass, violets &c & Lady cow bug. for Mr. Williams Boston (Williams & Everett) (sent off from Snedicors May 18) Paid per cheque May 26th / 1863.*

Note AFT records size different from actual measurements.

Courtesy of Christie's, New York, New York.

CHICKENS 63.27

[Unknown] [Unknown]: 10 × 12 [?]

[Unknown]

[No.] *252 Chickens 12 × 10 For frame 10¾ × 9¾ for Snedicor. Del'd May 18 to store.*

Exhibited and sold at Leeds Sale, December 18, 1863.

CHICKENS 63.28

A. F. Tait / N.Y. 1863 [LR] Panel: 8 × 11

No. 253 / A. F. Tait / Morrisania / Westchester Co. /
N.Y. / 1863

[No.] 253 Chickens. 11 × 8½ to fit frame 10½ × 8¼ for
Snedicor. del'd about May 18th to store.

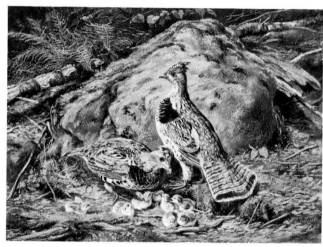

RUFFED GROUSE AND YOUNG 63.29

A. F. Tait / N.Y. '63 [LR] Panel: 11¾ × 16

No. 254 / A. F. Tait / Morrisania / Westchester Co. /
N.Y. U.S. / 1863

[No.] 254 [Dead Doe & two Fawns. "Orphans" Wm. Schaus
and an additional illegible word or two, all crossed out]
Ruffed Grouse & Young on Panel. Jas. B Blossom 18 × 12
paid for $150.00.

Note AFT records size different from actual mea-
surements.

PEACEFULNESS 63.30

[Unknown] [Unknown]: [Unknown]

[Unknown]

[No.] 255. [1863] Doe & two Fawns finished 4 July 1863
"Peacefulness". Williams & Everett—Boston.

CHICKENS 63.31

[Unknown] [Unknown]: 10 in. round [?]

[Unknown]

[No.] 256 Chickens. circle 10 in. charge. [$75.00] John C.
Force del'd per Snedicor.

CHICKENS 63.32

[Unknown] [Unknown]: 9 × 12 [?]

[Unknown]

[No.] 257 Chickens 12 × 9 square. Williams & Everett—
Boston. finished Jun 11, sent off June 15th.

CHICKENS 63.33

[Unknown] [Unknown]: 9 × 12 [?]

[Unknown]

[No.] 258 Chickens. 12 × 9 Williams & Everett Boston.
finished June 11th sent of[f] June 15th.

CHICKENS 63.34

[Unknown] [Unknown]: 10½ × 8¼ [?]

[Unknown]

[No.] 259 Chickens 10½ × 8¼ to Snedicors on sale—
Frame.

CHICKENS 63.35

[Unknown] [Unknown]: 7¾ × 9½ [?]

[Unknown]

[No.] 260 Chickens. 9½ × 7¾ to Schaus, June 15, on sale—
in Snedicor's Frame.

CHICKENS 63.36

A. F. Tait 1863 [?] [Unknown]: 10 × 11

No. 261 / A. F. Tait / Morrisania / Westchester Co. /
N.Y.

[No.] 261 [1863] Chickens. 10¾ × 9¾. sent to Snedicors
June 15 on sale (Frame).

CHICKENS 63.37

[Unknown] [Unknown]: 9 × 12 [?] oval

[Unknown]

[No.] 262 12 × 9 oval Chickens. young. sent to E. C.
Moore.

CHICKENS 63.38

[Unknown] [Unknown]: 9 × 12 [?]

[Unknown]

[No.] 263 Chickens. 12 × 9 square. Jas. S. Earle & Son.
finished July 6th.

QUAIL CHICKENS 63.39

[Unknown] [Unknown]: 9 × 12 [?] oval

[Unknown]

[No.] 264 Quail Chickens 12 × 9 oval. Jas. S. Earle & Son
finished July 6.

YOUNG RUFFED GROUSE 63.40

A. F. Tait, N.Y. [LR] Board: 9 × 12 oval

No. 265 / Young Ruffed Grouse / A. F. Tait / Morrisania
/ Westchester Co. N.Y. / 1863

[No.] 265 *Grouse chickens 12 × 9 oval. Jas. S. Earle & Son. finished July 6th.*

YOUNG QUAIL 63.41

[Unknown] Board: 10 × 8 [?]

[Unknown]

[No.] 266 *Young Quail 8 × 10 millboard. Jas. B. Blossom for wedding. Paid $50.00.*

[WOODCOCK AND YOUNG] 63.42

A. F. Tait / N.Y. 1863 [LR] Panel: 11¼ × 16

No. 267 A. F. Tait Morrisania Westchester Co. N.Y. 1863

[No.] 267. *Woodcock Male & Female & Young 16 × 12 on panel. Mr. Roy paid for $150.00.*

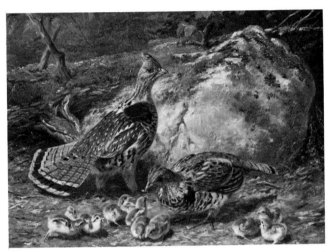

RUFFED GROUSE 63.43

A. F. Tait / N.Y. 1863 [LR] Panel: 11⅛ × 16⅛

No. 268 / Ruffed Grouse / A. F. Tait / Morrisania / Westchester Co. / N.Y. / U.S. / 1863.

[No.] 268 *Ruffed Grouse (Male & female) and young. 16 × 12 on panel. Mr. Ludkins Paid $150.00.*

YOUNG GROUSE 63.44

A. F. Tait / 1863 [LR] Panel: 10 × 12

No. 269. Young Grouse / A. F. Tait / Morrisania / N.Y. / 1863

[No.] 269. *Young Grouse. 12 × 10 Panel. Sale 1863. finished Nov. 13th.*

Exhibited and sold at Leeds Sale, December 18, 1863.

YOUNG RUFFED GROUSE 63.45

A. F. Tait / 1863 [LR] Panel: 10 × 12

No. 270 / Young Ruffed Grouse / A. F. Tait / Morrisania / N.Y. / 1863

[No.] 270 *Young Grouse. 12 × 10 Panel. Sale. Sale 1863. finish'd Nov 14.*

Exhibited and sold at Leeds Sale, December 18, 1863.

YOUNG CHICKENS 63.46

[Unknown] [Unknown]: 10 × 12 [?]

[Unknown]

[No.] 271 *Young Chickens. 12 × 10. sale 1863. finished Nov. 14.*

Exhibited and sold at Leeds Sale, December 18, 1863.

YOUNG CHICKENS 63.47

[Unknown] [Unknown]: 10 × 12 [?]

[Unknown]

[No.] 272 *Young Chickens 12 × 10. sale 1863 fin'd Nov. 15th.*

Exhibited and sold at Leeds Sale, December 18, 1863. One of a pair with 63.48.

THE PROTECTOR 63.48

A. F. Tait / N.Y. 1863 [LR] Panel: 17 × 23½

Morning / "The Protector" / No. 273 / A. F. Tait / Morrisania / Westchester County, / N.Y. 1863

[No.] 273 *[1863] The Protector. Morning (Buck Doe & Fawn) sale. Panel 24 × 18 finished Nov'r 17th.*

Exhibited and sold at Leeds Sale, December 18, 1863. One of a pair with 63.47.

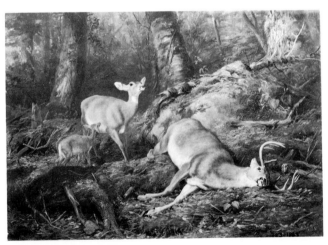

THE BEREAVED 63.49

A. F. Tait / 1863 [LR] Panel: 18 × 24

[Unknown]

[No.] 274 *Evening "The Bereaved." Dead Buck, Doe & Fawn. Panel 24 × 18. finished Nov. 20. Sale bought by Jas. Fraser, Esq.*

Exhibited and sold at Leeds Sale, December 18, 1863. Exhibited at the National Academy of Design 40th Annual Exhibition, 1865, titled "The Bereaved" and owned by James Fraser.

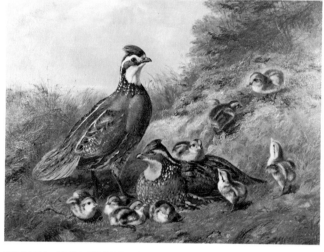

QUAIL AND YOUNG 63.50

A. F. Tait, 1963 [LL] Panel: 12 × 16

No. 275. Quail & Young. A. F. Tait, Morrisania, Westchester Co., N.Y. 1863

[No.] *275 Quail & Young. Cock & Hen & young. 18 × 12 Panel. Sale.*

Exhibited and sold at Leeds Sale, December 18, 1863.

Courtesy of Mrs. Ann Hoag Peirce.

QUAIL AND YOUNG 63.51

[Unknown] Board: 12 × 18 [?]

[Unknown]

[No.] *276 Quail & Young. Cock & Hen & young. 18 × 12 Millboard. sale.*

Exhibited and sold at Leeds Sale, December 18, 1863.

QUAIL AND YOUNG 63.52

[Unknown] Board: 12 × 18 [?]

[Unknown]

[No.] *277 Quail & Young. one Female & young. 18 × 12 Millboard. sale. Mr. Alex. White.*

Exhibited and sold at Leeds Sale, December 1863.

WOODCOCK 63.53

[Unknown] Panel: 12 × 18 [?]

[Unknown]

[No.] *278 [1863] Wookcock—Cock & Hen & Young. Sale. Panel 18 × 12.*

Exhibited and sold at Leeds Sale, December 18, 1863.

DOG AND DUCK 63.54

[Unknown] [Unknown]: 8 × 6 [?]

[Unknown]

[No.] *279 Dog & Duck—small oval 6 × 8. sale.*

Exhibited and sold at Leeds Sale, December 18, 1863.

DOG AND WOODCOCK 63.55

[Unknown] [Unknown]: 6½ × 5½ [?] oval [?]

[Unknown]

[No.] *280 Dog & two Woodcock. small oval. sale. 6½ × 5½.*

Exhibited and sold at Leeds Sale, December 18, 1863.

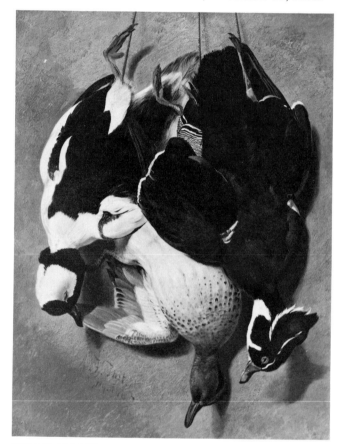

DEAD GAME 63.56

A. F. Tait / N.Y. 1863 [LL] Board: 15¼ × 11¼

Wood-duck, Green Winged Teal and Bufflehead / No. 281 / A. F. Tait N.Y. 1863.

[No.] *281 Dead Game (Wood Duck &c) 16 × 12 sale.* [Written over this entry but apparently partially erased: *not sent for sale;* this entry is preceded by the following, which was completely crossed out: *281 Deer leaping,* and several illegible words, *small oval 6 × 5½.*]

Exhibited and sold at Leeds Sale, December 18, 1863.

Courtesy of Mrs. Elizabeth E. Fosburgh for Mr. James H. E. Fosburgh.

[DEAD GAME: RUFFED GROUSE] 63.57

A. F. Tait / N.Y. 1863 [LR] Board: 15½ × 12

Am'n Ruffed Grouse / No. 282 / A. F. Tait / Morrisania / Westchester Co. / N.Y. / 1863

[No.] 282 *Dead game (Ruffed Grouse) for oval 14 × 12. Sale.*

Exhibited and sold at Leeds Sale, December 18, 1863.

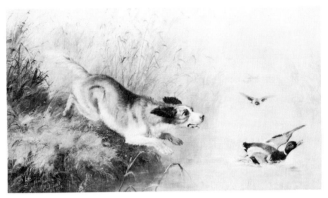

SPANIEL CHASING DUCK 63.60

A. F. Tait / N.Y. 1863 [LL] Canvas: 16 × 26

Spaniel Chasing Duck / A. F. Tait, 1863.

[No.] 285 *Dog & Duck 26 × 16 sale.*

Exhibited and sold Leeds Sale, December 18, 1863.

Courtesy of Mr. George A. Butler.

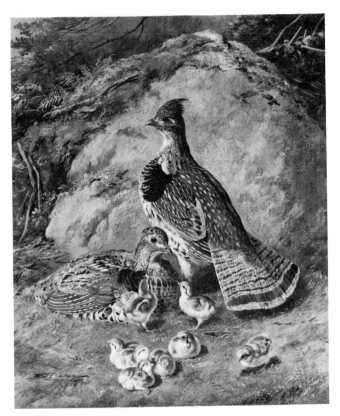

AMERICAN RUFFED GROUSE
AND YOUNG 63.58

A. F. Tait / N.Y. 1863 [LR] Canvas: 23½ × 19½

Am. Ruffed Grouse / and Young / A. F. Tait / Morrisania / Westchester Co. / N.Y. / No. 283 / 1863

[No.] 283 *[1863] Ruffed Grouse & young reposing. 24 × 20. sale.*

Exhibited and sold at Leeds Sale, December 18, 1863. Painting relined, March 1967.

DEAD GAME: CANVAS BACK DUCKS 63.59

[Unknown] [Unknown]: 9 × 12 [?]

[Unknown]

[No.] 284 *Dead Game. canvas back ducks. 12 × 9. finished Dec'r 17th / 1863. Sale.*

Exhibited and sold at Leeds Sale, December 18, 1863.

[DOG AND WOODCOCK] 63.61

[Unknown] [Unknown]: 18 × 24 [?]

[Unknown]

[No.] 286 *Dog & two Woodcock. 24 × 18. sale.*

Exhibited and sold at Leeds Sale, December 18, 1863.

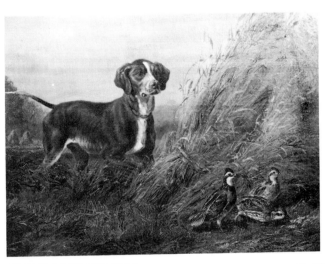

[DOG AND QUAIL] 63.62

A. F. Tait / N.Y. 1863 [LR] Canvas: 12 × 16

No. 287, A. F. Tait, Morrisania, Westchester Co., N.Y. 1863

[No.] 287 *Dog & Quail. corn stack 16 × 12. Alex White Sale.*

Exhibited and sold at Leeds Sale, December 18, 1863.

Courtesy of Mr. Peter K. Hoag.

JEALOUSY 63.63

[Unknown]

[Unknown] [Unknown]: 16 × 12 [?]

[Unknown]

[No.] 288 *Jealousy. Doe & two Fawns. 12 × 16. sale*

Exhibited and sold at Leeds Sale, December 18, 1863.

YOUNG CHICKENS 63.64

[Unknown] [Unknown]: 8 × 11 [?]

[Unknown]

[No.] 289 *[1863] Young Chickens & Moth. 11 × 8. finished
Dec'r 17 / 63. sale.*

Exhibited and sold at Leeds Sale, December 18, 1863.

RUFFED GROUSE AND YOUNG 63.65

[Unknown] [Unknown]: 12 × 18 [?]

[Unknown]

[No.] 290 *Ruffed Grouse & Young. 18 × 12. not painted yet
Dec. 18th / 63.*

POINTER 63.66

[Unknown] [Unknown]: 5½ × 6½ [?] oval

[Unknown]

[No.] 291 *Pointer (small oval) 6½ × 5½. sale.*

Exhibited and sold at Leeds Sale, December 18, 1863.

DOG RETRIEVING DEAD DUCK 63.67

[Unknown] [Unknown]: 8 × 6 [?] oval

[Unknown]

[No.] 292 *Dog & dead duck. retrieving. (Small oval) 6 × 8.
Sale Dec. 18th / 63. 23 for sale, recently painted for sale. 3 at
Snedicor since July around $150. 1 sketch Prairie on Fire from
J.B.B. [Total] 27.*

Exhibited and sold at Leeds Sale, December 18, 1863.

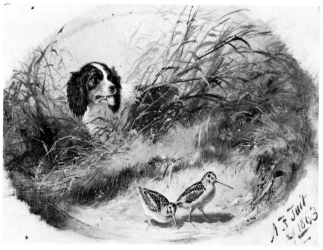

63.68

SETTER AND WOODCOCK 63.68

A. F. Tait [LR] Panel: 6½ × 8½ oval

[Nothing on back]

[No.] 310 *Setter & Woodcock. (two Birds) 6 × 8 oval Mr.
Emmett per Snedicor 50.00 paid.*

This signature appears at LR outside of painted oval:
"A. F. Tait / N.Y. 1863." For another AFT no. 310, see
64.27.

Courtesy of Mrs. John J. McClean.

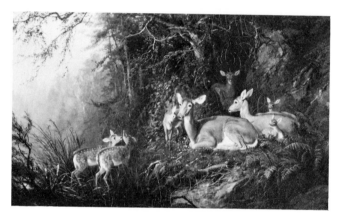

[AT HOME] 63.69

A. F. Tait, J. M. Hart, 1863 [LR] Canvas: 16 × 26

[Nothing on back by AFT]

[No AFT number; no Register entry]

Described as "Three does and six fawn in a forest set-
ting."

Courtesy of Mr. and Mrs. George Arden.

CHICKENS 64.1

[Unknown] [Unknown]: 9 × 12 [?]

[Unknown]

[No.] 293 *Chickens. 12 × 9. Williams & Everett. Boston.
sent of[f] per express Jan'y 26 / 64.*

Bracketed in the Register with No. 294 (64.2).

CHICKENS 64.2

[Unknown] [Unknown]: 9 × 12 [?]

[Unknown]

[No.] 294 *Chickens. 12 × 9 W & E* [Williams & Everett]
Boston. sent off same as above [64.1].

Bracketed with No. 293 (64.1).

YOUNG QUAIL 64.3

[Unknown] [Unknown]: 8 × 10 [?]

[Unknown]

[No.] *295 Young Quail. 10 × 8.*

[RUFFED GROUSE AND YOUNG] 64.4

[Unknown] Panel: 12 × 18 [?]

[Unknown]

[No.] *296 Cock & Hen Ruffed Grouse & young. 18 × 12 Panel. Maitland (Murray 13th St) del'd to Murray at my studio. Paid for Jan'y 25th $150.00.*

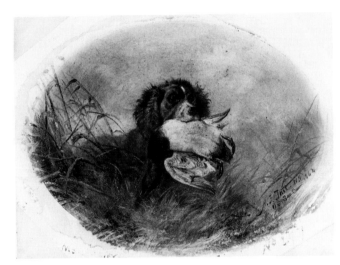

SPANIEL AND CANVAS BACK DUCK 64.5

A. F. Tait N.Y. / U.S. Paper: 6¾ × 8¾ oval
San Comm 1864 / No. 297 /
Westchester Country Fair
Sanitary Commission

[Unknown]

[No.] *297 Spaniel & Canvass Bk Duck on paper 8½ × 6½ oval for U.S. San. Com. Fair. Presented.*

Courtesy of Mr. and Mrs. George Arden.

CHICKENS 64.6

[Unknown] Board: 9 × 12 [?]

[Unknown]

[No.] *298 [1864] Chickens. Millboard 12 × 9 sqr. Farley Sim's Friend.*

CHICKENS 64.7

[Unknown] Board: 10 × 8 [?] oval

[Unknown]

[No.] *299 Chickens millboard 8 × 10 oval. Presented to Mrs. Leeds.*

See 64.76.

THE PORTAGE 64.8

[Unknown] Panel: 35 × 55 [?]

[Unknown]

[No.] *300 The Portage. on mahogany Panel size 55 × 35 on Panel. J. S. Hart painted background. finished March 1st 1865. Sent to England to Wm Cawkwell. Euston Sqr, London, in a frame for sale. price minimum 250 [250 pounds sterling] including frame. Came back and sold at my sale to Jas B. Blossom for $500. Frame paid for extra.*

Exhibited and sold at Leeds Sale, April 5, 1866. Exhibited at the U.S. Centennial Exhibition, 1876, owned by J. B. Blossom. *Official Catalogue of The Art Gallery and Annexes*, p. 20. Sold at Ortgies Auction Gallery, New York, March 27–29, 1889, titled "End of The Carry, Adirondacks." Referred to as "Carry Painting" by AFT in notation concerning its delivery with sixty-one other paintings to Leeds Sale in March 1866.

CHICKENS 64.9

[Unknown] [Unknown]: 10 × 8 [?] oval

[Unknown]

[No.] *301 Chickens—8 × 10 oval. Presented to Mrs. Snedicor.*

[THE YOUNG FORAGERS] 64.10

A. F. Tait / 1864 [LR] [Unknown]: 10 round

[Unknown]

[No.] *302 Chickens. 10 in. circle. Jas. M. Hart. del'd.*

A steel engraving by R. Hinshelwood, titled "The Young Foragers," was published in *The Ladies Repository* 27 (June 1867). The engraving is discussed on page 384, where its title is given as "The Little Foragers."

CHICKENS 64.11

A. F. Tait / N.Y. 1863 [LR] Board: 7⅝ × 9⁹⁄₁₆

No. 303, A. F. Tait, Morrisania, Westchester Co., N.Y. 1863

[No.] *303 Chickens. 7 × 9 millboard. sent to Snedicor (Brooklyn U.S. San'y Commission).*

CHICKENS 64.12

[Unknown] Board: 9 × 7 [?]

[Unknown]

[No.] *304 Chickens. 7 × 9 millboard. Sent to Snedicor. (Brooklyn U.S. Sanitary Commission).*

For another AFT No. 304 see 64.21.

GOATS AND DUCKS 64.13

[Unknown] [Unknown]: 10 × 12 [?]

[Unknown]

[No.] *305 Goats & Ducks. 12 × 10. Sent to Snedicor. (Brooklyn U.S. Sanitary Commission).*

For another AFT No. 305 see 64.22.

DOG AND QUAIL 64.14

[Unknown] [Unknown]: 14 × 22 [?]

[Unknown]

[No.] *306 Dog & quail. 22 × 14. Mr. T. P. Briggs del'd March 3. sent to Boston. paid per Ch'k $175.00.*

For another AFT No. 306 see 64.23. This painting was later exchanged with Briggs for No. 366 (64.75).

GOATS AND DUCKS 64.15

[Unknown] [Unknown]: 9 × 12 [?]

[Unknown]

[No.] *307 Goats & Ducks. 12 × 9. U.S. Sanitary Fair, Brooklyn.*

For another AFT No. 307 see 64.24.

SETTER AND WOODCOCK 64.16

[Unknown] [Unknown]: 8 × 6 [?] oval

[Unknown]

[No.] *308 Setter & Woodcock. small oval 6 × 8. per Snedicor.*

For another AFT No. 308 see 64.25.

GOATS AND DUCKS 64.17

[Unknown] [Unknown]: 9 × 12 [?]

[Unknown]

[No.] *309 Goats & Ducks. 12 × 9. Presented to Brooklyn U.S. Sanitary Commission Fair.*

For another AFT No. 309 see 64.26.

COCKER SPANIEL HEAD 64.18
AND WOODCOCK

[Unknown] [Unknown]: 10 × 6 [?]

[Unknown]

[No.] *311 Cocker Spaniel (Head) & Woodcock. 6 × 10 for N.Y. Sanitary Commission.*

For another AFT No. 311 see 64.28.

HEN QUAIL AND YOUNG 64.19

[Unknown] [Unknown]: 10 × 12 [?]

[Unknown]

[No.] *312 Hen Quail & Young. finished March 15th / 64. 12 × 10 Sgr. Williams & Everett, Boston.*

For another AFT No. 312 see 64.29.

YOUNG CHICKENS 64.20

[Unknown] [Unknown]: 10 × 12 [?]

[Unknown]

[No.] *313 Young Chickens. 12 × 10. finished March 16th.*

For another AFT No. 313 see 64.30.

BUCK AND DOE DEER 64.21

[Unknown] [Unknown]: 10 × 12 [?]

[Unknown]

[No.] *304 Deer. (Buck & Doe) 12 × 10. presented to the N.Y. Fair for U.S. Sanitary Comm. March 29th 1864.*

For another AFT No. 304 see 64.12.

[SIX PAINTINGS: 64.22–.27
FOUR QUAIL, TWO CHICKENS]

[See remarks] [See remarks]

[See remarks]

[Nos. 305–10] *April 12 sent off per Harndens Express. to Boston* [with bracket, in right margin:] *all sent off Ap' 12th. rec'd & paid for for Dpt.* [Deposit?] *per J. B. Blossom* [followed by individual entries and descriptions, Nos. 305–10 (64.22–64.27)].

Six paintings, four of quail, "12 × 10 oval," and two chickens, "12 × 10," one, and probably both, on panel, for which see the following individual entries (64.22–64.27).

HEN QUAIL AND YOUNG 64.22

[Unknown] Board: 10 × 12 [?] oval

[Unknown]

[No.] *305. April 12, sent off per Harnden's Express to Boston. Hen Quail & Young on millboard 12 × 10 oval. Williams & Everett—Boston. $80.*

For another AFT No. 305 see 64.13.

YOUNG QUAIL 64.23

[Unknown] [Unknown]: 10 × 12 [?] oval

[Unknown]

[No.] *306 [Quail &* crossed out] *Young Quail. 12 × 10 oval. Williams & Everett, Boston $80.*

For another AFT No. 306 see 64.14.

HEN QUAIL AND YOUNG 64.24

[Unknown] [Unknown]: 10 × 12 [?] oval

[Unknown]

[No.] *307 Hen Quail & Young. 12 × 10 oval. Williams & Everett, Boston. $80.*

For another AFT No. 307 see 64.15.

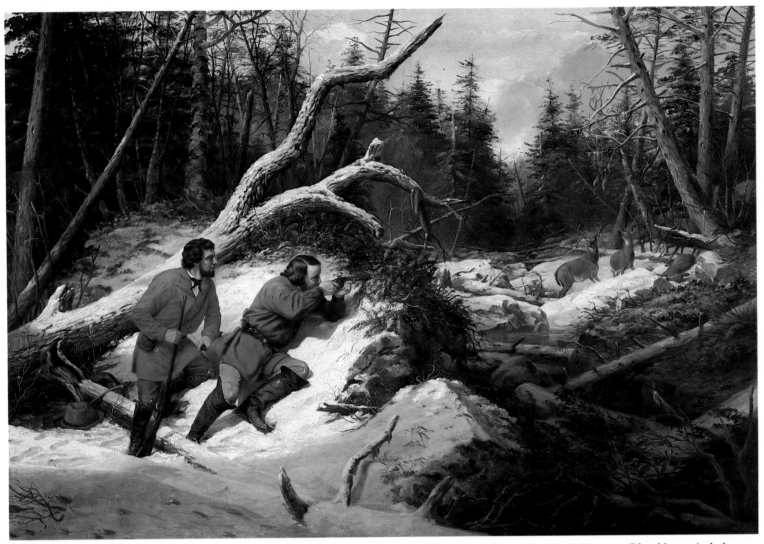

55.1 Still Hunting on the First Snow: A Second Shot, *canvas: 54 × 76. Collection of The Adirondack Museum, Blue Mountain Lake, New York. Courtesy of The Adirondack Museum.*

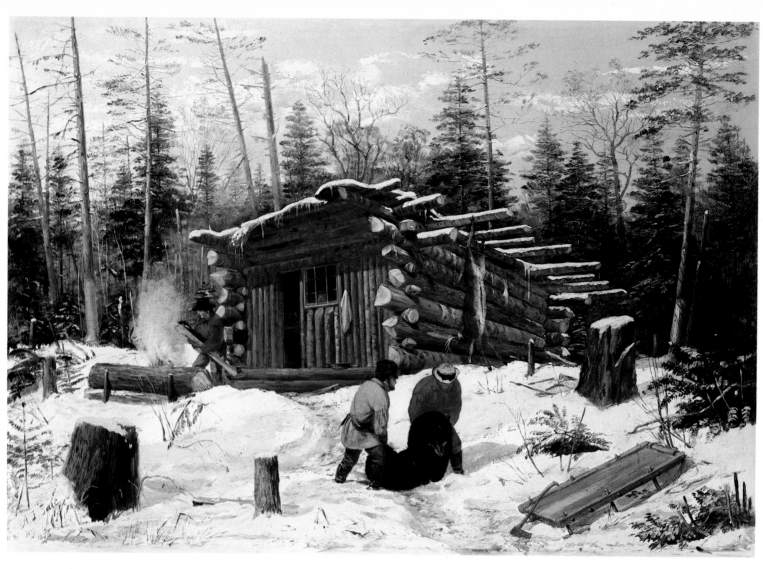

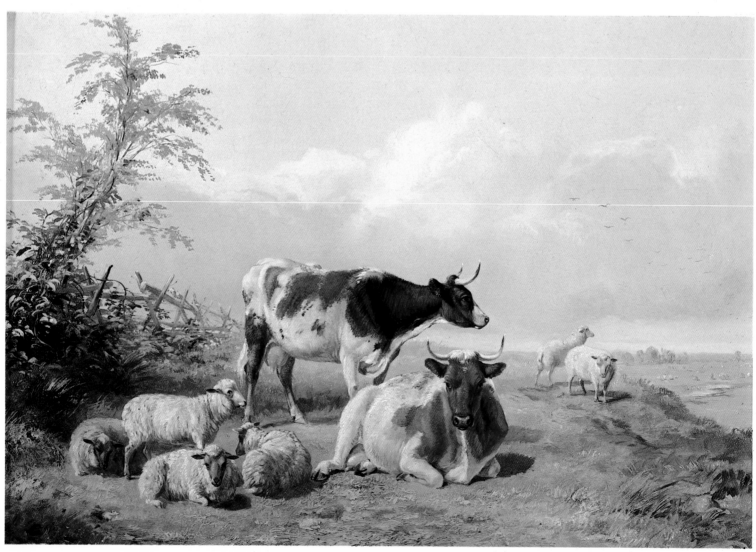

60.52 *[Study at Raquette Lake], canvas: 16¾ × 23¼. Collection of The Adirondack Museum, Blue
Mountain Lake, New York. Courtesy of The Adirondack Museum.*

61.1 *[Dorking Chickens], board: 8 × 10. Collection of The Adirondack Museum, Blue Mountain Lake, New
York. Courtesy of The Adirondack Museum.*

58.11 Cattle and Sheep, *board: 10¼ × 14.*

61.31 Duck Shooting with Decoys, *canvas: 14 × 22. Courtesy of Mr. and Mrs. George Arden.*

61.42–.50 [Camp in the Adirondacks, Nine Views of the Adirondacks]. Collection of The Adirondack Museum, Blue Mountain Lake, New York. Courtesy of The Adirondack Museum.

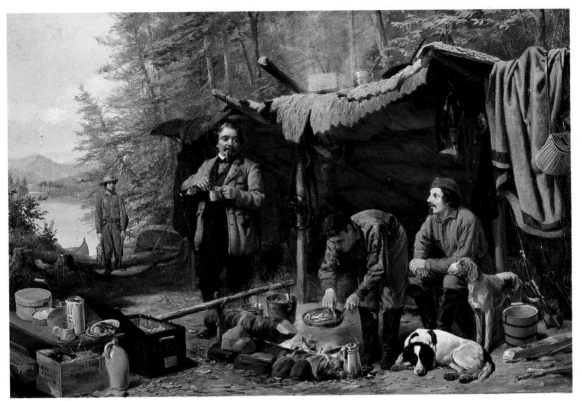

62.16 A Good Time Coming, *canvas: 20¼ × 30. Collection of The Adirondack Museum, Blue Mountain Lake, New York. Courtesy of The Adirondack Museum.*

63.69 [At Home], *canvas: 16 × 26. Courtesy of Mr. and Mrs. George Arden.*

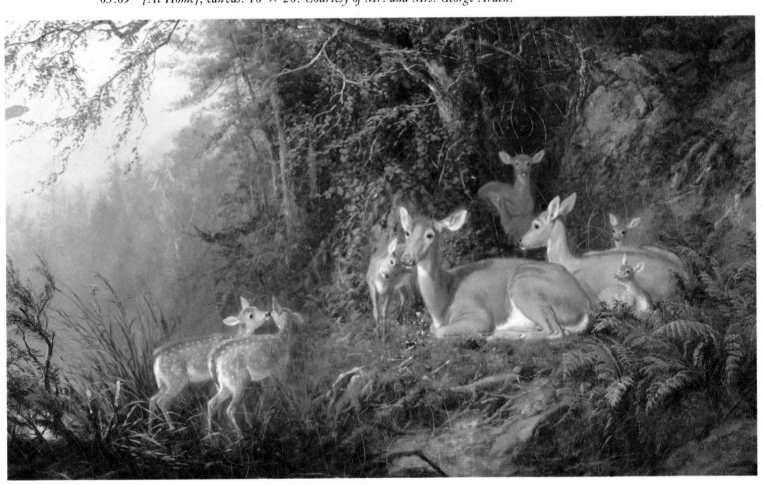

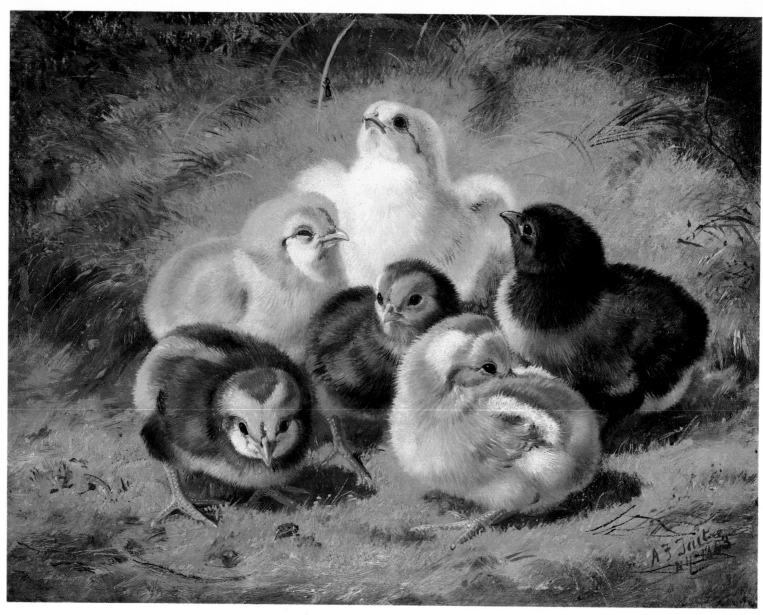

64.11 Chickens, *board: 7⅝ × 9%₁₆. Courtesy of Mrs. S. Dillon Ripley.*

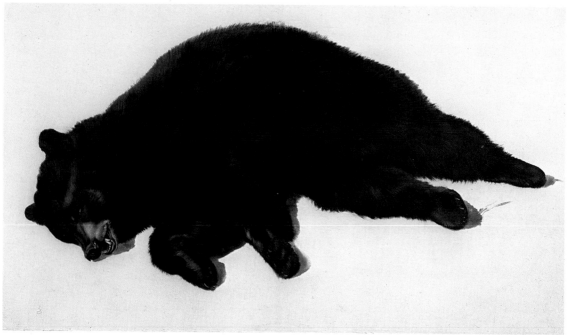

68.22 [American Black Bear], *canvas: 15 × 26. Collection of The Adirondack Museum, Blue Mountain Lake, New York. Courtesy of The Adirondack Museum.*

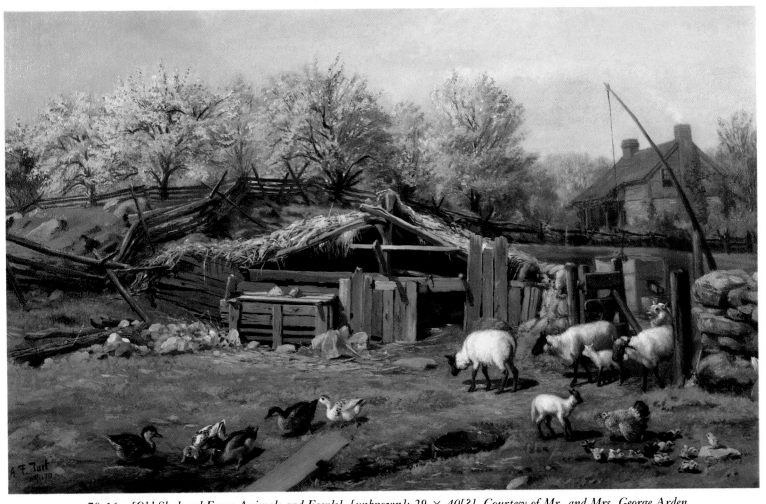

70.16 *[Old Shed and Farm Animals and Fowls], [unknown]: 29 × 40[?]. Courtesy of Mr. and Mrs. George Arden.*

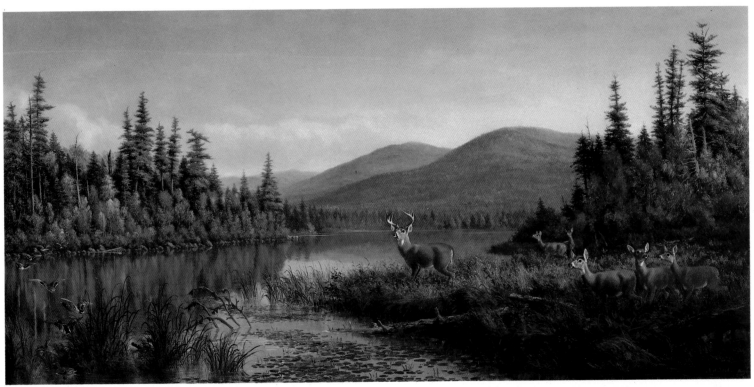

72.16 Autumn Morning, Racquette Lake, *canvas: 36 × 71¾. Collection of The Adirondack Museum, Blue Mountain Lake, New York. Courtesy of The Adirondack Museum.*

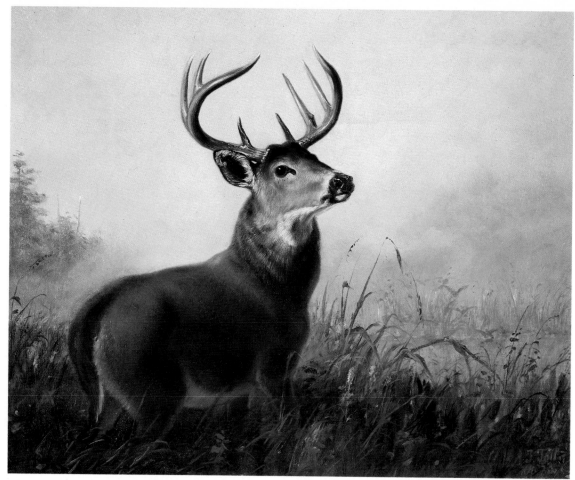

73.3 Morning on the Loon Lake, *canvas: 16 × 20. Collection of The Adirondack Museum, Blue Mountain Lake, New York. Courtesy of The Adirondack Museum.*

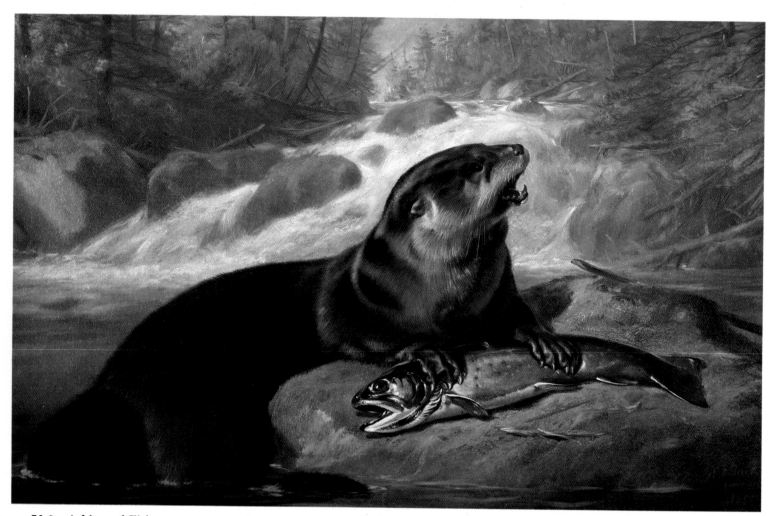

75.9 A Natural Fisherman, *canvas: 13½ × 21½. Collection of The Adirondack Museum, Blue Mountain Lake, New York. Courtesy of The Adirondack Museum.*

HEN QUAIL AND YOUNG 64.25

[Unknown] [Unknown]: 10 × 12 [?] oval

[Unknown]

[No.] *308 Hen Quail & Young. 12 × 10 oval. Williams & Everett, Boston. $80.*

For another AFT No. 308 see 64.16.

CHICKENS 64.26

[Unknown] Panel: 10 × 12 [?]

[Unknown]

[No.] *309 Chickens (something like Mrs. Schaus') vine leaves. 12 × 10 on panel. Williams & Everett, Boston. $100.00.*

For another AFT No. 309 see 64.17.

CHICKENS 64.27

[Unknown] Board: 10 × 12 [?]

[Unknown]

[No.] *310 Chickens. 12 × 10 millboard. Hay stack. $80.00. Williams & Everett, Boston.*

For another AFT No. 310 see 63.68.

HEN QUAIL AND YOUNG 64.28

[Unknown] Panel: 9 × 11 [?]

[Unknown]

[No.] *311 April 13th. 1864. Hen Quail & Young. Panel 11 × 9. dew drops on grass. Extra finish. Mr. Mill's friend. he paid J.B.B. $100.*

For another AFT No. 311 see 64.18.

CHICKENS 64.29

[Unknown] [Unknown]: 12 × 10 [?]

[Unknown]

[No.] *312 Chickens. 10 × 12 Williams & Everett. Sent off June 9th about.*

For another AFT No. 312 see 64.19.

CHICKENS 64.30

[Unknown] [Unknown]: 12 × 10 [?]

[Unknown]

[No.] *313 Chickens. 10 × 12 Williams & Everett. sent off June 9 about with No. 324.*

For another AFT No. 313 see 64.20.

CHICKENS 64.31

[Unknown] [Unknown]: 12 × 10 [?]

[Unknown]

[No.] *314 Chickens. W & E [Williams & Everett] Boston. 10 × 12.*

CHICKENS 64.32

[Unknown] [Unknown]: 12 × 10 [?]

[Unknown]

[No.] *315 Chickens. 10 × 12 W & E [Williams & Everett] Boston.*

CHICKENS 64.33

[Unknown] [Unknown]: 12 × 10 [?]

[Unknown]

[No.] *316 Williams & Everett. Chickens 10 × 12.*

CHICKENS 64.34

A. F. Tait N.Y. '64 Board: 10 × 12

No. 317, A. F. Tait, Morrisania, Westchester Co., N.Y. 1864

[No.] *317 Chickens. 10 × 12 Williams & Everett. Boston.*

HEN QUAIL 64.35

[Unknown] Panel: 9 × 11 [?]

[Unknown]

[No.] *318 [1864] Hen Quail. 11 × 9 Panel. at Snedicors not accounted for yet July 1st / 64.*

CHICKENS 64.36

[Unknown] [Unknown]: 10 × 12 [?] oval

[Unknown]

[No.] *319 Chickens. 12 × 10 oval. Goupils May 9th per Polly. sold at sale May 11 for $100 to a/c.*

CHICKENS 64.37

[Unknown] [Unknown]: 10 × 12 [?] oval

[Unknown]

[No.] *320 Chickens. 12 × 10 oval. To Goupils May 9th per Polly. sold at sale for $100 to a/c.*

CHICKENS 64.38

[Unknown] Board: 10 in. round [?]

[Unknown]

[No.] *321 Chickens. 10 in circle on millboard. Jas. Hart friend $100 del'd May 14th / 64. Paid $100 by J. M. Hart.*

CHICKENS 64.39

[Unknown] Panel: 10 × 12 [?]

[Unknown]

[No.] *322 Chickens. 12 × 10 Square Panel. del'd to Snedicor. paid me $100.*

CHICKENS 64.40

[Unknown] [Unknown]: 10 × 12 [?] oval

[Unknown]

[No.] *323 Chickens. 12 × 10 oval. Snedicor. paid $100. paid per chk sent to H. B. Mace $165.50 June 2nd / 64.*

CHICKENS 64.41

[Unknown] [Unknown]: 10 × 12 [?]

[Unknown]

[No.] *324 Chickens. 12 × 10. sent to Williams & Everett with 312 & 313 [64.29 and 64.30].*

CHICKENS 64.42

[Unknown] [Unknown]: 9 × 12 [?] oval

[Unknown]

[No.] *325 Chickens. 12 × 9 oval. Goupil paid for same time $100 June 2nd / 64.*

CHICKENS 64.43

[Unknown] [Unknown]: 9 × 12 [?] oval

[Unknown]

[No.] *326 [1864] Chickens. 12 × 9 oval. Goupil. del'd June 17th. paid for same time $100.*

CHICKENS 64.44

[Unknown] [Unknown]: 9 × 12 [?] oval

[Unknown]

[No.] *327 Chickens. 12 × 9 oval. Snedicor. del'd June 17th part paid for $65 per Maces a/c.*

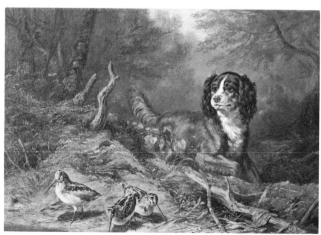

[THE INTRUDER] 64.45

A. F. Tait / N.Y. 1864 [LR] Panel: 14 × 20

No. 328 / A. F. Tait / Morrisania / Westchester Co. / N.Y. / 1864.

[No.] *328. Cocker Spaniel & 3 Woodcock 20 × 14 on panel. Williams & Everett.*

Courtesy of Mrs. Beatrice Rosenblum.

HEAD OF COCKER SPANIEL 64.46
AND WOOD DUCK

[Unknown] [Unknown]: 10 × 8 [?] oval

[Unknown]

[No.] *329 Head of Cocker Spaniel & Wood-duck. oval 8 × 10. Chas. W. Blossom.*

HEAD OF RETRIEVER AND QUAIL 64.47

[Unknown] [Unknown]: 10 × 8 [?]

[Unknown]

[No.] *330 Head of Retriever & Quail. 8 × 10. Si [Josiah] Blossom.*

QUAIL AND YOUNG 64.48

[Unknown] [Unknown]: 10 × 8 [?]

[Unknown]

[No.] *331 Quail & Young. Sqr 8 × 10. Chas W. Blossom.*

DOE AND FAWNS 64.49

[Unknown] [Unknown]: 10 × 8 [?] oval

[Unknown]

[No.] *332 Doe & Two Fawns. oval 8 × 10. Chas W. Blossom.*

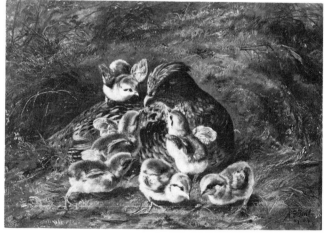

RUFFED GROUSE AND YOUNG 64.50

A. F. Tait / N.Y. 64 [LR] [Unknown]: 10 × 14

[Unknown]

[No.] *333 Ruffed Grouse & Young. 14 × 10. Mr McCoys friend.*

Courtesy of Kennedy Galleries, Inc., New York, New York.

HEN QUAIL AND YOUNG 64.51

[Unknown] [Unknown]: 10 × 14 [?]

[Unknown]

[No.] *334 Hen Quail & Young. 14 × 10. McCoys friend.*

QUAIL AND YOUNG 64.52

[Unknown] [Unknown]: 10 × 12 [?] arch top

[Unknown]

[No.] *335 Quail & Young. 12 × 10 [sketch of arch top] Mr. Hartshorne. [$125.00] Paid Sept 17th.*

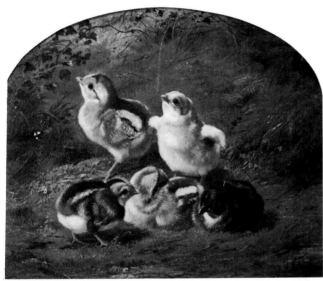

CHICKENS 64.53

A. F. Tait / N.Y. 1864 [LR] Board: 9½ × 11½
 arch top

No. 336 / A. F. Tait / Morrisania / Westchester / N.Y. / 1864

[No.] *336 Chickens. 12 × 10 [sketch of arch top] Mr. Hartshorne [$125.00]. Paid Sept 17th.*

See also 64.54 and 64.69.

Courtesy of a Massachusetts collection.

CHICKENS 64.54

A. F. Tait, 1864 [LR] Board: 10 × 14

1864, No. 337, A. F. Tait, Morrisania, Westchester Co., N.Y. Dr. Norman Smith, 740 Lexington Ave.

[No.] *337 Chickens. Extra. 14 × 10. Wm Schaus. Paid Sept 18th [$100.00].*

CHICKENS 64.55

[Unknown] [Unknown]: 10 × 14 [?]

[Unknown]

[No.] *338. Chickens. Extra. 14 × 10. Wm Schaus. Paid Sept'r 17 [$125.00].*

CHICKENS 64.56

[Unknown] [Unknown]: 10 × 14 [?]

[Unknown]

[No.] *339 [1864] Chickens. 14 × 10 del'd Wm Schaus Oct'r 29th.*

Bracketed with No. 340 (64.57).

CHICKENS 64.57

[Unknown] [Unknown]: 10 × 14 [?]

[Unknown]

[No.] *340 Chickens 14 × 10 Wm Schaus. del'd Oct 27th same time as 339 [64.56].*

Bracketed with No. 339 (64.56).

CHICKENS 64.58

[Unknown] [Unknown]: 10 × 14 [?]

[Unknown]

[No.] *341 Chickens. 14 × 10. Finished & del'd to Wm Schaus Nov'r 10th per Sam.*

Bracketed with No. 342 (64.59).

CHICKENS 64.59

[Unknown] [Unknown]: 10 × 14 [?]

[Unknown]

[No.] *342 Chickens. 14 × 10 del'd to Schaus Nov'r 10th (per Sam).*

Bracketed with No. 341 (64.58).

CAUSE OF OUR TROUBLES 64.60

A. F. Tait / N.Y. '64 [LR] Board 11¾ × 15¾

A. F. Tait / Morrisania / Westchester Co. / N.Y. / 1864

[No.] *343 Chickens. 14 × 10. Cause of our troubles. One black & 5 other chickens. del'd Nov'r 17th. Paid $100.*

CHICKENS 64.61

[Unknown] [Unknown]: 10 × 14 [?]

[Unknown]

[No.] *344 Chickens. 14 × 10 Del'd Nov 17—paid for Nov 28 per chk of 23rd.*

CHICKENS 64.62

[Unknown] Board: 10 × 14 [?]

[Unknown]

[No.] *345 Chickens 10 × 14 Millboard. Wm Schaus.*
[$100.00] *finished Nov'r 27th del'd. Paid Nov 29th.*

Bracketed with No. 346 (64.63).

CHICKENS 64.63

A. F. Tait / N.Y. / '64 [LR] Board: 10 × 14

346. A. F. Tait / Morrisania / Westchester C. / 1864.

[No.] *346 Chickens. 10 × 14. Wm Schaus* [$100.00]
finished Nov'r 27th. del'd. Paid for by chk Nov. 29.

Bracketed with No. 345 (64.62).

CHICKENS 64.64

[Unknown] Board: 10 × 14 [?]

[Unknown]

[No.] *346a Chickens. 10 × 14 millboard. Wm. Schaus.*

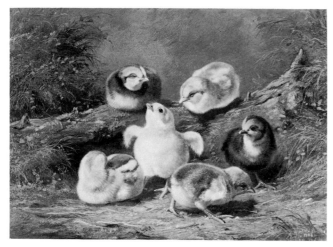

CHICKENS 64.65

A. F. Tait / N.Y. 1864 [LR] Panel: 10 × 14

No. 347, A. F. Tait, Morrisania, Westchester, N.Y.,
1864.

[No.] *347 Chickens. 10 × 14. Wm. Schaus, del'd. Paid.*

CHICKENS 64.66

[Unknown] [Unknown]: 9 × 12 [?]

[Unknown]

[No.] *348 Chickens. 12 × 9. at Schaus Sept'r 18th, 64. del'd
to Schaus.*

WOODCOCK AND SETTER 64.67

[Unknown] Panel: 18 × 12 [?]

Unknown]

[No.] *350 Woodcock & Setter. 12 × 18 Panel. Alex White.
delivered & paid Oct'r* [$200.00].

RUFFED GROUSE AND YOUNG 64.68

[Unknown] Panel: 18 × 12 [?]

[Unknown]

[No.] *351 Ruffed Grouse & Young. 12 × 18 Panel.*
[$200.00] *Alex White. del'd & Paid Oct'r.*

CHICKENS 64.69

[Unknown] [Unknown]: 14 × 10 [?]

[Unknown]

No. 337a [apparently corrected from *No. 336a*] *Chickens a
repetition of No. 336* [64.53, although No. 337 (64.54) may
actually be meant] *for Schaus 10 × 14.*

CHICKENS 64.70

[Unknown] Panel: 9 × 11 [?]

[Unknown]

[No.] *350.a. 11 × 9. Chickens on Panel. Exchange with
Rob't for Henry Repeater (at Schaus) for Henry Rifle.
Nov'r 27th. Paid & del'd.*

CHICKENS 64.71

A. F. Tait / N.Y. 1864 [LR] Board: 10 × 14

No. 352 / A. F. Tait / Morrisania / Westchester Co. /
N.Y. / 1864

[No.] *352 Chickens. 14 × 10 millboard. Wm. Schaus. del'd
Dec'r 14.*

Bracketed with No. 353 (64.72) and together marked:
Paid Dec'r 15.

CHICKENS 64.72

[Unknown] Board: 10 × 14 [?]

[Unknown]

[No.] *353 Chickens. 14 × 10 millboard. Wm. Schaus. del'd
Dec'r 14.*

Bracketed with No. 352 (64.71) and together marked:
Paid Dec'r 15.

CHICKENS 64.73

[Unknown] Board: 10 × 14 [?]

[Unknown]

[No.] *364 Chickens. 14 × 10 Millboard. Dock leaves Wm
Schaus. fin Dec'r 14 del'd Dec 15 / Paid for.*

Bracketed with No. 365 (64.74) and together marked:
Paid Dec'r 22d / 64.

CHICKENS 64.74

[Unknown] Board: 10 × 14 [?]

[Unknown]

[No.] *365 Chickens (Dock leaves) 14 × 10 Millboard. Wm
Schaus. finished Dec'r 15th del'd Dec'r 16. Paid for.*

Bracketed with No. 364 (64.73) and together marked: *Paid Dec'r 22d / 64.*

CHICKENS 64.75

[Unknown] [Unknown]: 10 round [?]

[Unknown]

[No.] 366 *T. P. Briggs—Chickens. 10 in circle. in exchange for No. 306* [64.14].

YOUNG CHICKENS 64.76

A. F. Tait [LR] Board: 7¾ × 9¾ oval

A. F. Tait / Morrisania / Westchester Co. / N.Y. / Feb. 12, 64 / 1864.

[No AFT number; no Register entry]

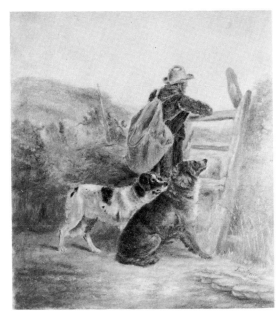

[UNKNOWN] 64.77

A. F. Tait / 1864 [LR] Board: 16 × 12½

[Nothing on back]

[No AFT number; no Register entry]

The owner describes this painting as a "man with a sack on his back looking over a fence, with two dogs in the foreground." He further states that it appears to be an oil-wash study.

[THREE CHICKS & RED SPIDER] 64.78

A. F. Tait / N.Y. 1864 [LR] Wood Panel: 11¾ × 14

[Nothing on back]

[No AFT number; no Register entry]

Described as three chicks, two of whom are going after a red spider.

CHICKENS 65.1

[Unknown] [Unknown]: 10 × 14 [?]

[Unknown]

No. 367 chickens 14 × 10. Schaus—finished Jan'y 16th. del'd Jan'y 17th.

CHICKENS 65.2

[Unknown] [Unknown]: 10 × 14 [?]

[Unknown]

[No.] 368 *Chickens. 14 × 10. Schaus. finished Jan 16. del'd 17th.*

CHICKENS 65.3

[Unknown] Board: 10 × 14 [?]

[Unknown]

[No.] 369 *Chickens. 14 × 10 millboard. Schaus. fin June 23rd del'd June 26. Paid.*

[DOE AND FAWNS] 65.4

[Unknown] [Unknown]: 12 × 10 [?]

[Unknown]

[No.] 369½ *Doe & Two Fawns. 10 × 12. Rob't Stalberg. exchange & paid. fin. July 8.*

CHICKENS 65.5

[Unknown] Board: 10 × 14 [?]

[Unknown]

[No.] 370 *Chickens. 14 × 10 mill'd. Schaus. fin June 23— del'd June 26. Paid.*

CHICKENS 65.6

A. F. Tait / N.Y. 1865 [LR] Board: 10 × 13½

No. 371. / A. F. Tait / Morrisania / Westchester Co. N.Y. / 1865.

[No.] 371 *Chickens. millboard 12 × 14. Schaus. finished July 8th. Del'd and put to a/c.*

CHICKENS 65.7

A. F. Tait / N.Y. 1865 [LR] Board: 12 × 14

No. 372. / A. F. Tait / Morrisania / Westchester Co. / N.Y. / 1865.

[No.] 372 *Chickens. Millboard 12 × 14. Schaus—finished July 10. Del'd & put to a/c.*

CHICKENS 65.8

[Unknown] Board: 14 × 12 [?]

[Unknown]

[No.] 373 *Chickens. Millboard 12 × 14. Schaus. finished Aug 23rd Paid.*

CHICKENS 65.9

A. F. Tait / N.Y. 1865 [LR] Board: 10 × 14

No. 374 / A. F. Tait / Morrisania / Westchester Co. /
N.Y. / 1865

*No. 374 [1865] Chickens. Millboard 12 × 10. Schaus.
finished Aug 24th. Paid.*

Courtesy of Mr. and Mrs. George Arden.

*Jno. F. McCoy present'd to him instead of interest April 15th,
1866.*

Courtesy of Mr. and Mrs. George Arden.

SHEEP	65.10
[Unknown]	Board: 9 × 11 [?]
[Unknown]	

*[No.] 375 Sheep. 11 × 9 Millboard. H. N. Camp for
(Sugar). finish'd Oct 16th / 65. returned October 1868 and
another in exchange to be painted. 375 sent to Snedicors for Sale.*

CHICKENS	65.11
[Unknown]	Board: 9 × 11 [?]
[Unknown]	

*[No.] 376 Chickens. 11 × 9 Millboard. finished Oct 17th /
65 H. N. Camp. (Sugar) had in 1864.*

DUCKS	65.12
[Unknown]	[Unknown]: 3 × 4 [?] oval
[Unknown]	

*[No.] 377 a small 3 × 4 oval of Ducks for Jim B. Blossom.
present Xmas 1865.*

DUCKS	65.13
[Unknown]	[Unknown]: 10 round [?]
[Unknown]	

[No.] 378 Ducks—10 in. Circle. Joint J. M. Hart & Tait.

DUCKS	65.14
James M. Hart and A. F. Tait /	Canvas: 10 round
N.Y. 1866 [LR]	

No. 379. Painted by James M. Hart and AFT.

[No.] 379 Ducks. 10 in. circle. Joint J. M. Hart & Tait.

CHICKENS	65.15
[Unknown]	Board: 10 × 14 [?]
[Unknown]	

*[No.] 396 [1865] Chickens. 14 × 10 M. To Feyer Balti-
more. finished Jan. 14. sent off by Adam's Express Jan'y 17th.*

CHICKENS	65.16
[Unknown]	Board: 10 × 14 [?]
[Unknown]	

*[No.] 397 Chickens. 14 × 10. N. fin'd Jan. 14. Feyer
Baltimore. sent by Adams Xpr Jan 17th.*

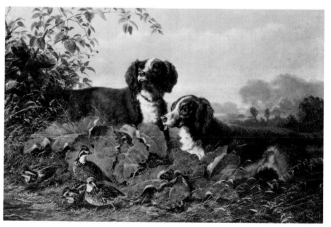

TWO SETTERS AND QUAIL	65.17
A. F. Tait, N.Y. / 1865 [LR]	Panel: 13¾ × 20

No. 398. / A. F. Tait / Morrisania / Westchester Co. /
N.Y. / 1865

[No.] *398 Two dogs. setters, & quail. Burdocks &c (12 ×
14 on Panel) finished Jan'y 14. del'd. Wm Tisdale, Geralamon
81, Brooklyn. Paid for Jan'y 15 / 65 $350.00.*

Courtesy of Mr. and Mrs. R. Philip Hanes, Jr.

SETTER AND WOODCOCK 65.18

A. F. Tait / N.Y. 1865 [LR] Canvas: 14 × 22

N399 / A. F. Tait, N.Y. 1865

[No.] *399 Dog (Setter) and woodcock. size 22 × 14. finished
Jan'y 21st. Sent to Williams & Everett of Boston. paid for per
cheque $175.00. Feb'y 1st 1865. Paid for Feb'y 1st.*

SETTER AND QUAIL 65.19

[Unknown] Panel: 12 × 14 [?]

[Unknown]

At this point in the Register there is an entry, largely
crossed out, as follows: [crossed out: *(No.) 400* (possibly
changed to *400a* or *498a*) *Two Dogs (Setter and Quail) 12
× 14 Panel something like 398* (65.17). *finished (?) Jan'y 24th
Feyer (?) Baltimore sent* (word unclear)] *sent per Adams Ex-
press.* [crossed out: *Jan'y] March 11th 1865. Paid. Rec'd for
[$300.00].*

It is not clear whether or not a painting fitting this de-
scription in any respect might still exist. The Register
then continues with No. 400 (65.20).

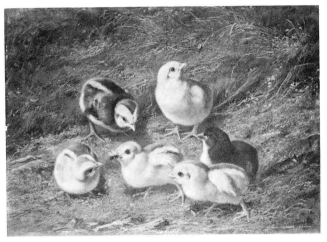

No. 401 / Westchester / 1865

[No.] *401. Chickens. 14 × 10. Jas. Feyer, Baltimore.*

Bracketed with Nos. 402, 403, and 403[A] (65.22–.24)
and together marked *Paid for.* See 65.24.

Collection of the Walters Art Gallery, Baltimore, Mary-
land. Courtesy of the Walters Art Gallery.

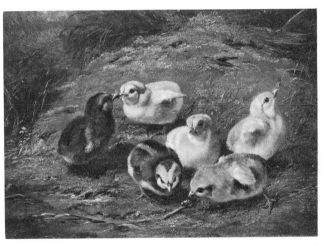

CHICKENS 65.22

A. F. Tait / N.Y. 1865 [LR] Board: 10 × 14

No. 402 / A. F. Tait / 1865

[No.] *402 [1865] Chickens. 14 × 10. Jas. Feyer, Baltimore.
Paid.*

Bracketed with Nos. 401, 403, and 403[A] (65.21, 65.23,
and 65.24) and together marked *Paid for.*

See 65.24.

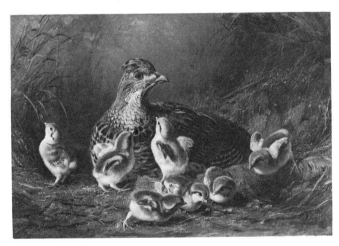

RUFFED GROUSE 65.20

A. F. Tait / N.Y. 1865 [LR] Canvas on panel:
 11 × 15½

[Nothing on back]

[No.] *400 Ruffed Grouse (Hen & chickens) S. P. Avery
friend. Paid March 22nd $170.*

CHICKENS 65.21

A. F. Tait / N.Y. 1865 [LR] Board: 10 × 14

CHICKENS 65.23

[Unknown] [Unknown]: 10 × 14 [?]

[Unknown]

[No.] *403 Chickens 14 × 10. Jas. Feyer.*

Another painting, No. 403 (65.24) follows. Bracketed

with Nos. 401, 402, and 403[A] (65.21, 65.22, and 65.24) and together marked *Paid for.*

See 65.24.

CHICKENS　　　　　　　　　　　　　　65.24

[Unknown]　　　　　　　　　[Unknown]: 10 × 14 [?]

[Unknown]

[No.] *403 [A]　Chickens. 14 × 10. Jas. Feyer. all 4 [65.21–65.24] finished Feb'y 12th. sent off per Xpress—Feb'y 13th.*

This painting was numbered *403* in the Register, as was 65.23. Bracketed with Nos. 401, 402, and 403 (65.21–.23) and together marked *Paid for.*

CHICKENS　　　　　　　　　　　　　　65.25

[Unknown]　　　　　　　　　[Unknown]: 10 × 14 [?]

[Unknown]

[No.] *404　Chickens. 14 × 10. M. O'Brien, Chicago. per Express June 5. price 120$.*

Bracketed with No. 405 (65.26) and together marked *Paid for by Draft.*

HEN QUAIL AND CHICKENS　　　　　65.26

A. F. Tait / N.Y. 1865 [LR]　　　Canvas: 10¼ × 14

A. F. Tait / Morrisania / Westchester Co. / N.Y. / June 1865 / No. 405

[No.] *405　Hen Quail & Chickens. 14 × 10. M. O'Brien. Chicago. per Express June 5th. price $110.*

Bracketed with No. 404 (65.25) and together marked *Paid for by Draft.*

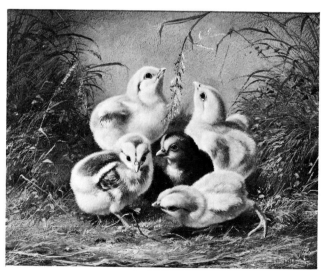

CHICKENS　　　　　　　　　　　　　　65.27

A. F. Tait / 1865 [LR]　　　　　Board: 8¾ × 11

No. 406 / A. F. Tait / Morrisania / Westchester Co. / N.Y. / 1865

[No.] *406　Chickens. 11 × 9 by Mary. Snedicor June 14th.*

Bracketed with No. 407 (65.28) and together marked *Paid for and $50 to a/c.*

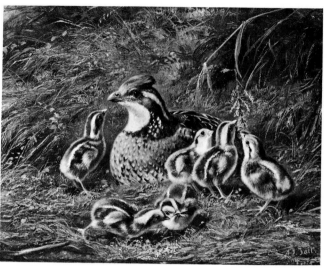

HEN QUAIL AND YOUNG　　　　　　65.28

A. F. Tait / N.Y. / 1865 [LR]　　　Board: 8¾ × 11

No. 407 / A. F. Tait / Morrisania / Westchester Co. / N.Y. / 1865.

[No.] *407　Hen Quail & Young. 11 × 9 Snedicor. June 14th. by Mary.*

Bracketed with No. 406 (65.27) and together marked *Paid for and $50 to a/c.*

[HEN QUAIL AND CHICKENS]　　　　65.29

[Unknown]　　　　　　　　　[Unknown]: 10 × 12 [?]

[Unknown]

[No.] *408　[1865] Hen Quail. Chickens. 12 × 10. finish'd July 19th. Mr. Heald. [$100.00] Home Insurance Co. Paid.*

CHICKENS　　　　　　　　　　　　　　65.30

[Unknown]　　　　　　　　　[Unknown]: 10 × 12 [?]

[Unknown]

[No.] *409　Chickens. [$100.00] 12 × 10. fin'd July 17th Mr. Heald, Home Insurance Co. Del'd & Paid for July 20th.*

CHICKENS　　　　　　　　　　　　　　65.31

[Unknown]　　　　　　　　　Board: 10 × 14 [?]

[Unknown]

[No.] *410　Mr. C. D. Culver, 80 E 17th St. near Everett & Co. Chickens on Millboard 14 × 10. finish'd July 27. del'd July 31st. paid same time [$150.00].*

CHICKENS　　　　　　　　　　　　　　65.32

[Unknown]　　　　　　　　　Board: 10 × 14 [?]

[Unknown]

[No.] *411 Chickens on millboard 14 × 10. fin'd July 28th. sent to Mr. O'Brien, Chicago August 2nd / 65. Paid for per draft* [$220.00] *for the 2* [i.e. for 65.32 and 65.33 together].

Bracketed with No. 412 (65.33).

CHICKENS 65.33

[Unknown] Panel: 10 × 12 [?]

[Unknown]

[No.] *412 Chickens on panel 12 × 10. fin'd Aug't 1st. sent to M. O'Brien, Chicago with 411* [65.32]. *Paid—per draft.*

Bracketed with No. 411 (65.32).

CHICKENS 65.34

[Unknown] Board: 10 × 12 [?]

[Unknown]

[No.] *413 Chickens 12 × 10 Millboard. finished Aug. 18th A. F. Goodnow. finish'd Aug. 21. Home 26 Remson* [?] *St. Bkl'yn—53 Beekman St.*

See 65.35.

QUAIL AND YOUNG 65.35

[Unknown] [Unknown]: 10 × 12 [?]

[Unknown]

[No.] *414 Quail (Hen) & Young. 12 × 10. finish'd Aug. 17th A. F. Goodnow. finish'd August 21st. Del'd. Delivered these Two* [65.34 and 65.35] *in frames—Aug.*

QUAIL AND YOUNG 65.36

A. F. Tait / 1865 [LR] Panel: 10 × 12

No. 415 / A. F. Tait / Morrisania / Westchester / Co. N.Y. / 1865

[No.] *415 1865 Quail & Young. Panel 12 × 10. J. B. Hutchinson, 57 & 59 Worth St., N.Y. Paid* [$100.00] *finished Aug. 19th. Del'd in frame. Paid (Sned).*

COCKER SPANIEL AND THREE 65.37
QUAIL

[Unknown] Panel: 10 × 14 [?]

[Unknown]

[No.] *416 Cocker Spaniel & 3 quail. Size 14 × 10 panel— for the sale. del'd to Snedicor.*

The sale referred to in the Register entry was the Leeds Sale of April 5, 1866, for which this was the first of 68 paintings (between Nos. 416 and 484 [65.37—66.46]).

See 66.46.

COCKER SPANIEL 65.38

[Unknown] Board: 12 × 10 [?]

[Unknown]

[No.] *417 Cocker Spaniel (feet on log in swamp) Size 10 × 12 on millboard (for Snedicor in exchange for 4 frames 12 / ea. for Nos. 413–414–415 & one other). finish'd Sep'r 10th.*

COCKER SPANIEL AND BIRD 65.39

A. F. Tait, N.Y. 1865 Panel: 11 × 9

No. 418 / A. F. Tait / Morrisania / Westchester / N.Y. / 1865

[No.] *418 Cocker Spaniel & Bird. 9 × 11 Panel. for the sale. (Dog sitting up on end lolling. Bird on Ground) Del'd Sned Dec 9th Sale.*

COCKER SPANIEL AND 65.40
TWO RUFFED GROUSE

A. F. Tait / N.Y. 1865 [LR] Panel: 11¾ × 19

[Nothing on back]

[No.] *419 Cocker Spaniel & two Ruffed Grouse in grass 18 × 14 Panel.*

Sold at Leeds Sale, April 5, 1866.

POINTER'S HEAD AND DEAD QUAIL 65.41

[Unknown] Panel: 14 × 17 [?]

[Unknown]

[No.] *420 Pointers Head & dead Quail. 17 × 14 Panel. finish'd Oct'r 12th.*

Sold at Leeds Sale, April 5, 1866.

SETTER'S HEAD AND 65.42
DEAD RUFFED GROUSE

[Not signed or dated] Panel: 13½ × 16½

No. 421. / A. F. Tait / Morrisania / Westchester Co. / N.Y. / 1865

[No.] *421 Setters Head & dead Ruffed Grouse. 17 × 14 Panel.*

Below the Register entry, ending the page, is the notation *sent to sale 5. Commenced Exhibition. March 28* [1866].

Sold at Leeds Sale, April 5, 1866.

TWO SPRINGERS AND WILD DUCKS 65.43

A. F. Tait / N.Y. '65 [LR] Board: 9¾ × 13¾

No. 422 / A. F. Tait / Morrisania / Westchester Co. / N.Y. / 1865

[No.] *422* [1865] *Two Springers or cockers & wild Ducks. Millboard 14 × 10.*

Sold at Leeds Sale, April 5, 1866.

[COCKER SPANIEL RETRIEVING 65.44
QUAIL]

A. F. Tait / N.Y. 1865 [LR] Panel: 14 × 18

No. 423. / A. F. Tait / Morrisania / Westchester Co. /
N.Y. 1865.

[No.] *423 Cockers Spaniel Head & dead Quail in his mouth.
Panel 18 × 14. Del'd Sned Dec 9th. Sale.*

Sold at Leeds Sale, April 5, 1866.

TWO POINTERS AND CORN STALK 65.45

[Unknown] [Unknown]: 10 × 14 [?]

[Unknown]

[No.] *424. Sketch two pointers & corn stalk. 14 × 10.*

COCKER SPANIEL AND 65.46
TWO WOODCOCK

[Unknown] Panel: 14 × 18 [?]

[Unknown]

[Entire entry crossed out: *No. 424½. Cocker Spaniel &
two Woodcock— / looking over a log. 18 × 14 on Panel.
Williams & Everett. Boston. finished Sept'r 28th / 65.*]

See 65.47 and 65.48.

COCKER SPANIEL AND WOODCOCK 65.47

[Unknown] Board: 10 × 14 [?]

[Unknown]

[No.] *425 Sketch for 226 [i.e., 426 (65.48)] Cocker Spaniel
& Woodcock. over a log. 14 × 10 millboard.*

See 65.46 and 65.48.

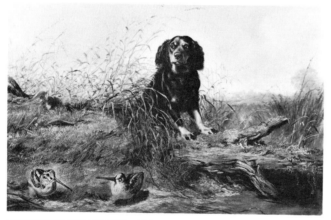

COCKER SPANIEL AND WOODCOCK 65.48

A. F. Tait / N.Y. / 1865 [LR] Panel: 15¾ × 24

No. 426 / A. F. Tait / Morrisania / Westchester / New
York / 1865.

[No.] *426 Cocker Spaniel & (2) Woodcock. looking over a log
on Panel 24 × 16.*

Sold at Leeds Sale, April 5, 1866. See 65.46 and 65.47.

Courtesy of Newhouse Galleries, Inc., New York, New
York.

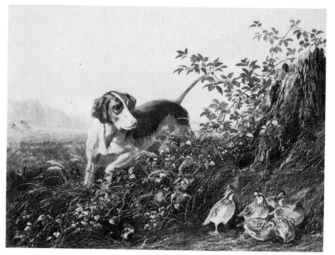

POINTER AND BEVY OF QUAIL 65.49

[Unknown] Panel: 14 × 18 [?]

[Unknown]

[No.] *427 Pointer & Bevy of Quail. 18 × 14 panel. del'd to
Sned for Sale. Dec.*

Sold at Leeds Sale, April 5, 1866.

[COCKER SPANIEL RETRIEVING 65.50
A WOODCOCK]

A. F. Tait / N.Y. 1865 [LR] Panel: 14 × 19

[Unknown]

[No.] *428 Cocker Spaniel's Head & Woodcock. 19 × 14
Panel. del'd to Snedicor for Sale Dec'r. del'd Dec'r 9th.*

Sold at Leeds Sale, April 5, 1866.

SETTER AND POINTER AND 65.51
PARTRIDGE

[Unknown] Board: 10 × 14 [?]

[Unknown]

[No.] *429 [1865] Setter & Pointer & Partridge in Wood. 14
× 14 millboard. Del'd to Snedicor for sale Dec'r. Del'd Dec'r
9th.*

Sold at Leeds Sale, April 5, 1866.

TWO WOODCOCK 65.52

[Unknown] Panel: 12 × 16 [?]

[Unknown]

[No.] *430 Two woodcock. 16 × 12 Panel.*

Bracketed with Nos. 431–35 (65.53–.57). Sold at Leeds
Sale, April 5, 1866.

TWO WOODCOCK 65.53

[Unknown] Panel: 12 × 16 [?]

[Unknown]

[No.] *431 Two woodcock. 16 × 12 Panel.*

Bracketed with Nos. 430 (65.52) and 432–35 (65.54–.57). Sold at Leeds Sale, April 5, 1866.

HEN RUFFED GROUSE AND YOUNG 65.54

A. F. Tait / N.Y. 1865 [LR] Panel: 10¾ × 15½

No. 432. A. F. Tait, Morrisania, Westchester Co., New York, 1865

[No.] *432 Hen Ruffed Grouse & Young. 16 × 12 Panel.*

Bracketed with Nos. 430–31 (65.52–.53) and 433–35 (65.55–.57). Description is of a hen ruffed grouse and seven chicks fluttering down from an old mossy log at right foreground. Sold at Leeds Sale, April 5, 1866.

PAIR OF QUAIL AND YOUNG 65.55

A. F. Tait / N.Y. 1865 [LR] Panel: 11¾ × 17¾

No. 433 / A. F. Tait / Morrisania, Westchester / N.Y. / 1865.

[No.] *433 Pair Quail & Young. 18 × 12 Panel.*

Bracketed with Nos. 430–32 (65.52–.54) and 434–35 (65.56–.57). Sold at Leeds Sale, April 5, 1866.

YOUNG QUAIL 65.56

[Unknown] Board: 10 × 8 [?]

[Unknown]

[No.] *434 Young Quail. 8 × 10 millboard.*

Bracketed with Nos. 430–33 (65.52–.55) and 435 (65.57). Sold at Leeds Sale, April 5, 1866.

HEN QUAIL AND YOUNG 65.57

A. F. Tait / N.Y. '65 [LR] Board: 8 × 10

435 / A. F. Tait / Morrisania / Westchester Co. / N.Y. / 1865.

[No.] *435 Hen Quail & Young. 8 × 10 millboard.*

Bracketed with Nos. 430–34 (65.52–.56).

[DUCKS AND GOATS] 65.58

A. F. Tait / N.Y. 1865 [LR] Board: 12¼ × 14

[Unknown]

[No.] *437 Ducks & two goats on Rock. (Millboard) Square 14 × 12.*

Exhibited and sold at Leeds Sale, April 5, 1866.

DOE AND FAWN 65.59

A. F. Tait / N.Y. 65 [LR] Panel: 9 × 11

No. 441 / A. F. Tait / Morrisania / Westchester Co. N.Y. / 1865.

No. 441. Doe & Fawn. (Doe lying down) 11 × 9 Panel.

Exhibited and sold at Leeds Sale, April 5, 1866.

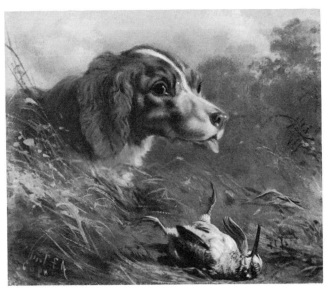

SETTER'S HEAD AND DEAD WOODCOCK 65.60

A. F. Tait, N.Y. '65 [LR] Board: 6 × 7

No. 476. A. F. Tait, Morrisania, Westchester, N.Y., 1865.

No. 476. Setter's Head & dead woodcock. Mill'd 6 × 5 in my own frame.

Exhibited and sold at Leeds Sale, April 5, 1866.

THREE WOODCOCK 65.61

A. F. Tait / N.Y. 1865 [LR] Panel: 11¾ × 16

A. F. Tait / Morrisania / Westchester Co. / N.Y. / 1865

[No AFT number; no Register entry]

There is no entry by AFT of three woodcock from 1864 to 1866, inclusive.

Courtesy of Christie's, New York, New York.

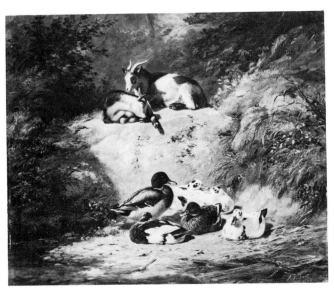

65.58

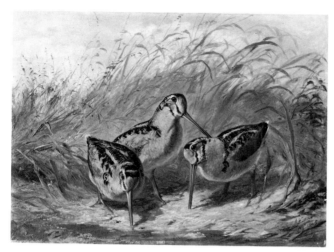

65.61

[CONSTABLE POINT CAMP] 65.62

[Not signed or dated] Board: 8 × 12

Our camp at Constable Pond [Point] / Racquette Lake / by A. F. Tait / 1865.

[No AFT number; no Register entry]

Collection of the Yale University Art Gallery, New Haven, Connecticut. Courtesy of Yale University Art Gallery, Whitney Collections of Sporting Art, given in memory of Harry Payne Whitney (B.A. 1894) and Payne Whitney (B.A. 1898) by Francis P. Garvan (B.A. 1897).

[ROCK AND FALLEN TREE 65.63
AT CONSTABLE POINT]

[Not signed or dated] Board: 8¼ × 12

Sketch from Nature / at Constable Point. Racquette Lake / Hamilton Co. NY / by A. F. Tait. / 1865

[No AFT number; no Register entry]

Collection of the Yale University Art Gallery, New Haven, Connecticut.

[LARGE ROCK AT RAQUETTE LAKE] 65.64

[Not signed or dated] Board: 8¼ × 12

A. F. Tait / 1865 / Racquette Lake.

[No AFT number; no Register entry]

Collection of the Yale University Art Gallery, New Haven, Connecticut.

[SKETCH OF ROCK AND 65.65
FALLEN TREE]

[Not signed or dated] Board: 7 × 10

On Racquette Lake Hamilton Co N.Y. / A. F. Tait 1865

[No AFT number; no Register entry]

Collection of the Yale University Art Gallery, New Haven, Connecticut.

OUR CAMP ON CONSTABLE POINT 65.66

[Not signed or dated] Board 8 × 12¼

A. F. Tait / 1865 / Our Camp on Constable Point / Racquette Lake / Hamilton Co / N.Y. / A. F. Tait and James B. Blossom.

[No AFT number; no Register entry]

Collection of the Yale University Art Gallery, New Haven, Connecticut.

[COWS FORDING A STREAM] 65.67

A. F. Tait / '65 [LL] Canvas: 10 × 14

[Nothing on back]

[No AFT number; no Register entry]

RUFFED GROUSE AND DEER 66.1

[Unknown] Canvas: 20 × 30 [?]

[Unknown]

[No.] 436 *Three Ruffed Grouse & deer. 30 × 20 canvas. sale. del'd by Sam Jan. 13 to Snedicor.*

Exhibited and sold at Leeds Sale, April 5, 1866.

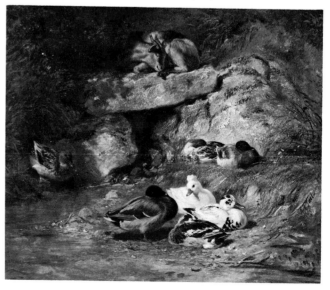

66.2

[DUCKS AND GOAT] 66.2

A. F. Tait / N.Y. '65 [CR] Board: 10 × 12 oval

No. 438, A. F. Tait, Morrisania, Westchester, N.Y. 1865

[No.] *438. Ducks & one goat on rock (millboard) oval 12 × 10.*

Sold at Leeds Sale, April 5, 1866.

Courtesy of Mr. and Mrs. George Arden.

[DUCKS SUNNING] 66.3

[Unknown] [Unknown]: 10 × 14 [?]

[Unknown]

[No.] *439 Ducks sunning themselves (Rock). 14 × 10.*

Sold at Leeds Sale, April 5, 1866.

[DEER] 66.4

[Unknown] Panel: 9 × 11 [?]

[Unknown]

[No.] *440 (Buck) Deer laying down. 11 × 9 panel. lent to Stearns, to be returned.*

Sold at Leeds Sale, April 5, 1866.

YOUNG QUAIL 66.5

[Unknown] Panel: 10 × 8 [?]

[Unknown]

[No.] *442 Young Quail. 8 × 10 panel.*

Sold at Leeds Sale, April 5, 1866.

YOUNG QUAIL 66.6

A. F. Tait / N.Y. 1866 [LR[Board: 8 × 10

No. 443 / A. F. Tait, 1866 / Morrisania West. Co. / N.Y.

[No.] *443 [1866] Young quail. millboard 8 × 10.*

Sold at Leeds Sale, April 5, 1866.

[RUFFED GROUSE AND YOUNG] 66.7

[Unknown] [Unknown]: 10 × 8 [?]

[Unknown]

[No.] *444 Ruffed Grouse, cock & Hen & young. 8 × 10.*

Sold at Leeds Sale, April 5, 1866.

HEN QUAIL AND YOUNG 66.8

[Unknown] Board: 9 × 12 [?] [oval]

[Unknown]

[No.] *445 Hen Quail & young. 12 × 9 oval millboard.*

Sold at Leeds Sale, April 5, 1866.

CHICKENS 66.9

[Unknown] Board: 9 × 12 [?] oval

[Unknown]

[No.] *446 Chickens. millboard 12 × 9 oval.*

Sold at Leeds Sale April 5, 1866.

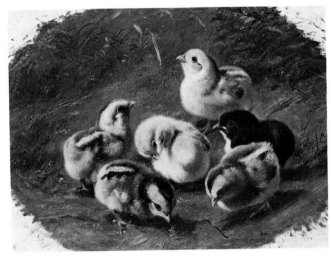

CHICKENS 66.10

A. F. Tait / N.Y. 1866 [R edge] Board: 9 × 12 oval

No. 447 / A. F. Tait / [word unclear] / Westch[ester] / N.Y. 1866

[No.] *447 Chickens. Mill'd 12 × 9 oval.*

Sold at Leeds Sale, April 5, 1866. In upper right corner outside oval on the front the number *447* is inscribed.

Courtesy of Post Road Gallery, Larchmont, New York.

CHICKENS 66.11

[Unknown] Board: 9 × 12 [?] oval

[Unknown]

[No.] *448 Chickens Mill'd 12 × 9 oval.*

Sold at Leeds Sale, April 5, 1866.

DUCKS 66.12

[Unknown] Panel: 10 × 8 [?]

[Unknown]

[No.] *449 Ducks. Panel 8 × 10.*

Sold at Leeds Sale, April 5, 1866.

DUCKS 66.13

[Unknown] Board: 8½ × 6½ [?]

[Unknown]

[No.] *450 Ducks. Mill'd 6½ × 8½.*

Sold at Leeds Sale, April 5, 1866.

RUFFED GROUSE 66.14

[Unknown] Board: 10 × 8 [?]

[Unknown]

[No.] *451* [*Feb'y 1866 Sale.*] *Ruffed Grouse on log &c. Mill'd 8 × 10.*

Sold at Leeds Sale, April 5, 1866.

HEN QUAIL AND YOUNG 66.15

A. F. Tait, N.Y. '66 [?] Panel: 9 × 12 oval

No. 452, A. F. Tait, Morrisania, N.Y. 1866.

[No.] *452* *Hen Quail & young 12 × 9 oval millboard.*

Sold at Leeds Sale, April 5, 1866.

RUFFED GROUSE AND YOUNG 66.16

A. F. Tait / N.Y. 1866 [LR] Canvas: 14½ × 20½

No. 453 / A. F. Tait / Morrisania / N.Y. / 1866.

[No.] *453* *Ruffed Grouse (Hen) & young. 20 × 14. my own frame (from Baltimore) Canvass. (returned from Snedicor.)*

Sold at Leeds Sale, April 5, 1866.

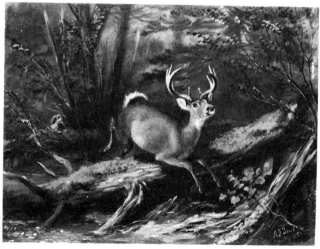

DEER RUNNING 66.17

A. F. Tait, 1858 [LR] Board: 6½ × 8½

No. 454. A. F. Tait / Morrisania / Westchester N.Y. / 1865. No. 454.

[No.] *454* *Deer—running. 6½ × 8½ in square.*

Sold at Leeds Sale, April 5, 1866.

Courtesy of Bernard & S. Dean Levy, Inc., New York, New York.

DUCKS AND YOUNG 66.18

Jas. M. Hart & A. F. Tait / Panel: 11¾ × 16
N.Y. 1866 [LR]

No. 455 / Painted by Jas. M. Hart & A. F. Tait / N.Y. 1866.

[No.] *455* *Ducks & young. Panel 16 × 12. Joint Jas. M. Hart & A. F. Tait.*

Sold at Leeds Sale, April 5, 1866.

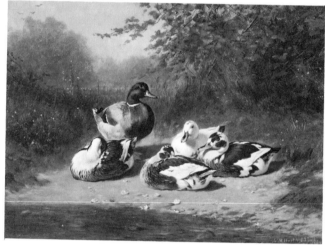

DUCKS 66.19

Jas. M. Hart & A. F. Tait, Panel: 11¾ × 16
N.Y. 1866 [LR]

No. 456 / Painted by Jas. M. Hart and A. F. Tait / N.Y. 1866

[No.] *456* *Ducks. panel 16 × 12. Joint Jas M Hart & A F Tait.*

Sold at Leeds Sale, April 5, 1866.

See 66.60.

PAIR OF QUAIL AND YOUNG 66.20

[Unknown] [Unknown]: 12 × 18 [?]

[Unknown]

[No.] *457* *Pair of Quail & young 18 × 12.*

Sold at Leeds Sale, April 5, 1866.

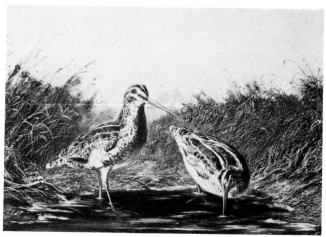

66.21

PAIR OF SNIPE 66.21

A. F. Tait [LR] Panel: 11¾ × 16

No. 458 / A. F. Tait / Morrisania / Westchester Co. / N.Y. / 1866.

[No.] *458* [*March 1866 Sale.*] *Pair of snipe 16 × 12 Panel.*

Sold at Leeds Sale April 5, 1866.

CHICKENS 66.22

[Unknown] Board: 9 × 12 [?]

[Unknown]

[No.] *459 Chickens. Millboard 12 × 9 sqr.*

Sold at Leeds Sale, April 5, 1866.

CHICKENS 66.23

A. F. Tait / N.Y. 1866 [LR] Board: 9¼ × 12¼

[Nothing on back]

[No.] *460 Chickens. millboard 12 × 9 sqr.*

Sold at Leeds Sale, April 5, 1866.

Collection of the George Walter Vincent Smith Art Museum, Springfield, Massachusetts. Courtesy of George Walter Vincent Smith Art Museum.

CHICKENS 66.24

[Unknown] Board: 9 × 12 [?]

[Unknown]

[No.] *461 Chickens millboard 12 × 9 sqr.*

Sold at Leeds Sale, April 5, 1866.

DOGS AND SNIPE 66.25

[Unknown] [Unknown]: 6½ × 9 [?]

[Unknown]

[No.] *462 Dogs & Snipe. 9 × 6½.*

Sold at Leeds Sale, April 5, 1866.

POINTER AND SNIPE 66.26

[Unknown] [Unknown]: 6½ × 9 [?]

[Unknown]

[No.] *463 Dog (Pointer) & Snipe 9 × 6½.*

Sold at Leeds Sale, April 5, 1866.

DOG AND SNIPE 66.27

A. F. Tait / '66 [LR] Board: 6 × 8½

No. 464. A. F. Tait, Morrisania, Westchester Co., N.Y. 1866.

[No.] *464 Dog &* [blank.] *9 × 6½.*

Sold at Leeds Sale, April 5, 1866.

DOGS AND QUAIL 66.28

[Not signed or dated] Board: 6½ × 9

No. 465. / A. F. Tait / Morrisania / Westchester Co. / N.Y. / 1866.

[No.] *465* [*March 1866 Sale.*] *Dogs & Quail. 9 × 6½.*

Sold at Leeds Sale, April 5, 1866.

DOE AND FAWNS 66.29

A. F. Tait / N.Y. '66. Board: 7 × 9½

No. 466. / A. F. Tait / Morrisania / Westchester Co. / 1866 / N.Y.

[No.] *466 Doe & Fawns. 9½ × 7.*

Sold at Leeds Sale, April 5, 1866.

DOE AND FAWNS 66.30

[Unknown] [Unknown]: 7½ × 9 [?]

[Unknown]

[No.] *467 Doe & Fawns—Buck in Distance. 9 × 7½.*

Sold at Leeds Sale, April 5, 1866.

DOE AND FAWNS 66.31

[Unknown] [Unknown]: 6½ × 10 [?]

[Unknown]

[No.] *468 Doe & Fawns—startled by ducks in fog. 10 × 6½.*

Sold at Leeds Sale, April 5, 1866.

CHICKENS 66.32

[Unknown] [Unknown]: 6½ × 9 [?]

[Unknown]

[No.] *469 Chickens. 9 × 6½.*

YOUNG DUCKS 66.33

[Unknown] [Unknown]: 8 × 11 [?]

[Unknown]

[No.] 470 Young Ducks. 11 × 8.

Sold at Leeds Sale, April 5, 1866.

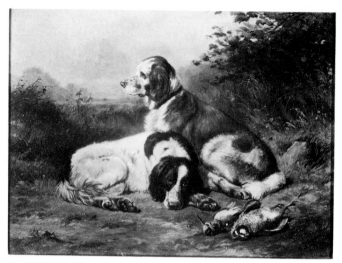

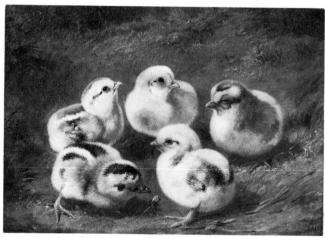

A. F. Tait / N.Y. '66 [LR] Canvas: 9 × 12

[Unknown]

[No.] 475 two dogs & quail & snipe. 12 × 9 square.

CHICKENS 66.34

A. F. Tait / N.Y. '66 [LR] Board: 7½ × 11

No. 471 / A. F. Tait / Morrisania / Westchester Co.,
N.Y. 1866.

[No.] 471 Chickens. 11 × 8.

YOUNG DUCKS AND CHICKENS 66.35

A. F. Tait / N.Y. '66 [LR] [Unknown]: 8 × 11 [?]

[Unknown]

[No.] 472 [March 1866 Sale.] Young ducks & chickens—
mixed 11 × 8.

Sold at Leeds Sale April 5, 1866.

MATERNAL AFFECTION 66.36

[Unknown] [Unknown]: 8 × 11 [?]

[Unknown]

[No.] 473 Maternal affection. 11 × 8. Cow & calf in Shed.

Sold at Leeds Sale, April 5, 1866.

SHEEP IN SHED 66.37

[Unknown] [Unknown]: 8 × 11 [?]

[Unknown]

[No.] 474 Sheep in Shed. 11 × 8.

Sold at Leeds Sale, April 5, 1866.

[TWO BIRD DOGS: DEAD QUAIL 66.38
AND SNIPE]

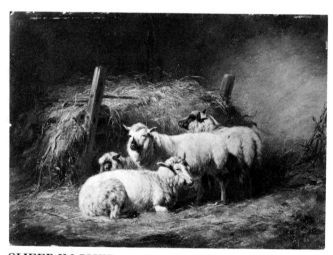

SHEEP IN SHED 66.39

A. F. Tait / N.Y. '66 [LR] Board: 9 × 12

No. 477. A. F. Tait, Morrisania, Westchester Co.,
N.Y., 1866.

[No.] 477 Sheep in Shed for Briggs frame. 12 × 9. 61
Pictures sent to the [Leeds] Sale up to March [blank] 1866
besides the large "Carry Painting" [64.8].

Sold at Leeds Sale, April 5, 1866.

HAPPY CHICKENS 66.40

A. F. Tait, '66 [LR] Board: 6 × 8 oval

No. 478 / A. F. Tait / N.Y. 1866

[No.] 478 Chickens (Happy) 8 × 6 oval.

Sold at Leeds Sale, April 5, 1866.

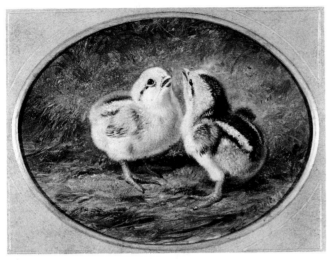

66.40

UNHAPPY CHICKENS 66.41

[Unknown] [Unknown]: 6 × 8 [?] oval

[Unknown]

[No.] *479 [April 1866] for the sale April 4th at Snedicors Chickens (unhappy &c) 8 × 6 oval.*

Sold at Leeds Sale, April 5, 1866.

A BUSY CHICK 66.42

[Unknown] [Unknown]: 6 × 8 [?] oval

[Unknown]

[No.] *480 Chicken. Busy Chick. 8 × 6 oval.*

Sold at Leeds Sale, April 5, 1866.

HAPPY CHICKS 66.43

[Unknown] [Unknown]: 6 × 8 [?] oval

[Unknown]

[No.] *481 Chicks (more happy) Oval 8 × 6.*

Sold at Leeds Sale, April 5, 1866.

QUARRELSOME CHICKS 66.44

[Unknown] [Unknown]: 6 × 8 [?] oval

[Unknown]

[No.] *482 Chicks. Quarrelsome Chicks. 8 × 6 oval.*

Sold at Leeds Sale, April 5, 1866.

QUAIL CHICKS 66.45

[Unknown] [Unknown]: 6 × 8 [?] oval

[Unknown]

[No.] *483 Quail chicks. 8 × 6 oval.*

Sold at Leeds Sale, April 5, 1866.

CHICKENS 66.46

[Unknown] [Unknown]: 8 × 11 [?]

[Unknown]

[No.] *484 Chickens (Extra one 11 × 8 miss counted) for the sale and sold after to Snedicor with my ½ interest in the above 6—6 × 8 ovals for [blank].*

Sold at Leeds Sale April 5, 1866. This was apparently the last of 68 paintings, Nos. 416–84 (65.37–.47) prepared for the Leeds Sale of April 5, 1866. Also included in the sale was 64.8.

DUCKLINGS 66.47

A. F. Tait / 1866 [LL] Board: 10 × 12

[Unknown]

No. 485. [August 22nd. 1866] Ducklings. 12 × 10. L. Prang. (Boston) for publication. I am to receive 10 per cent of the gross receipts of all sales of the prints. picture to be on joint a/c.

See Register entry for 66.48. A chromolithograph was published by Louis Prang, 1866, titled "Ducklings."

[PAIR OF QUAIL AND YOUNG] 66.48

A. F. Tait / N.Y. 1866 [LR] [Unknown]: 10 × 14 [?]

[Unknown]

No. 486 Pair of Quail (Cock & Hen) & chickens. 14 × 10 for 12 × 10. Louis Prang, Boston. same terms as 485 [66.47].

A chromolithograph was published by Louis Prang, 1867, titled "Quails."

CHICKENS 66.49

[Unknown] [Unknown]: 9 × 12 [?]

[Unknown]

[No.] *487. Chickens. Henry Wilson. 12 × 9. delivered to him Oct'r 7th as payment in part for transactions on acct of sale in the Spring. I paid him at that time on Settlement $100.00 as interest on money he advanced previous to the sale.*

CHICKENS 66.50

[Unknown] [Unknown]: 9 × 12 [?]

[Unknown]

[No.] *488 Chickens. 12 × 9. Wm. M. Goodrich. Wall Street to pay off old debt of Williams & Stevens & Williams. he holding it and giving me a receipt in full.*

CHICKENS 66.51

[Unknown] [Unknown]: 9 × 12 [?] oval

[Unknown]

[No.] *489 Chickens. Oval 12 × 9.*

RUFFED GROUSE AND YOUNG 66.52

[Unknown] Board: 10 × 14 [?]

[Unknown]

[No.] *490 [1866] Ruffed Grouse (Hen) & young. millboard 14 × 10. A. Raymond. paid.*

QUAIL CHICKENS 66.53

A. F. Tait / NY 1866 [LR] Board: 8 × 10

Copyright Reserved / No. 491 / A. F. Tait / Morrisania / Westchester N.Y. 1866

[No.] *491 Quail chickens 8 × 10 millboard. Mr. Frothingham, Jim's Friend. Paid to Jim.*

CHICKENS 66.54

[Unknown] [Unknown]: 7½ × 8 [?]

[Unknown]

[The following crossed out: *(No.) 492 4 Chickens. 8 × 7½ presented to Jno. L. Martin as wedding present Nov. 15, 1866.*] [Written over that:] *Sold 1867* [Below it:] *Transferred to Sale, gave Mr. Martin No. 501 [67.9] instead.*

See 67.13.

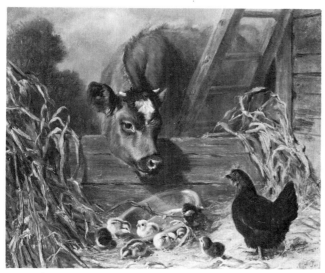

FARM SHED 66.55

A. F. Tait / N.Y. '66 [LR] Board: 9½ × 12

No. 493 / A. F. Tait / Morrisania, N.Y. / 1866 / Copyright secured [?] / A.F.T.

[No.] *493 Calf & Hen & Chickens (& red dish) 12 × 10. Xmas sold to Josiah Blossom with frame for $100.*

Courtesy of Kennedy Galleries, Inc., New York, New York.

FARM YARD 66.56

[Unknown] [Unknown]: 20 × 30 [?]

[Unknown]

[No.] *494 Farm Yard—Cow, Sheep & chickens in shed. 30 × 20. A. Raymond. paid in full.*

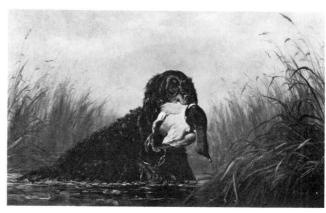

SPANIEL AND CANVAS BACK DUCK 66.57

A. F. Tait / N.Y. 1866 [LR] Canvas: 16 × 26

[Relined; inscription, if any, lost]

[No.] *513 Spaniel & Canvas Back. Canvass 26 × 16. finished May 7th. [1867] Del'd May 11/67.*

DEAD GAME 66.58

A. F. Tait / N.Y. 1866 [LL] Canvas: 22 × 14

[Nothing on back]

[No AFT number; no Register entry]

RUFFED GROUSE AND YOUNG 66.59

A. F. Tait 1866 [LR] Canvas: 14 × 20

[Relined; incription, if any, lost]

[No AFT number; no Register entry]

[DUCKS] 66.60

A. F. Tait, N.A. / N.Y. [LR] Panel: 8 × 12

[Nothing on back]

[No AFT number; no Register entry]

This is a reduction of 66.19 and was probably done by AFT alone.

[SKETCH OF LARGE ROCK] 66.61

[Not signed or dated] Board: 8 × 12

Racquette Lake, Hamilton Co N.Y. / A. F. Tait. 1866

[No AFT number; no Register entry]

Collection of the Yale University Art Gallery, New Haven, Connecticut.

[SKETCH OF DEAD TREES] 66.62

[Not signed or dated] Board: 8¼ × 14

At Constable Point, Racquette Lake / Hamilton Co N.Y. / by A. F. Tait, 1867 [corrected to 1866]

[No AFT number; no Register entry]

Collection of the Yale University Art Gallery, New Haven, Connecticut.

GRAPES 66.63

"Diana" / Sept. 1866 / A. F. Tait [UL] Paper: 10 × 7

[Nothing on back]

[No AFT number; no Register entry]

Collection of the Yale University Art Gallery, New Haven, Connecticut.

[RETRIEVER, SPANIEL WITH 66.64
CANVAS BACK DUCK]

AF Tait / N.Y. 1866 [LR] Canvas: 16 × 26

[Unknown]

[No AFT number; no Register entry]

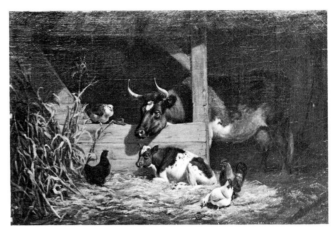

FARM YARD 67.3

A. F. Tait / N.Y. 1867 [LR] Canvas: 20¼ × 29½

No. 495. A. F. Tait / Morrisania / N.Y. / Jan'y 1867.

[No.] *495 Farm Yard. Cow & Calf & Chickens. 30 × 20. Jno. S. Martin Paid.*

Courtesy of Mr. and Mrs. Joseph P. Sontich.

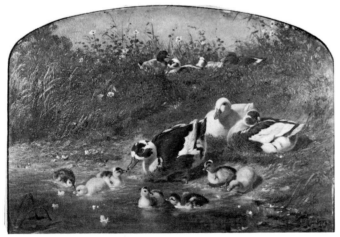

DUCKS 67.1

A. F. Tait / N.Y. 1867 [LR] Board: 10 × 14 arch top

No. 382, A. F. Tait, Morrisania, Westchester Co., N.Y., 1867. (Copyright reserved)

[No.] *382 [March 1st/67 1867 changed from 1865] Alex White. Ducks. 14 × 10. Paid.*

Courtesy of Mr. Pierre Hoag.

DOG AND CANVAS BACK DUCK 67.2

[Unknown] Board: 10 × 12 [?]

[Unknown]

[No.] *383 Dog and Canvass Back Duck. Millboard 12 × 10 finished April 24th/67. Mr. Filley for T. T. Richard, Jun'r. Sent off to St. Louis, Mo.*

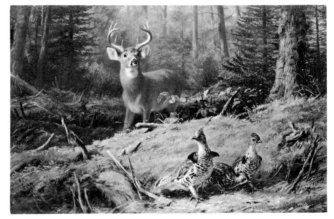

DEER AND RUFFED GROUSE 67.4

A. F. Tait / N.Y. 1867 [LR] Canvas: 20¼ × 30¼

No. 496 / A. F. Tait / Morrisania / Westchester Co. / N.Y. / Jan. 1867 / Copyright Reserved.

[No.] *496 [Jan'y 1867] 1 Deer & 3 Ruffed Grouse. (Forest Scene) 20 × 30. Jno. S. Martin. Paid.*

Courtesy of Kennedy Galleries, Inc., New York, New York.

QUAIL AND YOUNG 67.5

[Unknown] Board: 10 × 14 [?]

[Unknown]

[No.] *497. 2 Quail & Young. 14 × 10 Millboard. Jno. S. Martin. Paid.*

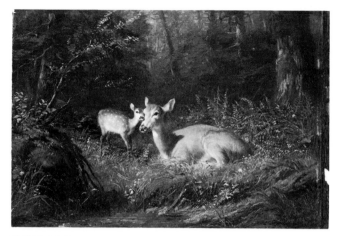

DOE AND FAWN 67.6

A. F. Tait / N.Y., 1867 [LR] Board: 10 × 14

[Inscription partially obliterated] . . . A. F. Tait / Morrisania / Westchester / N.Y. / 1867

[All of the following crossed out: *(No.) 498 Doe & Fawn. 14 × 10 millboard. returned by Jno. S. Martin and put in sale. Paid (two words unclear) from Feb'y 21st and his a/c to come out of 1867 (?) Settled in full per ch'k for $49 & his bill for $53.00 Feb'y 24/67] Transferred to sale.*

Courtesy of Sotheby Parke Bernet, Agent: Editorial Photocolor Archives, New York, New York.

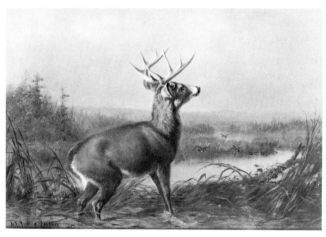

BUCK ALARMED 67.7

Jas. M. Hart & A. F. Tait / Panel: 11¾ × 16
1867 [LL]

No. 499. Jas. M. Hart & A. F. Tait, N.Y. Morrisania, Westchester Co., N.Y. 1367. From A. F. Tait to Josiah & Grace Blossom, Feb. 4, 1867.

[No.] *499 Buck alarmed. Boat in distance. Joint Jas. M. Hart and Tait. 16 × 12. Presented to Josiah Blossom and Grace P. on his wedding day, in a frame, Feb'y 21st, 1867 from A. F. Tait to Si & Wife.*

Bracketed with No. 500 (67.8) and together marked *Feb'y 21st / 67.*

GROUP OF DUCKS 67.8

A. F. Tait / '67 [LR] Panel: 5 × 6½

No. 500 / To Josiah & Grace P. Blossom / from M. A. Tait. Feb'y 21st. '67 / Painted by A. F. Tait / Morrisania, N.Y.

[No.] *500 Group of Ducks. side of Brook. 6 × 4. Presented Si Blossom & Wife. Grace P., by Mr. A. Tait as a wedding present same as 499 in Frame.*

Bracketed with No. 499 (67.7) and together marked *Feb'y 21st / 67.*

Courtesy of Mr. Henry O'Connor.

CHICKENS 67.9

[Unknown] [Unknown]: 10 × 12 [?]

[Unknown]

[No.] *501 Chickens. 12 × 10. Jno. S. Martin. Presented to Jno. S. Martin in Exchange for No. 492* [66.54; see also 67.13] *Wedding present.*

CHICKENS 67.10

[Unknown] [Unknown]: 7 × 10 [?]

[Unknown]

[No.] *502 [1867] Chickens (5). 10 × 7. Mr. Noadler [Knoedler] to Goupil to balance a/c to date. Mar. 25.*

THE REGRETTED SHOT 67.11

A. F. Tait & James M. Hart / Canvas: 25 × 30½ arch top
N.Y. 1867 [LR]

No. 503 / "Regretted Shot" / Copyright reserved / by A. F. Tait and Jas. M. Hart / N.Y. / 1867.

[No.] *503. The Regretted Shot. 30 × 26.* [Sketch of arch top on a square] *A.F.T. painted Figures and Foreground. Jas. M. Hart the background. Joint Hart & Tait. finished Mar 28th / 67. J. P. Crook, 97 Hudson St., Albany.*

This rectangular canvas was originally painted with an

arch top, but was repainted sometime before 1962 into rectangular form.

Courtesy of Mr. George A. Butler.

RUFFED GROUSE 67.12

[Unknown] [Unknown]: 14 × 24 [?]

[Unknown]

[No.] *504 3. Ruffed Grouse. 24 × 14. Presented to Hy Wilson, Canal Street and finished March 30th, 1867.*

CHICKENS 67.13

[Unknown] [Unknown]: 8 × 7½ [?]

[Unknown]

[No.] *492 Chickens.*

This item is entered in the Register in this order—but out of numerical sequence—and this entry probably amounts to nothing more than a reentry of a No. 492 (66.54) carried earlier in the register. In other words, both Nos. 492 (66.54 and 67.13) probably refer to a single painting.

See 66.54.

DOE AND FAWN 67.14

[Unknown] Board: 10 × 14 [?]

[Unknown]

No. *498. Doe and Fawn. 14 × 10. (From J. S. Martin) Millboard.*

The Register entry, in sequence but out of numerical order, is probably only a reentry of 67.6. In other words, 67.6 and 67.14 probably refer to a single painting.

See 67.6.

DUCK AND YOUNG 67.15

[Unknown] Board: 10 × 14 [?]

[Unknown]

[No.] *505 Duck & Young. 14 × 10 millboard. finished April 11th. Del'd to Jno. Snedicor Ap'l 15th / 67. Polly.*

CHICKENS 67.16

[Unknown] [Unknown]: 8 × 10 [?]

[Unknown]

No. *506 Chickens. 10 × 8. Finished Ap'l 4. Del'd to Jno. Snedicor by A.F.T. April 6th.*

Bracketed with No. 507 (67.17) and possibly with No. 505 (67.15). A large *X* is written over the numerals of both Nos. 506 and 507.

CHICKENS 67.17

[Unknown] [Unknown]: 8 × 10 [?]

[Unknown]

[No.] *507 Chickens 10 × 8 Finished Ap'l 5th. Del'd by A.F.T. April 6th.*

Bracketed with No. 506 (67.16) and possibly with No. 505 (67.15). A large *X* is written over the numerals of both Nos. 506 & 507.

DUCKS AND YOUNG 67.18

[Unknown] [Unknown]: 10 × 14 [?]

[Unknown]

[No.] *508 Ducks & Young. 14 × 10. Finished Ap'l 16. Del'd to Jno. Snedicor by A.F.T. April 20th.*

Bracketed with Nos. 509 (67.19) and 510 (67.20) and together marked *I received $300.*

CHICKENS 67.19

[Unknown] Board: 8 × 10 [?]

[Unknown]

[No.] *509 Chickens. millboard. finished April 16th. 10 × 8. Del'd April 20th by A.F.T.*

Bracketed with Nos. 508 (67.18) and 510 (67.20) and together marked *I received $300.*

CHICKENS 67.20

[Unknown] Board: 8 × 10 [?]

[Unknown]

[No.] *510 Chickens. millboard. finished Ap. 19th. 10 × 8 A.F.T. Del'd by A.F.T. April 20th.*

Bracketed with Nos. 508 (67.18) and 509 (67.19) and together marked *I received $300.*

CHICKENS 67.21

A. F. Tait / N.Y. 1867 [LR] Panel: 10 × 12

No. 511. A. F. Tait, 1867.

[No.] *511* [the serial number marked through] *7. Chickens on Rock. 10 × 8. finished May 10th. Del'd by Polly May 11. sold by Snedicor.*

Courtesy of Mr. George A. Butler.

CHICKENS 67.22

[Unknown] Board: 10 × 12 [?]

[Unknown]

[No.] *512* [the serial number marked through] *[Sale. 1867] May 10 Chickens. (Stick of wood &c) millboard 12 × 10. finished May 10 del'd by Polly May 11th / 67. Sold by Snedicor.*

DUCKS AND YOUNG 67.23

A. F. Tait, 1867 [LR] Board: 7 × 13

No. 514. Morrisania, N.Y. / 1867 / A. F. Tait / Copyright reserved.

[No.] *514* [the serial number marked through] *Ducks & Young. Millboard 12 × 7. finished June 21st. Del'd June 22nd (with 520 [67.29]) by Polly. Sold by Snedicor.*

CALF AND FOWLS 67.24

A. F. Tait / N.Y. 1867 [LR] Panel: 14 × 17

No. 515 / A. F. Tait / Morrisania / N.Y. / 1867 / Copyright Reserved.

[No.] *515 Calf & 4 Fowls. (Cock & hens) on Panel 17 × 14. with 518 [67.27] & 519 [67.28] Finished May 30th del'd by Polly June 15th by Polly with 518 & 519.*

STRAW YARD 67.25

[Unknown] Panel: 12 × 14 [?]

[Unknown]

[No.] *516 Cow & Calf & 4 Fowls. Strawyard. Panel 14 × 12. finished May 29, del'd by A.F.T. June 1st / 67.*

Bracketed with No. 517 (67.26) and together marked *sold by Snedicor.*

DOG'S HEAD AND CANVAS BACK 67.26
DUCK

[Unknown] Board: 10 × 12 [?]

[Unknown]

[No.] *517* [the serial number marked through] *Dog's Head & Canvas Back in his mouth. millboard 12 × 10. finished in April—del'd June 1st / 67 by A.F.T.*

Bracketed with No. 516 (67.25) and together marked *sold by Snedicor.*

MISSTRUST 67.27

[Unknown] Canvas: 16 × 26 [?]

[Unknown]

[No.] *518 Deer (Buck) "Misstrust". Canvass—26 × 16. finished June 14th, del'd by Polly June 15th with 515 [67.24] & 519 [67.28].*

COW EATING CORN STALKS 67.28

[Unknown] Board: 10 × 12 [?]

[Unknown]

[No.] *519 [Sale 1867] Cow (Eating Corn Stalks) millboard 12 × 10. Lesson Picture. finished June 14th del'd June 15th by Polly with 515 [67.24] & 518 [67.27].*

CALF, HEN AND CHICKENS 67.29

[Unknown] Panel: 14 × 18 [?]

[Unknown]

[No.] *520 Calf Hen & Chickens. Panel 18 × 14. finished June 18th del'd June 22nd (with 514 [67.23]) by Polly.*

THE REFUGE 67.30

[Unknown] Canvas: 20 × 30 [?]

[Unknown]

[No.] *521. Deer (Buck) The Refuge. Canvass 30 × 20. Joint Jas. M. Hart & A. F. Tait. finished July 1st, del'd July 6 by A.F.T.*

Nos. 521–24 (67.30–.33) bracketed together and marked *del July 6th. by A. F. Tait.*

DEER (BUCK) AMONGST RUSHES 67.31

[Unknown] Panel: 12 × 14 [?]

[Unknown]

[No.] *522 Deer (Buck) amongst Rushes. Panel. 14 × 12. finished July 4th del'd by A.F.T. July 6.*

See 67.30.

QUAIL AND CHICKENS 67.32

A. F. Tait / N.Y. '67 [LR] Board: 8 × 10

No. 523 / A. F. Tait / Morrisania / N.Y. / 1867 / Copyright Reserved.

[No.] *523 Quail & Chickens—in grass. 10 × 8 finished June 29th del'd by A.F.T.*

See 67.30.

QUAIL AND YOUNG 67.33

A. F. Tait / N.Y. '67 [LR] Board: 8 × 10

No. 524. / A. F. Tait / N.Y. 1867 / Copyright Reserved.

[No.] *524 Quail & young chickens. 10 × 8 finished July. del'd by A.F.T.*

See 67.30.

QUAIL AND YOUNG 67.34

[Unknown] Board: 10 × 14 [?]

[Unknown]

[No.] *525 Hen Quail & Young in buckwheat. millboard 14 × 10. finished July 15th del'd by* [blank] *July 20.*

QUAIL 67.35

A. F. Tait / N.Y. 1867 [LR] Board: 11 × 13¼

No. 526 / A. F. Tait / Morrisania / 1867 / Copyright reserved / "Quail."

[No.] *526 [1867 Sale] Quail & Young in clover. millboard 14 × 10. finished July 16th del'd July 20. del'd by* [blank].

Courtesy of S. Arthur Localio, M.D.

[QUAIL AND YOUNG] 67.36

[Unknown] Board: 9 × 12 [?]

[Unknown]

[No.] *527 Quail & Young. Flowers & Strawberry Leaves. Millboard 12 × 9. finished July 18th del'd by* [blank] *July 20th.*

CATTLE AND LANDSCAPE 67.37

A. F. Tait & J. M. Hart / 1867 / Canvas: 20⅛ × 30⅛
James M. Hart and A. F. Tait. /
N.Y. 1867 [LL]

[Unknown]

[No.] *528 Cattle & Landscape 20 × 30. Joint Hart & Tait. finished July* [blank] *del'd by A.F.T. July 23rd.*

Collection of The Brooklyn Museum, Brooklyn, New York, gift of The Brooklyn Union Gas Company. Courtesy of The Brooklyn Museum.

RUFFED GROUSE AND YOUNG 67.38

A. F. Tait / N.Y. 1867 [LR] Canvas: 24 × 32 arch top

No. 529, A. F. Tait, Morrisania, Westchester Co., N.Y.

[No.] *529 Ruffed Grouse & Young. 32 × 24* [Here appears a small sketch of shape of painting, showing an arch top.] *finished Sep'r 25th, del'd Oct'r 7th by Sam. Del by* [blank] *Oct'r 5th* [beneath the serial number appears:] *Oct'r 25th.*

Nos. 529–32 (67.38–.41) bracketed together and marked: *Del'd by Sam altogether.*

SHEEP 67.39

A. F. Tait / N.Y. 1867 [LR] Canvas: 16 × 26

Sheep. Morrisania. "Coppyright [*sic*] reserved"

[No.] *530 Sheep. 16 × 26. finished Sept'r 31st. del'd by Sam Oct'r 7th* [Beneath the serial number appears:] *Sep' 31.*

Courtesy of a Massachusetts collection.

See 67.38.

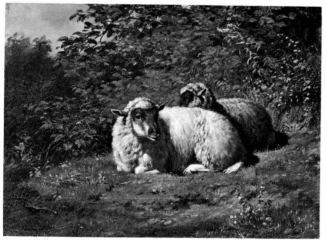

[SHEEP IN A SUNNY CLEARING] 67.40

A. F. Tait / N.Y. 1867 [LR] Board: 10 × 14

No. 531 / A. F. Tait / Morrisania / N.Y. Copy right [*sic*] reserved.

[No.] *531 Sheep. 14 × 10. finished Oct'r 2nd. Del'd Oct'r 7th by Sam.*

See 67.38.

SHEEP 67.41

[Unknown] [Unknown]: 10 × 14 [?]

[Unknown]

[No.] *532 Sheep. finished Oct'r 3rd 14 × 10. Del'd by Sam Oct'r 7th.*

See 67.38.

SHEEP AND WHITE HEN 67.42

[Unknown] [Unknown]: 10 × 12 arch top [?]

[Unknown]

[No.] *533 [1867 Sale] Sheep & White Hen. 12 × 10.* [Here appears a small sketch showing an arch top.] *finished Nov'r 21st. del'd by Polly Nov'r 30th with 541 & 542, 543 and 544* [67.50–.53].

SHEEP 67.43

[Unknown] [Unknown]: 14 × 22 [?]

[Unknown]

[No.] *534 Sheep. 22 × 14. finished Oct'r 19th del'd by Sam Oct'r 26.*

Bracketed with No. 535 (67.44).

COWS AND DUCKS 67.44

[Unknown] [Unknown]: 14 × 22 [?]

[Unknown]

[No.] *535 Cows & Ducks 22 × 14 Oct 24th Del'd by Sam Oct'r 26.*

Bracketed with No. 534 (67.43).

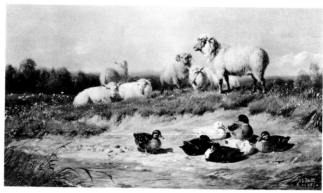

SHEEP AND DUCKS 67.45

A. F. Tait / N.Y. 1867 [LR] Canvas: 16 × 26

[Probably relined; inscription, if any, lost]

[No.] *536 Sheep & Ducks. 26 × 16. finished Oct'r 31st. Del'd by Polly Nov'r 9th.*

Bracketed with Nos. 537 and 538 (67.46 and 67.47).

COW AND DUCKS 67.46

[Unknown] [Unknown]: 14 × 22 [?]

[Unknown]

[No.] *537 Cow & Ducks. 22 × 14. finished Nov'r 4th Del'd Nov. 9th by Polly.*

Bracketed with Nos. 536 and 538 (67.45 and 67.47).

RUFFED GROUSE AND POINTER 67.47

A. F. Tait / N.Y. 1867 [LR] Board: 10 × 14

No. 538 / A. F. Tait / Morrisania / Westchester Co. N.Y. / 1867 Copyright Reserved.

[No.] *538 Ruffed Grouse & Pointer. 14 × 10 millboard. finished Nov'r 7th. Del'd by Polly Nov'r 9th.*

Bracketed with Nos. 536 and 537 (67.45 and 67.46).

DUCK AND YOUNG 67.48

A. F. Tait / N.Y. 1867 [LR] Panel: 11¾ × 16

No. 539. A. F. Tait, Morrisania, N.Y. 1867, Copyright reserved.

[No.] *539 Duck & Young. 16 × 12 Panel. finished Nov. 13th. Del'd Nov 16 by Polly with 540 [67.49].*

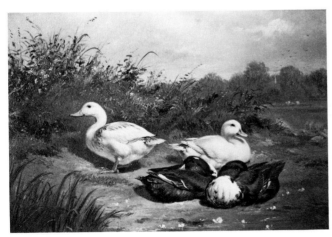

DUCKS 67.49

A. F. Tait / N.Y. '67 [LR] Board: 9 × 13

No. 540 / A. F. Tait / Morrisania/ N.Y. / 1867 / Copyright Reserved

[No.] *540 [Sale 1867] Ducks. 12 × 9 millb'd. finished No'r 13th. Del'd by Polly Nov'r 16th with 539 [67.48].*

Collection of the George Walter Vincent Smith Art Museum, Springfield, Massachusetts. Courtesy of George Walter Vincent Smith Art Museum.

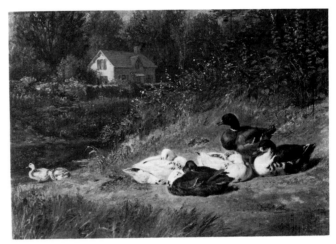

DUCKS RESTING, COTTAGE 67.50
IN THE DISTANCE

A. F. Tait / N.Y. 1867 [LR] Panel: 12 × 16.

No. 541, A. F. Tait, Morrisania, N.Y. 1867. Copyright reserved.

[No.] *541 Ducks resting, cottage in distance. 16 × 12 Panel. finished Nov. 14th del'd with 533 & 542. [67.42 and 67.51] Del'd by Polly Nov'r 30th.*

Nos. 541–44 (67.50–.53) variously bracketed and marked: *del with 533 (67.42).*

Courtesy of Mr. and Mrs. George Arden.

COW, CALF, AND HEN 67.51

[Unknown] Board: 8 × 11 [?]

[Unknown]

[No.] *542 Cow & Calf & Hen. 11 × 8 Millboard. finished Nov'r 22. Del'd by Polly Nov'r 30th.*

See 67.50.

GROUSE FLYING 67.52

[Unknown] [Unknown]: 10 × 14 [?]

[Unknown]

[No.] *543 Grouse Flying. 14 × 10. finished Nov'r 26. Del'd by Polly Nov. 30th.*

See 67.50.

WOODCOCK FLYING 67.53

A. F. Tait / N.Y. 1866. [LR] Canvas: 16 × 26

No. 544 / A. F. Tait / N.Y. 1866 / [words unclear]

[No.] *544 Woodcock Flying. 26 × 16. fin'd Nov 28. Del'd by Polly Nov 30.*

See 67.50.

Courtesy of Mr. and Mrs. Clyde W. Teel.

COCKER AND WOODCOCK 67.54

A. F. Tait / N.Y. 1867 [LR] Board: 14 × 22

[Unknown]

[No.] *545 Cocker Dog & Woodcock (Flying) 22 × 14. finished Nov. 30th Del'd by Polly Nov. 30th.*

CHICKENS 67.55

[Unknown] Board: 9 × 12 [?]

[Unknown]

[No.] *546 Chickens 12 × 9 millboard. Del'd Dec'r 14 by Sam & Arthur.*

67.56

CHICKENS 67.56

A. F. Tait / N.Y. 1867 [LR] Board: 9 × 12

No. 547 / A. F. Tait / Morrisania / N.Y. / 1867 / Coppyright [sic] reserved.

[No.] *547 [Sale 1867] Chickens. 12 × 9 Mill. Del'd Dec'r 14th by Sam & Arthur in Sleigh.*

Courtesy of Ms. Lee Appleton.

CHICKENS 67.57

[Unknown] Board: 9 × 12 [?]

[Unknown]

[No.] *548 Chickens. 12 × 9 Mill. Do. [Del'd Dec'r 14th by Sam & Arthur in sleigh.]*

CHICKENS 67.58

[Unknown] [Unknown]: 9 × 12 [?]

[Unknown]

[No.] *549 Chickens. 12 × 9 Do. [Del'd Dec'r 14th by Sam & Arthur in Sleigh.]*

CHICKENS 67.59

[Unknown] [Unknown]: 8 × 10 [?]

[Unknown]

[No.] *550 Chickens. 10 × 8 Do. [Del'd Dec'r 14th by Sam & Arthur in Sleigh.]*

CHICKENS 67.60

[Unknown] [Unknown]: 8 × 10 [?]

[Unknown]

[No.] *551 Chickens. 10 × 8. Do. [Del'd Dec'r 14th by Sam & Arthur in Sleigh.]*

DOE AND FAWN 67.61

[Unknown] [Unknown]: 9 × 12 [?]

[Unknown]

[No.] *552 Doe & Fawn. 12 × 9. Do. [Del'd Dec'r 14th by Sam & Arthur in Sleigh.]*

DUCKS 67.62

[Unknown] [Unknown]: 6 × 8 [?]

[Unknown]

[No.] *553 Ducks. 8 × 6 Do. [Del'd Dec'r 14th by Sam & Arthur in Sleigh.]*

DUCKS 67.63

[Unknown] [Unknown]: 6 × 8 [?]

[Unknown]

[No.] *554 Ducks. 8 × 6 Do. [Del'd Dec'r 14th by Sam & Arthur in Sleigh.]*

WOODCOCK 67.64

A. F. Tait / '67 [LR] Board: 9 × 11¾

No 554 [?] / Woodcock / A. F. Tait / N.Y. / Copyright reserved.

[No.] *555* [*Sale*] *Woodcock. 12 × 9.*

DEER AND FAWN 67.65

Jas. M. Hart & A. F. Tait / 1867 [LR] Board: 9 × 12

No. 556 / Jas. M. Hart & A. F. Tait / 1867 coppy right [*sic*] reserved

[No.] *556 Deer & Fawn. Joint Hart & Tait. 12 × 9. finished Dec'r 15th. Del'd by Sam Dec'r 17th.*

Courtesy of Mr. and Mrs. George Arden.

DEER AND FAWN 67.66

[Unknown] [Unknown]: 9 × 12 [?]

[Unknown]

[No.] *557 Deer & Fawn. Joint Hart & Tait. 12 × 9. finished Dec'r 15th. Del'd by Sam Dec'r 17.*

COCKER SPANIEL AND QUAIL 67.67

A. F. Tait / 1867 [LR] Board: 8 × 10

No. 558 / A. F. Tait / N.Y. / 1867. Coppy [*sic*] Right Reserved.

[No.] *558 Cocker Spaniel & Quail. 10 × 8.*

DOG'S HEAD 67.68

[Unknown] [Unknown]: 6 × 8 [?]

[Unknown]

[No.] *559 Dog's Head. 8 × 6. finished Dec'r 16. Del'd 17th Dec'r by Sam.*

DOG'S HEAD 67.69

[Unknown] [Unknown]: 6 × 8 [?]

[Unknown]

[No.] *560 Dog's Head. 8 × 6 finished Dec 16. Del'd 27th by Sam.*

DOG'S HEAD 67.70

A. F. Tait, '67 [LR] Panel: 6 × 8

No. 561, A. F. Tait 1867, Copyright Reserved.

[No.] *561 Dogs Head. 8 × 6.*

DOG'S HEAD 67.71

[Unknown] [Unknown]: 6 × 8 [?]

[Unknown]

[No.] *562 Dogs Head. 8 × 6.*

DOG'S HEAD 67.72

A.F.T. / N.Y. 67 [LR] Board: 6 × 8

No. 563 / A. F. Tait / 1867

[No.] *563 [Sale] Dogs Head 8 × 6.*

FOWLS 67.73

[Unknown] [Unknown]: 6 × 8 [?]

[Unknown]

[No.] *564 Fowls. 8 × 6.*

FOWLS 67.74

A. F. Tait / N.Y. 67 [LR] Board: 8 × 10

No. 565 / A. F. Tait / N.Y. / 1867 / Copyright reserved—A.F.T.

[No.] *565 Fowls 10 × 8.*

FOWLS 67.75

A. F. Tait / N.Y. 67 [LR] Board: 7½ × 9½

No. 566 / A. F. Tait / N.Y. 1867 / Copyright Reserved / A.F.T.

[No.] *566 Fowls. 10 × 8.*

FOWLS 67.76

[Unknown] [Unknown]: 8 × 10 [?]

[Unknown]

[No.] 567 Fowls 10 × 8.

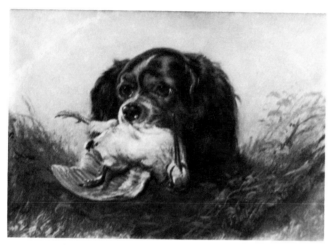

[COCKER AND WOODCOCK] 67.77

A. F. Tait / N.Y. 1867 [LR] Board: 6 × 8

No. 568. / A. F. Tait / N.Y. / 1867. / Xmass [sic] / 1867
Dr. Thurston / A. F. Tait.

[No.] 568 Cockers Head and Woodcock. 6 × 8. [oval on
square support shown by sketch] Presented to Dr. Thur-
ston.

There are marks on present painting showing where
original oval has been painted to a rectangular form. In
addition, signature and date show original shape as oval.

[COCKER'S HEAD AND WOODCOCK] 67.78

[Unknown] [Unknown]: 6 × 8 [?]

[Unknown]

[No.] 569. Cocker's Head and Woodcock. 6 × 8. Presented to
Mrs. Prang in Boston.

DOGS: POINTERS AND QUAIL 67.79

[Unknown] [Unknown]: 6 × 8 [?]

[Unknown]

[No.] 570. Dogs. (Pointers and Quail) 6 × 8.

[POINTER'S HEAD] 67.80

A. F. Tait / N.Y. '67 [LR] Canvas: 10 × 12

[Nothing on back]

[No AFT number; no Register entry]

[POINTER RETRIEVING A GROUSE] 67.81

A. F. Tait / N.Y. 67 [LR] Board: 6 × 8

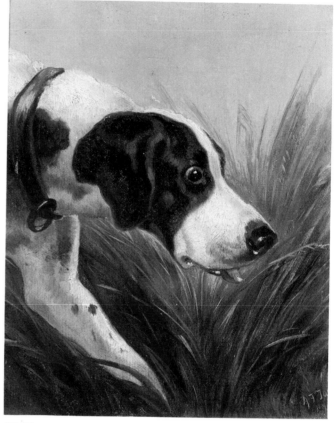

67.80

[Unknown]

[No AFT number; no Register entry]

[SKETCH OF ROCK GROWN OVER 67.82
WITH VINES]

[Not signed or dated] Board: 8¼ × 12

Sketch from Nature by A. F. Tait / at Constable Point
on Racquette Lake / by A. F. Tait / 1867.

[No AFT number; no Register entry]

Collection of the Yale University Art Gallery, New Ha-
ven, Connecticut.

[HERON AMONG EIGHT DUCKS 67.83
AT THE EDGE OF A POND]

A. F. Tait / N.Y. '67 [LR] Canvas: 26 × 17

[Unknown]

[No AFT number; no Register entry]

COCKER AND WOODCOCK 68.1

A. F. Tait / N.Y. 1868 [LR] Board: 10 × 12

[Unknown]

No. 571-4. Cocker & Woodcock. Chrome. Dog's head with
bird in mouth. 12 × 10 Millboard. Finished Feb. 26 for L.
Prang to Chromo—sent to Boston Feb. 27 and ret. to be re-
touched—sent with No. 5 [68.2] March 15 / 68.

A chromolithograph was published by Louis Prang, 1869, titled "Spaniel and Woodcock."

POINTER'S HEAD AND QUAIL 68.2

A. F. Tait / N.Y. 1868 [LR] Board: 10 × 12

No. 5 1868 / A. F. Tait / Morrisania / Westchester Co. / N.Y. / Copyright reserved by / the artist.

[No.] *572-5 Pointer's Head and Quail. Millboard 12 × 10. L. Prang (Boston) to Chromo. Sent with No. 4. [68.1] returned and sent to Snedicor's for sale.*

As this painting was not acceptable to Prang for reproduction, AFT made a duplicate, 68.3, which Prang accepted.

[POINTER'S HEAD AND QUAIL] 68.3

A. F. Tait / N.Y. 1868 [LR] Board: 10¼ × 12½

[Unknown]

[No.] *A575-A5 No. 4. March 16th. 1868. duplicate of Pointers Head and Quail and finished more and sent to Prang.*

This version was substituted for 68.2, which Prang found insufficiently finished to warrant reproduction. A chromolithograph was published by Louis Prang, 1869, titled "Pointer and Quail."

POINTER AND QUAIL 68.4

[Unknown] Board: 8 × 10 [?]

[Unknown]

[No.] *573-6 Pointer & Quail. Millboard 10 × 8. Exchange for Henry Rifle to Mr. Cooper (date 1866) began in 1866 finished May 1st / 68. with frame from Snedicor.*

DEAD GAME: CANVAS BACKS 68.5

[Unknown] [Unknown]: 14 × 17 [?]

[Unknown]

[No.] *574-7 Chromo. Dead Game (2 Canvas backs). 17 × 14. L. Prang, Boston (not approved) for Chromo Sent to NAD Exhibition 1869. Returned with No. 11 March 20 / 1869. Brown Sale April 1870.*

Exhibited at National Academy of Design 44th Annual Exhibition, 1869, titled "Dead Game, Canvas Backs" and listed as for sale.

BLACK BEARS 68.6

A. F. Tait / N.Y. [LR] Canvas: 13 × 16

No. 8. / A. F. Tait / Morrisania Westchester Co. N.Y. / 1868

[No.] *575-8 Black Bears. (Bear & two cubs) 13 × 16. Del'd to Snedicor October 24th / 68.*

[DOE AND FAWNS] 68.7

A. F. Tait / 68 [LR] Board: 10 × 14

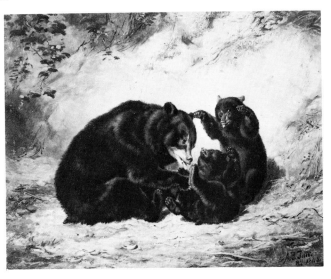

68.6

No. 9 / A. F. Tait / Morrisania / Westchester Co. N.Y. / 1868.

[No.] *576-9 Doe and Two Fawns. Del'd to Snedicor to frame Oct. 24/68. 14 × 10.*

MATERNAL AFFECTION 68.8

A. F. Tait / N.Y. 1868 [LR] [Unknown]: 12 × 16

[Unknown]

[No.] *577-10 Chromo. [1868] Maternal Affection Doe and Fawn. 16 × 12. L. Prang Boston. Chromo. (approved).*

A chromolithograph was published by Louis Prang, 1870, titled "Maternal Love."

DEAD GAME: MALLARD DUCKS 68.9

[Unknown] [Unknown]: 17 × 14 [?]

[Unknown]

[No.] *578-11 Dead Game. Mallard Duck & Drake. Chromo. 14 × 17. L. Prang-Boston. to be chromed (Not approved). Returned March 20th/69. Sent to NAD Exhibition 1869. Brown's Sale April 1870.*

Exhibited at the National Academy of Design 44th Annual Exhibition, 1869, titled "Dead Game, Mallard Ducks" and listed as for sale.

BLACK SPANIEL AND WOODCOCK 68.10

A. F. Tait / 1868 [LR] [Unknown]: 14 × 22

Black Spaniel and Woodcock / A. F. Tait / No. 12 / Morrisania, N.Y. / 1868.

[No.] *579-12 Cocker Spaniel & Woodcock flying. 22 × 14. Jno. L. Martin. del'd to Snedicor to frame about October 1st /68. in exchange for another picture and frame. returned for sale in 1867 and he (Mr. J. M.) paid $50 extra.*

Courtesy of Kennedy Galleries, Inc., New York, New York.

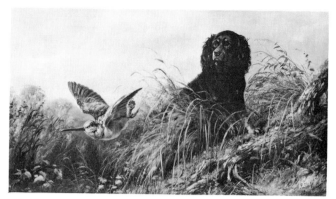

68.10

[COCKER SPANIEL AND WOODCOCK] 68.11

[Unknown] [Unknown]: 10 × 14 [?]

[Unknown]

[No.] 580-13 Cocker Spaniel & Woodcock 14 × 10. Del'd to Snedicor for sale Oct. 24th/68.

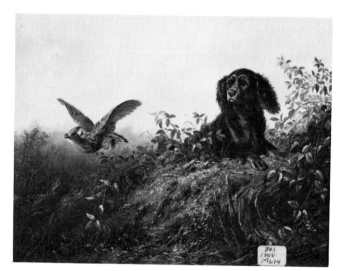

COCKER SPANIEL AND RUFFED 68.12
GROUSE

A. F. Tait / 1868 [LR] Canvas: 16¼ × 20¼

[Unknown]

[No.] 581-14 Cocker Spaniel and Ruffed Grouse 16 × 20 in Blackberry Bushes—paid for Nov. 2nd/1868 T. J. Pope.

Courtesy of Kennedy Galleries, Inc., New York, New York.

FARM YARD 68.13

[Unknown] [Unknown]: 10 × 14 [?]

[Unknown]

[No.] 582-15 Farm Yard. Finished Study for larger Picture. 14 × 10 Jas. B. Blossom—paid [$150.00] Dec. 19th. Frame at Snedicors.

[COCKER SPANIEL AND RUFFED 68.14
GROUSE]

A. F. Tait N.Y. 1868 [LR] Canvas: 15½ × 25½

No. 16 / A. F. Tait / Morrisania / New York / 1868.

[No.] 583-16 [1868] Cocker Spaniel & 2 Ruffed Grouse in Forest. 16 × 26 Nov.—at Snedicor's for sale. Sold Jan'y 20th. price with frame [$250.00]—rec'd Jan.22 cheque from Snedicor for [$250.00].

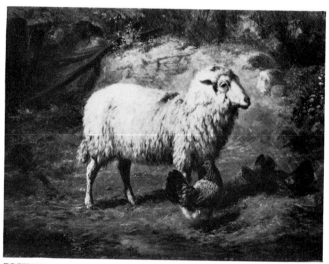

SHEEP AND FOWLS 68.15

A. F. Tait / 1868 [LR] Canvas: 15 × 24

No. 17. / A. F. Tait / 1868

[No.] 584-17 Sheep and Fowls. 14 × 10. Mr. Briggs. Dec'r 8. (sent to Snedicors by Sam) to settle a/c to date. Mr. B. to pay for frame.

Courtesy of Mr. and Mrs. George Arden.

[DOE AND FAWNS] 68.16

[Unknown] [Unknown]: 8 × 6 [?] Oval

[Unknown]

[No.] 585-18 Doe and two Fawns. Oval 6 × 8. presented to Mrs. Thos. J. Pope as Xmas present Dec'r 25/68.

[DOE AND FAWNS] 68.17

[Unknown] [Unknown]: 8 × 6 [?]

[Unknown]

[No.] 586-19 Doe and two Fawns in Frame. Square 6 × 8, at Goupil's (Noedler [Knoedler]). del'd Dec'r 30th for Sale.

[DOE AND FAWNS] 68.18

[Unknown] [Unknown]: 8 × 6 [?] Oval

[Unknown]

[No.] 587-20 Doe and Two Fawns. 6 × 8 oval S. P. Windmuller Xmas 1868 present to him.

FOWLS 68.19

A. F. Tait [L.R.] Board: 6 × 8

A. F. Tait, 1868, / #21 Morrisania West Chester Co. N.Y.

[No.] *588-21 Fowls. Noadler's* [Knoedler's] *(Goupil's) for sale 6 × 8. del'd Dec' 30 same time as No. 19* [68.17] *in frame.*

COCKER SPANIEL AND 68.20
FLYING RUFFED GROUSE

A. F. Tait / 1868 [LR] Canvas: 16¼ × 20¼

No. 24 / A. F. Tait / Morrisania, N.Y. / 1868

[No.] *591-24 Cocker Spaniel & Ruffed Grouse Flying. (f. Jan'y 9th) W. H. Wolff, Pittsburgh. sent off Jan'y 22nd by Express.*

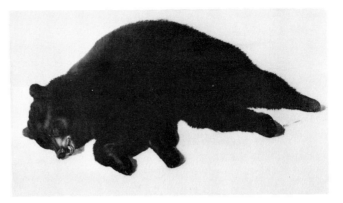

One of three studies, including 68.21 and 68.23, all probably of the same bear.

Collection of The Adirondack Museum, Blue Mountain Lake, New York. Courtesy of The Adirondack Museum.

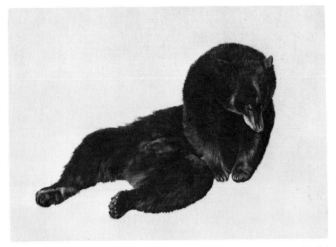

[STUDY OF RECLINING BEAR] 68.21

[Not signed or dated] Canvas: 16 × 22

From Portfolio of A. F. Tait, N.A. / "American Black Bear." / Painted from Nature about 1868 / by A. F. Tait. / Received from Estate of A. F. Tait / by his son, / Arthur J. B. Tait, 1905.

[No AFT number; no Register entry]

This is one of three studies of bears, including 68.22 and 68.23, believed to date from about 1868.

Courtesy of Mrs. Frederick W. Wright III.

[AMERICAN BLACK BEAR] 68.22

[Not signed or dated] Canvas: 15 × 26

"From portfolio of A. F. Tait, N. A. / 'American Black Bear' by A. F. Tait / Painted from nature about 1868. / Received from estate of A. F. Tait, 1905 / by his son / Arthur J. B. Tait, 1905. Presented to my dear friend of many years / John K. Lovell / from Arthur J. B. Tait, September 21, 1948."

[No AFT number; no Register entry]

[STUDY OF BEAR PLAYING] 68.23

[Not signed or dated] Canvas: 13 × 16

"From portfolio of A. F. Tait, N.A. 'American black bear cub.' Painted from nature about 1868. Received from estate of A. F. Tait by his son Arthur J. B. Tait, 1905."

[No AFT number; no Register entry]

One of three studies, including 68.21 and 68.22, probably all of the same bear.

Courtesy of Miss Alexandra S. Morgan.

[DOE AND FAWNS IN THE FOREST] 69.1

[See 70.12] [Unknown]: 10 × 8 [?]

[See 70.12]

[Following crossed out: (No.) *589-22 Jan'y 6th. 1869. Doe & two fawns in Forest. F. Jan'y 5th. 8 × 10. Snedicor by*

Sam Jan'y 22nd with No. 23 (69.2) in frame] Not Sold May 26th / 70. transferred to No. 28 (1870) [70.12] renumbered & retouched in new Frame (Snedicors).

COW AND FOWLS 69.2

[Unknown] Board: 8 × 10

No. 23 / A. F. Tait / Morrisania / Westchester Co. / N.Y. / 1868

[No.] 590-23 Cow and Fowls. finished Jan'y 7th. 8 × 10. to Snedicors by Sam with No. 22 [69.1] Jan'y 22nd in frame.

[BUCK AND DOE IN FOREST] 69.3

[Unknown] [Unknown]: 8 × 6 [?] oval

[Unknown]

[No.] 592-25 Deer in Forest (Buck & Doe) oval 6 × 8 to Snedicors for sale Jan'y 29th by Sam in frame. finished Jan 25th.

SHEEP AND CHICKENS 69.4

A. F. Tait / 1869 [LR] Board: 8 × 10

No. 25 [written over 26] / A. F. Tait / Morrisania / N.Y. / 1869. / Not to be published / Copyright retained / by the Artist / A. F. Tait.

[No.] 593-26 Sheep & chickens. 8 × 10. [Additional words lost due to faintness or erasure.]

Courtesy of Mr. and Mrs. George Arden.

FARM YARD 69.5

[See 70.3] Canvas: 16 × 26

[See 70.3]

[No.] 594-27 Farm Yard. Transfered to 1870. 26 × 16.

Burnt on stretcher, "A. F. Tait." This painting was not finished until 1870 and was relisted by AFT for that year (see 70.3).

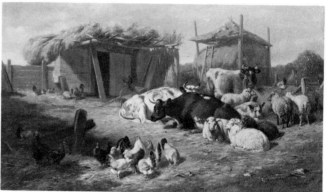

69.5

POINTER AND DEAD GROUSE 69.6

[Unknown] [Unknown]: 10 × 8 [?]

[Unknown]

[No.] 595-28 [1869] Pointer & Dead Grouse. in frame 8 × 10. Jno. S. Martin to balance a/c. del'd Jan'y in frame. (Frame) paid for by tub butter & cheese.

COCKER SPANIEL AND RUFFED GROUSE 69.7

[Unknown] [Unknown]: 9 × 11 [?]

[Unknown]

[No.] 596-29 Cocker Spaniel & Ruffed Grouse. 11 × 9 H. N. Camp in exchange for No. 375 [65.10] at Snedicors. no frame. del'd by Sam to his House Jan'y 23rd.

[BARN YARD SCENE] 69.8

A. F. Tait / N.Y. 1869 [LR] Board: 10 × 13¾

No. 30. / A. F. Tait / Morrisania / Westchester Co. / N.Y. 1868.

[No.] 597-30 Cow Yard. Shed & chickens. finished Jan'y 27th 14 × 10. Sent to Snedicor Feb'y 5th for sale. returned. Sold to Mr. Southwick thru Mr. Nelson.

Note that front and rear dates differ. AFT was changing his numbering system at this time, which may account for the variance.

SHEEP AND CHICKENS 69.9

[Unknown] [Unknown]: 10 × 14 [?]

[Unknown]

[No.] 598-10 Sheep & chickens. 14 × 10.

[RUFFED GROUSE] 69.10

[Unknown] [Unknown]: 30 × 20 [?]

[Unknown]

[No.] 599-11 2 Ruffed Grouse & Chickens 20 × 30. NAD. Exhibition 1869. Sold April 19th, 1871 to Thos. Nye, New Bedford [$300.00].

Exhibited at the National Academy of Design 44th Annual Exhibition, 1869, titled "Ruffed Grouse" and listed as for sale. Bracketed with No. 600–12 (69.11).

CHILDREN FEEDING DUCKS 69.11

[Unknown] [Unknown]: 30 × 20 [?]

[Unknown]

[No.] *600-12 Light & Shade. Children feeding Ducks. 20 × 30. Phebe Tait & Ally Momburger. Joint Hart & Tait. Sold April 19th, 1871 to Thos. Nye J'r, New Bedford. and No. 11:599. Paid* [$300.00].

Bracketed with No. 599-11 (69.10).

CHICKENS 69.12

[Unknown] Panel: 10 × 8 [?]

[Unknown]

[No AFT no.] *Chickens on Wood Panel 8 × 10. Jno. S. Martin—Wooden Wadding. Exchange for Tub of Butter & Cheese. he paid for frame $3.00 from Snedicor.*

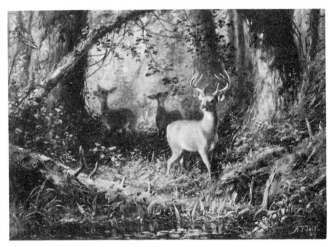

THE ADIRONDACKS 69.13

A. F. Tait / '69 [LR] Canvas: 10 × 14½

Adirondacks / 1869 / by A. F. Tait / 23rd St. Cor. / 4th Av / N.Y.

No. 10. !The Adirondacks! Buck and two Does (in Shade) 14 × 10. Sold with Frame to Alex White, Chicago. [$150.00].

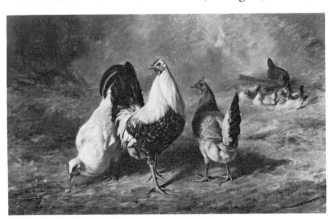

69.14

BARN YARD FOWLS 69.14

A. F. Tait / N.Y. 1769 [LR] Canvas: 16¼ × 26

No. 11 / A. F. Tait / N.Y. / 1869

No. 11. Barn Yard Fowls. size 26 × 16. sold thru Mr. E. D. Nelson with No. 13 [69.16], *1868 for* [$125.00] *No Frames.*

Collection of The Newark Museum, Newark, New Jersey. Courtesy of The Newark Museum.

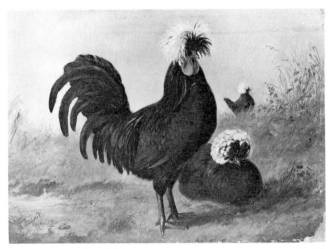

BLACK POLANDS 69.15

A. F. Tait, N.Y. 1869 [LL] Board: 10 × 14

No. 12 / A. F. Tait / 23rd St. 4th Av / N.Y. / 1869 / To Polly from Uncle / 1873.

No. 12 Black Polands. 14 × 10.

This painting was awarded a gold medal at the New York State Poultry Association exhibition for best oil painting, December 1869.

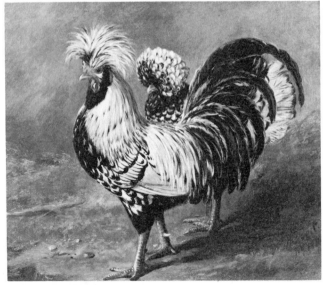

SILVER POLANDS 69.16

A. F. Tait / N.Y. 1871 [LR] Board: 10 × 12

No. 13 / "Silver Polands" / A. F. Tait / 23 S. N.Y. 1871

No. 13 [1869.] Silver Polands. 12 × 10.

Courtesy of Christie's New York, New York.

[FEED THE DUCKS] 69.17

A. F. Tait, 1869 [LR] Board: 10¼ × 14

[Unknown]

[No.] 14 !Little Phe! and the Ducks. 14 × 10. Dec'r 25th Xmas to dear Aunty—. No. 14 I afterwards gave to the Lotos Club as my initiation Fee.

CLASSEN'S POINT 69.18

[Not signed or dated] Canvas: 12 × 16

"Classens point" / Westchester / N.Y. / by A. F. Tait / 1869

[No AFT number; no Register entry]

[STUDY FROM NATURE] 69.19

[Not signed or dated] Canvas: 13 × 15

Study from Nature / A. F. Tait / 1869. / Near Palmers / Long Lake / Hamilton Co. / N.Y.

[No AFT number; no Register entry]

[STUDY FROM NATURE] 69.20

[Not signed or dated] Canvas: 12½ × 14¾

Palmers / Long Lake / A. F. Tait / 1869

[No AFT number; no Register entry]

[STUDY AT LONG LAKE] 69.21

[Not signed or dated] Canvas: [Unknown]

Near Palmer's / Long Lake / Hamilton Co. / N.Y. / From nature / by A. F. Tait / 1869.

[No AFT number; no Register entry]

SHEEP AND CALF 70.1

[Unknown] [Unknown]: 10 × 8 [?]

[Unknown]

[No.] 17 Sheep & Calf, 8 × 10. fin. Feb'y 16th 18 [blank] Sold to Mr. [blank] thru Mr. E. D. Nelson.

[THE MEXICAN DOG] 70.2

A. F. Tait / N.Y. 1870 [LR] Canvas: 12¾ × 15¾

No. 18 / A. F. Tait / Y.M.C.A. / N.Y. / 1870 / To Mrs. Chas. Stillman / with kindest regards / A. F. Tait

[No.] 18 Portrait of Dog. Mrs. Stillman. Presentation Picture. finished March. NAD Exhibition 1870. ret'd June 27 / 70. del'd to Mr. S. June and paid for [$100.00]. Paid by ch'k $100.00.

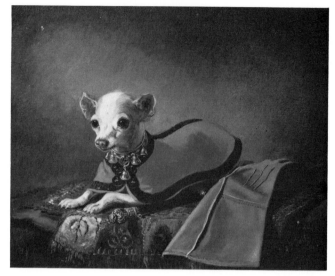

Name of Chihuahua dog, imported from Mexico by Mr. Stillman, was "Little Beppo." Exhibited at the National Academy of Design 45th Annual Exhibition, 1870, titled "Mexican Dog," and owned by Mrs. Charles Stillman.

Courtesy of Mr. Chauncey Stillman.

FARM YARD 70.3

A. F. Tait / N.Y. / 1870 [LR] Canvas: 16 × 26

No. 27. A. F. Tait / Morrisania N.Y. / 1869 / YMCA 1870 / finished.

[No.] 19 Farm Yard. 26 × 16 finished in YMCA Feb'y 1, at Snedicors June 30 / 70 in frame.

See 69.5.

DUCKS 70.4

[Unknown] [Unknown]: 6 × 8 [?] oval

[Unknown]

[No.] 20 Ducks. 8 × 6 oval 6 × 8. Brown Sale (Frame).

BUCK IN FOREST 70.5

[Unknown] [Unknown]: 10 × 8 [?]

[Unknown]

[No.] *21. [1870 Y.M.C.A.] Deer (Buck) in Forest. Ap. 12. 8 × 10. Brown sale (Frame).*

CALF AND DUCKS 70.6

[Unknown] [Unknown]: 12 × 10 [?]

[Unknown]

[No.] *22. Calf & Ducks. (Frame) April 10th. 10 × 12 Brown sale.*

SHEEP 70.7

[Unknown] [Unknown]: 8 × 10 [?]

[Unknown]

[No.] *23 Sheep—no Frame. 8 × 10 Mr. Nelson's friend.*

DUCKS 70.8

A. F. Tait / 1870 [LR] Panel: 6½ × 8½

No. 24. / April 27, 1870 / YMCA / 23rd St. & 4th Ave. / N.Y.

[No.] *24 "Ducks" (on Panel) no frame 6 × 8 April 17/70. Mr. S. F. B. Morse. Presented on his birthday.*

DUCKS 70.9

[Unknown] [Unknown]: 10 × 8 [?]

[Unknown]

[No.] *25 Ducks (in Frame) 8 × 10. Sold at Leeds Sale [$85.00] with Frame May 21st/70. Bo't by Benj. F. Carver.*

DUCKS AND YOUNG 70.10

[Unknown] [Unknown]: 10 × 8 [?]

[Unknown]

[No.] *26. [1870] Ducks & Young (Spring) 8 × 10. Mr. Jaques, 213 W. 14th St. Paid May 23rd [$150.00] [$75.00] each.*

Priced by AFT together with 70.11. Bracketed with No. 27 (70.11).

70.11

FOWLS AND CALF 70.11

A. F. Tait / 1870 [LR] Board: 8 × 10

No. 27 / A. F. Tait / Y.M.C.A. 23st N.Y. / 1870

[No.] *27 Fowls & Calf (Chickens &c) Apple Blossoms. Mr. Jaques. [$75.00] 8 × 10.*

Priced together by AFT with 70.10. Bracketed with No. 26 (70.10).

Courtesy of Mr. and Mrs. George Arden.

[DOE AND FAWNS] 70.12

A. F. Tait / 1868 [LR] Board: 8 × 10

No. 28 / 1870 / A. F. Tait. / Morrisania / N.Y.

[No.] *28 Doe & Two Fawns. 8 × 10. Transferred from No. 22 [69.1] (1868) retouched & renumbered to date. sent to Utica Ex 1871. paid for & Sold March 28th/71. this & No. 38 for [$140.00].*

DUCKS AND YOUNG 70.13

[Unknown] [Unknown]: 8 × 10 [?]

[Unknown]

[No.] *29 May Ducks & Young. 8 × 10. Leeds Sale June 3rd with frame. nett [$57.00] finished June 21st.*

POPHAM HOMESTEAD 70.14

[Unknown] [Unknown]: 29 × 40[?]

[Unknown]

[No.] *30. Farm Yard (Popham Homestead) 29 × 40. (Scarsdale Westchester Co. N.Y.) (Frame by Snedicor cost $88.) Shadow Box by Salor $6.50. W. H. Raynor. finished in June 22, de'd by Russell Dec'r 29th/70. Paid me [$500.00] a/c paid Snedicor for Frame [$87.00] Finished June 22nd.*

Sketch for this painting is 70.15.

POPHAM FARM 70.15

A. F. Tait / N.Y. 1870 [LR] Canvas: 14 × 22

No. 31 / A. F. Tait / Y.M.C.A. / 23rd St. N.Y. / 1870 / Popham Farm / Scarsdale / Westchester Co. / N.Y. / Painted from nature.

[No.] *31. Sketch for above. No. 30 [70.14]. 14 × 22. finished up very highly from nature and as a Picture. Artists Fund—Jan. 19th—1872 S. Frame $27.00.*

See 70.14.

[OLD SHED AND FARM ANIMALS AND FOWLS] 70.16

A. F. Tait / N.Y. '70 [LL] Canvas: 14¼ × 22

[Relined; inscription, if any, lost]

[No.] *32. [1870.] finished June 15th. Old Shed. (Popham Homestead) with Sheep, Ducks (& Lamb & Hen & Chicks,*

fighting) 14 × 22 (finished up highly from nature) bought by Jas. B. Blossom at Schenck's Sale 1871 (fall) no frame.

Courtesy of Mr. and Mrs. George Arden.

DUCKS AND DOGS 70.17

[Unknown] [Unknown]: 22 × 14 [?]

[Unknown]

[No.] *33 Ducks (scared) and Dogs. 14 × 22. Sold by Bogardus. June.*

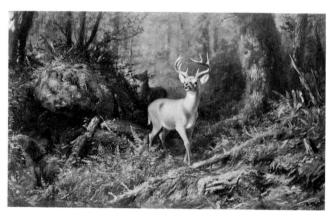

THE ADIRONDACKS IN 1869 70.18

A. F. Tait / N.Y. 1870 [LR] Canvas: 14 × 22

No. 34 / A. F. Tait / Y.M.C.A. / N.Y. 1870 / "The Adirondacks in 1869."

[No.] *34 Deer in Forest. in Frame 14 × 22. Mrs. M. G. Carson, 34 E 38th St. [$250.00] thru Mr Nelson Nov'r 4th 1870.*

[DEER ON THE MARSH] 70.19

[Unknown] [Unknown]: 8 × 6 [?]

[Unknown]

[No.] *35 Deer (On Marsh) 6 × 8 Mr. Caldenburg. Exchange for pipes. Delivered by Arthur July 8, 1870 in Frame. Frame to be paid for extra $16.00.*

[DEER ON THE MARSH] 70.20

[Unknown] [Unknown]: 10 × 8 [?]

[Unknown]

[No.] *36 Deer (on Marsh) 8 × 10 Sent to Mathew Sale Feb'y 22nd J. Caruth. Nov'r 11/70.*

LAMB, HEN, AND CHICKENS 70.21

A. F. Tait / N.Y. '70 [LR] Board: 8 × 10

No. 37 / 1870 / A. F. Tait / Y.M.C.A. / 23rd St. / N.Y.

[No.] *37 Lamb & Hen & Chickens. 8 × 10. Sold by Snedicor to a/c.*

DUCKS IN REPOSE 70.22

[Unknown] [Unknown]: 8 × 6 [?]

[Unknown]

[No.] *38 [1870] Ducks (repose) 6 × 8. sent to Utica and sold there. Paid March 28th 1871.*

COWS AND FOWLS 70.23

[Unknown] [Unknown]: 8 × 10 [?]

[Unknown]

[No.] *39 Two Cows & Fowls 8 × 10 Sold at Somerville sale Feb'y 1871 Ogilvie's Friend.*

CALF AND DUCKS 70.24

[Unknown] [Unknown]: 8 × 10 [?]

[Unknown]

[No.] *40 Calf & Ducks. 8 × 10. Mr Zabriskie.*

[UNKNOWN] 70.25

[Unknown] [Unknown]: 14 × 10 [?]

[Unknown]

[No.] *41 [The following in pen crossed out: Cows Ducks Apple Blossoms & Spring Head. & Ducks] 14 × 10 Artist Fund [The following in pencil crossed out: c 1 31-1-] Paid Dec'r 31st/70. with Frame but to be exchanged it required [?] [In pencil:] (it was returned painted No. [blank] instead) [Written above the entry in pencil:] Mr. Bulkly [Buckley] 450 W. 23rd Street. [In the margin left:] del'd to Artist Fund Jan'y 27th/71.*

DEER IN FOREST 70.26

[Unknown] [Unknown]: 10 × 14 [?]

[Unknown]

[No.] *42 Deer in Forest. 14 × 10. Artists Fund.*

SHEEP, DUCKS, AND FOWLS 70.27

A. F. Tait [LR] Canvas: 8 × 10¼

No. 43 / A. F. Tait / Y.M.C.A. / 23rd St / N.Y. / 1870.

[No.] *43 [1870.] Sheep Ducks & Fowls 8 × 10.*

HEN, CHICKENS, SHEEP, AND
LAMBS 70.28

[Unknown] Canvas: 8 × 10 [?]

[Unknown]

[No.] *44 Hen & Chickens with Sheep & Lambs in back-
ground in Shade of Apple Tree Blossoms &c on canvass &
stretcher 8 × 10.*

DEER IN FOREST 70.29

A. F. Tait / N.Y. 1870 [LR] Board: 10¼ × 14

No. 45. 1870 / A. F. Tait / Y.M.C.A. 23rd St / N.Y. /
Adirondacks / 1870.

[No.] *45 Deer in Forest in frame 14 × 10. Mr J. L. Buckley
450 W 23rd St N.Y. (Xmas 1870) with glass on. Paid
[$100.00] & Frame [$25.00].*

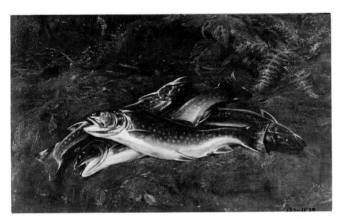

SPECKLED TROUT 70.30

A. F. Tait / '70 [LR] Canvas: 14 × 22

[Unknown]

[No.] *46 Speckled Trout from nature at South Pond (Long
Lake) Hamilton Co. N.Y. 14 × 22 Chas. Blossom. Remson St.
Brooklyn. Ex Union League.*

Bracketed with No. 47 (70.31).

SPECKLED TROUT 70.31

A. F. Tait / N.Y. 1870 [LR] Canvas: 14 × 22

[Unknown]

[No.] *47 Speckled Trout from nature. South Pond Hamilton
Co. N.Y. U. League 14 × 22 Ch Blossom Brooklyn.*

Bracketed with No. 46 (70.30).

LAKE TROUT 70.32

[Unknown] [Unknown]: 14 × 22 [?]

[Unknown]

[No.] *48 Lake Trout from nature as above. Union League
Sidman 14 × 22.*

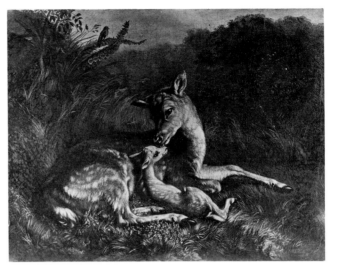

[DEER AND FAWN] 70.33

A. F. Tait / 1870 [LR] Canvas: 21¾ × 28½

[Nothing on back]

[No AFT number; no Register entry]

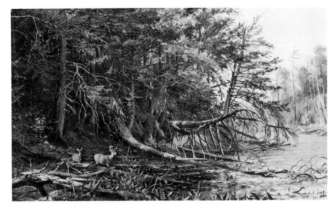

OUTLET OF ST. REGIS LAKE 70.34

A. F. Tait / 1870 [LR] Canvas: 14½ × 22

From nature by / A. F. Tait / "Outlet of St. Regis Lake" /
Franklin Co. / Aug. 1870.

[No AFT number; no Register entry]

Courtesy of Sotheby Parke Bernet, Agent: Editorial
Photocolor Archives, New York, New York.

AUTUMN, 1870, SOUTH POND 70.35

A. F. Tait / N.A. [LR] Canvas: 14½ × 22½

"Autumn," 1870, South Pond, near Long Lake, Hamil-
ton Co., N.Y.

[No AFT number; no Register entry]

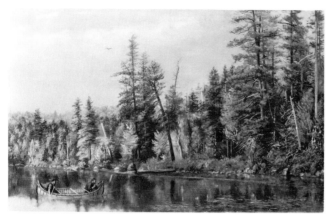

The original back inscription given above is from a statement attached to the painting following restoration and relining.

[THE REFRESHING SPRING 70.36
IN THE WOODS]

A. F. Tait, N.A. / N.Y. 1870 [LR] Canvas: 14 × 22

[Nothing on back]

[No AFT number; no Register entry]

[THE FARMYARD] 70.37

A. F. Tait / N. Y. 70 [LR] Board: 9½ × 11

No. 375 A. F. Tait / Morrisania / Westchester County /
N. Y. / also YMCA / 23rd Street / N. Y. 1870

[No AFT number; no Register entry]

While this painting is believed to be by AFT, the number 375 on the back does not coincide with Tait's coding for 1870.

SOUTH POND 70.38

South Pond / Aug. 1870 Paper: 10⁷⁄₁₆ × 14½
near Long Lake /
Hamilton Co. / NY [LR]

[Nothing on back]

[No AFT number; no Register entry]

Collection of the Yale University Art Gallery, New Haven, Connecticut.

RAQUETTE FALLS 70.39

A. F. Tait / 1870 [LR]; / Paper: 8⅜ × 11¾
[Raqu]ette Falls/
Below Long Lake / 1870 [UL]; K Rocks / grey-moss /
white foam [LL]; / . . . ch autumn [UR]

Raquette Falls / below Long Lake / Hamilton Co. N. Y. /
AF Tait 1870

[No AFT number; no Register entry]

Collection of the Yale University Art Gallery, New Haven, Connecticut.

SOUTH POND 70.40

South Pond / near Long Lake / Paper: 10⅞ × 14½
Aug. 26, 1870 [LR]

[Nothing on back]

[No AFT number; no Register entry]

Collection of the Yale University Art Gallery, New Haven, Connecticut.

SPRING 71.1

[Unknown] [Unknown]: 16 × 12½ [?]

[Unknown]

No. 10. [1871. Y.M.C.A. 23rd St. N.Y.] Spring. Apple Blossoms Sheep Lambs Chickens Fowls & Horses leaning over gate—16 × 12½ Exchange with Jas. M. Hart. Delivered to him Jan'y 18th/1871 for Xmas present to Aunty. Ex'd Union League Jan'y 26th.

DOGS AND QUAIL 71.2

[Unknown] [Unknown]: 14 × 22 [?]

[Unknown]

[No.] 11. Two Dogs & Quail (Pointer & Setter) 22 × 14. Ex Union League Jan 26. H. D. Polhemus, Esq. Remsen St Brooklyn. Paid [$300.00].

FARM YARD 71.3

[Unknown] [Unknown]: 22 × 16 [?]

[Unknown]

[No.] 12 Farm Yard. [Crossed out: Union League Jan 26/ 71.] returned. 16 × 22 sent to Artists Sale (Somerville Gallery) [$150.00] bought by Ogilvies Friend. he ordered a companion.

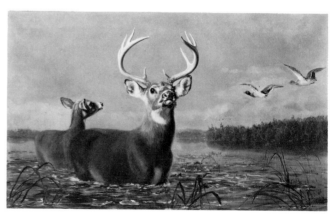

BUCK AND DOE IN WATER 71.4

A. F. Tait / N.Y. 1871 [LR] Canvas: 14 × 22

[Nothing on back]

[No.] 13 Buck & Doe in water amongst Lilly Pads. Ducks Flying (Mallard & Duck) 14 × 22 Sold at Schencks Sale with Frame. Nett [$150.00].

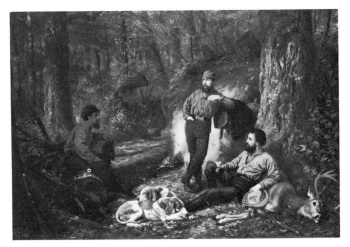

HALT ON THE PORTAGE 71.5

A. F. Tait / N.Y. 1871 [LL] Canvas: 19 × 28

No. 14 / A. F. Tait / Y.M.C.A. 23rd St / N.Y. 1871

[No.] *14 Halt on the Portage. 3 figures (Frank Smith) resting. Dogs. Dead Buck &c. 28 × 19 H. D. Polhemus Esq'r 48 Remsen St. Brooklyn Paid [$500.00] March 6th.*

Exhibited at the National Academy of Design 46th Annual Exhibition, 1871, titled "The Halt on the Carry, Racquette Lake, Adirondacks" and owned by Henry D. Polhemus.

Courtesy of M. R. Schweitzer and Kenneth Lux.

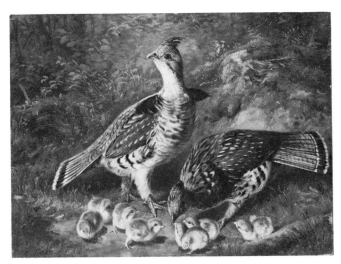

PAIR RUFFED GROUSE AND YOUNG 71.6

A. F. Tait / N.Y. 1871 [LR] [Unknown]: 14 × 10½ [?]

[Unknown]

[No.] *15. [1871 Y.M.C.A.] Pair Ruffed Grouse & Young. 14 × 10½ R. Buckley paid [$150.00] Lawlers Frame.*

TROUBLE AHEAD: IN THE 71.7
ADIRONDACKS

[Unknown]

Canvas: 40 × 26 [?]

[Unknown]

[No.] *16. "Trouble Ahead." in the Adirondacks. 40 × 26 (From Study on Long Lake near Palmers) with Hunter and two Bears in distance (Snedicors Frame) Sold to Mr. Horace Fairbanks, St Johnsbury Vt April 1872 [$400.00] with Frame.*

This painting was returned to AFT in 1877 by Horace Fairbanks, governor of Vermont, and Tait overpainted it and listed it anew in the Register for 1877 as No. 78 (77.5).

BUCK ALARMED 71.8

[Unknown] [Unknown]: 14 × 18 [?]

[Unknown]

[No.] *17. Deer (Buck) Alarmed Ducks flying 18 × 14 Boat in distance sent to Schencks Sale Sale Feb'y 20 / Paid no frame [$109.00].*

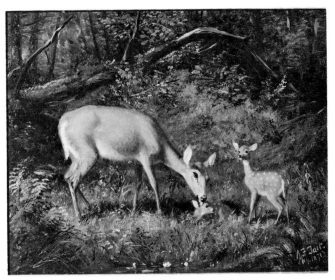

DOE AND FAWNS 71.9

A. F. Tait / N.Y. 1871 [LR] Board: 8 × 10

No. 18. / A. F. Tait / Y.M.C.A. 23rd St / N.Y. / 1871

[No.] *18 Doe & two Fawns (Forest) 10 × 8 Gramm's Emery Post present March 14th.*

ON THE QUI VIVE! 71.10

A. F. Tait / N.Y. 1871 [LR] Panel: 12 × 16

No. 19. 1871 / "On the Qui Vive!" / A. F. Tait / Y.M.C.A. / 23rd St / N.Y. / Racquette Lake / N.Y.

[No.] *19. Deer. on the qui vive! Buck & 3 Does. 16 × 12. Mr. Dorman, 109 E 27th St. Del'd to him March 17th & paid same time [$125.00] in his own frame by [blank].*

Collection of The Metropolitan Museum of Art, New York, New York, gift of Mrs. J. Augustus Barnard, 1979. Courtesy of The Metropolitan Museum of Art.

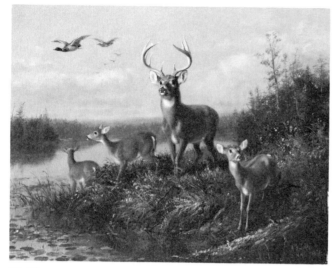

71.10

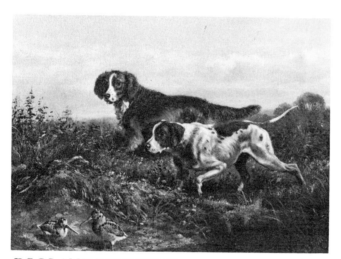

DOGS AND WOODCOCK 71.11

A. F. Tait / N.Y. 1871 [LR] Panel: 14½ × 13¾

[Nothing on back]

[No.] 20. [1871.] Dogs & Woodcock (Pointer & Setter) 14
× 10½ Mr E W Buckley 325 Fifth Av. sent home March 25th
by Aron in Frame [$150.00] Frame [$50.00] Paid April
13th—ch'k.

BUCK AND TWO DOES 71.12

[Unknown] [Unknown]: 12 × 16 [?]

[Unknown]

[No.] 21. Deer (Buck & 2 Does) Border of Lake & Ducks 16
× 12. Ogilvie's friend. Sent home by Aron March 27th to his
studio in frame. [$150.00] Frame [$13.00].

DOGS AND QUAIL 71.13

A. F. Tait / N.Y. / 1871 [LR] Canvas: 14 × 22

No. 22. / A. F. Tait / Y.M.C.A. / 23rd St / N.Y. / 1871

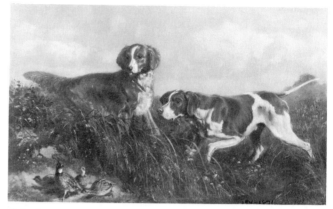

[No.] 22. Two Dogs (Pointer & Setter) & Quail 14 × 22
by Bogardus. to be [$250.00] nett—Paid May 30/71.

SPRING HEAD AND DUCKS 71.14

[Unknown] Panel: 10 × 14 [?]

[Unknown]

[No.] 23 Spring Head & Ducks. Panel 14 × 10 Rob't Hoe
thro (J. M. Hart) 111 E 16th St Paid [$150.00] Ap'l 25th/71
Del'd.

THE SPRING HEAD 71.15

A. F. Tait / '71 [LR] Board: 10½ × 14

No. 24. Painted by A. F. Tait, Y.M.C.A., N.Y. 1871.
The Spring Head.

[No.] 24 Spring Head & Ducks. Millboard 14 × 10 L. J.
Powers Springfield, Mass Del'd & paid May 17th/71.

See 71.17.

AN ANXIOUS MOMENT 71.16

A. F. Tait / N.Y. 1871 [LL] Canvas: 14½ × 22

No. 25. / "An Anxious Moment" / A. F. Tait /
Y.M.C.A. 23rd St / N.Y. / 1871

No. 25 [1871] An Anxious Moment. 2 Trout Hooked. 22 ×
14. fin. May 4th Schencks Sale sold to Jim B Blossom for
$105.00 paid by Schencks May 22nd/71 nett $92.40.

SPRINGTIME 71.17

[Unknown] [Unknown]: [Unknown]

[Unknown]

[No.] 26. Springtime. Ducks &c something same as "Spring
head." Schaus del'd & paid [$100.00] June 10th/71.

The "Spring Head" referred to by AFT is 71.15.

[GROUP OF TROUT] 71.18

A. F. Tait / N.Y. 1871 [LL] Panel: 12½ × 16

No. 27. / A. F. Tait / Y.M.C.A. / 1871 / 23rd St / N.Y.

[No.] 27 Trout—Group. background by J. M. Hart 16 ×

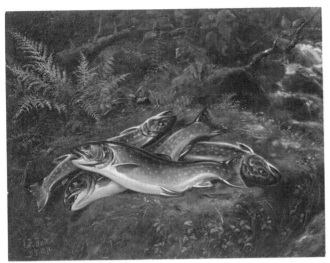

12½ finished May 25 Chas. Farley [$180.00] Mr. Chas. Farley.

Courtesy of Kennedy Galleries, Inc., New York, New York.

DUCKS IN BROOK 71.19

[Unknown] [Unknown]: 10 × 14 [?]

[Unknown]

[No.] *28 Ducks in Brook—Rock. [$100.00] 14 × 10 finished June 1st Schaus [$100.00] Del'd & paid June 10th.*

DEER IN FOREST 71.20

[Unknown] [Unknown]: 10 × 14 [?]

[Unknown]

[No.] *29. Deer in Forest. 14 × 10. finish'd June 6th Schaus [$100.00] Schaus. Del'd & paid [$100.00] June 10th.*

DOG'S HEAD WITH DEAD GROUSE 71.21

[Unknown] [Unknown]: 10 × 8 [?]

[Unknown]

[No.] *30 [1871] Dog's Head with dead Grouse 8 × 10 Albert Cooper June 12th in exchange for Winchester rifle. Frame extra.*

DOG AND WILD DUCKS 71.22

A. F. Tait / '71 [LL] Canvas: 10 × 14

[Relined; inscription, if any, lost]

[No.] *31. Dec'r 16th one Dog & Wild Ducks. 14 × 10 Schencks Sale Dec'r 21st/71.*

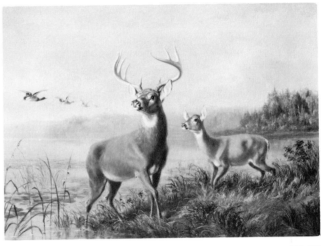

[STARTLED] 71.23

A. F. Tait / N.Y. 1871 [LR] Panel: 18 × 24

No. 32. A. F. Tait, 1871, N.Y.

[No.] *32. Deer (Buck & Doe) Lake Scene—alarmed at Ducks flying—24 × 20 sold by Schencks to Chas. Blossom for [$180.00] and Frame extra:*

Courtesy of Mr. and Mrs. George Arden.

BUCK ON SHORE OF LAKE 71.24

A. F. Tait / 1871 [LR] Board: 10 × 14 [?]

No. 33. / To Mr. Wm Brazier / Xmas 1871 / With the kind regards of A. F. Tait.

[No.] *33 Buck on Shore of Lake, 14 × 10 presented to Wm Brazier (Janitor) Xmas 1871 not Framed.*

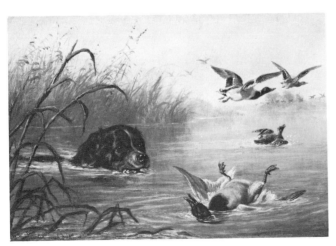

71.22

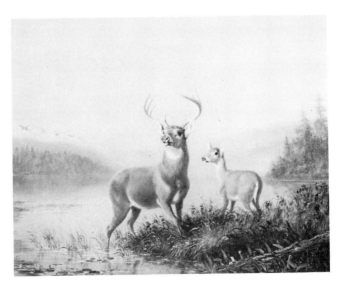

71.25

[THE ALARM: LONG LAKE, 71.25
HAMILTON CO., N.Y.]

A. F. Tait / N.Y. 1871 [LR] Panel: 15¾ × 20

No. 34./ A. F. Tait / N.Y. / 1871 Y.M.C.A. 23rd St.
"The Alarm."

[No.] 34 Deer—Lake Scene Panel 20 × 16 Rode $100 Paid
Jan'y 8th 1872.

Collection of the R. W. Norton Art Gallery, Shreveport,
Louisiana. Courtesy of the R. W. Norton Art Gallery.

DUCKS 71.26

A. F. Tait / N.Y. 1871 [LR] Panel: 15¾ × 20

No. 35 / Y.M.C.A. 23rd St.

[No.] 35 Ducks Foreground (Panel) 20 × 16. Rode $100.
paid Jan'y 8/72.

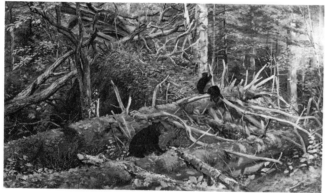

[BEAR AND YOUNG] 71.27

[Not signed or dated] Canvas: 14 × 25

Painted from Nature / Long Lake / Hamilton Co. / New
York / 1871 / by / A. F. Tait, N.A. / N.Y.

No. 36. Study from nature. Interior of Forest—old Birch &c
South Pond. 28 × 15.

Locale of this painting referred to in connection with
AFT No. 38 (71.29), which, although of slightly differ-
ent size, is a companion painting.

Courtesy of Schweitzer Gallery, Inc., New York, New
York.

OUR HOME IN THE WILDERNESS 71.28

[Unknown] [Unknown]: 14 × 22 [?]

[Unknown]

[No.] 37 Sept. 1871. "Our Home in the Wilderness." Shanty
on South Pond—painted in Sept'r 1871. 22 × 14 near Long
Lake Hamilton Co. N.Y.

THE FOREST 71.29

A. F. Tait, N.A. / N.Y. Canvas: 14½ × 22½
1871 [LR]

Painted from Nature / The Forest / Adirondacks / South
Pond near Long Lake / Hamilton Co. N.Y. / Sept. 1871 /
A. F. Tait, N.A.

[No.] 38 Forest. Old logs near the place of No. 36. South
Pond—Sept'r 1871. 22 × 14.

See 71.27.

VIEW ON SOUTH POND 71.30

[Not signed or dated] Canvas: 14½ × 38

[See 81.6]

[No.] 39 View on South Pond. Oct'r 1871. Autumn Color [a
horizontal rectangle]—32 × 14½.

This painting is entered again in 1881 (81.6) by AFT at
the time of presentation to Charles R. Flint. It was a
study for a much larger painting, 72.16.

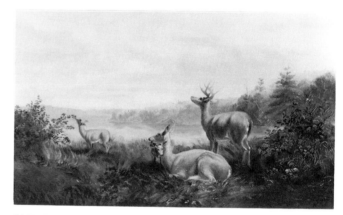

[ADIRONDACK DEER] 71.31

A. F. Tait / 1871 [LR] Canvas: 13¾ × 20

[Nothing on back]

[No AFT number; no Register entry]

On permanent loan to Amherst College, Amherst, Mas-
sachusetts. Courtesy of Mead Art Museum, Amherst,
Massachusetts.

LAKE SCENE: BUCK AND TWO DOES 72.1

[Unknown] Panel: 14 × 22 [?]

[Unknown]

No. 10 Deer painted on Panel 22 × 14 Lake Scene Buck & 2
Does. Ducks flying past lilly pads. Sold at Schencks Sale Jan'y
11 & 12th with Frame $125.00 in Frame. to Mr. Dunn 30th
St N.Y. for $125.00.

SPRING HEAD 72.2

[Unknown] Panel: 10 × 14 [?]

[Unknown]

[No.] 11. Ducks. Spring Head. on Panel 14 × 10. in

Schencks Sale Jan'y 11th & 12th returned Jan'y 15th unsold. Repainted & put in old trough & ducklings &c and sold at Schencks Sale March 15th for $85 and Frame $18. bought by Mr. Stillman Jun'r $103.00 including Frame.

[RUFFED GROUSE AND YOUNG] 72.3

[See remarks] Panel: 17½ × 24

[See remarks]

No. 12 [January 1872.] Ruffed Grouse on panel 18 × 24. This was not finished until April 1874 and is renumbered in that year as No. 21 [74.12].

DOGS AND WILD DUCKS 72.4

[Unknown] Canvas: 30 × 20 [?]

[Unknown]

No. 13 Dogs & Wild Ducks (Canvass) One dog swimming towards a Duck (dead) in Foreground—another Dog plunging into water. Ducks flying. 20 × 30 Canvass.

[SPRING HEAD] 72.5

A. F. Tait / N.Y. 1872 [LL] Panel: 13¾ × 22

No. 14 / by A. F. Tait / Y.M.C.A. 23 St / N.Y. 1872

No. 14 Spring Head with Ducks & Cattle coming down to drink—14 × 22 Panel. Artists Fund Jan'y 28/73. Feb'y 2 rubbed in—1 day. designed & drawn Jan'y 14th.

Exhibited at the Artists' Fund Society, January 28, 1873, titled "Coming To The Brook."

Collection of Washington and Lee University, Lexington, Virginia.

[BUCK AND DOE AT LAKE SHORE] 72.6

A. F. Tait / 1872 [LR] Board: 9 × 13¼

[Sealed; inscription, if any, unavailable]

No. 15. [1872.] Deer. a Buck & Doe. 12 × 9 millboard Shores of Lake. W. G. Morgan. 448 Clinton St. Brooklyn. $75.00. Paid. begun & laid in Jan'y 15th.

DOG AND WILD DUCKS 72.7

[Unknown] Board: 9 × 12 [?]

[Unknown]

No. 16 Dog & Wild ducks. 12 × 9 Millboard. Dog swimming—Mallard Flying one dead. H. C. Morgan $75.00 Paid. Designed Jan'y 15th & 19th.

PUTTING UP THE BARS 72.8

[Unknown] Panel: 14 × 22 [?]

[Unknown]

No. 17 Spring. Cattle coming down the bank out of Orchard to Trough at Road Side Ducks &c. "Putting up the Bars." 22 × 14 Panel. Frame $30.00. Sold for $220 & Frame included

$30. Snedicors Sale March 30th/72 Net $190. Designed & drawn Jan'y 14th finished Jan'y 25th.

[PUTTING UP THE BARS] 72.9

[Unknown] Canvas: 14 × 22 [?]

[Unknown]

[No.] 18 [January] Cows & Landscape. Old Trough. Boy pulling up the Bars—joint with [Lemuel] Wiles. 22 × 14 Canvass finished Jan'y 22nd. Sold at Schencks Sale with Frame $27.00 for $152.88 nett. Sold & Paid Jan'y 31. $152.88 nett with Frame for Schencks Sale.

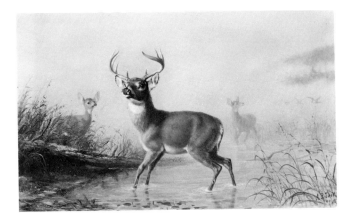

EARLY MORNING ON RACQUETTE LAKE 72.10

A. F. Tait / N.Y. 1872 [LR] Canvas: 14 × 22

No. 19 A. F. Tait / YMCA / 23rd St. N.Y. / 1872

[No.] 19 Deer. Early Morning Racquette Lake in the Adirondacks. 22 × 14 Canvass in Frame. Horace Fairbanks Esq'r St. Johnsbury, Vt Del'd & Paid for May 2nd, 1872. $200.00.

Collection of the St. Johnsbury Athenaeum, St. Johnsbury, Vermont. Courtesy of the St. Johnsbury Athenaeum.

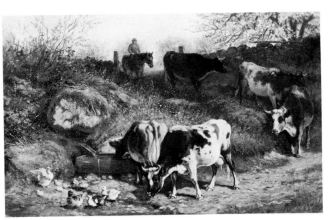

COMING HOME 72.11

A. F. Tait / N.Y. 1872 [LR] Canvas: 14 × 22

No. 20 "Coming Home" / Evening / Painted by / A. F. Tait / YMCA 23rd St. N.Y. / 1872

[No.] 20 *"Coming Home." Cattle & Ducks man on Horse behind. Cows drinking. 22 × 14 Canvass in Frame. H. Fairbanks Esq'r St Johnsbury. Del'd & Paid for May 3rd $200.00.*

Collection of the St. Johnsbury Athenaeum, St. Johnsbury, Vermont. Courtesy of the St. Johnsbury Athenaeum.

EARLY MORNING ON LOON LAKE 72.12

[Unknown] Panel: 14 × 22 [?]

[Unknown]

[No.] 21 *[1872.] Deer. Early Morning—Loon Lake in The Adirondacks. a single Buck. 22 × 14 Panel. $185.00 with Frame. Sold at Schencks Sale March 1st 1872 for $150 & frame $35—185 Com $23-38/100 nett $161.62. Paid per Ch'q Mar 5th.*

MATERNAL AFFECTION 72.13

[Unknown] Panel: 10 × 14 [?]

[Unknown]

[No.] 22 *"Maternal Affection" Doe & 2 Fawns 14 × 10 panel Wm Schaus finished April 5th. $100.*

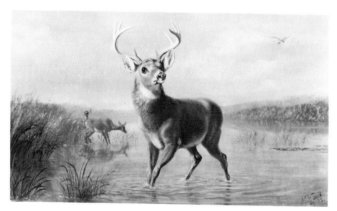

RACQUETTE LAKE 72.14

A. F. Tait / N.Y. '72 [LR] Canvas: 14 × 22½

No. 23 / A. F. Tait / Y.M.C.A., 23rd St / N.Y. 1872.

[No.] 23 *Buck & 2 Does & Fish Hawk "Racquette Lake" Panel 22 × 14 sold Snedicors Sale March 1872 for $225 in Frame to go to my a/c March 30/72 Frame $30 net $195 for Paint'g.*

Although AFT lists the support as "Panel," two reliable sources have reported the support as canvas.

SPRING BLOSSOMS 72.15

[Unknown] Panel: 12 × 18 [?]

[Unknown]

No. 24 *1872. "Spring Blossoms" Ducks in Brook with ducklings—Apple Tree in Blossom & two Children gathering bunches of Blossoms. 12 × 18 Panel finished March 23rd for Schencks Sale Mar 29th sold there for $115 & Frame $18— $133 com 16.88 with Frame $116.12 nett Paid April 3rd/72.*

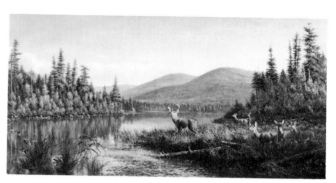

AUTUMN MORNING, 72.16
RACQUETTE LAKE

A. F. Tait / N.Y. 1872 [LR] Canvas: 36 × 71¾

"Autumn Morning" / on Racquette Lake / Adirondacks / Hamilton Co. N.Y. /// No. 25 / Painted by / A. F. Tait / N.Y. 1871–72 /// Racquette Lake / Hamilton Co. N.Y.

[No.] 25 *"Autumn Morning" Racquette Lake Hamilton Co N.Y. Adirondacks 72 × 36 Canvass Panel Back. finished Mar 26th & sent to N.A. Exhibition 1872 and Given as extra when I sold the lots. I think Jas Stillman has it. sent to N.A.D. Ex. April 1st/72 in Frame by Snedicor price $1250 Schaus sold it for Stillman $750.*

See entries 71.30 and 81.6

This painting has been rebacked with fiber glass after removal of the reinforced panel backing. The original back was formed of five panels joined together. The back inscription is shown in three parts separated by "///." Exhibited at the National Academy of Design 47th Annual Exhibition, 1872, titled "Autumn Morning on Racquette Lake, Adirondacks, Hamilton Co., N.Y." and listed as for sale.

Collection of The Adirondack Museum, Blue Mountain Lake, New York. Courtesy of The Adirondack Museum.

[DEER FAMILY] 72.17

A. F. Tait / N.Y. '72 [LR] Panel: 9½ × 13½

No. 26. / A. F. Tait / Y.M.C.A. 23rd St / N.Y. 1872

[No.] 26 *Doe & two Fawns in Forest 10 × 14 Panel $80.00. Wm Schaus—to be $80.00. finished May 4th Del'd May 7th and Paid for May 10th $80.00.*

DEER 72.18

[Unknown] Pastel Board: 10 × 14 [?]

[Unknown]

[No.] 27 *[1872.] "Deer." Buck in Forest on a French Panel— or Pastel Board. 14 × 10 Panel. French. sold to Wm Schaus $80.00 no Frame. $80.00.*

RANDOM SHOT 72.19

[Unknown] Panel: 12 × 10 [?]

[Unknown]

[No.] *28 Random Shot. Doe dead & Fawn. 10 × 12 Panel $80.00 Wm. Schaus—finished April 26th del'd May 7th & Paid for May 10th $80.00.*

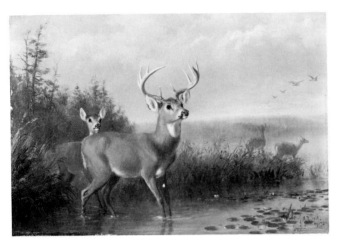

BUCK AND DOE: LAKE SCENE 72.20

A. F. Tait / NY 72 [?] Panel: 9¼ × 13½

[Unknown]

[No.] *29 Buck & Doe. Lake Scene. 14 × 10 $80.00. del'd & Paid for May 10th 1872 $80.00.*

Courtesy of Christie's, New York, New York.

COMING HOME 72.21

A. F. Tait / N.Y. '72 [LR] Panel: 20 × 15¾

No. 30 / A. F. Tait / Y.M.C.A. / 23rd St / N.Y. / 1872

[No.] *30 [1872.] "Coming Home" Cows coming down Hill to drink at old Trough. upright. Woods. 22 × 14 $250.00 for Mr. Nesmith Brooklyn paid June 4th/72.*

One of a pair with 72.22.

DOE AND TWO FAWNS 72.22

A. F. Tait / N.Y. 72 [LR] Panel: 20 × 15½

No. 31. / 1872 / A. F. Tait / Y.M.C.A. / 23rd St / N.Y.

[No.] *31 Doe & 2 Fawns Upright 22 × 14 Panel $250.00. Edge of Lake. Forest & distance. J. J. Nesmith—Brooklyn Paid for June 4th 1872.*

One of a pair with 72.21.

BUCK AND DOES 72.23

[Unknown] [Unknown]: 20 × 14 [?]

[Unknown]

[No.] *32 "Buck & Does" Lake Shore 14 × 20 Williams & Everett. Boston sent by Adams Ex. June 1st Paid by Dft thru F. P. Osborn. June 13th/72.*

DOE AND TWO FAWNS IN FOREST 72.24

[Unknown] [Unknown]: 10 × 14 [?]

[Unknown]

[No.] *33 [1872] "Doe & two Fawns in forest" 14 × 10 Williams & Everett Boston sent by Adams Ex June 1st Paid by Dft through Frank Osborn.*

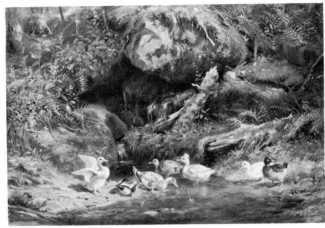

SPRING HEAD 72.25

A. F. Tait / N.Y. 1872 [LR] Panel: 9¾ × 14

No. 34 / A. F. Tait / Y.M.C.A. 23rd St / N.Y. / 1872

[No.] *34 Spring Head 14 × 10 Panel for Chas W. Blossom, 54 Remsen St Brooklyn L.I. Paid for June 4th 1872 $150.00 inc Frame.*

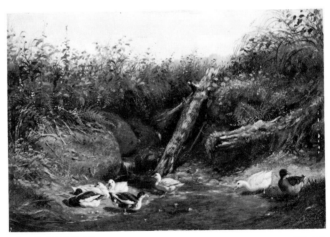

THE SPRING 72.26

[Unknown] Panel: 10 × 14 [?]

[Unknown]

[No.] *35 Spring (The Spring. Ducks & Sky in this) 14 × 10 Panel $125.00 Abraham Dowdney 61st Street N.Y. delivered to himself June 3rd & paid for same time $125.00 including Frame.*

Courtesy of Christie's, New York, New York.

BUCK AND DOE AT LAKE SHORE 72.27

A. F. Tait 1872 [LR] Panel: 10 × 13¾

No. 36.—A.F.T.—Y.M.C.A.—23rd St. N.Y.

[No.] *36 [1872] Buck & Doe (Lake Shore) 14 × 10 Panel $125.00 Abraham Dowdney 61st St N.Y. del'd to himself & paid same time $125.00 including frame. June 3rd 1872.*

The front signature and date, together with back inscription, probably are incomplete since they were taken from a letter written in 1948 to Arthur J. B. Tait by the then owner.

BUCK IN FOREST 72.28

[Unknown] Canvas; panel back: 16 × 20 [?]

[Unknown]

[No.] *37. Nov'r 8th. Buck in Forest 20 × 16. Snow Scene in Canvass with Panel back. sold at Schencks Sale Nov'r 14th No Frame finished Nov'r 13th.*

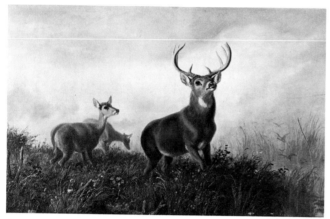

[DEER FAMILY] 72.29

A. F. Tait / N.Y. 1872 [LL] Panel: 13½ × 21½

No. 38 / A. F. Tait / Y.M.C.A. / 23rd St. N.Y.

[No.] *38 Deer on Margin of Lake in Grass. Buck & two Does—Ducks in Fog in Rushes in distance. Mass of Light Fog behind Buck. Palel [sic; panel] 22 × 14 finished Nov'r 24th Artists Fund Jan'y 28/73 for $280 net.*

Collection of the Shelburne Museum, Shelburne, Vermont. Courtesy of Shelburne Museum.

OUR OLD FAVORITE 72.30

[Unknown] Canvas: 14 × 22

"Our Old Favorite, retired from work" / No. 39 / A. F. Tait / Y.M.C.A. / 23rd St / N.Y. 1872

[No.] *39 Farm Yard—Old Horse Sheep & Fowls 22 × 14 Canvass delivered March 8th to Sillicks [sic] Boy. finished Nov'r 25th Sold to John Cummins 248—61st St N.Y. with No. 48 [73.5] for $500.00 in Frames.*

[SHEEP] 72.31

[Unknown] Panel: 14 × 22 [?]

[Unknown]

[No.] *40 Sheep in Shade Cows &c 14 × 22 Panel.*

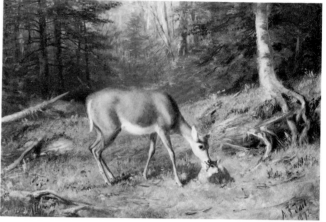

DOE AND FAWNS 72.32

A. F. Tait / 1872 [LR] Panel: 10 × 14

No. 141 / Y.M.C.A. / 52 East 23rd St. / NY / Xmass 1872

[No.] *41 Doe & Fawns. Presented to darling Polly Xmas 1872. 14 × 10 Panel. This was sold Dec'r 31 to Mr Briggs friend Mr Collins for $150.00 including Frame & del'd to his address in 5th Ave same day.*

Courtesy of Christie's, New York, New York.

FARM YARD 72.33

[Unknown] Canvas: 14 × 22 [?]

[Unknown]

[No.] *42 [1872] Farm Yard—old Horse Goat and Sheep. 14 × 22 Canvass. sold at Schencks sale Jan 30, 1893 [sic] for $120.00. To Fawning [?] in again Jan 29th/1874.*

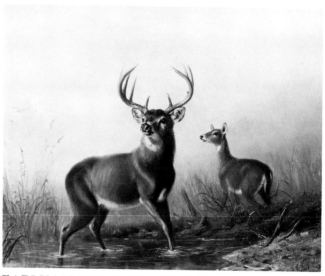

EARLY MORNING IN THE SARANACS 72.34

A. F. Tait '72 [LR] Canvas: 15½ × 18½

A. F. Tait, 52 E. 22nd St., N.Y., No. 44. "Early Morning in The Saranacs," 1872

[No.] *44 Buck & Doe. Foggy Morning. 20 × 16 Canvass Panel back. sold at Schencks sale Jan'y 30/73 for $150.00.*

Painting is backed with wooden panel.

[SKETCH OF EXTERIOR OF DAN CATLIN'S BARN] 72.35

[Not signed or dated] Canvas: 12¼ × 15¼

[Nothing on back]

[No AFT number, no Register entry]

Collection of the Yale University Art Gallery, New Haven, Connecticut.

[SKETCH OF INTERIOR OF DAN CATLIN'S BARN] 72.36

[Not signed or dated] Canvas: 12¼ × 15

Old Catlin's Barn / Long Lake / 1872.

[No AFT number; no Register entry]

Collection of the Yale University Art Gallery, New Haven, Connecticut.

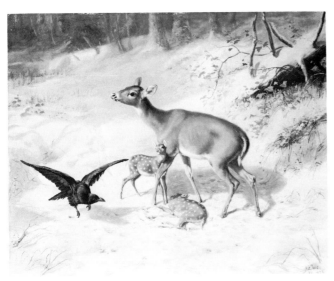

MATERNAL SOLICITUDE 73.1

A. F. Tait / N.Y. 1873 [LR] Panel: 19½ × 24

No. 46. "Maternal Solicitude" / The Dying Fawn / A. F. Tait / Y.M.C. A. / 23rd St / N.Y.

[No.] *43 Doe & two Fawns in Snow and Raven—"Maternal Solicitude." 24 × 20 Panel finished April 23rd/73 sold to Mr. [blank]Cleveland Ohio for $250 including Frame.*

Collection of The Cleveland Museum of Art, Cleveland, Ohio. Courtesy of The Cleveland Museum of Art, the Hinman B. Hurlbut Collection.

EAST INLET, RACQUETTE LAKE 73.2

A. F. Tait / N.Y. 1873 [LR] Canvas: 26 × 14

No. 45, A. F. Tait, 32 [?] E 23rd St., "East Inlet, Racquette Lake, Adirondacks, N.Y. 1873

[No.] *45 [1873] Deer [crossed out] Buck on Marsh—upright 22 × 14 Canvass "East Inlet. Racquette Lake" Adirondack's [sic]. Finished Feb'y 2nd 1873 Sold at Schencks Feb'y 27th/73 for $160. including Frame $28. Silleck.*

MORNING ON THE LOON LAKE 73.3

A. F. Tait / N.Y. 73 [LR] Canvas: 16 × 20

Morning on the Loon Lake / in 1872 / No. 46 / A F Tait / 52 E 23rd St / NY / 1873

[No.] *46 Buck turning round looking at you with Tail this way. Ducks in Grass in Background standing in Grass. Fog & c. 16 × 20 Canvass. finished Feb'y 8th 1873 sold at Schencks Feb'y 14th $110 in Frame from Cahil $25. paid him $20.*

This painting has been relined, and the back inscription is in a hand other than AFT's, which probably accounts for any wrong wording.

Collection of The Adirondack Museum, Blue Mountain Lake, New York.

EAST INLET RACQUETTE LAKE 73.4

[Unknown] Panel: 12 × 14 [?]

[Unknown]

[No.] *47. Deer. "East Inlet Racquette Lake" Adirondacks. 12 × 14 Panel finished Feb'y 20th/73. for Mr. Olyphants friend Approved March 12.*

EAST INLET, RACQUETTE LAKE 73.5

A. F. Tait / N.Y. '73 [LR] Canvas: 20 × 30

No. 48 East Inlet / Racquette Lake / Adirondacks N.Y. / A. F. Tait / N.Y. / 1873

[No.] *48 Buck large in Foreground with Tail towards you. looking back at you. in [on?] grassy point Lake Scene 20 × 30 Canvass Frame Sned'r $35. sold at Reception to John D. Crimmins 248 61st St. N.Y. with No. 39 Farm Yard [72.30] for $500. with Frames 20 × 30 Snedicor $34. and one 14 × 22 by Sillick [sic] $28. Paid by Chq March 13/73.*

A later painting, No. 58 (73.15), is noted by AFT as "something like" this one. Back inscription obtained prior to relining. Exhibited at the National Academy of Design 48th Annual Exhibition, 1873, titled "Racquette Lake, In The Adirondacks" and owned by John D. Crimmins.

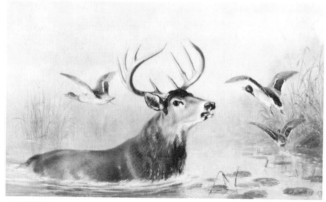

AFTER A HARD CHASE 73.6

A. F. Tait N.A. / N.Y. 1873 Canvas: 14¼ × 22

"After a Hard Chase" / A. F. Tait / Y.M.C.A. 52 E. 23rd St / N.Y / 1873 / No. 49.

[No.] *49 Buck Swimming in Lake, Ducks & Foggy. "After a hard Chase." 22 × 14 Canvas begun March 8th finished 10th 1873* [Crossed out: Schencks Sale March 12] *not sold finished more ducks large & sent to Snedicors Sale March.*

Courtesy of Mr. and Mrs. George Arden.

[A TEMPTING SHOT] 73.7

A. F. Tait / 1873 N.Y. [LL] Canvas: 15¼ × 25¼

No. 50 / Long Lake / Hamilton Co. / N.Y. / A. F. Tait . . .

[No.] *50 Buck! Shore of Lake. 21 × 25 Canvass Wyant painted on this some but I repainted almost all for Snedicors Sale.*

The painting has been rebacked and the original inscription, as shown above, can only be read through AFT's signature.

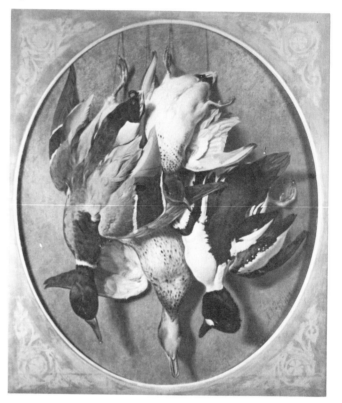

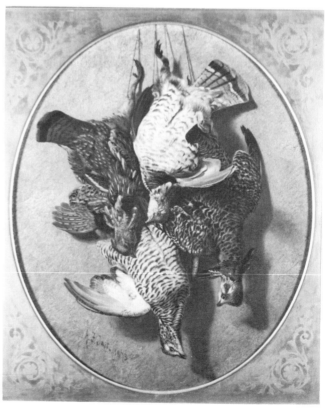

DEAD GAME: FOUR DUCKS 73.8

A. F. Tait / 1873 [LR] Canvas: 22 × 18 oval

No. 51 / A. F. Tait / 53 E 23rd St / New York City / 1 Mallard Duck / 1 Mallard Drake / 1 Green winged Teal / 1 Golden Eye Diver.

[No.] *51 [1873] Dead Game 4 Ducks. 18½ × 22½ Oval Canvass 2 Mallards Male & Female 1 Green Winged Teal and 1 Golden Eye'd Diver. finished April 5th 1873 Mr. J. J. Nesmith—Brooklyn.*

One of a pair with 73.9.

DEAD GAME: FOUR BIRDS 73.9

A. F. Tait 1873 [LL] Canvas: 20 × 18 oval

No. 52. 1873 / A. F. Tait / Y.M.C.A. / 23rd Street, N.Y. / Male & Female / Ruffed Grouse / Male & Female Prairie Chickens.

[No.] *52 Dead Game. 4 Birds 18½ × 22½ Oval Canvass 2 Male & Female Ruffed Grouse 2* [Dittos: *Male & Female*] *Prairie Chickens Mr. J. J. Nesmith—Brooklyn.*

One of a pair with 73.8.

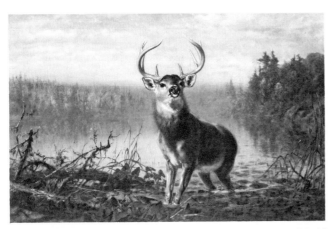

ON THE ALERT 73.10

A. F. Tait and Jas. M. Hart 1873 Canvas: 20 × 30
[LL on log]

No. 53 / Copyright Reserved / Not to be copied. Deer painted by A. F. Tait and the / Landscape by Jas. M. Hart / N.Y. 1873

[No.] *53 On the Alert. joint Tait & Hart 20 × 30 Canvass Buck Lake Scene. Jas. M Hart painted the Background Sold to Mr. Walter J. Price 25 W. 52nd St. with Frame for [$350.00].*

Painting has been relined.

[THE ESCAPE] 73.11

A. F. Tait / N.Y. '73 [LR] Canvas: 18¼ × 24¼

[Relined; inscription, if any, lost]

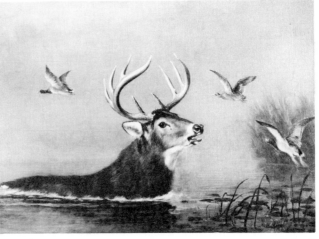

[No.] *54 [1873]* No. 43 [Crossed out: *Maternal Solicitude & Snow "Doe & 2 Fawns* ["] (*one dead and Raven. Snow Scene [?] in June*—the preceding actually refers to 73.1] *24 × 18 Canvass Deer Swimming Ducks & Foggy finished April 25th/73 Laflin & Rand Powder Co $250.00.*

A chromolithograph, 18 × 24, was published in 1873 for the Laflin & Rand Powder Co. of New York by the Peletreau, Raynor & Co. The chromolithographer was F. Jones. A copy is in the Library of Congress.

The words "Orange Sporting Powder" appear on the chromolithograph (and in the original) in an arc over the antlers of the deer. AFT himself probably had a number of these reproductions, some of which he apparently overpainted at various times as gifts for friends (for example, see 96.24). For a similar original painting see 73.6.

BUCK IN EDGE OF LAKE 73.12

[Unknown] Canvas: 14 × 22 [?]

[Unknown]

[No.] *55 Deer. Buck in Edge of Lake 14 × 22 Canvass Schencks Sale May.*

AFTER A HARD CHASE 73.13

A. F. Tait / N.Y. 1873 [LR] Canvas: 19¼ × 28¼

"A Hard Chase" / Racquette Lake / Adirondacks / No. 54/ A. F. Tait / N.Y. 1873

[No.] *56 "After a hard chase"* ["] *just struck shore" 19 × 28 Canvass Bucks head Ducks &c. Foggy morning.*

THE BOGERT HOMESTEAD 73.14

A. F. Tait / N.Y. / 1873 [LR] Canvas: 20¼ × 30¼

No. 57. / "Noonday" in "June" / Painted by / A. F. Tait / N.Y. / 1873 / The "Bogert Homestead" / Teaneck near / Englewood / N. Jersey

[No.] *57. "Old Homestead." Bogerts Farm N. J. 20 × 30 Canvass Farm Yard. Cows, Ducks, Chickens, old Well with old man at it. Large Apple Tree in Foreground &c.*

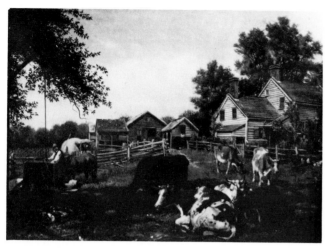

Exhibited at the National Academy of Design 49th Annual Exhibition, 1874, titled "The Bogert Homestead, Englewood, N.J." and owned by A. G. Bogert.

Collection of The New Jersey Historical Society, Newark, New Jersey, by bequest of Virginia Van Houten Perkins. Courtesy of The New Jersey Historical Society.

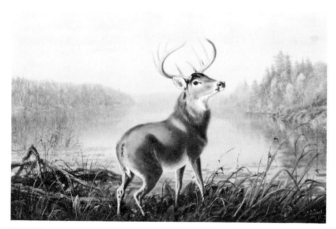

ON THE ALERT 73.15

A. F. Tait / N.Y. 1873 [LR] Canvas: 20 × 30

No. 58 / A. F. Tait / N.Y. 1873 / Racquette Lake / Hamilton Co. / Adirondacks N.Y.

[No.] 58 *"On the Alert" Deer in Edge of Lake looking back something like Crimmins No. 48 [73.5] 20 × 30 Canvass May 1888 owned by Mr. Silas Tuttle 243 Clinton Av. Bklyn.*

Courtesy of The Old Print Shop, Inc., New York, New York.

AN AMERICAN FAMILY AT HOME 73.16

A. F. Tait / N.Y. / 1873 [LR] Panel: 19½ × 24

An American Family / At Home / No. 59 / A. F. Tait / N.Y. 1873

[No.] 59. *An American Family at Home* [10 × 14 crossed out] *20 × 24 Buck, Doe, & 2 Fawns happy. Sold at Artists Fund Jan'y 27th 1874 for $285.00. no Frame.*

Note that AFT states that a buck is part of the painting, while actually only two spotted fawns and the head of a doe appear in it.

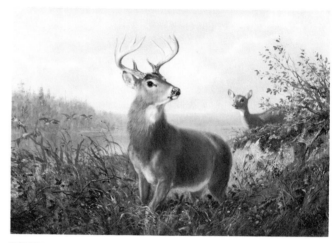

BUCK AND DOE 73.17

A. F. Tait / 1873 [LR] Canvas: 10 × 14

60. / "On Long Lake, Hamilton Co., N.Y. / A. F. Tait, N.Y. 1873

No. 60 [1873] Buck and Doe. 10 × 14 Panel Ab. Dowdney finished [Crossed out: *& sent home*] *& paid for Oct'r 10th sent home 11th $125—(with Frame $25).*

Courtesy of Christie's, New York, New York.

THE ADIRONDACKS 73.18

A. F. Tait / N.Y. 1873 [LR] Canvas: 12 × 18

No. 61. "The Adirondacks" / Long Lake / A. F. Tait / N.Y. 1873

[No.] *61 Deer (Autumn). on Shore of Lake 2 does in Back Ground. 12 × 18 Canvass Sold by Myers & Abram* [?] *Balt'o Paid $150 with Frame.*

DEER—LAKE 73.19

[Unknown] [Unknown]: 10 × 14 [?]

[Unknown]

[No.] *62 Deer—Lake 10 × 14* [The following, in pencil, is crossed out except for the year: *1873 sent to Schaus Oct'r 29th on sale Ret'd sent to Thomas 34th St. on Sale Nov'r.*]

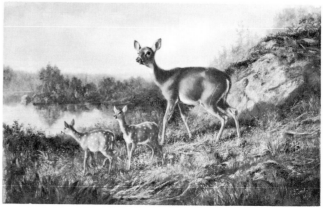

73.20

MORNING 73.20

A. F. Tait / N.Y. 1873 [LR] Canvas: 14 × 18

No. 63 / A. F. Tait / N.Y. 1873 / "Morning" / "Adirondacks"

No. 63 [1873] Doe & two Fawns 14 × 22 Canvass to Schencks Nov'r 5th in Frame by Remus $30. Sold for $102.00 only. Frame not sold. Sale Nov 13 & 14.

CHALLENGE 73.21

[Unknown] Canvas: 14 × 22 [?]

[Unknown]

[No.] 64 Buck on first Snow "Challenge"—14 × 22 Canvass to Schencks Sale Nov 14th in Frame by Sillick [sic] $25. sold for $72.00 only one of my best Pictures Frame $30.00.

QUAIL SHOOTING 73.22

[Unknown] Panel: 9½ × 16 [?]

[Unknown]

[No.] 65 Quail Shooting. Sportsman Two Dogs (Pointer & Setter) and a bevy of Quail in Wheat Field 9½ × 16 Panel in the Frame of Jas. Harts Picture Sketch for No. 66 [73.23]. Sent down to Jno. Osborn to Raffle gave it to Edw. Schenck.

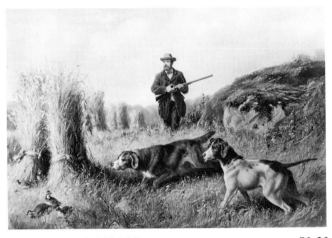

QUAIL SHOOTING 73.23

A. F. Tait / N.Y. '73 [LR] Panel: 19½ × 28¼

Quail Shooting / A. F. Tait 1873

No. 66 [1873] *Quail Shooting, with Figure and two Dogs— Pointer & Setter 19 × 28 French Panel finished Nov'r 20th. Sold at Artists Fund Jan'y 27th/74 Price $395.00. Frame Extra.*

Courtesy of Kennedy Galleries, Inc., New York, New York.

SAVED: A HARD CHASE 73.24

A. F. Tait / N.Y. 1874 [LR] Canvas: 21 × 16¼

No. 67 / Y.M.C.A. / 23rd St. / N.Y. / 1873 / "Saved" A Hard Chase.

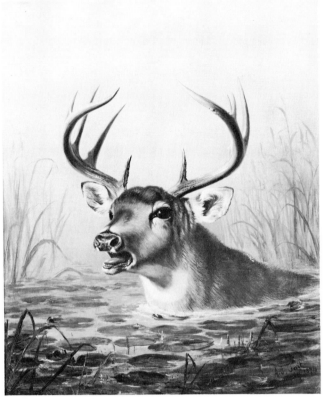

[No.] 67 Deers Head swimming towards front (oval upright) 17 × 21 Canvass [with sketch of oval in square] finished Nov'r 20th sold to Dr. Thos. F Cook. 1874 Feb. 19th Paid $100. no Frame.

Courtesy of Mrs. Ralph Earle.

QUAIL SHOOTING 73.25

[Unknown] Canvas: 10 × 14 [?]

[Unknown]

[No.] 68 Quail Shooting—two Dogs Rock Grasses and Quail. 10 × 14 Canvass.

STAG AT BAY IN SNOW 73.26

[Unknown] Canvas: 18 × 24 [?]

[Unknown]

No. 69 [1873] Stag at Bay in Snow with Hound 18 × 24 Canvass Sidman.

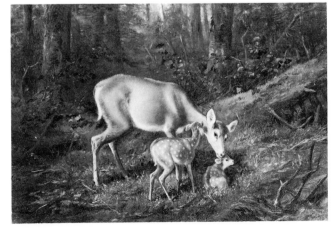

73.27

[DEER IN A FOREST] 73.27

A. F. Tait / N.Y. 1873 [LR] Panel: 9¾ × 14

No. 70 / A. F. Tait / N.Y. / 1873

[No.] *70 Doe & two Fawns in Forest. 10 × 14 Panel finished Nov'r 24th Schenck Dec'r 18.*

Courtesy of Kennedy Galleries, Inc., New York, New York.

[SPRING HEAD] 73.28

[Unknown] Panel: 10 × 14 [?]

[Unknown]

[No.] *71 Ducks something like Spring Head. finished Dec'r 11th 10 × 14 Panel Schenck. Dec'r 18th.*

For other paintings with the title "Spring Head" see 72.2, 72.5, 72.25, and 78.13.

[BUCK AMONG LILLY PADS] 73.29

[Unknown] Board: 8 × 10 [?]

[Unknown]

[No.] *72 [1873] Buck [s crossed out] in Lake eating Lilly Pads 8 × 10 Millboard Dr. Lundy presentation to him for his fee for officiating at my marriage with my darling Polly. Dec'r 18th 1873.*

DUCKS RESTING 73.30

[Unknown] Board: 7½ × 10¾

"William Brazier with the regards of the Artist". / No. 73 / A. F. Tait / Y.M.C.A. / 23rd Street / New York / Dec. 18, 1873.

[No.] *73 Ducks resting at Brook 11 × 7½ Millboard Brazier present Xmass.*

THE HAPPY FAMILY 73.31

[Unknown] Panel: 10 × 14 [?]

[Unknown]

[No.] *74 Happy Family something like No. 70 [73.27] 10 × 14 Panel for Mr. Cleveland Cady in Exchange for design of House for Woods.*

[STARTLED] 73.32

[Unknown] Canvas: 14 × 22 [?]

[Unknown]

[No.] *75 [1873] Deer foggy morning. startled with Raven flying right hand two does near background 14 × 22 Canvass Schencks sale sent Jan'y 9th by Joe. limit $100 with Frame $28 Shadow Box sold for $72.00 & Frame nett.*

QUAIL SHOOTING 73.33

[Unknown] Canvas: 14 × 22 [?]

[Unknown]

[No.] *76 Quail Shooting—Two Dogs Wheat Shucks & Quail. 22 × 14 Canvass. To Schencks sale Jan'y Sold for $165. Frame.*

QUAIL SHOOTING 73.34

A. F. Tait '74 [LR] Panel: 8½ × 15½

[Unknown]

[No.] *77 Quail Shooting. Brambles &c two Dogs & Quail 10 × 14. Panel Schencks Sale Feb'y 16.*

[CATTLE AND FIGURES ON 73.35
A WOODED PATH]

E. D. Nelson [and] A. F. Tait [LR] Canvas: 24 × 16¾

Kautskill / Study From Nature by / Edw. D. Nelson / Finished by A. F. Tait . . . / 1873 / Sidman

[No AFT number; no Register entry]

CHICKENS 74.1

A. F. Tait, N.A. / N.Y. '74 [LR] Panel: 10 × 13¾

No. 10 / 1874 / A. F. Tait

[No.] *10 Jan'y 1874 Chickens 10 × 14 Panel To Schencks Sale Feb'y 19th* [written over *16th*].

CHICKENS 74.2

[Unknown] Panel: 10 × 14 [?]

[Unknown]

[No.] *11 Chickens 10 × 14 Panel To Lotus* [sic: Lotos Club] *for Ex. Jan'y 31st/74 To Schencks Sale Feb'y 19th.*

See 74.27.

CHICKENS 74.3

A. F. Tait / N.Y. 1874 [LR] Board: 10 × 12

No. 12 / A. F. Tait / N.Y. 1874

[No.] *12 Chickens 10 × 12 for Schell & Dinen to pay for 4 Frames. 10 × 14.*

DOE AND FAWNS IN FOREST 74.4

[Unknown] Canvas: 10 × 14 [?]

[Unknown]

[No.] *13 [1874] Doe & Fawns in Forest 10 × 14 Canvass Painted for Mr. Anderson, but not del'd. Sold to Schaus for $75 & paid for Feb'y 24th with No. 15 [74.6].*

AFT did two other paintings in 1874 that are similar to this one and are of the same dimensions (74.13 and 74.16).

DOE AND FAWNS ON 74.5
A LAKE SHORE

A. F. Tait / N.Y. 1874 [LR] [Unknown]: 18 × 24

No. 14, A. F. Tait, N.Y. 1874 Sidman. Raquette Lake.

[No.] *14 Doe & Fawns—on Lake Shore 18 × 24 Painted for Mr. Sidman.*

This painting, together with 74.15, was used by AFT to repay a loan of $200.00 he had from Mr. Sidman.

DOE AND FAWN IN THE FOREST 74.6

[Unknown] [Unknown]: [Unknown]

[Unknown]

[No.] *15. Doe & one Fawn in Forest.* [*with a* crossed out] *on the banks of a Stream. for Schaus. paid for $75 Feb 24th.*

Sold together with 74.4.

THE CHALLENGE 74.7

[Unknown] Canvas: 20 × 30 [?]

[Unknown]

[No.] *16 [1874] The Challenge. 20 × 30 Canvass Buck & 3 Does. Lake View. Buck swimming across Lake lent to Mr Smith Sidmans Friend.*

See 74.10.

STARTLED: APPREHENSIVE OF DANGER 74.8

[Unknown] [Unknown]: 14 × 22 [?]

[Unknown]

[No.] *17 Startled. apprehensive of Danger 14 × 22.*

THE LITTLE PETS 74.9

A. F. Tait / N.Y. 1874 Canvas: 18 × 23½

"The Little Pets" / A. F. Tait / N.Y. 1874 / No. 18

[No.] *18 The Pets. 18 × 24 E E Dorman Esq'r De*[d] *& Paid for* [*April* crossed out] *March 31st/74 $300.00. Copyright retained expressly in receipt.*

See 74.14.

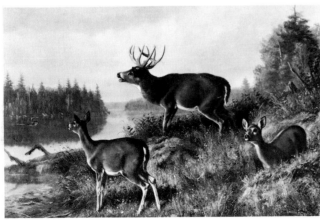

THE CHALLENGE 74.10

A. F. Tait / N.Y. 1874 [LR] Canvas: 20 × 30

No. 19 / The Challenge / A. F. Tait / N.Y. / 1874

[No.] *19 [1874] The Challenge 20 × 30 Canvass Panel Stretcher* [Strainer(?)]. *Nearly like No. 16* [74.7] *Snedicors Sale.*

Back of painting covered with wooden panel. This painting has two does and a buck in foreground whereas No. 16 (74.7) has three does and a buck in the foreground.

Courtesy of Mr. Abram R. Harpending.

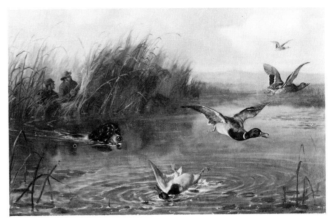

DUCK SHOOTING 74.11

A. F. Tait / N.Y. 1874 [LR] Canvas: 19½ × 30

[Relined; inscription, if any, lost]

[No.] *20 Duck Shooting 20 × 30 Canvass Dog swimming Dead Duck in water others flying 2 men in Boat in Rushes in Background. Snedicors Sale.*

Courtesy of Mr. George A. Butler.

RUFFED GROUSE AND YOUNG 74.12

A. F. Tait / N.Y. 1874 [LR] Panel: 17½ × 24

No. 121 / A. F. Tait / Y.M.C.A. 23rd St. N.Y. / 1874.

[No.] *21 Ruffed Grouse & Young. 18 × 24 Begun in 1872* [as No. 12 (72.3)] *finshed April 6th 1874. for Snedicors sale.*

Collection of the Museum of Art, Carnegie Institute, Pittsburgh, Pennsylvania, presented in memory of Samuel Brown Casey, 1963. Courtesy of Museum of Art, Carnegie Institute.

DOE AND TWO FAWNS IN THE FOREST 74.13

[Unknown] [Unknown]: 10 × 14 [?]

[Unknown]

No.. 22 *[1874] Doe & two Fawns in Forest something like No. 13/74 [74.4]. Painted for Mr. Anderson for Boat 10 × 14.*

See 74.4 and 74.16.

THE PETS: CHICKENS AND RABBITS 74.14

[Unknown] [Unknown]: 18 × 24 [?]

[Unknown]

[No.] 23 *April/74. Chickens & Rabbits (The Pets[)] 18 × 24. something like No. 18 [74.9]—sold to Jno Snedicor for Publication. $200.00. 10 pct royalty to me after the first Expence is paid. from all the copies.*

Apparently this work was intended for reproduction, but no prints after it are known.

AT BAY 74.15

A. F. Tait / 1874 [LR] [Unknown]: 18 × 24

No. 24. At Bay. A. F. Tait, N.Y. 1847—Sidman.

[No.] 24 *At Bay. Stag & Dog Snow in Forest. Mr. Sidman to pay off loan of $200. with No. 14 [74.5]. 18 × 24.*

DOE AND TWO FAWNS IN THE FOREST 74.16

[Unknown] [Unknown]: 10 × 14 [?]

[Unknown]

[No.] 25 *[1874] Doe & 2 Fawns in Forest 10 × 14 something like No. 22 [74.13]. Painted for Mr. Peter Brett in exchange for a Guy ("I'll tell you a secret ["]) in Frame. Frame on mine also.*

See 74.4 and 74.13.

RUFFED GROUSE SHOOTING: THE FIND 74.17

A. F. Tait / Adirondacks 1874 [LR] Canvas: 14 × 22

No. 260/ Painted by / A. F. Tait / From Nature / Long Lake / Hamilton Co. / Adirondacks / Ruffed Growse [*sic*] Shooting / The Fined [*sic*] / Oct 1874.

[No.] 26 *1874 Pointer & Ruffed Grouse (wounded) October 14 × 22 Canvass Painted from Nature in the Woods. October 1874, sent to Snedicor Nov 9th.*

This painting has been relined and the original inscrip-

tion was copied onto the new canvas with two prominent mistakes, as shown in the transcript above.

Courtesy of Mr. and Mrs. George Arden.

See 74.20.

BUCK ON THE LAKE SHORE 74.18

A. F. Tait / 1874 [LR] Canvas: 14 × 21½

No. 27 / Adirondacks / Painted by A. F. Tait / Long Lake / Hamilton Co., N.Y.

[No.] 27. *Buck on Lake Shore. Sand Beach Painted from Nature. View of Long Lake looking South from my Place Snedicor Nov. 9th.*

See 74.20.

BUCK IN THE FOREST 74.19

[Unknown] [Unknown]: 14 × 22 [?]

[Unknown]

[No.] 28 *"At Home." 1874 Buck in Forest. 14 × 22 Painted from Nature in the Woods sent to Snedicor Nov 9th from Minerva per Maguire to N. Creek.*

See 74.20.

RUFFED GROUSE SHOOTING: THE FIND 74.20

[Not signed or dated] Canvas: 12½ × 21½

No. 29 / Long Lake / Hamilton Co., N.Y. / Adirondacks / October 1874 / "The Surprise" / Painted from nature by A. F. Tait.

[No.] 29 *Ruffed Grouse Shooting "the find." Pointer & 3 Grouse in Forest—from Nature 14 × 22 Do. Nov 9th as above* [see 74.19] *all these four* [74.17–.20] *went together by Express.*

BUCK AND TWO DOES AT A LAKE SHORE 74.21

A. F. Tait / N.Y. 74 [LR] Canvas: 14 × 22

No. 30 / A. F. Tait / Woodside / Long Lake / Hamilton Co. / N.Y. / September 1874 / Adirondacks

[No.] *30 Deer (3) Buck & two Does. Lake Shore. 14 × 22 Snedicor by Express from Dunlap's.*

"Woodside" was the name of AFT's home at Long Lake, New York.

ADIRONDACKS: OCTOBER 74.22

[Not signed or dated] Canvas: 14½ × 22

Adirondacks "October," A. F. Tait, Woodside, Long Lake, Hamilton Co. "October." No. 31 / 1874

[No.] *31 [1874] Forest Scene. Buck. 14 × 22 Canvass partly painted from Nature Snedicor by Express from Dunlap's.*

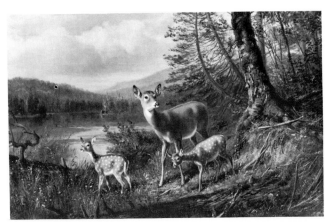

DOE AND TWO FAWNS AT 74.23 EDGE OF LAKE

[Unknown] Canvas: 14 × 22 [?]

[Unknown]

[No.] *32 Doe & Fawn's (2) Lake Shore Edge of Forest. flock of Ducks in distance 14 × 22 Canvass fin Dec'r. by me X'mas to Snedicor with 33, 34 & 35 [74.24–.26].*

Courtesy of Newhouse Galleries, Inc., New York, New York.

DOE AND TWO FAWNS AT 74.24 BROOK IN FOREST

[Unknown] [Unknown]: 14 × 22 [?]

[Unknown]

[No.] *33 Doe & 2 Fawns. Brook in Forest large rock 14 × 22 fin'd Dec'r 27th by me X'mas to Snedicor [with 74.23, 74.25, and 74.26].*

THE FOREST: AUGUST 74.25

A. F. Tait / Adirondacks / 1874 [LR] Panel: 10 × 13¾

No. 34 / "The Forest" / August / A. F. Tait / Long Lake / Hamilton Co / N.Y. / 1874

[No.] *34 [1874 & 5] Doe & 2 Fawns in Forest. fin Dec'r 10 × 14 Panel I took these down myself in X'mas 1874 to Snedicor in Frame by Express from N Creek [with 74.23, 74.24, and 74.26].*

DUCKS SUNNING 74.26

[Unknown] [Unknown]: 10 × 14 [?]

[Unknown]

[No.] *35 Ducks Sunning [Swimming (?)]. Spring Brook. finished Dec'r. 10 × 14 X'mass 1874 taken down to Snedicor in Frame by Express to N Creek [with 74.23–.25].*

[CHICKENS] 74.27

A. F. Tait / N.Y. 1874 [LL] Board: 10 × 14

[Unknown]

Knowing only the support, size, and date of this painting of five domestic chickens, it is impossible to positively identify it in the Register, although it is probably 74.2.

[THE HUNTER'S CATCH] 74.28

[Not signed or dated] Board: 8 × 14

A. F. Tait / N.Y. '74

[No AFT number; no Register entry]

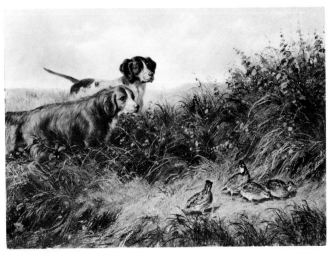

[ON POINT] 74.29

A. F. Tait / NY 1874 [LR] Panel: 10 × 13¾

[Nothing on back]

[No AFT number; no Register entry]

Collection of The Metropolitan Museum of Art, New York, New York, gift of Mrs. J. Augustus Barnard, 1979. Courtesy of The Metropolitan Museum of Art.

THE ADIRONDACKS 75.1

A. F. Tait / N.Y. 1875 [LR] Canvas: 17¼ × 23½

"The Adirondacks / No. 36 / A. F. Tait / Long Lake / Hamilton Co. / N.Y. / 1875

[No.] *36 [1875] Doe & 2 Fawns on Lake Shore 18 × 24 Painted for Mr. Jno. E Sidman 144 West 36th St N.Y. finished Feb'y 10th & sent off by Express in case for him to Snedecor with No. 37 [75.2] & 38 [75.3] Feb'y 15th / 75.*

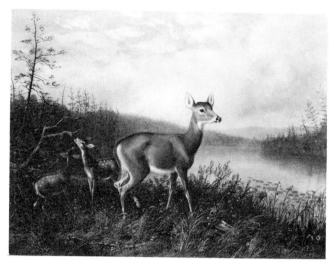

Courtesy of Schweitzer Gallery, Inc., New York, New York.

DUCKS SUNNING 75.2

[Unknown] Panel: 10 × 14 [?]

[Unknown]

[No.] 37 [1875] Duck's Sunning—large rock 10 × 14 Panel finished Feb'y 13th sent by Express to Snedecor with 36 [75.1] & 39 [actually "38" or 75.3] by Shaw Feb'y 16th.

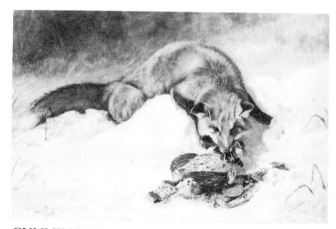

CUNNING: NOT TO BE CAUGHT 75.3

A. F. Tait / 1875 [LR] Panel: 11¾ × 18

No. 38 / "Cunning" / "Not to Be Caught" / by A. F. Tait / Hamilton Co. / N.Y. / 1875

[No.] 38 "Cunning." ["] not to be caught" 12 × 18 Panel Fox stealing Ruffed Grouse out of a Trap in the Snow. sent to Snedecor by Express with 36 [75.1] & 37 [75.2]. sent off by Shaw Feb'y 16th Sold for $100.00 paid to Mr. Lloyd by Snedecor.

Courtesy of Pebble Hill Foundation, Thomasville, Georgia.

HAPPY FAMILY 75.4

A. F. Tait / 1875 [LR] Canvas: 10¼ × 14¼

To Sam H. Lloyd / with regards by / A. F. Tait. Feb. 1875 / No. 39 / A. F. Tait / Long Lake / Hamilton Co. / N.Y.

[No.] 39. Happy Family. Doe & 2 Fawns for Mr. Sam'l H Lloyd—life Insurance N.Y. sent off by Shaw (for Express) Feb'y 23rd. [No dimensions given.]

TIRED OUT: AFTER A LONG CHASE 75.5

[Unknown] [Unknown]: [Unknown]

[Unknown]

No. 40 [1875] Tired Out. After a long chase Deer (Buck[]) just landing [?] on shallow water—Ducks, Reeds &c long Pic. for R. G. Dun Esq'r N.Y. finished & sent off—March 29th / 75 by Express Paid for $500. went down to N.Y. to finish it. [No dimensions given.]

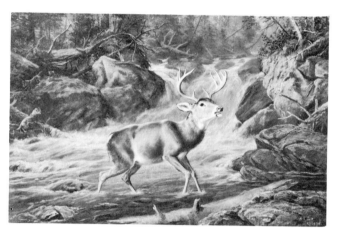

THE ESCAPE 75.6

A. F. Tait / N.Y. 1875 [LR] Canvas: 20 × 30

[Unknown]

[No.] 41 The Escape—Buck tired. Waterfall & Wolves—20 × 30 finished October 24th / 75 from Buttermilk Falls. sent off by Express for Artists Fund Sale Oct'r 25th to Snedecor in Schencks sale Dec'r. now with Mr. Hatfield. loan $300.

See 75.16 and 75.17.

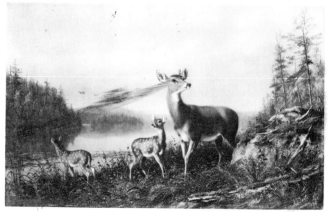

75.7

DOE AND TWO FAWNS AT
THE LAKE SHORE 75.7

A. F. Tait / Adirondacks /
1875 [LR] Canvas: 14 × 22 [?]

[Unknown]

No. 1. [*A & V. Albany 1875*] *Doe & 2 Fawns. Lake Shore
14 × 22 Canvass sent to Annesly & Vint Albany (my
Agents[)]) May 17th with 3 others* [75.8–.10].

GOOD DOG 75.8

A. F. Tait / N.Y. 75 [LR] Panel: 10 × 13¼

No. 2 / "Good Dog" / A. F. Tait / Long Lake / Hamilton
Co. / N.Y. / 1875

[No.] 2 *Dog. (Pointer with Ruffed Grouse dead in his Mouth
[)] 10 × 14 Panel to Annesly & Vint—Albany* [with 75.7,
75.9, and 75.10].

Collection of the Museum of Fine Arts, Springfield,
Massachusetts. Courtesy of Museum of Fine Arts.

A NATURAL FISHERMAN 75.9

A. F. Tait / Adirondacks /
1875 [LR] Canvas: 13½ × 21½

No. 3 / "A Natural Fisherman" / 1875 / Otter & Trout /
A. F. Tait / Long Lake, Hamilton Co. / N.Y.

[No.] 3 *Otter & Speckled Trout 22 × 14 Canvas to Annesly
& Vint* [with 75.7, 75.8, and 75.10].

Collection of The Adirondack Museum, Blue Mountain
Lake, New York.

[DUCKS AT THE SPRING HEAD] 75.10

[Unknown] Panel: 10 × 14 [?]

[Unknown]

[No.] 4 [*1875*] *Spring Head & Ducks 10 × 14 Panel to
Annesley & Vint with 3 others No. 1, 2, 3, 4* [75.7–.10].

SHEEP REPOSING 75.11

[Unknown] Canvas: 14 × 22 [?]

[Unknown]

[No.] 5 *Sheep. reposing by Rock. 14 × 22 Canvass back-
ground & Sky from Nature in front of House to Annesly &
Vint—August 16th / 75* [with 75.12 and 75.13].

PERPLEXITY 75.12

A. F. Tait / '75 [LR] Panel: 10¾ × 15

No. 6 / "Perplexity" / A. F. Tait / Long Lake / Hamilton
Co / N.Y. / 1875.

[No.] 6 *Perplexity. Pointer with dead Grouse in mouth look-
ing at another wounded close at his feet 11 × 15 Panel To A &
V. with No. 5* [75.11; also with 75.13].

FARM YARD 75.13

[Unknown] Canvas: 16 × 20 [?]

[Unknown]

[No.] 7 [*A & V. Albany 1875*] *Farm Yard. Bay Horse &
Sheep. Hen & Chickens & Apple Trees in Background in Blos-
som 16 × 20 Canvass August 16th / 75 To A & V with No. 5*
[75.11] *& 6* [75.12] *August 16th / 75.*

DEER FAMILY 75.14

A. F. Tait / 1875 / [LL] Canvas: 14 × 21½

Deer Family / 1875 / No. 42 / A. F. Tait / Long Lake /
Hamilton Co. / N.Y.

No. 42 [7A crossed out] *Deer. Buck & 2 Does Lake Shore 14
× 22 Canvass Sent off to Snedecor by Express with No. 8A &
9A* [renumbered *43 & 44* by AFT (75.15 and 75.16)] *Nov
22nd.*

QUAIL SHOOTING 75.15

A. F. Tait / 1875 [LL] Canvas: 14 × 22

No. 43 / A. F. Tait / Long Lake / Hamilton Co. / N.Y./
1875

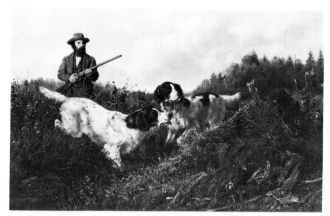

No. 43 [8A crossed out] *Quail Shooting (Amos Robinson)
Man & 2 Dogs open Country. 14 × 22 Canvass Painted in
Foreground from Pasture sent to Snedecor Nov'r 22nd* [with
75.14 and 75.16].

Courtesy of Kennedy Galleries, Inc., New York, New
York.

RUFFED GROUSE SHOOTING 75.16

[Unknown] Panel: 16 × 20 [?]

[Unknown]

No. 44 [9A crossed out] [1875] *Ruffed Grouse Shooting
(Forest) Man & 2 dogs. Amos's 16 × 20 panel. sent off to
Snedecor Nov'r 22* [with 75.14 and 75.15] *let Wm. Hatfield
have this to pay loan of $100.00 in full to date Dec'r 6th / 75.*

See 75.6 and 75.17.

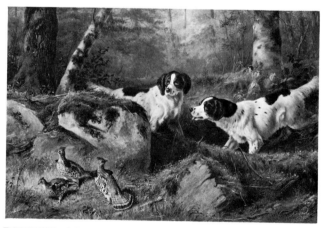

RUFFED GROUSE SHOOTING 75.17

A. F. Tait / 1875 [LR] Canvas: 20½ × 29¾

[Unknown]

[No.] 45 *Ruffed Grouse Shooting 3 Grouse & 2 Dogs in Forest
20 × 30 I took this down with me to N.Y. Dec'r 1st. 1875. left
with* [Snedecor crossed out] *Wm. Hatfield for A F. Society to
repay loan of $300.00 by Wm. Hatfield after paying dues to
A.F.S. Sold at A F Sale Jan'y 27. 1876 to a Mr. Josh'h Park
of Harrison near Rye N.Y.*

See 75.6 and 75.16.

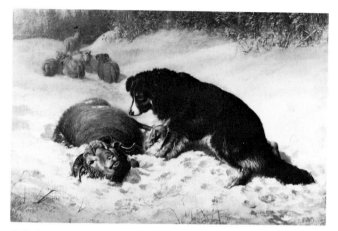

GOOD DOG SCOTTY 75.18

A. F. Tait / N.Y. 1875 [LR] Canvas: 20¼ × 30¼

A. F. Tait / Long Lake / Hamilton Co / N.Y. / 1875 / No.
46 / "Good Dog Scotty"

[No.] 46 *Good Dog Scotty. Dog trying to dig Sheep out of
Snow. 20 × 30 Canvass finished Jan'y 7th 1876. sent off to
Wm. Hatfield (Snedecors[)] Jan'y 10th 1876 for Artist Fund
Sale sold there to a Mr. L G Tillotson for $540 without Frame
Jan'y 27th 1876.*

Painting on permanent loan to Amherst College from
The Jones Library, Amherst, Massachusetts. Courtesy
of The Jones Library.

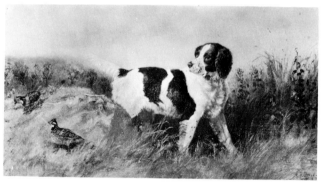

MARCO 75.19

A. F. Tait / N.Y. 1875 [LR] Canvas: 14 × 24

[Relined; inscription, if any, lost]

[No.] 48 *"Marco." Portrait of Setter Dog with Quail 14 ×
22.*

Exhibited at the National Academy of Design 51st An-
nual Exhibition, 1876, titled "Marco" and owned by
R. Lamb.

See 75.20.

"MARCO" 75.20

[Unknown] Canvas: 14 × 22 [?]

[Unknown]

[No.] *48½ Do.* [*48 "Marco." Portrait of Setter Dog with Quail 14 × 22*] *Sketch, same. the other side of Dog not so much finished 14 × 22 Canvas both Painted for a Mr. Lamb of Carmine St New York whilst I was down in Dec'r 1875 Paid for same time as delivered $125.00 for the two (Mr. Jno E. Sidmans friend*[)]*.*

See 75.19.

THREE WOODCOCK 75.21

A. F. Tait / N.Y. 1875 [LR] [Unknown]: [Unknown]

[Unknown]

[No AFT number; no Register entry]

[CARES OF A FAMILY] 75.22

A. F. Tait, 1875 [LR] Canvas: 13¼ × 19¼

[Nothing on back, since backing has been removed]

[No AFT number; no Register entry]

A family of ruffed grouse, male and female with five young; titled by the Racquet and Tennis Club, New York City, where it is now part of their collection.

AFFECTION 76.1

A. F. Tait / '76 [LR] Panel: 10 × 13¾

No. 47. "Affection" by A. F. Tait, Long Lake, Hamilton Co., N.Y. 1876.

[No.] *47* [*1876*] *Doe & Fawns (2). Maternal Aff. Sent off to Frank Osborn Jan'y 10th as a present to get him to pay my Life Insurance as a temporary loan. 10 × 14 Panel.*

DOE AND TWO FAWNS BY A STREAM 76.2

[Unknown] Board: 10 × 14 [?]

[Unknown]

[No.] *49. Doe & Fawns (2) in Forest by Stream 10 × 14 Millboard Painted for Peter Brett whilst I was in the City. he ordered 3 same size* [including 76.3 and 76.4] *of which this is the first. to be $100.00 for the 3 he paid me in advance Dec'r 1875.*

MATERNAL AFFECTION 76.3

[Unknown] Board: 10 × 14 [?]

[Unknown]

[No.] *50* [*1876*] *"Maternal Affection." Doe & 2 Fawns one laying down Doe licking it the other standing up. 10 × 14 Millboard finished Jan'y 15th Painted for P. Brett. one of the 3 ordered* [75.2–.4] *whilst in the City with 49* [76.2] *sent off by express Jan'y 24th with No 51* [76.4].

RACQUETTE LAKE 76.4

A. F. Tait / N.Y. '76 [LR] Board: 10 × 14

No. 51 / Racquette Lake / A. F. Tait / Long Lake / Hamilton Co. / N.Y. / 1876

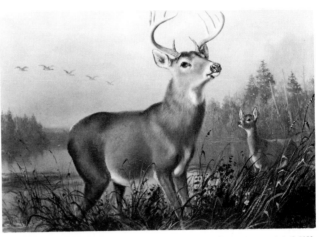

[No.] *51 Buck & Doe Lake Shore. Ducks. 10 × 14 Millboard for P Brett with 49* [76.2] *& 50* [76.3]. *sent off by Express Jan'y 24th fin'd Jan'y 18 these 3 paid for* [$100.00]*whilst in the City.*

Collection of the Parrish Art Museum, Southampton, Long Island, New York. Courtesy of Kennedy Galleries, Inc., New York, New York.

TREE'D: A GOOD TIME COMING 76.5

A. F. Tait / 1876 [LR] Canvas: 30 × 25

No. 52. / A. F. Tait / 1876

[No.] *52 "Tree'd" Bear & 2 Hounds. Bear up Tree & Hounds barking at foot Old Bear in distance. Forest finished March 3rd 1876. 25 × 30 upright Canvas and sent to Ex N.A.D. price $500.00 then to Snedecor for Sale sold for $350 by Snedecor.*

Exhibited at the National Academy of Design 51st Annual Exhibition, 1876, titled "There's A Good Time Coming," priced at $500.00.

See 76.7.

BUCK AND DOE IN LAKE SCENE 76.6

A. F. Tait [LR] Canvas: 14 × 22

"Alarmed" / Raquette Lake" / No. 8 / A. F. Tait / Long Lake / Hamilton Co. / N.Y. / 1878

[No.] *8* [53 crossed out] [*1876*] *A & Vint sent off Feb'y 7th 1876 by Express. by itself. 14 × 22 Canvass Deer. Buck & Doe Lake Scene another Deer in distance on Marsh sent this to Snedecor 1877. I sent it 1878 to Utica & sold it there for $150.00 including Frame paid by Cheque March 2nd/78.* [in margin left:] *A & V Jan'y.*

TREE'D 76.7

[Unknown] Canvas: 22 × 14 [?]

[Unknown]

[No.] *9.* [54 crossed out] *A. &. Vint. "Tree'd." 14 × 22 Canvass Upright* [Upright emphasized] *Young Bear up Tree in forest two hounds at the foot of Tree barking at him sent off*

Feb'y 14th sold to Mr. Ten Eyck of Albany.

See 76.5.

TWO GROUSE AND YOUNG 76.8

[Unknown] Canvas: 18 × 24 [?]

[Unknown]

[No.] 55 2 Grouse & Young (all foreground) 18 × 24 Canvass Painted for Jno E Sidman 144 W. 36th St N.Y. finished Feb'y 1876 sent to him thru Snedecor March 6th. Paid for in advance.

QUAIL AND SETTER 76.9

A. F. Tait / N.Y. 1876 [LL] Canvas: 18 × 24

A. F. Tait / Long Lake / Hamilton Co / N.Y.

[No.] 56 1876 Quail & Setter Dog. 18 × 24 Canvass Jno E Sidman. sent off with No. 57 [76.10]—April 17th 1876 Paid for in advance.

This painting has been relined and the back inscription is copied on the new canvas.

REPOSE 76.10

A. F. Tait / 1876 [LR] Panel: 9½ × 12¼

"Repose" No. 57 / 1876 / A. F. Tait / Long Lake / Hamilton Co / N.Y.

[No.] 57 Farm Yard. Calf & Sheep "Repose" for Mr. Lamb, Sidmans friend 10 × 12 Panel sent off with No. 56 [76.9] Paid for & rec'd cash $50.00.

SPRINGTIME 76.11

A. F. Tait / N.Y. 1876 [LL] Canvas: 14½ × 22

[Unknown]

[No.] 58 "Springtime." Old Horse Sheep & Lambs. Orchard & Apple Trees in Blossom in Back Ground. (old wall) 14 × 22 Canvass sent to Snedecor May 27th 1876 for sale.

AUGUST IN THE FOREST 76.12

[Unknown] Canvas: 14 × 22 [?]

[Unknown]

[No.] 59 [1876] altered to No. 99. August in the Forest. 14 × 22 Canvass Buck in the Velvet—Doe & 2 Fawns in Forest. finished Nov'r 1st/76 Sent to Snedecor Nov'r 8th/76 [with 76.15] by Kellogg for Express Sold by me April 1878 to Mr. Ladd of Oregon & paid for $250.00 with Frame by Snedecor to go with No. 93 [78.3].

THE MOTHER 76.13

[Unknown] Panel: 10 × 14 [?]

[Unknown]

[No.] 60. The Mother. Doe & 2 Fawns in the Forest. 10 × 14 Panel Finished Nov'r 1st sent to Wm. Schaus Nov 8 thru [?] Kellogg Sold and paid me whilst in the City Dec'r 1876 [Changed from 1877; bracketed with No. 61 (76.14) and sold with it December 1879 for $135.00 net, without frames.]

REPOSE 76.14

[Unknown] Panel: 11 × 15 [?]

[Unknown]

[No.] 61 Ducks side of Brook. ("Repose")—Rock &c 11 × 15 Panel finished Nov'r 1st to Schaus with No. 60 [76.13] sold & paid me for the two in 1876 Dec'r. nett $135.00 no Frames.

Bracketed with No. 60 (76.13).

AUGUST, ADIRONDACKS 76.15

[Unknown] Panel: 16 × 20 [?]

[Unknown]

[No.] 62 [1876] "August" Adirondacks. Lake Shore. Buck Horns in the Velvet two Does in the distance 16 × 20 Panel finished Nov'r 9th/76 sent to Snedecor with No. 59 [76.12].

DENISONS OF THE HILLS: 76.16
ADIRONDACKS

[Unknown] Canvas: 24 × 32 [?]

[Unknown]

[No.] 63 Denisons [sic] of the Hills. Adirondacks 24 × 32 Canvass Buck & Doe on the Hill Side. Foggy Morning two does in the distance. Sent off to Snedecor for Artist Fund Sale. Dec'r 4th/76 sold 1877.

PRAIRIE SHOOTING: STEADY 76.17

A. F Tait / N.Y. 76 [LL] Panel: 13¾ × 22

"Pinnated Grouse." No. 64 "Prairie Shooting," "Steady," A. F. Tait, Long Lake, Hamilton Co. N.Y. 1876.

[No.] 64 ["]Prairie Shooting." 14 × 22 Panel a Sportsman & 2 dogs pointing at a flock of 7 Prairie Grouse in Foreground a stretch of Prairie & man on horseback leading another horse (in the distance) dogs from my Setter Dash—one of my best Paintings sent off to Snedecor Nov'r 27th with No. 65, 69, & 70 [76.18, 76.22, and 76.23] sold by Snedecor.

The study for this painting is 76.18 and shows only two grouse and a hunter on foot without a horse in the background. Also like 76.19.

Collection of the Gilcrease Institute of American History and Art, Tulsa, Oklahoma.

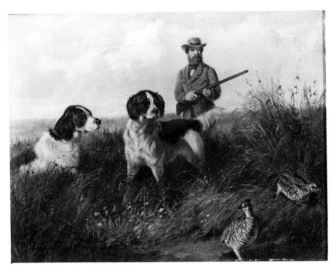

PRAIRIE SHOOTING 76.18

A. F. Tait /N.Y. 72 [LL] Board: 10 × 12¾

No. 65. / "Prairie Shooting" / A. F. Tait / Long Lake / Hamilton Co. / N.Y. / 1876

[No.] 65 [1876] Prairie Shooting. something like No. 64 [76.17] (the original Sketch for No. 64) 9 × 12 Millboard only two grouse in it. painted for Mr. Bird as pay for loan sent to Snedecor sent off Nov'r 27th [with 76.17, 76.22, and 76.23].

The finished painting (76.17) shows the two dogs in the same positions but the hunter on foot has been replaced by a man on horseback in the background and there are six grouse in the foreground. AFT painted another scene (76.19) very similar to this painting, but replaced the two pinnated grouse with two quail.

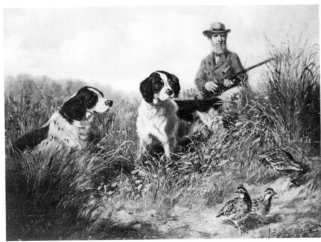

QUAIL SHOOTING 76.19

A. F. Tait / N.Y. '76 [LL] Panel: 8½ × 11½

No. 66. / 1876 / A. F. Tait / Long Lake / Hamilton Co. / N.Y.

[No.] 66 Quail Shooting—Sportsman & 2 Dogs (Like No. 64) [76.17] & Quail. 11½ × 8½ Panel dogs on a point.—a good Picture painted for Mr. Clane Mr. Sidmans friend. sent off [with 76.21] Nov'r 27th.

Courtesy of Mr. Colin Simkin.

See 76.17 and 76.18.

RUFFED GROUSE IN THE FOREST 76.20

[Unknown] [Unknown]: 20 × 30 [?]

[Unknown]

[No.] 67 [Quail Shooting crossed out] 3 Ruffed Grouse in Forest. Snow Scene with Pointer in Background. sent to Snedecor Dec'r 11th 1876 (for Artist Fund Sale) by Express 20 × 30 Sold 1877.

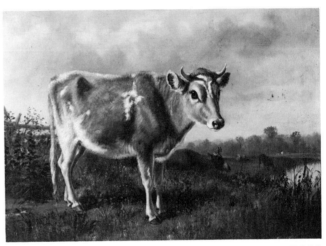

JERSEY HEIFER, FOREST FAIRY 76.21

A. F. Tait / Adirondacks / 1876 / [LR] Board: 10 × 14

No. 63. [sic] / "Jersey Heifer" / "Forest Fairy/ / A. F. Tait / Long Lake / Hamilton Co / N.Y. / 1876.

[No.] 68 [1876] Portrait of Jersey Heifer for Mr. Smith Sidmans friend 10 × 14 Millboard sent off with No. 66 [76.19]—Nov'r 27th delivered to him by J.E.S.

The number on the painting is a mistake by AFT and should be No. 68. In addition to the back inscription there is a statement in pen and ink as follows: "This was painted for / M. B. Smith by whom / the Heifer was presented / to Mr. Tait when she / was four or five weeks old."

Courtesy of Sotheby Parke Bernet, Agent: Editorial Photocolor Archives, New York, New York.

QUAIL SHOOTING 76.22

[Unknown] Panel: 7 × 12 [?]

[Unknown]

[No.] *69. Quail Shooting. 7 × 12 Panel two Dogs & Sportsman in the distance—open ground sent off to Snedecor—Nov'r 27th sold by Snedecor Schencks sale March 1877 nett for this & No. 70 [76.23] $104.12 rec'd cash March 14th 1877 p'd in Bank.*

Sent to New York with 76.17, 76.18, and 76.23.

RUFFED GROUSE: FOREST SHOOTING 76.23

[Unknown] Canvas: 7 × 12

70 / Ruffed Grouse / shooting / No. 11.29 / A. F. Tait / Long Lake / Hamilton Co. / N.Y. / 1876.

[No.] *70 Ruffed Grouse Forest Shooting 7 × 12 one Dog behind Rock two Ruffed Grouse in foreground sent off with No. 69 Nov. 27.*

Sent to New York with 76.22, 76.17, and 76.18. Sold with No. 69 (76.22) for $104.12 net, cash received March 14, 1877.

PORTRAIT OF CAT 76.24

[Unknown] Board: [Unknown]

[Unknown]

[No.] *71 [1876] Portrait of Cat for Mr. Haddon. Crams Son in law on Millboard done whilst in the City Dec'r 1876* [changed from *1877*] *paid same time* [$]*30* [?].

DEER 76.25

A. F. Tait / 1876 [LL] Board: 9½ × 12½

[Nothing on back]

[No.] *72 Deer.—for Mr. Bird 9 × 12 to pay for a loan of $300. painted in Mr. Wiles studio whilst in the City Dec'r 1876 del'd to Mr. Hatfield for him.*

On frame, which appears to be the original, the following is written at the top: "540/448 F. M. Bird, Eng #20."

DUCKS REPOSING 76.26

[Unknown] Board: 10 × 14 [?]

[Unknown]

[No.] *73. Ducks reposing. Rock & Brook on Millboard & painted in City & presented to Mr. Sidman as X'mas present 1876 Mr. Sidman paid me for Frame $20.00 my frame from Snedecor 10 × 14 millboard.*

Courtesy of Bernard & S. Dean Levy, Inc., New York, New York.

[YOUNG BUCK AND DOE] 76.27

AF Tait / NY '76 [LR] Board: 10 × 13⅞

No. 5 /Raquette Lake / A. F. Tait / Long Lake / Hamilton Co. / N.Y. / 1876

[No Register entry]

Tait did not record an entry No. 5 for 1876.

THOROUGHBREDS 77.1

[Unknown] Canvas 20 × 30 [?]

[Unknown]

[No.] *74 [1877 Colyers Studio Y M C A] "Thoroughbreds" (Wine Picture) 20 × 30 Canvass and Panel Stretcher $500.00 Painted for Frank Osborn to be Chromo'ed—began it in December/66* [sic: probably should be *76*] *finished it in Feb'y 10th. Paid in two installments—$200. & $300. sent to Utica Ex Jan'6 10th/79 to Union League & Lotos Club.*

Also sent with 81.20 to Kedcan Art Gallery, Chicago, in December 1881. Noted as returned to Chicago again in 1882.

Panel backing. This painting was reproduced twice as a chromolithograph to advertise Piper-Heidsieck champagne:
1. Size: 20 × 30 inches
 Signed, lower right: A.F. Tait N. Y. 1877
 Letterpress lower margin: H. Bencke Chromo Lith.
 Copyright by F. P. Osborn, N.Y. 1878
 Copy in the Library of Congress.

2. In this second printing the copyist has changed somewhat the arrangement of the two small dogs, and the cases of champagne:
 Size: 20 × 30 inches
 Signed, lower right: D'apres A.F. Tait / N.Y. USA
 1877 / Geo. Blott '06
 Letterpress Lower margin: Draeger Imp. Made in
 France.
 Copy at The Adirondack Museum, Blue Mountain
 Lake, New York.

[ALERT DEER] 77.2

A. F. Tait / N.Y. 1877 [LR] Canvas: 24 × 36

[Unknown]

[No.] *75 Deer. Buck & Doe Lake Scene startled by Ducks, 24 × 36 Canvass painted for a friend of Somerville (Wilmington Del).*

This painting may have been relined or sealed as on the stretcher is written, "Cleaned 1951 by Col. C.W. Fur-

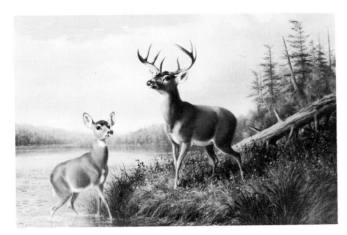

long—1950. A.F. Tait, N.Y. No. 75."

Courtesy of Mrs. James L. Kirby, Jr.

See 77.3.

DEER	77.3
[Unknown]	Panel: 10 × 14 [?]

[Unknown]

[No.] 76 *Deer. small study for No. 75* [77.2] *10 × 14 Panel.*

DEER	77.4
[Unknown]	Canvas: 12 × 16 [?]

[Unknown]

[No.] 77 *[Colyers Studio Y M C A. 1877] Small Deer 12 × 16 Canvass painted for Th. Knotz [?], Dentist, in Exchange for work thru Brazier (Janitor of Y M C.A.) sent it to him by B. March 20th/77.*

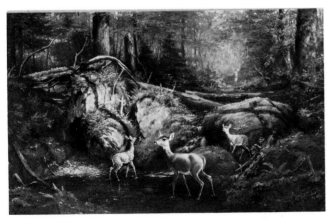

FLATBROOK	77.5
A. F. Tait / N.Y. 1877 [LR]	Canvas: 26 × 40

No. 16. / A. F. Tait / Y.M.C.A. / 23rd St. / N.Y. / 1877

[No.] 78 *or No. 16. 1871* [71.7]. *Flat Brook. 26 × 40 returned from Horace Fairbanks Gov'r of Vermont to be Exchanged for another Pic* [see 82.8]. *I repainted it and painted Doe & Fawns in Foreground Got new Frame from Snedecor for it Mrs. Farwell.*

Originally depicted a hunter and two bears as No. 16 for 1871 (71.7) prior to being overpainted by AFT.

Courtesy of Mr. Richard Green, London, England.

DEER'S HEAD	77.6
[Unknown]	[Unknown]: 10 × 12 [?]

[Unknown]

[No.] 79 *Deers Head. 10 × 12 Presented to Mr. Bierstadt Photographer Photo Plate Co—58 Reade St N.Y. April 3rd 1877.*

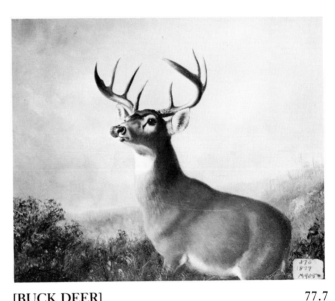

[BUCK DEER]	77.7
A. F. Tait / 1877 [LL]	Board: 12 × 13¾

No. 80. /A. F. Tait / N.Y. 1877 / F. P. Osborn, Esq.

[No.] 80 *[1877] Deers Head. 12 × 14 Millboard upright Painted for Frank Osborn April 1877.*

Courtesy of Kennedy Galleries, Inc., New York, New York.

[SETTER'S HEAD]	77.8
[Unknown]	[Unknown]: 10 × 12 [?]

[Unknown]

[No.] 81 *Dogs Head. Setter 10 × 12 Presented to Brazier April 7th/77.*

PRAIRIE GROUSE SHOOTING	77.9
[Unknown]	[Unknown]: 24 × 40 [?]

[Unknown]

[No.] 82 *[Long Lake 1877 Summer] Prairie Grouse Shooting 24 × 40 (Dr. Perkins as Sportsman) & 2 Dogs (Dash) & 5 Prairie Chickens sent off to Snedecor Oct'r 29th with 3 others following No. 83, 84 & 85* [77.10, 77.11 and 77.12] *all in one Case by Express. sold at Artist Fund Sale Jan'y 1878—for $200.00 Frame Extra.*

PRAIRIE SHOOTING 77.10

[See 78.1] Canvas: 14½ × 22

[See 78.1]

[No.] *83 altered to [blank] Prairie shooting. Canvass 22 × 14 Sportsman & one Dog. Wounded Prairie grouse. sent to Snedecor with No. 82 [77.9, and with 77.11 and 77.12] altered May 1878 painted man out and put in another dog [see 78.1]. sent to Schencks May.*

This original version was sent with 77.9, 77.11, and 77.12 to Snedecor on October 29 but was apparently returned and altered in May 1878 to become 78.1.

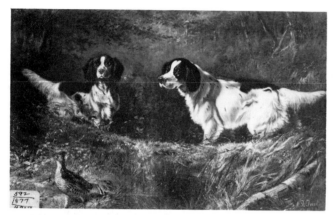

OCTOBER IN THE FOREST 77.11

A. F. Tait / N.Y. 1877 [LR] Canvas: 14¼ × 22½

"October in The Forest." / Long Lake, Hamilton County/ No. 84. Ruffed Grouse. / A. F. Tait.

[No.] *84 Ruffed Grouse Shooting Canvas 14 × 22 2 Dogs (Dash & brown & white Dog) Ruffed Grouse in foreground sent to Snedecor with 82 [77.9, and with 77.10 and 77.12].*

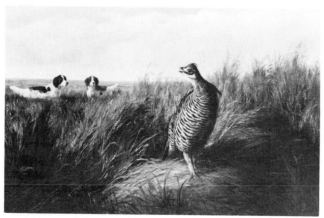

THE CHALLENGE 77.12

A. F. Tait / N.Y. 1877 [LR] Canvas: 20 × 30

Prairie Shooting / "The Challenge" / Pinnated Grouse / A. F. Tait / N.Y. 1877 / No. 85.

[No.] *85 The Challenge. Prairie Grouse in Foreground crow-*

ing. two Dogs in background (small) grass &c. sent to Snedecor with No. 82 [77.9, and with 77.10 and 77.11] Canvass 20 × 30 sold at Schencks Sale Jan'y 1878 for $175. with Frame nett $108.00.

Courtesy of Mr. and Mrs. George Arden.

SNOWED IN 77.13

A. F. Tait / N.Y. 1877 [LL] Canvas: 36 × 28

No. 86. "Snowed In" "The morning after the storm." "Uncle Dan Catlin," Long Lake, Hamilton Co. N.Y. A. F. Tait—1878.

[No.] *86 Snowed in. 28 × 36 Uncle Dan Catlin & Scotty dog rescuing Sheep in Snow after a Snow Storm. Artist Fund Sold Jan'y 1868 [sic; must be 1878] to Judge Hilton for $590.00. (Frame extra) Snedecor $55.00 Sold at Stuart [Stewart] Sale for $1300.00.*

Sold American Art Association sale, March 23—31, 1887. Illustrated and described by Edward Strahan, *The Art Treasures of America* (1879).

Collection of The Adirondack Museum, Blue Mountain Lake, New York.

For similar paintings see 78.16, 79.16, and 80.7.

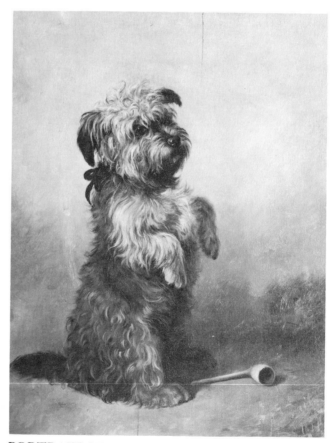

PORTRAIT OF LITTLE WOOLY 77.14

A. F. Tait 1877 [L.R.] Panel: 18 × 14½

"Little Wooly," No. 87, by A. F. Tait / Long Lake / Hamilton Co. / N.Y. 1877.

[No.] *87 Portrait of Wooly, our little Scotch Terrier. 10 ×
13 Painted for Dr. Strachan. presented in Exchange for Dog.*

Courtesy of Mr. and Mrs. George Arden.

QUAIL SHOOTING	77.15
[Unknown]	Panel: 14 × 18 [?]

[Unknown]

[No.] *88 Quail Shooting. 14 × 18 French Panel Dash. for
Dr. Strachan to Pay for Dog.*

Similar to 77.16 and 77.17.

QUAIL SHOOTING	77.16
[Unknown]	Board: 12 × 16 [?]

[Unknown]

[No.] *89* [All of the following crossed out: *Quail Shooting
something like No. 88* [77.15]. *Rich'd* [blank] *6th Av to pay for
loan of $400.00 12 × 16 Millboard*].

Essentially the same entry falls under No. 90 (77.17),
suggesting that there never was an actual painting for
77.16.

QUAIL SHOOTING	77.17
[Unknown]	[Unknown]: 12 × 16 [?]

[Unknown]

[No.] *90 "Quail Shooting" something like No. 88* [77.15]. *for
Rich'd Mears. 6th Av. for loan of $400.00 repaid in cheque
today—bal $216.30. Feb'y 1st/78.*

See 77.15 and 77.16.

DEER	77.18
[Unknown]	[Unknown]: 10 × 14 [?]

[Unknown]

[No.] *91 Deer.—Lake 10 × 14 painted for P. Britt* [sic;
AFT means *P. Brett*] [$30.00].

[TWO DOGS POINTING QUAIL]	77.19
A. F. Tait / 1877 [LR]	Board: 10¼ × 13¾

[Nothing on back]

[No AFT number; no Register entry]

[GROUSE HUNTER AND RETRIEVER]	77.20
A. F. Tait / N.Y. 1877 [LR]	Canvas: 14 × 22

[Relined; inscription, if any, lost]

[No AFT number, no Register entry]

PRAIRIE SHOOTING: FIND HIM	78.1
A. F. Tait / N.Y. 1878 [LR]	Canvas: 14¼ × 22

No. 83 / "Prairie Shooting" / "Find Him" / A. F. Tait /
N.Y. 1878

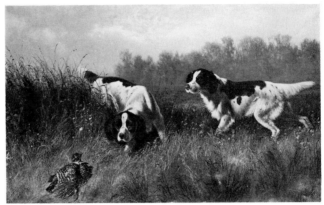

[*No. 83;* for Register entry see 77.10].

This entry represents an altered revision of No. 83 for
1877 (77.10).

Courtesy of Mr. George A. Butler.

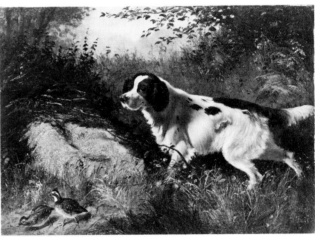

DOG AND QUAIL	78.2
A. F. Tait / N.Y. '78 [LR]	Panel [?]: 10 × 14

[Unknown]

[No.] *92* [*1878*] *Dog & Quail Painted for P. Brett* [$30.00]
10 × 14 Millboard.

Courtesy of Mr. George A. Butler.

RUFFED GROUSE	78.3
A. F. Tait / N.Y. 1878 [LL]	Canvas: 13¾ × 21¾

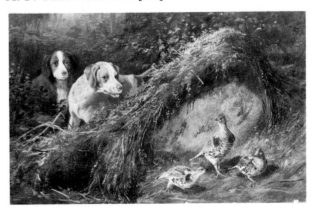

No. 73 [sic] / "Ruffed Grouse" / A. F. Tait / 1878 N.Y.

[No.] 93. [Following crossed out: *Ruffed Grouse Shooting 2 Dogs & 2 Grouse. P. Brett.* ($100.00); reentered as No. 95 (78.5)] *2 Pointers & Ruffed Grouse Rock in Forest 22 × 14 Schencks Sale March 29th Sold to Mr. Ladd, Oregon* [with No. 59 (or 99) of 1876 (76.12)].

This painting has been relined and the back inscription copied on the new canvas as shown above.

DEER 78.4

A. F. Tait / N.Y. 78 [LR] Canvas: 30¼ × 22¾

[Possibly relined; inscription, if any, lost]

[No.] 94 [Following crossed out: *Quail Shooting 2 dogs & 2 Quail. 14 × 22*] [may have been reentered later as "M" (78.10)] *Deer. P. Brett 22 × 30* [$100.00].

RUFFED GROUSE AND POINTERS 78.5

[Unknown] [Unknown]: 19 × 27 [?]

[Unknown]

[No.] 95 [1878] *Ruffed Grouse & Pointers Forest Scene 19 × 27 P. Brett for* [$100.00].

DOG AND GROUSE 78.6

[Unknown] [Unknown]: [Unknown]

[Unknown]

[No.] 96 *Dog & Grouse (3) Forest Scene* [penciled dimensions *22½ × 29* erased].

CHICKENS 78.7

[Unknown] [Unknown]: 9 × 14 [?]

[Unknown]

[No.] 97. *Chickens. 9 × 14 painted for Jno E Sidman. for painting the Rooms.*

JOLLY WASHERWOMAN 78.8

[Unknown] [Unknown]: 22 × 26 [?]

[Unknown]

C. *"Jolly Washerwoman" 22 × 26 For Bencke. Chromo'd 1879.*

There is doubt that AFT painted this, since a receipt on the inside of the back cover of volume 3 of his Register reads: "New York, Jan'y 25/68. Received from A. F. Tait fifty dollars for the Copyright of the Painting of The Jolly Washerwoman now in The possession of John Osborn, Esq. of Brooklyn and I promise not to Paint or publish or allow to be published any painting of mine of the same subject. [Signed] Lilly M. Spencer."

BUCK AND DOE ON LAKE SHORE 78.9

[Unknown] [Unknown]: 10 × 15 [?]

[Unknown]

U. *Deer. (Buck & Doe) on Lake Shore for P. Brett. (3 ordered for $100.00) 10 × 15 Paid May 1878. 2 to be del'd in the Fall* [but in fact not delivered until the following spring; see 79.9 and 79.12].

STEADY 78.10

[Unknown] [Unknown]: 14 × 22 [?]

[Unknown]

M. *[1878] "Steady" Two Dogs & Quail 14 × 22.*

[DEER IN A FOREST LANDSCAPE] 78.11

A. F. Tait / N.Y. 1878 [LR] Canvas: 29 × 22

[Relined; inscription, if any, lost]

B. *Deer. Buck & Doe Lake Scene 22 × 29 for Jno Snedecor to pay for Frames $150.00 he sent it [to] Schencks Sale Jan'y 10th.*

THE RESCUE 78.12

[Unknown] [Unknown]: 22 × 26 [?]

[Unknown]

E. *1879 [sic] The Rescue. Dog barking (Scotty) & Old Ram down in Snow. dog like No. A [78.15]. 22 × 26 Schencks Sale sent down Jan'y 6th/79 ret'd not sold sent to Utica Ex. del'd to Renner Jan'y 13th Price to be $300.00 or $275. not sold at Utica. ret'd Ex. by Wm. Hatfield April Sold by Schenck Dec'r '79 for $225.00. $192.25 nett.*

See 78.15.

SPRING HEAD 78.13

[Not signed or dated] Panel: 9¼ × 12¾

Long Lake, Hamilton Co. N.Y., Sept. 21, 1878, from A. F. Tait [also on back appears the date 1882]

R. *1878 Spring Head—Ducks &c. Painted for the birthday of our dear little Son, Arthur James Blossom Tait on his third birthday at Long Lake. Sept'r 21st Panel 10 × 14.*

Sent to Utica in 1882 for exhibition and sale where it brought $150.00, or $130.00 net.

THE OLD PIONEER: UNCLE DAN 78.14
AND HIS PETS

A. F. Tait / N.Y. 1878 [LR] Canvas: 20 × 30

L. / "The Old Pioneer" / "Uncle Dan & his pets" / Long Lake / Hamilton Co / N.Y. / by / A. F. Tait / Y.M.C.A. / 23rd St. N.Y.

L. *"The Old Pioneer" "Uncle Dan & his pets." 20 × 30 for Artist Fund Sale Sold Jan'y 28th/79 to [blank] for $250.00 a great Slaughter. one of my best & most carefully finished works Frame Extra $38. Sold to Mr. Young 38th St near 6th Av. N.Y. Whiting & Young.*

"The Old Pioneer" was painted at the cabin of Dan Catlin, who is depicted in the painting. He has no connection with Catlin, the famous artist. The cabin was built

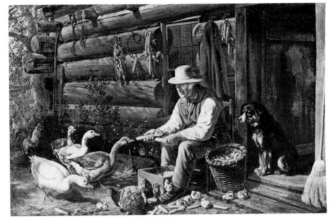

where the Endion Club stood for many years, on the west side of Long Lake.

Collection of the Shelburne Museum, Shelburne, Vermont. Courtesy of Shelburne Museum.

THE RESCUE: CALLING FOR HELP 78.15

[Unknown] Canvas: 20 × 30 [?]

[Unknown]

A. The Rescue. Calling for help. Dog & Sheep & two Lambs in Snow one Lamb fallen down. Dog Barking (Scotty Dog) 20 × 30 Artist Fund Sale Jan'y 27th/79 sold for $280.00 Frame Extra $38.00.

Similar to 78.12.

SNOWED IN 78.16

A. F. Tait / N.Y. 1878 [LL] Panel: 17 × 13¾

A. F. Tait / 1878 / No. 91.

C. M. Snowed in. 14 × 17 Panel something like No. 86 [77.13] *for Thos. Maguire for a loan of $325 for 2 months Dec'r 3 to Feb'y 10th when I paid it off by cheque.*

For similar paintings see 77.13, 79.16, and 80.17.

GIRL WITH GUITAR 78.17

[Not signed or dated] Canvas: 20 × 16

New York, March 8th—78 / This is to certify that I painted / the scarf and guitar handle in this / painting by Fagnani [*sic*] and in doing so / I had to paint over his signature / but had no authority to resign it. A. F. Tait.

[No AFT number; no Register entry]

AFT spelled Guiseppe Fagnini's name incorrectly. Fagnini (1819–73) was a New York artist.

[SPRING ON THE HILLSIDE] 78.18

A. F. Tait 1878 [LR] [Unknown]: 20 × 30

[Unknown]

[No AFT number; no Register entry]

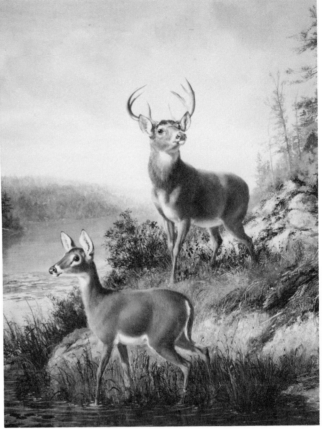

[WIDE AWAKE: RAQUETTE LAKE] 79.1

A. F. Tait N.Y. 1879 [LR] Canvas: 26 × 22½

N. 1879 / August / A. F. Tait / Y.M.C.A. / 23rd St N.Y. / Racquette Lake / Adirondacks / N.Y.

N. [*1879.*] *"Buck & Doe" Lake Scene, Buck up on Rocks 22 × 26 finished Jan'y 8th Sent to Utica Exhibition Jan'y 13th 250.00. sold for $225.00 nett with Frame Snedecors Frame.*

See 79.16.

THE INTRUDERS 79.2

[Unknown] [Unknown]: 12 × 17 [?]

[Unknown]

D. "The Intruders" 2 Sheep and Hen & Chickens 12 × 17. [Following crossed out: *finished Jan 20th/79 Schencks Sale*] *not sold Sold to Mr. Thos. Grinnell (St. Nicholas* [*Knickerbocker* crossed out] *Club) Feb'y 4th/79* [At bottom of same page, below next entry, "C.C." (79.3), appear details marked with a bracket and the note *mistake. this is No. D* as follows:] *"The Intruders" D Frame by Renner $20. Exhibited at Saint Nicholas Club Feb'y 3rd & 4th Sold to Thos. Grinnel 177 W. 34th St. N.Y. sent Feb'y 5th by Rossell. $75.00.*

THE SURPRISE 79.3

A. F. Tait / N.Y. '79 [LR] Canvas: 12¼ × 16½

CC / The Surprise / A. F. Tait / N.Y. 1879

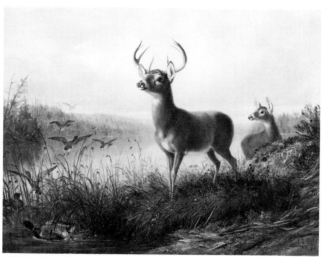

C.C. Deer.&c. [Schencks Sale Feb'y 6 or 7th crossed out] 12½ × 16½ [additional words in the entry, bracketed and marked mistake. this is No. D. See 79.2].

[DEER AND DUCKS] 79.4

[Unknown] Panel: 10 × 14 [?]

[Unknown]

C.U. [1879] 2 Deer. Ducks &c. Painted for Springfield Ex. 10 × 14 my [?] Frame Snedecor Panel.

THE SURPRISE 79.5

[Unknown] [Unknown]: 12 × 16 [?]

[Unknown]

C.U.-A. Deer &c The Surprise Schencks Sale sold in his Frame for $75 nett about $55.13. 12 × 16.

A CLOSE POINT 79.6

A. F. Tait / N.Y. 79 [LL] Canvas: 14 × 22

A Close Point / A. F. Tait / N.Y. '79 / 1879 / C.B.

C.B. Quail & Dogs (2) called "A Close Point." Canvass 14 × 22 Moore's Sale. Feb'y 79 (Wheelers Frame $23.50[]). sold nett $126.62 with Frame.

Courtesy of Mr. George A. Butler.

JERSEY BULL 79.7

[Unknown] Canvas: 14 × 22 [?]

[Unknown]

C.E. [1879] Portrait of "Jersey Bull" for Mr. Kittridge of Keckskill [see below] N.Y. for Bull Calf "Adirondack Chief" now on my Farm at Long Lake 14 × 22 Canvas finished Feb'y 17th. begun July 1878 Frame by Wheeler price $22.00 & Paid for Frame same time.

Gazetteers of the period do not list a town by the name of Keckskill.

BUSY BODIES 79.8

A. F. Tait / N.Y. '79 [LR] Board: 10 × 14

C.R. 1879 / A. F. Tait, N.Y. / "Little Busybodies" / Studies from nature.

C.R. Chickens & Hen in Coop called "Busybodies" 10 × 14 Millboard sold to R. Somerville for $100.00 with Frame $80 only. my frame by Snedecor I paid for last year. I sold this to Pic at [Knickerbocker crossed out] St. Nicholas Club April 7th through W. Saterles to C. Vanderbilt Esq'r for $150.00 & paid Mr. Somerville $25.00 Interest &c & kept the $80. toward another Chickens.

Description is "Hen in coop—head out twixt bars—11 chickens outside—2 in red dish." Inscription and date, size, front, and back from notebook of A. J. B. Tait.

[DUCKS RESTING] 79.9

[Unknown] Board: 10 × 14 [?]

[Unknown]

C.F. Ducks. Rock. Millboard 10 × 14. P. Brett. paid for last year. [$300.00; one of three paintings, with 78.9 and 79.12, ordered by Brett for $100 in advance; see 78.9.]

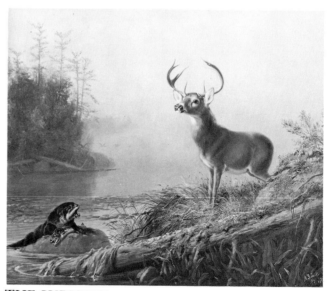

THE SURPRISE 79.10

A. F. Tait / N.Y. '79 [LR] Canvas: 22¼ × 26

C.A. / "The Surprise" / Adirondacks / "Outlet of Rac-
quette Lake" / A. F. Tait / N.Y. / 1879

*C.A. [1879] "The Surprise" Buck & Otter. Foggy Morning on
Lake. 22 × 26 Exhibition N.A.D. sold by Mr. Peabody to
[blank] for $250. with Frame. Snedecors Frame, $27.00. Sold
for $250.00 to Mr. Reed 57 W. 57th St. N.Y. by Mr. Pea-
body.*

Exhibited at the National Academy of Design Annual
Exhibition, 1879, titled "The Surprise," priced at
$300.00.

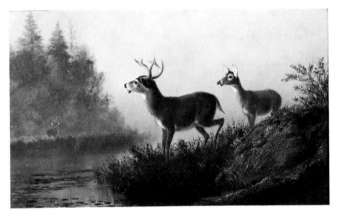

THE CHALLENGE 79.11

A. F. Tait / N.Y. '79 [LR] Canvas: 9¾ × 16

[Nothing on back]

*C.N. "The Challenge" Millboard 10 × 6 Buck & Doe. Foggy
morning Lake. Buck in the distance Schencks Sale at Knights in
Brooklyn sent Mar 10. sold for $66.00 with Frame nett.
Wheelers Frame $14.00.*

DOE AND FAWNS IN FOREST 79.12

[Unknown] Board: 10 × 14 [?]

[Unknown]

*U.Z.[C.D. crossed out] Doe & Fawns Forest Millboard
10 × 14. P. Brett. March 14th Paid for last year [$30.00;
one of three paintings, with 78.9 and 79.9, ordered by
Brett for $100 in advance; see 78.9.]*

QUAIL SHOOTING 79.13

[Unknown] Panel: 9 × 15 [?]

[Unknown]

*U.C. [1879] Quail Shooting Thin Panel 9. × 15. Mathews
Sale—April 8 & 9. Wheelers Frame $14.00 sold for $105.00
with Frame Com off. Nett $91.88.*

HARD FARE 79.14

[Unknown] Board: 10 × 14 [?]

[Unknown]

*U.U. Chickens "Hard Fare" with Cob of Corn. Millboard
10 × 14 Renners Frame Ex at [Knickerbocker crossed out] St.
Nicholas Club April 7th Renners Frame.*

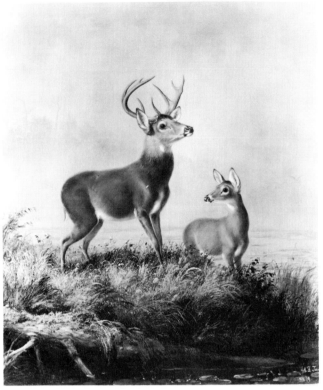

A SEPTEMBER MORNING 79.15

A. F. Tait / N.Y. 79 [LR] Canvas: 26 × 22

U.M. / "A September Morning" / "Adirondacks" / N.Y.
/ A. F. Tait / Y.M.C.A. / 23rd St / N.Y. / 1879.

*U.M. "Early Morning" on "Raquette Lake." Canvas 22 × 26
upright.*

Courtesy of Bernard & S. Dean Levy, Inc., New York,
New York.

FINDING THE LOST SHEEP 79.16

A. F. Tait / 79 [LR] Canvas: 11 × 15

[Nothing on back]

*U.B. 1879 "Finding the lost Sheep" Canvas 11 × 16 like
Snowed in Snow Scene for Mr. Bird. W. Hatfields friend to pay
for a loan in Feb'y/79 of $300.00 $225 paid of this in March by
sale of No. N./79 [79.1] At Utica Exhibition.*

For similar paintings see 77.13, 78.16, and 80.17.

RATHER HARD FARE 79.17

[Unknown] [Unknown]: 10 × 14 [?]

[Unknown]

*U.E. Ear of Corn & Chickens "Rather hard Fare" Finished
April 19th 10 × 14 Renners Frame.*

[A BUCK: FOGGY MORNING] 79.18

A. F. Tait / N.Y. 79 [LL] Canvas: 22¼ × 14¼

No. 45. [See remarks]

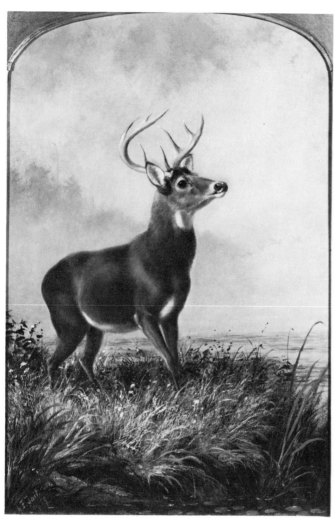

U.R. A Buck. foggy morning Canvass 14 × 22 upright Painted for Dr. J. A. Perkins of Albany to pay for a loan of $500.00 for 6 months—due May 1st 1879.

The inscription *No. 45* on the back is evidently in error and was placed there at time of rebacking. As AFT used only code after 1878, the "U.R." could readily have been misinterpreted as "45." The back of the painting is covered with a wooden panel.

Courtesy of Kennedy Galleries, Inc., New York, New York.

[SIX PAINTINGS FOR THE YACHT *NETTIE*] 79.19–.24

[See remarks] [See remarks] [See remarks]

[See remarks]

[U.L., U.A., U.N., U.D., M.C., M.U.]1878 & 1879 [See 79.19–.24 for individual entries for each painting; the following, after Register entry for "M.U." (79.24), may refer to all paintings in this series.] *finished & put in the yacht May 1879.*

Six paintings, all with panel backing, for F. P. Osborn's yacht *Nettie*. All have concave ends, either at one or both upper ends, in order that they could be fitted around the portholes of the yacht's dining room. Frames of all six paintings were made of Manila rope. See individual entries for 79.19–.24.

DUCK SHOOTING WITH DECOYS 79.19

A. F. Tait / N.Y. 79 [LL] Canvas: 9½ × 70

[Nothing on back]

U.L. Duck Shooting with Decoys Long Picture for F. P. Osborn for his Yacht Nettie. (Picture painted in 1878 & remounted & Enlarged in 1879[]).

First of six paintings done for F. P. Osborn's yacht *Nettie*. See entries 79.19–.24. This painting is concave at both upper ends.

SUNSET 79.20

A. F. Tait / N.Y. 79 [LR] Canvas: 9½ × 70

[Nothing on back]

U.A. Long Picture—"Sunset" a Deer Coming out of the Lake after a long Swim. Duck's & Reed's Lake Scene.

Second of six paintings done for F. P. Osborn's yacht *Nettie*. See entries 79.19–.24. This painting is concave at both upper ends.

SNIPE SHOOTING 79.21

A. F. Tait / N.Y. 79 [LL] Canvas: 9½ × 30¾

[Nothing on back]

U.N. Snipe Shooting Yacht Nettie.

Third of six paintings done for F. P. Osborn's yacht *Nettie*. See entries 79.19–.24. This painting is concave at the upper right end.

Courtesy of Kennedy Galleries, Inc., New York, New York.

POINTER AND QUAIL 79.22

A. F. Tait / N.Y. 79 [LR] Canvas: 9½ × 30¾

[Nothing on back]

U.D. Pointer & Quail Yacht Nettie.

Fourth of six paintings done for F. P. Osborn's yacht *Nettie*. See entries 79.19–.24. This painting is concave at the upper left end.

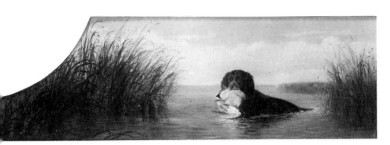

[SPANIEL RETRIEVING A DUCK] 79.23

[Not signed or dated] Canvas: 9½ × 30¾

[Nothing on back]

M.C. Blk & Tan. Spaniel & Duck in his mouth Coming out of the water Yacht.

Fifth of six paintings done for F. P. Osborn's yacht *Nettie.* See entries 79.19–.24. This painting is concave at the upper left end.

Courtesy of Kennedy Galleries, Inc., New York, New York.

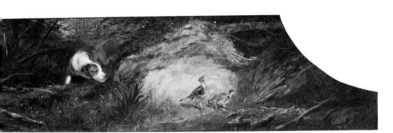

GROUSE SHOOTING: ON A POINT 79.24

A. F. Tait / N.Y. '79 [LR] Canvas: 9½ × 30¾

[Nothing on back]

M.U. Grouse Shooting on a Point. Yacht finished & put in the yacht May 1879. [This may refer to all six paintings (79.19–.24).]

Sixth of six paintings done for F. P. Osborn's yacht *Nettie.* See entries 79.19–.24. This painting is concave at the upper right end.

Courtesy of Kennedy Galleries, Inc., New York, New York.

LITTLE "BUZZ FUZ" 79.25

[Unknown] Canvas: 10 × 14 [?]

[Unknown]

U.B. [1879] Little "Buzz Fuz" a Scotch Terrier Canvass 10 × 14 painted for Jas. Stillman (owned by Mrs. Roosevelt Schuyler) Frame by [blank] finished May 29th/79.

VANITY FAIR 79.26

[Unknown] Canvas: 20 × 30 [?]

[Unknown]

U.E. Vanity Fair Canvas 20 × 30 Painted for H Bencke for a Show Card "for Tobacco & Cigarette" finished—[blank] A Girl laying off on Couch smoking a Cigarette puffing Smoke into a Sky Terriers Face. King Charles Spaniel on cushion at her head, another on her arm & a Sky Terrier, on a Table. Cigarette Boxes &c all round. W. S. Kimball Co Rochester N.Y. finished June 19th 1879. repainted much of it & sent it off again June 24th.

Neither this painting nor any reproduction of it has ever been located.

OTTER, ADIRONDACKS 79.27

A. F. Tait / N.Y. 1879 [LR] Canvas 20 × 30

U.R. / "Otter" / "Adirondacks" / A. F. Tait / 52 E. 23rd St. / N.Y.

U.R. 2 Otter. 20 × 30. Snedecors Frame. June 28th 1879 left this Pic with C H Maguire Tailor 175. 5th Av 22nd & 23rd St. on Store for the Summer & as Security for a loan of $200.00. today [?]—in Frame also the Easle [easel?] fine one I gave $50.00 to Snedecor for sold Jan'y 16th this Britcher [?] to his Friend Paid & sold Jan'y 16/80.

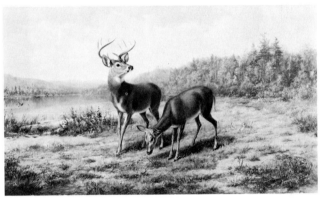

BUCK & DOE: OCTOBER 79.28

[See 83.1] Canvas: 24 × 40

[See 83.1]

U.L. [1879] Buck & Doe. October. 24 × 40 on the sand Beach. Long Lake Hamilton Co N.Y.—Painted from Nature. Sold Nov'r 18th/79 to Peter Brett with the two following ones No. U A [79.29] & U N [sic, but actually U.D. (79.31)] for $600.00 without Frames.

This painting was apparently redone in 1883 by Tait in collaboration with James M. Hart (see 83.1).

Courtesy of Mr. Edward S. Litchfield.

OCTOBER 79.29

[Unknown] [Unknown: 20 × 30 [?]

[Unknown]

U.A. Buck & Doe. Sand Beach 20 × 30 October. Painted from Nature Long Lake Hamilton Co N.Y. sold to P. Brett [with 79.28 and 79.31 for $600.00 without frames].

POINTER AND RUFFED GROUSE 79.30

[Unknown] [Unknown]: 14 × 22 [?]

[Unknown]

U.N. Pointer & [Quail crossed out] Ruffed Grouse. (in the Forest) 14 × 22 Long Lake Hamilton Co N.Y. from Nature [sold to P. Brett crossed out] sold to Peter Bret Jan'y 30th/81 [or 80] and paid for $125.00 with Frame by Renner.

OCTOBER 79.31

A. F. Tait / 1879 [LR] Canvas: 20¼ × 30¼

U.D. / October / A. F. Tait / Long Lake / Hamilton Co. / N.Y. / Painted from nature.

U.D. [1879] Quail & two Setters. Corn Field. 20 × 30 Painted from Nature and the Dogs from my Setter "Flirt" Long Lake Hamilton Co N.Y. Sold to Peter Brett with U.L. & U.A. [79.28 and 79.29, respectively; all three for $600.00 without frames].

Collection of the Gilcrease Institute of American History and Art, Tulsa, Oklahoma.

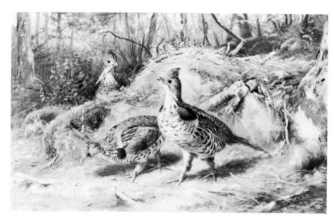

THREE RUFFED GROUSE 79.32

A. F. Tait / 1879 [LR] Canvas: 14 × 22

M.A. "Painted from nature" "Ruffed Grouse," A. F. Tait, Long Lake, Hamilton Co. N.Y. Sept. 21, 1879.

M.C. [M.D. and 3 Quail & Pointer crossed out] Three Ruffed Grouse 14 × 22 From Nature in the Forest Painted for my dear little Son Arthur James Blossom Tait as a Birthday present on his fourth (Sep'r 21st) (1879) Birthday at Long Lake Hamilton Co N.Y. left up at Long Lake.

Sent to Utica in 1882 for exhibition and sale, where it brought $200.00 or $175.00 net.

Note discrepancies between inscription on painting and Register entry codes.

[DOG FETCHING MALLARD DUCK] 79.33

A. F. Tait / N.Y. '79 [LR] Canvas: 12½ × 16½

U M [?] / A. F. Tait / Y.M.C.A. 23 [?] / N.Y. 1879

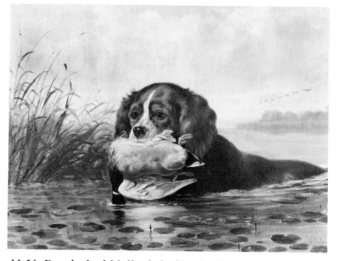

M.U. Dog & dead Mallard. fetching it 12½ × 16½ out of the water. 16½ × 12½ Canvass for Mr. Mears. (Burt & Mears) Reads St. in Exchange for Shoes del'd.

Courtesy of Mr. and Mrs. Meredith J. Long.

[SIX SMALL PICTURES FOR 79.34–.39 L. PRANG]

[See remarks] [Unknown]: 4 × 6 [?]

[See remarks]

M. M. 1879 Six small Pictures L. Prang [79.34–.39] Chickens 4 × 6 design for L. Prang. Nov'r 79 [79.34] Duck & Young. 4 × 6. [79.35] 2. Fawns. 4 × 6 sent off Dec'18/79 [79.36] Evening & Wild ducks 4 × 6 [79.37] 2 Chickens [79.38 and 79.39] Six designs in all $25.00 each in Exchange for a Diamond Ring for my dear little wife as a X'mass present.

CHICKENS 79.34

[Unknown] [Unknown]: 4 × 6 [?]

[Unknown]

[*M.M.*; see 79.34–.39].

DUCK AND YOUNG 79.35

[Unknown] [Unknown]: 4 × 6 [?]

[Unknown]

[*M.M.*; see 79.34–.39].

TWO FAWNS 79.36

[Unknown] [Unknown]: 4 × 6 [?]

[Unknown]

[*M.M.*; see 79.34–.39].

EVENING AND WILD DUCKS 79.37

[Unknown] [Unknown]: 4 × 6 [?]

[Unknown]

[*M.M.*; 79.34–.39].

CHICKENS [I] 79.38

[Unknown] [Unknown]:4 × 6 [?]

[Unknown]

[*M.M.*; see 79.34–.39].

CHICKENS [II] 79.39

[Unknown] [Unknown]: 4 × 6 [?]

[Unknown]

[*M.M.*; see 79.34–.39].

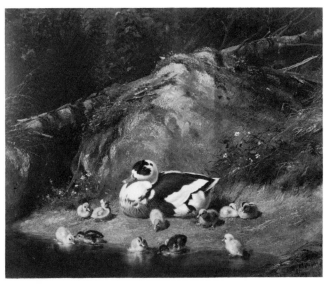

[Nothing on back]

M.A. [*1880*] *Duck & Young. 10 × 12 Painted as a Xmass present for Frank Osborn to his wife and with Frame presented to them X'mass 1879.*

Courtesy of Sotheby Parke Bernet, Agent: Editorial Photocolor Archives, New York, New York.

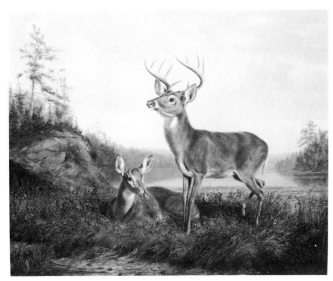

RACQUETTE LAKE 79.40

A. F. Tait / 79 [LR] Canvas: 22 × 26

M.B. Racquette Lake / October 1879 / Painted by / A. F. Tait / N.Y.

M.B. Deer. Buck Standing & Doe Lying down 22 × 26 Painted for Mrs. Talcott del'd Dec'r 24th 1879 (in Frame— Wheelers) Frame $30.00 Price to be $300.00. without Frame Paid for Jan'y 7th 1880—$300.00 and Frame $30.00 [total:] $330.00 & Paid Wheeler same time this date $27.00 for this Frame by ch'q.

Collection of The Adirondack Museum, Blue Mountain Lake, New York. Courtesy of The Adirondack Museum.

A SURPRISE 79.41

[Unknown] [Unknown]: 24 × 42 [?]

[Unknown]

M.E. "A Surprise." Adirondacks South Pond. 24 × 42 Snedecors Frame $53.00 Sold at Artist Fund Sale—Feb'y 12th & 13 brought $500.00. Frame $50.00 extra.

DUCK AND YOUNG 79.42

A. F. Tait / Xmas '79 [LR] Board: 10 × 12

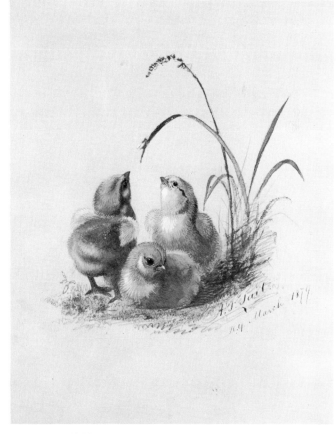

CHICKENS 79.43

A. F. Tait / N.Y. Watercolor on paper:
March 1879 [LR] 10½ × 8¼

[Nothing on back]

[No AFT number; no Register entry]

This is a watercolor, possibly mixed media, done on gray paper showing three domestic chickens, one of which is looking at a fly on a blade of grass.

Courtesy of Rainone Galleries, Inc., Arlington, Texas.

CHICKENS 79.44

A. F. Tait / 1879 [LR] Paper: 8¼ × 7

[Nothing on back]

[No AFT number; no Register entry]

This painting was formerly in an album that belonged to Mrs. F. P. Osborn. In addition to this painting there are a number of others, all done by artists contemporary with AFT, still remaining in the album.

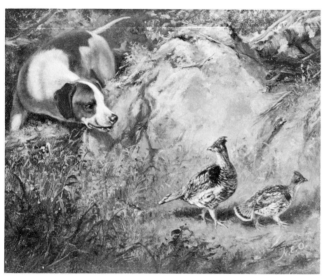

[NO TITLE] 79.45

N.E.O. [LR] Canvas: 8 × 10

[Nothing on back]

[No AFT number; no Register entry]

This painting may have been a study for 79.24, and AFT may have put the initials N.E.O. at the LR as a compliment to Mrs. F. P. Osborn whose initials were N.E.O.

Courtesy of Kennedy Galleries, Inc., New York, New York.

[DOG'S HEAD] 79.46

To Mamie / with kindest regards Paper: 8¼ × 6½
of / A. F. Tait / Long Lake Hamilton Co. N.Y. Aug 1879
[across the bottom]

[Nothing on back]

[No AFT number; no Register entry]

Collection of The Adirondack Museum, Blue Mountain Lake, New York.

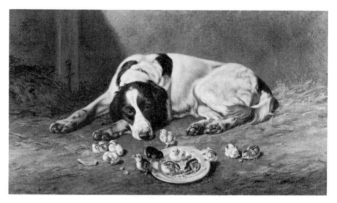

GOOD DOGGY: OUR PETS 80.1

A. F. Tait / N.Y. 1880 [?] [Unknown]: 14¾ × 24½

[Unknown]

M.R. [1880] "Good Doggy." Our Pets 14 × 24 Setter lying down (Sleepy) with little chickens round. a good Picture. Artist Fund Feb'y 13th. & 12th brought $275.00. Frame $25. extra.

Exhibited at the Artists' Fund Society, 20th Annual Sale, February 12–13, 1880, priced at $350.00, frame $25.00, 14 × 20 and titled "Good Doggy, Our Pets."

Courtesy of Mr. and Mrs. George Arden.

HARD HIT 80.2

[Unknown] [Unknown]: 13 × 17 [?]

[Unknown]

M.L. "Setter & Wounded Grouse" called "Hard hit" 13 × 17. Wheelers Frame. Schencks Sale Feb'y 3rd/80 Sold Feb'y 7th/80 for $87.00 nett with Frame.

SPRINGTIME 80.3

[Unknown] [Unknown]: 14 × 22 [?]

[Unknown]

M.N. [1880] Springtime. 14 × 22. Ducks by Brook reposing & a lot of them coming down a Path Rocks & Brook. Sunny. finished Feb'y 26th to 29th & 1st March. Feb'y 18th. 6 days in all. Sold at Schencks Sale Mar 8th $146.6 [sic] nett.

[SIX PRANG'S DESIGNS] 80.4–.9

[See remarks] [Unknown]: 4 × 6 [?]

[See remarks]

M.D. 6 Prang's Designs Diamond Ring $150.00. 4 × 6 [followed by the six paintings, bracketed and individually listed, for which see entries under 80.4–.9, then the following in closing:] *Paid for March 8th/80 $200.00.*

DUCKS SUNNING 80.4

[Unknown] [Unknown]: 4 × 6 [?]

[Unknown]

[*M.D.; see 80.4–.9*] *1 Ducks Sunning.*

DOE AND TWO FAWNS 80.5

[Unknown] [Unknown]: 6 × 4 [?]

[Unknown]

[*M.D.*; see 80.4–.9] *1 Doe & two Fawns upright.*

DOE AND TWO FAWNS LYING DOWN 80.6

[Unknown] [Unknown]: 4 × 6 [?]

[Unknown]

[*M.D.*; see 80.4–.9] *1 Doe & two Fawns lying down.*

[BUCK AT GAZE] 80.7

[Unknown] [Unknown]: 4 × 6 [?]

[Unknown]

[*M.D.*; see 80.4–.9] *1 Deers [sic] (Buck) head & Shoulders at gaze.*

CHICKENS AND BUTTERFLY 80.8

[Unknown] [Unknown]: 4 × 6 [?]

[Unknown]

[*M.D.*; see 80.4–.9] *1 Chickens & Butterfly.*

HEN, CHICKENS, AND SPANIEL 80.9

[Unknown] [Unknown]: 4 × 6 [?]

[Unknown]

[*M.D.*; see 80.4–.9] *1 Hen & Chickens & Spaniel.*

THE INTRUDER: MOTHERLY 80.10
PROTECTION

[Unknown] [Unknown]: 14 × 22 [?]

[Unknown]

B.Z. "The Intruder." "Motherly Protection" Hen Chicken & King Charles Spaniel. Hen flying up at Dog 14 × 22 In Ex N.A.D. 1880 bought by P. Brett $200.00 and paid for Ap'l 2nd.

Exhibited at the National Academy of Design Annual Exhibition, 1880, titled "The Intruder, Motherly Protection."

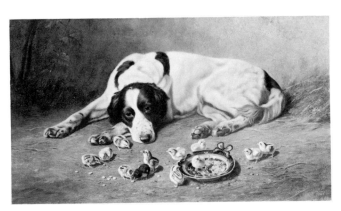

80.11

GOOD NATURE: THE INTRUDER 80.11

A. F. Tait / N.Y. 1880 [LR] Panel: 14 × 22

B.C. [The rest is so faded it cannot be deciphered.]

B.C. [1880] "Good Nature" ["]The Intruder" 14 × 22 on Panel Setter lying down sleepy [or sleeping] with chickens round and a Butterfly on a Blue Willow Plate sent to Schencks Sale March 16th in Renners Frame Sold nett $178.00.

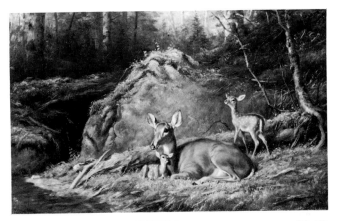

MOTHERLY AFFECTION 80.12

A. F. Tait / N.Y. 1880 [LR] Canvas: 14¼ × 22

B.U. / Motherly Affection / A. F. Tait / N.Y. 1880.

B.U. "The Mother." Doe lying down and 2 Fawns in Forest 14 × 22 in Wheelers Frame 18.00 Schencks Sale May 11th To Hy Wilson for loan June 24th/80.

Courtesy of Kennedy Galleries, Inc., New York, New York.

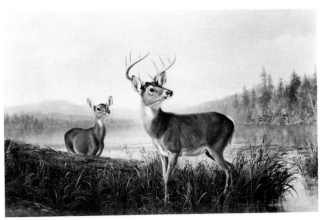

ON THE ALERT 80.13

A. F. Tait / N.Y. 1880 [LL] Canvas: 20 × 30

B.M. / On The Alert / A. F. Tait / N.Y. 1880.

B.M. "On the Alert" Buck & Doe. Lake Scene 20 × 30 For Dr. Strachan—finished May 6th to pay him for professional services up to this date.

ALERT 80.14

A. F. Tait / N.Y. '80 [LL] Canvas: 22 × 26

B.B. / "Alert" / A. F. Tait / N.Y. / 1880

B.B. [1880] "Alert" Buck & Doe. 22 × 26 Chas. H [?] Maguire Tailor for Cloaths & loan full to date finished May 11th.

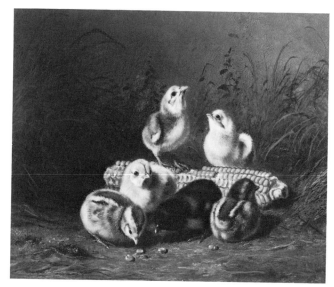

HARD FARE 80.15

A. F. Tait / N.Y. 80. [LR] Panel: 10 × 12

B.E. / "Hard Fare" / A. F. Tait / 1880.

B.E. "Hard Fare" Chickens. 10 × 12 F P. Osborn in Exchange for Champagne & Whiskey.

Courtesy of Sotheby Parke Bernet, Agent: Editorial Photocolor Archives, New York, New York.

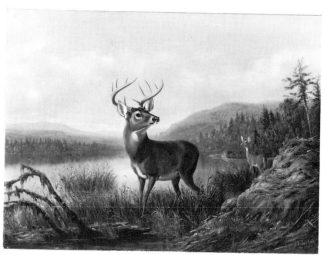

[HOME OF THE DEER: 80.16
RAQUETTE LAKE, ADIRONDACKS]

A. F. Tait N.A. / N.Y. 1880 [LR] Canvas: 23 × 29

B.R. A. F. Tait / N.Y. 1880

B.R. "Deer" Buck & Doe 22 × 29 To settle his a/c for $150.00. for Jno. Snedecor Del'd in May.

SNOWED IN 80.17

A. F. Tait, N.A. / N.Y. 1880 Canvas: 28 × 36

"After the Blizzard" painted by A. F. Tait, 1880, and retouched, cleaned, and varnished in June, 1896. Portrait of old Dan Catlin of Long Lake, Hamilton County. [See remarks]

B.L. [1880] "Snowed in" 28 × 36 Uncle Dan Catlin & Sheep in Snow like No. 86 [77.13] Paid for & Del'd Ab'n Doudney [Dowdney] $400.00.

Inscription taken from label on back of painting.

For similar paintings see 77.13, 78.16, and 79.16.

QUAIL COCK 80.18

A. F. Tait / N.Y. 1881 [LR] Canvas: 10 × 14

[Sealed; inscription, if any, unavailable]

[No AFT code] Quail. Long Lake 10 × 14 for Blossoms 5th Birthday.

Blossom was the family name for AFT's eldest son Arthur James Blossom Tait. Painting sent to Springfield in 1882.

PLATTS CAMP, LONG LAKE 80.19

A. F. Tait / 1880 [LR] Canvas: 11½ × 29½

Birch Point / Long Lake / Hamilton Co. N.Y. / 1880 / Sketch from nature by A. F. Tait.

[No AFT code] View of Platts Camp Sketch from Nature— on Long Lake. Birch Point from my floating Studio or Scow Paid $50.00.

This painting has been relined.

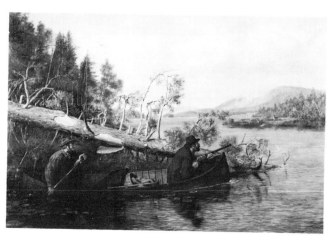

AN ANXIOUS MOMENT 80.20

A. F. Tait, N.A. / 1880 [LL] Canvas: 20 × 30

[Nothing on back]

B.A. but no No. on Picture 20 × 30 "An Anxious Moment" a

View on Long Lake. two Guides in a Boat going to shoot at two Deer in distance large fallen Spruce Tree behind the Boat taken just below Plumley's looking down the Lake. Painted for Dr. Luke Corcoran of Springfield and sent off in a Frame (Wheelers) on Dec'r 7th to be $300.00. Picture & Frame Extra $35.00. Painted entirely from Nature.

This is thought to be the only painting by AFT depicting an Adirondack guideboat, a type of boat indigenous to the Adirondacks.

Collection of the Museum of Fine Arts, Springfield, Massachusetts. Courtesy of Museum of Fine Arts.

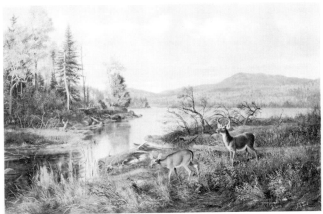

$350.00 Frame Extra [In margin, crossed out, *N.A.D.*] *Not Ex at N.A.D. returned to Mr. Flint.*

Courtesy of Mr. Bronson Trevor.

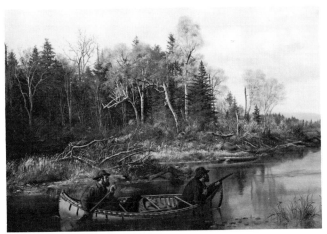

AN ANXIOUS MOMENT 80.21

A. F. Tait, N.Y. / 1880 [LR] Canvas: 20¼ × 30¼

B.N. / "An Anxious Moment / Suspense / Long Lake / Study from nature / Adirondacks / Painted by A. F. Tait, N.A. / Y.M.C.A. 23rd St.

B.N. [1880] "An Anxious Moment" 20 × 30 Painted from Nature—Two Guides in a Canoe. coming up to two Deer View on Long Lake looking across towards the big [Swamp crossed out] Marsh. bought by a Mr. Chas. R. Flint Paid for Dec'r 20th/80 $350.00 Ex National Academy [and in margin:] *NAD.*

Exhibited at the National Academy of Design 56th Annual Exhibition, 1881, titled "An Anxious Time, A Study from Nature, Long Lake, Adirondacks" and owned by C. R. Flint, who had purchased it, together with 80.22 in 1880.

Collection of The Adirondack Museum, Blue Mountain Lake, New York. Courtesy of The Adirondack Museum.

VIEW ON LONG LAKE 80.22

A. F. Tait / N.Y. 1880 [LR] Canvas: 19½ × 29½

B.D. 1880, Long Lake, Hamilton Co. N.Y. Painted from nature in October by A. F. Tait 3 miles below the bridge in 1880.

B.D. "View on Long Lake Hamilton Co. N.Y. 20 × 30 with Deer & Ducks. painted from Nature opposite big Swamp. finished in the City. Chas. R Flint. Paid for Dec'r 20/80

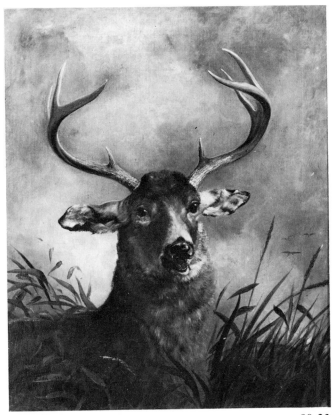

DEER 80.23

A. F. Tait / 1880 / N.Y. [LL] Canvas: 29¾ × 25¼

[Nothing on back]

[No AFT code; no Register entry]

Collection of the Shelburne Museum, Shelburne, Vermont. Courtesy of Shelburne Museum.

[DEER DRIVING IN FOG] 80.24

A. F. Tait '80 [LR] Canvas: 14 × 22

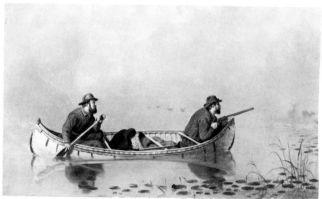

[Nothing on back]

[No AFT code; no Register entry]

VIEW ON LONG LAKE 81.1

A. F. Tait, N.A. / 1881 [LR] Canvas: 20 × 30

E.Z. View on Long Lake / Hamilton Co. / N.Y. / Painted from Nature / by A. F. Tait / N.Y. / October 1880.

E.Z. View on Long Lake. 20 × 30 2 Deer in it & Ducks. Painted from Nature looking down the Lake sent to Williams & Everett & sold to them for nett $275.00 Paid [faintly written: *for $100.00] May 6/81.*

Note that the front date is *1881*, whereas the inscription date is *1880*.

LATE AUTUMN 81.2

[Unknown] [Unknown]: 27 × 41 [?]

[Unknown]

E.C. [1881] *"Late Autumn" View on Long Lake Hamilton Co N.Y. Adirondacks finished Jan'y 25th 1881 for Artist Fund Sale. Wheelers Frame $45.00 Sold for $485.00. Frame Extra 27 × 41* [In pencil but erased; *Ex National Academy of Design.*]

HAPPY CHICKENS 81.3

A. F. Tait, N.A. / N.Y. 1881 [LR] Board: 10 × 14

E.U. / "Happy" / A. F. Tait / N.Y. / 1881.

E.U. Chickens. 10 × 14 Sent to Springfield Gill's Exhibition in Frame. & sold to Mrs. Gill for $100.00. Feb'y 1881.

Exhibited at Gill's 4th Annual Exhibition, 1881, and not priced.

STILL HUNTING IN SNOW 81.4

A. F. Tait / N.Y. 81 [LL] Canvas: 35½ × 23½

E.M. / Study from Nature / A. F. Tait / 1881. / Adirondacks / Capt'n Parker / my old Guide / for 20 years / Long Lake / Hamilton Co / N.Y.

E.M. Still Hunting in Snow. 24 × 36 Capt'n Parker my old

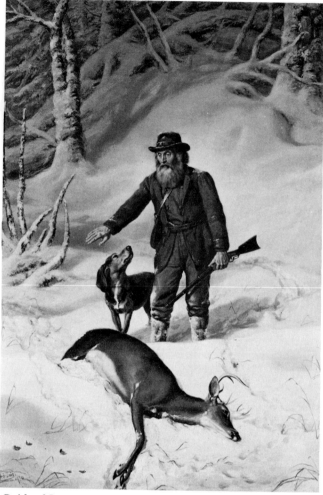

Guide of Long Lake with Dog, just finding Dead Deer. sold to Chas. R. Flint for $600.00 Exhibited in N.A.D. 1881.

Exhibited at the National Academy of Design 56th Annual Exhibition, 1881, titled "Still Hunting, Adirondacks," and owned by Charles R. Flint.

Collection of the Shelburne Museum, Shelburne, Vermont. Courtesy of Shelburne Museum.

For study of this painting see 81.7.

CHICKENS 81.5

[Unknown] Panel: 7 × 10 [?]

[Unknown]

E.B. [1881] *Chickens on Panel 7 × 10 Painted for Mr. Wm. J. Arkell. Reception at N.A.D. "Artist Fund Voyage" Feb 21st.*

VIEW ON SOUTH POND 81.6

[Not signed or dated] Canvas: 14½ × 38

(E.E.) 1881. To Charles R. Flint, Esq. With regards of the artist. Study from nature by A. F. Tait, Y.M.C.A. 23rd St. N.Y. South Pond, Long Lake, Hamilton Co., N.Y. Oct. 1871. No. 39.

E.E. Study from Nature. South Pond 14 × 38 painted in 1871. finished in 1881 presented to Mr. Chas. R. Flint of N.Y.

This painting was originally entered by AFT in 1871 (71.30), and was a study for 72.16.

CAPTAIN PARKER STILL HUNTING 81.7

[Unknown] Panel: 12 × 16 [?]

[Unknown]

E.R. Study for Cap'n Parker Still Hunting No. E.M. [81.4] size Panel 12 × 16 sent to Morston Ream on Sale $200.00. thru Mr. Bird 1881 Dec'r sent to Boston to Mr. [or Wm.] Hatfield at [blank].

See 81.4.

A HARD CASE 81.8

A. F. Tait, N.Y. 1881 [LL] Canvas: 13¼ × 17¼

"A Hard Case" / A. F. Tait / 52 E. 23rd St. N.Y. / E.L. 1881.

E.L. [1881] 15 × 17 "A Hard Case", Hen in coup. floating with a brood [of] Young Ducklings swimming round & a small Spaniel Dog on the Bank Painted for F M. Bird as pay for a loan of $500.00. for a year due June 1st 1881—finished in March delivered March 10th/81 no Frame.

DOE AND TWO FAWNS 81.9

A. F. Tait / 1881 [LL] Canvas: 16 × 12

E.A. / 1881 / A. F. Tait / N.Y.

E.A. Doe & two Fawns. 12 × 16. sold to Reichardt. Picture dealer for $75.00.—Paid.

DOG AND TWO RUFFED GROUSE 81.10

A. F. Tait / N.Y. 1881 [LR] Canvas: 12 × 16

E.N. 1881 / A. F. Tait / Y.M.C.A. 23rd St. / N.Y.

E.N. Dog & 2 Ruffed Grouse. 12 × 16 Painted for Reichardt—for $75.00. Paid.

Collection of The Adirondack Museum, Blue Mountain Lake, New York.

AN ANXIOUS MOMENT 81.11

[Unknown] Canvas: 24 × 36 [?]

[Unknown]

E.D. [1881] An Anxious Moment 24 × 36 View on South Pond. two men in a Canoe going to shoot two Deer in distance. Nett 300.00 sold to Williams & Everett Boston with Frame Paid for June.

For a possible study for this painting see 81.13.

ON THE ALERT 81.12

A. F. Tait 1881 [LL] Canvas: 19½ × 29½

E.Z.I. A. F. Tait, 1881 / "On The Alert" / Early Morning / Adirondacks.

E.Z.i. "Startled" 20 × 30 Buck in Fog. early morning. boat & two men very indistinct in background Shore also indistinct. [The following crossed out: *sent to Morston Ream on Sale thru*] *Mr. Bird ret'd sent to Schencks Sale Jan'y 14th 1882.*

Noted as sent to Schenck's with a $250.00 limit on January 14, 1882, and sold on January 24 (or 29) for $225.00. For a possible study for this painting see 81.14.

[THREE PAINTINGS FOR DR. PERKINS] 81.13–.15

[See remarks] [See remarks]

[See remarks]

R.C. South Pond. Study for larger Pictu[re] 14 × 22 [81.13]. Canoe & two men in Fog—14 × 22 [81.14] & Doe & two Fawns—12 × 16 [81.15]. sent to Dr. Perkins Albany, as payment for a loan of $500.00. paid March 17/81. this is now paid off in full these 3 Paintings sent off by Express May 21st 1881.

See individual listings 81.13 through 81.15 for each painting.

SOUTH POND 81.13

[Unknown] [Unknown]: 14 × 22 [?]

[Unknown]

R.C. [1] South Pond. a Study for larger Pict[ure] 14 × 22.

See 81.13–.15.

AN ANXIOUS MOMENT 81.14

A. F. Tait / N.Y. 1881 [LL] Canvas: 14 × 22

R.C. 2. / "An Anxious Moment" / A. F. Tait / N.Y. 1881

R.C. [2] Canoe & two men in Fog. 14 × 22.

See 81.13–.15.

DOE AND TWO FAWNS 81.15

[Unknown] [Unknown]: 12 × 16

[Unknown]

R.C. [3] *Doe & two Fawns. 12 × 16.*

See 81.13–.15.

FARM YARD 81.16

A. F. Tait, N.A. / Canvas: 14¼ × 22
N.Y. 1881 [LR]

[Relined; inscription, if any, lost]

R.U. [1881] *Farm Yard. Cattle Ducks &c 14 × 22 Painted for F. M. Bird as interest for extending my Note for $500.00. for 12 Months from June 28th/81 to June 28th 1882—finished & sent off to him June 6th/81.*

Courtesy of Mr. and Mrs. George Arden.

DOG AND GROUSE 81.17

[Unknown] [Unknown]: 10 × 14 [?]

[Unknown]

R.N. Dog & Grouse Wood Scene 10 × 14 Painted for Rich'd Meares—Hotel Royal 6th Av & 40th St. delivered by Louis Contoit June.

FARM YARD 81.18

A. F. Tait and James M. Hart Canvas: 16 × 23¾
1880—1881 [LR]

C. B. / Painted by A. F. Tait and / James M. Hart 1880—1881.

C.B. [1881] *Farm Yard. 16 × 24 Painted for F. P. Osborn as pay for the 2 Wardrobes I had from him last Winter finished & sent home June 1881 he paid for Frame delivered Jas. M Hart painted in distance.*

Back of painting covered with wooden panel.

RUFFED GROUSE 81.19

[Unknown] [Unknown]: 20 × 30 [?]

[Unknown]

C.E. Ruffed Grouse 20 × 30 Painted for Dr. A Russell Strachan to pay for Professional services—delivered by Russell June 18th.

HARD FARE 81.20

[Unknown] [Unknown]: 12 × 16 [?]

[Unknown]

C.R. Chickens. 2 ears of corn 12 × 16 "Hard Fare"—(in Frame & Box Wheeler) [Crossed out: *sent to Burlington Vt. to Morston Ream for sale thru* [?] *for Mr. Bird June 20th/81*] *Dec'r 1881 sent to Chicago with Piper Heidsieck* [see 77.1] *to Kedcan Art Gallery.*

Noted as returned to Chicago with 77.1 in 1882.

DUCKS AND DUCKLINGS SUNNING 81.21

[Unknown] [Unknown]: 10 × 14 [?]

[Unknown]

C.L. Ducks & Ducklings Sunning. 10 × 14 Painted for C H Maguire 176 Fifth Av as terms for a loan of $300.00, until Spring.

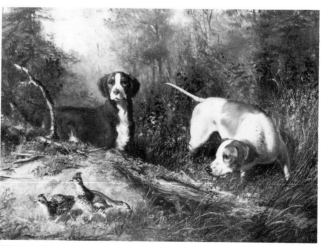

TWO DOGS AND GROUSE 81.22

A. F. Tait / N.Y. 1881 [LR] Panel: 10 × 14

"Ruffed Grouse" Shooting / A. F. Tait / N.Y. 1881

C.A. Two Dogs & Grouse 10 × 15. For Mr. Crane, Sidman's friend, for $50.00.

Courtesy of Mr. and Mrs. George Leiter Doolittle.

DOG'S HEAD 81.23

[Unknown] [Unknown]: 10 × 16 [?]

[Unknown]

C.N. Dogs head (Finished Sketch) 10 × 16 for P. Brett. $25.00.

VIEW ON LONG LAKE
OVEN POINT STREAM 81.24

[Unknown] Canvas: 20 × 30[?]

C.D. / View on Long Lake / Hamilton Co. / N.Y. / "Oven Point Stream" / Painted from Nature Oct'r 1881 / A. F. Tait, N.A.

C.D. [1881] View on Long Lake (Oven Point Stream) 20 × 30 Painted from Nature Sept'r for Hy Wilson—del'd Dec'r 24th given to him as pay for advances in this year. Wheelers Frame paid for by Hy Wilson. Extra and I paid Wheeler $45.00. Dec'r 23rd.

A LONG SHOT 81.25

[Unknown] [Unknown]: 20 × 26 [?]

[Unknown]

U.Z. View on Long Lake (Rocks opposite Palmers). October 28th 1881. Painted from Nature. 20 × 26 [The preceding, except code and size, is lightly crossed out in pencil; the following added in pencil:] *Called a "Long Shot" canoe & 2 Men & Deer sold to Hy Wilson with Frame & 2 others* [82.4 and 82.5. Crossed out: *N.A.D. Gall Ex. Oct'r 1882*] *ret'd Nov'r home.*

The three paintings sold to Wilson (81.25, 82.4, and 82.5) brought $600.00 for the lot in March 1882. Exhibited at the National Academy of Design, special Autumn Exhibition, 1882, titled "A Long Shot, Long Lake, Adirondacks," priced at $350.00.

THE HOME OF THE DEER 81.26

[Unknown] [Unknown]: 20 × 30 [?]

[Unknown]

U.C. View on Long Lake. opposite Palmers painted from Nature August 1881—20 × 30 looking across the Lake finished in the Studio in N.Y. Artist Fund. Jan 4th/81 [the preceding lightly crossed out in pencil]. *Called The Home of The Deer & sold for $275.00. Frame Extra.*

Exhibited and sold at the Artists' Fund Society sale January 16–17, 1882, titled "The Home of The Deer, Adirondacks, N.Y."

GOOD HUNTING GROUND 81.27

A. F. Tait, N.A. / N.Y. 1881 [LR] Canvas: 20 × 26

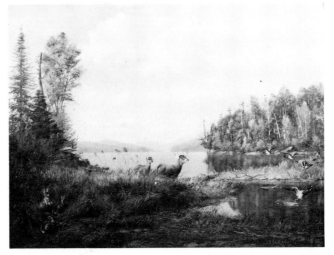

"Good Hunting Ground" / A Study from nature / Long Lake / Hamilton Co. / N.Y. / A. F. Tait / N.Y. / U.M. / Adirondacks / 1882.

U.M. View on Long Lake painted from Nature. Oven Point Stream 22 × 26 [corrected from *20 × 30*] *called "Good Hunting Ground" sent to Williams & Everett Boston Jan'y 24th/82 ret'd & sent to N.A.D. Exhibition price $400.00. March 9th/82 Oct'r 6th sent to Schencks as security for loan on note at 90 days for $300.00. to pay Maguire's note due on the 7th (tomorrow) Oct'r 7.*

Exhibited at the National Academy of Design 57th Annual Exhibition, 1882, titled "Good Hunting Ground, Adirondacks, Hamilton County, N.Y.," priced at $400.00.

Collection of The Adirondack Museum, Blue Mountain Lake, New York. Courtesy of The Adirondack Museum.

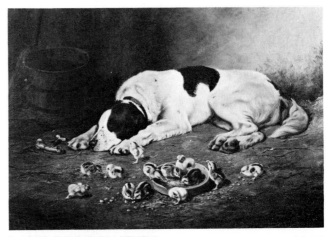

LAZY GOOD NATURE 81.28

A. F. Tait / N.Y. 1881 [LL] Canvas: 15½ × 21

C.Z.M. / "Lazy Good Nature" / A. F. Tait / N.Y. 1881

C.Z.M. "Lazy Good Nature["] 14 × 22 Setter Dog lying down & chickens—this was painted in 1881, but not registered

& sent to N.A.D. Ex I never numbered it [or I now number it]. painted for Mrs. Rob't Rogers 64 E. 61st St. and I had it to Exhibit at the reception in this Y.M.C.A. Building on March 1st 1883. Painted & sold in 1881.

Courtesy of The Old Print Shop, Inc., New York, New York.

[BUCK] 81.29

A. F. Tait / N.Y. 81 [LL] Canvas: 16¼ × 12¼

[Nothing on back]

[No AFT code; no Register entry]

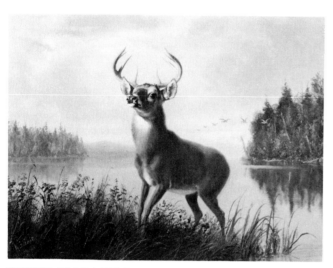

[BUCK ON LAKE SHORE] 81.30

A. F. Tait / N.Y. 1881 [LL] Canvas: 12 × 16

[Nothing on back]

[No AFT code; no Register entry]

In pencil on the back of the stretcher the words *Racquette Lake* appear.

Courtesy of Sotheby Parke Bernet, Agent: Editorial Photocolor Archives, New York, New York.

[EIGHT CHICKS AND BUG] 81.31

A. F. Tait, N.A. / [Unknown]: 10½ × 14¼
N.Y. '81 [LR]

[Nothing on back]

[No AFT number; no Register entry]

GOOD HUNTING GROUND: 82.1
THE HOME OF THE DEER

A. F. Tait, N.A. / Canvas: 19¾ × 30¼
N.Y. 1882 [LL]

Good Hunting Ground / The Home of the Deer / Painted from Nature by / A. F. Tait, N.A. / 1881 / Long Lake / Hamilton Co / N.Y.

U.U. View of [or on] Long Lake Hamilton Co N.Y. Painted

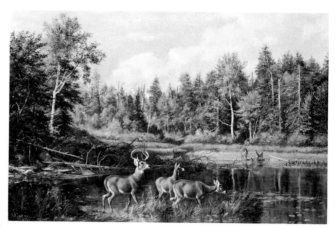

from Nature. August opposite Palmers (up the lake) looking into the Bay 20 × 30 Utica—Jan'y 16th 1882 price $400. including Frame nett $350 N.A.D. Ex. Oct'r 1882 Sold at Schencks sale April 2 & 3/83 for $190.00.

Exhibited at the National Academy of Design Special Autumn Exhibition, 1882, titled "Early Summer, Home of The Deer, Adirondacks."

Courtesy of Newhouse Galleries, Inc., New York, New York.

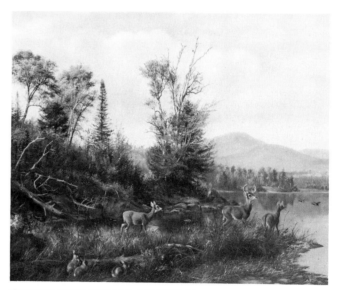

GOOD HUNTING GROUND 82.2

A. F. Tait, N.A. / 1882 / N.Y. Canvas: 22 × 26
[LL on log]

U.B. / Good Hunting Ground / Painted from Nature / View on Long Lake / Hamilton Co. / N.Y. / A. F. Tait / New York.

U.B. View on Long Lake. Painted from Nature. 22 × 26 [changed from 20 × 30] Oven Pond [should be Point] Stream looking north across the Lake to big Marsh. with Deer. [Following partially erased: sent to Utica Ex.]

This painting has been restored and relined and the back inscription preserved by the restorer.

AN ALARM 82.3

[Unknown] [Unknown]: 24 × 36 [?]

[Unknown]

U.E. [1882] "An Alarm" size 24 × 36 Adirondacks Sep'r Joint Tait & Sonntag. Artist Fund Sale Jan'y 16th [changed from 4] 1882 sold for $375.00. Frame extra. $50.00.

VIEW ON LONG LAKE 82.4

[Unknown] [Unknown]: 20 × 30 [?]

[Unknown]

U.R. View on Long Lake Painted from Nature 1881. 20 × 30 near Round Island. sand Beach looking West sold to Hy Wilson March 11th/82. [A comment about sale or exhibit, ending *Oct'r 1882*, is crossed out.]

Sold by AFT together with 81.25 and 82.5 for $600.00 for all three.

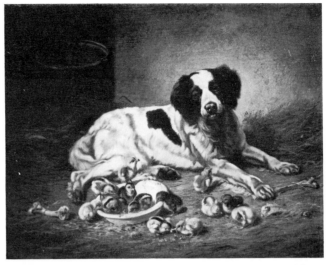

Dine" Canvass 12 × 16 Dog (Setter) laying down, with 13 chickens round Eating &c. sent off to Springfield To Gill's Art Gallery ret'd in March 1882 sold at Schencks in April for $130.00.

Courtesy of Mr. and Mrs. George Arden.

CHICKENS 82.7

[Unknown] Board: 8 × 10 [?]

[Unknown]

A.N. Chickens 8 × 10 millboard 8 × 10 Tiffany & Co to pay for Emerald Ring. to settle in full to date Satisfactory very.

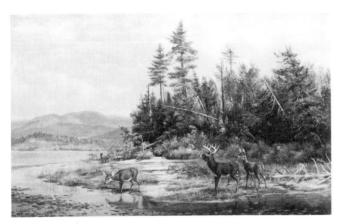

VIEW ON LONG LAKE 82.5

A. F. Tait N.A. / 1881—2 [LL] Canvas: 20½ × 30½

U.L. / Long Lake / Hamilton Co / N.Y. / Adirondacks / Near Round Island looking East / Painted from nature / A. F. Tait, N.A. / Sept 1881.

U.L. View on Long Lake 20 × 30 Painted from Nature 1881 near Round Island. looking East sand Beach. [Except for the code and size, the preceding is lightly penciled through.] *sold to Hy Wilson with No. U.R. [82.4] & U Z. [81.25] or 3 in all in Frames for $600.00. the three March 11th/82 del'd by Raoul March 13th in Frame N.A.D fall Ex & retu[r]ned Nov'r/82.*

Exhibited at the National Academy of Design Special Fall Exhibition, 1882, titled "My Old Hunting Ground, Adirondacks, N.Y."

SATISFIED GOOD NATURE: 82.6
NOW ALL THE WORLD MAY DINE

A. F. Tait. N. A. / 1882 [LR] Canvas: 12 × 16

[Relined; inscription, if any, lost]

U.A. 1882 "Satisfied Good Nature." "Now all the world may

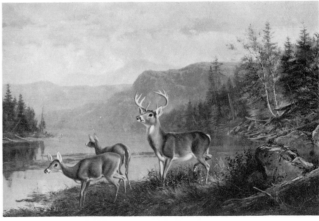

ADIRONDACKS: OCTOBER 82.8

A. F. Tait, N.A. / Canvas: 25¾ × 41
N.Y. 1882 [LR]

[Nothing on back]

A.d. ["]Adirondacks October." distance by Sonntag. the middle from Study from Nature. Long Lake for H. Fairbanks, St. Johnsbury Vt. sent in Exchange for a Painting returned several years ago [77.5] sent off March 29 1882.

Courtesy of Mr. William D. Harmsen.

CHICKENS 82.9

[Unknown] Board: 10 × 12 [?]

[Unknown]

N.Z. [corrected from A.Z.] Chickens. Millboard 10 × 12 for Montreal Art Ass'n to be $100.00. sent off May 15th 1882 received check May 29th $100.00.

TWO WOODCOCK 82.10

[Unknown] Panel: 8 × 12 [?]

[Unknown]

N.C. 2 Woodcock 8 × 12 Painted on a Wood Panel Brett left for P. Brett—to be $25.00.

DOG AND WOODCOCK 82.11

[Unknown] [Unknown]: 20 × 32 [?]

[Unknown]

N.U. Dog (Daisy) & Woodcock 20 × 32 Painted for Dr. Strachan in exchange for Proff. Services.

TWO DOGS AND WOODCOCK 82.12

[Unknown] [Unknown]: [Unknown]

[Unknown]

N.M. 1882 two Dogs & Woodcock for Jas. M. Burt in exchange for Shoes &c May.

SMALL CHICKENS 82.13

[Unknown] [Unknown]: 8 × 10 [?]

[Unknown]

N.B. Small Chickens 8 × 10 painted for a Mr. Gardner at Tiffany's to be $25.00. finished May 29th.

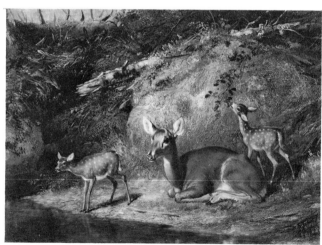

[FAMILY OF DEER] 82.14

A. F. Tait, N.A. / N.Y. '82 [LR] Board: 10 × 14

[Nothing on back]

N.E. Doe & 2 Fawns 12 × 16 sold to Reichard for $100.00.

Collection of The Metropolitan Museum of Art, New York, New York, gift of Mrs. Darwin Morse, 1963. Courtesy of The Metropolitan Museum of Art.

[SETTER RETRIEVING A QUAIL] 82.15

A. F. Tait, N.A. / N.Y. '82 [LL] Panel: 8¼ × 12½

N.R. Setter "Retrieving" / A. F. Tait, N.A., N.Y. 1882

N.R. 1882 Setter & Quail (Retrieving[)] on Panel—12 × 8 Peter Brett—paid $25.00 delivered July 12/82.

DOG AND MALLARD DUCK 82.16

[Unknown] [Unknown]: 8 × 16 [?]

[Unknown]

N.L. Dog & Duck (Mallard) 8 × 16 Peter Brett paid $25.00 July 19th.

DUCKS SUNNING 82.17

[Unknown] [Unknown]: 6½ × 10½ [?]

[Unknown]

N.A. Ducks Sunning 6½ × 10½ Peter Brett Paid $25.00. July 19.

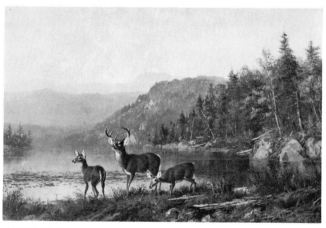

ADIRONDACKS, N.Y.: OCTOBER 82.18

A. F. Tait & W. L. Sonntag / Canvas: 24 × 36
N.Y. 1882 [LR]

N.N. A. F. Tait, N.A. / and W. L. Sonntag, N.A. / N.Y. 1882 / "Adirondacks, N.Y." / 'October'.

N.N. Lake Scene with Buck & 2 Does Joint Tait & Sonntag 24 × 36 finished July 27th. Painted for J. H. Johnston Jeweller Bowery & Broon Sts. to pay for the Diamond Engagement Ring I gave to my little wife. I lent him a Frame until he gets his made.

Canvas has been relined twice and the inscription copied onto the new canvas. A detail of this painting showing only the buck and one doe was reproduced in 1893 by Montague Marx, titled "In The Adirondacks."

Courtesy of Mr. Bronson Trevor.

AN ANXIOUS MOMENT 82.19

A. F. Tait, N.A. / 1882 [LR] Canvas: 13½ × 21½

N.D. / "An Anxious Moment" / Early Morning / Rac-quette Lake / Adirondacks / N.Y. / A. F. Tait / N.Y. / 1882.

N.D. Canoe & two men Deer Hunting on the Lake Foggy Morning 14 × 22 Painted for F M Bird to pay for Interest on my Note renewed for a year from July 26th 1882 to July 27th 1883. sent to Canton Mass August 12th [In pencil:] *not Satifactory.*

MATERNAL SOLICITUDE 82.20

[Unknown] [Unknown]: 14 × 22 [?]

[Unknown]

D.Z. "Maternal Solicitude" large St. Bernard Dog lying in Kennel with a King Charles Spaniel crouching near him & Hen & Chickens in front. 14 × 22 N.A.D. fall Ex. sent there Octr 7th. my own Frame (Wheelers make paid for) Price $400.00. returned sent to Bkly Art Ex Nov'r/82 Sold for $150.00 to [crossed out].

Exhibited at the National Academy of Design Special Fall Exhibition, 1882, titled "Maternal Solicitude," priced at $400.00.

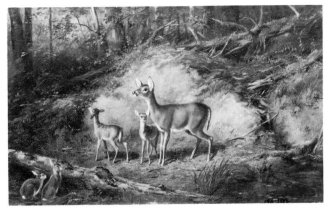

TIMIDITY: THE FOREST 82.21

A. F. Tait, N.A. / N.Y. 1882 [LR] Canvas: 14 × 22

[Unknown]

D.C. "Timidity." "The Forest." 14 × 22 Doe & 2 Fawns in the Forest with two Rabbits in Foreground. my Frame (Wheelers paid for) [Crossed out: N.A.D. Fall Ex] *price $250.00 Returned, Nov'r 20th/82* [Crossed out: *Exh. by Ream, Newark returned Sent to Phila. Artists Society Ex. Dec'r 18th/82 by Wilmurt*] *Ret'd Feb'y.*

Exhibited at the National Academy of Design Special Fall Exhibition, 1882, titled "Timidity—The Forest, Adirondacks," priced at $250.00.

Courtesy of Kennedy Galleries, Inc., New York, New York.

THE JACK IN OFFICE 82.22

[Unknown] [Unknown]: 14 × 24 [?]

[Unknown]

D.U. "The Jack in Office." 14 × 24 in Shed & Scotch Shep-pard Dog sitting on Sacks of oats at Door of Barn with a lot of Sheep round him N.A.D. fall Ex Sillicks [sic] Frame price $400.00. Sold to Pratt Bkly'n for $350.00. Com. 35.00 nett $315 net 315 Commission off 10 per ct Paid by cheque 2nd Nat Bank Nov'r 23rd/82.

Apparently sold with 82.23. Exhibited at the National Academy of Design Special Fall Exhibition, 1882, titled "The Jack In Office," priced at $400.00.

NOVEMBER: A DEER YARD IN THE ADIRONDACKS 82.23

[Unknown] [Unknown]: 22 × 26 [?]

[Unknown]

D.M. [Winter crossed out] *"November." Deer yard in the Adirondacks. / Buck & 2 Does browsing Buck startled. (my Frame[)] (Wheelers make Paid for) 22 × 26 N.A.D. fall Ex Oct'r 1882. price* [blank] *Sold to Pratt. Bkly'n for $250.00. Commission 10 pr c off $250.00* [minus] *25* [equals] *$225 nett paid by cheque 2nd Nat Bk Nov 23rd/82.*

Apparently sold with 82.22 Exhibited at the National Academy of Design Special Fall Exhibition, 1882, titled "November. A Deer Yard In The Adirondacks," priced at $350.00.

RETRIEVER AND MALLARD 82.24

A. F. Tait / N.Y. 1882 [LL] Panel: 10 × 20

A. F. Tait, N.A. / "Retrieved"—Spaniel & Mallard / N.Y. 1882.

D.B. Spaniel with Mallard Duck in his mouth coming out of water 12 × 16 painted for Miss Smith. Mr. Woodgards rela-tive to be $50.00. Paid Nov'r 1st/82.

Note the discrepancy in sizes as recorded by AFT and as reported by owner.

THE BROOK 82.25

[Unknown] [Unknown]: 10 × 14 [?]

[Unknown]

D.E. Ducks by Brook 10 × 14 sold in Fall Ex N.A. Design for $125.00 comm off. my Frame Paid Nov'r 23rd by cheque 2nd Nat Bank $125.00 comm off $12.50. $112.50 nett.

Exhibited at the National Academy of Design Special Fall Exhibition, 1882, titled "The Brook," priced at $125.00.

THE INTRUDERS 82.26

A. F. Tait / N.Y. 82 [LR] Canvas: 12¼ × 16¼

[Unknown]

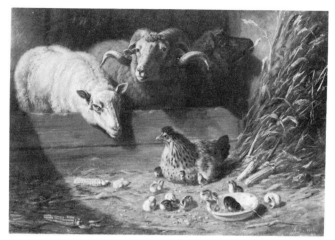

D.R. The Intruders. 12 × 16 3 Sheep and Hen & Chickens Sold at Bklyn Ex. for $250.00. Sillecks Frame.

Courtesy of Mr. and Mrs. George Arden.

D.A. "Peace" "Spring time." / A. F. Tait. / N.Y. 1882.

D.A. "Springtime" (Peace). 12 × 16 3 Sheep lying down one in background up in Shed and a lot of young chickens sent to Phila Artists Ex. Phila Dec'r 1882 Sillecks Frame. ret'd & sent to Springfield to Gill's Ex Jan'y 29th/83 Sold for $150.00. & chq rec'd March 27th/83.

This painting, formerly at the Springfield Museum of Art, Springfield, Massachusetts, is now at the Springfield Home for Aged Men, Springfield, Massachusetts.

CHICKENS 82.29

[Unknown] [Unknown]: 10 × 14 [?]

[Unknown]

D.A.½ Chickens 10 × 14 Mrs. Raymond No. 20 Fifth Av. Del'd Nov'r Paid $150.00. Frame to be extra I lent them a Frame of Sillecks until theirs is finished ordered from Silleck.

CHICKENS AND A STRAWBERRY 82.30

A. F. Tait, N.Y. '82 [LR] Board: 6 × 8

[Nothing on back]

[No AFT code; no Register entry]

AT HOME 83.1

James M. Hart—A.F. Tait Canvas: 24 × 40
N.A. / 1883 [LR]

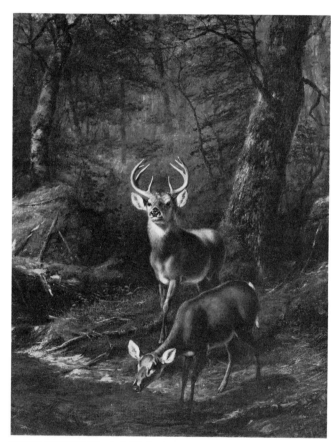

THE FOREST: ADIRONDACKS 82.27

A. F. Tait / N.Y. '82 [LR] Canvas: 16¼ × 12¼

[Nothing on back]

D.L. [1882] The Forest—Adirondacks 12 × 16 2 Deer in Forest Sold in Bklyn Ex. Nov'r/82 for 150.00 Sillecks Frame.

PEACE: SPRINGTIME 82.28

A. F. Tait / N.Y. '82 [LR] Canvas: 12¼ × 16½

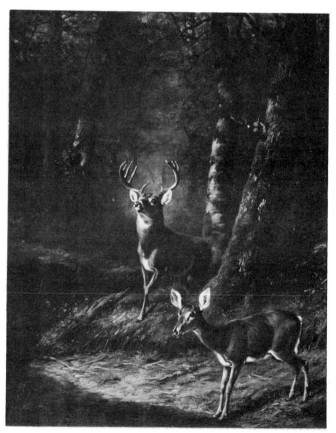

83.2

"At Home", / U.L. Sketch from Nature / Long Lake, Hamilton Co., N.Y. / James M. Hart / A. F. Tait, N.A. 1883

[U.L.; for this Register entry see 79.28].

This painting was apparently originally done in 1879 (79.28), sold, subsequently returned to Tait, reworked in collaboration with James M. Hart, jointly signed and dated 1883.

THE FOREST: ADIRONDACKS 83.2

A. F. Tait N.A. / N.Y. '83 Canvas: 20 × 26

[Relined; inscription, if any, lost]

D.N. [1883] "The Forest" Adirondacks. 9 day's 20 × 26 Buck & Doe in Forest. with a grey Squirrel on Tree Trunk. from Nelson Study Artist Fund Jan'y 24th 1883 Sillecks Frame. [In margin:] J. W. Silleck Frame.

Courtesy of Mr. and Mrs. George Arden.

IN A TIGHT PLACE 83.3

[Unknown] [Unknown]: 20 × 26 [?]

[Unknown]

Z.D. In a tight [Fix crossed out] place 6 days 20 × 26 Jock

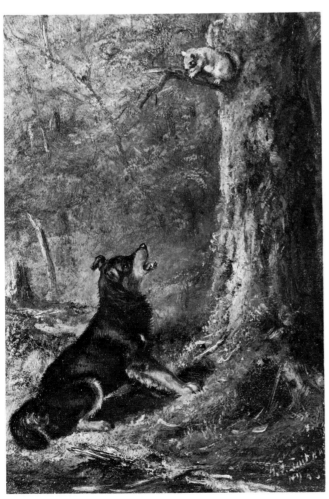

83.4

& Sheep. the latter stuck by the Horns in a Fence. Dog barking Artist Fund Jan'y 24th 1883 Sillecks Frame [In margin:] John Sillecks Frame.

TREE'D: IMPUDENCE 83.4

A. F. Tait N.A. / N.Y. '83 Panel: 8 × 5¼

[Unknown]

C.Z.Z. "Treed." Impudence Jock & grey Squirrel. the last up a Tree sent to Jas. D. Gill Springfield Ex. Feb'y 1st/83 (Wheelers Frame) my own. Returned April and sold to a friend of Mr. Frazer's for $75.00.

Courtesy of Kennedy Galleries, Inc., New York, New York.

GOOD DOG 83.5

[Unknown] [Unknown]: 12 × 16 [?]

[Unknown]

C.Z.C. ["]Good Dog." Dog with Drake in his mouth coming out of Water 12 × 16. sent to Jas. D Gill Springfield Feb'y 1st/83 to his Ex. Sillicks [sic] Frame.

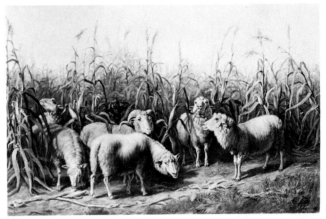

THE TRESPASSERS 83.6

A. F. Tait, N.A. / N.Y. 1883 [LR] Canvas: 24 × 36

"The Trespassers" / A. F. Tait, N.A. / N.Y. 1883 C.Z.U.

C.Z.U. "The Trespassers" 24 × 36 6 Sheep in a Corn Field Wheelers Frame (my own). sent to N.A.D. March 7th 1883. ret'd and sold at Schencks Sale June 13th 1883 for $210.00.

Exhibited at the National Academy of Design 58th Annual Exhibition, 1883, titled "The Trespassers," priced at $500.00.

A SLIGHT CHANCE 83.7

A. F. Tait, N.A. / N.Y. 83 [LL] Canvas: 20 × 30

[Relined; inscription, if any, lost]

C.Z.b. 1883 "A Slight Chance" 20 × 30 2 Men in Canoe. Deer in distance Lake View. big Rock in Foreground Sold at

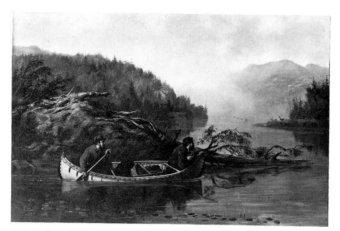

Schencks sale for $170.00 Apr 3 & 4th.

Courtesy of Vose Galleries, Boston, Massachusetts.

THE DUCKLINGS' BATH 83.8

A. F. Tait, N.A. / N.Y. '83 [LR] Panel: 10 × 14

C.Z.E. "The Ducklings Bath" / A. F. Tait / N.Y. 1883

C.Z.e. "The Ducklings Bath" 10 × 14 sold to Mr. Pulsford Frazers Brother in Law with some Chickens for $50.00.

LITTLE PETS 83.9

[Unknown] [Unknown]: 9 × 12 [?]

[Unknown]

C.Z.r. "Little Pets" 9 × 12 sold to Frank Osborn for 77.50 at Schencks Sale Ap'l 3 & 4th.

See 83.47.

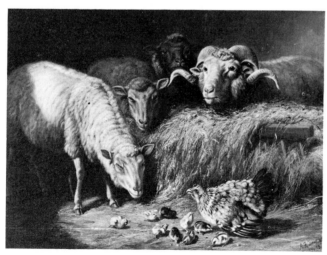

MATERNAL SOLICITUDE 83.10

A. F. Tait, N.A. / Canvas: 12¼ × 16¼
N.Y. '83 [LR]

[Relined; inscription, if any, lost]

C.Z.l. 1883 "Maternal Solicitude" 12 × 16 Sheep in a shed.

Hen & chickens highly finished Ordered by a Mr. Hentz— Jun'r.

Collection of the North Carolina Museum of Art, Raleigh, North Carolina. Courtesy of the North Carolina Museum of Art.

[UNKNOWN] 83.11

[Unknown] [Unknown]: 40 × 50 [?]

[Unknown]

C.Z.a. 1 Joint Picture Sonntag & Tait large 40 × 50 sold at Schencks Sale April 3 & 4th sold for $425.00 and 1 joint Sonntag & Tait 20 × 30 [83.12] sold for $152.50.

SUMMER MORNING—NEW HAMPSHIRE 83.12

W. L. Sonntag / A. F. Tait Canvas: 20 × 30 [?]

[Unknown]

[C.Z.a.; see also 83.11] 1 Joint Sonntag & Tait 20 × 30 sold [at Schencks sale April 3 & 4th.] for $152.50.

SOLITUDE: ADIRONDACKS 83.13

A. F. Tait, N.A. / N.Y. '83 [LR] Canvas: 20 × 30

[Relined with new stretcher; inscription, if any, lost]

C.Z.n. [""]Solitude" Adirondacks 20 × 30 Sonntag background my Foreground Snedecors Frame price $25.00. Schencks Sale May 1 & 2nd paid him.

This painting has been titled by others "Solitude: Eagle Bay, N.Y.," a title that may have been on the inscription, which is now lost due to relining.

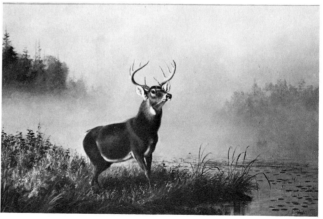

THE ALARM 83.14

A. F. Tait, N.A. / N.Y. 83 [LR] Canvas: 20 × 30

"The Alarm" / Adirondacks / A. F. Tait / N.Y. 1883
C.Z.D.

C.Z.d. "The Alarm" 20 × 30 Snedecor Frame $25.00 Schencks sale May 1–2 paid for.

Courtesy of Kennedy Galleries, Inc., New York, New York.

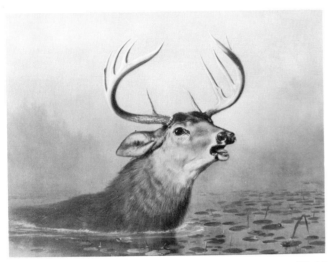

ESCAPED 83.15

A. F. Tait, N.A. / N.Y. 1883 [LR] Canvas: 18 × 22

Study from nature / and finished 1883 / N.Y. C.Z.Z. /
A. F. Tait / Long Lake / Hamilton Co. / N.Y.

C.Z.Z. "Escaped." 17½ × 21. Snedecors Frame paid for do.
[Schencks sale May 1 & 2].

A label on the stretcher reads: "'The Escape' / Price of
frame $25.00. / Made by Snedecor / 900 B'way / Pre-
sented by A. F. Tait, N.A. / Y.M.C.A. / 52 E. 23rd St. /
N.Y."

HARD HIT 83.16

A. F. Tait, N.A. / N.Y. 1883 [LR] Canvas: 20 × 30

No. U.Z.Z. / Pointer & Ruffed Grouse / A. F. Tait / 52
East 23rd St. N.Y. / Adirondacks.

U.Z.Z. 1883 Hard hit. Pointer & wounded [and added in
pencil] *Partridge 20 × 30. 20 × 30 [repeated] I also sent to*
this Sale my Pic of "Trespassers" 24 × 36 that was in the Ex. of
the NAD [83.6] May 26th Snedecors Frame $25.00. new. Not
sold Schencks Sale June 4th & 5 I sold this Pic to Mr. Hy [?]
Hentz for $212.00.

BUCK AND DOE: LAKE 83.17

[Unknown] [Unknown]: 30 × 20 [?]

[Unknown]

U.Z.u. Buck and Doe. Lake upright 20 × 30 rec'd. May 26
Snedecors Frame $25.00. new not sold Schencks sale June 4th &
5th. June 9th left at Schenck as security for the loan of $325.00.
note due Aug 1st Sold for $210.00. Jan'y 9th 1884 paid
Snedecor Jan'y 21st/84 for frame $25.00.

HARD HIT 83.18

A. F. Tait, N.A. / N.Y. Canvas: 10 × 14¼
1883 [LR]

"Hard Hit" / A. F. Tait, N.A.

U.Z.M. Wounded Grouse & Pointer's Head 12 × 16 my

Frame not sold Schencks Sale June 5 & 6 sent down by
L. Contoit [?] June 2. I sold this to Mr. Frazer for $40.00 del'd
June 16 to his Sister.

The back inscription was obtained prior to relining and
restoring. Note discrepancy in AFT's sizes and those
given by owner.

Courtesy of Mrs. Henry F. Marsh.

RUFFED GROUSE 83.19

A. F. Tait, N.A. / N.Y. '83 [LR] Canvas: 14 × 24

[Unknown]

U.Z.b. ["]A Group of Ruffed Grouse" 14 × 24. Schencks Sale
not sold sent down by L. C. June 2 [Following crossed out:
sold to Mr. Frazer's Brother Will for $40.00; following re-
tained:] left with Schenck June 9th.

Courtesy of Mr. George A. Butler.

AT HOME: IN THE FOREST 83.20

A. F. Tait, N.A. / 1883 [LR] Canvas: 20 × 16

"At Home" / Slim Pond / Hamilton Co. / N.Y. / U.Z.E.
/ A. F. Tait / 1883 / Adirondacks, N.Y.

u.z.e. [1883] "At Home" in the Forest. 16 × 20 Buck & Doe.
$200. Painted for Dr. Corcoran, Springfield Mass sent off June
12th paid for all lovely.

Collection of the Springfield Science Museum,
Springfield, Massachusetts.

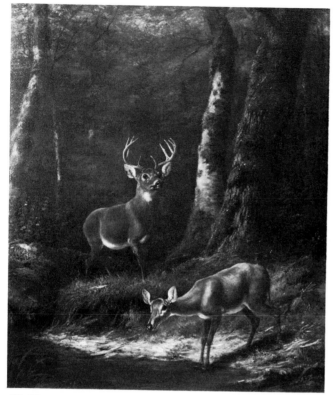

83.20

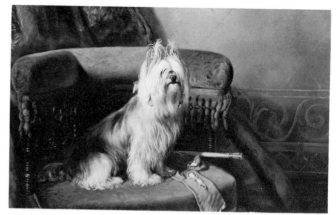

[?] *W H. 22 W 33rd St. to be $300.00 Paid for they were pleased with it.*

DOG AND THREE QUAIL 83.23

A. F. Tait, N.A. / N.Y. 1883 [?] Canvas: 14 × 22

[Unknown]

u.z.a. Dog and 3 Quail 14 × 22 I gave this as a bonus to FM Bird Canton & took it down there for a loan of $500.00 June 28th/83.

A FOX TERRIER 83.24

[Unknown]

[Unknown] [Unknown]: 16 × 24 [?]

[Unknown]

U.Z.N. Dog. Fox Terrier. 16 × 24 Painted for a Mr. Auchincloss sent it home unfinished June 29th. until the Fall when I will finish it finished it Oct'r when I returned from England & del' Oc'r 30th 83.

[MOTHERLY WORRIES] 83.25

[Unknown] [Unknown]: [Unknown]

[Unknown]

u.z.d. 1883 Hen in Coop. & Chickens on a Plate little Kitten in background. this I gave to Chas. H Maguire in exchange for Clothes June 29th worth $150 00 and settled his a/c in full to date.

See 83.47.

[TWO SMALL PICTURES FOR 83.26–.27
P. BRETT]

[See remarks] [See remarks]

[See remarks]

U.c.Z. Two small Pictures of Quail and Ducks. for P. Brett. to be $25 each 8 × 10.

See individual listings, 83.26 and 83.27.

DUCKS 83.26

[Unknown]

[Unknown]: 8 × 10 [?]

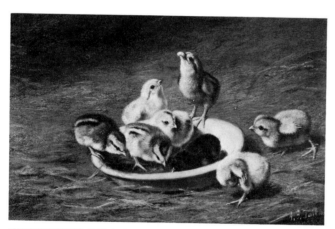

CHICKENS IN A DISH 83.21

A. F. Tait, N.A. / 1883 [LR] Canvas: 8½ × 12½

[Nothing on back]

u.z.r. ["]Chickens in a Dish" 8½ × 12½ Mr. Pulsford. to be $50.00 Paid and Snedecors Frame & I paid Snedecor.

Courtesy: Anonymous.

WHO SAID MOUSE 83.22

A. F. Tait / N.Y. 1883 [LR] Canvas: 16 × 24

[Unknown]

u.z.l. "Who said Mouse" Portrait of Minnie a Yorkshire Terrier on Crimson Velvet Chair 16 × 24 Painted for Mr. Taylor

[Unknown]

[*u c Z.*; see 83.26–.27].

One of a pair with 83.27.

QUAIL 83.27

[Unknown] [Unknown]: 8 × 10 [?]

[Unknown]

[*u c Z.*; see 83.26–.27].

One of a pair with 83.26.

CHICKENS 83.28

[Unknown] [Unknown]: 10 × 12 [?]

[Unknown]

U.U.l. [letter *L* or *c*(?)] *Chickens 10 × 12 fin Nov'r 16th for Mr. Hentz Jun'r to be $100.00 without Frame Frame by Snedecor.*

See 83.47.

CHICKENS 83.29

A. F. Tait, N.A. / N.Y. '83 [LR] Canvas: 10 × 12

A. F. Tait, N.A. / 1883

U.U.U. Chickens 10 × 12 10 × 12 [repeated] *sold at Bkly'n Ex for $100.00 nett $90.00.*

For another painting entered in the Register as *U.U.U.*, see 83.41. See also 83.47.

[PORTRAIT OF "SNIP"] 83.30

[Unknown] [Unknown]: 14 × 17 [?]

[Unknown]

[No AFT code] *Portrait of Fox Terrier (Snip) 14 × 17 Mr. Daubman* [?] *Paid $100.0* [*sic*] *October.*

[NINE SMALL PAINTINGS 83.31–.39
FOR PETER BRETT]

[See remarks] [See remarks]

[See remarks]

[No AFT code] [*1883*] *9 small Paintings various sizes done for Peter Brett and paid for Dec'r 7th $90.00 leaving balance of $240.00.*

See individual entries 83.31 through 83.39.

[DOE AND FAWN] 83.31

A. F. Tait / N.Y. 83 [LR] Panel: 5½ × 8

[Nothing on back]

[No AFT code; see 83.31–.39].

[THREE GROUSE] 83.32

A. F. Tait / N.Y. 83 [LL] Board: 7½ × 9

[Nothing on back]

[No AFT code; see 83.31–.39].

[PAINTING FOR PETER BRETT] 83.33

[Unknown] [Unknown]: [Unknown]

[Unknown]

[No AFT code; see 83.31–.39].

See 83.47.

[PAINTING FOR PETER BRETT] 83.34

[Unknown] [Unknown]: [Unknown]

[Unknown]

[No AFT code; see 83.31–.39].

See 83.47.

[PAINTING FOR PETER BRETT] 83.35

[Unknown] [Unknown]: [Unknown]

[Unknown]

[No AFT code; see 83.31–.39].

See 83.47.

[PAINTING FOR PETER BRETT] 83.36

[Unknown] [Unknown]: [Unknown]

[Unknown]

[No AFT code; see 83.31–.39].

See 83.47.

[PAINTING FOR PETER BRETT] 83.37

[Unknown] [Unknown]: [Unknown]

[Unknown]

[No AFT code; see 83.31–.39].

See 83.47.

[PAINTING FOR PETER BRETT] 83.38

[Unknown] [Unknown]: [Unknown]

[Unknown]

[No AFT code; see 83.31–.39].

See 83.47.

[PAINTING FOR PETER BRETT] 83.39

[Unknown] [Unknown]: [Unknown]

[Unknown]

[No AFT code; see 83.31–.39].

See 83.47.

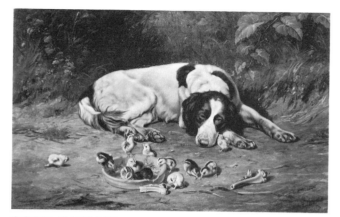

GOOD DOGGIE 83.40

A. F. Tait, N.A. / N.Y. Canvas: 16 × 24
1883 [LR]

"Good Doggie" / A. F. Tait / Y.M.C.A. / 23rd St. N.Y. /
U.U.C. Dec / 1883.

U.U.C. [changed from *U.U.N.*] *Dog and Chickens. "Lazy
Good Nature" L. Prang of Boston 16 × 24 finished Dec'r 22nd.*

Courtesy of Schweitzer Gallery, Inc., New York, New
York.

TWO SETTERS AND QUAIL 83.41

A. F. Tait, N.A. / N.Y. [Unknown]: 12 × 16
83 [LR]

[Relined; inscription, if any, lost]

u.u.U. [changed from *u u.D(?)*] *2 Setters and Quail 12 × 16
Mr. Hy Hentz (Sen'r)*] *for X'mas. to be $100.00 Frame extra.*

For another painting entered in the Register as *U.U.U.*,
see 83.29.

STEADY 83.42

A. F. Tait, N.A., N.Y. [Unknown]: 13¾ × 21½
1833 [LR]

UUB / 1883 / Steady / A. F. Tait, N.A., 52 East 23rd
Street, N.Y.

U.U.B. Steady 1 [changed from *2*] *Pointer & Setter, &
Quail. 14 × 22* [Following crossed out: *Artist Fund Jan'y
3rd*] *84 not sold there. Sold to Gill Springfield. del'd Jan'y for
$100 without Frame.*

[CHICKENS] 83.43

[Unknown] [Unknown]: 10 × 12 [?]

[Unknown]

[No AFT code] *A Chicken Pic 10 × 12 was painted for Miss
Smith early in Spring 1883, paid $50.00—not Numbered.*

See 83.47.

[BUCK'S HEAD] 83.44

A. F. Tait, N.A. / N.Y. 1883 [LR] Canvas: 14 × 10

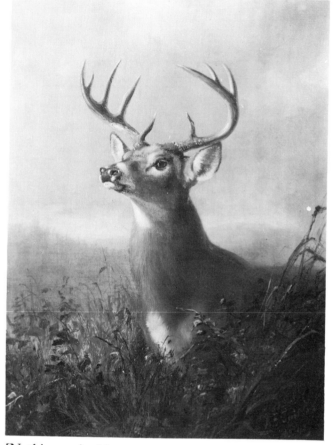

[Nothing on back]

[No AFT code; no Register entry]

Courtesy of Mrs. Henry F. Marsh.

[THE PLAYFUL KITTEN] 83.45

A.F.T. and L.C. / N.Y. '83 [LR] Canvas: 8 × 10

Mrs. F. P. Osborn / Xmas 1883 / From A. F. Tait and /
Louis Contoit / with best wishes.

[No AFT code; no Register entry]

Collection of the Robert Hull Fleming Museum, Bur-
lington, Vermont. Courtesy of the Robert Hull Fleming
Museum.

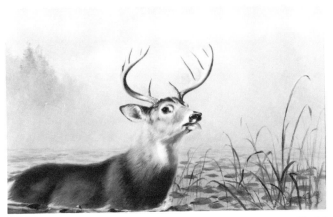

[A MISTY MORNING] 83.46

A. F. Tait, N.A. / N.Y. Canvas: 14½ × 22
1883 [LR]

Xmas 1883 / H. Grant Frazer / with best wishes of /
A. F. Tait.

[No AFT code; no Register entry]

This painting has been relined and restored and the in-
scription previously obtained has been lost.

Courtesy of Sotheby Parke Bernet, Agent: Editorial
Photocolor Archives, New York, New York.

[EIGHT DOMESTIC CHICKENS] 83.47

A. F. Tait / N.Y. 1883 [LR] [Unknown]: [Unknown]

[Unknown]

[Unknown]

With what information is available it is impossible to
identify this painting in AFT's Register; it might be
83.9, 83.25, 83.28, 83.29, 83.33–.39, 83.43, or it might
be a work that was never registered.

SUNSET: RAQUETTE LAKE 84.1

A. F. Tait, N.Y. 1884 [?] Canvas: 12½ × 16½

[Unknown]

*U.U.M. [Chickens crossed out] Sunset Raquette Lake Adiron-
dacks. 12 × 16 [following crossed out: Miss Smith to be
$50.00] returned Jan'y 19 and I gave this to A J. Pulsford.*

DEAD GAME 84.2

[Unknown] [Unknown]: 16 × 12 [?]

[Unknown]

*U.U.e. 1884 Dead Game. 16 × 12 Pair of Canvas Backs &
Green wing Teal sent down to Schencks Sale Jan 7th and sold for
$49.00.*

CHICKENS 84.3

[Unknown] [Unknown]: 10 × 12 [?]

[Unknown]

*U.U.r. Chickens. 10 × 12 Artist Fund Sale Jan'y 15th 1884.
Sold for $127.50 without Frame Paid Jan'y 24th 84 Paid
W. Snedecors for Frame $16.00 in Studio Jan'y 24th 84.*

CHICKENS 84.4

[Unknown] [Unknown]: 10 × 12 [?]

[Unknown]

*U.U.l. Chickens 5 days finished Jan'y 18th 10 × 12 for Gill's
Ex. Springfield in Frame.*

MATERNAL AFFECTION 84.5

A. F. Tait, N.A. / N.Y. Panel: 7¾ × 9¾
1884 [LR]

"Maternal Affection" / A. F. Tait, N.A. / N.Y. 1884 /
U.U.Z.

*u.u.a. Doe & 2 Fawns. 4 days finished Jan'y 21st 10 × 12
Gill Springfield in Frame. ret'd March 26th and sent to Jno.
Snedecors March 30th. sale or return price 150.00.*

Note that AFT has numbered the painting as U.U.Z.
but has recorded it as u.u.a. and that the actual and
recorded sizes vary. See 84.8 for AFT's record of
U.U.Z., which is of a much different subject.

DOE AND TWO FAWNS 84.6

[Unknown] [Unknown]: 10 × 12 [?]

[Unknown]

*U.U.n. [Mr. Le crossed out] Doe & 2 Fawns. 10 × 12 Mr.
Leeman (Hentz[?] & Co[)] to be $100.00 including Frame paid
for & I paid Snedecor for his Frame.*

The code on the back of this painting may be different
from that entered by AFT in the Register since his num-
bering system at this point is not in order. See also 84.5
and 84.8.

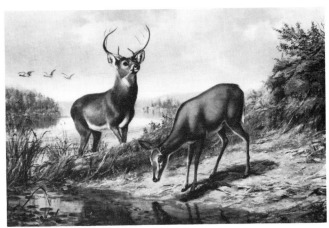

A FALSE ALARM 84.7

A. F. Tait, N.A. / N.Y. Canvas: 20¼ × 30½
'84 [LR]

"A False Alarm" / Racquette Lake / Adirondacks / September / U.U.d. 1884 / A. F. Tait, N.A. / N.Y. Y.M.C.A. / 23rd St.

u.u.d. [1884] Buck & Doe. Lake Scene 2 Deer 20 × 30 in Snedecors Frame $25.00. sent to Schencks sale March 13th.

STEADY: GOOD DOG 84.8

[Unknown] [Unknown]: 10 × 14 [?]

[Unknown]

U.U.Z. Spaniel & two Woodcock (one flying) 10 × 14 in Snedecors Frame $13.00 [Following crossed out: *March 15 Newark Ex. May 1st at Snedecors Store on Sale ret'd May 27th by A.F.T. and sent to Doll & Richards Boston to Wm. Hatfield on a/c of F M Bird*] *got it back again Mar'h 11th 90 at Studio 53 E 56th St. with 3 others* [84.9, 84.22, and 85.13; see also 84.12]. *sent March 13th to N.A. Design Spring Ex (with 2 others)* [90.2 (CZ) and 90.3 (CU)] *price $150.00 new Frame by Lewis* [Following added above entry and apparently later:] *Ret'd from F M Bird Spring of 1890, and sold to P. Leman Hy Hentz & Co for $100.00. paid and delivered Nov'r 1st 90* [large pencil *X* in left margin].

Exhibited at the National Academy of Design 65th Annual Exhibition, 1890, titled "Steady, Good Dog," priced at $150.00. The code on the back of this painting may differ from AFT's recorded code. See also 84.5 and 84.6.

RUFFED GROUSE AT HOME: SUMMER 84.9

[Unknown] [Unknown]: 14 × 22 [?]

[Unknown]

U.Z. 3 Ruffed Grouse in Forest 14 × 22 [in Snedecors Frame *and* crossed out] *sent to the* [*N A Design Ex. March 12th. Ret'd* crossed out] *May 21st.* [Following crossed out: *sent to Doll & Richards (Mr. Hatfield) Boston on a/c of F.M Bird for sale got it back again Mch 11th./90*] [large pencil *X* in left margin].

One of the five paintings used as collateral for a loan from Bird (see also 84.8, 84.12, 84.22, and 85.13). Exhibited at the National Academy of Design 59th Annual Exhibition, 1884, titled "Ruffed Grouse At Home, Summer," priced at $200.00.

THREE RUFFED GROUSE 84.10
IN THE FOREST

[Unknown] [Unknown]: 12 × 16 [?]

[Unknown]

u.c. 3 Ruffed Grouse in forest 12 × 16 Schencks sale sent March 13th Sold.

THREE RUFFED GROUSE 84.11
IN THE FOREST

[Unknown] [Unknown]: 14 × 22 [?]

[Unknown]

u.u. 3 Ruffed Grouse in forest 14 × 22. [Following crossed out: *sent to NA Design Ex March 12th/84 price to be $200.00 called.*]

MATERNAL AFFECTION 84.12

A. F. Tait, N.A. / N.Y. Canvas: 12½ × 16½
1884 [?]

[Unknown]

u.m. [1884] Doe & 2 Fawns in Forest & Grey Squirrel 12 × 16 finished March 11th [Crossed out: *and sent to N A Design Ex March 12th price to be $200.00. NAD sold to Mr. [blank] ret'd May 26th* [Crossed out: *sent to Wm. Hatfield (Doll & Richards)*] *Boston May 27 on a/c of F. M. Bird. Returned Mch 11/90 and gave this to him on settlement in full* [*April* crossed out] *March 11th/90* [large pencil *X* in left margin].

One of five paintings used as collateral for a loan from Bird (see also 84.8, 84.9, 84.22, and 85.13). Exhibited at the National Academy of Design 59th Annual Exhibition, 1884, titled "Maternal Affection, Summer, Adirondacks," priced at $150.00.

RUFFED GROUSE 84.13

[Unknown] [Unknown]: 12 × 16 [?]

[Unknown]

u.b. "Ruffed Grouse" 12 × 16 Schencks sale March 13th sold.

LITTLE PETS 84.14

[Unknown] [Unknown]: 10 × 14 [?]

[Unknown]

u.e. Chickens "Little Pets" 10 × 14 [Crossed out: *March 15th to N.A. Design*] *Ex ret'd May 21st and sent to Buffalo.*

A FALSE ALARM 84.15

A. F. Tait, N.A. / N.Y. Canvas: 20 × 30
1884 [LR]

"A False Alarm" / A. F. Tait, N.A. / 1884 / 52 East 23rd St / N.Y. / In The Adirondacks / Racquette Lake / Hamilton Co / N.Y. / U.R.

U.R. "False Alarm." Buck & Doe on Lake Shore Ducks flying Dist [or *Past*] *Raquette Lake Adirondacks 20 × 30 Painted for Brett.*

STARTLED 84.16

A. F. Tait, N.A. / N.Y. '84 [LR] Canvas: 16 × 24

A. F. Tait, 52 E 23rd St. N.Y., U.L. 1884, "Startled," Racquette Lake, Adirondacks, N.Y.

U.L. [1884] Buck and Doe Lake Shore D.H. [see below] *16 × 24 Painted for Williamson Tailor and del'd Ap'l 28th by me at his store in 9th St. in Exchange for clothes[?] I had last year to be $200.00* [In left margin:] *D.H.*

The *D.H.* appearing twice in this entry is AFT's abbreviation for "Dead Horse" (see also 84.17, 84.18, and

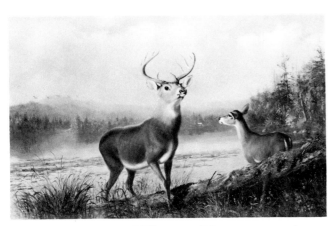

89.12). Perhaps Mr. Williamson did not agree to the exchange suggested by AFT.

TWO SETTER DOGS AND QUAIL 84.17

[Unknown] [Unknown]: 12 × 16 [?]

[Unknown]

U.A. Two Setter Dogs & Quail. 12 × 16 Painted for & del'd to Hy Wilson to pay for advances last year. del'd by me & Emma at his House 123 W. 48th St. Aprl 29th he was out [In margin left:] *D. Horse.*

See 84.16.

AT HOME 84.18

A. F. Tait, N.A. / N.Y. Canvas: 10 × 14¼
'84 [LR]

U.N. / At Home / A. F. Tait / 1884

U.N. Doe & 2 Fawns. Lake Scene with a Grey Squirrel. 10 × 14 Painted for Edw'd Brown, salesman at the N.A. Design, as a present del'd to him May 17 finished May 12th. 5 days on it [In margin left:] *D. Horse.*

See 84.16.

NOON 84.19

A. F. Tait / N.Y. '84 [LL] Canvas: 19½ × 29½

[Sealed; inscription, if any, unavailable]

U.D. "Noon" Cattle in Shallow Stream 20 × 30 Henry Hentz—finished it May 15th. 9 Days this was paid for Feb'y 25 by cash $200.00 and sent home in (Snedecors) Frame May 22nd by "Le March" he called to see it.

[STARTLED] 84.20

A. F. Tait / '84 [LL] Canvas: 12 × 10

U.Z. / 1884 / A. F. Tait

U.Z. [1884] Buck startled 10 × 12 in Exchange for large Frame made by Silleck and $15.00 to boot. to Mr. Sullivan 6th Dist Court—4th Av. del'd May 27. no Frame This Frame was sold to Miss Smith on No. M.U. [84.23].

THE CHALLENGE 84.21

[Unknown] [Unknown]: 14 × 22 [?]

[Unknown]

M. The Challenge 14 × 22 Buck & Doe. Buck swimming in Lake in distance Snedecor Frame Schencks Sale June 16th limit $100 held over until Fall.

[ON THE ALERT] 84.22

[Unknown] [Unknown]: 16 × 24 [?]

[Unknown]

M.C. Buck & Doe. Boat in distance Lake 16 × 24 sent to Boston July 14/84 [Changed later to 89(?)] to Wm Hatfield (Doll & Richards) on a/c of F. M. Bird as colateral for loan with 4 other Pictures [including 84.8, 84.9, 84.12, and 85.13] Returned Mch 11th/90 [large pencil X in left margin].

MORNING IN THE ADIRONDACKS 84.23

A. F. Tait, N.A. / N.Y. Canvas: 40¼ × 30
'84 [LR]

[Relined; inscription, if any, lost]

M.U. Morning Adirondacks. Raquette Lake sold this to Miss Smith for $250.00 with Frame. 30 × 40 Sillecks make got from Sullivan No. UZ [84.20] Am Art Ex Fall Oct'r 16th/84 Sold for $300.00. & Repaid Miss Smith by cheque from A.A. Assoc (less com) $245.00.

PERPLEXITY 84.24

[Unknown] [Unknown]: 20 × 30 [?]

[Unknown]

M.M. [1884] "Perplexity" 20 × 30 Colly dog & Sheep in Snow. N A D Ex. Oct'r 18th/84 Fall Ex Sold for $300.00. nett 270.00. to Mr Walker.

Exhibited at the National Academy of Design Autumn Exhibition, 1884, titled "Perplexity," priced at $600.00.

MOTHERLY CARE 84.25

[Unknown] [Unknown]: 14 × 22 [?]

[Unknown]

M.b. "Doe & Fawns" "Motherly Care" 14 × 22 N.A.D. Fall Ex Oct'r 18/84 sent to Bklyn Ex. Nov'r sold at S[blank].

Sent with 84.29 to the Artists' Fund Sale, December 30, 1884. Exhibited at the National Academy of Design Autumn Exhibition, 1884, titled "Motherly Care," priced at $250.00.

SPRINGTIME 84.26

[Unknown] [Unknown]: 10 × 14 [?]

[Unknown]

M.E. Spring. Farm Yard. Calf and Sheep 10 × 14 N.A.D.

Fall Ex Oct'r 18th/84 sent to Brooklyn Ex Dec'r 1st/84 Sold to Mr. Leman for $125.00 including Frame.

BILLY 84.27

A. F. Tait, N.A. / N.Y. Canvas: 12 × 16
'84 [LR]

Nellie [?] L. Hentz / Christmas 1884 / from Mama. [Preceding written in ink at upper left in hand other than AFT's] "Billy" / A. F. Tait / M.R. N.Y. 1884.

M.R. Billy Goat 12 × 16 painted for Mr. Leman being a Portrait for X'mass to Mr. Hentz little daughter. to be $100.00 Frame Extra Paid for Dec'r 4th. Snedecors Frame.

HORSES AT GRASS 84.28

[Unknown] [Unknown]: 20 × 30 [?]

[Unknown]

M.L. [1884] Horses at Grass. 20 × 30 Portraits of Mr. Hy Hentz Horses Painted at Madison N.J. 3 Horses & Shetland Pony.

limit $200.00[sic; repeated] with Snedecors Frame $43.00. Sold for $257.00.

Collection of the Yale University Art Gallery, New Haven, Connecticut. Courtesy of Yale University Art Gallery, Whitney Collections of Sporting Art, given in memory of Harry Payne Whitney (B.A. 1894) and Payne Whitney (B.A. 1898) by Francis P. Garvan (B.A. 1897).

BUCK 84.30

[Unknown] [Unknown]: 14 × 22 [?]

[Unknown]

M.N. Buck 14 × 22 New Years present to A. J. Pulsford this X'mass.

EARLY MORNING: REPOSE 84.31

[Unknown] [Unknown]: 24 × 36 [?]

[Unknown]

M.D. Early Morning (Repose) 24 × 36 Buck standing. 2 Does lying down. Lake Scene. 3 Ducks flying across sent to Schencks Sale Jan'y 23rd 1885.

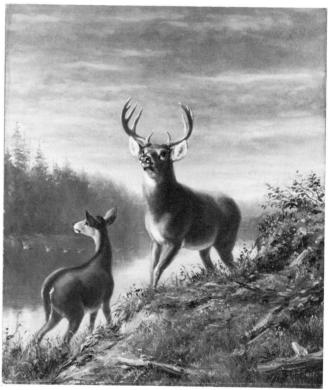

[STARTLED DEER] 84.29

A. F. Tait, N.A. / N.Y. Canvas: 39 × 29¼
1884 [LR]

[Nothing on back]

M.A. Buck & Doe—Lake 30 × 40 sent to Artist Fund sale with M.B. Doe & Fawns [84.25]. Dec'r 30th by J. Elliott ret'd—not sold sent to Schenck Sale Jan 23rd/85 limit $200

EVENING ON FORKED LAKE 84.32

A. F. Tait / N.Y. '84 [LR] Canvas: 12 × 10

Evening / Forked Lake / Hamilton Co / N.Y. / 1884–5 / M.//.

M//. [1885] Evening on Forked Lake Hamilton Co Adirondacks. 10 × 12 in Frame (Sned's) sent to Schencks Sale Jan'y 23rd/85.

77.13 Snowed In, *canvas: 36 × 28. Collection of The Adirondack Museum, Blue Mountain Lake, New York. Courtesy of The Adirondack Museum.*

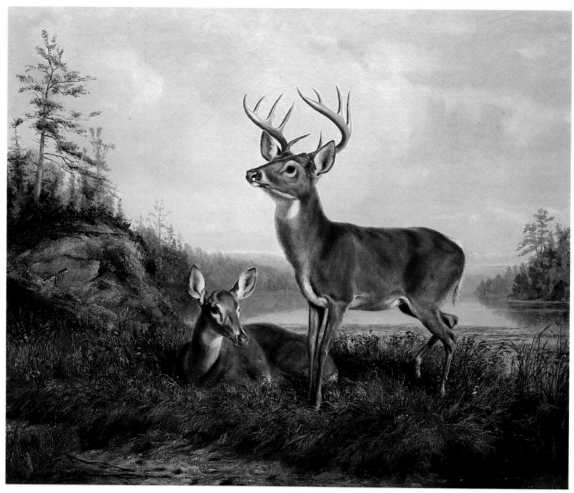

79.40 Racquette Lake, *canvas: 22 × 26. Collection of The Adirondack Museum, Blue Mountain Lake, New York. Courtesy of The Adirondack Museum.*

79.46 [Dog's Head], *paper: 8¼ × 6½. Collection of The Adirondack Museum, Blue Mountain Lake, New York. Courtesy of The Adirondack Museum.*

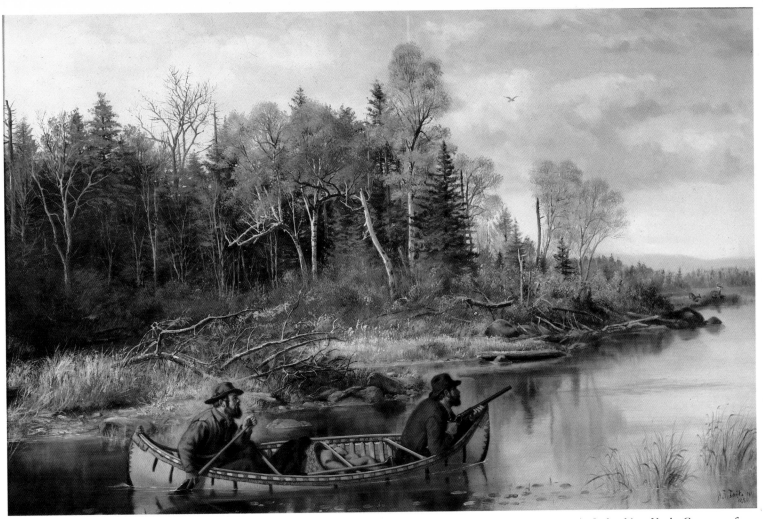

80.21　An Anxious Moment, *canvas: 20¼ × 30¼. Collection of The Adirondack Museum, Blue Mountain Lake, New York. Courtesy of The Adirondack Museum.*

81.16　Farm Yard, *canvas: 14½ × 22. Courtesy of Mr. and Mrs. George Arden.*

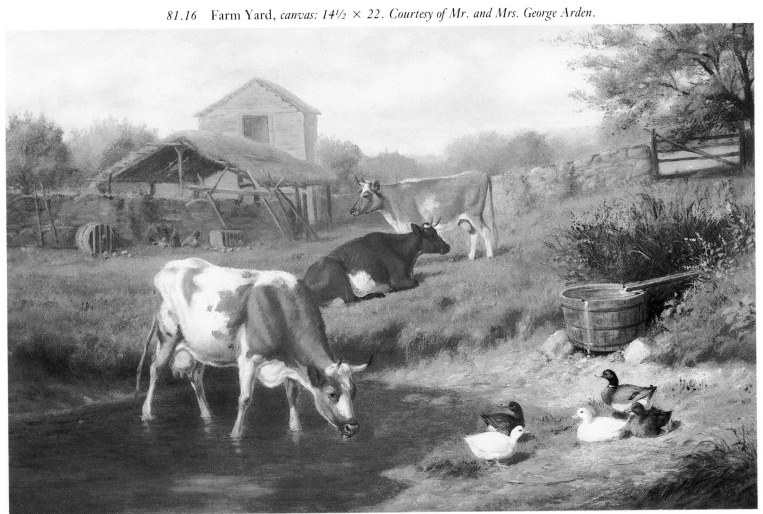

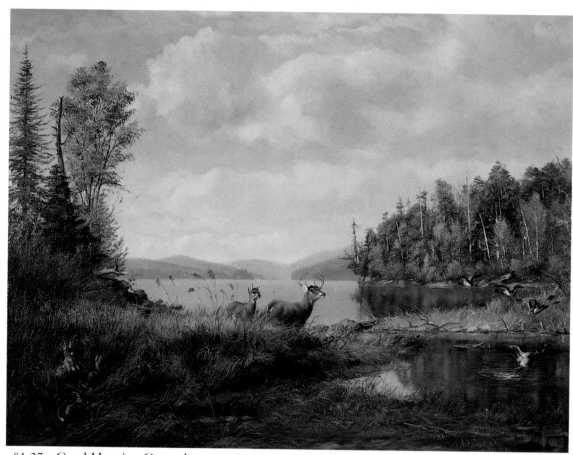

81.27 Good Hunting Ground, *canvas: 20 × 26. Collection of The Adirondack Museum, Blue Mountain Lake, New York. Courtesy of The Adirondack Museum.*

82.19 An Anxious Moment, *canvas: 13½ × 21½.*

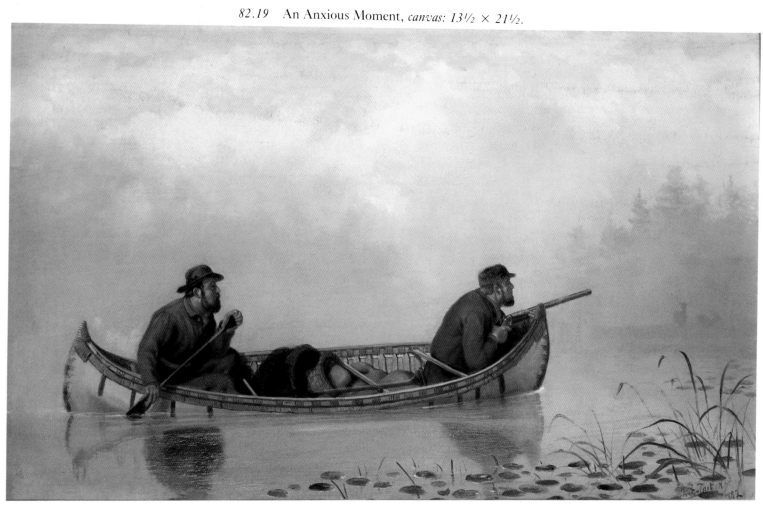

86.16 Rats, *canvas: 10 × 14¹/₂. Courtesy of Mr. and Mrs. George Arden.*

85.31 On the Alert, *canvas: 30 × 40¼. Courtesy of Mr. and Mrs. George Arden.*

89.16 Our Little Pets, *board: 10 × 15. Courtesy of Petersen Galleries, Beverly Hills, California.*

93.2 The Gap in the Fence, *canvas: 14 × 22. Collection of The Adirondack Museum, Blue Mountain Lake, New York. Courtesy of The Adirondack Museum.*

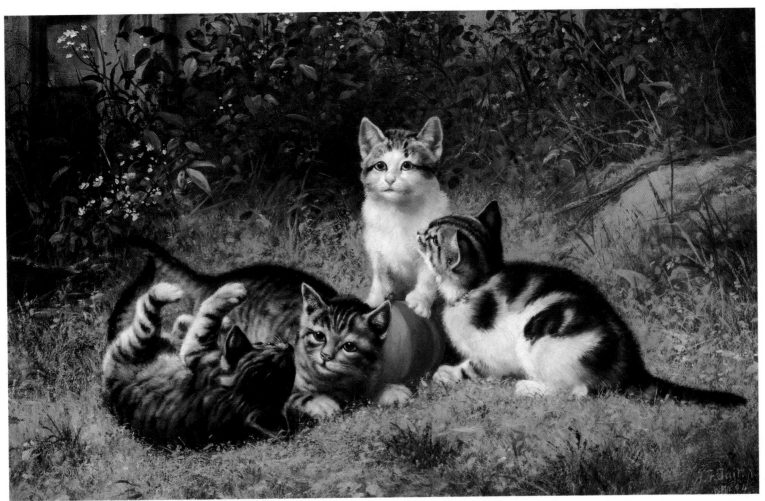

94.9 Play Fellows, *canvas: 13¼ × 21¼. Collection of The Adirondack Museum, Blue Mountain Lake, New York. Courtesy of The Adirondack Museum.*

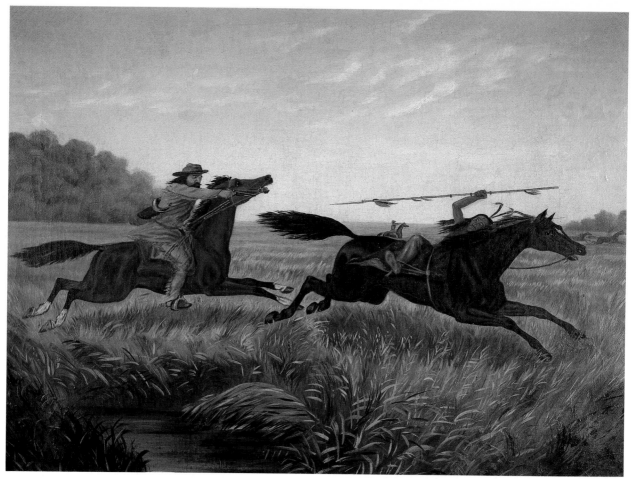

ND.38 The Pursuit, *canvas: 18 × 24. Courtesy of Mr. George J. Dittmar, Jr.*

ND.39 The Last War Whoop, *canvas: 18 × 24. Courtesy of Mr. George J. Dittmar, Jr.*

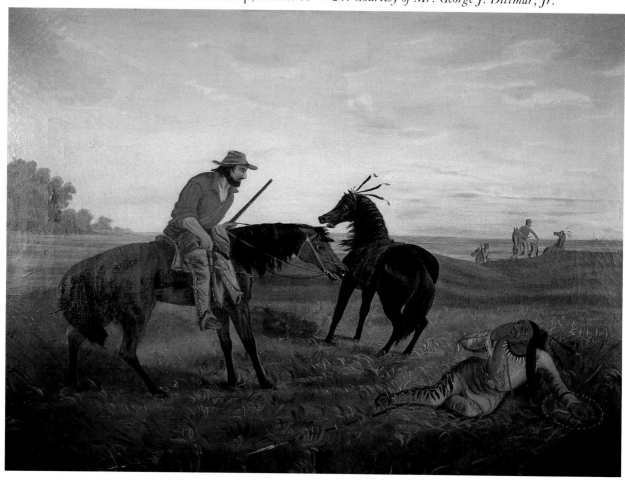

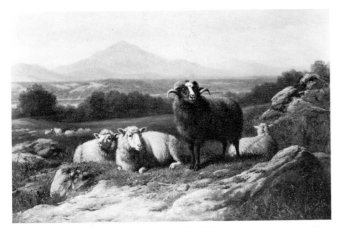

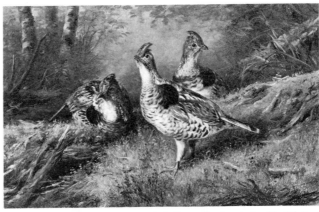

MORNING ON THE HUDSON 85.1

A. F. Tait, N.A. / N.Y. Canvas: 20½ × 30¼
'85 [LR]

B. / Morning on the Hudson / A. F. Tait, N.A. / N.Y.
1885.

B. *Morning on the Hudson 20 × 30 Sheep on a Hill overlooking the River Schencks Sale Feb'y 6th/85 in Cahills Frame $25.00 Sold for $152.50.*

Courtesy of Schweitzer Gallery, Inc., New York, New York.

MATERNAL AFFECTION 85.2

[Unknown] [Unknown]: 8 × 10 [?]

[Unknown]

B.½ *8 × 10. [*"*]Maternal Affection." Doe lying down & 2 Fawns Sold at Schencks Sale Feb'y 6th/85 for $50.00.*

WHO SAID "CATS" 85.3

[Unknown] [Unknown]: 20 × 30 [?]

[Unknown]

B.C. *"Who said "Cats." 20 × 30 Fox Terrier & cat on Blanket Feb'y 20 sent down to Schencks Sale by Frank limit $150.00 with B.U. [85.4] Sold for $177.50.*

SUMMER, ORANGE COUNTY, N.Y. 85.4

[Unknown] [Unknown]: 24 × 30 [?]

[Unknown]

B.U. *Sheep. View in Summer Orange Co. N.Y. 24 × 30 finished Feb'y 16th for Schenck's Sale sent to Schencks sale by Frank limit $150.00 after repainting March 20 sold Apl 21st for only 96.00 slaughtered.*

Sent to Schencks February 20, 1885, with 85.3.

RUFFED GROUSE 85.5

A. F. Tait / N.Y. '85 [LR] Canvas: 14 × 22

"B.M." / Ruffed Grouse / Adirondacks / A. F. Tait / Studio 411, E [address incomplete] N.Y.

B.M. *[1885] Ruffed Grouse. Adirondacks 14 × 22 Schencks Sale del'd by Frank Mch 19th McCully's Frame $15.00 limit $125.00.*

Courtesy of Schweitzer Gallery, Inc., New York, New York.

JACK IN OFFICE 85.6

A. F. Tait / N.Y. 85 [LR] Canvas: 24½ × 36

[Unknown]

B.B. *"Jack in Office" 24 × 36 This was on hand 4 years. finished March 12th and is to be sent to the Am Art Asso'n. sent there March 28th/85 by Delany Ex & Frank sent to Am Art Gallery Apl 1st Snedecors Frame. Presented to Ab'm Dowdney for favors rec'd Rent &c Nov'r 1885.*

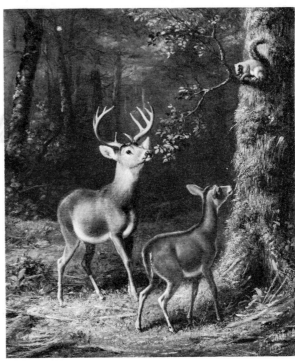

85.7

THE FOREST: ADIRONDACKS 85.7

A. F. Tait, N.A. / 1885 [LR] [Canvas]: 12 × 10

"The Forest" /Adirondacks / A. F. Tait, N.A. / 411 East 65th St. / N.Y. / 1885.

B.E. "In the Forest" Adirondacks 10 × 12 [Crossed out: finished March 29th for Mr Ed. Steele [Steese?] Boston for 75.00 no Frame sent off by Express March 31st 1885] returned not liked—sent to Schencks Sale April 21st & sold for $40.00—Rose's Frame $13.50.

[CATTLE AND DUCKS] 85.8

[Unknown] [Unknown]: 18 × 24 [?]

[Unknown]

[No AFT code; one of] 2 Paintings [along with 85.9] by [Edward B.] Gay & A F Tait I put in Cattle & Ducks (by Frank) sent to Edw'd Schenck. he bot [sic] their frames [?] from Gay for $25.00. [Crossed out: I did the Cattle etc. & gave him my work. he to pay for Frames by Snedecor.] One sold for $130.00 the other ret'd to me to put cattle in it [Following added above entry later apparently:] Snedecors 2 Frames Schenck paid him for them 18 × 24.

First of two paintings (see also 85.9) in which Tait did the figures; Edward B. Gay (1837–1928), most probably, did the backgrounds.

[CATTLE] 85.9

[Unknown] [Unknown]: 18 × 24 [?]

[Unknown]

[No AFT code; see combined Register entry for 85.8]

Second of two paintings (see also 85.8) in which Tait did the figures; Edward B. Gay (1837–1928), most probably, did the backgrounds.

LET ME ALONE 85.10

A. F. Tait, N.A. / N.Y Canvas: 14 × 22¼
'85 [LR]

1885 / Let me Alone / A. F. Tait, N.A. / N.Y.

B.R. [1885] King Charles Spaniel & Hen & Chickens called "Let me alone" 14 × 22 finished May 8th/85 sent to Schencks Sale May 9th. Cahill's Frame $16.50.

This painting has been relined and the original inscription copied on the new canvas, with the resultant loss of AFT's code.

GOOD NATURED 85.11

[Unknown] [Unknown]: 14 × 22 [?]

[Unknown]

B.L. "Good Natured" 14 × 22. Gordon Setter & Hen & Chickens for F. M. Bird to pay for Interest on Loan of June 25th 1884. sent off with No. B N. [85.13] to Wm. Hatfield Boston. del'd by Frank May 16th to Mr Rose & Packed & sent off by Express by Rose [large pencilled X with double cross stroke in margin].

MORNING ON FORKED LAKE 85.12

A. F. Tait, N.A. / N.Y Canvas: 24 × 30
'85 [LR]

"B.A." / Morning / Racquette lake / Adirondacks / N.Y. / A. F. Tait, N.A. / N.Y. 1885

B.A. ["]Morning on Forked Lake" 24 × 30 Buck & Doe. Lake Scene Painted for Mr. Ed S. Hobbs, Bkl'yn & paid for (Apl 30th price $200.00.).

See 85.13.

MORNING, RAQUETTE LAKE, 85.13
ADIRONDACKS, N.Y.

A. F. Tait, N.A. / N.Y Canvas: 23¾ × 29¾
'85 [LR]

[Relined; inscription, if any, lost]

B.N. Morning Raquette Lake Adirondacks N.Y. 24 × 30 something like the preceeding one [85.12] finished May 14th (Rose Frame) sent to Wm Hatfield (Doll & Richards) Boston Mass on a/c of Mr F M Bird May 16th Packed & sent off by Mr Rose. del'd by Frank with No. B.L. [85.11] ret'd March 11th/ 90 on Settlement in full by cash $500.00 then it went to Gill Springfield for Exhibition & Sale. [large pencilled X in left margin].

One of five paintings used as collateral for a loan from Bird (see also 84.8, 84.9, 84.12, and 84.22).

A CLOSE POINT 85.14

[Unknown] [Unknown]: 20 × 30 [?]

[Unknown]

B.C. [1885] Snow Scene. " A Close Point"—20 × 30 Gordon Setter & Ruffed Grouse finished May 30th 1885 Schencks June 10th not sold ret'd & sent to Chicago (O'Briens), when I was there.

See 87.16.

GOOD DOG 85.15

[Unknown] [Unknown]: 8 × 10 [?]

[Unknown]

E.C. "Good Dog" Gordon Setter with Woodcock in his mouth— "Nipersa[?]". Schencks June 10.

"Nipersa[?]" or "Nip" was a dog belonging to James B. Blossom. See 85.16 and 85.17.

NIP 85.16

A. F. Tait, NY '85 Canvas: 8 × 10¼

A F Tait NA / NY 1885

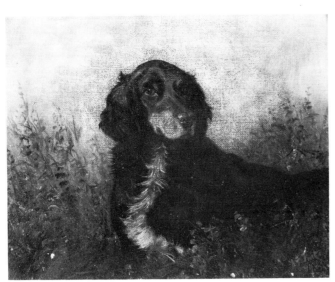

E.U. Nip—a Gordon Setter. for Jas B Blossom 8 × 10 [Crossed out: *Schencks June 10th*].

See 85.15 and 85.17.

Courtesy of Christie's, New York, New York.

[NIP RETRIEVING A QUAIL] 85.17

[Unknown] [Unknown]: 8 × 10 [?]

[Unknown]

E.M. Another of "Nip"—with a [Crossed out: *Woodcock in mouth*] *Quail in his mouth Schencks June 10th 8 × 10* [In pencil:] *Bric a brac.*

See 85.15 and 85.16.

A MORNING ON RAQUETTE LAKE 85.18

[Unknown] [Unknown]: 24 × 30 [?]

[Unknown]

E.b. A Morning on Raquette Lake 24 × 30 Foggy—Buck & Doe. Boat in distance in the Fog Schencks June 10th.

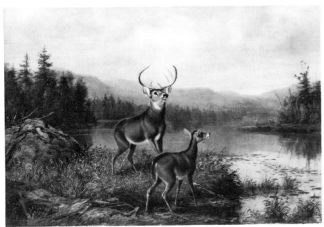

85.19

SOLITUDE, FORKED LAKE 85.19

A. F. Tait, N.A. / N.Y. Canvas: 20½ × 30¼
'85 [LL]

E.E. / A. F. Tait, N.A. /1885 / "Solitude" / Forked Lake / Hamilton Co. / N.Y. / Adirondacks

E.E. [1885] *Lake Scene. Deer &c 20 × 30 for Schencks Sale sent down June 15th Frame by Snedecor sent June 11th finished 10th.*

Collection of the Yale University Art Gallery, New Haven, Connecticut. Courtesy of Yale University Art Gallery, Whitney Collections of Sporting Art, given in memory of Harry Payne Whitney (B.A. 1894) and Payne Whitney (B.A. 1898) by Francis P. Garvan (B.A. 1897).

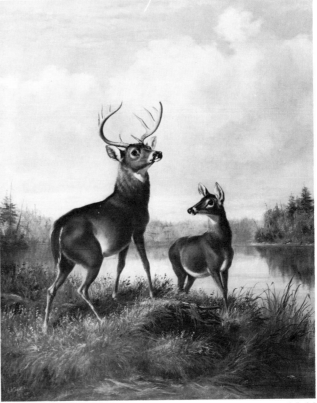

BUCK AND DOE 85.20

A. F. Tait, N.A. / N.Y. 85 [LL] Canvas: 40 × 30

A Pleasant Remembrance—Forked Lake

E.R.—[Entire entry crossed out: *Buck & Doe—30 × 40 Painted for Geo E Woodward & Miss Smith finished July. sent home in Frame (McCulleys) July 30th/85.*]

This painting was probably in fact not delivered to George E. Woodward. See 85.22.

Collection of the North Carolina Museum of Art, Raleigh, North Carolina. Courtesy of the North Carolina Museum of Art.

THE TWINS: PERPLEXITY 85.21

[Unknown] [Unknown]: 20 × 30 [?]

[Unknown]

E.L. ("The Twins") Perplexity 20 × 30 Two Colly Dogs &
Sheep & two little lambs in light Snow finished July 19th.

EARLY SUMMER 85.22

[Unknown] [Unknown]: 20 × 30[?]

[Unknown]

E.A. "Early Summer" 20 × 30 A Brook. cattle &c finished
July 8th sold to Geo E Woodward for $150.00 rec'd $100 Aug
1st $50 to be in place of one I promised him.

This painting probably replaced 85.20, which was origi-
nally painted for George E. Woodward.

VIEW ON THE CROTON RIVER 85.23
AT CARMEL, NEW YORK

[Unknown] [Unknown]: 20 × 30 [?]

[Unknown]

E.N. [1885] View on the Croton River at Carmel Putnam Co
N.Y. 20 × 30 painted from Nature sold to Mr A Wright—for
$225.00 no Frame Sloan's Bill for Linoleum 77.50 deducted
from this.

SUMMER, CROTON RIVER 85.24

[Unknown] [Unknown]: 20 × 30 [?]

[Unknown]

E.d. Croton River Carmel Putnam Co N.Y. Painted from
Nature 20 × 30 Fall Ex. N A D—price $350.00 Nov 5
Schencks Sale Nov 18th/85 [6?].

Exhibited at the National Academy of Design Autumn
Exhibition, 1885, titled "Summer, Croton River, Put-
nam County, N.Y.," priced at $350.00.

SPRING-TIME ON THE 85.25
CROTON RIVER

[Unknown] [Unknown]: 20 × 30 [?]

[Unknown]

R.C. Croton River. Carmel Put. Co. N.Y. 20 × 30 Painted
from Nature Fall Ex N A D.

Exhibited at the National Academy of Design Autumn
Exhibition, 1885, titled "Spring-Time On the Croton
River, Putnam County, N.Y.," priced at $350.00.

[CATTLE] 85.26

[Unknown] [Unknown]: 24 × 36 [?]

[Unknown]

R.U. Landscape by C. H. Eaton Cattle by me. 24 × 36.
See 85.28.

OUR FARM YARD 85.27

A. F. Tait, N.A. / N.Y. [LL] Panel: 12 × 14

R.M. 1885 / "Our Farm Yard" / A. F. Tait / 411 E. 65th
St / N.Y.

R.M. [1885] Our Farm Yard 12 × 16 Sheep, Calf &c. Fall
Ex N A D Nov 6th sold for 100.00 10% Comm 10.00 nett
90.00 paid to Ab Dowdney's a/c Dec'r 24th / & he repaid this to
me Jan'y 12th/86.

Exhibited at the National Academy of Design Autumn
Exhibition, 1885, titled "Our Farm Yard," priced at
$150.00.

THE BROOK AND CATTLE 85.28

[Unknown] [Unknown]: 10 × 14 [?]

[Unknown]

R.B. [Entire entry crossed out: The Brook & Cattle 10 ×
14 something like C H Eaton [85.26] painted for Mr Joe Boyle
to pay for loan I paid him Nov'r 29th.]

BUCK 85.29

[Unknown] [Unknown]: 12 × 16 [?]

[Unknown]

R.E. [Entire entry crossed out: Buck for Mr Macy 12 × 16
to pay for Tents—del'd Dec'r 8th.]

FALSE ALARM 85.30

[Unknown] [Unknown]: 20 × 30 [?]

[Unknown]

R.R. The Adirondacks "False Alarm" 20 × 30 Lake. Buck &
Doe—Ducks &c. fin'd Dec'r 13th Not accepted for Packard Sold
at Schencks Sale Feb 12th for $125.00 will nett about 85.00.

ON THE ALERT 85.31

A. F. Tait, N.A. / N.Y. Canvas: 30 × 40¼
1885 [LR]

R.L. / A. F. Tait, N.A. / N.Y. 1885 / "On The Alert" /
Adirondacks, N.Y. / Forked Lake / Hamilton Co. N.Y.

R.L. A False Alarm. 24 × 36 Buck & Doe's Lake 2 Does lying

down fin Dec'r 17th Sold at A [Artists'] Fund Sale Feb'y for 250.00 Frame 40.00 Extra.

STARTLED 85.32

[Unknown] [Unknown]: 14 × 22 [?]

[Unknown]

R.A. [1885] [Entire entry crossed out: *"A Buck. Startled" 14 × 22 finished Dec'r 23rd Exchanged for Bronzes at Fullertons 4th Av near 18th St.*]

The bronzes referred to above are of two pointers and one setter, all on point, by P. J. Mene.

DEER 85.33

[Unknown] [Unknown]: [Unknown]

[Unknown]

[No AFT code; this and 85.34 entry crossed out: *Sketch on Plaque Deer for Mrs Fraser for an X'mas present.*]

PORTRAIT OF A LADY 85.34

A. F. Tait, N.Y. '85 [LR] Board: 12 inch round

[Unknown]

[No AFT code; this and 85.33 entries crossed out: *Female Head On Plaque gave to Miss Smith (Woodward) as New Years present.*]

This painting is done on a square support in a diamond fashion.

A CLOSE POINT 86.1

A. F. Tait, N.A. / N.Y. '86 [LR] Canvas: 16½ × 24

"R.N." / (A Close Point) / A. F. Tait, N.A. / 1885 & 6 / 411 E. 56th St. / N.Y.

R.N. [Jan'y 1886] 2 Dogs & Grouse 16 × 24 Forest painted for Story's friend finished Jan'y 24th 9 days [Crossed out: *not*] *accepted & paid for $200.00—Frame by Rose & Dorn. paid for Feb. Mr. Packard or Packet 122 E. 73rd St N.Y. Paid cheque to A Dowdney & he repaid it to me.*

A CLOSE POINT: A GOOD TIME COMING 86.2

[Unknown] [Unknown]: 16 × 24 [?]

[Unknown]

R.D. [1886] Dog & Grouse 16 × 24 a Close Point sold at A Fund Sale Feb'y 15th for $170.00. frame extra. Frame— 25.00. by Lewis paid for Feb'y 26th $22.00.

Exhibited at the Artists' Fund Society, February 15–16, 1886, titled "A Close Point. A Good Time Coming."

CHICKENS 86.3

[Unknown] Board: 10 × 14 [?]

[Unknown]

R.Z. Chickens (Millboard) 10 × 14 painted for Jas D Gill Springfield for Sale & return Mrs Gill presented to her.

A SUNNY NOOK 86.4

A. F. Tait, N.A. / N.Y. '86 [LR] Canvas: 10¼ × 14¼

L.L. / "A Sunny Nook" / by A. F. Tait, N.A. / N.Y. 1886

L.L. Ducks "A Sunny Nook" (Canvass) 10 × 14 painted for Gill, Springfield sold for nett $80.00.

STEADY: WOODCOCK SHOOTING 86.5

A. F. Tait, N.A. / N.Y. '86 [LR] Canvas: 16 × 24

A.M. / "Steady" / "Woodcock Shooting" / A. F. Tait, N.A. / 411 E. 65th St. N.Y. 1886

A.M. [other codes *A.U.* and *Z.Z.*(?) crossed out] *Steady— 16 × 24 2 dogs & 2 Woodcock. Painted for the N.A.D. Ex finished Mar 10th/86.*

Exhibited at the National Academy of Design 61st Annual Exhibition, 1886, titled "Steady, Woodcock Shooting," priced at $250.00.

MATERNAL ANXIETY 86.6

A. F. Tait, N.A. / N.Y. 1886 [LR] Canvas: 20 × 30

[Relined; inscription, if any, lost]

L.C. [1886] *Maternal Anxiety 20 × 30 Jerseys. Orange Co N.Y. sent to Fall Ex N.A.D Nov'r. my Frame (R & D.) Price $350.00.*

Bracketed with *L.U.* (86.7) and *L.M.* (86.8) and marked "sent to Fall Ex N A Design." Exhibited at the National Academy of Design Autumn Exhibition, 1886, titled, "Maternal Anxiety, Jerseys, Orange Co., N.Y.," priced at $350.00.

Courtesy of Mr. Peter H. B. Frelinghuysen.

RUMINATING 86.7

A. F. Tait / N.Y. '86 [LL] Canvas: 20 × 30

[Relined; inscription, if any, lost]

L.U. "Ruminating" *20 × 30 Jersey's Orange Co N.Y. sent to Fall Ex. N A D price $350.00 New Frame by Rose & Dorn Sold for $300.00. 300.00 less Com 30 nett 270 00.*

Bracketed with *L.C.* (86.6) and *L.M.* (86.8) and marked "sent to Fall Ex N A Design." Exhibited at the National Academy of Design Autumn Exhibition, 1886, titled "Ruminating, Jerseys, Orange Co., N.Y."

TRESPASSERS 86.8

A. F. Tait, N.A. / N.Y. Canvas: 22½ × 14
'86 [LR]

Jerseys / Painted from Nature / Orange Co. N.Y. / A. F. Tait / N.Y. 1886–87 / "Trespassers."

L.M. Out of Bounds. 14 × 22 sent to Fall Ex. N.A.D. Nov'r [()my old Frame by R[oss] & Dorn) $130.00.

Bracketed with *L.C.* (86.6) and *L. U.* (86.7) and marked "sent to Fall Ex N A Design." Exhibited at the National Academy of Design Autumn Exhibition, 1886, titled "Out of Bounds, Orange Co. N.Y."

[MR. AND MRS. F. P. OSBORN WITH 86.9
"BLACK EAGLE" AND "PRINCESS"]

A. F. Tait, N.A. / N.Y. 1886 [LR] Canvas: 20 × 30

New York / L. B. 1886 / Painted by A. F. Tait, N.A. / F. P. Osborn and Wife of N.Y. / Black Eagle / Princess

L.B. [1886] *Frank P Osborn & Wife 20 × 30 with Black Eagle and Princess Horses price $400.00.*

Courtesy of Mr. William B. Ruger.

JEALOUSY 86.10

[Unknown] [Unknown]: 20 × 30 [?]

[Unknown]

L.E. Jealousy 20 × 30 Jersey Cow & 2 Calves New Frame by Ross & Dorn Schencks Sale.

PORTRAIT OF A POINTER 86.11

[Unknown] [Unknown]: 20 × 30 [?]

[Unknown]

L.R. Portrait of Pointer 20 × 30 painted at Wt Plains for Mr Jules Reynal $250.00.

PORTRAIT OF A SETTER 86.12

[Unknown] [Unknown]: 20 × 30 [?]

[Unknown]

L.L. Portrait of Setter 20 × 30 for Mr Jules Reynal $250.00.

COWS AND DUCKS 86.13

[Unknown] [Unknown]: 16 × 24 [?]

[Unknown]

L.A. [1886] Cows & Ducks 16 × 24 finished Nov 30th/86 given to Mr Boyle for bonus.

SUSPICIOUS 86.14

A. F. Tait, N.A. / N.Y. '86 [LL] Canvas: 30 × 24

[Unknown]

A.U. [1886–87] "Suspicious" Raquette Lake Adirondacks N.Y. 24 × 30 Artist Fund Dec'r 28th/86 not sold sent to Ed Schencks M'ch 1st/87 at Schencks & sold for nett 87.00.

Exhibited at the Artists' Fund Society, January 11–12, 1887, titled "Suspicious, Raquette Lake, Adirondacks, New York."

[BEAR AND THREE CUBS] 86.15

A. F. Tait, N.A. / N.Y. '86 [LL] Canvas: 16 × 24

[Relined; inscription, if any, lost]

[No AFT number; no Register entry]

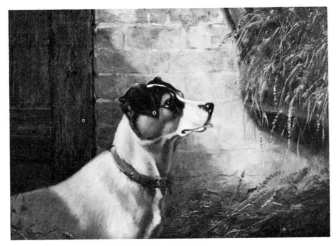

RATS 86.16

A. F. Tait, N.A. / N.Y. 1886 [LR] Canvas: 10 × 14½

"Rats" / A. F. Tait, N.A. / N.Y. 1886

[No AFT number; no Register entry]

Courtesy of Mr. and Mrs. George Arden.

[POINTER RETRIEVING A QUAIL] 86.17

A. F. Tait / 1886 [LR] Canvas: 8 × 10

Painted by / A. F. Tait, N.A. / N.Y. 1886

[No AFT number; no Register entry]

On the frame is scratched, "$750.00—pair," the pair being this painting and 86.18.

[SETTER RETRIEVING A WOODCOCK] 86.18

A. F. Tait, N.A. / '86 [LL] Canvas: 8 × 10

Painted by / A. F. Tait, N.A. / N.Y. / 1886

[No AFT number; no Register entry]

This is one of a pair with 86.17.

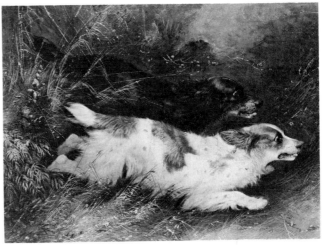

[COCKER SPANIEL] 86.19

[Not signed or dated] Canvas: 11 × 13½

A. F. Tait, 1886

[No AFT number; no Register entry]

Courtesy of The American Kennel Club, New York, New York.

DOLLY 86.20

A. F. Tait, N.A. / N.Y. Canvas: 11¾ × 15¼
1886 [LL]

"Dolly" / Rocky Dell / N.Y. / August 1886 / A. F. Tait, N.A.

[No AFT number; no Register entry]

BIJOU 86.21

A. F. Tait / N.Y. 1886 [LR] Board: 10 × 13

"Bijou" / Rocky Dell. White Plaines, N.Y., 1886

[No AFT number; no Register entry]

Courtesy of Mr. and Mrs. George Arden.

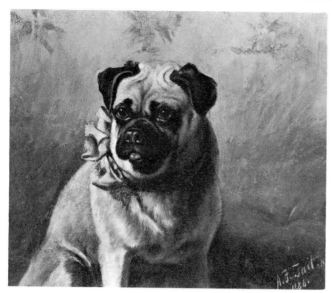

86.21

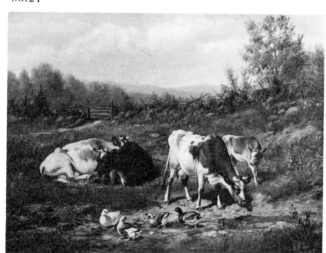

JERSEYS, ORANGE COUNTY, N.Y. 87.1

A. F. Tait, N.A. / N.Y. '87 [LR] Canvas: 12 × 16

1887 / "Jerseys" / Orange Co. / N.Y. / A. F. Tait, N.A.

C. [*1887*] *Landscape & Cows & Ducks 12 × 16 sent to Gill Springfield with C.U.* [87.2].

Painting has been relined and the inscription copied onto new canvas, which probably accounts for the lack of code on the painting.

CHICKENS AND CALF 87.2

[Unknown] [Unknown]: 10 × 14 [?]

[Unknown]

C.U. Chickens & Calf. 10 × 14 sent to Gill Springfield am [?] *sold for nett $75.00.*

MOTHERLY SOLICITUDE 87.3

[Unknown] [Unknown]: 24 × 30 [?]

[Unknown]

C.M. Motherly Solicitude 24 × 30 Cows & Calves. $350.00 sent to N.A. Design. March 10th/87 Lewis Frame sold for 275.00 com off 10 pr ct 27 50 247.50.

Exhibited at the National Academy of Design 62d Annual Exhibition, 1887, titled "Motherly Solicitude, Jerseys, Orange Co., N.Y.," priced at $350.00.

DEAR LITTLE PETS 87.4

[Unknown] [Unknown]: 10 × 14 [?]

[Unknown]

C.B. [*1887*] *Chickens. 10 × 14 "Pets" Lewis Frame $135.00 N.A.D. Ex. Mch 10th/87 sold at Ex for $135.00 com off 13.50.*

Exhibited at the National Academy of Design 62d Annual Exhibition, 1887, titled "Dear Little Pets," priced at $135.00.

LITTLE BUSYBODIES 87.5

A. F. Tait, N.A. / N.Y. '87 [LR] Canvas: 10 × 12

C.E. / "Little Busybodies" / A. F. Tait, N.A. / N.Y. 1887.

C.E. "Chickens" "Little Busybodies" 10 × 12 N.A.D. M'ch 10/87 $100.00 sold at Ex for $100.00 $10.00.

Exhibited at the National Academy of Design 62d Annual Exhibition, 1887, titled "Little Busybodies," priced at $100.00.

APPLES AND CHIPMUNK [I] 87.6

A. F. Tait, N.A. / N.Y. '87 [LL] Panel: 8 × 10

No. 44 / Y.M.C.A. / 23rd St / N.Y. / A. F. Tait.

C.R. Apples & Chipmunk 8 × 10 Elias did part Rose & Dorn M'ch 15th.

APPLES AND CHIPMUNK [II] 87.7

[Unknown] [Unknown]: 10 × 12 [?]

[Unknown]

C.R.A. Apples & Chipmunk 10 × 12.

For another painting of same title see 87.6.

BA—AH 87.8

A. F. Tait, N.A. / 1887 [LR] Canvas: 16 × 24

"Ba—ah" / C.L. / A. F. Tait, N.A. / Orange Co., N.Y. / 1887

C.L. [*1887*] *2 Cows & Calf & Ducks Cattle & Ducks. 16 × 24 in Frame Lewis Velvet Shadow Box & Glass Schencks Sale March 25th limit $135.00 with 2 Gay & Taits. 17 × 27. In Silver Gilt Frames from Chicago sold for $205.00 com off 35.00 nett $170.00 including a Gay & Tait $45.00.*

The "2 Gay & Taits" may be 85.8 and 85.9.

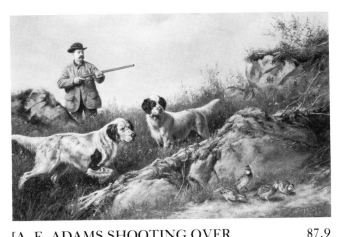

[A. F. ADAMS SHOOTING OVER 87.9
GUS BONDHER AND SON,
COUNT BONDHER]

A. F. Tait, N.A. / N.Y. 1887 [LR] Canvas: 20 × 30

Painted by A. F. Tait / New York 1887 / Presented to the Wellington / Gun Club, Boston, May 1887 / by the artist. / Portrait of Mr. A. F. Adams / Ex. Pres. Wellington Gun / Club / Boston Mass. / & / Llewellen Setters, Gus / Bondher, & son, Count Bondher. / Field Trial Winnings / National Field Trial / 1885 / Bench Show Winning / Boston 1885–1886 / Bench Show Winning / Philadelphia 1885 / Bred by Purcel / Llewellen of / England / Imported by the late / D. C. Sanborn.

C.A. Mr Adams & 2 Setters. 20 × 30 for Wellington Gun Club. New England. Shooting Tournament Llewellen Setters. "Gus Bondher & Son Count Bondher." Portraits of Dogs & Adams—given by me as a Prize for best Amateur Shot They found the Frame (by Lewis, $40.00) I went to Boston to paint the Dogs.

This painting has been relined and the back inscription copied onto the new canvas, which probably accounts for the loss of the code letters.

Courtesy of Mr. Peter H. B. Frelinghuysen.

COLLEEN 87.10

[Unknown] [Unknown]: 14 × 22 [?]

[Unknown]

C.N. Colleen 14 × 22 Portrait of Red Setter for Mr. Leman. paid 150 no Frame.

DOG'S HEAD 87.11

[Unknown] [Unknown]: 10 × 12 [?]

[Unknown]

C.d. [1887] Dogs Head 10 × 12 Fullerton no Frame.

Sold together with 87.12.

DOG'S HEAD 87.12

[Unknown] [Unknown]: 10 × 12 [?]

[Unknown]

U.Z. Dogs Head 10 × 12 Fullerton $40.00 the two [including 87.11].

FOUND 87.13

A. F. Tait, N.A. / N.Y. '87 [LR] Canvas: 10 × 12

"Found" / A. F. Tait, N.A. / N.Y. 1887

U.C. Dogs Head 10 × 12 Leman for Mr. Cox paid—$20.00.

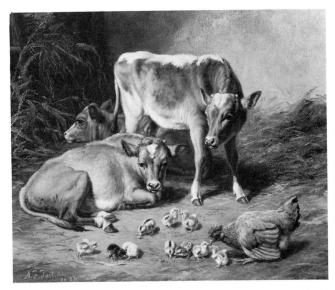

SOME OF OUR PETS 87.14

A. F. Tait, N.A. / N.Y. '87 [LL] Canvas: 10 × 12

"Some of our Pets" / A. F. Tait, N.A. / N.Y. / Jan. '87

[No AFT number; no Register entry]

[TERRIER WITH CAT] 87.15

A. F. Tait, N.A. / N.Y. '87 [LR] Canvas: 14 × 22

1887 / N.Y.

[No AFT number; no Register entry]

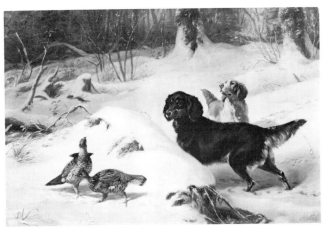

[A CLOSE POINT] 87.16

A. F. Tait, N.A. / N.Y. 1887 [LR] Canvas: 20 × 30

[Unknown]

[No AFT number; no Register entry]

This painting is a winter scene with two ruffed grouse, a Gordon Setter, and a Springer Spaniel. For another painting of the same size and title, also a winter scene, see 85.14.

Courtesy of Newhouse Galleries, Inc., New York, New York.

[DAN CATLIN'S BARN] 87.17

A. F. Tait [Unknown] Canvas: 18 × 24

Painted from nature 1887 [marked over 1872] / Finished in 1887 / Dan Catlins Barn / Long Lake / Hamilton Co. / Adirondacks N.Y. / A. F. Tait, N.A.

[No AFT number; no Register entry]

[LANDSCAPE WITH THREE CATTLE] 87.18

A. F. Tait, N.A. / N.Y. '87 [LR] Canvas: 16 × 12

[Exact wording unknown—inscribed on the stretcher "James M. Hart, N.A. and A. F. Tait, N.A."]

[No AFT number; no Register entry]

STARTLED 88.1

A. F. Tait, N.A. / N.Y. '88 [LR] Canvas: 21 × 30

"Startled." Racquette Lake / Hamilton Co. / N.Y. / Adirondacks / A. F. Tait, N.A. / N.Y. Jan 1888.

C. [Jan'y 9th. 1888] Deer Alarmed. 20 × 30 Jan'y 9th Anna Murray paid for—$300.00.

CATTLE 88.2

[Unknown] [Unknown]: 14 × 22 [?]

[Unknown]

C.U. Feb'y 4th Cattle. 14 × 22 Cow & 2 Calves sold at Mathews Sale for to pay $70.00 A [Artists'] Fund for nett $78.50.

WAITING FOR THE BARS 88.3
TO BE LET DOWN

A. F. Tait, N.A. / N.Y. '88 [LR] Canvas: 20 × 30

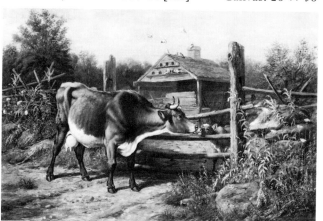

[Unknown]

C.M. [Feb'y 14th 1888] "Cow & Calf" 20 × 30 waiting for the Bars to be let down Schencks Sale & Dog's Head with Woodcock in his mouth [88.30] sold together for nett $147.12.

SUSPICIOUS ON RAQUETTE LAKE 88.4

[Unknown] [Unknown]: 22 × 29 [?]

[Unknown]

C.B. [March] "Suspicious" [Measurement 18½ × 25 crossed out] on Raquette Lake 22 × 29 March 8th 1888 [Crossed out: N.A.D. Ex. price] $350.00 not sold [Crossed out: sent to Schencks Sale May] 23rd not sold.

Exhibited at the National Academy of Design 63d Annual Exhibition, 1888, titled "Suspicious, on Racquette Lake, Adirondacks, N.Y.," priced at $350.00.

MATERNAL SOLICITUDE: 88.5
LET 'EM ALONE

[Unknown] [Unknown]: 18½ × 25 [?]

[Unknown]

C.E. Maternal Solicitude 18½ × 25 King Charles Dog & Hen & Chickens March 8 N.A.D. Exhibition price $400.00 Sold for $275.00.

Exhibited at the National Academy of Design 63d Annual Exhibition, 1888, titled "Maternal Solicitude, Let 'em Alone," priced at $400.00.

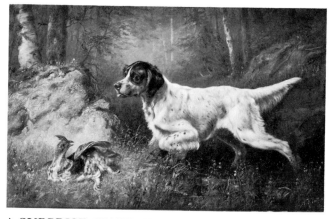

A SURPRISE: HARD HIT 88.6

A. F. Tait, N.A. / N.Y. '88 [LR] Canvas: 14 × 22

C.R. / A. F. Tait, N.A. / N.Y. / 1888 / "A Surprise" / "Hard Hit"

C.R. "Hard hit." good Painting English Setter & Wounded Grouse 14 × 22 [Crossed out: sent to Schencks Sale March] 30th/88 not sold & sent to Chicago Ex. by Wilmurt rejected came back & sold to Fullerton.

Sent to Schenck's sale with 88.7.

Collection of the Genesee Country Museum, Mumford, New York. Courtesy of Genesee Country Museum, Gallery of Sporting Art.

DOG'S HEAD AND WOODCOCK 88.7

[Unknown] [Unknown]: 10 × 12 [?]

[Unknown]

C.L. [1888] Dogs Head & Woodcock 10 × 12 sent to Schenck's sale with C.R. [88.6] (Mch 30th/88) for Apl 5 & 6. sold for $24.00.

A SURPRISE 88.8

[Unknown] [Unknown]: 14 × 22 [?]

[Unknown]

C.A. "A Surprise." Sumac tangle & Golden Rods English Setter & Red Do [ditto] the first with a Quail in his mouth, and another Quail in foreground flying. 14 × 22 Schencks Sale May 22, 23.

KELSO: A RED SETTER 88.9

[Unknown] [Unknown]: 10 × 12 [?]

[Unknown]

C.N. Red Setter's Head. Kelso 10 × 12 Presented to Jim B Blossom for a Birth day present.

[SETTER AND CHICKENS] 88.10

[Unknown] [Unknown]: 8 × 10 [?]

[Unknown]

C.d. Setter lying down & a lot of Chickens 8 × 10 eating out of a red Flower pot stand Schencks Sale May 22 & 23rd.

CATTLE 88.11

[Unknown] [Unknown]: 20 × 30 [?]

[Unknown]

U.C. Cattle. 20 × 30 for Dr Strachan Del'd.

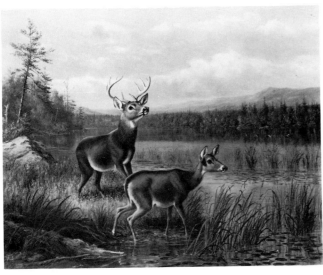

88.12

STARTLED: RACQUETTE LAKE 88.12

A. F. Tait, N.A. / N.Y. '88 [LL] Canvas: 24 × 29½

Startled / Racquette Lake / Adirondacks, N.Y. / U.U. / N.Y. 1888 / A. F. Tait, N.A.

U.U. Deer—Adirondacks 24 × 30 for Alex McDonald, Cambridge Mass to pay for monument at Woodlawn he called to see the Painting July 19th & was much pleased with it. the Monument (a large Block of Stone over 10 Tons[)] is now finished.

DEER 88.13

[Unknown] [Unknown]: 24 × 30 [?]

[Unknown]

U.M. Deer 24 × 30 [Crossed out: Painted for Miss Smith to pay for Milk & Cream from Sweet Clover Dairy] sent to Rob't Fullerton 206 Third Av as part Security for a loan of $150.00. August 1st/88 with U.N. [88.19] 20 × 30 Deer in a Frame now at his store.

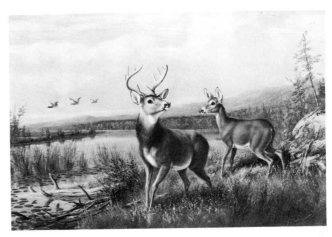

ON THE ALERT 88.14

A. F. Tait / N.Y. 88 [LR] Canvas: 24 × 36

Tait / "On the Alert" / Raquette Lake in 1888 / Adirondacks, N.Y.

U.B. Deer 24 × 36.

This painting has been relined and some of original inscription copied on the new canvas with the resulting loss of coding.

Courtesy of Kennedy Galleries, Inc., New York, New York.

[THE DOG IN THE MANGER] 88.15

A. F. Tait, N.A. / N.Y. '88 Board: 10 × 12

[Nothing on back by AFT]

U.E. [1888] Dog in Manger 10 × 12 2 Calves. Fox Terrier & Duck. Fullerton—$20.00.

Collection of the Tweed Museum of Art at the University of Minnesota, Duluth, Minnesota. Courtesy of Tweed Museum of Art.

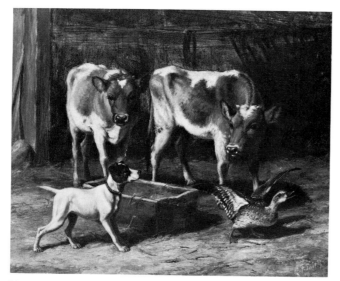

88.15

CALF AND CHICKENS 88.16

[Unknown] [Unknown]: 8 × 10 [?]

[Unknown]

U.R. Calf lying down & Chickens 8 × 10 Fullerton $20.00.

RED SETTER AND WOODCOCK 88.17

[Unknown] [Unknown]: 10 × 12 [?]

[Unknown]

U.L. Red Setter & Woodcock 10 × 12 Fullerton $20.00 Del'd & paid.

ON THE ALERT, ADIRONDACKS 88.18

A. F. Tait, N.A. / N.Y. 1888 [LR] Canvas: 24 × 30

U.A. / A. F. Tait / N.Y. 1888 / Long Lake / Adirondacks / N.Y.

U.A. 2 Deer & Ducks, Lake. 24 × 36 "Good Painting" [Crossed out: *N.A. Design Ex October 31st*] */88 sent to Artist Fund Sale Feb'y 26th/89. Frame $35.00* [In margin:] *Sold M'ch for $150.00 & Frame Extra.*

Exhibited at the National Academy of Design Autumn Exhibition, 1888, titled "On the Alert, Adirondacks," priced at $400.00.

DEER 88.19

[Unknown] [Unknown]: 20 × 30 [?]

[Unknown]

U.N. Deer. 20 × 30 [Crossed out: *N.A. Design Ex Oct'r 31st/88 Frame by Lewis & Son*] *To Fullertons friend pledged for loan of $150.00 (Frame by Lewis & Son) Note payable Nov'r 4th/88 dated July 1st/88. 4 mo returned.*

This painting was pledged as security, together with 88.13.

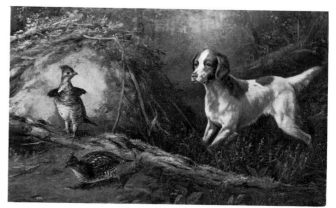

[SETTER ON POINT TO TWO GROUSE] 88.20

A. F. Tait, N.A. / N.Y. '88 [LR] Canvas: 14 × 20

[Unknown]

U.D. [1888] Dog & Grouse in Wood 14 × 22 Rob't Fullerton (Wh & Red English Setter).

[ENGLISH SETTER AND QUAIL] 88.21

[Unknown] [Unknown]: 14 × 22 [?]

[Unknown]

M.Z. Dog & Quail part of Photogravure 14 × 22 Rob't Fullerton Aug/88. Blk & Wh English Setter.

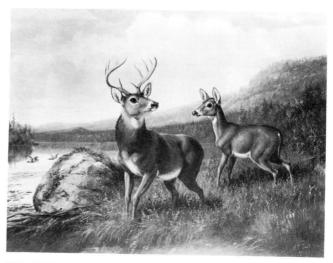

STARTLED 88.22

A. F. Tait, N.A. / N.Y. 1888 [LR] Canvas: 24 × 30

"M.C." / "Startled" / A. F. Tait, N.A. / N.Y. 88 / Adirondacks / N.Y.

M.C. Deer Buck & Doe 24 × 30 Painted for Miss Smith. Sweet Clover Farm fin August 15/88 del'd no Frame.

Courtesy of Kennedy Galleries, Inc., New York, New York.

THE TWINS 88.23

[Unknown] [Unknown]: 20 × 30 [?]

[Unknown]

M.U. "The Twins." Jerseys Orange Co N.Y. 20 × 30 Painted from Nature at Johnsons Orange Co N.Y. Two Cows & 2 Calves. Bar Gate Landscape &c N.A. Design Exhibition Oct'r 31st/88 price $500.00 Sold for $400.00.

Exhibited at the National Academy of Design Autumn Exhibition, 1888, titled "The Twins, Jerseys, Orange County, N.Y.," priced at $600.00.

A SUNNY CORNER 88.24

[Unknown] [Unknown]: 12 × 15 [?]

[Unknown]

M.M. [1888] "A Sunny Corner." Orange Co N.Y. 12 × 15 old shed in Farm Yard with Sheep & White Fowls. Painted from Nature at Johnsons Orange Co N.Y. (very good) price $225.00. Sold for $200.00.

Exhibited at the National Academy of Design Autumn Exhibition, 1888, titled "A Sunny Corner, Orange Co., N.Y.," priced at $225.00.

CALF AND CHICKENS 88.25

[Unknown] [Unknown]: 8 × 10 [?]

[Unknown]

M.B. Calf & Chickens 8 × 10 present to Fullerton for Favors [In margin:] *D. Horse.*

"D. Horse" is AFT's abbreviation for "Dead Horse."

WHO LEFT THE BARS DOWN 88.26

[Unknown] [Unknown]: 20 × 30 [?]

[Unknown]

M.E. "Good" "Who left the Bars down ["] 20 × 30 2 Cows & 2 Calves in Corn sent to Gills Art Store in Springfield Mass on Ex. returned Mch 13th/89 & sent to the Spring Ex at N.A.D. price $500.00.

Exhibited at the National Academy of Design 64th Annual Exhibition, 1889, titled "Who Left the Bars Down, Breeze Hill, Orange Co., N.Y.," priced at $500.00.

WELL 88.27

[Unknown] [Unknown]: 8 × 10 [?]

[Unknown]

M.R. "Well"—8 × 10 Scotch Colly with Calf (in Stall), two Fowls & some Chicks in yard. finished Dec'r 14th/88 Sold from Studio to Mr [blank] for $40.00 no Frame.

NOONDAY IN AUGUST 88.28

A. F. Tait, N.A. / N.Y. '88 [LR] Canvas: 20 × 30

Noonday in August / Orange Co. N.Y. / Painted by / A. F. Tait, N.A. / N.Y. 1888 / Geo. Kernicks / Arrow Farm / Johnsons / Orange Co. / N.Y.

M.L. [1888] "Noonday" in August Orange Co N.Y. 20 × 30

Farm Yard (Orange Co. N.Y. [)] Sheep & Fowls, and a Colly Dog by Stable Door. Finished carefully for Mrs A. Murray (nee Anna Dowdney) for a X'mass present paid $300.00 & $40 for Frame.

JEALOUSY 88.29

A. F. Tait, N.A. / N.Y. Canvas: 13½ × 20
'88 [LR]

"Jealousy" / A. F. Tait, N.A. / 107 E 75th St. N.Y. / 1888

[No AFT number; no Register entry]

SETTER RETRIEVING WOODCOCK 88.30

A. F. Tait, N.A. / N.Y. '88 [LR] Canvas: 10 × 14

[Relined; inscription, if any, lost]

[No AFT number; no Register entry]

Originally sold with 88.3 for $147.12.

SHEEP AND FOWLS IN A BARN YARD 89.1

[Unknown] [Unknown]: 20 × 30 [?]

[Unknown]

C. [code *M.A.(?)* crossed out] *This is one of my best Pictures. 20 × 30 Sheep & Fowls in Barn Yard (Arrow Farm) Orange Co N.Y. Sheds and Dog in Barn Door painted for Mr Billings (Diamonds) and Del'd at Dacota Flats. Feb'y 23rd / price $400.00 sent home Feb'y 23rd very satisfied with it Picture $400.00 Frame to be $40.00 got a cheque for $500.00 from Mrs Billings she is very generous.*

THE MOTHERS: HOME AGAIN 89.2

A. F. Tait, N.A. / N.Y. Canvas: 24½ × 35¼
'89 [LR]

"The Mothers" / "Home again" / Orange Co. N.Y. / A. F. Tait, N.A. / N.Y. / 1889 / U. / Z / From Arrow Farm / Johnson's / Orange Co. N.Y.

U. [code *M.N.(?)* crossed out] *Cattle—Maternal Anxiety 24 × 36* [Crossed out: *"The Mothers: Home again"*] *Orange Co N.Y. (Johnsons Arrow Farm)* [Crossed out: *Artist Fund Sale sent down Feb'y 26th/89 finished Feb'y 25th/89 Frame $35.00.*] *returned not sold at A Fund Schencks Sale April 20th/89.*

In AFT's Register his numbering went awry, which may account for the coding discrepancies between the Register and the back of the picture. In addition, AFT crossed out the title shown in quotation marks in the Register entry but inscribed the title on the back of the painting.

Collection of the Newark Museum, Newark, New Jersey.

MATERNAL ANXIETY: DON'T 89.3

[Unknown] Panel: 8 × 10 [?]

[Unknown]

M. [1889] "Now dont" ["]Springtime" 8 × 10 Two Lambs on Rock & old Hen & Chickens Apple Blossoms Hen going to fly at Lambs—very good on Panel. price $200.00 [Crossed out: N.A. Design Ex. Mch 13th/89] Ret'd Frame by Lewis $25.00. sold to Lewis for $25.00 in frame Feb'y/90 by Emma.

Exhibited at the National Academy of Design 64th Annual Exhibition, 1889, titled "Maternal Anxiety, Don't," priced at $175.00.

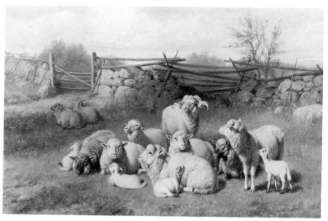

R. Sheep & Lambs (Panel) 14 × 22 "A Quiet Time." "Spring." Orange Co N Y price $300.00. A.A. Asso'n with little Pets. [89.5] April 19th/89 sold for $250.00.

Courtesy of Sotheby Parke Bernet, Agent: Editorial Photocolor Archives, New York, New York.

See 89.10.

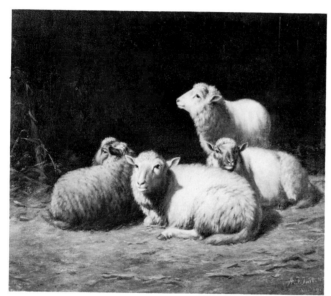

A QUIET TIME 89.4

A. F. Tait, N.A. / N.Y. Canvas
'89 [LR] on masonite: 9½ × 11½

[Rebacked, inscription, if any, lost]

B. [written over code M] Sheep. "A Quiet Time" 10 × 12 Frame by Lewis price $25.00 price [$175 crossed out] 200. N.A. Design Ex Mch 13th/89 Sold for $100.00. paid me by N.A.D. May 15th/89.

Exhibited at the National Academy of Design 64th Annual Exhibition, 1889, titled "A Quiet Time," priced at $200.00.

LITTLE PETS 89.5

A. F. Tait, N.A. / N.Y. '89 [LR] Canvas: 10 × 14

[Card on back of frame states, " 'Little Pets' / A. F. Tait, N.A. / 107 East 75th St, N.Y. / Price $150."]

E. Little Pets. (Chickens[)] 10 × 14 in handsome Frame price $150.00. Ex. of Am A Asso'n April 19th/89 sold for $100.00 bad.

Offered along with 89.6 at American Art Association sale for $300.00.

A QUIET TIME: SPRING 89.6

[Unknown] Panel: 14 × 22 [?]

[Unknown]

NEW ARRIVALS 89.7

[Unknown] [Unknown]: 10 × 14 [?]

[Unknown]

L. [1889] "New Arrivals" 10 × 14 Group of Chickens. Painted for Mrs Chester Billings "The Dacota," West 72nd St. N.Y del'd May 13th/89 and paid for May 18th $150.00.— Frame by Lewis Velvet Shadow Box $25.00.

MIDSUMMER 89.8

A. F. Tait, N.A. / N.Y. [Unknown]: 20 × 30 [?]
'89 [LR]

[Unknown]

A. "Midsummer" 2 Cows in River 20 × 30 Gardnerville. Johnsons Orange Co N.Y. Orgies Ex ret'd [Added over erased line:] sent to Gills Ex Jan'y/90 with D./90 [90.1].

INNOCENTS 89.9

[Unknown] [Unknown]: 10 × 14 [?]

[Unknown]

N. [code N D (?) crossed out] "Innocents" 10 × 14 Group of Chickens & cob of Corn finished Sep'r 30th and sent to Am Art Asso'n for Sale $150.00 Nov 28th sold for 100.00 Frame by Lewis cost 20.00.

A QUIET NOOK 89.10

[Unknown] [Unknown]: 10 × 14 [?]

[Unknown]

D. A Quiet Nook. Ducks & Ducklings 10 × 14 sold by Am Art Asso'n Nov'r 28th for $100.00 Frame by Lewis. price $20–25 with No. R. [89.6].

Exhibited at the National Academy of Design Autumn Exhibition, 1889, titled "A Quiet Nook By The Way, Westchester Co., N.Y.," priced at $300.00.

MILKING TIME: COMING HOME 89.11

[Unknown] [Unknown]: 10 × 14 [?]

[Unknown]

C.C. [1889] Milking time Coming home 10 × 14 Orange Co N.Y. N A Design Nov'r Ex price $200 refused $100.00 ret'd not sold. sold to Lewis for $50.00 & bought Emma's Writing Desk & Table—good.

Exhibited at the National Academy of Design Autumn Exhibition, 1889, titled "Milking Time, Orange Co., N.Y.," priced at $200.00.

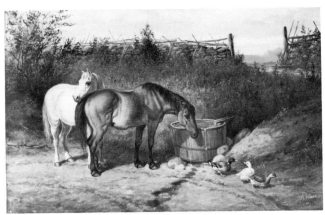

[HORSES IN PASTURE] 89.12

A. F. Tait, N.Y. / '89 [LR] Canvas: 13½ × 21¾

[Relined; inscription, if any, lost]

C.U. [Entire entry crossed out:] 2 Horses at a Trough by the Roadside (and Ducks) 14 × 22 N.A. Design Nov'r Ex—price $300.00. gave this to Mr Boyle for accomodations [In margin:] D Horse.

"D. Horse" is AFT's abbreviation for "Dead Horse." From the register entry and the lack of a record of hanging at the National Academy of Design, it seems that the picture never was exhibited and therefore was a complete loss—a "Dead Horse."

Collection of The Baltimore Museum of Art, Baltimore, Maryland. Courtesy of The Baltimore Museum of Art, bequest of Elise Agnus Daingerfield, the Daingerfield Collection.

AN AMERICAN FARM YARD 89.13

[Unknown] [Unknown]: 20 × 30 [?]

[Unknown]

C.M. An American Farm Yard 20 × 30 Sheep Fowls & Ducks (Trough &c) good. from Curriers near Johnsons Orange Co N.Y. N.A. Design Nov'r Ex. price $500.00 sold for $400.00 by Galt.

Exhibited at the National Academy of Design Autumn Exhibition, 1889, titled "An American Farm Yard, Orange Co., N.Y.," priced at $500.00.

ON GUARD 89.14

[Unknown] [Unknown]: 14 × 22 [?]

[Unknown]

C.B. "On Guard". (very Good) 14 × 22 Colly Dog & Sheep. Gateway old stone fence Corn field in background. Am Art Asso'n Nov'r 19th/89. I took it down Frame by Lewis sent down next day Price $350.00. good Pic sold to C. J. Hood Apothicanus [Apothicarius(?)] Lowel[l] Mass for $250.00, nett $205.00—15 pr ct off.

WAITING TO BE LET IN 89.15

[Unknown] [Unknown]: 10 × 14 [?]

[Unknown]

C.E. [1889–1890] "Waiting to be let in" 10 × 14 Orange Co N.Y. Colly Dog, Sheep & Lambs [In margin:] Good.

OUR LITTLE PETS 89.16

A. F. Tait, N.A. / N.Y. 1889 [LR] Board: 10 × 15

"Our Little Pets" Christmas 1889 / A. F. Tait

C.R. "Our Little Pets" 10 × 15 Chickens. sold at A A Asso'n.

[THE DASH FOR LIBERTY] 89.17

A. F. Tait / 1889 [LR] [Unknown]: 6 × 11¼

[Unknown]

[No AFT number; no Register entry]

A chromolithograph was published by L. Prang, 1889, titled "The Dash For Liberty." Size, front signature, and date are taken from the lithograph. This painting sold at American Art Association sale, February 16, 1892, titled "The Dash For Liberty."

[QUAIL AND YOUNG] 89.18

A. F. Tait / N.Y. '89 [LR] Canvas: 9½ × 13½

[Relined; inscription, if any, lost]

[No A.F.T. number; no Register entry]

See 58.59 for a similar painting.

REPOSE: THE SUNNY SIDE OF THE YARD 90.1

[Unknown] [Unknown]: 14 × 22 [?]

[Unknown]

D.90. [1890] Sheep in Shed (Sunny) 14 × 22 "Repose" "(The Sunny Side of the Yard)" sent to Gill's Ex. Springfield Mass Jan'y 15th/90 with a/89 [89.8] sold for $200.00 nett rec'd ch'q Mch 11th/90.

JUST LET OUT 90.2

A. F. Tait [LR] Canvas: 19 × 28½

"Just let out" / A. F. Tait, N.A. / N.Y. / '90 / C.Z.

C.Z. Sheep. "Just let out" 20 × 30 Sheep & Fowls. shed for boiling feed. Wall &c. sent to Am Art Ass'n for Sale—returned sent to N.A.D Ex. Mch 12th/90 price $500.00 sold for $250.00.

Exhibited at the National Academy of Design 55th Annual Exhibition, 1890, titled "Just Let Out, Orange Co., N.Y.," priced at $500.00.

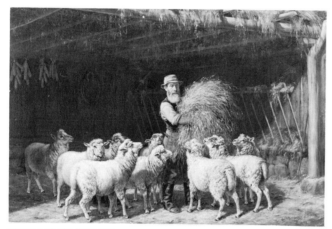

FEEDING TIME 90.3

A. F. Tait, N.A. / N.Y. '90 [LR] Canvas: 24 × 36

[Unknown]

C.U. [1890] "Feeding Time" 24 × 36 Sheep & man (Major Stewart of Garnerville Orange Co N Y). Dark Shed as background. man with Hay in his arms (a good Picture) finished March 12th/90 and sent to the N.A.D. Spring Ex. Lewis Frame price $750.00 sold for $250.00.

Exhibited at the National Academy of Design 55th Annual Exhibition, 1890, titled "Feeding Time, Orange Co., N.Y.," priced at $750.00.

THERE YOU ARE 90.4

A. F. Tait, N.A. / N.Y. [LR] Canvas: 20¼ × 30

[Unknown]

C.M. "There you are" 20 × 30 Sheep in a Corn Field. Colly Dog on the wall in background. Lewis Frame $31.00 to Am Art Asso'n May 2nd/90 on Ex & Sale sent to N.A.D. & sold for $200.00 less com.

Exhibited at the National Academy of Design Autumn Exhibition, 1890, titled "There You Are, Orange Co., N.Y.," priced at $400.00.

GOING TO PASTURE 90.5

A. F. Tait, N.A. / N.Y. [LR] Canvas: 20 × 30

C.B. "Going to Pasture" / Putnam Co. N.Y. / a country

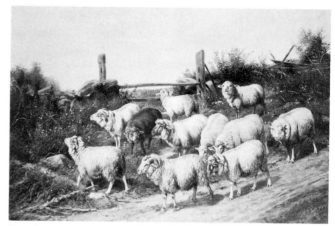

Road near Carmel / A. F. Tait, N.A. / 53 E. 56th St. N.Y.

c.b. "Coming Home" Sheep coming down a Road 20 × 30 in Putnam Co N.Y. (Hazen's near Carmel])] Painted in August & Sept'r. from Nature Fall N.A.D. Ex & returned & sent to Boston Art Club with 2 of Phillipoteaux returned sent to Schencks Sale Mch 12th & 13th.

Exhibited at the National Academy of Design Autumn Exhibition, 1890, titled "Going To Pasture," priced at $500.00.

GOING TO PASTURE 90.6

[Unknown] [Unknown]: 14 × 22 [?]

[Unknown]

C.R. [90] Going to Pasture Painted from Nature Sheep. a Country Lane in Putnam Co N.Y. 14 × 22 near Carmel [Following erased: sent to Am A Asso'n for sale & then to Lotos Club.]

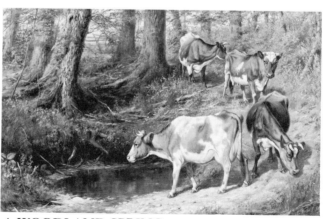

A WOODLAND SPRING 90.7

A. F. Tait, N.A. / N.Y. [LR] Canvas: 15 × 22

[Unknown]

C.A. "A Woodland Spring" 15 × 22 4 Cows coming down a path to drink a very carefully finished Painting sent to Fall Ex N A D Nov'r 3rd & Sold for $200.00.

Exhibited at the National Academy of Design Autumn Exhibition, 1890, titled "The Woodland Spring," priced at $300.00.

MOTHERLY PROTECTION 90.8

A. F. Tait, N.A. / N.Y. [LR] [Unknown]: 10½ × 13½

[Unknown]

C.N. "Motherly Protection." 10 × 14 Hen, Tiny (dog) & chickens Painted for Prang—accepted and paid for $200.00 Oct'r.

Delivered to Prang with 90.9. A chromolithograph was published by L. Prang, 1891, titled "Take Care." Sold American Art Association sale, February 16, 1892.

See 90.13.

CLUCK, CLUCK 90.9

A. F. Tait, N.A. [LR] [Unknown]: 10½ × 13½

[Unknown]

C.D. "Cluck" ["]Cluck" 10 × 14 Hen & Chickens Prang & Co Boston Paid for $200.00 del'd October with No. C.N. [90.8].

A chromolithograph was published by L. Prang, 1891, titled "Kluck, Kluck." Sold American Art Association sale, February 16, 1892.

See 90.13.

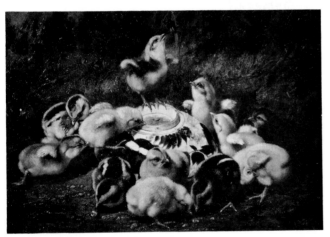

CHICKENS 90.10

A. F. Tait, N.A. / N.Y. '90 [LR] Panel: 10 × 14

[Relined; inscription, if any, lost]

U.C. "Chickens" round a blue Bowl 10 × 14 Mrs Thompson "The Osborn" price $150.00 & Frame 25. $175.00 paid Dec'r 13th/90 Handsome Frame Plush Box & Glass.

Courtesy of Mr. and Mrs. George Arden.

GROUP OF SHEEP 90.11

[Unknown] [Unknown]: 8 × 10 [?]

[Unknown]

U.U. Group of Sheep 8 × 10 Mrs Thompson "The Osborn" Paid Dec'r 13th/90 Paid $125.00 with Frame & Plush Shadow Box & Glass.

LADY HILARY 90.12

[Unknown] [Unknown]: 12 × 16 [?]

[Unknown]

U.B. [1890–91] "Lady Hilary" X'mass 12 × 16 belongs to Mr Franklyn 15 E 56th St. N.Y. painted for Mr P. Leman. paid $100.00 without Frame.

See 91.6.

[THE INTRUDER] 90.13

A. F. Tait N.A. [LL] [Unknown]: 6 × 11½ [?]

[Unknown]

[No AFT number; no Register entry]

A chromolithograph was published by L. Prang, 1891, titled "The Intruder." Sold American Art Association sale February 16, 1892. Size taken from sale record. Assumed to date from 1890 and be related to other Prang subjects, 90.8 and 90.9.

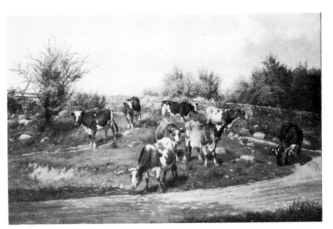

MILKING TIME 91.1

A. F. Tait / N.Y. '91 [LL] Canvas: 20½ × 30

C.E. / "A Country Road" / Opposite Our Home / Summer 1890. / "Comig [sic] Home" / Milking Time / A. F. Tait, N.A. / N.Y.

C.E. "Milking Time". Cows down a Cross Road 20 × 30 opposite Hazens near Carmel Putnam Co. N.Y. Painted from Nature. finished March 12th 91—and sent to N.A. Design Ex March 16th/91 ret'd and gave to Jim Boyle to pay for Loan of $300.00 and interest and I got my Wifes Diamonds back.

Begun in 1890 but not finished and dated until 1891. Exhibited at the National Academy of Design 66th Annual Exhibition, 1891, titled "Milking Time, Carmel, N.Y.," priced at $400.00.

MILKING TIME 91.2

A. F. Tait, N.A. / N.Y. '91 [LR] Canvas: 14 × 22

C.L. Country Road / Painted from Nature / Summer of 1890 / A. F. Tait, N.A. / N.Y. 91

C.L. *"Milking Time" A Country Road 14 × 22 in Putnam Co Near Carmel N.Y. Painted from Nature sent to Gills Springfield Mass.*

Begun in 1890 but not finished and dated until 1891.

GROUP OF SHEEP 91.3

[Unknown] [Unknown]: 8 × 10 [?]

[Unknown]

U.M. [1891] Group of Sheep 8 × 10 Frame Plush Shadow Box & Glass Gill Springfield Ex Jan'y/91 price nett 125.00 sold nett $100 March 91.

GROUP OF SHEEP 91.4

[Unknown] [Unknown]: 8 × 10 [?]

[Unknown]

U.E. 1891 Group of Sheep 8 × 10 Frame Plush Shadow Box & Glass sent to Gills Ex Springfield Jan'y 91—price nett 125.00 Sold for $100 nett March 91.

REPOSE 91.5

[Unknown] Panel: 14 × 22 [?]

[Unknown]

C. [year *1890* erased] *Sheep Repose 14 × 22 on a Panel (W. & Newton's) Sent to Am Art Asso'n Ret'd and sent to N.A. Design Ex Mch 16th/91 ret'd & sent to Gill Springfield & sold by him nett $150.00 rec'd cheque Aug 5th/91.*

Begins 1891 coding. Exhibited at the National Academy of Design 66th Annual Exhibition, 1891, titled "Repose," priced at $400.00.

WHO ARE YOU? 91.6

A. F. Tait, N.A., '91 / N.Y. [LR] Canvas: 14 × 22

U. 91x / "Who Are You" / A. F. Tait, N.A. / N.Y. / "Lady Hilary" / and her new Chickens.

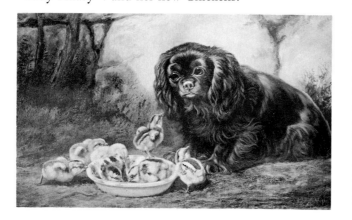

U. *"Who Are You" 14 × 22 King Charles Spaniel & Chickens (Lady Hillery). sent to N.A. Design Ex March 16th/91 sold to Ed Schenck & Frame $100.00.*

Compare "Lady Hilary" (90.12). Exhibited at the National Academy of Design 66th Annual Exhibition, 1891, titled "Who Are You?," priced at $325.00.

SETTER'S HEAD 91.7

[Unknown] [Unknown]: 16 × 24 [?]

[Unknown]

U/A. Dogs Head (Setter) 16 × 24 for Herbert H. Sidman to pay for Photos in 1890 at Hazene.

REPOSE 91.8

[Unknown] [Unknown]: 14 × 22 [?]

[Unknown]

M. [1891] Sheep. "Repose" 14 × 22 a group lying down 2 standing a good Picture. took from Mch 17th to 26th. sent to Schenck's sale Mch 27th/91.

SHEEP 91.9

A. F. Tait, N.A. / N.Y. 1891 [LR] Millboard: 8 × 12

[Unknown]

B. "Sheep" 8 × 12 sent to Schencks Sale June 5th/91 limit $75.00.

THE TWINS 91.10

A. F. Tait, N.Y. '91 [LR] Canvas: 16 × 24

"E" 1891 / "The Twins" / A. F. Tait, N.A. / N.Y.

E. *"The Twins" 16 × 24* [unknown figure (?)] *Cow & Two Calves. finished Oct'r 4th/91. sold to Herbert H. Sidman for $175.00 with (handsome Frame. $35.00 by Lewis) paid for Oct'r 6th/91 Delivered by Express Oct'r 14th/91 to Mr Canun No 20 West 83rd St sent to N.A.D. Ex Oct'r 31st/91 for H H.S. price $275.00.*

Exhibited at the National Academy of Design Autumn Exhibition, 1891, titled "The Twins, Orange Co., N.Y.," priced at $275.00.

THE RESCUE 91.11

[Unknown] [Unknown]: 20 × 30 [?]

[Unknown]

R. "The Rescue." after the Blizzard 20 × 30 Sheep in Snow & old man & Dog sent to N.A.D. Ex Oct'r 31st/91.price $500.00 not sold. sold to Edw'd Schenck Jan 23rd/92 for $125.00 without Frame very cheap Sold to Mr Hillas of Fidelity Co 146 B'way for $200.00 for Schenck with Frame sent home.

Exhibited at the National Academy of Design Autumn Exhibition, 1891, titled "The Rescue," priced at $500.00.

ON GUARD 91.12

[Unknown] [Unknown]: 16 × 24 [?]

[Unknown]

L. [1891] On Guard. 16 × 24 Sheep—Dog & Fowls. sent to N.A. Design Ex Nov'r 2nd/91 price $300.00.

Exhibited at the National Academy of Design Autumn Exhibition, 1891, titled "On Guard," priced at $300.00.

SHEEP AND LAMBS 91.13

[Unknown] [Unknown]: 8 × 12 [?]

[Unknown]

A. Sheep & Lambs 8 × 12 sold to Ed Schenck in Studio for $25.00 del'd by Emma Nov'r 24th/91 Paid.

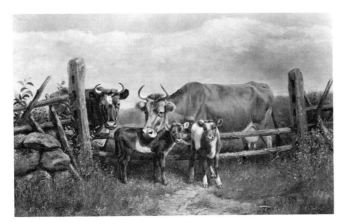

MOTHERLY AFFECTION 91.14

A. F. Tait, N.A. / N.Y. '91 [LR] Canvas: 20 × 30

[Relined; inscription, if any, lost]

N. ["]Motherly Affection" 20 × 30 2 Cows & 2 Calves. good Picture Sold to Edw'd Schenck for $150.00 with Frame Jan'y 23rd/92. very Cheap.

Courtesy of Mr. and Mrs. George Arden.

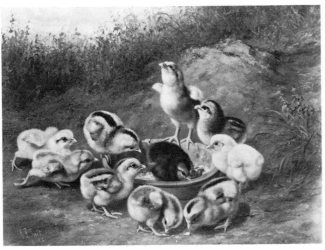

92.1

LITTLE PETS 92.1

A. F. Tait, N.A. / N.Y. '92 [LR] Canvas: 12 × 16

D. Little Pets / A. F. Tait, N.A. / N.Y.

D. Chickens. Little Pets 12 × 16 to Gills Ex Jan'y 92 sold with D A [92.2] Paid for Apr/92 nett both $225.00.

Probably begun in 1891 and listed in the 1891 Register series following code *N* (91.14).

COMING HOME 92.2

A. F. Tait, N.A. [LR] Panel: 12¼ × 18

D.A. / Coming Home / A. F. Tait, N.A. / N.Y. / 91–92.

D.A. Sheep "Coming Home" 12 × 16 To Gills Ex Jan'y 92.

This painting sold with 92.1 for $225.00 for the two. Illustrated in *Gill's Catalogue* of *15th Annual Exhibition,* 1892, priced at $225.00. Probably begun in 1891.

See 92.1.

GORDON SETTER'S HEAD 92.3

A. F. Tait, N.A. / N.Y. '92 [LR] Panel: 21 × 12½

[Nothing on back]

C. [1892] 21¼ × 12¾ Gordon Setter's Head & dead Grouse in his mouth. Painted for Frank P. Osborns Yacht on panel from "Beaumont" to be $150.00. Paid.

One of a pair with 92.4.

IRISH WATER SPANIEL'S HEAD 92.4

A. F. Tait, N.A. / N.Y. / Panel: 21 × 12½
'92 [LR]

[Nothing on back]

U. Irish Water Spaniel's Head. with dead Canvas Back duck in his Mouth 21½ × 12¾ for F. P. Osborn's Yacht on Panel Painted from Nature. "Romeo" to be $150.00.without Frame Paid.

One of a pair with 92.3.

COWS 92.5

A. F. Tait / N.Y. 1892 [LR] Canvas: 18 × 27

A. F. Tait, N.A. / N.Y. 1892

M. Cows. 18 × 27. sold to Mr. Bloomingdale. nett no Frame $200.00 nett.

THE FIRST ARRIVAL: 92.6
EARLY SPRING

[Unknown] [Unknown]: 20 × 30 [?]

[Unknown]

B. An "Early Arrival". early Spring 20 × 30 N A Design Spring Exhibition. Sheep & one Lamb reposing. Price $450.00.

Exhibited at the National Academy of Design 67th Annual Exhibition, 1892, titled "The First Arrival, Early Spring," priced at $450.00.

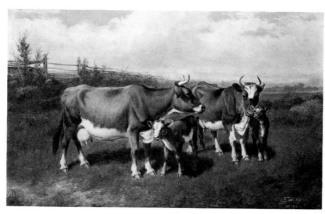

THE RIVAL MOTHERS 92.7

A. F. Tait, N.A. / N.Y. '92 [LR] Canvas: 18¼ × 27½

E 92 A. F. Tait, N.Y.

E. [Words *Envy or* (?) crossed out] *Rival Mothers. 18 × 27 2 Cows & two Calves. repainted April 9th/92 and paid for Schenck no Frame $150.00.*

Courtesy of Mr. and Mrs. Fred D. Bentley, Sr., and Mr. and Mrs. J. Alan Sellars.

REPOSE 92.8

[Unknown] [Unknown]: 16 × 27 [?]

[Unknown]

R. [1892] *Repose Two Cows & 2 Calves. 18 × 27 Painted for Schenck & paid April 9th/92 $150.00. no Frame.*

CHICKENS 92.9

A. F. Tait, N.A. / N.Y. '92 [LL] Canvas: 12 × 16

[Nothing on back]

L. *Chickens 12 × 16 sent to Mr E C Waller Chicago in handsome Frame Velvet Shadow Bx & Glass sent by Lewis and I paid xpress $150.00.*

SHEEP AND LAMB 92.10

[Unknown] [Unknown]: 14 × 22 [?]

[Unknown]

A. *Sheep & Lambs coming down Path to drink 14 × 22 sent to Mr Ed C Waller Chicago Frame Velvet Shadow Box & Glass. $250.00.*

SPANIEL AND CANVAS BACK DUCK 92.11

[Unknown] [Unknown]: 12 × 16 [?]

[Unknown]

N. *Dog Spaniel & Canvass Back. 12 × 16 Exchanged it to Mr Maasch Dentist for work no Frame July.*

REPOSE 92.12

[Unknown] [Unknown]: 14 × 22 [?]

[Unknown]

D. *Repose 14 × 22 Cows in Pasture Sent to Schencks Sale Oct'r 14th/92 ret'd not sold sent again Nov 25th.*

CHICKENS 92.13

[Unknown] [Unknown]: 10 × 14 [?]

[Unknown]

C.Z. [1892] *Chickens (good) 10 × 14 in Frame velvet Shadow Box & Glass sent to Mr John Barkley New Orleans L.A. bought by Mr Cullom, Geo Richardson's Brother in Law price to be $150.00. sent off by Morgan Line S.S. Co Oct'r 17th/92. by Lewis & Son paid Nov'r 3rd/92 O.K.*

SHEEP IN REPOSE 92.14

[Unknown] [Unknown]: 18 × 27 [?]

[Unknown]

C.C. *Sheep in Repose. 18 × 27 Lewis Frame for Mr W. R. Smith 112 Rooney St. Brooklyn Sold & paid $250.00 Oct'r/ 92.*

GOOD FRIENDS 92.15

[Unknown] [Unknown]: 20 × 30 [?]

[Unknown]

C.U. *"Friends" two Cows one licking the other 2 Cows lying in background 20 × 30 Lewis Frame & velvet Shadow Box price 400.00* [Crossed out: *N.A. Design Nov'r 1st/92*] *Returned Dec'r 19th not sold. and sold Jan'y 1st/93 to Robt J. Hilles, West Hoboken Fidelity & Casualty Co 146 Bway del'd Jan 4th/93.*

Exhibited at the National Academy of Design Autumn Exhibition, 1892, titled "Good Friends," priced at $400.00.

THE MOTHERS 92.16

[Unknown] [Unknown]: 12 × 16 [?]

[Unknown]

C.M. *"The Mothers" 12 × 16 Sheep & Lambs price $175.00* [Crossed out: *N.A.D. Nov'r 1st/92*] *ret'd not sold Dec'r 19th gave this to Bert Sidman in Exchange for the work he did for me in Photos.*

Exhibited at the National Academy of Design Autumn Exhibition, 1892, titled "The Mothers," priced at $275.00.

THE NEAREST WAY HOME 92.17

[Unknown] [Unknown]: 14 × 22 [?]

[Unknown]

C.B. [1892] *The nearest way Home 14 × 22 Sheep coming*

down Path. price $250.00 N A Design Ex Nov'r 1st Lewis Frame. Ret'd not sold Dec'r 19/92 and I then sold it to Jas B. Cousins 197 Grand St. paid for & del'd same day $150.00 (Sol Estes) Carman to 498 Fulton St. Brooklyn.

Exhibited at the National Academy of Design Autumn Exhibition, 1892, titled "The Nearest Way Home," priced at $250.00. This painting is very similar to 93.3.

[SHEEP IN REPOSE] 92.18

[Unknown] [Unknown]: 14 × 22 [?]

[Unknown]

C.E. Repose. Sheep. 14 × 22 Jas D. Gill. to Worcester for sale price $250.00 sent off Nov'r 23rd/ in velvet Shadow Box netted $165.00 Lewis Frame $24.50 with Velvet Shadow Box Sold.

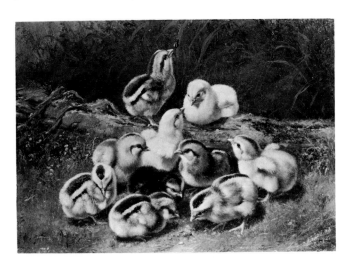

LITTLE PETS 92.19

A. F. Tait, N.A. / N.Y. '92 [LR] Panel: 10 × 14

C.R. / Little Pets / 53 East 56th St. N.Y.

C.R. Chickens. 10 × 14 Lewis Frame sent to Jas D Gill Worcester Mass for Ex. sold nett $150.00.

Exhibited and sold at Gill's 16th Annual Exhibition, 1893, priced at $175.00.

JEALOUSY 92.20

[Unknown] Canvas: 18¼ × 27

C.L. / "jealousy" / A. F. Tait, N.A. / 53 E 56th St / N.Y. / Dec'r 8th / 92.

C.L. Jealousy 2 Cows & 2 Calves 18 × 27 To Schencks Sale Dec 10th/92. Del'd by Emma limit $150.00 sold nett 155 sold.

Bracketed with 92.21 and together sold for $215.75.

SPRING PETS 92.21

[Unknown] [Unknown]: 10 × 12 [?]

[Unknown]

C.A. Chickens "Spring Pets" 10 × 12 To Schencks Sale Dec'r 12th/92 [Delivered] by Emma limit $100.00 sold net 95. Sold.

Bracketed with 92.20 and together sold for $215.75.

SPANIEL AND CANVAS BACK DUCK 92.22

[Unknown] [Unknown]: 12 × 16 [?]

[Unknown]

C.N. [1892] Spaniel & Canvass Back 12 × 16 Dog with dead Duck in mouth retrieving. finished Dec'r 20th/92 sold in Hanover Club nett $125.00.

A SUNNY NOOK 93.1

[Unknown] [Unknown]: 10 × 12 [?]

[Unknown]

C. [1893] "A Sunny Nook". nett $100.00 10 × 12 Group of Sheep sold to Jas D Gill. from the Studio Frame by Lewis $24.00. Sent of [?] by Wilmurt Jan'y 16.

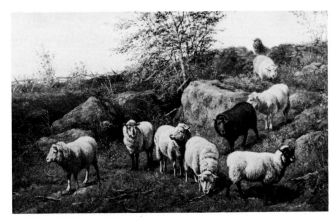

THE GAP IN THE FENCE 93.2

A. F. Tait, N.A. 93 [LL] Canvas: 14 × 22

U. 1893 / "The Gap in the Fence" / A. F. Tait, N.A. / N.Y. 53 E. 56th St.

U. "The Gap in the France" 14 × 22 Sheep coming down a bank thru a Gap in a Wall. Gill Springfield Sold nett $165.00 Frame by Lewis.

Collection of The Adirondack Museum, Blue Mountain Lake, New York. Courtesy of The Adirondack Museum.

NEAREST WAY HOME 93.3

[Unknown] [Unknown]: 14 × 22 [?]

[Unknown]

M. (Nearest way home) Sheep coming home (like C.B. 92) [92.17] 14 × 22 Painted for Mr D L Hayes 32 W. 47th St NY. paid for Jan'y 31st & sent home by Janitor Feb'y 1st price $175.00. Frame included.

GROUP OF SHEEP 93.4

[Unknown] [Unknown]: 12 × 16 [?]

[Unknown]

B. *[1893] Group of Sheep. finished Feb'y 3 12 × 16 (well finished) Frame Lewis sent to Gill Springfield Feb'y 4th nett $150.00. sold.*

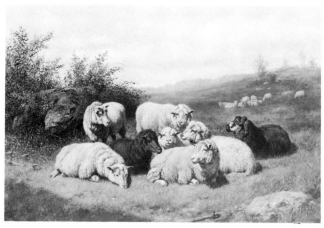

A SUNNY SPOT IN THE PASTURE 93.5

A. F. Tait, N.A. / N.Y. 93 [LR] Canvas: 18 × 27

(E) "A Sunny spot in the Pasture" / A. F. Tait, N.A. / 53 E 56th St / N.Y. [and stamped LL] A. F. Tait.

E. *"A Sunny spot in the Pasture" 18 × 27 (finished Feb'y 14th) a Group of Sheep "good" sent to Hanover Club Brooklyn for Ex Feb'y 16th sold—nett $200.00 to Club.*

DROWSY NOON-TIDE 93.6

[Unknown] [Unknown]: 12 × 16 [?]

[Unknown]

R. *"Drowsy noon tide" 12 × 16 Sheep lying down &c sent to Gill Springfield Feb'y by Express to be nett [$150.00 crossed out] $125.00.*

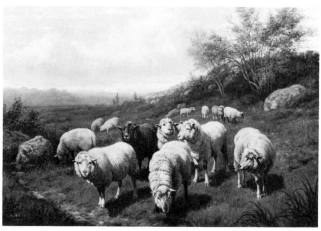

MIDSUMMER 93.7

A. F. Tait, N.A. / N.Y. '93 [LL] Canvas: 18¼ × 27

A. F. Tait, N.A. / 53 E. 56th St / N.Y. / "L" 1893 / "Midsummer" / Orange Co / N.Y. / A. F. Tait

L. *"Midsummer" "good" 18 × 27. Orange Co N.Y. finished Mch 5th/93 & sold same day to Mr Trask. Springfield Mas's for $350.00 and Frame to be sent to Gill and I allow him $50.00 commission Sold I present Gill Pic 14 × 22 [93.8] instead of Com.*

HAVING A QUIET TIME 93.8

A. F. Tait, N.A. / N.Y. 93 [LR] Canvas: 14 × 22

A. 1893 / "Having a quiet time" / A. F. Tait, N.A. / 53 E 56th St / New York

A. *[1893] Sheep. Repose 14 × 22 Painted for Jas D Gill Springfield Mass instead of commission on Trasks Sale No. M [actually L, 93.7] finished April 1st worth $200.00.*

[GROUP OF SHEEP RESTING] 93.9

[Unknown] [Unknown]: 10 × 14 [?]

[Unknown]

N. *Sheep. (a Group) resting 10 × 14 Group of Sheep. [Erased: one of my best works.]*

Erased remark was probably intended for 93.11, where it again appears.

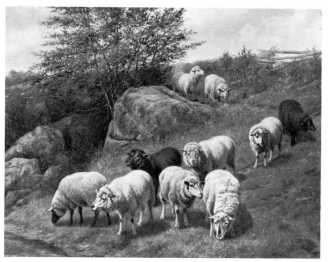

THE SPRING HEAD: APRIL 93.10

A. F. Tait, N.A./N.Y. Canvas: 17¾ × 26½
93 [LR]

The Spring Head / Putnam Co. N.Y. / A. F. Tait. N.A. / 53 E 56th St. N.Y. / D. 1893

D. *The Spring Head April 18 × 27 Sheep coming down bank to drink one of my best works sent in Frames on approval to [blank line].*

Bracketed with 93.11 as *"sold to J S Fowler Holyoke Mass."*

Collection of The Holyoke Museum, Holyoke, Massachusetts. Courtesy of The Holyoke Museum.

REPOSE 93.11

[Unknown] [Unknown]: 18 × 27 [?]

[Unknown]

C. Repose. (finished May 18th/93) 18 × 27 Group of Sheep one of my best works.

Bracketed with 93.10 as "*sold to J S Fowler Holyoke Mass.*"

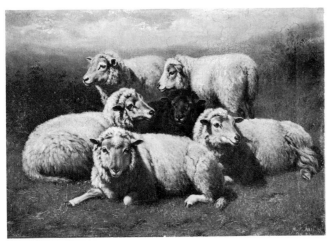

SHEEP REPOSING 93.12

A. F. Tait, N.A. / N.Y. 93 [LR] Canvas: 10 × 14

[Nothing on back]

C.U. Sheep reposing 10 × 12 Chicago. Aug 14th. Plush Shad[ow] Box & Glass sold to W. H. Winslow thru Mr Edw'd C Waller & paid by cheque Nov 25th—$150.00 [In margin:] *Sold in Chicago.*

For other Chicago paintings see 93.13 and 93.26.

GOING TO PASTURE 93.13

[Unknown] [Unknown]: 18 × 27 [?]

[Unknown]

C.M. [1893] Going to Pasture Sheep (A No. 1) Chicago. Frame (Lewis[)] Aug 14th 18 × 27 Sold there for $250.00 [In margin:] *Sold in Chicago.*

For other Chicago paintings see 93.12 and 93.26.

REPOSE 93.14

[Unknown] [Unknown]: 14 × 22 [?]

[Unknown]

C.B. Re Entered further on in 1894 C R [94.18] Kittens [94.9] sent to Mr Waller in Exchange [Rest of entry, including initial code, crossed out: *Sheep reposing. (AA No. 1) 14 × 22 Chicago. (Lewis frame) very good bought by Ed C Waller & paid for $200.00. But to be exchanged for Kittens [94.9] later ret'd to Studio Nov'r 24th/94.*]

This painting appears in both Register and Checklist at two places, here as *C.B.* (93.14) and later as *C.R.* (94.18). It is possible the painting was redated 1894.

DAISY 93.15

[Unknown] [Unknown]: 10 × 12 [?]

[Unknown]

C.E. "Daisy". Pointer with Woodcock in mouth—10 × 12 an old Study finished sold 1894 to Mr [Mrs(?)] Herrick for $50.00 in Frame.

UNDER THE APPLE BLOSSOMS 93.16

A. F. Tait, N.A. / N.Y. [Unknown:] 18 × 27 [?]
93 [LR]

[Unknown]

C.R. Under the Apple Blossoms. [Crossed out: "*A warm day in Spring*"] *Good 18 × 27 Group of Sheep & Lambs reposing in Shade of Apple Tree in blossom "(Good)" View from Hills Farm Putnam Co. N.Y. taken in May, Fall Ex N.A.D. Nov'r Sold.*

Exhibited at the National Academy of Design Autumn Exhibition, 1893, titled "Under the Apple Blossoms," priced at $425.00.

MORNING 93.17

[Unknown] [Unknown]: 18 × 27 [?]

[Unknown]

C.L. "Morning" [Crossed out: "*Going to Pasture*"] *Good 18 × 27 Sheep coming* [Crossed out: *going*] *down the Road "(Good")" from Hills Farm. Mahopac Mines. Putnam Co. N Y N.A. Design Ex Nov'r.*

Exhibited at the National Academy of Design Autumn Exhibition, 1893, titled "Morning, Putnam County, N.Y.," priced at $400.00. Exhibited at Gill's 17th Annual Exhibition, Springfield, Massachusetts, 1894, priced at $400.00.

THE TWINS [or] THE MOTHERS 93.18

A. F. Tait, N.A. / N.Y. Canvas: 14½ × 22
93 [LR]

C.A. / A. F. Tait, N.A. / N.Y. 93 / THE MOTHERS / 53 E 56th St. N.Y.

C.A. [1893] to Folsom "The Twins" ["]very Good" 14 × 22 a Sheep & 2 Lambs under an Apple Tree with Blossoms. To N.A. Design Fall Ex Nov'r Returned not sold then to Buffalo Ex. returned and sent to Schencks April limit $125.00 ret'd not sold. then to Scito ret'd Frame to Waller.

The Register entry describes the first version of this painting, "The Twins." Tait subsequently added a sheep and a lamb to the background, retitled the painting "The Mothers," and sold it to an unknown publisher for reproduction, titled "The Twins."

CHICKENS IN AN OLD SUN SHADE 93.19

[Unknown] [Unknown]: 10 × 12 [?]

[Unknown]

C N. "Chickens in an old Sun Shade" 10 × 12 Sold in Chicago for to a [sic] $100.00 Mr. Alexander thru Mr Waller [In margin:] *Sold in Chicago.*

[SPRING] 93.20

[Unknown] [Unknown]: 12 × 16 [?]

[Unknown]

C.D. ["*]Spring time" Sheep 12 × 16 Dec'r 2nd sold to Gill Springfield.*

Exhibited at Gill's 17th Annual Exhibition, 1894, titled "Spring," priced at $225.00.

SPRING PETS 93.21

[Unknown] [Unknown]: 10 × 14 [?]

[Unknown]

U.Z. "Spring Pets" Chickens good 10 × 14 finished Dec'r 29th price $150.00 with Frame nett to Gill $125.00. $100.00 no frame cash down.

[CATTLE] 93.22

A. F. Tait, N.A. / N.Y. [LR] Canvas: 20 × 27

[Signed over: Edward Gay, N.A.]

[Relined; inscription, if any, lost]

U.C. Cattle joint with Gay 20 × 27 Shad[ow] Box Plush & Glass. Metal Frame. Lewis. offered to Mrs Murray for $100.00 cheap.

Collection of Washington County Museum of Fine Arts, Hagerstown, Maryland. Courtesy of Washington County Museum of Fine Arts.

[CATTLE IN REPOSE] 93.23

[Unknown] [Unknown]: 18 × 22 [?]

[Unknown]

U.U. ½ finished by 1893 Cattle. repose 18 × 22 in the Frame made for Gay & Tait for Auction price to be in Studio $200.00 to Gill.

[SHEEP IN REPOSE] 93.24

[Unknown] [Unknown]: 12 × 16 [?]

[Unknown]

U.M. Sheep repose 12 × 16 sold to Gill for $75.00 no Frame.

CATTLE IN REPOSE 93.25

[Unknown] [Unknown]: 18 × 22 [?]

[Unknown]

M.U. Cattle in repose 18 × 22 Cheap Gay Frame sent to Schencks sale Jan'y 5th by Salvadores Boy.

JACK ON GUARD 93.26

A. F. Tait, N.A. July '93 [LR] Canvas: 9¾ × 12

"Jack" / "on Guard" / A. F. Tait, N.A. / Septr 1893 / Auvergne / River Forest / Chicago.

[No AFT code; no Register entry]

This painting was done in Chicago while AFT was visiting Edward C. Waller and apparently was never recorded by AFT since Waller purchased the painting.

For other Chicago paintings see 93.12 and 93.13.

[NINE CHICKS AND LEAF] 93.27

AF Tait, N.A. / NY [73 or 93] [LR] Canvas: 10 × 14

[Nothing on back]

[No AFT number; no Register entry]

May have been painted in 1873.

JUST LET OUT 94.1

[Unknown] [Unknown]: 20 × 27 [?]

[Unknown]

C. [1894] "Just let out" Sheep 20 × 27 Early morning. Putnam Co N.Y. in metal Frame vel[vet] Shadow Box & Glass Sold at Schencks Sale Feb'y 1st & 2nd. $144 nett.

A CLOSE POINT 94.2

[Unknown] [Unknown]: 10 × 14 [?]

[Unknown]

C.U. [The U has a diagonal mark through it that could be either accidental or intentional] "A close point" 10 × 14 2 Dogs, Gordon Setter & Red Setter & 2 Quail for Dr Powers to pay his Bill of $50.00. finished Feb'y 8th.

THE HAPPY MOTHER 94.3

[Unknown] [Unknown]: 18 × 22

[Unknown]

M. [1894] "The happy Mother" 18 × 22 Cow & 2 Calves one lying down (7 days) finished March 17th (metal Frame) Lewis & Son N A.D. Ex April 12th price $300 Sold $300.00 [less] Com 30 [total] nett 270.00 paid by cheque from N.A.D. May 8th/94.

Bracketed with *B.* (94.4) and *E.* (94.5). Exhibited at the National Academy of Design 69th Annual Exhibition, 1894, titled "The Happy Mother," priced at $300.00.

Courtesy of Mr. and Mrs. George Arden.

WHO LEFT THE BARS DOWN 94.4

A. F. Tait, N.A. / N.Y. [Unknown]: 18 × 27
94 [LR]

[Unknown]

B. "Who left the Bars down" (13 days) 18 × 27 Sheep getting out of bounds (Lewis & Son Frame) finished Mch 3rd N.A.D. Ex April 12th price $400.00 Sold to Mr George A Rawson 41 Vernon S Newton Mass $250.00.

Bracketed with *M.* (94.3) and *E.* (94.5). Exhibited at the National Academy of Design 69th Annual Exhibition, 1894, titled "Who Left The Bars Down?," priced at $400.00.

OUR LITTLE PETS 94.5

A. F. Tait, N.A. / N.Y. Canvas: 10½ × 14
'94 [LR]

[Nothing on back]

E. "Our little Pets" (chickens) 10 × 14 (Lewis Frame) finished Mch 11th 8 days. N.A.D. Ex-April 12th price $175.00 sold for $125.00.

Bracketed with *M.* (94.3) and *B.* (94.4). Exhibited at the National Academy of Design 69th Annual Exhibition, 1894, titled "Our Little Pets," priced at $175.00.

THE LONELY PET 94.6

[Unknown] [Unknown]: 18 × 27 [?]

[Unknown]

R. The lonely Pet [this written over erasure of earlier title ending with word *Mother*] *18 × 27* [Added later on lines above entry:] *Repainted Jan'y 1895. put one cow out & a calf*

& painted in another calf Two Cows & 2 Calves (Twins) good bought by A H Bultman 10 E 72nd St for 250.00 paid Mch 7th 95 with No. B/95 [95.4].

Entry includes other erasures (probably referring to original version of painting) that are mostly indecipherable except for *Boston for sale ret'd* at end.

GROUP OF FOUR SHEEP 94.7

[Unknown] [Unknown]: 12 × 16 [?]

[Unknown]

R.1. Group of 4 Sheep 3 lying down one standing up 12 × 16 June sent for Sale to G C Folsom Boston Sold no Frame nett $100.00 with No. N [94.10] *chickens.*

FOLLOWING THE LEADER 94.8

[Unknown] [Unknown]: 18 × 27 [?]

[Unknown]

L. [1894] *"Following the leader" 18 × 27 a flock of Sheep going thru a break in an old stone Wall. finished April* [Crossed out: *To Schencks Sale April.*] *ret'd* [Crossed out: *not sold sent to Gill for Sale] returned July and then sent to Snedecor for Milwaukee Ex price $300.00 $225 nett Ret'd Nov'r 24th/94 sold Jan'y 15th/95 to Mrs Alker 338 Madison Av for $175.00. no Frame.*

PLAY FELLOWS 94.9

A. F. Tait, N.A. / Canvas: 13¼ × 21¼
Nov 94 [LR]

"Playfellows" / Apr May & June / 1894 / A / A. F. Tait, N.A. / 53 E 56 St / N.Y.

A. "The playfellows" 14 × 22 4 Kittens at play in Grass sent to Mr Waller Chicago on approval June 18th. (this Pic took me 2 months to do) in place of Sheep [93.14].

Sent to Waller in June 1894 to replace "Repose" (see both 93.14 and 94.18), which Waller returned to Tait in November and which Tait in turn exhibited and sold at the National Academy of Design that same month.

Collection of The Adirondack Museum, Blue Mountain Lake, New York.

CHICKENS 94.10

[Unknown] [Unknown]: 12 × 16 [?]

[Unknown]

N. Chickens. 12 × 16 sent to Geo C Folsom July 14th for sale no Frame price Nett $120.00 Sold nett $100.

This painting sold together with 94.7.

JUST LET OUT 94.11

A. F. Tait, N.A. / N.Y. 94 [LR] Canvas: 14 × 22

D. 1894 / "Just let Out" / A. F. Tait, N.A. / 53. E. 56th St. / N.Y.

D. Just let out. Sheep. Hill Farm Yard 14 × 22 sent to Ex'n Amsterdam N.Y. Sold there low price ½ price $137.50.

A DROWSY DAY 94.12

[No signature legible] Canvas: 13 × 17

C.Z. 1894 / "A drowsy day" / A. F. Tait, N.A. / 53 E. 56th St / N.Y.

C.Z. [1894] Sheep in Repose odd size 12½ × 16¾ "A Drowsy time" [time crossed out] sent to Amsterdam N.Y. Ex. Wilmurt collected Sold ½ price $87.50.

Courtesy of Sotheby Parke Bernet, Agent: Editorial Photocolor Archives, New York, New York.

AT REST 94.13

[Unknown] [Unknown]: 15 × 22½ [?]

[Unknown]

C.C. Sheep in and out of Shed 15 × 22½ "At rest" (a strong Picture) sent to Mr Folsom Boston.

SPRING PETS 94.14

[Unknown] [Unknown]: 10 × 12 [?]

[Unknown]

U.d. Chickens. "Spring Pets" 10 × 12 for Mr Steven Fowler, Holyoke as bonus—a nice Group Frame x'tra sent home thru Bohne.

AFT's code in the Register should be *C.U.*, but it appears as if he wrote *U.d.* over *C.U.*

A GOOD DOGGIE 94.15

A. F. Tait, N.A. / N.Y. Canvas: 13½ × 21¼
94 [LR]

C.M. 1894 / "Good Doggie" / A. F. Tait, N.A. / 53 E 56th St. N.Y.

C.M. "A Good Doggie" 14 × 22 2 Cows drinking & Colly on

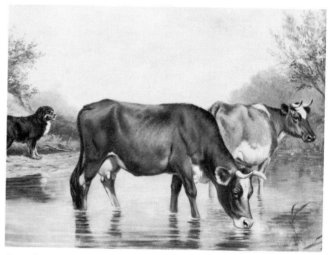

Guard sold to Mr S. Fowler Holyoke Frame Extra Price to be $100.00 sent thru Bohne. Gilder Oct'r $30.

Collection of The Holyoke Museum, Holyoke, Massachusetts. Courtesy of The Holyoke Museum.

ON GUARD 94.16

[Unknown] [Unknown]: 15 × 23 [?]

[Unknown]

C.B. [1894] "On Guard" 15 × 23 Group of Sheep and Collie Dog Dog lying on a Wall Keeping Guard at the Bars. in Bohne's Frame sold to Wm Bagg. Holyoke Mass Nov'r 225.00.

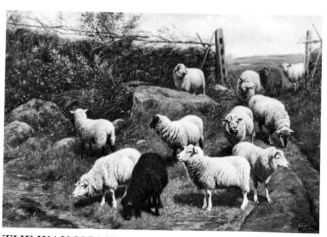

THE WAY HOME 94.17

A. F. Tait, N.A. / N.Y. '94 Canvas: 18 × 27¼

C.E. 1894 / "The Way Home" / A. F. Tait, N.A. / 53 E. 56th St. / New York

C.E. "The way home" 18 × 27 Frame by Bohne $350.00 To the N.A.D. Ex Nov'r 30th sold for $225.00 [Less:] comm 22.50 [Total:] nett 202.50.

Exhibited at the National Academy of Design Autumn Exhibition, 1894, titled "The Way Home, Putnam Co. N.Y.," priced at $350.00.

Collection of The New Jersey Historical Society, Newark, New Jersey. Courtesy of The New Jersey Historical Society, bequest of Caroline Rose Foster.

REPOSE 94.18

[Unknown] [Unknown]: 14 × 22 [?]

[Unknown]

C.R. "Repose" Painted in 1893 & Re-entered from 93. [93.14] This was returned from Mr Waller Nov'r 94 [in exchange for 94.9] sent to N.A.D. Ex Nov'r Price to be 250.00 Sold for $125.00 without Frame [Less:] com. 12.50 [total:] $112.50 nett.

Exhibited at the National Academy of Design Autumn Exhibition, 1894, titled "Repose," priced at $250.00.

See 93.14 and 94.9.

HARD PICKING 94.19

[Unknown] [Unknown]: 10 × 14 [?]

[Unknown]

C.L. "Hard picking" 10 × 14 [Chickens["] & "Dog Biscuit" price $150.00 to N.A. Ex Nov'r 30. not sold ret'd Jan'y 9th/95 To Gill Springfield price nett to be $100.00 Jan'y 14th/95.

Exhibited at the National Academy of Design Autumn Exhibition, 1894, titled "Hard Picking," priced at $150.00.

A BARN YARD CORNER 94.20

A. F. Tait, N.A. / N.Y. 94 [LR] Canvas: 12 × 16

C.D. "A Barn Yard Corner" / A. F. Tait, N.A. / N.Y. 1894

C.d. [cL added below] "A Barn Yard Corner" 12 × 16 (Sheep in repose Shed &c). sent to Gill Jan'y 15/95 nett price to be $150.00.

THE SPRING 95.1

A. F. Tait, N.A. / N.Y. 95 [LR] Panel: 13¾ × 22

[Unknown]

C. "The Spring" (good) 14 × 22 Sheep coming down Bank towards a little stream of water. nett $175.00 to Gill Springfield Jan'y 15th/95.

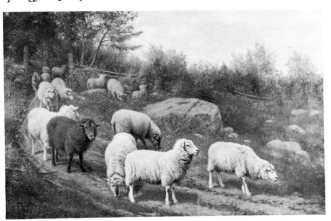

95.2

GOING TO PASTURE 95.2

A. F. Tait, N.A. / N.Y. 95 [LL] Canvas: 14 × 22

U. 1895 / "Going to Pasture" / A. F. Tait, N.A. / 53 E. 56th St / New York [Also stamped LL "A. F. Tait."]

U. "Going to Pasture" 14 × 22 Sheep coming down a Lane Dec'r 30 sent to A W Esleeck Holyoke on approval $225.00 Sold and paid for Jan'y 30.

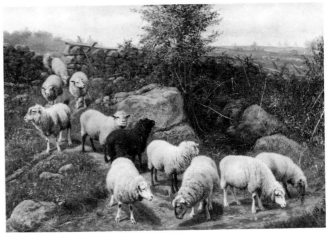

OUT OF THE PASTURE 95.3

A. F. Tait, N.A. / N.Y. 95 [LR] Canvas: 16 × 24

[Relined; inscription, if any, lost]

M. "Out of the Pasture" 16 × 24 Sheep coming down the bank thru a broken Wall down to a small run of Water good sent to Folsom Boston price $200.00 no Frame Feb'y 15.

Courtesy of Dr. John R. Hilsabeck.

PLEASE LET US OUT 95.4

[Unknown] [Unknown]: 18 × 27 [?]

[Unknown]

B. [1895] "Please let us out" (Good) 18 × 27 Colly on Wall. Bars, Sheep want to get out finished March 7 and sold same day to A H Bultman 10 East 72nd St for $350.00. thru W J Murray—4th Av to N.A.D. Ex Mch 9th/95 Del'd home to Bultman May 14th.

Exhibited at the National Academy of Design 70th Annual Exhibition, 1895, titled "Please Let Us Out," and owned by A. H. Bultman, Esq. This painting sold together with 94.6.

MIDSUMMER 95.5

[Unknown] [Unknown]: 12 × 16 [?]

[Unknown]

E. "Midsummer" 12 × 16 Group of Sheep in Repose (good) sent to Gill for sale Mch 18/95.

THE HILLSIDE SPRING 95.6

[Unknown] [Unknown]: 18 × 27 [?]

[Unknown]

R. The Hillside Spring 18 × 27 Sheep coming down a Road thru Pasture finished April 8th/95. sent to Gill Apl 17 nett $250.00.

IN THE PASTURE 95.7

A. F. Tait, N.A. / N.Y. '95 [LR] Canvas: 14 × 22

In The Pasture / Orange Co. N.Y. / A.F. Tait, N.A. / 1895

L. In the Pasture 14 × 22 To Gill, Springfield April 24th nett $175.00.

Also rubber-stamped "A. F. Tait" on reverse of canvas and stretcher.

A QUIET CORNER OF THE PASTURE 95.8

[Unknown] [Unknown]: 14 × 22 [?]

[Unknown]

A. [1895] "A Quiet Corner of the Pasture" 14 × 22 finished May 4th "Good" Sheep lying down Sent to Davis Worcester. (Silleck Wilmurt Carman) with N. [95.9] May 14th.

SPRING PETS 95.9

[Unknown] [Unknown]: 8 × 10 [?]

[Unknown]

N. (Chickens) "Spring Pets" 8 × 10 with Strawberry Plants & Berries in foreground finished May 12th / sent to Mr Davis Worcester Mass on May 14th by (Silleck) to Wilmurts with A. [95.8] Ret'd & bought by Mrs Brinckman, Mr Bultman's Sister Paid $175.00 in June.

A QUIET DAY 95.10

A. F. Tait, N.A. / N.Y. '95 [LR] Canvas: 14 × 22

D. 1895 / A Quiet Day / A. F. Tait, N.A. / 53 E. 56th St. / New York

D. "A Quiet day" Putnam Co N.Y. 14 × 22 Sheep lying down in Pasture view of Hill's House in background (a very bright Picture) sold to Mrs Brinkman (Mr Bultmans Sister) Paid $250.00.

Courtesy of Butterfields Auctioneers, San Francisco, California.

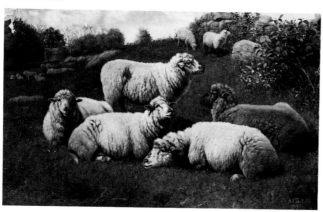

BUSY LITTLE PETS 95.11

[Unknown] [Unknown]: 12 × 16 [?]

[Unknown]

C.D. Chickens. "Busy Little Pets" 12 × 16 this was painted last Dec'r/94 not registered altered to 95. sent to Folsom Boston & returned May 25th in his Frame (I paid him for Frame).

THE PLAYFELLOWS 95.12

A. F. Tait, N.A. / Canvas with board
N.Y. '95 [LR] backing: 14 × 20¼

[Relined; inscription, if any, lost]

C.C.—[1895] "The Playfellows" (good) 14 × 22 4 Kittens in Basket. curtains &c for Mrs. A Murray 75th St del'd June 26th.

THE MOTHERS 95.13

A. F. Tait, N. A. / Canvas: 12¼ × 16
N.Y. 95 [LR]

C.U. 1895 / "The Mothers" / A. F. Tait, N.A. / N.Y.

C.U. [Code and entire entry crossed out: Sheep. "The Mothers" 12 × 16 for Mr M G Murray as commission and Frame he paid for $16.00 Frame from Folsom Boston and paid for] Dead Horse [written over crossed-out entry].

The crossed out Register entry is preceded by the following: "*returned Home Aug'st 29th from Carmel.*"

WAITING 95.14

[Unknown] [Unknown]: 18 × 27 [?]

[Unknown]

C.M. "Waiting" ("good") 18 × 27 Sheep in yard. Dog on Fence painted in Carmel at Barnes House sold to R C Bultman 128. W 81st St for $350.00 nett in Frame.

BRINGING THEM HOME 95.15

[Unknown] [Unknown]: 18 × 27 [?]

[Unknown]

C.B. "Bringing them home" 18 × 27. Sheep coming down a road Dog on Stone Wall watching them pass (Good) begun in Carmel finished after my return to city Sept'r 21st.

Exhibited at the National Academy of Design Autumn Exhibition, 1895, titled "Bringing Them Home," priced at $400.00.

[SHEEP COMING TO DRINK] 95.16

[Unknown] [Unknown]: 14 × 22 [?]

[Unknown]

C.E. [1895] Sheep. in action (to drink) 14 × 22 Sent to Folsom Boston Aug 10th from Carmel. Painted in Carmel (at Barnes) sold by Folsom (Boston) nett $180.00 November.

SPRINGTIME 95.17

[Unknown] [Unknown]: 12 × 16 [?]

[Unknown]

C.R. [Entire entry crossed out: *Springtime 12 × 16 Sheep and Lambs presented to Mrs Macy (by Boyle Oct'r 27th)—no Frame*] *Dead Head* [written above crossed out entry].

FIRST SPRING BROOD 95.18

A. F. Tait, N.A. / N.Y. 95 [LL] Panel: 10 × 14

C.L. / "Spring" First Brood / A. F. Tait, N.A. / N.Y. 1895

C.L. "Chickens First Spring Brood" 10 × 14 finished Oct'r 20th sold to A. H. Bultman 10 E 72nd St N Y $150.00 in Frame & Plush shadow Box.

A HOT DAY 95.19

[Unknown] [Unknown]: 14 × 22 [?]

[Unknown]

C.A. "A Hot Day". 14 × 22 Sheep in Sun & Shadow sold by Mr Hallat 426 Fifth Av nett $225.00 [Noted at bottom of page:] *1895* [and below it:] *19.*

THE MOTHERS 95.20

[Unknown] [Unknown]: 18 × 27 [?]

[Unknown]

C.N. [1895] *"The Mothers" 18 × 27 Sheep & Lambs in Farm Yard N.A.D. Fall Ex ret'd not sold. sent to Folsom Boston.*

Exhibited at the National Academy of Design Autumn Exhibition, 1895, titled "Spring: The Mothers," priced at $450.00.

CHANGING PASTURES 95.21

A. F. Tait, N.A. / N.Y. 95 [LR] Canvas: 14 × 22

U.Z. 1895 / Changing Pastures / A. F. Tait, N.A. / N.Y. / 53 East 56th St.

U.Z. "Changing Pastures"—14 × 22 Sheep coming thru a Gateway Nov'r sent to Gill Jan'y 13 sold. paid for Mch 27th.

A WARM MIDDAY 95.22

[Unknown] [Unknown]: 14 × 22 [?]

[Unknown]

U.C. "A Warm Midday" 14 × 22 finished Dec'r 17th Sheep at rest sent to Folsom Boston Dec'r 24th.

ON GUARD 96.1

[Unknown] [Unknown]: 18 × 27 [?]

[Unknown]

U.U. [1896] *On* [*watch* crossed out] *Guard ½ 1895 & half Jan'y 96 18 × 27 Dog on wall. Sheep lying down and Stand-*

ing in yard for Gill Springfield ret'd March 6th and sent to N.A.D. Ex Mch 7th not sold Ret'd May 18 Sep'r at Folsom May 18.

Exhibited at the National Academy of Design 71st Annual Exhibition, 1896, titled "On Guard, Putnam Co, N.Y.," priced at $450.00. This painting was begun in 1895 and completed in 1896, as indicated both in Register entry and in continuation of 1895 code series.

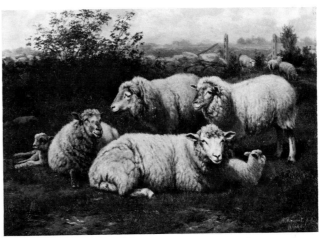

A RESTFUL TIME 96.2

A. F. Tait, N.A. / N.Y. '96 [LR] Panel: 9¾ × 14

N.Y. 1896 / U.M. / "A Restful Time" / A. F. Tait. N.A.

U.M. "A Restful Time" 10 × 14 for Gill sent Jan'y 16th paid Mch 5th.

Probably begun in 1895 and completed in 1896, since the coding continues the 1895 series.

Courtesy of Mrs. Robert H. Williams.

LITTLE PETS 96.3

[Unknown] Panel: 10 × 14 [?]

[Unknown]

C. [1896] *Chickens (Little Pets) on Panel 10 × 14 painted for Anna Murray for wedding present for Tom Crimmins daughter. Jan'y 12th to 29th and sent it home to 55 E. 75th St Jan'y 30 to be $100.00 and Frame by Lewis & Son $25.00 $125.00 Paid Feb'y 8th or 10.*

THE WAY HOME 96.4

A. F. Tait / N.Y. '96 Canvas on panel: 14 × 22

U. / "The Way Home" / Putnam Co. / N.Y. / 53 E. 56th St. / New York / 1896 [plus artist's stamp]

U. "The Way Home" 14 × 22 Finished Feb. 25th [*for the N.A.D.* crossed out] *sent to J. D. Gill. Springfield Feb'y 26 paid May 4th.*

CONTENTMENT 96.5

[Unknown] [Unknown]: 18 × 27 [?]

[Unknown]

M. "Contentment." 18 × 27 sent to N.A.D. Ex March 7th (with on Guard No. U U. [96.1] /Sheep in Repose) Ret'd not Sold May 18 sent to Folsom & sold to Mr Rothwell Brookline Boston.

Exhibited at the National Academy of Design 71st Annual Exhibition, 1896, titled "Contentment," priced at $450.00.

SPRING TIME 96.6

[Unknown] [Unknown]: 10 × 14 [?]

[Unknown]

B. "Spring Time"—10 × 14 Sheep in repose in field for Gill Springfield finished Mch 20th sent of Mch [blank] Paid $75 (no Frame nett).

THE SPRING IN THE PASTURE 96.7

[Unknown] [Unknown]: 14 × 22 [?]

[Unknown]

E. [1896] "The spring in the Pasture["] 14 × 22 Sheep coming down Bank to drink for Folsom (Boston) finished Mch 27th no Frame to be $180.00 nett. sent by Adams Express Mch 28th.

A DREAMY DAY 96.8

[Unknown] [Unknown]: 12 × 16 [?]

[Unknown]

R. "A Dreamy Day" (good) 12 × 16 for Gill. finished April 4th sent off by Adams Xp's April 6th. Sheep in repose some on Rocks Paid $100 nett no Frame.

A DRY TIME 96.9

[Unknown] [Unknown]: 14 × 22 [?]

[Unknown]

L. "A Dry Time"—14 × 22 Sheep in action coming down bank small stream in foreground To Folsom no Frame April 21st by Adams X [Express].

THE OLD SPRING 96.10

[Unknown] [Unknown]: 14 × 22 [?]

[Unknown]

A. "The Old Spring" [over erased title ending in Pasture] 14 × 22 Sheep coming down bank to Spring at the right hand lower corner (good) for Gill. sent May 2nd by Adams X [Express].

REPOSE 96.11

A. F. Tait, N.A. / Canvas with board
N.Y. 1896 [LL] backing: 12¼ × 16¼

N. 1896 / "Repose" / A. F. Tait, N.A. / 53. E. 56th St / N.Y. [In addition, at upper right and upper left is the stamp "A. F. Tait"]

N. [1896] "Repose" 12 × 16 5 Sheep lying down 2 Standing (good)] for Folsom finished May 9th sent May 11th by Adams X [Express].

OLD SPRING IN THE PASTURE 96.12

[Unknown] Panel: 14 × 22 [?]

[Unknown]

D. [Entire entry crossed out: "Old Spring in the Pasture" on Panel 14 × 22 finished for Ella May 20th begun 10th (but dated 1895) (very good Picture) $250.00 paid for in 1895 in a pet.]

Ella probably refers to Mrs. F. P. Osborn.

CONTENTMENT 96.13

[Unknown] [Unknown]: 18 × 27 [?]

[Unknown]

C.C. Contentment [written above crossed out Quietude] (Carmel) 18 × 27 Sent to Pitsburg Ex Aug 10th Sheep at rest in Pasture.

NOONDAY REST 96.14

A. F. Tait, N.A. / N.Y. '96 [LR] Canvas: 14 × 22

C.U. 1896 / Noonday Rest / Putnam Co / Near Mahopac Mines, N.Y. / A. F. Tait, N.A. / 53 E. 56th St, N.Y.

C.U. Noonday Rest (Sheep) Painted at Carmel 14 × 22 Sent to Mr Harding Sep'r 10 and sold by him & paid for $250.00.

IN THE PASTURE 96.15

[Unknown] [Unknown]: 14 × 22 [?]

[Unknown]

C.M. Sheep in Pasture 14 × 22 sent to Mr Harding Sep 15th Ret'd Oct'r 3rd [see 96.17 Register entry] Painted at Carmel & finished Home N.A.D. Autumn Ex price $300.00.

Exhibited at the National Academy of Design Autumn Exhibition, 1896, titled "In The Pasture, Putnam Co., N.Y.," priced at $300.00.

CHICKENS 96.16

[Unknown] [Unknown]: 10 × 14 [?]

[Unknown]

C.B. [1896] Chickens. 10 × 14 Painted at home after we came back from Carmel finished. Sep'r 18 & sent on approval to Mr Brigham, Worcester Mass Sept'r 21st ($150.00) 10 days.

Entry preceded by note: "Ret'd from Carmel Sep 8th."

A QUIET DAY 96.17

[Unknown] [Unknown]: 14 × 22 [?]

[Unknown]

C.E. "A Quiet Day" 14 × 22 Sheep at rest 5 lying down 2 Standing (Good) finished October 3rd (two weeks) sent to Mr

Harding on Ex & sold same day for $250.00 to be paid for in Jan'y next. I brought No C.M. [96.15] back same time.

A WARM DAY 96.18

A. F. Tait, N.A. / Panel: 18¼ × 27½
N.Y. '97 [LR]

C.R. 1897 / "A Warm Day" / Putnam Co. / N.Y. / A. F. Tait, N.A. / 53 E 56th St. / N.Y.

[Also stamped LL "A. F. Tait"]

C.R. (Sheep) "A warm day" in Putnam Co N.Y 18 × 27 (finished Oct'r 28) (very good) N.A.D. Autumn Ex 450.00 returned Sent to Folsom Boston Jan'y 6th for sale nett 225.00.

Exhibited at the National Academy of Design Autumn Exhibition, 1896, titled "A Warm Day in Putnam County, N.Y." and not priced.

This painting is dated front and back 1897, but appears in the Register in 1896.

A QUIET CORNER IN THE PASTURE 96.19

[Unknown] Panel: 14 × 22 [?]

[Unknown]

C.L. [Oct'r] "A Quiet Corner in the Pasture["] Panel 14 × 22 4 Sheep lying down. 2 standing (good one).

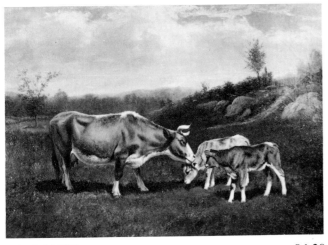

JEALOUSY 96.20

A. F. Tait, N.A. / Canvas: 17½ × 23½
N.Y. 96 [LR]

[Relined; inscription, if any, lost]

C.A. [Nov 1896] "Jelousy" 18 × 24 Cow & 2 Calves.

Courtesy of Dr. David Kleiner.

MY FARM FRIENDS 96.21

[Unknown] [Unknown]: 14 × 22 [?]

[Unknown]

C.N. "My Farm Friends" 14 × 22 Sheep lying down good. finished Nov'r 28th. 11 days sent to Mr Harding Dec'r 2nd sold for $250.00.

THE NEW ARRIVALS 96.22

A. F. Tait, N.A. / N.Y. '96 [LR] Panel: 8 × 10

U.U. 1896 / "The New Arrivals" / A. F. Tait, N.A. / New York

U.U. [1896] "The New Arrivals" 8 × 10 6 Chickens very young [()X'mass present to Mr H B. Harding for Kindness in selling pictures for me sent by Mas Boy) Dec'r 24th. very nice good Plush Shadow Box & Glass.

Courtesy of Mr. Arthur F. Tait II.

A QUIET TIME 96.23

[Unknown] [Unknown]: 12 × 16 [?]

[Unknown]

U.M. "A Quiet Time". 12 × 16 for Dr Bulkley exchange for Proffess Services to be $125.00 without Frame sent to him by Janitor Dec'r 24th a very good Pic. Frame to be $18.00 Paid.

THE ESCAPE 96.24

A. F. Tait / 1896 Canvas: 18¼ × 24½

"The Escape" / Racquette Lake N.Y. / A. F. Tait, N.A. / Carmel, N.Y. 1896.

[No AFT number; no Register entry]

This is a chromolithographic reproduction of an advertisement done for the Laflin and Rand Powder Co., over which AFT has painted out the advertising copy and added a few original touches.

See 73.11 for original painting.

SOME OF MY FRIENDS 97.1

A. F. Tait, N.A. / Canvas: 11¾ × 22
N.Y. '97 [LR]

C.D. 1896 / 1897 / "Some of my Friends" / in Putnam Co / N.Y. / A. F. Tait, N.A. / New York / 53 E. 56th St

C.D. [code U(?) crossed out] Sheep 14 × 22 began it Dec'r

3rd finished it Jan'y 17th 10 days sent to Folsom Jan'y 18th no Frame.

Begun and registered in 1896 but not completed until 1897.

Courtesy of Dr. and Mrs. George G. Hart.

EARLY PETS 97.2

A. F. Tait, '97 [LR] [Unknown]: 9¾ × 14

[Unknown]

U.C. Chickens. "Early Pets" 10 × 14 begun Dec'r 10 ½ day fin Dec'r 20th. sent to Mr Harding to show. not sold sent to Gill's Ex Jan'y 16th Ret'd Mch 10th. I altered the date from 96 to 97 & sold in Studio to Mr Tannenbaum with No U [97.5] & E. [97.8] Mch 12th/97 for $450.00 no Frame & paid by cheque same time.

Sold American Art Association sale March 1, 1906. This picture, although registered by AFT in 1896 as U.C., has been catalogued in 1897 due to change of date by AFT.

FEEDING TIME 97.3

A. F. Tait 1897 [LR] Canvas: 14 × 22

U.B. "Feeding Time" / A. F. Tait, N.A. / 53. E. 56th St / New York / 1897.

U.B. [1897] Sheep. ("Feeding Time"[)] 14 × 22 in Frame to be sent to Gill. finished Jan 11 15 days. Sheep and Dog on Wall

a ½ Bushel measure on wall near the Dog (good) sent to Gill Jan 16 by Wilmurt.

First entry under 1897 in the Register; begun in 1896, finished 1897. Exhibited at Gill's 20th Annual Exhibition, 1897, priced at $300.00.

Collection of the Everhart Museum of Natural History, Science and Art, Scranton, Pennsylvania. Courtesy of the Everhart Museum of Natural History, Science and Art.

A SUMMER DAY 97.4

[Unknown] [Unknown]: 10 × 14 [?]

[Unknown]

C. Sheep in repose "a Summer Day" 10 × 14 began this Jan'y 17th for Gill. finished 27 Jan'y sent to him by Adams Ex Jan'y 28th to be $100.00 his Frame. Ret'd end of August (very unsatisfactory) repainted it & sent to N.A.D. Ex Oct'r 29th. to Bohne by Frank repainted & sent to Gills Ex Jan'y 1898 $175.00 & sold price $115.00 with Frame.

Probably begun in 1897, hence beginning of fresh coding series. Sold with 98.2 and 98.3.

FRIENDS 97.5

A. F. Tait, N.A. / Panel: 17¾ × 26¾
N.Y. '97 [LR]

[Nothing on back]

U. [1897] "Friends" 18 × 27 Sheep with Dog on a Rock Sold to Tannenbaum no Frame begun Jan'y 28th finished Feb'y 19th & sent to the Ohio Club Ex on Feb 20 ret March 10th Mch 12/ 97 Sold to Mr Tannenbaum with 14 × 22 Sheep No E [97.8] & Chickens 10 × 14 [97.2] for $450.00 no Frames sent to N.A.D. Spring Ex.

Similar to 97.10 and 97.11. Exhibited at the National Academy of Design 72d Annual Exhibition, 1897, titled "Friends" and owned by M. Tannenbaum, Esq. Sold American Art Association sale, March 1, 1906.

EARLY EVENING 97.6

[Unknown] [Unknown]: 12 × 16 [?]

[Unknown]

M. "Early Evening" (5 Sheep in repose) 12 × 16 for Gill. sent off by Adams X [Express] (7 days) Feb'y 9th (very good) to be 120.00 without Frame.

AMONGST FRIENDS 97.7

[Unknown] [Unknown]: 14 × 22 [?]

[Unknown]

B. "Amongst Friends" 14 × 22 6 sheep 4 lying down. & chipmunk on Rock—(8 days) sent off to Gill Springfield [Feb crossed out] March 2nd/97 no Frame to nett $175.00. very good Picture Ret'd painted out Chipmunk.

WITH FRIENDS 97.8

[Unknown] [Unknown]: 14 × 22 [?]

[Unknown]

E. With Friends 14 × 22 6 Sheep "chipmunk on Rock.["] began M'ch fini'd Mch sold to Mr Tannenbaum March 12 with No. U [97.5] 18 × 27.

Also sold with *U.C.* (97.2), all three for $450.00.

REPOSE 97.9

[Unknown] [Unknown]: 10 × 14 [?]

[Unknown]

R. [1897] Sheep ("Repose") 10 × 14 finished April 3rd. 7 days Sent to Mr Harding on Ex returned. and No. D. [97.12] sent to Harding in exchange for Ex.

[MY COUNTRY FRIENDS] 97.10

A. F. Tait, N.A. / 1897 [LR] [Unknown]: 18 × 27

[Unknown]

A. Sheep very like No. U [97.5] 18 × 27 began in New Studio N 82 Waring place Yonkers May 30th—same time begun N. [97.11] finished this June 25th. Good for a Mr H. Hamlin Smithport Pa Paid. $400.00 through Mr Allison to pay him 10 pr ct commission.

[FRIENDS] 97.11

[Unknown] [Unknown]: 18 × 27 [?]

[Unknown]

N. (9 Sheep lying down with Dog on Rock[)] 18 × 27 like Friends [97.5] but altered some for Mr Herbert Jun'r Helmette, N.J. finished July 23rd.

See 97.10.

THE WATCH 97.12

A. F. Tait, N.A. Canvas: 14 × 22

D. 1897 / "The Guardian" / A. F. Tait, N.A. / Yonkers, N.Y.

half background on a Stone. Group of Sheep lying in distance finished Aug 16 and sent it on Ex to Mr Harding sent to N.A.D. Ex Oct'r 30th by Bohne Price $275.00. [See 97.9]

Exhibited at the National Academy of Design Autumn Exhibition, 1897, titled "On Watch."

THE "TWA" DOGS 97.13

A. F. Tait, N.A. / Canvas with board
N.Y. '97 [LR] backing: 18 × 27

C. D. 1897 / The Twa Dogs / Burns / A. F. Tait N.A. / Yonkers / N.Y.

C.D. "The "Twa" Dogs. 18 × 27 9 Sheep lying & standing & 2 Dogs near a Well in yard one lying on 2 Sacks one sitting up [along (?) crossed out] alongside (good) finished Sept'r 11th sold to Mr M. C. Tannenbaum [word crossed out] Paid by cheque Sep 21st.

Sold with 97.14 for $650.00. Reproduced in 1902 by Gray Lithography Co., New York, titled "The Faithful Shepherds." AFT records 9 sheep in painting but only 8 are shown.

GUARDING THE FLOCK 97.14

[Unknown] [Unknown]: 24 × 36 [?]

[Unknown]

C.C. "Guarding the Flock" 24 × 36 Sheep in Repose on side hill Colly Dog in background Mr Tannenbaum with his sister in law & Boy came up to my Studio and bought this and C.D. [97.13] same time for $650.00 no Frame sent to N.A.D. Ex Oct'r 30 to Bohne by Frank Begun Sep'r 12th finished Oct'r 16th sold to Mr Tannenbaum Oc'r 17th.

Exhibited at the National Academy of Design Autumn Exhibition, 1897, titled "Guarding The Flock" and owned by M. Tannenbaum.

A LAZY TIME 97.15

A. F. Tait, N.A. / N.Y. 97 [LR] Canvas with board
 backing: 15 × 22

C.U. / 1897 / A. F. Tait, N.A. / 82 Waring Place / Yonkers / N.Y. / "A Lazy Time" / Putnam Co / N.Y.

C.U. "A Lazy Time." 14 × 22 Putnam Co N.Y. Nov'r 6

begun finished 25th of Nov [?] *sent to Mr Carr. Nov'r 29th 1897 sold & paid for Jan'y 98.*

Courtesy of Vose Galleries, Boston, Massachusetts.

[TWELVE SHEEP AT PASTURE] 97.16

A. F. Tait, N.A. / N.Y. 97 [LR] Canvas: 14 × 22

[Sealed; inscription, if any, unavailable]

[AFT number and Register entry, if any, unknown]

This painting in a shadow box is now in a hotel lobby and is screwed to the wall, making it impossible to obtain the back inscription without which the painting cannot be identified in AFT's Register. Paintings registered for 1897 that measure approximately 14 × 22, one of which may possibly match this work, include: 97.3, 97.7, 97.8, 97.12, and 97.15.

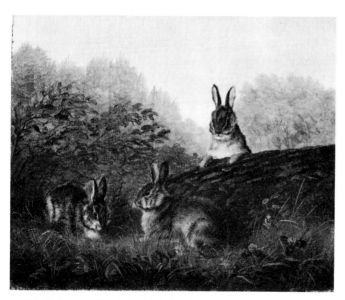

[RABBITS ON A LOG] 97.17

A. F. Tait / NY [9] 7 [LR] Canvas: 10 × 12

[Relined: inscription, if any, lost]

[No AFT number; no Register entry]

Collection of The Metropolitan Museum of Art, New York, New York, gift of Mrs. J. Augustus Barnard, 1979. Courtesy of The Metropolitan Museum of Art.

A SLEEPY GUARDIAN 98.1

A. F. Tait, N.A. / N.Y. '98 [LR] Canvas: 24 × 36

[Unknown]

C.M. [1898] *"A Sleepy Guardian" 24 × 36 began Nov'r* [1897] *finished March 6th 98 and sent to N A D Ex Mch 7/98 price $750.00 handsome Frame $40.00 Dec'r 18.19.20* [1898?] *put in 4 Fowls (good).*

Exhibited at the National Academy of Design 73d Annual Exhibition, 1898, titled "A Sleepy Guardian." The illustration in the catalogue does not show the four fowls

added by AFT. Exhibited at Gill's 22d Annual Exhibition, 1899, priced at $750.00. This catalogue illustration does show the four fowls added by AFT in December of 1898. Registered under heading "1898." Coded under 1897 series and begun November of that year but not finished until March 1898.

A MARSHY PASTURE 98.2

[Unknown] [Unknown]: 14 × 22 [?]

[Unknown]

C.B. ["The Spring" erased] *Finished Jan'y 5th 1898 14 × 22 Dec'r 1st "A Marshy Pasture" sent to Gill Jan 5th sold* [other erasures].

Exhibited at Gill's 21st Annual Exhibition, titled "A Marshy Pasture," priced at $300.00. Coded in the 1897 series and begun in December of that year but finished in 1898. Sold with 97.4 and 98.3.

QUIETUDE 98.3

[Unknown] [Unknown:] 14 × 22 [?]

[Unknown]

C.E. "Quietude" 14 × 22 Sent to Harding and returned Jan 3rd 1898 by Bohne for Gills Ex Jan'y 98 sent to Gills Exhibition with C.B. [98.2] *and C. 97* [97.4]—*three Paintings Sold.*

Exhibited at Gill's 21st Annual Exhibition, 1898, titled "Quietude," priced at $300.00. Coded and probably begun in 1897 but finished in 1898.

EARLY SUMMER 98.4

[Unknown] [Unknown:] 18 × 27 [?]

[Unknown]

C. [82 Waring Place 1898 Yonkers N.Y.] *"Early Summer" 18 × 27. began Jan'y 7th 97 Finished Feby 98 sent to N.A.D. Ex March 7th/98 price $400.00 Bohne's Frame & paid for.*

Exhibited at the National Academy of Design 73d Annual Exhibition, 1898, titled "Early Summer, Putnam Co., N.Y." This painting begins a fresh code series for 1898.

A PASTORAL 98.5

[Unknown] [Unknown:] 18 × 27 [?]

[Unknown]

U. [Entire entry crossed out: *"A Pastoral" 18 × 27. Sheep & Boy for Mr Herbert of Helmette N.J. came to nothing*] *rejected.*

THE WAY HOME 98.6

[Unknown] [Unknown]: 14 × 22 [?]

[Unknown]

M. "The way home" 14 × 22 Sheep in action begun March 12th.

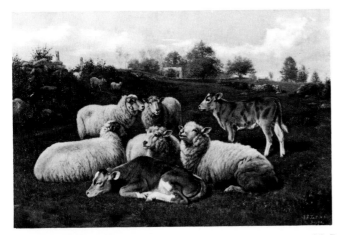

COUNTRY FRIENDS 98.7

A. F. Tait, N.A. /　　　　Canvas with board
N.Y. 98 [LR]　　　　backing: 18¼ × 27

B 1898. / "Country friends" / A. F. Tait, N.A. / 82 Waring Place / Yonkers / N.Y.

B. "Country friends" 18 × 27 Sheep & 2 Calves in repose finished in May & retouched on June 30th.

Collection of the George Walter Vincent Smith Museum, Springfield, Massachusetts. Courtesy of George Walter Vincent Smith Art Museum.

COMRADES 98.8

[Unknown]　　　　Panel: 12 × 18 [?]

[Unknown]

E. [1898] Sheep and one Calf Landscape Panel 12 × 18 "Comrades" Cushers sold $90.00 Mch 24th/99.

JUST HOME 98.9

[Unknown]　　　　Panel: 12 × 18 [?]

[Unknown]

R. "Just Home["] Fowls Yard & Shed Panel 12 × 18 Sheep lying round.

AT HOME 98.10

[Unknown]　　　　[Unknown]: 14 × 22 [?]

[Unknown]

L. "At Home" 14 × 22 Sheep [Fowls crossed out] &c old shed finished Aug 6. N.A.D Ex Oct'r 20th by Bohne Sold for $200.00 nett $180.00.

Exhibited at the National Academy of Design Autumn Exhibition, 1898, titled "At Home."

AN AMERICAN FARM YARD 98.11

[Unknown]　　　　[Unknown]: 18 × 27 [?]

[Unknown]

A. "An American Farm Yard" 18 × 27 (4) four [?] Calves at

ease with a lot of Sheep in background. Hills Yard finished Sep 3rd. N.A.D. Ex Oct'r 20 by Bohne ret'd to Bohne.

Exhibited at the National Academy of Design Autumn Exhibition, 1898, titled "An American Farm Yard, Putnam Co., N.Y."

EARLY MORNING 98.12

[Unknown]　　　　[Unknown]: 24 × 36 [?]

[Unknown]

N. [98] [A Foggy Morning crossed out] "Early Morning" 24 × 36 Putnam Co N.Y. Sheep on Hill side in Fog finished Oct'r 5. N.A.D. Ex Oct'r 20th $300.00 Sold Dec'r 8th to Mr H I. Judson 7 Nassau St.

Exhibited at the National Academy of Design Autumn Exhibition, 1898, titled "A Foggy Morning."

A SUMMER DAY 98.13

[Unknown]　　　　[Unknown]: 14 × 22 [?]

[Unknown]

D. "A Summer Day" 14 × 22 Sheep in Repose (good[)] begun Oct'r first fin Oct'r 27th.

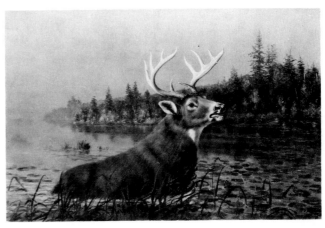

JUST ESCAPED 98.14

A. F. Tait / N.Y. '03 [LR]　　　　Canvas: 20½ × 30½

"Just escaped." A. F. Tait, N.A., Yonkers, N.Y. 1898.

Repainted in 1903 and presented to my son Frank and Edith his wife, July [see below]

C.C. (Deer). "Just Escaped" 20 × 30 finished Sep'r.

Repainted in 1903 and presented to son Frank and his wife Edith in July of that year (03.1). At that time the back inscription was probably added to and the front inscription probably changed altogether.

VERY GOOD FRIENDS 98.15

A. F. Tait, N.Y. /　　　　Canvas: 14¼ × 22½
New York 1898 [LR]

[Unknown]

C.U. Very Good Friends. Sheep & Dog on Rock 14 × 22 begun Oct'r 28. fin Nov'r 12 (3 days off) or 10 days.

A CITY VISITOR 98.16

[Unknown] [Unknown]: 14 × 22 [?]

[Unknown]

C.M. "A City Visitor" [City and Country crossed out] 14 × 22 Colly Dog—Tiney & Fowls finished Dec'r 8th [Added later in pen:] *N.A.D. Spring Ex. 99.*

Exhibited at the National Academy of Design 74th Annual Exhibition, 1899, titled "A City Visitor."

[THREE SHEEP] 98.17

A. F. Tait, N.A. / N.Y. '98 [LL] Canvas: 8 × 10

[Sealed; inscription, if any, unavailable]

[AFT code, if any, and possible Register entry unknown]

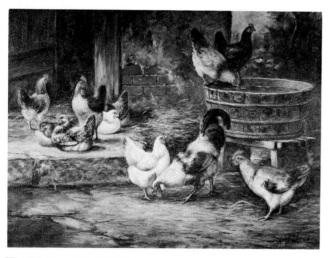

[BARNYARD FOWL] 98.18

A. F. Tait / 1898 [LR] Canvas: 10 × 14

[Unknown]

[No AFT number; no Register entry]

Courtesy of Sotheby Parke Bernet, Agent: Editorial Photocolor Archives, New York, New York.

SUMMERTIME 99.1

[Unknown] [Unknown]: 14 × 22 [?]

[Unknown]

L. Sheep [in pen:] *"Summertime"* [again in pencil:] *14 × 22 sent to Folsom & sent back* [to] *me to have a Dog put in sent back to Folsom & brought home again in March 99 to go to the Spring Ex Painted Dog out & brightened it up & changed date to 99 Yonkers May 5th-97* [Added above entry in pen:] *N.A.D. Spring Ex 99.*

Exhibited at the National Academy of Design 74th Annual Exhibition, 1899, titled "Summer Time."

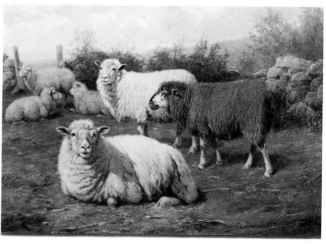

OUR FARM YARD 99.2

A. F. Tait, N.A. / Panel: 9¼ × 13¾
N.Y. 99 [LR]

C.B. 1899 / "Our Farm Yard" / Putnam Co N.Y. / A. F. Tait, N.A. / 82 Waring Place / Yonkers N.Y.

C.B. [98. & 99] "A Farm Yard" Putnam Co N Y Panel 10 × 14. Sheep & Fowls (very nice) finished Dec'r 15 [1898]—7 days.

Courtesy of Sotheby Parke Bernet, Agent: Editorial Photocolor Archives, New York, New York.

CONTENTMENT 99.3

[Unknown] [Unknown]: 14 × 22 [?]

[Unknown]

C.E. [1899] Contentment—14 × 22 Sheep in repose Sold by Bohne.

Continues 1898 coding and probably begun that year but finished in 1899.

EXPECTATION 99.4

[Unknown] [Unknown]: 18 × 27 [?]

[Unknown]

C. [Entry over considerable erasure, including dimensions *14 × 22*] *"Expectation" 18 × 27 Sheep—. Horse & Dog. Dec'r & Jan'y begun Dec'r 22. finished Jan 8th 99 took about 12 days Holidays—* [bag of oats erased] *Lotos Club* [other erasures].

Exhibited at the National Academy of Design 74th Annual Exhibition, 1899, titled "Expectation." This painting begins new coding series for 1899.

EARLY SUMMER 99.5

[Unknown] [Unknown]: 8 × 10 [?]

[Unknown]

U. Early Summer Putnam Co N Y. 8 × 10 for Mr Cushier sent to him Feb'y 17 [Sold by him crossed out] *Sold to Mr Busby $50.00.*

A DREAMY TIME 99.6

[Unknown] [Unknown]: 10 × 14 [?]

[Unknown]

M. A Dreamy Time 10 × 14 for Gill very good sent off Feby 16 sent Feb'y 16.

CONTENTMENT 99.7

[Unknown] [Unknown]: 8 × 10 [?]

[Unknown]

B. "Contentment" 2 Sheep 1 lying down 1 up 8 × 10 Sold by for Cushier.

[FOUR SHEEP] 99.8

[Unknown] [Unknown]: 10 × 14 [?]

[Unknown]

E. 4 Sheep one up 10 × 14 [erasures].

[THREE SHEEP] 99.9

[Unknown] [Unknown]: 10 × 14 [?]

[Unknown]

R. 3 Sheep. 2 down 1 up 10 × 14 finished Mch 27/99 for Carr.

A DREAMY DAY 99.10

A. F. Tait, N.A. / N.Y. 99 [LR] Canvas: 18 × 27

L. 1899 / "A Dreamy Day" / A. F. Tait, N.A. / Yonkers / N.Y.

L. "A Peacefull Time" 18 × 27 6 Sheep on hill side 3 lying down 3 up some in background finished Ap'l 2nd 14 days sent to Bendan (Baltimore) Xpress.

SPRING TIME 99.11

A. F. Tait, N.A. / Canvas: 12¼ × 18¼
N.Y. 1899 [LR]

(A) 1899 "Spring Time" / A. F. Tait, N.A. / N.Y.

A. 12 × 18 2 Sheep down 1 up begun Ap'l 5th—fin Ap'l 12 6 days [for Cushier ret'd April crossed out] to Folsom.

A SUMMER NOON 99.12

[Unknown] [Unknown:] 14 × 22 [?]

[Unknown]

N. A Summer Noon 14 × 22 for Gill to be $175.00 with Frame 9 days finished Ap 29th.

A SUMMER MORNING 99.13

[Unknown] [Unknown:] 14 × 22 [?]

[Unknown]

D. [1899] (Sheep) "A Summer Morning" 14 × 22 for Gill to be same price as N. [99.12] 12 days finished May 5th.

Exhibited at Gill's 23d Annual Exhibition, 1900, titled "Summer Morning," priced at $200.00.

THE PATRIARCH 99.14

[Unknown] [Unknown]: 18 × 27 [?]

[Unknown]

C.D. "The Patriarch" 18 × 27 5 Sheep one an old Buck big horns.

EARLY SPRING 99.15

[Unknown] [Unknown]: 14 × 22 [?]

[Unknown]

C.C. Early Spring 14 × 22 5 Sheep 3 lying down.

OUR PETS 99.16

A. F. Tait, N.A. / '99 [LR] Canvas: 14 × 22

C.U. / A. F. Tait, N.A. / "Our Pets" / Yonkers, N.Y.

C.U. "Pets" 14 × 22 3 Sheep in repose & little chicks 3 lying down.

Courtesy of Vose Galleries, Boston, Massachusetts.

EARLY SPRING 99.17

[Unknown] [Unknown]: 8 × 10 [?]

[Unknown]

C.M. [1899] Chickens Early Spring 8 × 10 for Mr Busby finished & Paid for $50.00.

[FOUR SHEEP] 99.18

[Unknown] [Unknown]: 12 × 16 [?]

[Unknown]

C.B. 4 Sheep 2 up & 2 down 12 × 16.

MATERNAL ANXIETY 99.19

A. F. Tait, N.A. / Board: 11¾ × 18
N.Y. 99 [LR]

July / C.E. 1899 / "Maternal Anxiety" / A. F. Tait, N.A. /Yonkers N.Y.

C.E. Maternal Anxiety Two dogs, Colly & Setter 12 × 16 Chicks & Fowls—old Hen setting at Dogs.

Exhibited at the National Academy of Design 75th Annual Exhibition, 1900, titled "Maternal Anxiety."

PETS 99.20

A. F. Tait, N.A. / '99 [LR] Canvas with board
 backing: 9½ × 13½

C.R. 1899. / "Pets" / A. F. Tait, N.A. / Yonkers, N.Y.

C.R. Chickens Pets 10 × 14 begun Sep'r 12th finished Sep'r [October?] 2.

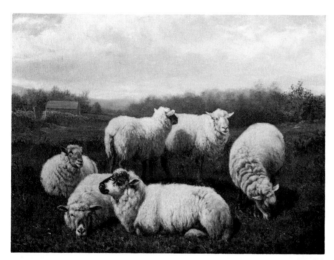

A QUIET DAY 99.21

A. F. Tait, N.A. / Canvas with board
N.Y. '99 [LR] backing: 12¼ × 16¼

C.L. 1899 / "A Quiet Day" / A. F. Tait, N.A. / Yonkers, N.Y.

C.L. [1899] A Quiet Day 12 × 16 Sheep to Bohm [Bohne] Oc'r 17 Sep 29th[–]Oct'r 14th.

A SUMMER DAY 99.22

[Unknown] [Unknown]: 8 × 10 [?]

[Unknown]

C.A. A Summer Day 8 × 10 Sheep to Bohne Oc. 17 Oct'r 1st[–]Oct'r 14.

WHO LEFT THE BARS DOWN 99.23

A. F. Tait, N.A. / N.Y. 99 [LR] Board: 14 × 22

(C.N.) 1899 / "Who Left the Bars Down" / A. F. Tait, N.A. New York / Yonkers N.Y.

C.N. "Who left the Bars down" 14 × 22 Sheep coming thru a Gateway Oct'r 18 fin Nov. 2 15 days.

LITTLE PETS 99.24

A. F. Tait, N.A. / N.Y. 99 [LR] Board: 9¾ × 14

(CD) 1899 Nov'r / Little Pets / A. F. Tait, N.A. / Yonkers / P.S. To dear Tim / and his bride.

C.D. [()Chickens) Little Pets Panel 10 × 14 Wedding Present to Tim Murray Nov'r.

EARLY MORNING ON THE HILLS 99.25

[Unknown] [Unknown]: 18 × 27 [?]

[Unknown]

U.C. [1899] Early morning on the Hills. Sheep in Fog 18 × 27 for N.A.D. Ex Dec'r 15th finished Dec'r 3rd.

Exhibited at the National Academy of Design 75th Annual Exhibition, 1900, titled "An Early Morning On The Hills."

SPRINGTIME 99.26

[Unknown] [Unknown]: 8 × 10 [?]

[Unknown]

U.U. Spring time 8 × 10 Chickens for Ella to be E.d. [$50.00] with Frame Dec'r 4.

Ella is Mrs. F. P. Osborn.

THE GUARDIAN 99.27

[See entry 00.1] Canvas: 13½ × 21¾

[Unknown]

U.U.(A) [The Guardian crossed out] painted dog out Sheep at Ease 14 × 22 Dec'r 20. Bohne's.

First stage of a painting, probably called "The Guardian" originally but altered in 1900 by painting the dog out and changing the date. Original inscription may be on the back of the canvas, but it is covered by board backing that was probably applied following repainting. Exhibited at the National Academy of Design 75th Annual Exhibition, 1900, titled "The Guardian" but unsold and therefore repainted. For second stage see 00.1.

SPRING 99.28

[Unknown] Panel: 10 × 12 [?]

[Unknown]

U.M. Spring copy of Pencil Drawing by Glasgow for Mr John Boyle 10 × 12 Panel to be [$100.00] del'd no Frame Paid finished Dec'r 8 5 days.

THE BARN YARD 99.29

[Unknown] [Unknown]: 14 × 22 [?]

[Unknown]

U.B. "Barn Yard" Sheep in Shed 14 × 22 Gill to Bohne Jan'y 8.

Exhibited at Gill's 23d Annual Exhibition, 1900, titled "The Barnyard," priced at $300.00.

A SUMMER MORNING 99.30

[Unknown] [Unknown]: 12 × 18 [?]

[Unknown]

U.E. [1899 & 1900] A Summer Morning 12 × 18 4 Sheep 2 up 2 down Gill by Bohne Jan'y 8th/19 [00] fin Dec'r 20.

Exhibited at Gill's 23d Annual Exhibition, 1900, titled "A Summer Morning," priced at $200.00.

[PEACOCKS AND FOWL] 99.31

A. F. Tait / 1899 [LR] Canvas: 17 × 27½

[Nothing on back]

[No AFT number; no Register entry]

Courtesy of Mr. and Mrs. George Arden.

A SUMMER MORNING 00.1

A. F. Tait, N.A. / N.Y. 1900 [LR] Canvas with board backing: 13½ × 21¾

A. F. Tait, N.A. / Yonkers, NY / (UUa) 1900 / "A Summer Morning" / Putnam Co N.Y. / 15 Fairfield Place /Ludlow Park.

U.U.(A) [See Register entry for 99.27.]

Second stage of painting originally called "The Guardian," painted and registered in 1899 (99.27). Exhibited in original stage at the National Academy of Design in 1900 but unsold and therefore altered and redated.

THE HILLSIDE SPRING 00.2

[Unknown] [Unknown]: 14 × 22 [?]

[Unknown]

C. "The Hill Side Spring" 14 × 22 Jan'y 8 [ditto Jan'y] 19th.

A QUIET WAY HOME 00.3

A. F. Tait, N.A. / N.Y. 1900 [LR] Canvas: 18 × 27

[Unknown]

U. A Quiet Way Home 18 × 27 [erasures] Jan'y 21 fin Mch 9th Bendan Jan'y 1901 $225.00.

MID DAY 00.4

[Unknown] [Unknown]: 12 × 16 [?]

[Unknown]

M. Mid day 12 × 16 Jan 25.

A QUIET REST 00.5

A. F. Tait, N.A. / N.Y. 1900 [LR] Canvas: 10 × 14½

[Sealed; inscription, if any, unavailable]

B. [1900] A Quiet Rest 10 × 14 Jan 29.

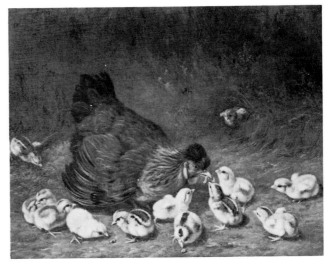

MOTHERLY CARE 00.6

A. F. Tait, N.A. / N.Y. 1900 [LR] Canvas: 12 × 17½

E. 1900 / "Motherly Cares" / A. F. Tait. N.A. / 82 Waring Place, Yonkers, N.Y.

E. Motherly Care 12 × 16 Hen & Chickens Mr Fowler [blank] & Frame $50 Paid [$55.00] & Frame Mch 18 fin April 1st.

Collection of The Holyoke Museum, Holyoke, Massachusetts. Courtesy of The Holyoke Museum.

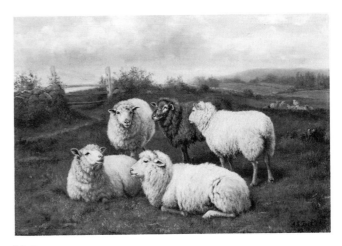

00.7

A QUIET MORNING 00.7

A. F. Tait, N.A. / Canvas: 12¼ × 17¼
N.Y. 1900 [LR]

"R" 1900 / "Quiet Morning" A. F. Tait, N.A. N.Y.

*R. A Restful Day 12 × 17 2 Sheep down 3 up Gill Mch 23
Mch [no date].*

ON THE HILLS 00.8

A. F. Tait, N.A. / N.Y. 1900 [LR] Canvas: 14 × 22

(L) 1900 / "On the Hills" / Putnam Co / N.Y. / A. F.
Tait, N.A.

*L. Morning 14 × 22 To Bohne May 4th Ap'l 11 [ditto Ap'l]
25.*

NOON IN THE PASTURE 00.9

A. F. Tait, N.A. / N.Y. 1900 [LR] Canvas with board
 backing: 12 × 16

A. F. Tait, N.A. / Noon in The Pasture / 82 Waring
Place / Yonkers, N.Y. "A" 1900.

A. [1900] Sheep 12 × 16 May 27.

This painting, given by A. J. B. Tait, AFT's son, to Dr.
Wilson E. Alsop, January 1947, was lost by fire April
1947. All details about the painting were received from
A. J. B. Tait.

[SHEEP RESTING] 00.10

[Unknown] [Unknown]: 12 × 18 [?]

[Unknown]

N. Sheep in Shed 12 × 18 June 3rd.

SHEEP 00.11

[Unknown] [Unknown]: [Unknown]

[Unknown]

D. Sheep June 14.

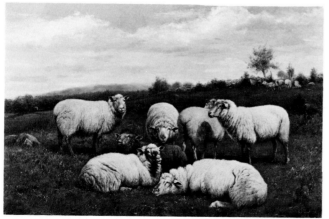

IN THE PASTURE 00.12

A. F. Tait N.A. / N.Y. 1900 [LR] Canvas: 18 × 27

C.C. "In The Pasture" August 30, 1900, A. F. Tait
N.A. N.Y.

*C.C. "In the Pasture" 18 × 27 4 up 3 down Sheep June 25
T J. Murray (Tim) August 16th. Paid $300.00 [plus:] and
Frame 20.00 [total:] $320.00 Sep'r 25/1900.*

Courtesy of Ms. Susan Powell.

A SUMMER DAY 00.13

[Unknown] Panel: 14 × 10 [?]

[Unknown]

*C.U. [1900] A Summer Day Panel 10 × 14 3 Sheep one up 2
down FOT office Mr Middlebrook A Present Aug 7.*

THE SPRING ON THE HILLSIDE 00.14

[Unknown] [Unknown]: 12 × 16 [?]

[Unknown]

*C.M. "The Spring on the Hillside" 12 × 16 Sheep by the
Spring coming down the Hill.*

SHEEP: EVENING 00.15

[Unknown] [Unknown]: 10 × 14 [?]

[Unknown]

C.B. Sheep Evening 10 × 14 Bohne Oct'r 11.

HEN AND CHICKENS 00.16

[See 01.16] [See 01.16]

[See 01.16]

*C.E. [Entire entry crossed out: Hen & Chickens 14 × 22
Oct'r 20th for Mr Tannenbaum] No C. B. 1901 [01.16].*

Possibly not finished in 1900, then reworked and re-
dated, hence reentry in Register for 1901 (01.16).

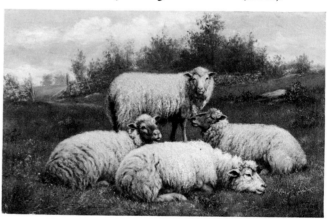

A QUIET GROUP 00.17

A. F. Tait, N.A. / N.Y. 1900 [LR] Panel: 8 × 12

C.R. / Dec 1900 / "A Quiet Group" / A. F. Tait, N.A. /
Ludlow Park / Yonkers, N.Y.

*C.R. [1900] fin Dec'r 4 Sheep 8 × 12 Ella Osborn A Quiet
Group Paid 15th Dec'r $75.00 with Frame.*

EVENING: HOME COMING 00.18

[Unknown] [Unknown]: 14 × 22 [?]

[Unknown]

C.L. Dec'r 20th "Evening" Home Coming 14 × 22 Flock of Sheep coming down Hill begun Nov'r. 3 days.

PEACEFULLNESS 00.19

[Unknown] [Unknown]: 8 × 10 [?]

[Unknown]

C.A. Dec'r 24th 3 Sheep 2 down 1 up 8 × 10 Peacefullness to Bohne by A J B T.

THE OLD SPRING ON THE HILL 01.1

[Unknown] [Unknown]: 14 × 22 [?]

[Unknown]

C.C. [1901] The Old Spring on Hill 14 × 22 flock of Sheep coming down Hillside to Bohne Jan'y 14. & then to Gill. Sold Mch 6th. pd by Chk $200.00. [In margin:] *Dec 1900[–]Jan 1901.*

Exhibited at Gill's 24th Annual Exhibition, 1901, titled "The Old Well," priced at $300.00. Begun in 1900, completed in 1901.

QUITE CONTENTED 01.2

A. F. Tait, N.A. / N.Y. 1901 [LR] Panel: 18 × 24

C.U. / 1901 "Quite Content" / A. F. Tait, N.A. Ludlow Park Yonkers, N.Y.

C.U. "Quite Contented" 18 × 24 3 large Sheep 2 down 1 up on a Panel. very highly finished $350—Hill landscape in Background Jan'y 12 [—ditto Jan'y] 29th [ditto Jan'y] 30 sent to Bohne by Arthur Feb & to Lotos Ex Feb'y 23rd. then to Gill.

CONTENTMENT 01.3

[Unknown] [Unknown]: 18 × 27 [?]

[Unknown]

C.M. Sheep. 3 down 2 up 18 × 27 ["At Home" crossed out] *Contentment Jan'y 31 fin Feb 20 To Bohne 21st sent to Mr J. E. Rothwell Brookline. Boston Mch 16 by Bohne Paid $300.00. Ap'l 11th 1901 all right.*

[UNKNOWN] 01.4

[Unknown] [Unknown]: 10 × 12 [?]

[Unknown]

[1900] [(C) B. Feb 20 Chickens crossed out] *10 × 12.*

EVENING 01.5

[Unknown] [Unknown]: 10 × 12 [?]

[Unknown]

(C)E. Evening. Sheep for Gill. very nice 10 × 12 Feb 24.[–] Mch 3rd finished & sent off Mch 4th.

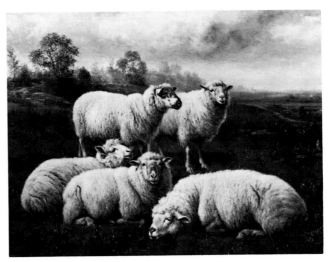

MID DAY 01.6

A. F. Tait, N.A. / Board: 16 × 20½
1901 N.Y. [LR]

(R) 1901 / "Mid Day" / Putnam Co / N.Y. / A. F. Tait, N.A. / Ludlow Park / Yonkers, / N.Y.

(C)R. Mid Day [Erased: *Panel*] *16 × 20 Putnam Co fin Mch 20 Gill no Frame sent off Mch 22nd Xpress.*

Courtesy of Mr. and Mrs. George Arden.

LITTLE SPRING PETS 01.7

[Unknown] [Unknown]: 10 × 14 [?]

[Unknown]

B. [1901] Little Spring Pets 10 × 14 Chickens fin'd Mch 31st.

GOOD FRIENDS 01.8

[Unknown] [Unknown]: 14 × 22 [?]

[Unknown]

[A crossed out] *L. Sheep. Good Friends 14 × 22* [A Friend crossed out] *4 Sheep & Colly sitting up 2 down 2 up April 4th fin'd Ap'l 20th.*

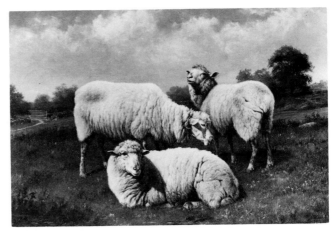

01.9

QUIETUDE 01.9

A. F. Tait, N.A. / Canvas: 18¼ × 27
N.Y. 1901 [LR]

(A), 1901., Quietude, A. F. Tait, N.A., Ludlow Park,
Yonkers, N.Y.

A. 3 Sheep 1 down 2 up 18 × 27 [In margin:] *Ap'l 20 May 9
Quietude to Bohne May 16th.*

Collection of The New-York Historical Society, New
York, N.Y. Courtesy of The New-York Historical Society.

LOST 01.10

A. F. Tait, N.Y., 1901 [LR] Panel: 6 × 8

"Lost." (N) *1901* / A. F. Tait, N.A. / Yonkers, / N.Y.

*N. [1901] "Lost Lambs["] 2 "Enfante Perdue" 6 × 8 Panel to
be $25.00 with Frame May 10th[–ditto May] 13th.*

Courtesy of Mrs. Ronald Trumbull.

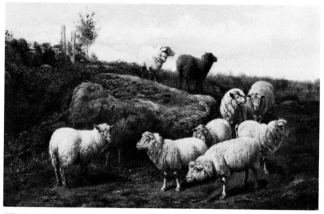

THE ROCK WELL 01.11

A. F. Tait, N.A. / N.Y. 1901 [LR] Canvas: 14 × 22

(D) 1901 / "The Spring" / in the Pasture / A. F. Tait,
N.A. / Ludlow Park / Yonkers / N.Y.

D. Sheep down a Hill (action) 14 × 22 The Rock Well [In
margin:] *May 14 fin June 8 sent to Bohne by Emma June 10.*

[SHEEP] 01.12

[Unknown] [Unknown]: 10 × 14 [?]

[Unknown]

C.C. 3 Sheep 2 up 1 down 10 × 14 fin July 15.

SUNDOWN 01.13

[Unknown] [Unknown]: 10 × 14 [?]

[Unknown]

C.U. Sheep. Sundown 10 × 14 2 up 1 down.

[SHEEP] 01.14

[Unknown] [Unknown]: 14 × 22 [?]

[Unknown]

C.M. [1901] 4 Sheep large 14 × 22 2 up 2 down fin July 20.

EARLY SPRING 01.15

[Unknown] [Unknown]: 18 × 27 [?]

[Unknown]

*C.B.A. "Early Spring" (Sheep 3 up 2 down) 18 × 27 fin
Sept'r 30 Bohne Oct'r 2nd.*

MOTHERLY CARE 01.16

A. F. Tait, N.A. / N.Y. '01 [LR] Canvas: 14 × 22

"CB" / 1901 / "Motherly Cares" / A. F. Tait, N.A. /
Ludlow Park / N.Y.

*C.B. Motherly Care 14 × 22 Chickens July 24th fin Aug 30
Tannenbaum Xchange for Tiney Jack & Hens.*

This painting was originally registered as *C.E. 1900* but
the entry was crossed out by AFT and reentered here.

A QUIET TIME 01.17

[Unknown] Panel: 8 × 12 [?]

[Unknown]

*C.E. Sheep 1 down 2 up Panel 8 × 12 Sep'r 16th To Bohne for
N.A.D.*

Exhibited at the National Academy of Design 77th Annual Exhibition, 1902, titled "A Quiet Time."

[SHEEP] 01.18

[Unknown] [Unknown]: 18 × 27 [?]

[Unknown]

C.R. Sheep 18 × 27 fin Oct'r 9.

SPRING PETS 01.19

A. F. Tait, N.A. / N.Y. 1901 [LR] Panel: 8 × 12

(CL) 1901 / "Spring Pets" / A. F. Tait, N.A. / Ludlow Park / N.Y.

C.L. Little Pets Panel 8 × 12 Chickens A J. B. Tait Oct'r 2 fin.

A SHADY SPOT 01.20

[Unknown] [Unknown]: 18 × 27 [?]

[Unknown]

C.A. Sheep in Shade of Tree 18 × 27 Oct'r down to Bohne Nov 18 N.A.D. Dec'r 11th.

Exhibited at the National Academy of Design 77th Annual Exhibition, 1902, titled "A Shady Spot."

MORNING ON THE HILLS 01.21

[Unknown] [Unknown]: 14 × 22 [?]

[Unknown]

C.N. [At Rest crossed out] Morning on the Hills 3 down 2 up back 14 × 22 Nov'r Dec'r 10 fin.

THE SPRING ON THE HILLSIDE 01.22

A. F. Tait, N.A. / Canvas: 14¼ × 22¼
N.Y. '01 [?]

C D / 1901 / Spring on the Hill Side / A. F. Tait, N.A. / Ludlow Park / Yonkers / N.Y.

C.D. [word crossed out] The Spring on the Hill Side 8 Sheep coming down 14 × 22 Nov'r [–] Dec'r 15th to Bohne for Academy.

Exhibited at the National Academy of Design 77th Annual Exhibition, 1902, titled "The Spring On The Hillside."

Stamped on stretcher and on the backing, "Tait's Pat. / Oct. 16, 1900," which refers to AFT's patented stretcher.

AT HOME 01.23

[Unknown] [Unknown]: 14 × 22 [?]

[Unknown]

C.Z. [1901] At Home Sheep in Shed 14 × 22 sent to Gill Jan'y 6 [1902] Dec'r 16[–]Jan'y 5 [1902].

May be dated 1902 despite inclusion by AFT in Register under 1901.

EASTER MORN 01.24

A. F. Tait [LR] [Date obliterated] Panel: 9 × 11½

[Nothing on back]

[No AFT number; no Register entry]

A.J.B. Tait stated that he remembered his father painting this for L. Prang to be reproduced as an Easter card and that Prang returned it, saying he wanted a young lamb, not a sheep. AFT tried adding chicks, etc., but

never was satisfied. A.J.B. Tait kept the picture when AFT thought of burning it in the furnace.

Courtesy: Anonymous.

ON THE HILLS 02.1

A. F. Tait, N.A. / Canvas: 11¾ × 15¾
N.Y. 1902 [LR]

(C) 1891 / "On the Hills" / A. F. Tait, N.A. / Ludlow Park / Yonkers. / N.Y

C. [1902] On the Hills 12 × 16 Sheep coming down Path and on right a spring in Rocks. from old Sketch Jan'y 6 14 [ditto Jan'y] 19 fin.

Note difference in dates, front and back, and that AFT record states, "from old Sketch."

GOOD FRIENDS 02.2

[Unknown] Panel: 17¾ × 24 [?]

[Unknown]

[C crossed out] U. Good Friends Panel 17¾ × 24 Sheep in Yard. Dog on Wall at left Jan'y 18 [–] Feby 14th To Bohne.

QUIET CONTENT 02.3

[Unknown] [Unknown]: 18 × 27 [?]

[Unknown]

M. [1902] [Peace crossed out] Quiet Content 18 × 27 Feb'y 15 [–] March 10 to Bendan and Sold & paid for April 21st & wanted a companion $250.00.

MIDSUMMER 02.4

[Unknown] [Unknown]: 24 × 36 [?]

[Unknown]

B. "Midsummer" 24 × 36 Mch 14.

EARLY EVENING 02.5

[Unknown] [Unknown]: 14 × 22 [?]

[Unknown]

E. Early Evening 14 × 22 6 Sheep 4 up 2 down to Bohne Ap'
16 Mch 27[–]Ap' 16.

[UNKNOWN] 02.6

[Unknown] [Unknown]: 18 × 27 [?]

[Unknown]

R. [1902] [Title and description blank] 18 × 27 Apr'l 21st.

CONTENTMENT 02.7

A. F. Tait, N.A. / Canvas with board
N.Y. 02 [LR] backing: 14 × 22

(L.E.) 1902 / A. F. Tait, N.A. / Ludlow Park / Yonkers
N.Y. / "Contentment" / To my Son A.JB Tait and / his
Bride Edith Miles / From the Artist / Oct'r 7, 1902

L.A. Content 14 × 22 5 Sheep 2 up 3 down Present to A J B
Tait & Edith Miles (Oct'r 7th) their Wedding Day. 3 days
June 27 [,] 7 [days] Sep 13th Fin Sep'r 26 [,] 10 days all.

Note discrepancy between code on back inscription and
code in Register entry.

Courtesy of Mr. Arthur F. Tait II.

A QUIET DAY 02.8

A. F. Tait, N.A. / N.Y. '02 [LR] Board: 12 × 18

(L) 1902 / "A Quiet Day" / A. F. Tait, N.A. / Ludlow
Park / Yonkers, N.Y.

A. Sheep 12 × 16 Mrs Ludlow Paid for $150.00.

Note that code on painting is *L* and AFT Register is "A."
This is due to his entering 02.7 as *L.A.*

AN OCTOBER DAY 02.9

[Unknown] [Unknown]: 10 × 14 [?]

[Unknown]

N. 3 Sheep. An October Day 10 × 14 Putnam Co NY. fin
June 27 to Bohne 28th Price to be nett [figures crossed out]
110.

EARLY MORNING 02.10

[Unknown] [Unknown]: 18 × 27 [?]

[Unknown]

D. [1902] Early morning 18 × 27 5 Sheep. 2 up 3 down for
Bendan sold $250 Nov'r 12th Paid July 11 fin July 25.

COMING HOME 02.11

[Unknown] [Unknown]: 24 × 36 [?]

[Unknown]

C.C. Sheep & Shed 24 × 36 "coming home" July 30 & fin Sep
23rd.

Exhibited at the National Academy of Design 78th An-
nual Exhibition, 1903, titled "Coming Home."

NOON: SUMMER 02.12

[Unknown] [Unknown]: 16 × 24 [?]

[Unknown]

C.U. Noon. Summer 16 × 24 6 Sheep 2 down 4 up Sep. 30 3
days & Nov'r 15 Fin Nov'r 29th.

QUIET CONTENT 02.13

[Unknown] [Unknown]: 14 × 22 [?]

[Unknown]

C.M. [1902] Quiet Content 14 × 22 6 Sheep 4 down 2 up
Oct'r 1st fin Oct'r 24th to Bohne 25th.

FRIENDS 02.14

A. F. Tait, N.A. / N.Y. 02 [LR] Canvas: 14¼ × 22

(CB) 1902 / Friends / A. F. Tait, N.A. / Ludlow Park /
Yonkers / N.Y.

C.B. Friends 14 × 22 Oct'r 25 fin Nov'r 14 sent to Bohne
Dec'r 1. by Mama.

Exhibited at the National Academy of Design 78th An-
nual Exhibition, 1903, titled "Friends." Stamped on the
back is "Tait's Patent / Oct. 10, 1900," which refers to
AFT's patented stretcher.

THE BROKEN FENCE 02.15

[Unknown] [Unknown]: 16 × 21 [?]

[Unknown]

C.E. The Broken Fence 16 × 21 Sheep coming thru Fence &
coming down Bank Dec'r 1st Fin Dec. 20 to Bohne Dec'r 21st.

JUST ESCAPED 03.1

A. F. Tait, N.A. / Canvas: 20½ × 30½
N.Y. '03 [LR]

"Just escaped," A. F. Tait, N.A., Yonkers, N.Y. 1898.
Repainted in 1903 and presented to my son Frank and
Edith, his wife, July

[See 98.14]

Originally code *C.C.* of 1898 (98.14) but, as indicated by that back description, repainted with probable alterations of the front inscription and addition to the back inscription.

A ROCKY PASTURE 03.2

A. F. Tait, N.A. / N.Y. 03 [LR] Board: 14 × 22

(CR) 1903. / "A Rocky Pasture" / Putnam Co. N.Y. / A. F. Tait, N.A. / Ludlow Park / Yonkers. / N.Y.

C. [1903] A Rocky Pasture 14 × 22 Good. repose 2 up on Rock fin Jan'y 11. for Gill.

AFT's coding is wrong, since he shows it as *C.R.* on the picture and lists it as *C* in the Register. There is stamped on the left side of the back, "Patent Applied For *in England* / Patented *in U.S. 1900*," and on the right side, "Tait's Patent / Oct. 16, 1900." Exhibited at Gill's 26th Annual Exhibition, 1903, titled "A Rocky Pasture," priced at $300.00.

SUMMER TIME 03.3

[Unknown] [Unknown]: 16 × 20 [?]

[Unknown]

U. Summer 16 × 20 3 Sheep [Erased: 2 up 1 down] Begun Jan 17 [Erased: fin [ditto Jan.] 28 to Gills].

Exhibited at Gill's 26th Annual Exhibition, 1903, titled "Summer Time," priced at $300.00.

EVENING 03.4

[Unknown] [Unknown]: 12 × 16 [?]

[Unknown]

M. Evening 12 × 16 3 Sheep 2 up 1 down fin Jan 28 to Bohne for Gills Jan 29 by A.J.B.T.

Exhibited at Gill's 26th Annual Exhibition, 1903, titled "Evening," priced at $225.00.

A SPRING DAY 03.5

[Unknown] [Unknown]: 14 × 22 [?]

[Unknown]

B. [1903] 5 Sheep 3 up 2 down 14 × 22 "A Spring Day." Putnam Co N.Y. Sent to Gill by Bohne Ap'l 3rd Ap'l 23 [ditto Ap'l] 26.

NOON 03.6

[Unknown] [Unknown]: 14 × 22 [?]

[Unknown]

E. "Noon" 14 × 22 5 Sheep 3 down 2 up paid for $200.00. May 28th Ap'l 26[–]May 8th.

A SPRING DAY 03.7

[Unknown] [Unknown]: 16 × 20 [?]

[Unknown; but see below]

R. A Spring day 16 × 20 to Bohne for Gill R no record on back. May 9th fin May 27.

A SUMMER MORNING 03.8

[Unknown] [Unknown]: 18 × 27 [?]

[Unknown]

L. [1903] "A Summer Morning" 18 × 27 To Bohne for Gill 3 Sheep down 2 up May 28 f [in?] June 25 [ditto June] 30 [?].

A SUMMER NOON 03.9

[Unknown] [Unknown]: 14 × 22 [?]

[Unknown]

A. A Summer Noon 14 × 22 5 Sheep 3 up 2 down June 27 fin July.

AMONG THE HILLS 03.10

A. F. Tait, N.A. / Canvas with board
N.Y. 03 [LR] backing: 18¼ × 27¼

[Unknown]

N. Among the Hills 18 × 27 Putnam Co N.Y. for Bendan Balt'o July 20 sent Aug 10th.

A SPRING DAY 03.11

[Unknown] [Unknown]: 18 × 27 [?]

[Unknown]

B. [1903] A Spring Day 18 × 27 6 Sheep 4 down 2 up for Bendan to Bohne by Emma Sep'r 9th Aug 12th[–]Sep'r 7 [written over 6].

ON THE HILLSIDE 03.12

[Unknown] Canvas: 18 × 27 [?]

[Unknown]

C.C. On the Hill side 18 × 27 2 down 2 up To Bohne Oct'r 13th by Emma Sep'r 10[–]Oct'r 10.

Exhibited at the National Academy of Design 79th Annual Exhibition, 1904, titled "On The Hillside." Exhibited at Gill's 27th Annual Exhibition, 1904, titled "On The Hillside," priced at $400.00.

SUMMER NOON 03.13

[Unknown] [Unknown]: 14 × 22 [?]

[Unknown]

C.U. Summer Noon Sheep 2 down 3 up 14 × 22 Oct 10 fin 26.

EARLY MORNING 03.14

[Unknown] [Unknown]: 18 × 27 [?]

[Unknown]

C.M. [1903] Early Morning 18 × 27 Sheep 3 down 2 up Begun Nov'r 2 fin [ditto *Nov'r*] *29.*

A DRY TIME 03.15

[Unknown] [Unknown]: 14 × 22 [?]

[Unknown]

C.B. A dry Time 14 × 22 7 Sheep down Bank old Rock & Spring Dec'r 2nd fin Dec'r 18.

Exhibited at Gill's 27th Annual Exhibition, 1904, titled "A Dry Time," priced at $325.00.

EARLY EVENING IN THE FOLD 04.1

[Unknown] [Unknown]: 15 × 22 [?]

[Unknown]

C.E. [1904] Early Evening in the Fold 15 × 22 Dec'r 21 [1903–] *Jan'y 14th* [1904].

Coding continues series of 1903.

A WARM MAY DAY 04.2

[Unknown] [Unknown]: 16 × 20 [?]

[Unknown]

C. [1904] A Warm May day 16 × 20 Jan'y 16th Fin 25 To Bohne 26th for Gill.

Exhibited at Gill's 27th Annual Exhibition, 1904, titled "A Warm May Day," priced at $325.00.

SPRING 04.3

[Unknown] [Unknown]: 14 × 22 [?]

[Unknown]

U. Spring 14 × 22 4 Sheep Express to Garver [?] Amer. Express Jan'y 26[–]Feb 12.

THE ROCKEY PASTURAGE 04.4

A. F. Tait / 1904 [LR] Canvas: 14 × 22

M.E. 94 / (M) 1904 / "The Rockey Pasturage" / Putnam Co N.Y. / A. F. Tait, N.A. / Ludlow Park / N.Y.

M. A Rock Pasturage 14 × 22 5 Sheep 3 down 2 up Feby 14 Fin March 5th sent to Folsom. Boston Mch 7th.

A SUNNY CORNER 04.5

[Unknown] [Unknown]: 14 × 22 [?]

[Unknown]

B. [1904] A Sunny Corner 14 × 22 Mch 8 Do [ditto *Mch*] *26.*

FRIENDS 04.6

[Unknown] [Unknown]: 14 × 22 [?]

[Unknown]

E. [Sick 3 weeks until May 7 & 11.] Friends 14 × 22 sent to Folsom. Mch 29[–]May 12th.

EARLY SPRING 04.7

[Unknown] [Unknown]: 14 × 22 [?]

[Unknown]

R. Early Spring 14 × 22 Putnam Co N.Y. fin June 3.

A JUNE DAY 04.8

A. F. Tait, N.A. / 1904 [LR] Canvas: 14 × 22

(L) 1904 / "A June Day" A. F. Tait, N.A. / Ludlow Park / Yonkers, / N.Y.

L. [1904] A June day 14 × 22 Putnam Co N.Y. fin June 25.

NOON DAY 04.9

[Unknown] [Unknown]: 14 × 22 [?]

[Unknown]

A. [Summer crossed out] Noon day 14 × 22 Frank Wife & Baby here can't do much June 27[–]July 25.

Exhibited at the National Academy of Design 80th Annual Exhibition, 1905, titled "Noontide."

AUTUMN 04.10

[Unknown] [Unknown]: 18 × 27 [?]

[Unknown]

N. "Autumn" Wayside Spring 18 × 27 very much work Elaborate Aug 1st[–]Sep 14 [possibly 12].

Exhibited at Gill's 29th Annual Exhibition, 1906, titled "Autumn," priced at $550.00.

JUNE 04.11

[Unknown] [Unknown]: 18 × 27 [?]

[Unknown]

D. [*1904*] ["] *June" 18 × 27 Putnam Co NY 4 Sheep 1 up 3 down Good Sep'r 14[–]Oct 8.*

Exhibited at the National Academy of Design 80th Annual Exhibition, 1905, titled "June, Putnam Co., N.Y."

[UNKNOWN] 04.12

[Unknown] [Unknown]: 14 × 22 [?]

[Unknown]

C.C. [subject description lacking] *14 × 22 for Gill Oct'r 13[–]Nov 1 [ditto Nov] 15.*

JULY 04.13

A. F. Tait, N.A. / Canvas with board
N.Y. '04 [LR] backing: 18 × 27¼

(C U) / 1904 / "July" Putnam Co., N.Y. / A. F. Tait, N.A. / Ludlow Park / Yonkers / N.Y.

C.U. "July" 18 × 27 Putnam Co. N.Y. Nov 16[–]Dec'r 1st.

THE FOLD 04.14

A. F. Tait, N.A. / 1904, N.Y. [LR] Canvas: 14 × 22

(C.M.) 1904 / "The Fold" / A. F. Tait, N.A. / Ludlow Park / Yonkers, N.Y.

C.M. [1904] [subject description lacking] *14 × 22 Dec'r 5.*

This is the last entry in the Registers.

[ENGLISH STAGS AND HINDS] ND.1

A. Tait [LR] Canvas: 21¾ × 34¼

[Relined; inscription, if any, lost]

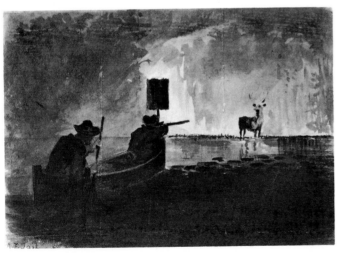

[JACKING DEER] ND.2

A. F. Tait [LL] Wash on paper: 7 × 10

[Nothing on back]

Collection of The Adirondack Museum, Blue Mountain Lake, New York. Courtesy of The Adirondack Museum.

[TWO LAMBS AND OLD HEN] ND.3

[Not signed or dated] Canvas: 10 × 14

[Nothing on back]

An unfinished work that has been in the Tait family since AFT's death. The stretcher is stamped: "A. F. Tait."

[AFTER THE CHASE] ND.4

A. F. Tait [LR] Board: 14 × 18

[Nothing on back]

Painting depicts head, upper body of swimming buck.

[STUDY OF BIRCH BARK CANOE] ND.5

[Not signed or dated] Canvas: 11½ × 15½

[Nothing on back]

This sketch was used by AFT in many paintings including 57.8, 62.9, 80.21, 80.24, 81.14, 82.19, 83.7.

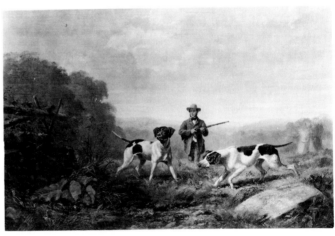

[A CLOSE POINT] ND.6

[Not signed or dated] Canvas: 23½ × 36

[Nothing on back]

Painting depicts a man with gun, two pointers, five quail in a field.

Courtesy of Kennedy Galleries, Inc., New York, New York.

[PORTRAIT OF A SMALL DOG] ND.7

[Not signed or dated] Paper: 8 × 10 oval

[Nothing on back]

Originally given by AFT to George W. Hale of Malone, N.Y. and has descended in the family to the present time.

RETRIEVING, BY W. RANNEY ND.8

W. R. & A. F. T. & W. S. M. Canvas: 11 × 14½

Retrieving, by W. Ranney

This painting was unfinished at the time of William Ranney's death, November 18, 1857. AFT and William Sidney Mount completed the picture so that it could be sold for the benefit of the Ranney estate in December 1858.

[QUAIL AND YOUNG] ND.9

[Not signed or dated] Canvas: 19½ × 24

[Relined; inscription, if any, lost]

Painting relined and restored in December, 1950.

[FELINE COMPETITION] ND.10

A. F. Tait, N.A. Canvas: 36 × 27
[Lower center on basin]

[Relined; inscription, if any, lost]

Painting depicts two Skye Terriers jumping at a cat on a rain barrel.

[ON THE ALERT] ND.11

A. F. Tait [LR] Canvas: 22 × 14

[Nothing on back]

Painting depicts full figure of buck facing left and standing on a grassy knoll. Lake in background.

[TWO POINTERS] ND.12

A. F. Tait [LL] Pencil on paper: 8¾ × 13¼

[An indistinct wash sketch]

Collection of the Boston Museum of Fine Arts, Boston, Massachusetts, the Karolik Collection.

[DEER AT THE LAKE] ND.13

A. F. Tait / Edward Gay [LR] Canvas: 24¼ × 36¼

[Unknown]

Collection of the Parrish Art Museum, Southampton, New York.

[SHEEP AT PASTURE] ND.14

Edward Gay, A.N.A. / Canvas: 20 × 27
A. F. Tait, N.A. [LL]

[Relined; inscription, if any, lost]

It appears that Gay painted the landscape and AFT painted the sheep.

[BEAR AND TWO CUBS] ND.15

A. F. Tait & J. M. Hart [LL] Canvas: 7 × 12

[Nothing on back]

The signature is not by AFT and may be by J. M. Hart.

[CHICKENS] ND.16

A. F. Tait, [LR] Board: 9 × 11 [?]

[Nothing on back]

[HEN AND CHICKENS] ND.17

A. F. Tait [Date [Unknown]: 6 × 8 [?]
indistinct, LR]

[Unknown]

[HEN AND CHICKENS] ND.18

A. F. Tait [Date [Unknown]: 6 × 8 [?]
indistinct, LR]

[Unknown]

[COCKER FLUSHING TWO ND.19
RUFFED GROUSE]

[Signature and date [Unknown]: [Unknown]
are illegible in available
photograph of painting]

[Unknown]

[THE CARES OF A FAMILY] ND.20

A. F. Tait / N.Y. [LR] [Unknown]: [Unknown]

[Unknown]

Reproduced by Currier & Ives, undated, and titled, "The Cares of a Family."

C & I print depicts a grouse and eight chicks. A similar C & I print published in 1856 shows two grouse and eight chicks.

See 55.10.

[BIRD DOG ON POINT TO ND.21
TWO WOODCOCK]

A. F. Tait / N.Y. [LR] [Unknown]: [Unknown]

[Unknown]

This painting may be dated 1865 or 1866 as the available photograph of the painting accompanied others identifiable as 1865 and 1866.

[RUFFED GROUSE AND YOUNG] ND.22

A. F. Tait / Morrisania, [Unknown]: [Unknown]
N.Y. [UL] Oval

[Unknown]

This painting may be dated 1865 or 1866 as the available photograph of the painting accompanied others identifiable as 1865 and 1866.

[A POINTER FINDING ND.23
A DEAD GROUSE]

A. F. Tait / N.Y. [LR; [Unknown]: [Unknown]
date illegible in

available photograph]

[Unknown]

[SPOTTED FAWN AND DOE] ND.24

A. F. Tait [LR] [Unknown]: 10 × 14

[Unknown]

[DOE AND TWO FAWNS] ND.25

[Unknown] [Unknown]: [Unknown]

[Unknown]

[GROUP OF GROUSE] ND.26

A. F. Tait [LL] Board: 9 × 13

[Nothing on back]

[PHEASANT CHICKS WITH ND.27
STRAWBERRY]

A. F. Tait, N.A. Canvas: 9¾ × 12⅓ Oval
[LR; date blurred]

[Relined; inscription, if any, lost]

[DUCKS] ND.28

A. F. Tait [LR; date [Unknown]: [Unknown]
illegible in available photograph]

[Unknown]

[A RUFFED GROUSE FAMILY] ND.29

[Unknown] [Unknown]: [Unknown]

[Unknown]

[SIX DOMESTIC CHICKS] ND.30

A. F. Tait [LR; date [Unknown]: [Unknown]
illegible in available photograph]

[Unknown]

[THE GUARDIAN] ND.31

A. F. Tait [LL; date [Unknown]: [Unknown]
illegible in available photograph]

[Unknown]

Painting depicts buck facing front, foreground; two does behind on foggy lake shore.

[BUCK AND DOE AT A ND.32
LAKE SIDE]

A. F. Tait [LR; date [Unknown]: [Unknown]
illegible in available photograph]

[Unknown]

[SEVEN DOMESTIC CHICKS] ND.33

A. F. Tait / N.Y. [LR; date Board: 10 × 14

illegible in available photograph]

[Nothing on back]

[DUCKS BESIDE A BROOK] ND.34

A. F. Tait, N.A. / N.Y. [LL] Board: 5¼ × 9¼

[Nothing on back]

[SPORTSMAN WITH DOGS] ND.35

[Unknown] Canvas: 10 × 21½

[Unknown]

Painting bequeathed to the Brooklyn Museum by a Mr. Polhemus in 1906 and destroyed in the 1930s by the museum due to extremely poor condition.

[SUMMER MORNING] ND.36

A. F. Tait [LR of oval] Canvas: 20¼ × 23¼ oval

[Rebacked; inscription, if any, lost]

Painting depicts a rooster and five hens in a field, foreground. A cottage surrounded by trees stands in background.

[GROUP OF CHICKENS] ND.37

A. F. Tait / N.Y. [LR; date Board: 10 × 12¹/₁₆
illegible, possibly 1866]

[Relined; inscription, if any, lost]

This painting was bought by Louis Prang who published it as a chromolithograph in 1866 titled "Group of Chickens." Cleaned and repaired in 1968, the painting is still owned by Prang's descendants.

THE PURSUIT ND.38

A. F. Tait [LR] Canvas: 18 × 24

[Stencil of Williams, Stevens & Williams]

Probably painted in 1855. See 55.9.

Companion to ND.39.

A hand-colored lithograph was published by N. Currier, 1856, titled "The Pursuit."

THE LAST WAR WHOOP ND.39

A. F. Tait [LR] Canvas: 18 × 24

[Stencil of Williams, Stevens & Williams]

Probably painted in 1855. See 55.8.

Companion to ND.38.

A hand-colored lithograph was published by N. Currier, 1856, titled "The Last War Whoop."

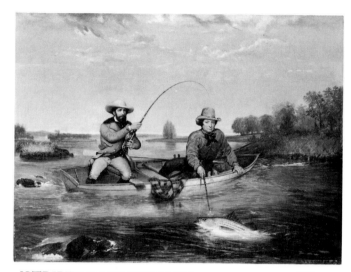

[STRIPED BASS FISHING] ND.40

[Not signed or dated] Canvas: 37½ × 49¾

[Relined; inscription, if any, lost]

This painting has been attributed to AFT by H. T. Peters.

Courtesy of Congoleum Corporation.

[TWO SMALL CHICKS] ND.41

[Not signed or dated] Canvas: 5½ × 7⅛

[Nothing on back]

Writing appears on back of stretcher but it is too faint to be made out.

[THREE DEER BY A STREAM] ND.42

A.F.T. [LR] Watercolor on paper: 6⅛ × 16¼

[Nothing on back]

[DEAD FISH] ND.43

A. F. Tait / 150 Spring Pastel drawing
St. / N.Y. [LL] on paper: 24 × 10½

[Nothing on back]

Probably done between 1850 and 1854 when AFT was living at above address. May be Checklist 53.10.

[DEAD GAME] ND.44

A. F. Tait / 150 Spring Pastel drawing
St. / N.Y. [LR] on paper: 24 × 10½

[Nothing on back]

Probably done between 1850 and 1854 when AFT was living at above address.

[CHICKENS IN A BASKET] ND.45

A. F. Tait, N.Y. [LR] Canvas: 12 × 16

[Nothing on back]

[CHICKS ROUND A BUTTERFLY] ND.46

[Not signed or dated] Board: 9¼ × 14¼

[Nothing on back]

[CHICKS AND LARGE BUTTERFLY] ND.47

[Not signed or dated] Canvas: 10¾ × 13½

[Nothing on back]

Indistinct writing apparent on back of stretcher.

[DEER: A SKETCH FROM NATURE] ND.48

A. F. Tait [LR] Canvas: 11⅛ × 14⅛

[Nothing on back]

Collection of The Metropolitan Museum of Art, New York, New York, gift of Mrs. Darwin Morse, 1963.

[DEER IN LANDSCAPE] ND.49

W. L. Sonntag—A. F. Tait [LL] Canvas: 39 × 56

[Nothing on back]

[OIL SKETCHES—AMERICA] ND.50

[Not signed or dated] Canvas: 12 × 18

[Nothing on back]

Three oil sketches depicting a forest scene in winter and broken, snow covered trees.

Collection of the Yale University Art Gallery, New Haven, Connecticut.

[INK AND WATERCOLOR ND.51
SKETCHES—AMERICA]

[Not signed or [See remarks]: [See remarks]
dated]

[See remarks]

Four sketches depicting a dwelling built into the rocks, trees and rocks on a brook, a farm, and a doe resting. Ink and/or watercolor; dimensions vary. Three are numbered on back.

Collection of the Yale University Art Gallery, New Haven, Connecticut.

[PENCIL SKETCHES] ND.52

[See remarks] Pencil on paper: [See remarks]

[See remarks]

A group of 144 pencil sketches of English and American subjects dating from 1832 to 1889 and of various dimensions. Not all of these sketches have been signed or dated and some may have been done after 1889. Another sketch and/or writing appears on back of some.

Collection of the Yale University Art Gallery, New Haven, Connecticut.

[SKETCHES—SCOTLAND] ND.53

[Not signed or [See remarks]: [See remarks]
dated]

[See remarks]

Fourteen sketches done in Scotland in 1840 and 1841.
Five are dated on back and all are numbered. Pencil, ink
or watercolor—dimensions vary.

Collection of the Yale University Art Gallery, New Ha-
ven, Connecticut.

[RAILROAD SKETCHES] ND.54

[Not signed or [See remarks]: [See remarks]
dated]

[See remarks]

Ten sketches depicting views along the Manchester and
Leeds Railway, the London and North Western Rail-
way, and the Manchester and Liverpool Railway done in
the 1840s. Two are dated and nine are numbered and/or
annotated on back. Pencil, ink or watercolor on paper—
dimensions vary.

Collection of the Yale University Art Gallery, New Ha-
ven, Connecticut.

Appendix
Lithographic Work by Arthur F. Tait Done in England

1. THE COLLEGIATE INSTITUTION, LIVERPOOL
 Size: 3½ × 5½ inches
 Signed lower right: A. F. Tait '42
 Letterpress, lower margin: "H. Lonsdale Elmes, Esq., Architect / The Collegiate Institution, Liverpool"
 From: Alexander Brown, *Smith's Stranger's Guide to Liverpool, Its Environs, and Part of Cheshire, for 1842* (Liverpool: Printed and Published by Benjamin Smith, South Castle Street, 1842), opposite p. 82. Copy in the British Museum.

2. SIR THOMAS FAIRFAX
 Size: Unknown
 Letterpress, lower margin, left to right: "Painted by R. Ansdell Printed by A. Miller, Liverpool on Stone by A. F. Tait / Sir Thomas Fairfax, / a Celebrated Short-Horned Bull . . . / Published by Messrs. Ackermann & Co., Strand, London; and Mr. Agnew's Repository of Arts, Exchange Street, Manchester. May 16, 1842."
 Photostat copy at The Adirondack Museum, No. 63.65.6. Another lithograph (but not this one) of the same large bull is recorded in D. H. Boalch, *Prints and Paintings of British Farm Livestock, 1780–1910* (Harpenden, England: Rothamsted Experimental Station Library, 1958), p. 25.

3. THE SENTINEL
 Size: 8½ × 11½ inches
 Signed lower right: A. F. Tait 1842
 Letterpress, lower margin, left to right: "Drawn and Lithographed by A. F. Tait Published by A. F. Tait, 59 Islington, 9 December 1842. Printed by A. Miller, 4 Harrington St. L'pool / To Wilfred Troutbeck, Esq., this drawing is respectively inscribed / . . ."
 A defective copy, lacking the remainder of the inscription, is at The Adirondack Museum, No. 63.65.10.

4. ST. JUDE'S CHURCH, LIVERPOOL
 Size: 12 × 16 inches
 Signed lower right: A. F. Tait 1843
 Letterpress, lower margin: left, "A. F. Tait del et lith."; right, "Day & Haghe Lith. to the Queen" / "To the Rev'd Hugh McNeile A-M. &c&C&C and the Congregation of / St. Jude's Church, Liverpool / this Drawing is respectfully dedicated by their most obedient Servant / A. F. Tait / 50 Islington, Liverpool, Dec. 1st, 1843."
 Photostat copies at The Adirondack Museum, Nos. 63.64.40 and 63.65.12–13.

5. CHURCHES OF THE MIDDLE AGES

Henry Bowman and J[oseph] S[tretch] Crowther, *The Churches of the Middle Ages, being select specimens of Early and Middle Pointed structures with a few of the purest Late Pointed examples*, 2 vols. (London: George Bell, [1845]).

This folio of lithographs (which had no accompanying text) was reprinted in 1849 (2 vols. in one), 1853 (2 vols.), and 1857 (2 vols. in one). The plates are numbered not in one series but with a fresh series of roman numerals for each church. They are marked "Churches of the Middle Ages" at the top with the name of the church at the bottom, and each is about 11 by 18 inches in size.

From a total of 118 plates the following are signed lower right in letterpress: "On Stone by A. F. T."

 I. St. Andrew's, Ewerby, Lincolnshire:
 Plate I: View from the South West
 Plate II: Ground Plan
 Plate III: West Elevation
 Plate IV: South Elevation
 Plate V: East Elevation
 Plate VI and VII (double page): Longitudinal Section
 Plate VIII: Elevations of West Window of Tower
 Plate XV: Elevations of East Window of Chancel
 II. St. Mary's Chapel, Temple Balsall, Warwickshire
 Plate I: Perspective View from the South West
 Plate II: Ground Plan
 Plate III: East and West Elevations
 Plate IV: South Elevation
 Plate VII: Elevation of Window in Western Bay
 Plate XI: Elevations of West Doorway
 III. St. Andrew's, Heckington, Lincolnshire
 Plate II: Ground Plan
 Plate III: West Elevation
 Plate XVII: Elevation of South Window

6. MANCHESTER & LEEDS RAILWAY

The first title page of this volume of lithographs reads: "Views / on the / Manchester & Leeds Railway, / Drawn from Nature, and on Stone, / by / A. F. Tait: / with a Descriptive History, / by / Edwin Butterworth. / Published for A. F. Tait, / by Bradshaw and Blacklock, 59, Fleet Street, London; and 27, Brown Street, Manchester; / Publishers of the Railway and Steam Navigation Guide, etc. etc. / 1845"

Text: Title, verso blank: Dedication, 1 leaf, verso blank: Text within double ruled frame, pages (1) to 34.

Plates: Each is about 10 × 14 inches, unnumbered, signed in letterpress "A. F. Tait lith." and "Day & Haghe." and with titles on engraved surface.

 1. (Engraved title.) Views, / on the / Manchester and Leeds / Railway / Drawn from Nature and on Stone by / A. F. Tait. / (colored view 'East Entrance to Elland Tunnel') / Published by A. F. Tait, 59 Islington, Liverpool. / Day & Haghe Lithrs. to the Queen.
 2. Bridge over the Irwell, Victoria Station, Manchester
 3. Victoria Station, Hunt's Bank, Manchester (exterior)
 4. Victoria Station, Hunt's Bank, Manchester (interior)
 5. Rochdale Station
 6. Littleboro and Rochdale
 7. The Todmorden Valley, from above Mytholm Church
 8. Gawksholme [Gauxholme] Viaduct and Bridge
 9. West Entrance, Summit Tunnel [vertical]
 10. Todmorden, from the North
 11. Todmorden Viaduct & Bridge
 12. Whiteleys Viaduct, Charleston Curves

13. Hebden Bridge Station
14. Sowerby Bridge, from King's Cross
15. Halifax
16. Rastrick Terrace and Viaduct
17. Brighouse Station
18. Brighouse
19. Wakefield
20. Normanton Station

7. HYDE UNITARIAN CHAPEL, CHESIRE
Size: 13 × 9½ inches
Letterpress, lower margin: "A. F. Tait, Lith. Manchester M. Donkhouse, Printer, York /
 Hyde Unitarian Chapel, Cheshire / Henry Bowman and J. S. Crowther, Architects /
 Manchester"
Copy of lithograph at The Adirondack Museum, No. 63.65.3. Another copy at Yale
 University Art Gallery, Accession No. 1949.222.42.
Note: The church was built in 1846.

8. THE LONDON AND NORTH WESTERN RAILWAY
The following series of apparently unrecorded lithographs is part of the collections of
the National Railway Museum, York, U.K. They were probably printed shortly after
1846 when the London and North Western Railway was organized, but do not seem to
have been published and offered for sale.
 The prints are unnumbered but each is 257 × 385 mm. Except for the title page, each
has the following notations in letterpress underneath the bottom margin: lower left, "On
Stone by A. F. Tait"; lower right, "Bradshaw & Blacklock, printers"; in the center,
"Published by Bradshaw & Blacklock, London & Manchester."
Title page: "Views / on the / London and North Western Railway / Northern Division. /
 [Unidentified scenic vignette, signed A. F. Tait] / by A. F. Tait Esqre. / Printed and
 Published by / Bradshaw & Blacklock, Fleet St. London & Brown St. Manchester."
 1. Olive Mount Cutting
 2. Edge Hill Station
 3. Viaduct nr. Alderley Edge
 4. View from Alderley Edge
 5. London Road Station
 6. Parkside Station
 7. Crewe Station
 8. Victoria Station, Manchester
 9. Chat Moss
 10. Sankey Viaduct
 11. Stockport Viaduct
 12. Warrington Junction
 13. Weaver Viaduct
 14. Newton
 15. Stafford from the Castle

9. ALBERT TOWER, ISLE OF MAN
Size: 9 × 12 inches
Letterpress, lower margin, left to right: "Bradshaw and Blacklock, Lith. Manchester
 View of Albert Tower, Ramsey, Isle of Man"
Inside the plate, lower left, is the monogram "AFT."
Copy at Yale University Art Gallery, Accession No. 1949.222.41.
Note: This tower was erected some time after the visit of the Prince Consort on Septem-
 ber 20, 1847.

Appendix
American Prints after Arthur F. Tait

This list of titles of American prints after Tait's works which were published during his life time is a guide to the entry number in the checklist of each of the original paintings. Some of these pictures are discussed in the biographical sketch and are also noted in its index.

I Prints Published by N. Currier and Currier & Ives

Detailed information about these prints regarding their sizes, states, lithographers and copyright may readily be found in several reference works devoted exclusively to the publishing firm and its history. The most recent and complete is *Currier & Ives: A Catalogue Raisonné . . . with an Introduction by Bernard F. Reilly* (Detroit: Gale Research Co., 1984).

In a few instances it has not been possible to identify the original painting in Tait's records and no checklist entry number is given.

The Alarm 61.14
American Feathered Game, Mallard and Canvas Back Ducks 54.12
American Feathered Game, Partridges
American Feathered Game, Wood Duck and Golden Eye
American Feathered Game, Woodcock and Snipe
American Field Sports, "A Chance for Both Barrels" 57.7
American Field Sports, "Flush'd" 57.5
American Field Sports, "On a Point" 57.4
American Field Sports, "Retrieving" 57.14
American Forest Scene, Maple Sugaring 55.5
American Frontier Life, "The Hunter's Strategem" 62.2
American Frontier Life, On the War Path
American Hunting Scenes, "An Early Start" 62.17
American Hunting Scenes, "A Good Chance" 62.9
American Speckled Brook Trout 63.1
American Winter Sports, Trout Fishing "On Chateaugay Lake" 54.27
Arguing the Point 54.28
Babes in the Woods
Brook Trout Fishing, "An Anxious Moment" 62.14
Camping in the Woods, "A Good Time Coming" 62.15
Camping in the Woods, "Laying Off" 62.18
The Cares of a Family 55.10
Catching a Trout, "We hab you now, sar!" 54.21
A Check, "Keep your Distance" 52.23
The Home of the Deer, Morning in The Adirondacks 61.32

Select Bibliography to Tait's Career

Adirondack Museum. *A. F. Tait: Artist in the Adirondacks.* Blue Mountain Lake, N.Y.: The Adirondack Museum, 1974.

[Avery, Samuel P.] "Arthur F. Tait." *Cosmopolitan Art Journal* 2 (1858): 103–4.

Bennett, Mary. *Merseyside Painters, People and Places.* Liverpool: Walker Art Gallery, 1978.

Boalch, H. D. *Prints and Paintings of British Farm Livestock, 1780–1910.* Harpenden, England: Rothamsted Experimental Station Library, 1958.

Callow, James T. *Kindred Spirits, Knickerbocker Writers and American Artists, 1807–1855.* Chapel Hill: The University of North Carolina Press, 1967.

Clark, Kenneth. *Animals and Men.* New York: W. Morrow, 1977.

Coker, Richard G. *Portrait of an American Painter: Edward Gay.* New York: Vantage Press, 1973.

Frankenstein, Alfred. *William Sidney Mount.* New York: Harry N. Abrams, 1975.

Grubar, Francis S. *William Ranney, Painter of the Early West.* New York: C. N. Potter, 1962.

Harris, Neil. *The Artist in American Society: The Formative Years, 1790–1860.* New York: George Braziller, 1966.

Hitchcock, Henry-Russell. *Early Victorian Architecture in Britain.* New Haven, Conn.: Yale University Press, 1954.

Klingender, Francis D. *Art and the Industrial Revolution* [revised and edited by Arthur Elton]. St. Albans, Herts.: Paladin, 1972.

Lewin, Henry G. *The Railway Mania and its Aftermath, 1845–1852.* London: Railway Gazette, 1936.

Lynes, Russell. *The Art Makers of Nineteenth Century America.* New York: G. P. Putnam's Sons, 1970.

Mann, Maybelle. *The American Art-Union.* Otisville, N.Y.: ALM Associates, 1977.

Marlor, Clark S. *A History of the Brooklyn Art Association with an Index of Exhibitions.* New York: J. F. Carr, 1970.

Marshall, John. *The Lancashire and Yorkshire Railway.* New York: Augustus M. Kelley, 1969.

Marzio, Peter C. *The Democratic Art, Lithography, 1840–1900, Pictures for a 19th Century America.* Boston: David R. Godine, 1979.

Miller, Lillian B. *Patrons and Patriotism: The Encouragement of the Fine Arts in the United States, 1790–1860.* Chicago: University of Chicago Press, 1966.

Ormond, Richard. *Sir Edwin Landseer.* Philadelphia, Pa.: Philadelphia Museum of Art, 1981.

Peters, Harry T. *Currier & Ives: Printmakers to the American People.* 2 vols. Garden City, N.Y.: Doubleday, Doran & Co., 1929–31.

Rees, Gareth. *Early Railway Prints, a Social History of the Railways from 1825 to 1850.* Oxford: Phaidon Press, 1980.

Richardson, Edgar P. *A Short History of Painting in America.* New York: Thomas Y. Crowell Co., 1963.

Walker, Stella A. *Sporting Art, England, 1700–1900.* New York: Clarkson N. Potter, 1972.

Whitehead, Charles E. *Wild Sports in the South; or, the Camp-Fires of the Everglades.* New York: Derby & Jackson, 1860.

Williams, Hermann Warner, Jr. *Mirror to the American Past, A Survey of American Genre Painting: 1700–1900.* Greenwich, Conn.: New York Graphic Society, 1973.

Index to Tait's Career

Title Index to the Checklist

Figures in boldface type indicate illustrations.